AVEDON

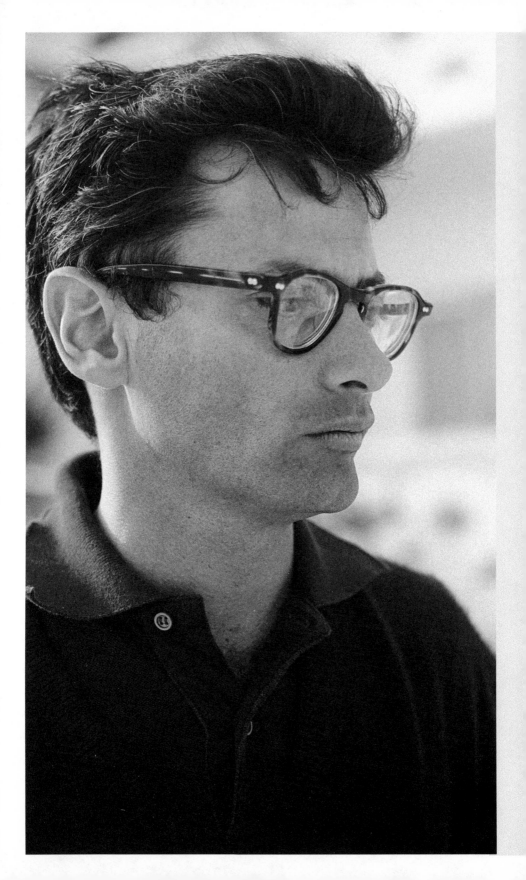

AVEDON

something personal

NORMA STEVENS & STEVEN M. L. ARONSON

SPI
EGE
L&G
RAU

SPIEGEL & GRAU / NEW YORK

Published in the United States by Spiegel & Grau,
an imprint of Random House, a division of
Penguin Random House LLC, New York.

SPIEGEL & GRAU and Design is a registered
trademark of Penguin Random House LLC.

Full photograph credits can be found beginning on page 679.

Hardback ISBN 978-0-8129-9443-8
Ebook ISBN 978-0-8129-9444-5

Printed in the United States of America on acid-free paper

randomhousebooks.com
spiegelandgrau.com

246897531

First Edition

*Endpaper images and frontispiece
photo by Alen MacWeeney*

Book design by Barbara M. Bachman

For Martin

Star-Quality: it can shine, on peacock days,
like a plume of luck above your genius.

—WALTER SICKERT

CONTENTS

—

AVEDON

1

OVERTURE

—

NEW YEAR'S EVE 1975. MY HUSBAND AND I WERE HAVING a few friends over for a champagne toast. Martin was the worldwide creative director of Revlon at the time and had invited to drop by— should he have nothing better to do—his go-to photographer for big splashy four-color "lips and matching fingertips" ad campaigns ("Fire and Ice," "Persian Melon," "Cherries in the Snow," "Stormy Pink," "Wine with Everything"...). A little before midnight Richard Avedon—the ne-plus-ultra arbiter of feminine grace and beauty, the ambassador of glamour, the epitome of chic—burst through our front door bearing a dozen American Beauty roses, which he presented to me with romantic-comedy panache, fanning them out as if he were showing his hand in a card game. "You shouldn't have," I said, "but now I think I'd be disappointed if you hadn't."

It was an entrance—a performance—worthy of Fred Astaire. And why not, I thought, since Astaire's character in the film *Funny Face* had been modeled on *him*. I remember what he had on that night: lavender silk shirt, skinny black knitted tie, dove-gray double-breasted suit fitted to his wiry frame. And behind the horn-rimmed glasses, those black mile-a-minute pinwheel eyes! And then the crowning glory—his untamed mane of silvery hair.

After I'd introduced him to our other guests, he pulled me aside and said, "I've got to talk to you. Where can we go?"

I HAD MET RICHARD AVEDON for the first time in the late 1960s when I was a Mad Woman—the creative director of a small advertising agency. I worked on girlie accounts like Coty, Charles of the Ritz, and Monsanto—cosmetics, fibers, and fabrics—while aching to cut my teeth on bigger-budget stuff like cars and booze. One of my clients, Almay, was about to launch a hypoallergenic line to compete with Estée Lauder's Clinique, for which Irving Penn had produced a series of pristine still lifes that spoke to the product's immaculate conception. There was only one photographer who could give Penn a run for his money, and that was Richard Avedon.

I contacted his longtime rep, Laura Kanelous, who asked right off the bat, "What's in the budget?" When I told her, she said, "Forget it. He won't work for that." I doubled the money. She said, "Keep going!" I said, "That's it." She said, "Okay, but you only get six months' usage," and she put me through to Avedon. "What's up?" he barked. I was hearing that unmistakably New York voice for the first time. In *my* New York voice I told him how I saw the ad: clean, white, pure, nun-like. He said "I got it" and hung up.

The morning of the sitting I dressed expressly for him—cream silk shirt, crisp blue blazer with gold buttons, designer shoes. I walked the few blocks from my office to the Avedon studio on East Fifty-eighth Street eager to meet the legend, and I'm not embarrassed to admit that when he charged into the reception area to greet me I felt the electricity.

Over coffee he fired off a volley of personal questions—where had I gone to college, what was I reading, what did I like to eat?—but before I could get two words out he was directing my attention to one of his celebrated portraits of Marilyn Monroe that was propped against a wall. And before I knew it he was telling me how she had reached out to him from a phone booth in Beverly Hills just a couple of days before she "committed sui" because she needed him to know that he was the only photographer she implicitly trusted and that more people complimented her on the pictures he had taken of her than on the pictures—

DICK AND MARILYN, 1959.

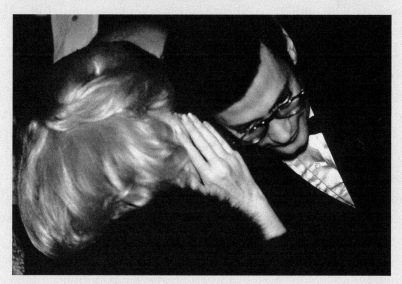

HIGHLY CONFIDENTIAL.

the movies—she'd made. "She confided in me an awful lot," he said. "She even gave me the phone number she said no one else had."

At that point the stylist appeared and said, "We're ready," and the model, a Swedish beauty, emerged from the dressing room. Avedon approved her hair and makeup, and then back she went, to be dressed.

But when she reappeared, she was swathed not in white organdy like the virgin I'd envisioned but embalmed head to toe in rolls of Saran Wrap. He said to me, "Don't you love this!" I did—I recognized it as something that had never been done before. No surprise there: Avedon was the photographer of so many firsts—the first portrait of *the* First Family, JFK and Jackie; the first belly button in an American high-fashion mag, Suzy Parker's; the first bared breasts, Contessa Christina Paolozzi's; the first ménage à trois; the first fashion-mag cover boy, Steve McQueen; the first haute-couture black beauty, Donyale Luna; the first to shoot outdoors in Paris after the Occupation . . . So why not, now, the first hypoallergenic mummy?

He led the model onto the set, turned up the music (Ella Fitzgerald), and clicked away. When I presented the image to my client, they didn't buy it: they wanted something literal. I broke the news to Laura Kanelous, who said, "No reshoot. And Avedon gets paid in full." This felt like the ending of Dick and Me. It was just the beginning.

THE NEXT TIME I encountered Richard Avedon, I had just married his biggest client. He sent Martin the following telegram: CONGRATU-LATIONS STOP YOU HAVE JUST WON THE MARRIAGE PORTRAIT OF THE YEAR STOP YOU AND YOUR BRIDE ARE EXPECTED AT THE AVEDON STU-DIO ON THURSDAY 10 A.M. LOVE DICK. I slipped back into my flowered black voile wedding dress for the occasion. Avedon took one look at me and said, "Oh, it's *you*! The Almay girl. The girl with white on the brain. Who I see got married in a black dress. This union is doomed," he said, laughing.

The celebrity hairdresser Ernie Adler was on hand to do my hair. When he was done, Avedon turned on the big-band music he knew Martin liked, and said to us, "Dance!" I did an arabesque holding on to Martin's arm (I had once, briefly, been a bunhead—a baby ballerina). He said "Fabulous!" and clicked. It was over so quickly I had post-performance depression. Which lifted the minute he brought out champagne and caviar, crying, "Eat! Drink!" Later that week he sent us a complete album of wedding photographs, ending with a signed formal portrait: the first of the innumerable Avedons we were to own, and the most precious.

———

IT WOULD BE A COUPLE of years before I saw Avedon again. Martin and I ran into him and his onetime star model Dorian Leigh in 1972 in the lobby of the Paris Ritz, and he insisted that we join them for a drink in the bar. Martin and Dorian were nose to nose, catching up, so Dick turned his attention to me. "I've just bought a carriage house way over east on Seventy-fifth Street that I'm going to make into my new studio," he said. "I'm planning to live there, too. Over the store—like the Goodmans do, above Bergdorf." I asked him how his wife felt about the move. "I'm running away from home," he told me. "I'm flying the coop. I'm going to go it alone. Only I haven't told her yet. What do you think I should say?" I was so startled by his question

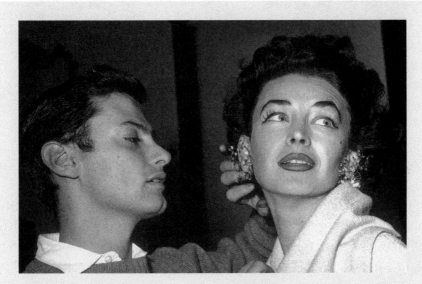

DICK AND DORIAN LEIGH, HIS "FIRE AND ICE" GIRL, 1955.

that I had to take a sip of champagne before answering, "Tell her it's nothing personal, it's just about work." He said, "Oh, that's good. You've saved my life."

"*Dick*," Dorian was elbowing him, "you've been ignoring me!" He spun around. "How could I possibly ignore my first *Bazaar* cover?" he exclaimed. "My first face for Revlon. My Fire and Ice girl, who 'loves

to flirt with fire,' who 'dares to skate on thin ice.' I even forgave her for having once been engaged to Irving Penn." He turned to Martin: "Did I ever tell you that Dorian and I won first prize in a Charleston contest

MARTIN STEVENS AND EVELYN AVEDON ON
THE LEFT, DICK AND MALE MODEL ROBIN TATTERSALL
ON THE RIGHT, PARIS, 1959.

at the Tavern on the Green when we were kids? Actually, I was twenty-nine and leaving the next morning on my honeymoon with Evelyn. Oh *boy*," he said, turning back to Dorian, who was giving him an icy stare and breathing fire, "let's go—we have a reservation at Véfour."

No sooner were these avatars of glamour out of earshot than Martin was regaling me with how, once when he had had to put a Revlon shoot on hold because Dorian was outrageously late, Dick had amused himself by compiling a list of all the men he knew for a fact she had slept with. He had gotten up to sixty-two by the time she appeared, and had just finished saying, "She'd go to bed with anything." Martin sheepishly informed me that he was on the list.

Within the year I heard that Richard Avedon had left his wife. I remember wondering if he had used my line of departure.

———

NOW, THREE YEARS LATER, he was back in my life. He was standing in my living room, having just asked me where we—I was pinching myself: he and I—could go to be private.

I led him into the library, where he sank into the couch, put his head in his hands, and broke down. "Forgive me for making an exhibition of myself," he finally said, "but the single most important person in my life for the past twenty-five years just died." I had noticed Laura Kanelous's name in the *Times* paid obituaries—she had slipped away on Christmas Eve, at only fifty. Everyone in the business had known for a long time that she was deathly ill. "I never saw it coming," Dick insisted. I mentioned that I had run into her a couple of times at lunch at the Isle of Capri and she was wearing the telltale turban. He said, "Yeah, but I thought it was just a fashion statement—Laura trying to be stylish." Terminal denial.

Now he was welling up again. "Laura was so funny!" he said. "The week before she died she was carrying on that I owed her a full-length mink. She claimed that schlepping my heavy portfolio all around town to all the art directors in the early days had worn a big bald spot on her dark ranch coat. I went straight to Maximilian the next morning and dropped ten grand. I have the beast hidden in my studio. I can't face going to work. I'm totally lost without her. I'm probably going to have to close the studio. The last deal she made for me was with a Japanese client who kept going back and forth on the fee. In the end she wore him down. The guy said, 'Okay, okay. We'll start shooting December seventh,' and she quipped, 'Not *this* time you won't!' That was Laura for you all over. And now it *is* all over. Where am I ever going to find a mouthpiece like that again?"

I said, "Don't worry, Dick, you'll find someone great—they're going to be lining up around the block to work for you." He apologized again for "the waterworks," and downed a third flute of champagne before calling it a night on the last night of the year.

AT TWO IN THE MORNING, Martin and I were in bed rehashing the party when the phone rang. The voice on the other end said, "Did I

wake you? It's Dick. I was so impressed with how you received my flowers tonight—with open arms and then holding them close. That's my dream of how flowers should be received." I said, "Are you all right?" He said, "I *will* be—if you promise to come work with me and never leave." I said, "Dick, you've had too much to drink."

He said, "I'm serious. Laura got 10 percent of advertising, I'll give you 15. And I'll give you a month off every summer, and a month in the winter. We're going to make a lot of money together and have a lot of fun." (A year later, he upped my percentage to 25, but I never got even a week off without a fight.) Whenever anyone asked me how I got the job, I left out Dick's wild middle-of-the-night call, thinking it made the win less "earned," somehow. But now I want to own it.

AFTER HANGING UP, I rolled over in bed and said to Martin, "You're never going to believe this . . ." He said, "Grab it! It's the perfect job for you. You're going to really click with Dick." I protested that I didn't know enough about the photography business. He reassured me, "If Laura could do it, *you* can. She knew advertising from the outside in, *you* know it from the inside out."

Later that morning Martin methodically laid out the pros and cons for me. He had, after all, been experiencing the ups and downs of working with Richard Avedon for years—they had done fifty Revlon ads together. First of all, he pointed out that if I became Avedon's agent, studio director, and business manager, he and I would be reversing roles in relation to Dick: he would become "Norma's husband," and I would no longer be just "Martin's wife."

"He's overwhelming," Martin warned me, "but you can handle him. You're also going to have to be the bad cop with the clients, because nothing is ever too much where Dick is concerned when it's OPM—other people's money—he's spending." Martin then rattled off a few examples of how extravagant Avedon could be. For the shade ad "Persian Melon," Dick had a replica of a Persian palace built, which turned out to be too big for the studio Martin was renting, so he had to rent a more palatial one. Another Revlon shade ad had a jazz theme, and Dick had thought nothing of hiring a clarinetist from the New York Philharmonic to show the model how to hold the instrument.

Then, for an ad for Revlon's "Rio!" lipstick campaign, after Martin had approved the booking of a carnival dancer to back up model Janice Dickinson, Dick hired the whole cast of a Broadway show: twenty-four hoofers in full costume. "See this!" Martin gestured toward the bouquet of handmade lilacs in our bedroom that he had recently brought home from a "Lilacs in the Snow" shoot. "There's a city block full of places where you can get beautiful, realistic-looking artificial flowers, but that's not Dick's way—he had to have them custom-made in silk by a French floral couturier. And if you take the job, it's you who are going to have to make the client understand that this is all part of getting the perfect picture.

"He's an incredible stickler for perfection," Martin went on. "Even if he was only doing a head shot and the hands and feet weren't going to show, he would insist on a manicurist for the nails and toes so the model would feel totally beautiful. You'll have to watch out—he can get very emotional about his work. One time, when he clashed with the Revlon marketing director over the size of the product shot, he grabbed him by the throat and wrestled him to the floor—which to this day remains that guy's claim to fame.

"With only a day and a half to go before the deadline for our new lipstick and nail color, 'Tawny,' he was reviewing contacts and decided he didn't like the model's body, although he loved her face. They both belonged to Candice Bergen, by the way. So how does Dick solve the problem? The next afternoon he's photographing Jean Shrimpton for another client, and at the end of the session he has her lie down in the 'Tawny' position, and then later, in the darkroom, he puts Candy's head on The Shrimp's body, like a jigsaw puzzle. And remember the picture he did of Elizabeth Taylor with the diamonds on her back? It wasn't her back."

I thought, This is going to be fun! The next morning I gave notice at my ad agency, and a couple of weeks later I went to work for Dick.

HOW MANY PEOPLE CAN say they were never for a minute bored with their job? For the next thirty years, I had the time of my life managing all aspects of Richard Avedon's professional life. To the degree that he was married to his work, which was the *nth* degree, I was his

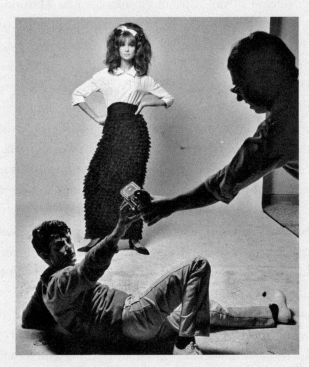

DICK
SHOOTING
SHRIMPTON,
1965.

work wife. This meant I had two husbands. Every once in a while my marriages would collide. During my first year with Dick, Martin and I had a standoff: my real-life husband had a certain amount budgeted for my business husband's Revlon fee, and I wanted double. Martin said, "C'mon, back off—you have to do this for me." "No," I said, "it's Dick I have to do it for." I got the fee. "I created a monster," Martin groaned.

From the moment I started working at the studio, I was pulled in two directions—Dick in one, Martin and our son and daughter in the other. No matter which way I went, right or left, I felt guilty. There were no boundaries as to when Dick would call or what he would demand. Martin would answer the phone in the middle of the night, and Dick would growl, "Norma there?" and Martin would answer, sarcastically, "She's been expecting your call." Dick worked 24/7 and expected the same of me. When I got in at nine in the morning he would be standing there looking at his watch and going, "Where have you been?"

And when I tried to leave at six-thirty to go home to my family, he would say, "Half a day?"

I was earning my keep, believe me. Over time I drove up Dick's prices to the point where one client felt entitled to call me a pig to my face. I came up with the idea that for select clients Dick should function in the capacity of creative director as well as photographer: he would conceive, conceptualize, copy-write, art-direct, design, cast, and produce TV commercials and print ads, and thereby receive, in addition to his fee for per-print ad shots, 15 percent of the media budget. He would be operating in effect as a one-man ad agency. Among the clients who jumped at the opportunity to have Dick do everything for them were Calvin Klein and Christian Dior. The day the first check cleared as a result of this new arrangement, Dick left this little billet-doux on my desk: "Norma, love and money forever, the two of us!" (Dick was funny about money. There was the time he was mugged, at knifepoint—he had pocketsful of cash and his life was on the line, yet he pulled out a dollar. The guy repaid him with a punch in the eye socket. Never one to waste a photo op, the next morning Dick took a self-portrait-with-shiner.)

Dick and I stuck together through thick and thick. The commissions I received often verged on the torrential—they poured in. And this wasn't counting the perks: front-row seats, first-class travel, four-star restaurants, five-star hotels, cars and drivers. And clothes—the latest Versaces, Pradas, Calvins, YSLs, Diors, and so forth—all complimentary. Not to mention jewels: one morning I arrived at work to find my desk strewn with emeralds, diamonds, and rubies, all of them neatly scissored out of magazine ads by Dick, who personally pinned each one on my blouse.

During the course of our business marriage—our thirty years in cahoots—Dick never made a move of any consequence without me. I negotiated all his advertising and editorial contracts, plus his portrait commissions; I collaborated on all the presentations to clients; I participated in the final choice of every photograph submitted to magazines and museums; I accompanied him on all his far-flung lecture tours and to all his exhibitions here and abroad; and I had significant input in his groundbreaking books. Dick could be temperamental—to

the point of storming off the set when he wasn't getting his way. It would then be left to me to placate often equally ornery clients, magazine editors, art directors, models, and stars.

Dick and I talked on the telephone the first thing every morning and the last thing every night. He was never not telling a story, but it was usually very late at night or on weekends when all the deep tales of his childhood and adolescence, all the really personal stuff, came spilling out, backward and forward, sideways and upside down, and he would say, "Did you get that?" They were too good not to scribble down occasionally. Some of them, truth to tell, were too good to possibly be true. (Dick would sometimes make merry with the facts—he even joked that if he ever wrote an autobiography he would call it *Here Lies Richard Avedon*. He said, "There is no truth, no history—there is only the way in which the story is told.")

In 2004 I was at his side when he left this world. And he expected me to be there beyond. Dick's Last Will and Testament instructed the directors of the eponymous foundation he was creating to "employ Norma Stevens as its executive administrator and as agent with respect to sales of and licensing of rights in my photographs (in which capacity she is acting during my life and in which capacity I desire her to continue after my death)."

I duly launched the Richard Avedon Foundation, and led it for five productive years, protecting Dick's work and extending his legacy. I initiated gallery and museum exhibitions (complete with heavy-duty catalogues), including, in 2008, the first Avedon retrospective in France—at Paris's Jeu de Paume. And I oversaw the execution of five books of Avedon photographs: *Richard Avedon: Photographs 1946–2004; Performance; Woman in the Mirror; Portraits of Power;* and *Avedon Fashion: 1944–2000.*

Avedon Fashion, designed by one of Dick's most talented stalwarts, Yolanda Cuomo, was published in conjunction with the final exhibition that I coordinated as the official keeper of Dick's flame: the International Center of Photography's 2009 full-dress survey of his fashion work. It occupied the entire museum and ended up being one of the best-attended shows in ICP's history. It brought me full circle from the

first museum show I'd worked on with Dick: the Metropolitan Museum's thirty-year retrospective of his fashion work, in 1978.

WRITING ABOUT DICK WAS something I had never given a thought to, until one day in the mid-eighties when he was sitting in the Eames chair in his living room reading and he began laughing out loud. I asked him what was so funny. He handed me the book—a bestseller called *Madame*, an irreverent, sharply affectionate chronicle of the life and times of his erstwhile client the colorful cosmetics tycoon Helena Rubinstein, written by her closest associate. "I hope *your* book will be this much fun," he said.

"*My* book?"

"I know what an irresistible subject I am," he said, laughing. "Let's face it—you're going to write about me someday."

Later, right around the millennium, Dick and I were flying home from Qatar, where he had just completed the most exotic and lucrative private commission of his sixty-year-long career: photographing the pri-

DICK AND NORMA AT WORK, CIRCA 1980.

vate menagerie of endangered species belonging to a movie-star-handsome, art-and-photography-collecting billionaire sheikh. Dick turned to me and said, "This was certainly one for the books. You're going to put it in yours, I hope." By this time I knew what he meant, because periodically in the intervening years he would refer to the book he presumed I'd one day be writing, which he was far more sure of than I was. He called up the famous curtain line of *Tea and Sympathy*, mock-intoning, "Years from now, when you talk about this, and you will, be kind," quickly adding, "Only, *don't* be kind—I don't want a tribute, I want a portrait, and the best portrait is always the truth. Make me into an Avedon."

2

CURTAIN RAISERS

—

WHEN I JUMPED HEADLONG INTO THE WORLD OF RICH-
ard Avedon, the master of the fashion-photography universe was up to
his eyeballs in eye shadow, eyeliner, mascara, lipstick, blusher, per-
fume, and just about every other habit-forming product in the United
States of Advertising. He was in demand: his ads all "pulled." My job
was to keep it all going, and then some.

While Dick was putting almost everything he had into his commer-
cial work, it wasn't what he got the most out of (aside from money,
needless to say). What nourished him was his portrait work, which
drew on the artist in him. The instrument of choice for his portraits was
his eight-by-ten mahogany Deardorff view camera mounted on a vin-
tage Majestic tripod. This contraption looked like a cross between
the camera that Mathew Brady used during the Civil War and the
monolith in Stanley Kubrick's *2001* — it was, in other words, the
four-hundred-pound gorilla in the room. Dick counted on its intimi-
datingness to heighten the gravity of the occasion for the sitter. He had
switched to it at the end of the sixties when the small handheld Rol-
leiflex he'd been using for a quarter of a century began to feel like a
reflex. Also, you had to look down through its viewfinder, which Dick

came to regard as a barrier between him and his subject. "You know—three's a crowd!" he quipped.

"*This* dinosaur I don't even need to stand behind," he explained, of the Deardorff, which he had had souped up. "I can just stand a couple of inches to the left of the lens and control the shutter with the cable release I'm holding in my hand, and meet my subject eye to eye." For a lecture Dick would often come onstage dragging the Deardorff behind him. "This is my best friend," he would tell the audience, and they were indeed, for all practical purposes, joined at the hip.

The meet-greet-and-eat area of the studio served as a platform for Dick and the sitter to get acquainted. He referred to this as "the foreplay," which wasn't that much of an exaggeration—Dick could get intimate with anybody in nothing flat. At the far end of the carriage house's first floor was the set—the cyclorama, or cyc, for short. It consisted of a cove, a curving eggshell-shaped wall painted white (and repainted for each sitting). The floor was white as well—"as white as a Beckett landscape," Dick maintained, "or a snowstorm." And the white was flat and without depth and therefore seemingly without end; the space engendered a feeling of spaciness. There were no props, no trappings, in sight—the sitters were isolated in the cyc and could thereby "become symbolic of themselves." Dick's oft-stated aim was to use what he called "the emotional topography" of the face to expose and explode the façade. "The portrait photograph is Avedon's naked stage, his blasted heath," Salman Rushdie, whose portrait Dick took twice, once wrote.

Richard Avedon called the shots: as far as he was concerned, there were only two things involved in any sitting—manipulation and submission. (He had confessed to the photographer Walker Evans in 1969, in the hope of securing a sitting, that "much of my past work has been manipulative, in a way that would make *me* reluctant to pose for *me*.") What's more, Dick believed that he was manipulating his sitters in order to express him*self*. "I key right into them, try to get them to donate themselves to my own feelings and ideas, and then I squeeze them out," he declared—small wonder he was taken to task for leaving his figurative fingerprints all over their faces. He felt he could will what he wanted to see, which was, more often than not, what the subject wanted

to hide—it was literally a command performance on Dick's part. "A sitting can become a kind of duel," Dick admitted—to which one critic retorted, "Avedon is supremely seductive and few are inclined to turn down his invitation to a beheading." Though I witnessed the process times beyond number, all I can say is there was a lot more to it than met the eye. It was witchery, black-and-white magic—the art that concealed art.

I hadn't been working at the studio more than a few weeks when Dick walked into my office, closing the door behind him. All this commercial work he was getting was great, he said, but it was also serving to confirm the jaundiced view the art world had of him. He told me that there was a proposal for an Avedon fashion retrospective being floated in the sacrosanct precincts of America's grandest temple of art, the Metropolitan Museum, but that things were moving at the molasses pace of bureaucracy: at museum speed, which didn't register on *his* odometer. He said, "The Met's never going to give me a show." To which, quick on the uptake, I replied, "Not so fast!"

DICK HADN'T HAD MUCH of a history in terms of museums. His first exhibition, however, had been held in a place that was American history incarnate—the Smithsonian Institution. In 1962 he had called them cold to say that he was considering donating some of his early negatives and prints. The upshot of that short conversation was a mini fashion-and-portraits retrospective that November. Dick had bristled when he learned they wanted to put him in what he characterized as "a ghetto"—their *photography* gallery. "I explained to them that I considered myself an *artist*—an artist who happened to work in the medium of photography—and that I didn't want my pictures treated like stepkids." They told him he could take it or leave it.

To help with the show, Dick recruited Marvin Israel, a graphic designer and a painter of original vision, whose judgment he trusted and often deferred to. Marvin came from a similar background—his father owned a chain of women's specialty shops. He was scruffy, grouchy, short-fused, and combustible—he once kicked one of his female students at the Parsons School of Design in the shin. Some of Marvin's paintings were of aggressive dogs, and some of *them* he described as

ALEN MACWEENEY

MARVIN ISRAEL
"AT WORK,"
TERRACE OF
HOTEL
SAN RÉGIS,
PARIS, 1961.

self-portraits. Dick wittily said of him that "he refused to rub life the right way." At the time of the Smithsonian, Marvin was the newly installed art director of the magazine with which Dick's name had been synonymous since the mid-forties—*Harper's Bazaar.* When he was fired the next year, after a mere twenty issues, Dick graciously commented, "Marvin found the pressure of commercialism emasculating." But by the time I arrived on the scene, they were no longer speaking. In fact, one of the first things Dick said to me was, "If somebody by the name of Marvin Israel calls, hang up."

Marvin had leapt at the chance to work with Dick on the show. "He was a genius at taking bits and pieces with seemingly no connection and making them look like they were meant for each other," Dick explained to me. "He came up with a new way for the viewer to experience a photography exhibition—more like magazine pages." Marvin's

inspiration was Dick's own studio wall. The museum was expecting cohesion, but what they got looked more like chaos: a patchwork of photographs interspersed with archival material such as notes to and from sitters, ad-page proofs, Photostats, contact sheets complete with instructions for retouching and marks for cropping, and even an engraver's plate. The Smithsonian craftily promoted the show as a "100-foot-long collage . . . a panoramic composite."

Two of Marvin's innovations were no-nos: no identification labels on the photographs, and no frames on many of them (they were to be simply tacked up at the top and left to hang loose). Several were blown up to an unprecedented size—"to have the impact of Easter Island statues," no less. Visitors to the exhibition were for the most part taken aback, and the reviews were not even few and far between. The sole mention the show received was in Betty Beale's gossip column "Exclusively Yours" in the Washington *Evening Star*. She groused that "unless you recognized them you would not know that two of the beautiful women photographed were out-of-town guests at private dinner dances in the White House last year: Princess Elizabeth of Yugoslavia and Mrs. Gianni Agnelli, wife of the Fiat tycoon. You also wouldn't know that the beauteous young woman who was photographed standing full-faced and nude from the hips up is Countess Christina Paolozzi of Italy." As Dick and Marvin saw it, ignorance was bliss.

Dick would have to wait until 1965 for his next show. The venue was admittedly a bit of a comedown from the toplofty Smithsonian: the halls of an ad agency—McCann-Erickson, of future *Mad Men* fame. The installation, once again, amounted to an oxymoron: controlled chaos. The material was mainly Dick's commercial stuff: page proofs, layouts, tear sheets, contact sheets, and blowups tacked up on or propped against the walls. The opening was wall-to-wall, too—"more like a happening," Dick recalled. At the end of the evening, various items were missing, and the agency hired a couple of security guards for the duration. This time Dick had a hit on his hands—the critic for *Popular Photography* gushed that it was "the most spectacular photographic show ever," adding presciently, "This explosive talent called Avedon will have long-range effects on all men who think seriously about hanging pictures on walls."

Five years later Dick would actually have the most spectacular photography show ever—the largest yet devoted to the work of a single photographer by any American museum. Ted Hartwell, the founding curator of photography at the Minneapolis Institute of Arts, was the first in the photography-curator fraternity to recognize that Richard Avedon was far more than just a fashion photographer, and he was prepared to deploy the better part of his museum to make his case. The press release heralding the exhibition described Dick as "a photographer previously known primarily for his fashion photography." (Previously? For the rest of his natural life Dick would go on being primarily described as primarily a fashion photographer, and the headline of his front-page obituary in *The New York Times* would read "RICHARD AVEDON, THE EYE OF FASHION, DIES AT 81.") At the outset Dick stipulated that the show not include a single fashion picture. "Even *one* would confuse the issue," he insisted. "*Fashion* is the *f* word, the dirtiest word in the eyes of the art world."

Again he collaborated with Marvin on the show, and the fur flew. In the week leading up to the opening people saw Marvin literally pushing Richard Avedon around—possibly to show off in front of his girlfriend, Diane Arbus, who was in Minneapolis to lend a helping hand. Dick recalled that Diane was out of sorts, having recently discovered that Marvin was also "doing Doon," her older daughter, who had just gone to work for Dick (something Diane also deeply resented). Why did Dick, of all take-charge people, put up with Marvin's take-no-prisoners behavior? "I needed him," he explained. It was Marvin who suggested the silver palette for the Masonite walls and the silver-foil coating for the catalogue. Together with Dick he created a sense of momentum, even of suspense, for the show; there was no way for the viewer to anticipate what kind of thing he might be seeing next, whether a mummy from the Capuchin catacombs of Palermo or a Manhattan City Hall wedding.

The approximately 250 portraits—taken in Dick's by then signature style, with the subject isolated against the background of stark-white seamless paper, facing into the lens for a head-on view—represented a cross section of his portrait work since 1947. Most of them already occupied a place in the visual vocabulary of the magazine-reading public.

Among the literary leading lights on view in Minneapolis were Dick's friend Truman Capote (they had collaborated on the landmark 1959 book *Observations*), his high-school classmate James Baldwin (they had collaborated on the divisive 1964 book *Nothing Personal*), Noël Coward, Dorothy Parker, Somerset Maugham, Isak Dinesen, two wordsmiths named Miller (Arthur and Henry), one Mailer, E. M. Forster, T. S. Eliot, W. H. Auden, Marianne Moore, and Ezra Pound, taken the day after the poet's release from a psychiatric hospital and showing him in three-quarter-length view with eyes squeezed shut and mouth pried open—a work that Dick justifiably felt rivaled the great nineteenth-century photographer Julia Margaret Cameron's portrait of Thomas Carlyle.

Artists in the exhibition included Giacometti, de Kooning, Braque, Chagall, Duchamp, Georgia O'Keeffe, and Picasso (his son Claude had been one of Dick's studio assistants); performing artists numbered Charlie Chaplin, Judy Garland, Bogart, Nureyev, Mae West, Marilyn Monroe, Charles Laughton, Louis Armstrong, Jimmy Durante, Bert Lahr, Ethel Merman, Arthur Rubinstein, Van Cliburn, Ringo Starr, Maurice Chevalier, and Igor Stravinsky; and political figures were represented by Adlai Stevenson, Adam Clayton Powell, Malcolm X, George Wallace, and Billy Graham (the latter two were pointedly hung next to each other).

At the eleventh hour Dick decided to exhibit his portraits of the antiwar activists known as the Chicago Seven, which he had taken in his suite at the Hilton in September 1969, the day after their conspiracy trial began—they were ultimately convicted of crossing state lines with intent to incite a riot and of delivering inflammatory speeches. "They're heroes," Dick declared, "and they need to be seen, and seen as such, *now.*" He had the individual photographs blown up huge, and the group portrait enlarged to mural-size. The pictures may have looked like mugshots, but they felt tectonic. Marvin knew at a glance that the only place to display them was the corner gallery—the last stop in the show.

The room he designed had a black entrance curtain, black carpeting, a black bench, and skylights blacked out—amounting to, in Marvin's words, "installation as social commentary." Dick had the

photographs individually lit. It was also his idea to have, in place of music, speakers on the ceiling broadcasting a tape of choice incendiary remarks that the Seven had made during interviews with Doon Arbus, such as Abbie Hoffman's incendiary "Living in America I expect to get killed." Such recriminations were sure to be music to the ears of the counterculturists whom Dick and Marvin were counting on to show up in force and occupy the room at the July 2, 1970, opening. Dick and Marvin went to exceptional lengths to pack the house with the most anti-establishment characters they could find: night after night they drove up and down the mean streets of conservative Minneapolis dispensing invitations through the window to anybody objectionable-looking enough to offend, if not appall, the museum board.

An unholy number of hippies turned up in fringes, beads, sandals, and headbands, some of the boys barefoot and bare-chested. In the words of curator Hartwell, "The trustees thought the revolution had caught up with them." Many of them had loosened up enough by the end of the long evening to join in when Sweet Mama, the fiery, redheaded singer Dick had hired, belted out "God Bless America," "The Star-Spangled Banner," and "America the Beautiful"—in, let's not forget, the Chicago Seven gallery. This was all a radical departure for any museum in 1970, let alone one in the Midwest.

And speaking of sweet mamas, Dick's very own, Anna Polonsky Avedon, was there, singing along, while his antisocial wife, Evelyn, stylishly outfitted in a cream-colored white cotton dress, didn't utter a peep. Dick was also attended by two other *Harper's Bazaar* art directors—Marvin's immediate predecessor, Henry Wolf, and one of his two successors, Ruth Ansel.

Post-opening, Dick and Marvin hosted a poolside party at the suburban motel they were staying in. Upon arrival each guest was handed a favor in the form of a stick mask of Dick's face fashioned from Dick's passport photograph by his studio manager, Gideon Lewin, who later took an eerily apt photograph of Dick himself wearing his mask. The bash soon got out of hand—Dick would later refer to it as "the swimming pool riot." Hordes of unwashed hippies stripped down and propelled themselves off the diving board. Then Dick jumped in, fully

clothed, risking his Cartier watch and patent leather shoes. Having failed in his attempt to drag Marvin in, the minute he got out, dripping wet, he ran over and drenched him. The high spirits turned out to be justified—the Minneapolis notices were ecstatic.

Back in New York, Dick learned that a *New York Times* review would run on July 26. Anticipating another rave, he grabbed a cab to the *Times* building on West Forty-third Street around midnight when the first copies of the paper went on sale in the lobby. With the first words of the review, Dick realized that he had made a fatal mistake in neglecting to invite the *Times* photography critic, Gene Thornton, whom he had spotted in the opening-night crowd at the museum, to the pool party:

> The first thing you see . . . is a larger-than-life-size picture of two hairy men locked in a loving embrace and gazing down the length of three galleries toward the entrance where you stand . . . They are naked as frogs, and unlike Adam and Eve they feel no shame at their nakedness . . . I found it hard to go right up and look at [the picture] . . . At one point during the opening, so many people were standing with their backs to it that it was almost invisible from halfway across the room. The reason for all this embarrassment was not just the subject matter, though of course that helped. It was also the failure of the photographer to connect with any ordinary human feelings. The picture challenged us to accept and understand the love that only a few years ago dared not speak its name, but it gave us no sense of what that love was like, and how it resembled more familiar kinds. It dared us not to accept it, but gave us no reason why we should.
>
> The same lack of interest in what human beings are really like characterized most of the pictures in the exhibit . . . In spite of their lack of humanity they made a splendid theatrical spectacle.

The hirsute men in question were, famously, Allen Ginsberg and his longtime lover Peter Orlovsky, and Ginsberg had written Dick to express his admiration and gratitude for the image—in his own estima-

tion, it was no less than "a photo of humane art." In Dick's 1993 picture book, *An Autobiography*, he would wickedly juxtapose this photograph with his portrait of Henry Kissinger—who had pleaded before the shutter clicked, "Be kind to me"—after having overheard him utter the word *faggots* at a Washington dinner party.

Thornton went on to sum up the portraits that filled five of the six galleries as "ugly," saving his most savage epithet for the central gallery, where Dick had placed what he considered his strongest work—"the Chamber of Horrors," he labeled it. (He later conclusively dismissed Richard Avedon as "a brilliantly gifted fashion photographer, an immensely successful advertising artist, and a first-rate glamour portraitist of famous ladies.") As Dick stood in the *Times* lobby, reeling, he promised himself he would never say yes to another show.

FOR ALL HIS PROTESTATIONS, four years later, in 1974, when he was offered his first museum show in New York—an astonishingly late milestone for a by then fifty-year-old major photographer—he said yes in a New York second. It was to consist solely of the photographs he had been taking, over the previous seven years, of his father, with whom he had had what he once described to me as "a lifelong adversarial."

In the wake of Jacob Israel Avedon's death the year before, Dick had enlarged well over a hundred out of the thousands of exposures he had made and pinned them floor-to-ceiling on the white-painted beaverboard walls of his studio. "I made my own private wailing wall," he said. "The pictures added up to a truthful portrait of our relationship—the truth of love, the truth of hate, the truth of truth, the truth of lies."

Hearing that the head of the photography department at the Museum of Modern Art, John Szarkowski, no great fan of Dick's work ("Avedon has a very keen eye for the discovery of those objects that conform to his intuition of what the world is like," he had stated), had just lost *his* father, Dick realized that this would be an opportune time to have him look at the work. "He was visibly moved by what he saw," Dick told me. "He said, 'I've *got* to do this—it will make the perfect small show,' and he put it on the books for that May." Szarkowski even agreed to let Dick and Marvin design the installation.

Marvin began working on the plans in his messy studio in an oc-

tagonal cupola of a Beaux-Arts building on lower Fifth Avenue. He had the idea to build a twenty-foot-square chapel-like chamber off the museum lobby for the eight portraits that he and Dick had whittled the show down to—the biggest of them to be blown up to the size of a large-scale Abstract Expressionist painting. As in Minneapolis, the photographs were left unframed and unmounted, tacked from their top corners to the walls so they would hang like tapestries.

Dick titled the show simply "Jacob Israel Avedon" and had the silk-screened wall text reflect only the bare facts of his father's chronology, womb to tomb. When it came to the time line of the photographs, however, the chronology was "something you can always move around," as Marvin put it. The image of Dick's father looking hale and even debonair was a shoo-in to go first (it was shot well before Jacob Avedon was ravaged by cancer), but when it came to selecting the show's terminal portrait, Marvin persuaded Dick that it didn't have to be from the final sitting. Together they picked an earlier portrait—"one where the face looks the most like an actual death mask and my father looks like a mummy." Dick told me that when his mother, who had been abandoned by her husband in the early 1950s, saw this photograph for the first time, at the MoMA preview, she said to him, "You made him look too good."

That night Dick lay awake anxiously anticipating the critical reaction and nervous about the television interview the museum had arranged for the next morning. At around two a.m. he experienced severe chest pains. He managed to get himself to the emergency room at New York Hospital. The diagnosis was pericarditis—an inflammation of the lining of the heart, which Dick never tired of describing as the perfect metaphor for the relationship he had had with his father. A few days later, as he was resting in a private room, one of his assistants dropped off the Arts and Leisure section of the *Times* containing a review of the exhibition, poisonously penned by the Thornton in his side.

Once again the critic lit into Dick with a vengeance, finding no "real penetration of the subject matter" and equating the pictures— taken in what he described as "Avedon's ugly, distressing style"—with Dick's celebrity portraits. The last line of the review drew Jewish blood: "The average conventional viewer (whose voice I try to be) is bound to

ask what kind of son it could be who would take such pictures of his dying father, yet." A year later, when I went to work for Dick, he was still fuming about it: "That anti-Semitic bastard! Putting the comma before the *yet* to get the idea of the Yiddish accent across."

Dick called his friend the writer Renata Adler for advice and sympathy. She told him to take a match to the review. He took her at her word—loopy as he was from his heart medication, he found the strength to stagger down the hallway to the nurses' station to pinch a pack of matches. He then draped the entire Arts and Leisure section over the open toilet in his bathroom and fired away. The flames did more than he had bargained for—they quickly enveloped the plastic seat, charring it, cracking it in places, and leaving scorch marks on the wall. Unbelievably, he claimed to the hospital authorities that he had no idea how the fire started.

"Dick took even the mildest criticism harder than anybody I ever knew," Renata recalls. "I would tell him, 'How dare you be so outraged by what people say about you in print? You're devastating people all the time with photographs that show the sweat marks under their armpits and the black rings under their eyes, and not only do you take pictures of people by which they are mortified for life, because you are often the last word on the subject, but you maintain that they were complicit in their own destruction, that it was a collaboration, so that then they're forever implicated in some grotesque image of themselves.'"

During his five-week hospital stay, Dick was heartened by some highly positive reviews. Janet Malcolm wrote in *The New Yorker*: "These are not portraits of an individual but anatomies of aging, suffering and fear of death; they are almost unbearably painful. Avedon is the most conceptual of photographic portraitists—all his portraits express ideas about humanity rather than the particulars of personality . . ." The art critic Dore Ashton rhapsodized that "Avedon, with a minimum of compositional means, has produced an abstraction equal to a poetic portrait by Yeats or Eliot." Of the final portrait in the show, the one whose placement Marvin had insisted on, she waxed downright poetic: "The highlights are like the lights on fine porcelain; the values are thinned to the highest degree and the eyes, even with their urgent look, are filled with a thousand benign reflections . . . I studied those por-

traits as I would a painting by any of the great portraitists of the past, looking at light and shadow, the composition of lines, contours, and angle of vision. In short, I could and did linger and seek as one does with a work of art."

Most soothing of all was a second *Times* review, by the paper's new chief art critic, Hilton Kramer. He began by warning readers that a visit to the Avedon exhibition would be a harrowing experience, then went on to make them want to risk that visit: "We feel ourselves, oddly enough, intensely in touch with life — and with a side of life that rarely, if ever, is captured in the art of any medium. Avedon has brought courage and affection to his 'forbidden' subject, and the result will forever alter the way we think about such subjects in the future." Dick recognized that the two most selling words in the review were *harrowing experience*: "That's what would make *me* want to go see it," he said.

Photography critic Owen Edwards did Kramer one better, declaring that those "eight portraits of an ill, rapidly aging, frightened, accepting, ultimately transfigured man rank with the best of Cameron and Nadar." Art critic Harold Rosenberg, in his essay for Dick's 1976 book *Portraits*, would rate them "the apogee of Avedon's fidelity to objective truth." Yet there were to be plenty of occasions when Dick would practically have to put on boxing gloves to ward off his attackers on this score. Susan Sontag, for one, characterized those photographs as "ruthless" and careerist. "I was never out to *get* my father," Dick counterpunched. "I was simply trying to 'get' him. Connection was what it was about — not destruction."

One afternoon in the early nineties, fresh from a session with his analyst, Dick burst into my office. "After all these years," he recounted, "I finally had the guts to ask Kleinschmidt if he thought those photographs of my father were cruel. 'Vell,' he said, 'since you ask, I do consider them a form of patricide.' He then asked if I was by any chance familiar with Sylvia Plath's poem 'Daddy.' I was speechless — I said, 'So you think I used my camera like a weapon, when my father was too far gone to defend himself? Then why didn't you try and stop me?' Kleinschmidt explained that it was his policy to never actively interfere with the creative process, that he preferred to be 'indirectly directive.' So now I know that my analyst thinks there's a dead body behind me. The

funny thing was I had actually wanted to photograph my father stone-dead—the only reason I didn't was Diane Arbus had photographed *her* father in his coffin in the early sixties."

Distaste for this body of work persists. A couple of days after Dick's death, in 2004, Irving Penn confided to Dick's dealer, Jeffrey Fraenkel, that he found the pictures to be "cruel," displaying an "anger that should not have been made public." (And yet, when in the late seventies Penn and Dick exchanged prints, it was one of the Jacob Israel Avedons that Penn requested; he later explained to longtime *Time* magazine photo editor Robert Stevens that the image was "like the finger of death pointing" at him.) Dick's best friend, Mike Nichols, told me—after Dick was gone—that he remained "horrified" by them. "*Atrocious* is the only word for those photos," he maintained. "I always thought it was unjust as well as unkind of Dick to photograph his father in that state. I wouldn't have done that to *my* father, and I would hate it if any kid of mine ever did anything like that to me. And I *don't* think it gave him a relationship with his father—what it gave him was a certain respect within the community of art and photography."

Three of Dick's photographs of Jacob Israel Avedon would appear in his next show, which opened the following year, 1975; and twenty years later all eight would be featured in the Avedon retrospective at the Whitney Museum of American Art, in a dedicated small room near the end of the exhibition that had been designed to replicate the nondenominational chapel that Marvin had created for them at MoMA.

DICK'S 1975 SHOW OPENED not in a museum but, faute de mieux (the Met, MoMA, and the Whitney had all passed on it), in an art gallery. But not just any old art gallery—Marlborough at the time represented the likes of Pollock, Rothko, Lipchitz, and Clyfford Still. Every one of the hundred prints that Dick and Marvin chose was the product of what Dick liked to call "non-assignment photography," meaning subjects he was personally drawn to. Many had never before been published or exhibited. "This was our entry into the photography field, and we were determined to make the biggest splash imaginable," says Pierre Apraxine, Marlborough's then newly hired photography curator, "and Avedon was as marketable a name as Disney."

Marlborough, being the savviest of galleries, would go on to sell from that show alone a respectable number of limited editions of Dick's photographs, starting at $175. (For $200 each, Martin and I purchased three sixteen-inch-square pictures: the drugged-to-the-gills pianist, character actor, and mordant raconteur Oscar Levant, maniacally laughing, or howling—a study that Dick later told me was the product of the most powerful sitting he had ever experienced and that he described as "the greatest pharmacological picture ever taken," a riff on Levant's own remark to Dick that when he hugged Judy Garland it was the "greatest pharmacological embrace in history"; a pensive Groucho Marx, a far cry from the cigar-wagging jokester host of TV's *You Bet Your Life*; and an exaggeratedly devilish Charlie Chaplin.)

The show was to be titled "Portraits 1969–1975," and with that end in sight Dick devoted the summer before the opening to making a number of new ones. (There would never be a show he *didn't* want to make new portraits for at the last minute. Or a book, for that matter. The spring before *Observations* was to go to the printer, he had flown to Europe to—as his collaborator Truman Capote exhorted him—"get more greats." He certainly delivered the goods: eighteen new portraits, including Picasso, Cocteau, Dinesen, and Maugham. Dick saw beauty in Maugham's decay, writing Truman that "the smile from the corner of Maugham's mouth down puts anything on Jackie Kennedy's face out of business.") He flew to Nova Scotia to photograph Robert Frank, and then to Buenos Aires to make a portrait of Jorge Luis Borges. "He lived with his mother, and she had died the day before and was laid out in the room adjoining the one we were sitting in," Dick recounted. "That should have been the biggest icebreaker of all time, but he remained totally composed in every way, and the portrait came out dead. I even considered not putting it in the show. I photographed him the next year, in New York, where he showed up at the appointed hour—only the day before. But better early than never."

Marvin set about reconfiguring the Marlborough space, while Dick commissioned a scaled-down model of it and had thumbnail prints made in all different sizes (starting at one inch square) to endlessly pin and re-pin to the maquette's beaverboard walls. Fortunately, both Dick

and Marvin were small enough to crawl in and out of the miniature structure with relative ease.

Here, once again, scale was key. Marvin was urging Dick to think even bigger. "I felt that some of the portraits should be competitive in size with the paintings that would normally be hanging in that gallery," Marvin told me. Bigger, certainly, than the people looking at them—the show was designed to be literally larger than life. Marvin convinced Dick to dispense with name identifications here, too, on the grounds that they would compromise the integrity of the photographs. As a consequence, President and Mrs. Eisenhower and the Duke and Duchess of Windsor were each risibly described as a mere "couple." Dick and Marvin refused to recognize that name recognition was crucial to a full experience of the portraits, never minding that nobody would have been able to come up with the names of all of the subjects. But the day after the opening, the gallery saw fit to install a good-sized identification chart on a far wall. "Everyone was playing Who's Who and running back and forth from the photographs to the chart and bumping into each other—it was like a farce, you needed traffic control," Dick told me, laughing.

Dick and Marvin had a serious falling-out over Marvin's demand for "co-equal credit" for his role in the show. Marvin had always held that the presentation of a photograph was on a par with the taking of it, and that therefore any show he designed was—to use his own self-serving phrase—a "joint venture." He saw Dick as someone who knew instinctively how to take advantage of things, and himself as just one of those things. "He wouldn't put my name in big enough letters on the gallery wall," Marvin complained to me long afterward. "I told him I was sick and tired of being his fucking chef who stayed quiet in the kitchen while he boasted to the world that he'd cooked the meal all by himself, and then maybe he throws me a fucking nugget. Dick works for Avedon, period." Marvin said that in his outsize outrage he made a huge sign saying "Marvin Israel did it all" and tacked it up in the gallery—it was soon enough yanked down. Pierre Apraxine recalls that "Avedon instructed us not to allow Marvin Israel into the gallery under any circumstances." Dick told me he had been afraid Marvin might go so far as to slash some of the photographs—"he had that much rage in him." As it was, he crashed the opening.

That night, September 9, 1975, Martin and I were among the three thousand so-called movers and shakers in a line that stretched along the entire block of Fifty-seventh Street between Fifth and Sixth avenues. I was looking forward to seeing Dick again, for the first time since our accidental meeting at the Paris Ritz three years before, when he had told me he was about to leave his wife. This was the first big art event of the autumn season, and I was wearing my Saint Laurent "Mondrian" dress, a wool number in blocks of black, white, red, blue, and yellow: all the *Broadway Boogie Woogie* colors.

The installation was jazzier than any Broadway offering. For sheer stagy showiness you couldn't beat the three segmented group murals that overwhelmed you as you entered, each of them at least eight feet tall and hanging like tapestries. These were pictures that defiantly posed the question, Who is looking at whom. Looming ahead was the 35-foot-wide *Mission Council* composed of the U.S. top brass that ran the Vietnam War, which one critic observed was "like *Catch-22*, a terrifying picture of business as usual" (it had been accomplished in under fifteen minutes, thanks to Dick's having mapped it out beforehand based on the sitters' rank and height, and it was its appearance on the *Times* Op-Ed page, illustrating a piece by veteran war reporter Gloria Emerson, that had spurred Marlborough to approach Dick about a show). Uncomfortably close by was the 18.5-foot-wide Chicago Seven lineup. And then the 30-plus-foot-wide *Andy Warhol and Members of the Factory*, bristling with raunchy full-frontal nudity.

Making a scene worthy of a diva in front of the Warhol tableau was Toscanini's daughter, Wanda Horowitz. She was demonstratively objecting to the placement of her husband Vladimir's smiling, laughing portrait directly across from "all those vile private parts." (Little did I dream, standing there, that a couple of years later, after I had started working for Dick and happened to mention that I had just dragged out of storage the Steinway baby grand my parents had given me for my sixteenth birthday, Richard Avedon would present me with a print of that photograph.) Those protuberances notwithstanding, on every side and all around, in the "new" Marlborough space, were Avedons both old and new, including diptychs and triptychs—and all of them displayed the way everybody agreed nobody had ever seen photographs

displayed before. Dick's father, someone pointed out, was the only non-famous or non-notorious figure on view.

In the crowd I recognized several people I didn't know personally, including Halston, David Hockney, Norman Mailer, Francis Ford Coppola, Susan Sontag, Clay Felker, Elaine Kaufman, and Warren Beatty, who was visibly and olfactorily overheating in his rumpled tweeds. And some I did know—the Eurasian model China Machado, looking gorgeous; Lauren Hutton, looking wildly out of place in a cowboy hat; the renowned fashion photographer Louise Dahl-Wolfe; the Metropolitan Museum's imperial director Thomas Hoving, who was my weekend neighbor in the country; Vogue editor Grace Mirabella in her trademark beige; and Dick's early fashion model, the statuesque upper-class English import Maxime de la Falaise.

Polly Mellen, the Vogue fashion editor and Dick's longtime favorite stylist, came rushing up to Martin, for whom she had styled the odd Revlon ad over the years (mind you, she wasn't allowed to do them, but Diana Vreeland had told her, "Go ahead, just don't tell me"). "These are tears of joy," she sighed, dramatically dabbing at her cheeks. "Dick took my portrait three weeks ago, but I only just now saw it for the first time—saw how *he* sees *me*—and as *you* can see, I'm overcome."

Nowhere to be seen was Truman Capote. He had announced to one and all that he hated his puffy-faced, hooded-eyed 1974 portrait. "It's a cheap shot," he declared. "I was taken, in more ways than one—I wasn't feeling so hot that day." (As far back as 1949, Truman was taking exception to an Avedon portrait of himself, writing his friend Cecil Beaton that "Little Avedon has proved himself quite untrustworthy." This, by the way, from someone four inches "littler" than little Dick!)

Andy Warhol was there, hamming it up for photographers, standing next to the 1969 photograph of his hand resting on his exposed bullet-holed, Frankenstein-stitched stomach ("special effects" courtesy of radical-feminist SCUMbag Valerie Solanas, who had attempted to assassinate him the year before). Dick found beauty in the mutilation: he told me later that Andy's stitches had called to mind the seams of a couture dress. The open black-leather jacket Andy was wearing lent a tinge of fetish. That portrait, taken the year before the Factory mural, was the only one in the show minus a face. It had legs, however: dis-

turbing as it was (I overheard someone describe it as a "sick exploitation shot"), it was the exhibition's bestselling print.

Another big seller was Dick's 1957 portrait of the Duke and Duchess of Windsor. Of all his photographs this is the one most frequently cited to illustrate Dick's putative brutality, his disposition to victimize his sitters—in the eyes of one critic, it was "as cruel as a Goya painting of the Spanish royal family." By the night of the Marlborough opening, Dick had told the story behind that famous photograph so often that surely some of the guests would have been able to repeat it almost verbatim—the picture was in effect pre-framed by the anecdote. Which went like this: one summer in the early fifties when he was vacationing in the South of France he spent several evenings closely observing the Windsors as they played a high-stakes game of roulette behind the red rope at a casino, so when *Harper's Bazaar* assigned him to photograph them in their suite at the Waldorf Towers, he was primed; he was nonetheless late, he claimed, to this momentous sitting. Finding himself at an uncharacteristic loss to unsettle their camera-ready faces, and deducing, from the small army of pugs in attendance, that they were fanatical dog fanciers, he offered an inspired explanation for his tardiness: his cab had run over a dog on Park Avenue. Their faces—their crests— fell, and Dick got his vaunted picture: "two people without a country and without a soul."

It was only after I had been working with Dick for a quarter of a century that he was able to admit to me, having long since owned up to all manner of other things, that he had made up the story about making up the story. "The truth is I made an unbelievable gaffe: I addressed the duchess as 'Your Royal Highness,' which was the single worst thing you could say to her, since she had been famously—*royally*, you could say—denied the word *royal*. I was scared stiff, because they were rabid Nazis, those two."

Dick was forever prepared to wield his camera to avenge the six million dead. (Or not wield it, as the case may be: he had flat-out refused to photograph the French novelist Louis-Ferdinand Céline because of the anti-Semitic pamphlets he'd penned.) The year after the Windsor sitting, he shot two other virulent anti-Semites: Ezra Pound, whom he baited by announcing, just before clicking the shutter, "I think you

should know that I am a Jew," and T. S. Eliot, who in *After Strange Gods* had opined that "reasons of race and religion combine to make any large number of free-thinking Jews undesirable." Earlier, in 1948, when photographing Coco Chanel, a wartime collaborator, in Paris for the *Bazaar*, he had set her up by maneuvering her into standing obliviously beneath a banner that advertised an article in *Paris Match* and contained the words *Pourquoi Hitler?* When the *Bazaar* wanted to crop out the "Hitler," Dick asked, *"Pourquoi?"* and the photograph went unpublished by the magazine. And finally, one of the reasons Dick ended his celebrated friendship with the French photographer Lartigue, whose work he had passionately promoted as "Proust made visual," was that Lartigue had described his stay in Vichy during World War II to him as *"très amusant."*

At the Marlborough event, I never even got to say hello to Dick. I merely glimpsed him in his black suit, white shirt, and black tie—he was making like someone running for public office, nervously shaking hands and kissing air. "I did a very stupid thing and picked a fight with a fashion writer that night," he told me the next year. "She asked me if the Windsors had liked their portrait when she knew perfectly well what the answer was, and I let her have it. I said, 'That's a really dumb question. I mean, is that something you would have dared to ask Rembrandt or Modigliani? No? Then why ask *me?*' And why are you presuming that it's just a portrait of the Windsors? If you saw Van Gogh's portrait of Dr. Gachet, you wouldn't say, 'That's Dr. Gachet,' you would say, 'That's a Van Gogh.' My adrenaline was flowing, because then I went and said to another reporter, who ran with it, that my show proved that photography was now the great event in art and that painting was just going to have to take a back seat. I was really asking for it."

And he really got it. From *The New York Times*, at least, with both barrels. And not once but twice, two weeks apart. The first salvo was headlined "AVEDON'S LENS CELEBRATES CELEBRITY." "The roster of subjects insistently evokes the glamour of publicity and rides effortlessly on the publicity of glamour," Hilton Kramer wrote, going on to take Dick to task for his portraits of "human ruins" such as Pound, Stravinsky, Levant, and Jean Renoir: "There is an awful intimacy in

this geriatric portraiture—an unearned invasion of privacy bordering at times on the voyeuristic—that fascinates and offends in equal measure." And yet, Kramer continued, "Even in the harshest pictures of celebrities, antiglamour serves to give the romance of glamour a new and unexpected lease on our attention . . . Mr. Avedon's is a powerful and original talent, and it adds a significant increment to—indeed, it significantly alters—one of the great traditions of photography: the tradition of the posed celebrity portrait. But for all its franknesses, it remains tethered to that tradition, and offers photography little that can be usefully applied outside its narrow boundaries."

A couple of weeks later came Kramer's follow-up, headlined "AVEDON'S WORK LEAVES US SKEPTICAL." "In the end," the critic carped, "it is the very speciousness of [Avedon's] candor that arouses our skepticism, reminding us that his realism is only, after all, another form of artifice . . . These are still studio portraits intended to lavish romance on their subjects . . . We leave this exhibition feeling that photography . . . is not to be trusted." Kramer brutally concluded that the show "really has very little to do . . . with the ongoing life of serious photography in our time." Janet Malcolm joined in the kill, writing in *The New Yorker* that "one feels about the oversize group pictures, as one feels about so many of the portraits, that the most enormous and elaborate lengths have been gone to for too small returns. One finally balks at the low sensationalism that is being offered as high seriousness."

Reviews such as these left their mark, to be sure, but what cut Dick to the quick were the fulsome mentions of the exhibition's unmentionable editor and designer, whom Dick had not invited to design his forthcoming book, *Portraits*. One critic held that the show "was notable for an installation that was so extraordinarily innovative that it masked the flaws in the works themselves." And maddeningly, Kramer wrote in his first review that "the exhibition . . . has been beautifully designed by Marvin Israel, who has transformed the gallery's large and ungainly space into a masterpiece of dramatic installation." In his second review, he described Marvin's installation as "dazzling," with every image orchestrated "to maximum effect." *Newsweek* jumped on the Marvin bandwagon: "The show is installed with a panache . . . and extraordi-

nary theatrical flair . . . that has not been seen in photography exhibitions since Steichen's 1955 show 'The Family of Man' at the Museum of Modern Art."

Edward Steichen, at the time the director of MoMA's department of photography, had included an Avedon in that legendary exhibition, which Dick always claimed to have hated for its pretentiousness. Now, twenty years later, with his own family of man glaringly on view at Marlborough, Dick took hope from the fact that Steichen had also once been "just" a *Vogue* photographer (in fact, Dick regarded him as no more than a "classier Hurrell"), and gone on to be universally acclaimed as an artist. Meanwhile, an unexpected tribute came Dick's way from a contemporary *Vogue* photographer who had also gone on to be embraced by the art world. "I found it magnificent," Irving Penn told Robert Stevens. "It was a new way of presenting photographs— exhibitions of photography will never be quite the same. Avedon dared to break through the conventional scale of exhibition photography. Those pictures were not just blow-ups—they reached their full *meaning* in the large scale. The event, too, was remarkable. The theater of it—the kind of people who were there." For Dick, that panegyric in itself amounted to another step forward.

3

HIS SHOW OF SHOWS

—

T HIS, THEN, WAS WHERE RICHARD AVEDON STOOD—WHERE
he and I now stood together—at the beginning of 1976 when I joined
the studio. The ground beneath his feet was commercially sound but
critically shaky. The Metropolitan Museum fashion show that he had
told me was in the offing seemed more off than on. And little wonder.
Dick, I discovered, had been his own worst enemy. In interview after
interview over the years he had defensively dismissed his fashion pho-
tography as "easy," "fun," "superficial," "decorative," "a vacation from
life . . . a holiday," "my bed and breakfast." (As late as 2002, the chief art
critic of *The New York Times* would be writing, "Now Avedon is the only
one who fails to take his fashion pictures seriously enough.") He main-
tained that he drew on a very different part of himself to do his portraits
and that he prided himself on his ability to shift gears. I told him, "You
sound like a split personality, a schizo. The fact is, your fashion photo-
graphs are cut from the same cloth as your portraits: they're social his-
tory, and you, dear Dick, whether you like it or not, are a social historian."

"Keep talking!" he said.

"What's more, since your work has always been made for the printed
page, in a museum people will be getting to see it in a completely dif-
ferent light."

DICK WITH NORMA AND HER SON, MAX, CELEBRATING
THE PUBLICATION OF A LANDMARK BOOK AND A
LANDMARK MAGAZINE PORTFOLIO, 1976.

"Me at the Met is still going to be a hard sell."

"That's *my* job," I reminded him. "Let me give it a shot."

Dick quickly filled me in on the particulars. The year before, he had approached the curator in charge of the Met's department of prints and photographs, a lanky Canadian by the name of John McKendry. Happily, McKendry was married—if not exactly happily married—to Maxime de la Falaise, whom Dick had taken splendid photographs of over the years, beginning with the spring 1948 Paris collections. And so McKendry was up, in both senses of the preposition, on fashion photography. Dick told him that the book of his fashion photographs that was in the works with Farrar, Straus and Giroux could serve as the road map for a museum show. McKendry in turn touted Dick to the Met's staid Exhibition Program Committee as the successor to Baron de Meyer, Man Ray, Munkácsi, Hoyningen-Huene, Beaton, and Steichen, arguing that, like them, Dick used fashion as a means of making a significant contribution to the field of photography and, moreover, that his work approached the dimensions of great court painting. He played all the angles, citing the likelihood of Dick's being able to in-

veigle one of his rich lady friends into funding the show, and ending his presentation by confidently predicting a "large opening." Alas, before he could nail the show for Dick, McKendry died, at the untimely age of forty-two, leaving, in addition to his widow, what Dick was now calling an orphan: the Avedon exhibition.

"Poor baby," I found myself saying, as I ran to the phone. The Met director took my call right away—in the mistaken belief, as he undiplomatically informed me, that it was about "something really important, like lake rights" in the Dutchess County town where we both had weekend places. I explained to Tom Hoving that I was now working with Richard Avedon, and then, laughing, I told him it was high time he put Dick's show on the museum calendar. He hadn't the faintest idea what I was talking about, the McKendry proposal never having made it as far as *his* desk. I quickly brought him up to speed. Then, because the Met was in full fundraising mode for major renovations, I announced, "This is a show that isn't going to cost the museum one red cent—it has net-positive cash flow written all over it." He said, "Now you're talking *my* language, baby." I spelled out just what a big-wow-wow Avedon show could mean for *his* baby: unprecedented attendance, including by many who had never even set foot in the place; unlimited PR; and fun fun fun. "Vroom vroom!" he responded, as much of a showman as Dick—and both of them were right up there with P. T. Barnum.

As Mayor Lindsay's parks commissioner, Hoving had staged happenings as well as concerts, and since becoming head of the Met in 1967 he had delivered a number of so-called blockbuster exhibits, publicizing them by draping banners over the museum's hitherto noli-me-tangere façade, turning them into veritable marquees. He was Dick's kind of guy, not to mention mine. He said, "Baby, let's do it, let's get those sexy photos on the runway at the Met!"

One day, Hoving paid an unannounced visit to the studio on his motorcycle, roaring in under the arch. He unzipped his leather jacket, threw it on the floor, then tossed his helmet on top of it, followed by his T. Anthony attaché case. "He'd been riding that bike since he was parks commissioner," his spirited widow, Nancy, reminds me, adding with a laugh, "It wound up getting stolen out of the Met garage, if you can

believe it." Dick immediately took Tom aside to say, as if it had just occurred to him when in fact it was part of our master plan, "You're really something! I've just *got* to photograph you. If you can ever find the time." Hoving said, "How about Friday?" They then got down to the business at hand, flipping through the dummy of Dick's Farrar, Straus book. Hoving's eyes lit up, with more than dollar signs. "Tommy considered Dick a great artist on the basis of his fashion pictures alone," Nancy confirms.

When Hoving was done with the dummy, he stepped back dramatically and announced, "I'm going to give you our four or five most important galleries—the north-wing humdingers on the second floor. The biggest exhibition space in the museum, one of the biggest in the city—*cavernous*—we call it the airplane hangar. And by the way, you'll be succeeding Napoleon—our exhibition of the arts during his reign." "I'm taller," Dick exclaimed. He and I high-fived. We were both forgivably giddy by this point: Richard Avedon had just been anointed the first fashion photographer—in point of fact, the first photographer—to be shown at the museum in such depth and in such prominent galleries. And he would be only the second living artist in the Met's long history to be given a retrospective, Hoving's close friend Andrew Wyeth having beaten Dick to the banner.

A few months later Hoving, in true showman form, electrified the museum world with his announcement that he was leaving the Met to head a new Walter Annenberg–funded communications center affiliated with the museum (which didn't come off in the long run). The Avedon show was by then written in stone—etched into the schedule for a year and a half hence. A lucky thing, too: Hoving's more classically inclined successor, Philippe de Montebello, looked down his patrician nose at photography, let alone fashion photography; during the course of Dick's show he would comment to the press, "We look upon this exhibition not only as a splendid event in itself, but also as an opportunity to unite the concerns of the Metropolitan's photography department and the Costume Institute."

The way it usually works in museums is *they* select the art, *they* design the installation, *they* publish the catalogue/book. But that was not the Avedon Way. Dick was always the one who selected and hung his

pictures (with or without a collaborator of *his* choosing), and it was always Dick who produced the book. With the Met, he took the reins before a curator could even be assigned. "Richard Avedon received concessions on a variety of levels for his personal involvement that would not be achieved by any other artist in any other museum of any consequence anywhere in the world until at least two decades later—he virtually wrote his own ticket," an official at the Met recalls disapprovingly. "Avedon was permitted to stipulate not only which photographs, and how many, and how big, but to control their framing, lighting, and placement, as well as to dictate choice of wall and carpet color and texture. Nor did the raft of concessions end there—he got to provide all the graphics, such as posters, himself, and to have the final say on publicity and advertising. And on top of all that he had the gall to demand *four* tickets for his *mother* to a pre-opening of the King Tut show that was the toughest ticket in town." (Anna Avedon was more than Dick's mother—she was the power behind his throne. He would crown her the guest of honor at the opening, and on the acknowledgments page of the published book he would thank her, his original creator, over and above all the other people who had helped to create it—and him.)

Museum personnel recoiled at this unprecedented level of artist involvement, which one of them diplomatically described as "independence of action with regard to the show." In plainer language, it was a takeover—a coup. (Years later, when Dick and I were in Washington negotiating with the National Gallery of Art for an Avedon retrospective, in exchange for which, it turned out, they expected him to donate a print of practically everything, its director, J. Carter Brown, well aware of Dick's reputation as a control freak, put it to him bluntly: "On a scale of one to ten, what would you say your direct involvement needs to be? Five?" Dick answered, "Eleven." Carter couldn't believe his ears. He said, "This will be a National Gallery show, period," to which Dick replied, "It will be a Richard Avedon show, period." No show.)

Since there had to be someone with curatorial credentials at least nominally associated with the exhibition, the newly appointed curator in charge of the department of prints and photographs, Colta Ives, stepped in, though her expertise lay far afield, in French printmaking

ALAN KLEINBERG

DICK PAYING HOMAGE TO HIS MOTHER, ANNA,
AT THE ENTRANCE TO HIS METROPOLITAN MUSEUM
FASHION RETROSPECTIVE.

of the latter part of the nineteenth century. "There was a kind of in-house notoriety to the exhibition," she recalls, "since, like the Andrew Wyeth show that prompted Henry Geldzahler, our curator of twentieth-century art, to resign in protest, it was a project that had been strong-armed by the museum's administration. I, for my part, thought the photographs ravishing and well worth prime wall space. So it was a pleasant adventure for me to play handmaiden to the presentation and

to witness the drama of its realization." Ives assigned the department's associate curator, Weston Naef, to be the nuts-and-bolts person for the show, though *his* area of expertise at the time — old-master prints — was no more suited to the task at hand than hers. He would, however, go on to an illustrious career as curator of photographs at the Getty, almost single-handedly building its lofty collection from the ground up.

Dick's first major decision was to have the exhibition begin with the international style-setter Marella Agnelli — her image would not only preside over the entrance to the exhibition but also grace the cover of the book — and end with the sculptor June Leaf. Most of the roughly two hundred other pictures in the show had been taken for *Harper's Bazaar* (between 1945 and 1965) and *Vogue* (between 1966 and 1977). From the time Dick was twenty-one, no issue, of first the one magazine and then the other, had gone to press without an Avedon photograph in it. Many of them had been made during Dick's storied trips to Paris to photograph the semiannual collections, and some had never before been published and were now to be seen by the public for the first time.

The fix was in. *The New York Times Magazine* had committed to running a cover story on the exhibition the Sunday before it opened, with twenty pages of photographs, and *Newsweek* had guaranteed a cover story. These exclusive media arrangements had been engineered by Dick, leaving his primary editorial employer, *Vogue*, with its up-turned nose a bit out of joint. (The *Times* cover never materialized: all three New York newspapers would be shut down by a multi-union strike in August 1978, and not resume publication until November 6, the morning after the Avedon show closed. Dick was philosophical: "An act of God spared me another hit from that crabapple Kramer," he said to me.)

In June 1977, in an effort to secure outside funding, Dick began working his Rolodex in earnest, aided and abetted by his friend Ashton Hawkins, the Met's chief counsel and the liaison to its trustees, who was the show's most powerful in-house advocate. Not one of the corporations that Dick personally solicited — Bristol-Meyers, Revlon, Braniff, Polaroid — came through. He had no choice but to appeal to friends, a prospect he found unappealing, to say the least. He had a long and, he

complained, expensive transatlantic conversation with Marella Agnelli, which ended disappointingly, with her merely offering to consider funding the show should it travel to her home base of Turin. Dick was livid, insisting that he had practically invented her. Before her marriage to the head of Fiat, she had been "just one of those-down-at-the-Ferragamo-heels Italian principessas playing at working in New York—in her case, in Erwin Blumenfeld's studio. Diana Vreeland sent me to photograph her for the *Bazaar,* and at first glance she struck me as an emu, or a giraffe. She was so big and awkward I didn't know what to do with her, so I just said, 'Off with her hair!' It was only then that I was able to see what Diana had seen all along—the nobility and strength of character in her face. But the so-called Modigliani-neck and Brancusi-skin effect in my photograph was all the product of I don't know how many bottles of bleaching agent."

Originally published in the April 1953 issue of the *Bazaar,* Dick's exquisite, cinquecento Marella Agnelli became the most influential fashion image of the year. In fact, it created fashion: the next season, Christian Dior, whom Dick considered the "greatest artist of dressmaking," sought out the *Bazaar's* editor-in-chief, Carmel Snow, at the collections to tell her that it had been the inspiration for his new line, the narrow, subtly fitted, elongated *H* silhouette. For the Met show, Dick would include two additional photographs of Marella that he had made in the years between. In both, he had endeavored to present her not as an ageless beauty but as a beauty who was aging gracefully, as indeed she was.

By November, with time fast running out for Dick to come up with funding, he had just about exhausted his list of pigeons. Then, at a first-night, he ran into Mitzi Newhouse, the wife of the newspaper magnate Samuel I. Newhouse, who had reportedly bought Condé Nast as a present for her—to keep her, in effect, perennially in vogue. "She confided in me how bored she was in Palm Beach and how badly she needed a lift," Dick said. He lost no time inviting her to lunch at the studio—baked potato and caviar, which Truman had assured Dick was a winning combination—a sure-fire way to get your way.

Dick waited until coffee to produce the dummy of the fashion book. He shamelessly said to her, "This is for Mitzi's eyes only." After paging

her way through it, she said, simply, "Oh!" As soon as she left, Dick began obsessing: "She only said 'Oh!'—I mean, not 'Oooh!'" I told him to call her and say she could have her own guest list for the opening, and that's when she said, "Oooh!" Dick informed the Met that "Mrs. Newhouse came through with flying colors, all of them green— seventy-five grand for the exhibition and another ten for the party."

Marvin was still out of the picture. Dick was working now, on both the exhibition and the book (which Marvin had begun), with a young graphic designer by the name of Elizabeth "Betti" Paul, who happened also to be his daughter-in-law. He was quick to embrace her idea that the pictures, as well as the rooms they would be hanging in, progress from small to large to, finally, huge. The photographs, they agreed, should be glazed with Plexiglas and framed, with the exception of the monumentally scaled prints in the last gallery, which would be linen-mounted and push-pinned to the wall. The museum insisted Dick sign a waiver of indemnification, holding it harmless in the matter of any damage incurred in the mounting of his work in this unorthodox manner.

The book, now titled simply *Avedon*, was also moving forward (replete with two hundred photographs, it would become a coffee-table

DICK AT THE MET WITH HIS SON, JOHN, AND
DAUGHTER-IN-LAW, BETTI, WHO DESIGNED THE SHOW.

bestseller at the then unprecedented price of fifty dollars). Dick had commissioned an introduction from his friend the novelist and short-story writer Harold Brodkey (he once characterized their intense relationship for me as "Harold is the intellectual, I'm the instinctual"). He handed the essay to me saying, "Tell me *this* isn't great!" I had to tell him what I thought: "It's pretentious and unreadable. It's double-talk—triple-speak. How else to describe *this*: 'We are so immersed in time and in our times that fashion is . . . an okay, is sanity, or an okayed insanity.' Or this? 'The conspiracy of confession has here a gaiety—and often a ribald or impassioned or implicated sarcasm—a sexuality, a wryness, a madness, a madness of love and excitement . . . a dance and a confession—a defiance: a form of meaning.' I mean, what does any of it mean?" "I don't know," Dick admitted. "But it *sounds* deep. It sounds *profound*. And it has to be, if Harold wrote it."

The museum was counting on Dick to produce Jacqueline Onassis at the opening. "Landing 'The Jackie' is our number-one priority now," he announced to me one morning. "Should I tell her I need her there for just fifteen minutes, or should I make it thirty?" he asked. "Should I have her to lunch or dinner? What should we give her to eat? Does she even eat? If it's lunch, do you think she would get a kick out of eating downstairs with the assistants? Should I promise to let her publish my next book? Let's find out who her authors are. Do you think it would be a good idea to invite Mike Nichols with her? I heard that Caroline Kennedy is taking photographs these days—should I offer a summer internship?"

I told him, "Half an hour, definitely. Lunch. Upstairs. Beluga. No book. No Mike. No Caroline." Dick put in a call to The Jackie—a few, in fact. They went unreturned. He was deflated. They had a history, and part of that history *was* history. In the first days of January 1961, three weeks before the inauguration, she chose Dick to take a series of both informal and formal photographs of the family. Published in both *Harper's Bazaar* and *Look*, they would play no small part in the creation of the bright and shining Kennedy image. Dick also later photographed The Jackie in her Oleg Cassini inaugural gown and sent her a print as a gift.

It was, however, a photograph that Dick had taken of her for the

Bazaar, back when she was just a senator's wife, that he selected for the Met show. He had asked Diana Vreeland, who had known her "forever," what particularly she wanted him to capture—"her wide-apart eyes?" Diana answered, "Just get that voice."

The Met got Dick's mind off Jackie when it called to say that his banner was ready for inspection. It consisted of his looping signature,

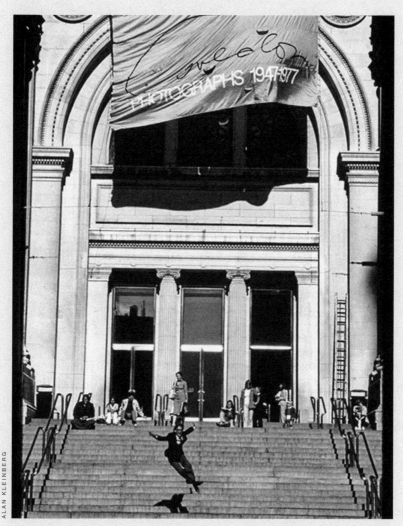

DICK IN ECSTASY ON THE STEPS OF
THE MET BENEATH THE AVEDON BANNER.

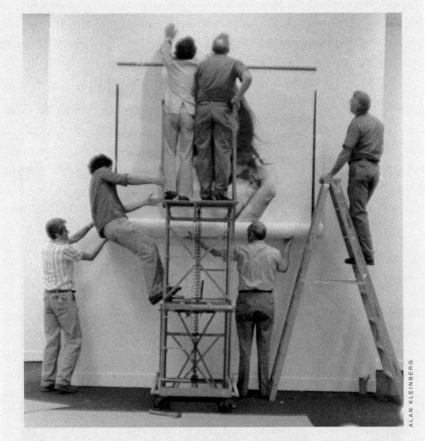

ALAN KLEINBERG

IT TAKES A VILLAGE TO INSTALL AN AVEDON.

in red on a blue background, and the words *Photographs 1947–1977* in white. What was there not to like? Yet he detected an infinitesimal gap in the line connecting the A and the V and sent it back to be redone. "The giant banner hanging outside the museum, high above Fifth Avenue, was an important victory for photography," says Philippe Garner, the reigning photography and decorative-arts expert at Sotheby's and later Christie's. "It was a grand gesture of achievement both for the medium Avedon had championed and for him personally. That banner was like a flag planted by a conqueror."

Napoleon came down on July 30 and Avedon began going up. The positioning of the pictures in the galleries followed the chronological

layout of the book. The first gallery would contain fifty-seven eight-by-ten gilt-framed, individually spotlit photographs from the late forties through the mid-fifties, all of them shot on location in Paris for *Harper's Bazaar*. These were the images that had made Dick's name, thanks to their spontaneity, insouciance, and joie de vivre, not to mention their narrative wit, nervous energy, and sheer nerviness. In their flash and flair, they were light-years removed from the fashion photographs of yore where the models looked aloof and dehumanized. From the beginning, Dick encouraged *his* models to have attitudes—he wanted his pictures to convey a sense of what might be going on behind their eyes.

The models in this gallery were ones whom Dick had for all practical purposes created: Dorian Leigh, her sister Suzy Parker, Elise Daniels, Sunny Harnett, Dovima . . . He knew instinctively how to assuage their vestigial insecurities and make them feel, and look, even *more* beautiful than they were. He even allowed the model to have a say in the choice of the print he submitted to the *Bazaar* (having of course told her which one *he* preferred).

Suzy Parker was Dick's all-time favorite model. Starting in 1951, he photographed the ravishing redhead time and again, turning her into the highest-paid and most recognizable model in the world, what Eileen Ford described as "everybody's everything"—the ideal of the modern American woman. He had first laid eyes on her at Dorian's wedding, when she was all of fourteen, a skinny tomboy, already tall. She was glowering at her sister, and that was a sign of things to come, for jealousy, Dick maintained, was Suzy's besetting sin. She would do things like rummage around in his desk drawers for contact prints in order to see which other models he was photographing. He in retaliation would make up messages for her to find, like "Dovima, Wednesday all day." Finally he became so exasperated he sent her an actual drawer stuffed full of fake sittings with her competitors.

Suzy would count how many photographs of her, as opposed to his other models, Dick put in his books, and become irate if there were more of Dorian than of her. When he began photographing Barbra Streisand, for example, Suzy flew into a rage: "How could you! She's so ugly!" This behavior outlasted Suzy's retirement from modeling. The day Dick's Chanel No. 5 ad with Catherine Deneuve began running,

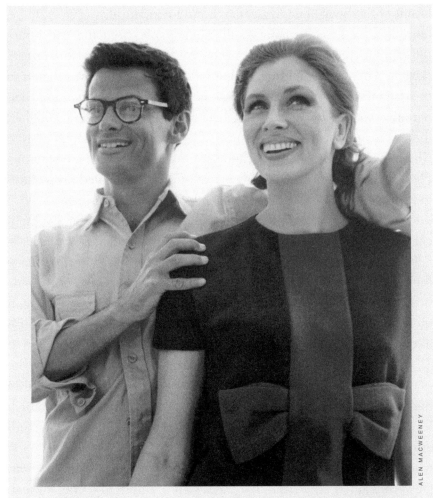

ALEN MACWEENEY

DICK AND HIS FAVORITE MODEL, SUZY PARKER, ON A
HARPER'S BAZAAR SHOOT, ANTIGUA, 1962.

in the early seventies, she called Dick and ranted, "Why use *her*? She's
so *bourgeoise*." In the fifties, Dick had photographed Suzy for No. 5,
and now she was claiming that Chanel had invented the perfume for
her, so close were they. (The Pulitzer Prize–winning novelist Alison
Lurie interpreted that closeness this way, based on a 1959 Avedon pho-
tograph of the pair: "Parker, smiling girlishly and showing her famous
dimples, leans against the much smaller designer as if unable to sup-
port her own weight; Chanel, looking like a murderous lesbian alliga-

tor, clutches a heavy chain in one claw and thrusts the other into her model's neckline, so that we want to ask, Why is this woman smiling?") Later, Suzy could never bring herself to say the name Stephanie Seymour. "She could never understand that there was always going to be a next girl for me," Dick explained.

Back in the day, Suzy had gone out on a limb for Dick—literally. She was the co-conspirator in one of his highest-risk photographs, climbing out into the gutter on the roof of the cathedral of Notre-Dame in 1951 to pose beside one of its signature gargoyles. The single biggest crowd-pleaser of the Met show would be Dick's 1956 photograph of her in a Dior cape roller-skating with the English male model Robin Tattersall on the uneven cobblestones of the Place de la Concorde. Carmel Snow hesitated to run this irresistible picture, changing her mind only at the urging of her art director, Alexey Brodovitch, and then perhaps wishing she hadn't, when the Chambre Syndicale de la Haute Couture Parisienne lodged an official complaint to the effect that the photograph not only insulted the dignity of the garment but defiled all of French fashion.

It was Dovima with whom Dick collaborated on what is incontestably the most celebrated single image in the history of fashion photography: *Dovima with Elephants*, which was now gracing the landing leading to the Met exhibition. Dick had created this fantastical vision of beauty and the beast in August 1955, at the Cirque d'Hiver, which at the time was being used as a location for the Burt Lancaster vehicle *Trapeze* (a friend of Dick's who was working on the film had invited him to visit the set). The pachyderms—Jumbo and Tarzan, chained at the ankle on a carpet of scattered hay—served as the perfect foil for the unfettered Dovima. All coiffed by Alexandre, she held sway in a black-velvet, white-sashed, tight-sleeved, ankle-length gown designed by Christian Dior's brilliant young assistant Yves Saint Laurent. Dick told me that when one of the elephants began stepping on the train of the dress, he directed Dovima to maintain her pose and "look fearless." When he submitted this one-of-a-kind, once-in-a-lifetime, photograph to the *Bazaar*, Brodovitch commented that he should take more pictures like it.

The exotic-looking, comic-book-loving, Queens-reared daughter of

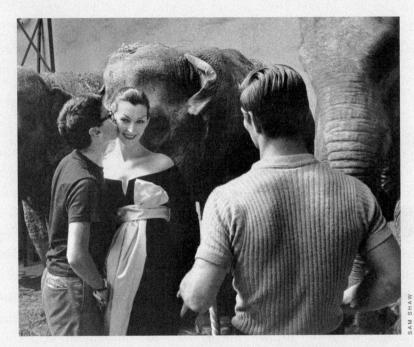

DICK AND DOVIMA ON THE SET OF THE MOST
FAMOUS FASHION PHOTOGRAPH EVER MADE,
DOVIMA WITH ELEPHANTS, PARIS, 1955.

a Polish American cop and an Irish farm girl, Dovima had fabricated her name—some said from the first two letters of her three given ones, Dorothy Virginia Margaret; others claimed from the first two letters of "Dorothy," "victory," and "Ma," for her mother. The only known person who ever rated *Dovima with Elephants* as anything other than perfection was Dick. He was troubled by what he called his "mistake," his "failure": the white satin sash should have been wafting out to the left to echo the line of the elephant's leg to Dovima's right.

Dick had a six-by-five-foot print of the image made for the Met show, and afterward he hung it in the entryway to the studio, where it held dominion for the rest of his life. When he was scrupulously editing his archive, purging it of the prints he judged to be less than his best, he made a point of retaining every single one of the *Dovima with Elephants* images, just as he had with his Ezra Pound and Oscar Levant prints.

Dovima with Elephants was far from the only photograph in the Met show that had shocked and awed when it first broke upon the world in the pages of the *Bazaar*. Witness ash-blond film-noirish Sunny Harnett smoldering in a one-shoulder Grès jersey as she leans over the roulette wheel at the casino in Le Touquet, in 1954. (A tragic fate lay in store for this Avedon model, of whom Diana Vreeland once said, "She wore chinchilla and diamonds as carelessly as if they really belonged to her, and Dick had a way of making her believe that they did": in the early sixties she died in a fire in the state mental hospital to which she had been committed.) Witness picture-hatted, Balenciaga-suited Elise Daniels, engaged by a troupe of street performers in the Marais. And the one-name model Renée, twirling the fabric-rich skirt of her Dior suit in the Place de la Concorde, transfixing three young male passersby and, now, in 1976, thirty-some years later, visitors to the Met show, young and old, male and female.

And then the drumbeat of Dorian: Dorian anxiously preparing her face before a mirror at Helena Rubinstein's Paris apartment; Dorian in Dior, embracing a sweaty Tour de France cyclist on the Champs-Élysées; Dorian in tears, in a railway car at the Gare de Lyon (a photograph rejected by Carmel Snow on the preposterous grounds that any woman in a position to be wearing a Dior hat couldn't possibly have anything to cry about). Dick told me that to induce the waterworks he had brought onions, teardrops, and menthol to the sitting that far-off day in 1949, but that Dorian turned out to be a natural at it: "a regular Anna Karenina—her tears flowed like rain."

Dick excelled in creating vignettes and mini-dramas—forerunners of the print and television ads that he would later produce for Revlon, Chanel, Calvin Klein, and Versace. Every Paris sitting, its feeling of improvisation notwithstanding, was rehearsed, each flurry of movement choreographed (down to the flapping of pigeons in the background of one Suzy Parker picture). The locations included cafés, pool halls, bistros, boîtes, brasseries, and scenic bridges—Dick rented gigantic projectors on generator trucks to light the stone-paved streets for atmospheric effect.

For all the artifice, Dick's Paris created conviction. One of his oft-repeated stories had the designer Christian Lacroix running up to him

in an airport to say that he mined Dick's books for inspiration for his collections—"*J'adore votre Paris, que malheureusement n'existe plus.*" Dick laughingly set him straight: "'My' Paris never existed. I fabricated it—not out of whole cloth exactly, but out of swatches of Lubitsch, René Clair, Rogers and Astaire movies, and Cole Porter songs, and out of the stories that my mentor, Alexey Brodovitch, told me of the Paris he knew before the war. It was my own elation that I was photographing, and it got whipped up to the point where I was able to give an emotional dimension to the couture itself." In the retelling, the sheen of satin, the texture of tweed, the folds of a gown, the architecture of each piece of clothing could bring Dick to tears.

In a portrait in the next gallery at the Met, the model had no clothes on to speak of. When Dick photographed Contessa Christina Paolozzi bare-breasted in 1961 for the *Bazaar,* he was banking on the scandalizing potential (at the time, nudes in magazines were kittenish, come-hither). Indeed, Nancy White, who had succeeded her aunt Carmel Snow as editor-in-chief and who was a practicing Catholic (she wore white gloves at work, and Dick referred to her as Snow White), consulted the magazine's prissy literary editor, Alice Morris, who found the image objectionable but came up with a possible way to save it— commission the eminent English art historian Kenneth Clark, who was the last word on the distinction between naked and nude, to write about the photograph for the magazine. When Clark refused, Dick succeeded in selling Nancy on the idea of being the first to publish an in-your-face nude in a leading fashion magazine.

Dick saw the photograph as a political statement, declaring that "it marked the beginning of a social movement about nudity in the sixties." First and foremost, of course, it was perceived as a fashion statement—Rudi Gernreich credited it as the impetus for his revolutionary topless swimsuit, the monokini. The photograph was published the world over, invariably headlined "THE NAKED CONTESSA."

It had repercussions closer to home. Christina Paolozzi was a figure in more ways than one, or even two: she was the daughter not only of a Neapolitan count but of an American heiress. Her mother, a founder of the artsy Spoleto Festival and a competitive race-car driver to boot, strode unannounced into the Avedon studio one morning and decked

Dick. "She was already out the door by the time I picked myself up off the floor," he told me. Dick pulled *his* punches by not calling the cops on her. "I wasn't going to give her the publicity I suspected she was after."

Another photograph of a titled woman, Vicomtesse Jacqueline de Ribes, taken the same year as the Paolozzi lollapalooza, was almost as much of a showstopper. She is shown in profile, gazing at a profiled fake Chilean marquis. Dick said, "It's the length of their noses and the degree of their narcissism that makes the picture." The *New Republic's* art critic Jed Perl summed up the photograph as "Proust meets mod fashion; these two are the pop stars of the Guermantes Way." Dick himself pronounced it his "one great Proustian picture," attributing its inspiration to the party in the last volume of *À la Recherche du Temps Perdu*. Nor was it lost on Dick that de Ribes's father, Comte Jean de Beaumont, had been a notorious Nazi sympathizer.

The gallery up ahead pulsed with Dick's pictures of the girls who embodied the sixties "youthquake" (Diana Vreeland coined the word for what she described as "the razzle-dazzle of everybody doing their own thing"). His models were always steps ahead of other photographers'—leaping, loping, wheeling (and freewheeling), prancing, romping, sprinting, twisting, and gyrating, in Courrèges, Ungaro, Cardin, Paco Rabanne . . . One of Dick's favorite positions for a sitter was midair. "I invented a whole confetti of movement," he declared. Alison Lurie went so far as to posit that "anyone who saw these kinetic, hyperactive portraits . . . might have predicted the women's lib movement."

Perhaps Dick's most iconoclastic model at the end of the sixties was Twiggy, a.k.a. "The Twig": the waiflike flower child with the huge eyes and Cockney accent who was the biggest thing that had happened in Britain since the Beatles. She came to New York expressly to be photographed by Avedon for *Vogue*. In anticipation, Diana Vreeland fired off one of her inimitable rat-a-tat-tat memos to Dick and Polly Mellen proclaiming that Twiggy "represents beauty not twiggery" and reminding them that she was "dreadfully swaybacked" and "should be treated as a perfect flower with a straight stem and a bloom at the top and not like a half-deformed teenager." Dick found her perfectly beautiful and

decided to photograph her as "the symbol of her generation," which he did to the strains of a record by the Kinks that she had brought to the sitting.

And where there was a Twig, could a Tree be far behind? In this case, the exotic Penelope Tree. And then there was "The Amazon"—in the form of the six-foot-one Veruschka. And the willowy, sinewy Donyale Luna, the first black model shown at such length (six pages) in a mainstream American fashion magazine. (The *Bazaar* took care to cover its tracks, in a caption proclaiming that Luna wore the clothes, which included a Galanos tiger chiffon sheath, "with all the grace and strength of a Masai warrior"—a politically incorrect comment that, however, paled beside Dick's to an interviewer that "beauty comes in all colors, including chocolate.")

Interspersed with these fashion pictures were Dick's celebrity portraits: Elizabeth Taylor (her face framed by cock feathers), Brigitte Bardot (all lips and Alexandre hair), Marilyn Monroe (all hips and sequins), Sophia Loren, Cyd Charisse, both Hepburns, Dietrich, Swanson, Bacall, Lena Horne, Janis Joplin, Tina Turner, Joan Baez, and Bette Midler. Dick had originally hung the Midler portrait in a roomful of beauties where she looked uncomfortable; in her stead he hung Anjelica Huston, pictured with his onetime assistant Harvey Mattison, on a *Vogue* shoot in the depths of the Irish countryside. "They only *look* romantic," Dick told me. "Anjelica refused to go to bed with him, the foolish girl—Harvey was glorious."

Among the loudest conversation pieces in the show was a series of photographs that resonated from a time in the sixties when Dick was feeling coltish enough to nip the hand that fed him—*Harper's Bazaar.* He asked Mike Nichols to create an elaborate satire for him to photograph under the guise and cover of the Paris fall collections. It was based on the torrid extramarital carryings-on of Elizabeth Taylor and Richard Burton, who had fallen in love while co-starring in *Cleopatra* and were being mercilessly hounded by paparazzi. Dick cast Suzy Parker as Liz, and Mike himself as Burton. ("The blond Nichols could be a stand-in for the dark Avedon," a critic would later write. "These good-looking, incredibly bright young men have a knack for finding themselves in the thick of things.") The ten-page portfolio was designed

by Marvin Israel to look like a tabloid, complete with the sensational headline "MIKE NICHOLS SUZY PARKER ROCK EUROPE . . . PARIS SHOCKED." Only it was American advertisers who were rocked, and American readers who were shocked, by Dick's parody of celebrity culture and haute couture.

Another object of intense curiosity in the Met exhibition was Dick's photographs of two sultry young Spanish women and a decadent-looking older man — "Three is *never* boring," Dick always maintained — published in a *Bazaar* portfolio titled "Illusive Iberians." Irving Penn had been among the first to recognize it for what it was: "a much more profound statement of fashion — fashion in living, fashion in feeling, and in thinking." Dick conceded that "twenty-three pages of sexual ambiguity was not something you would normally be seeing in print in 1965, and that was the reason I did it — it was my *intention* to go almost too far. I wanted to celebrate the narcissism and cynicism of the people who lived by fashion magazines. That story was partially responsible for my ultimately leaving the *Bazaar*." Dick was amused when Mad Man and, later, film director Stan Dragoti approached him wanting to know more about the ménage à trois. "You almost took it out of fashion for me," Dragoti told him. "I almost want to know about them personally. Did you run the gamut of pre-thought about these people?" Well, Dick certainly had their numbers.

And yet, as coded with sexual implications as some of Dick's photographs of women were, they all lacked heat. As Irving Penn once put it, "Avedon's greatest creation has been a kind of woman who is sisterly." And David Bailey said to me, "Dick and I both photographed beauties like Jean Shrimpton, Catherine Deneuve, and Penelope Tree. The difference is I slept with them and he didn't. That gives me a bit of an edge there, don't you think?" Peter Beard, for his part, declaims, "I'd bet my fucking life that Dick Avedon never once had sex with any model he photographed. He really missed out, too, and I say that as someone who slept with every model I ever photographed. Sexuality is the only truth."

On a flight from Nîmes to Paris in the late eighties, the French actor Pierre Clémenti, who played the gangster lover of Catherine Deneuve in *Belle de Jour*, stumbled over to Dick in a drunken stupor,

chanting, "Avedon, Avedon, Avedon . . . I fucked all the women you photographed, Avedon, Avedon, Avedon." (Clémenti then began methodically shedding his clothes, and wound up giving Dick the T-shirt off his own back, then sinking to his knees in the aisle and kissing Dick's hand. Dick recognized that the actor was probably clinically insane—and also that he would have made as great a pharmacological portrait as Oscar Levant!)

A couple of years after Dick died, I was having lunch at the Chateau Marmont in L.A. with June Newton, who was Helmut's agent as well as his widow. She said in a loud voice, "The difference between me and you, Norma, is I fucked Helmie and you never slept with Dick." Everyone was staring. I have to wonder what is wrong with these people who think the only way you can know someone intimately is to go to bed with them.

I learned from the recent biography of the poet James Merrill that he was addicted to anagrams: he would take a proper name and rearrange its letters to produce new words. "Mary McCarthy" yielded "Cry at my charm" and "Marcel Proust," "pearl scrotum." With "Richard Avedon," Merrill went to town—"The model's confession: Richard Avedon's hard-ons I craved." Reading that, I thought, Dream on, girl! Dick rejected the myth of the fashion photographer as sexual conqueror. As he once said, "Taking pictures of models is not a matter of arousal—it's hard work."

All of that insistent sedulousness of his culminated in the final gallery of the Met exhibition. The seven heroically scaled, unframed photographs on display there—simply dressed, casually stanced women staring at the viewer head-on—were emblematic of the new style of portraiture that Dick had invented. Renata Adler is all aura, her intelligence blazing out of her large, dark eyes, her braid as thick as a horse tail. In a 1961 letter to a friend, Mary McCarthy described her as "a thin, rather Biblical-looking Jewish girl . . . who is either quite homely or a beauty, according to taste." Now, thanks to Dick's photograph, Renata stood immortalized as the intellectual beauty she is. Why, Janet Malcolm was moved to write in *The New Yorker* that "the portrait of Renata Adler was taken in the French West Indies, and its sun-struck aspect turns one's mind to the novels of Conrad, suggests exquisite

Conradian moral dilemmas for the boyishly slender young woman with tragic eyes and proud mouth and long castaway braid."

Also enshrined in the last room were the exhibition's designer, Betti Paul Avedon, with a braid of her own, yet; Loulou de la Falaise, Yves Saint Laurent's muse and, more to the point here at the Met, John McKendry's stepdaughter; Fiat heiress Priscilla Rattazzi in jeans, her hands in her pockets; and further along the wall, her aunt, Marella Agnelli, circa 1976, hands also in pockets (a family trait?), and looking, for a wonder, downright approachable.

Last, but anything but least—in point of fact, most, at nine feet high and eight feet wide—was Dick's portrait of the gifted sculptor June Leaf. She is wearing a short-sleeve top and her arms are flagrantly veined, her stringy long dark hair is streaked with gray, her eyes are darkly ringed, and her breasts are sagging. This portrait was a radical choice for the ending to an exhibition of fashion photography. "June is a stranger to makeup, and she's never been to a beauty parlor, but she radiates honesty and goodness—as a human being she's a knockout," Dick declared, adding, "Let's put it another way—who would you rather spend an evening with, June Leaf or a wackadoodle like Lauren Hutton?" (Listen, Lauren was a lot of fun, and Dick had once adored her, hailing her as "the link between the dream and the drugstore." But he felt that she hadn't been loyal enough in the long run, given that he had made her a star, first by insisting, over Eileen Ford's objection, that she not fill in the gap in her teeth, and ultimately by orchestrating her headline-making million-dollar-plus exclusive Ultima contract with Revlon in 1973.)

"June Leaf is the most beautiful woman I ever photographed, and this is my favorite portrait of a woman," Dick declared at the time of the Met show. He then escalated the claim, telling the Washington Post's Sally Quinn that Leaf was the most beautiful woman he had ever seen, and later raving, in both senses of the word, to Women's Wear Daily that Leaf left Catherine Deneuve in the dust. To Whitney Museum director David Ross, he would later enthuse, "She's the muse, the earth mother, she's gorgeous in her give-and-take and lack of cosmetics and in her generosity with her self. To me she's also a sexual creature—so womanly. She presides over my life, in my image of her." In Owen

Edwards's interpretation, when Dick was "paying the bills himself"—that is, serving his own needs rather than those of a fashion magazine—"he was able to widen his definition of beauty."

The exhibition was now installed to Dick's exacting satisfaction. It had flow and momentum, contradiction and contradistinction—each picture had just enough breathing room. A technical adviser who stood in those galleries day after day during the two-week installation marvels, "Avedon's great supporter Mrs. Vreeland never once ventured up from the Costume Institute in the basement, to which she had become the 'special consultant' a few years before, to see how things were unfolding. She should have been a cheerleader for the show—at the very least, popped in for a minute to say, as only she could say it, '*Fabulous!*' But she didn't stick that big nose of hers into the exhibition until the night of the opening." (Of *course* Diana hadn't popped in during the installation—it wasn't *her* baby. She was like Dick in that regard: everything had to be all or nothing. I was there, standing right beside him, when she said to him, using her pet name for him, "Good show, Aberdeen!")

On the night of nights, September 13, 1978, I hosted a small dinner

DICK UP IN ARMS—HIS SON'S.

in my apartment around the corner from the museum. My peckish guests did not include Dick, who had said, "See you at the Met—I'm too nervous to eat." Polly Mellen came with her adorable husband, Henry; Hiro, who had been the first of Dick's many Japanese assistants, with his Canadian wife, Elizabeth; the fashion journalist Carrie Donovan, with Perry Ellis; and the artist Wendy Vanderbilt, with her husband, New York State parks commissioner Orin Lehman. I had laid on royalty of a sort, the "Omelet King" Rudy Stanish, who had started out as Bunny Mellon's supper (as opposed to dinner) chef and wound up making the eggs for JFK's inaugural breakfast and writing a cookbook garnished with a foreword by Edward Albee. (That night in my kitchen Rudy confessed to me that he himself was allergic to eggs.)

It was around nine, an hour into the black-tie shindig, when our little party pulled up at the museum—only to confront a line that one observer described as looping around itself like some huge intestinal tract. The crowd was as clamorous as it was glamorous. A full four thousand of the Met's sustaining and supporting members showed up (three times the usual number), not to mention Dick's twenty-five hundred invited guests, plus Mitzi Newhouse's and Farrar, Straus's. The "large opening" that John McKendry had predicted four years before in his proposal for an Avedon fashion exhibition would turn out to be a record at that time for a social event at the Met. The institution was overwhelmed—by ten o'clock, the party's halfway point, the bars that had been set up in all four corners of the cavernous entrance hall ran out of glasses, and the thirteen-man combo suffered an acoustical collapse.

My ten-year-old son, Max, had insisted on coming along. He was all dressed up, in a blue blazer accented with a red silk tie. I had wanted to give him some cute little purpose to accomplish at the museum so he wouldn't get bored, and Dick came up with the perfect thing: Max should tell everyone he was a reporter for his Dalton School paper and ask them, "Do you think a show like this belongs in a museum like this?" I made him promise to approach only people he knew. His first victim was Hiro, who snarled, "Show me your credentials, kid." Polly of course took Max's question hopelessly seriously, answering, "And how! It's the most fabulous show the Met has ever put on, and that's saying something. And by the way, dear, your tie is fabulous, too." Car-

DICK GIVING *CONDÉ NAST*
EDITORIAL DIRECTOR
ALEXANDER LIBERMAN
A TOUR OF THE MET
INSTALLATION. BELOW:
ART-WORLD VALIDATION—
DICK WITH TOP DEALER
LEO CASTELLI AND
COLLECTOR BARBARA
JAKOBSON AT THE
SEPTEMBER 13 OPENING.
BOTTOM: DICK, BETTI,
AND JOHN AVEDON WITH
MARVIN ISRAEL AND
DOON ARBUS AT THE
AFTER-PARTY AT THE
CLUB XENON.

PHOTOS BY ALAN KLEINBERG

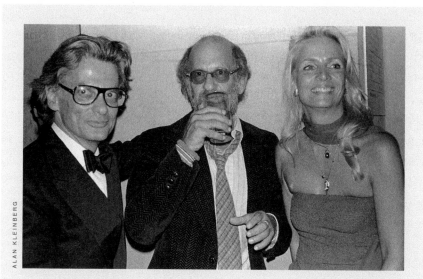

ALAN KLEINBERG

DICK AND MARVIN ISRAEL AT THE MET OPENING, WITH
CONTESSA CHRISTINA PAOLOZZI, THE FIRST "TOPLESS" IN A
FASHION MAGAZINE, WHOSE PORTRAIT WAS IN THE SHOW.

rie Donovan held forth pompously on the vulnerability and dedication of young models while giddily indicating all the celebrities in attendance. "Why don't you go and ask that divine movie star over there what *she* thinks?" she said, and pointed Max in the direction of Diane Keaton, who was there with Warren Beatty, her boyfriend at the time, and being mobbed by the real press. It was literally a crush, but Max, being little, managed to get close enough to hear Diane say to Warren, or Warren say to Diane, "Let's get the fuck out of here!" He told me he felt the exact same way, and I told him in no uncertain terms that he had to stick it out.

I spotted Sidney Lumet, Susan Sarandon, Betty Comden, Adolph Green, and the art collector Ethel Scull, who nudged me with her sharp elbow and said, "What's wrong with Richard Avedon? Andy photographed me thirty-six fucking times, and Dick hasn't photographed me even once!" Diane von Furstenberg was there, looking impossibly chic, and Gordon Parks, looking snazzy. And Mike Nichols, with wife number three. Nora Ephron fessed up that this was her first night on the town since having her baby. (That baby, a.k.a. Jacob Bernstein, would grow up to write a profile of Dick's photographer grandson, Mi-

chael, for *The New York Times* in 2012, titled "ANOTHER AVEDON BE-
HIND THE LENS"—I guess it's true what they say: time flies.) Zandra
Rhodes streaked past with green hair, followed by Met opera patron
Mrs. John Barry Ryan—"Nin" to her intimates, and mother-in-law to
one of Dick's favorite *Vogue* fashion editors, D. D. Ryan. Dick was
gratified to see Mrs. Ryan, who represented the upper crust that, taking
a page from Proust, he had begun insufferably referring to as the *le
gratin*. Lauren Bacall was there, too, vamping for the photographers.
"She was in my little play group at temple when we were kids," Dick
whispered to me, "and she's gotten no less pushy with rapidly advanc-
ing age." Eileen Ford came over to us to complain about the models in
attendance: "I *made* most of those girls—you would think they would
be a little more attentive to me." The Jackie was the show's biggest no-
show. (She would wait to make her appearance until the following
Monday, the day the museum was closed to the public, after which she
wrote Dick a note in purple ink and prose.)

The first model I ran into when I made the push upstairs into the
galleries was Dovima, now fifty, her hair teased in a bouffant, her face
fringed with fake eyelashes. This woman who had appeared on the cov-
ers of *Vogue* and *Harper's Bazaar* upward of 150 times told me up front
that she had had to borrow money for the bus fare from Fort Lauder-
dale (she had a job there hostessing at the Two Guys Pizzeria, where
she had put up a poster of *Dovima with Elephants* in the back room—so
much for *her* slice of the pie). Across the gallery was Christina Paolozzi,
in a mauve gown, standing abreast her topless portrait—she was milk-
ing that picture for everything it was worth. She said to me, "I still look
like that." Max said hi to her—he knew her from the football field, of
all places. Her son Andy was his Dalton teammate and friend, and
Christina would often show up at practice with elaborate lunches in
antique-wicker picnic baskets for the boys. Max commented later, of
the unmentionable photograph, "Andy's mother is no Playboy Bunny."
I mean, leave it to Beaver! (In 2007 Andy's wedding announcement in
The New York Times included the line: "A nude picture of his mother by
Richard Avedon has been shown at the Metropolitan Museum of Art.")

Christina was far from the only Avedon model positioned in front of
a photograph of herself that night. Pat Cleveland was taking in Dick's

ALAN KLEINBERG

DICK DRESSING—OR UNDRESSING—FOR HIS MET OPENING.

picture of her from the perch of her husband's shoulders, and Ingrid Boulting was imitating herself, leaping back and forth in front of her jumping picture as the flashbulbs popped. The imposing Maxime de la Falaise, John McKendry's widow, had stationed herself in the last gallery, next to the portrait of her daughter, Loulou, in a punk leather jacket taken in Paris the year before. "This show is John's baby," she reminded me, "only he didn't live to see it grow up. I'm going to burst into tears."

Dick was in his height and glory, gathering up his former models in their old original pecking order—first Suzy, then Dovima, then Dorian. He led them over to their photographs, each to each. Dorian stopped short in front of one of hers—a never-published print from an August 1949 sitting at the Pré Catelan restaurant in the Bois de Boulogne that she was seeing for the first time. In the picture she has a Schiaparelli rhinestone ornament in her hair and she's laughing uproariously, belly laughing, her mouth open. She immediately began making a scene. Suzy, who had come from Santa Barbara for the opening, was in full troublemaking mode, claiming not to be able to recognize her own sister in the photo: "That can't be *you*! With that big double chin? It looks like Princess Margaret on a bender." At that point Dorian began

shouting epithets at Dick, who announced sheepishly to the crowd that was beginning to gather, "Don't believe a word she says! She's my girl. My Fire and Ice girl. Dorian and I go all the way back."

When both Dorian and Dovima were safely out of earshot, Suzy said to Dick, "Dorian's not aging at *all* well. And *Dovima*! She's a wreck, a street accident. I mean, look at that hair!" When Suzy was out of hearing range herself, Dick said to me, "She's one to talk! She's totally let herself go—she's over the California hill. But that's how you get when your life is nothing but car pools."

Dick described his old models to me that night with a distaste almost stomach-churning: to him they all looked "like chocolate that has turned—or milk." With the forgivable exception of Dorian, they happily posed with him for the photographers in front of his photographs of them. I said to Dick, "Not so smart of them." He replied, "They know the newspapers are on strike."

Irving Penn came over to congratulate Dick, and gave him an awkward hug. Dick said to me afterward, "That was for the cameras." Penn was followed in close succession by Condé Nast editorial director Alexander Liberman, who said to Dick, "*Cher collègue*, my heartfelt congratulations," placing his hand cornily over his heart. After he left, Dick commented, "He doesn't have one—he's one of the biggest killers in this business." Then we repaired to the after-party at the trendy club Xenon, where Dick had made the password for the evening "Dovima," savoring the thought of Dorian, and especially Suzy, having to utter it to get in.

On his way out of Xenon, Mike Nichols caught Dick up in a bear hug and said, simply, "You're the top." Indisputably now, Dick *was*: he was not only the Met but, by extension, and with apologies to his one-time sitter Cole Porter, "the Louvre Museum . . . the Tower of Pisa . . . the National Gallery," not to mention—the greatest of accolades in Dick's book—"the nimble tread of the feet of Fred Astaire."

A quarter of a century later, the photographer Alan Kleinberg made Dick a present of the photographs he had taken that night. Dick reviewed them feeling, as he wrote Alan, that he was in the middle of the episode of the madeleine in Proust, and he always referred to them as a "treasured time capsule." He enlarged the picture dearest to his heart:

For Norma—in our Prime — Dick

SEEING EYE TO EYE AT THE MET OPENING.

NORMA AND MARTIN, JOHN AND DICK,
AT THE MET AFTER-PARTY.

the one of him on his knees to his mother, had it framed by his favored framer, Jed Bark, and placed it by his bed. He also had one of Alan's photographs of the two of us enlarged, and I placed it by *my* bed.

The October 16, 1978, *Newsweek* cover, a self-portrait of Dick, trumpeted "The Avedon Look." (Dick would make the cover of *Newsweek* again: the September 13, 1993, issue, heralding a "30-page Richard Avedon Photos portfolio.") At the time Dick was the first photographer ever to appear on the cover of a national magazine, which was the ultimate measure of celebrity in America. "As a *Newsweek* cover boy, he was suddenly right up there with Mike Nichols and Leonard Bernstein and Jerome Robbins, the people he admired the most—intellectual, artistic achievers—and whose circle he had always longed to be part of," says the writer of the story, Charles Michener. "And that cover would continue to be a huge calling card for him."

Other magazines weighed in with paeans, compensating to some extent for the stricken newspapers. Susan Sontag, whom Dick was touting at the time as the "biggest brain in the universe," modeled her review in *Vogue* on Dick's deeply held premise that fashion was based on "the recognition of the profundity of surfaces." "Many other photographers have produced memorable images: none has a body of work which deploys so intelligently the powers and ironies of fashion photography," she wrote. "Endlessly knowing about and loyal to fashion as spectacle (the theatricalization of beauty; the erotic as artifice; the stylization of appearances as such), Avedon has taken pains in recent years to show fashion photography not to be limited to fashion." Dick said, "I couldn't have said it any better myself."

Owen Edwards said it best. "With his vibrant, swirling, brilliant exhibition, Richard Avedon has at last, surely, routed for good the tedious vestiges of defense against the idea that fashion photography deserves a place in the pantheon of camera art," he proclaimed in the *Saturday Review*. "The show is a triumph, a symphony dedicated to the long liaison between his wondering eye and women . . . These sumptuous pictures . . . seen on the walls of a temple of art, on a grand, highly dramatic scale, take on an unexpectedly splendid, epic quality . . . Avedon has no peer in his style, his composition, his graphic instinct, his conveyance of energy, vibrancy, fun, Proustian gossip." Edwards went

on to pay tribute to Dick's "uncanny directorial genius for bringing women out of their skins, up beyond the fabric of the diverting clothes they wear, and into a realm of drama and emotion rarely seen in the best street photography."

By the time the show closed, almost a quarter of a million people had been to see it.

THE EXHIBITION WAS SUCH a success that I said to Dick, "Let's keep it going! Let's make a limited edition." He had ended his relationship with Marlborough, chafing at having to pay the stiff gallery commission, and I had stepped up to the plate in that capacity as well, becoming his fine-art representative. He said, "How many should we do? Which ones?" I said I thought a dozen or so, and that everything should be on the table except for the Dovima. He said, "Are you crazy? That'll sell the others." I said, "Down, Dick! Let's hold the most salable one back—to sell separately. Later we can make several editions of the Dovima alone. She'll be our cash cow. Our cash *elephant* cow."

We created a brochure to send to four thousand potential portfolio buyers. Included was the essay on Dick's fashion work by his fashionable Francophile friend Rosamond Bernier, a founding editor of the prestigious French art magazine *L'Oeil* and now the wife of the *New York Times* art critic John Russell. Dick had commissioned it as an introduction to the exhibition's illustrated checklist that was on sale at the museum, and he had gotten his money's worth: Rosamond exalted him as "a philosopher, a historian, a moralist, a poet, and a wit," let alone a great artist. "Fashions were his material," she wrote, "and he went to work among them the way Claude Monet went to work among his water lilies."

We limited the fashion edition to seventy-five portfolios with ten artist's proofs, each consisting of eleven signed-on-the-front, stamped-on-the-back, and numbered silver eight-by-ten prints—all of them Paris images from the show. We priced the portfolio at five thousand dollars (remember, nobody was collecting photography as art at the time). Dick gave one to Mike Nichols. Martin and I purchased two. And I personally sold two, to one person—one personage, rather. I lugged a portfolio over to Marella Agnelli's apartment at 770 Park, where I sat on

the floor, at her knee, and with white gloves opened the white-linen box inscribed with the Avedon signature in red, and presented the prints to her one by one. She made no comment till I got to the end, when she said matter-of-factly, "I'll take two." I returned to the studio, loaded up another portfolio, and proceeded to Dick's butcher, Stanley Lobel, on Madison Avenue. The fashion portfolio turned out to be his meat—he forked up on the spot. But no more than ten got sold on the initial offering. Dick gave one to Mike Nichols.

The Dovima editions that we eventually printed—in various sizes, starting with a hundred eight-by-tens—would turn out to be Dick's most successful ever. And when in 2010, to help fund its philanthropic activities, the Richard Avedon Foundation put sixty-five of the best-known Avedons up for auction at Christie's Paris, the huge Dovima print that was made in 1978 for the Met fashion retrospective and that had hung in the studio thereafter was sold to the House of Dior (the creator, after all, of the sumptuous evening gown she was wearing) for a little over a million dollars: an Avedon record.

A FULL DECADE ON from the Met show, Dick would learn just how viciously ad hominem Hilton Kramer's review in *The New York Times* would have been, had the paper of record not been on strike at the time. His retroactive attack was published in 1988 in *Art & Antiques* magazine, and took as its departure point "crossover careers—careers that originate in the fashion world and now find a flourishing market in the art world":

The most spectacular of these crossover careers has undoubt- edly been that of Richard Avedon, who made his reputation (and fortune) as a highly successful fashion photographer, and then, with breathtaking audacity, persuaded our most presti- gious art museums to take him seriously as a major 20th-century artist. Although we couldn't have known it at the time, we were actually given a preview of the ethos that would come to domi- nate the art world of the Eighties when the Metropolitan Mu- seum of Art mounted its mammoth Avedon exhibition in 1978. I well remember the press conference that Avedon held at the

Met on the day of the opening of the exhibition. It was the first time, by the way, that I had ever seen an "artist" hold a press conference . . . I think it was an Italian journalist who dared to ask the key question. Pointing out what was perfectly obvious to all — that the bulk of the pictures in the show had been produced to promote the sale of certain dresses, hats, coats, etc. — he asked why we should now be expected to take these pictures seriously as works of art just because they had been removed from the pages of the fashion magazines and the advertising campaigns for which they were created and hung on the walls of a museum. In his response to this question, Avedon showed his characteristic flair for unembarrassed self-promotion. He used hats in his work, he said, the way that Proust and Matisse used hats in their work. I shall never forget the stunned silence that greeted this remarkable statement. I think we all recognized that we were in the presence of a master — though a master of something other than art.

Four years later, when Dick's friend David Ross was appointed director of the Whitney Museum and announced that his first blockbuster show would be a fifty-year Avedon retrospective, Kramer, once again up in arms, relaunched his attack, this time in his column in *The New York Observer:*

It would be hard to say which aspect of this decision is the most appalling — its cynicism, its commercialism, or the insult it administers to the real artists in our midst . . . This is the ultimate capitulation to celebrity, money, and fashion at the expense of art . . . Now, thanks to the regime at the Whitney, one of the most shameful museum events of the 1970s is going to be re-enacted on an even larger and more shameful scale in the 1990s.

When the Whitney show finally debuted, in 1994, Kramer again turned the knife in the weeping wound. "He tore me a real one on that one — I mean, the things he said!" David Ross exclaims, going on to say

some questionable things of his own: "Kramer was a guy so intent on hiding his Jewishness he changed his first name from Milton to Hilton."

The Whitney show was in fact widely denigrated—as sprawling, badly edited, unevenly printed, and woefully overdesigned. One critic blasted it for its "special effects," and another commented that its title "Evidence" sounded like the name of a postmodern perfume. Serious critics lamented the dearth of fashion pictures, of which Dick had misguidedly insisted there be no more than ten (for all that, the exhibition was underwritten by *Harper's Bazaar*). The analogy of a huge Avedon survey show without fashion pictures, the *New York Times* art critic Michael Kimmelman later wrote, would be to "a Picasso retrospective without Cubism or a Woody Allen one without the comedies." To Arthur Danto, the art critic for *The Nation*, Dick's failure to include *Dovima with Elephants* was "like James Taylor giving a concert but refusing to sing 'Sweet Baby James.'"

And yet, when in 2007 the International Center of Photography first proposed a reprise of the Met fashion retrospective, supplemented with a selection of Dick's fashion pictures up to the millennium, I didn't jump at it. Even though by this time I had for three years been making decisions for the benefit of Dick without the benefit of Dick, for this one I had to take a deep breath: I wasn't so sure he would have agreed to an exhibition in a museum devoted solely to photography. But the presentation by ICP's astute curator, Carol Squiers, and its discerning adjunct curator, photography critic Vince Aletti, quickly convinced me that the show would serve as a significant legacy-enhancing engine.

Working on it, I found myself missing Dick more acutely than at any time since his death. Those fashion pictures had been our first trip down the museum aisle together. When Dick was alive, I had always had the next-to-last word, but now I *was* the last word on everything Richard Avedon, and that was a lonely feeling.

At the packed opening I encountered the long-ago lad whom Dick had so serendipitously paired with Suzy Parker for that iconic roller-skating photograph in the Place de la Concorde. Here was Robin Tattersall in the flesh, filling me in on his life in the years between: he was

NORMA AT THE PODIUM OF THE POSTHUMOUS AVEDON
FASHION RETROSPECTIVE AT THE INTERNATIONAL
CENTER OF PHOTOGRAPHY, NEW YORK, 2009.

a plastic surgeon practicing in the British Virgin Islands, at a facility named the Bougainvillea Clinic that he founded in 1973. I wasn't going to let an opportunity like this slip by—I asked if he thought I needed any work done. "Don't be ridiculous," he chivalrously replied, adding, "I wonder, Norma, is there any scope for a seventy-eight-year-old male model these days? My wife is keen for me to get back in the game, and frankly, it would be fun to work again. Though it would be *more* fun, it goes without saying, if Dick were around to take my picture."

If only Dick *could* have been there—to revel in the reviews. I would have given a lot to see the look in his eyes as he read them. The notices added up to "the long delayed but always expected something" he had been living for. *New York Times* art critic Roberta Smith's review, "Starting with Fashion, Ending with Art," flatly stated, "Richard Avedon was indeed a great artist, and his fashion photographs are his greatest work . . . [The show's] nearly 180 images confirm his place in the history and the art of his time. Avedon's fashion photographs from the late 1940s to the early '60s are everything you want great art to be: exhilarating, startlingly new, and rich enough with life and form to sustain re-

peated viewings. Their beauty is joy incarnate and contagious. The best of them are as perfect on their own terms as the best work of Jackson Pollock or Jasper Johns from that era, and as profoundly representative of it."

Reading those resounding words, I couldn't help thinking, One in the eye to Milton Kramer!

4

FEATURED PLAYERS

—

JUNE LEAF: AVEDON CAME TO US FIRST IN 1973, WITH HIS son—to celebrate the son's birthday, he said. And he brought some food from Zabar's. He must have thought it would impress the son to

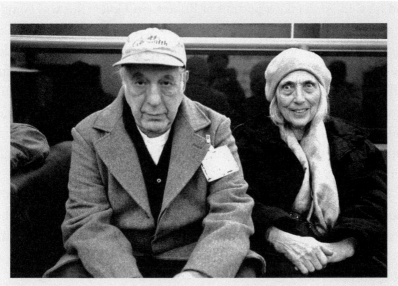

ROBERT FRANK AND JUNE LEAF.

go to Nova Scotia to have delicatessen with Robert Frank. It just wasn't
my thing, that somebody comes and brings their son to be impressed. I
don't like it so much when people are *in awe*, you know—it doesn't
make for me wanting to know them.

Of course by then I was used to people coming because they wanted
to meet my husband—Robert Frank's work stirs people, like nobody
else's really. And I do like to feature him, that's one of my pleasures—
I'm very much of a woman that way. But when you're married to that
kind of icon, it prevents people from appreciating *you*. And in some
ways that works for me, because I'm able to stay private. Actually, I'm
much more interesting than Robert. A friend of ours once compared
our dynamic to Frida Kahlo and Diego Rivera, and I thought it was
nice that he said *them*.

With Avedon I stayed out of the picture—I just served tea. I remem-
ber I had a hood on. He kept his distance, and I can't say that I paid any
more attention to him than he paid to me. I really didn't know very
much about him, except what any American girl would know about
Richard Avedon—that he photographed beautiful models.

A couple of summers later he asked if he could come back. He told
us he was having a big show at the Marlborough Gallery in September
and he wanted to take a portrait of Robert. So I knew this was going to
be another one of those in-awe visits. This second time, though, I liked
Dick right away, because suddenly he reminded me of a very dear
friend of mine who had just died, a Chicago artist and impresario
called Don Baum. With both of them, sexually, you couldn't quite
perceive what was going on. Also the way they looked, sort of delicate—
and lonely. Dick mentioned that he had been having some heart prob-
lems, so I must have felt sorry for him, but maybe that's not a very nice
thing to say.

Robert wanted to have our mongrel sheepdog, Sport, in the picture.
Avedon photographed Robert standing against the house, and then
again the next morning. It's a wonderful image: Robert's unshaven and
his hair is a mess and he's extending his hand to Sport, who recipro-
cates with his paw.

I took Dick for a walk on the beach afterward—we spent hours col-
lecting stones—and that's when I felt like now I'd really met him.

When we got back, Robert said, "Why don't you show Dick your new studio?" It's a separate building next to our farmhouse, and I had recently emptied it out in order to paint the inside. I thought fine—since I had put all my work away, I would only be showing him the building, which I was quite proud of. But once we were inside, he very politely said, "May I see some of your work?" I hate it when people do that, when I can't tell if they're really interested. But maybe I underestimated his interest in me from the beginning, because I knew that he had only come to photograph Robert. Which was fine with me—I wasn't there to present myself.

That past winter Robert's daughter, Andrea, had been killed in a plane crash, and it was a very difficult time, and because I was happiest when I was drawing, I started doing portraits of our neighbors—fishermen, farmers . . . So I thought, I'll just show Dick those drawings. I put one up, then another, and another and another, and he kept saying, "I want to see more!" I very quickly ran out of neighbors—we only had about ten of them—and then there was just this explosion: *all* my stuff came out, at least two hundred drawings. Well, I needed to put my work back up anyway. He sat there and he was watching me, and I felt he *saw* me.

He suddenly said, "I'm going to photograph you tomorrow." I was very surprised, but I really didn't take it seriously, because his style of life and work was famous people. And even though I felt I was totally worthy of being photographed, I knew I was not Richard Avedon material—because, among other things, I was somebody who wasn't famous in her own right, I hadn't had one of those big, logical careers. And the next morning he came, and just as he and his Japanese assistant, Kaz I think his name was, were getting ready to leave he said, "Don't think I've forgotten." So we went outside, and he put up a white backdrop, and it was over very soon.

Two days later he called Robert from New York: "I'm going to put my picture of June in the Marlborough show—it's the most wonderful portrait I've ever done of a woman." And I thought, again, he was just being polite, you know—I didn't really believe any of it. But then later somebody told me that they had read that in *Newsweek,* and that's when I realized he must have meant what he said, in a way.

It certainly wasn't a very good likeness of me. No, because my eyes are dark, and I'm not so still. And I didn't like that my boobs looked kind of pushed down. Though not as much as they look now! And where was my smile? As my mother would always say, "June has a very nice smile." Which is exactly what she told *him* when she met him.

Robert never said what he thought of the photograph, but he must have been jealous of how famous it became, because only then did he take a real portrait of me for the first time.

All those years I kept reading how Richard Avedon thought I was the most beautiful woman he'd ever photographed. I just felt it was because of that walk on the beach, because we had *talked*—and I'm someone who gives everything she has to a moment with somebody. It seems sort of silly to me that people get so excited about a photograph. I mean, Richard Avedon didn't make *me*. You know. He just made the photograph. Painters are different—sometimes they do make something that's equivalent to making somebody. A painting can be a whole *being*—created from nothing. A photograph is just something that somebody already *was*. And so I don't love photographs the way I love paintings. To me, the way people talk about Dick's photograph of me is like the emperor with no clothes.

My mother, who was a wonderful, wonderful woman, lived in Chicago and she wrote me a letter every two weeks right up until she died, at age ninety-five—and she always enclosed a five- or ten-dollar bill. I say a letter but it was never even as much as a full page. She would write me when she was at the beauty parlor, and she would begin, "I'm sitting under the dryer." One day in our mailbox in Nova Scotia I found a letter from her that was much longer than usual, one endless run-on sentence: "Hello Junie I'm getting my hair done I just thought I would write to say I had heard Richard Avedon was having a book signing at the Max Siegel bookstore and so I thought I'd go down there and introduce myself and when I did he said right off the bat how do you like my picture of your daughter and I said well I didn't think she looked so good I thought her hair was scraggly I didn't like it that it wasn't washed and I think she has a nicer smile than the one you gave her and I like my son-in-law's pictures of my daughter much better and there was a man standing next to me who said he wrote for a paper and he was writ-

ing down what I was saying and Richard Avedon never even offered me a free book." In her next letter she enclosed the reporter's article, along with a ten-dollar bill. It ended with the words "And Richard Avedon turned and walked away from the woman." I could only assume that he'd been offended when my mother told him she preferred Robert's pictures of me to his.

I went to the Avedon fashion show at the Metropolitan for one reason only: to take a photograph of my photograph on the museum wall to send my mother. And then I got a friend to go and take a picture of all those visitors staring up at me—I mean, I was like ten feet tall! I wanted to show my mother that I was really big stuff.

RENATA ADLER: Dick had this funny thing going with my mother. I had naturally told him what she said when she first saw one of his unflattering photographs of me: "It really doesn't do you justice." So finally he said, because it had really gotten to be a kind of cruel running joke between us, "I'm going to do a picture of you that your mother will love." And then what he does is call in Way Bandy, the makeup artiste. So there was all this very heavy makeup. And my mother didn't like the photograph that re-

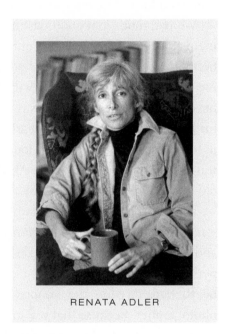

RENATA ADLER

sulted, *at all*. And mercifully Dick didn't, either—at least to the degree that he never published it.

He kept on saying how determined he was to get a picture of me that looked a certain way—a "good-looking picture," he called it—and in the end he took me to an island in the Caribbean expressly to do it. And *that's* the one that went into his Met fashion show: the one with the braid that became so famous. By the way, it said on the label and text panel that it had been taken in Saint Martin when in fact it was

Saint Bart's. Anyway, with that one, he had finally succeeded in taking a photograph of me that even my mother loved. And of course I loved it myself—how could you not? I remember confronting it at the Met opening and being amazed, overjoyed. So you see, he *could* be a wonderful friend—he could be many wonderful things. I really was his best friend. He was a very important figure in my life, too. I believe that I knew him in a certain emotional way that nobody else did. I mean, he's one of the people I still love, and there aren't so many. *And* admire— although there were things *not* to admire about him. For instance, he told me he'd sworn to Nureyev that he would destroy *all* the priapic pictures he'd taken of him, and then of course he didn't. Nureyev had produced for Dick every stage of an erection—at will.

We had feuds that could last more than a year, and these estrangements had many agents. One of them was that I went off to Yale Law School. And another was that I adopted my son. Because he expected me to go to every single event with him. He said it was "good for business," and *that*, we all know, was the most important consideration in his life. We were an item for years, and I think it was useful to him for us to be an item. Useful to me, too, of course. So we used each other—I was perfectly aware of all that. And I supported the act as much as *he* did—it was *my* act, too, in a way.

How I met Dick in the first place: Sidney Lumet invited me to a screening of his film *The Pawnbroker*—so this had to be 1964, right?— and sitting next to me was this downcast-looking, shy-seeming small person whose head was literally sort of hanging. And he turned out to be Richard Avedon the famous photographer—the famous *fashion* photographer, because that was *all* he was then.

A few years later I was having a book published about my brief stint as the film critic for *The New York Times*—*A Year in the Dark* it was called—and the question of who should take the author photograph came up. Harold Brodkey, a telephone friend of mine, who was full of deep mischief, to put it a nice way, said, "I think Avedon would do it, but you have to understand one thing—he can make you look any way he wants. You'll be taking your chances." I was only too happy to take them, though of course I was secretly hoping he would make me look like Dovima.

I was tense and nervous and inhibited during the sitting, which took place on the last day of July in 1969. I felt like I was auditioning, as it were, for a way to look, and I did that thing with the mouth that people do when somebody's taking their picture—you can't help it, you don't even know you're doing it. Out of self-consciousness you set your mouth in some way that affects the picture badly.

I said to him when he showed me the print, "You made me look like a terrorist." Or in those days it wasn't a terrorist, it was a hijacker. I told him I would never get on a plane with a person who looked anything like that. And he didn't understand what I was talking about. He said, "You're a verbal, not a visual." Well, I was visual enough, believe me—I had eyes. He said, maddeningly, "That picture was a collaboration, between you and me"—about a process over which I had never had the slightest control whatsoever. I'd been helpless, in fact—not only did he have the upper hand, he had the only hand.

He said, "I can prove to you how dead wrong you are about how you think I made you look—I'm going to send you a photograph I took before yours, of myself, looking exactly like that." And so presently there arrived in a single frame the picture of him and the picture of me. We were dressed more or less the same—white shirt, beige corduroy trousers—and we did indeed look uncomfortably alike. And of course in many ways we *were* alike. I had once even described him as my near twin, although we each had sides where we were very far apart. That inexhaustible, forward-acceleration quality he had—I couldn't follow him a lot of *that* way. And some of the enthusiasms that sprang from that energy struck me as not . . . you know, *no.* Like those deep, ponderous French philosophers. That was Dick's intellectual side, and he really *wasn't* an intellectual. He wasn't even a true verbal: language was not his language. Dick was glib—he had a great rap. To me, everything he said about photography was just sales talk. I was deaf to it.

So anyway, those two photos in one frame that he sent me was no consolation at all. I said, "*You* look like a hijacker, too. These are *two* hijackers, thank you very much." Someone told me that at a Christie's New York photography auction a few years ago, where his portrait of Stephanie Seymour's crotch fetched around a quarter of a million dollars, his hijacker portrait of me sold for only six thousand dollars. I

hated that picture so much I found myself feeling bad for the person who had paid even that little for it.

I had told him, I thought definitively, that I didn't want him to ever again take my portrait, but one day he simply announced, "I'm going to do another picture of you." And then in that one he gave me a goiter! I mean, it was really an actively repellent face—I looked like I could give the viewer some contagious infection through the photograph. I realize that people don't always look the way they want to in a photograph, but the least they can ask is not to be *grotesquely* misrepresented. When I first saw it, I thought there must have been a certain ambivalence in his attitude toward me, but you know, maybe not—because by then there'd been Diane Arbus, and he was starting to take, in my view, his really ugly pictures. In a way, I may have been one of the first in his gallery of freaks. He kept insisting that the hijacker and goiter portraits were both truly beautiful; he actually had the nerve to say to me, of one or the other, "You never looked that good in your life."

He promised me he would never show the goiter picture to anybody—that one, by the way, also showed me with a bandaged ankle. But then a year later he broke his promise. He told me that he had showed it to Mike Nichols and that Mike had pronounced it beautiful, so he was going to use it in his Marlborough exhibition. Thankfully he didn't. He used the terrorist one instead—I mean the hijacker.

I sort of fought with Dick about the Diane Arbus side of him. We certainly had very different notions of ugly. His was that "ugly" equaled truth and art, and that "beautiful" carried the stigma of the commercial. I considered almost all the portraits in his Marlborough show ugly, as well as all those pictures he took later on of the derelicts and creeps and people with real goiters. Oh, I got it all right that he'd gotten tired of being Velázquez and was now trying to be Goya, that he'd gotten bored with his matchless capacity to glamorize. I explained to him, "I have this housemaid's syndrome—I like things to be beautiful and glamorous, I like novels to have sort of soppy plots, I like to cry at movies," and he said, without hesitation, "Well, I hate all that." He had this fear of kitsch, you see—a modernist disdain for what I valued as sentiment.

He took yet another photograph of me, in 1975, on the Greek island of Patmos, which he knew his way around a bit—he had been

there once before, to visit a photography-critic friend of his. Everybody in our little house party was taking pictures of everybody else. Dick posed for us all holding this fish skeleton he'd found on the beach over his mouth. He then presented the skeleton to Felicia Bernstein, and made a big thing about how he was only loaning it to her. He turned out not to be kidding, because when she died three years later he *immediately* claimed it from Lenny. The little photograph he took of her in Patmos sitting under a tree in her wonderful straw hat with a big brim became the memorial picture the family sent to friends. In the picture he took of *me* that day I'm wearing Felicia's hat. I remember goats and chickens wandering around, and how everybody had the flu, and that this hideous thing was fried up for lunch, which I called "hearts and minds"—it was the Vietnam period. And it was Greek Orthodox Easter. And then Dick left with Felicia and their fish skeleton on a tour of Greece, and I left in a helicopter with my dear friend Amyn Aga Khan, who later bought the house we'd all just been staying in, and went . . . wherever we went.

Years later I took Dick to one of Amyn's parties, actually a full-dress ball that he was giving jointly with his brother, Karim Aga Khan. It took place under a voluminous tent in Karim's French château, and it was full of women Dick had photographed in the forties and fifties. Dick and I had fun together that night, we always had fun, and of course he had the greatest sense of fun of anybody, an *enormous* sense of fun— which I'm not sure, however, is the same as a sense of humor. He was always trying to teach me what to look at and how to see, and he taught me how to read the white spaces in photographs, the negative spaces. I loved his use of empty space—it was like a use of silence. He wasn't taking pictures at the ball, but he called my attention to something I would never have noticed without him that will stay in my head probably the rest of my life: Drue Heinz dancing in place with one of the Brandolinis. They were just standing there, cheek to cheek, in a dream world of their own, and, I mean, she wasn't so young anymore, and it was just so touching.

ROBIN TATTERSALL: Dick always told people that he had discovered me at an outdoor café in Paris, sitting alone, sipping a beer, and

that he had to sweet-talk me into modeling for him, but that's not remotely the way it happened.

I'd been in the British Army and then up at university, Cambridge, and in 1953 I was a medical student at St. George's Hospital in London. I was married by then and faced with having to make a little money. I'd been doing some washing up at the Savoy, but then one night at a rather smart dinner party—those were still the days when the ladies withdrew after

ROBIN TATTERSALL

dinner and the gentlemen were left to themselves with their port and cigars—a young man-about-town public-relations type said to me out of the blue, "Why don't you try your hand at this male modeling thing?" and he gave me the number of an agent to call. My wife was very keen for me to follow this up.

The agent, it turned out, had lately been representing Roger Moore, before he went into movies, and I took Moore's spot. My first gig was a live show at the Chez Auguste in Soho—the opening of something called the Waistcoat Club, which was the brainchild of Peter Ustinov. I was called upon to model various waistcoats through the ages, including ones Tyrone Power and Errol Flynn had worn in their swashbuckling films. For which, as I recall, I was paid the sum of two pounds.

I quite quickly became one of the top male models in London. Thanks to my medical school being smack in the center of town, just behind Buckingham Palace, I could nip out and do a job and be back in time for my next-scheduled class. Tony Armstrong-Jones, a Cambridge contemporary of mine, had just gotten into the photography game and I worked a lot with him in the early days, and a lot with Norman Parkinson and John French. And I worked some with a young

hotshot by the name of David Bailey, who, incidentally, immediately after I got back to London from working with Avedon in Paris, had me around and tried to worm all Dick's tricks out of me—you know, "How did he light you? What cameras did he use? Do you happen to remember the settings?" But I'm getting way ahead of the story.

The top female models in London would hotfoot it over to Paris twice a year for the collections and come back with their pocketbooks full of gold, so finally in the summer of '56 I decided to try my luck at that. The first place I presented myself was the Paris office of *Harper's Bazaar*, where the manageress gave me the once-over and said, "*Un moment—Monsieur Avedon vous verra.*" So then out popped this little guy who looked so young I assumed he must just be an assistant. He peered closely at me, then disappeared into an adjoining room, from which he soon reemerged with this long-legged redheaded beauty in tow. He said, "This is Suzy—take her in your arms." I was an Army man, I obeyed orders. Then he peered at me again, this time through his little camera, and said, "Okay, you'll do."

Suzy was of course Suzy Parker, the world's number-one female model. The male model who had been booked to work with her was an exceedingly handsome California specimen by the name of Gardner McKay. Avedon told me that five minutes before I walked into that office, he had simultaneously received the first dress from Dior to photograph and a cable from McKay saying he was going to be six days late. He had the best excuse in the world, I must say: he was coming by sea, as one mostly did in those days, and he had the ill luck to be on the *Ile de France* outbound from New York on July 25 when the Swedish liner *Stockholm* collided with the Italian liner *Andrea Doria* off Nantucket Island, and the *France* had had to turn back to assist in rescue operations. For me, this was a godsend, given that the show had to go on in Paris, because there I was, approximately the same height as McKay—six-three to his six-five. And I was certain I possessed a far better wardrobe, my tailor being Watson, Fagerstrom & Hughes of Savile Row, and American suits in those days not having a patch on ours. Since it was the autumn/winter collection that was being done in summer, I had taken care to turn up in my best charcoal-gray wool suit, complete

with a waistcoat with lapels, and I was sporting a gold watch and chain into the bargain. Avedon got the picture right away: in every photograph he took of me he let me wear my own clothes.

Our first morning of work he presented Suzy and me with a pair of roller skates and whisked us off to the Place de la Concorde. Being such an all-American girl-next-door type, she performed like a pro. But I was an English boy who hadn't skated since he was five or six. After watching me at it for a while Dick threw his hands up and said, "You'd better go off somewhere by yourself for a couple of hours and get the hang of it." Picture me with my bespoke suit and bowler hat and rolled umbrella trying to teach myself how to roller-skate on some godforsaken street in the middle of Paris. I kept falling over—little kids were pointing at me and laughing. Eventually I went back to Dick and confessed that I just couldn't hack it. He said, "Then we'll just have to fake it," which he did, with invisible strings or wires. And that photograph of Suzy and me became one of the most talked-about of his pictures, certainly of that year, and today it's considered one of the top fashion pictures of all time—I heard that a print sold at auction for almost half a million a few years ago.

My other favorite Avedon of me is the one where I'm with Suzy and China Machado and another doctor, of all things—Reg Kernan, an American—and I'm trying to feed Suzy with chopsticks. I was a very virile twenty-six-year-old, but for me Suzy didn't exude an ounce of sex appeal, which, by the way, was what Brigitte Bardot's husband, Roger Vadim, said about Brigitte. Absolutely beautiful, mind you. And totally lovely to work with. And *play* with—she and Dick and I would go out together all the time, we made for quite a good family.

Then McKay showed up, impressing the hell out of Dick with the photos he'd snapped of the sinking ship, which I believe were later published in the newspapers. By this point Dick had finished much of the shooting, but he made a heroic effort to fit McKay in wherever he could. He continued using me—and I was really cleaning up, at ten pounds an hour—because Suzy had taken an instant, almost chemical, dislike to McKay. It was hate at first sight on her part—repulsion. That presented a problem, because the theme of the shoot

was "An American Woman in Love in Paris." Dick told her to act like she at least *liked* him, but whenever he tried to do a close-up of them kissing, she would put her hand up to her lips to thwart it. Gardner went running to Dick to ask what was wrong. Dick told him, "Don't worry, you're perfect—there's something wrong with *her.*" Well, within three years Gardner had landed the lead role in the TV series *Adventures in Paradise* and *Life* magazine put him on the cover—"a new Apollo whose face would launch a million sighs and burn its way into the hearts of hordes of American females"—and Marilyn Monroe was wooing him to star in a movie with her. I remember Dick saying to me that if there was one guy in the world he wished he could look like, it was Gardner McKay—tall, sportif. He described him as "all animal," he said he was everything he wished *he* were. Gardner and I got on great, by the way, but I didn't catch up with him again, as it were, until I saw his obituary, somewhere around the millennium.

Dick booked me for the collections the next summer: a two-week stint, again with Suzy, and with Carmen Dell'Orefice. I potted over from London in my vintage motorcar—a 1926 Humber Open Tourer in mint condition, with button-leather seats, which I polished myself, starting with the handle. I would motor around Paris in this highly conspicuous contraption, in the company of the equally conspicuous Carmen and Suzy. One night when we were driving back to the hotel from a shoot, all three of us still in our evening clothes, we were held up by traffic in the Place de l'Alma and a waiter came scampering out of a bistro carrying a tray with three glasses of champagne. He handed them into the car to us as the maître d' called out from the balcony, *"Mes compliments!"*

Suzy moved on into movies, disastrously, and then disappeared altogether into a happy marriage to the handsome actor Bradford Dillman, a fourth-generation Californian. When Dick called to invite me to the opening of his fashion show at the Metropolitan in 1978, he told me how excited he was that she was coming all the way from California for it. Unfortunately I couldn't get away at the time. I did make it over to New York a month or so later, and I had to stand in line, and then

actually pay to see myself hung in a museum. There was an awful lot of me up there, I must say.

CARMEN DELL'OREFICE: Avedon? I didn't even know of his existence when I started, which was right after World War II. Why should I have? He was the new kid on the block—the protégé of Brodovitch, the *Harper's Bazaar* art director. The photographers I knew were Penn and Beaton and Horst.

CARMEN DELL'OREFICE

And Erwin Blumenfeld, who had shot my first *Vogue* cover, in '47, when I was sixteen. And they all treated me as beautifully as they photographed me. Not that I understood the first thing about what I was doing, but I must have been doing something right because all of them kept having me back. And I'm still working—at going on eighty-seven. I've never aged out of the business.

The sittings were like playdates for me. I would roller-skate to the studios. It was faster—I was a demon skater. Sometimes I'd let my cocker spaniel, Honey, pull me, and that took a little longer. I didn't always have bus fare. At the end of every month my mother would have to pawn our sewing machine to pay the rent. She was making Dorian Leigh's clothes; both of us were—we were sewing like maniacs. My mother was a Hunky who came here not speaking a word of English and ended up—after I'd put her through college—winning spelling bees and editing educational pamphlets for New York State. I mean, only in America, right?

Avedon hadn't even wanted to use me. But Diana Vreeland, who was at *Harper's Bazaar* in those days, had seen me in *Vogue* and wanted me in *her* magazine. Plus I was going around with her son Freckie. I'd won this contest sewing dolls—I was a very busy little bee—and he

wanted one of my clown numbers in the worst way. So naturally I made him one, and it's so funny because now there's a company making a doll of *me*.

By 1948, I had posed for so many cultivated, attractive photographers that to me Richard Avedon was just a little . . . a little guy. I didn't find him charming, and how in God's name could he have found *me* charming when he was being forced to use me? My first day in his studio he wanted to spend the whole time photographing Barbara Mullen, who had far and away the longest neck in the world. The wall between the cubbyholes he'd put us each in didn't go all the way up to the ceiling and I heard him say to her, "Good God, what am I going to do with her? She has shoulders like a goddamn football player!" It felt like forever before he told me to get out there on the set, and I remember turning sideways to spare him the view of at least one of my offending shoulders. I mean, every photographer who ever shot me loved my shoulders, and Diana Vreeland adored them—she described them as *Egyptian*. I was biting my lip hard, so as not to have tears streaming down my face. I just had to accept the fact that I wasn't this particular photographer's type. I was five-nine and weighed less than a hundred pounds and, frankly, I wasn't my own type.

He had put me in a smart suit, and a hat with a veil, and a fur around my neck, because I always photographed older than I was. It was so damn hot under those big lights, and there was no flash, and I had to hold perfectly still. He didn't overshoot—he guided me very quickly to the picture he must already have had in his head. He said, "I got it!" And boy did he ever! He went on using me, because the advertisers all loved me, so we got a good working thing going. But it was a long time coming before we came together in any kind of human way.

For the collections he would always use Suzy and Dovima and Sunny Harnett and Elise Daniels and a few other really arrived ladies of the time. Dovima and Sunny were what I would call ear-sores, with their Brooklyn and Queens accents. Sunny and me were like a sisterhood you wouldn't believe. And Dovima was my closest friend—*the* most adorable female person you could ever imagine. And the most unbelievable artist. She really missed her vocation—she did cross-hatching and drawing that could have been in museums. I was with

her in Fort Lauderdale the week she died. She died broke, by the way. I was always astounded how Avedon made all those pictures and books and posters—and a positive fortune—out of her, and that poor gal had nothing, not even one lousy print. But why dwell on it, they ended how they ended. I don't think he ever went out of his way to help any of them personally—they were just business to him. Suzy was another story, because she married a movie star from a good family.

Sunny and I were doing a lingerie shoot with Dick in 1957 when he had to take an urgent phone call from the *Bazaar*. When he got off the line he turned to Sunny and said, with me standing right there, "They don't want me repeating models—they're not letting me use you again for the collections, and they're considering not even letting me use Suzy. I don't know what I'm going to do." Sunny, God bless her, piped up: "What about Carmen here? You've never used *her*." Dick looked in the mirror at me and said to Sunny, "What can I do with that hair of hers?" Sunny picked up a pair of scissors and just went at it—she gave me a blunt cut. He said, "So far so good, but what am I going to do about her hairline?" He asked me if I would be willing to have some electrolysis to push it back, "because if you would, then I think I can fix what's wrong with your mouth." Because at the time my teeth weren't perfect. Clearly, to him, I was a case of rent-a-body-fix-it.

I did have the electrolysis done, and I kept it up for years. Don't have to anymore, believe me—nothing grows back now. It probably did make my face look better. He also showed me how to contour with shading and—I have to give credit where credit is due—Dick Avedon was a great makeup artist in his own right. But all the other photographers I worked with had been creative with me *the way I was*. He was the only one who wanted to make me into something else—I guess an Avedon.

So anyway, he told the *Bazaar*, "I'm taking Carmen to Paris, but I'm not one-hundred-percent sure she's going to work out, so I'm taking Suzy, too." She was his security blanket, always—his single most dependable and sophisticated creation. At night he would leave me behind in the San Régis hotel while he did the town with her. Psychologically—emotionally—they were the right fit; they were both full of mischief. I was the odd one out. And I didn't speak a word of French and I didn't know a soul in Paris. I couldn't wait to get home.

I remember another lonely time with Avedon. He and I and D. D. Ryan, a socialite fashion stylist, went to Washington, D.C., for the *Bazaar*, and the two of them talked as if I wasn't even there. Dick was a big snob, you know, very socially attuned, and I was just a model. I had no social position and no social friends—I didn't even go to dinner parties. I was nobody in the world that he valued—I didn't even read, so I couldn't talk about books—and I was a freak in the world I worked in, in that I didn't give a fig what people looked like. The only thing that mattered to me was how they behaved—you didn't have to be beautiful or wear a certain thing a certain way to be my friend. That weekend in Washington the French art movie *La Ronde* was opening, and Dick and D.D. were off to see it. When they were practically out the door, he turned to me and said, "Oh, maybe you'd like to come." I'm embarrassed to admit I went, but what else was I going to do. It was better than sitting in the hotel—this was 1950 and there were no televisions in the rooms. But what the hell, when all is said and done, he did some of the most beautiful pictures of me ever, including nine of my twenty-eight *Vogue* covers.

PENELOPE TREE

PENELOPE TREE: I was very flattered when Truman invited me to his Black and White Ball separately from my parents. Whenever he came to our house on East Seventy-ninth Street, I had always made a beeline for him. He and I had a really good connection—I idolized him, which didn't hurt our relationship one bit. I used to send him my writings, and he would send very sweet, very encouraging letters back.

I invented my own

makeup for the ball—black triangles. And I designed my own dress, with Betsey Johnson of Paraphernalia. A stark black V-necked tunic, sleeveless and backless except for some crisscrossed spaghetti straps. It was quite narrow, and cut way down, to about my ankles, and my midriff was completely bare. I had on form-fitting black tights underneath, and black hip-hugger briefs underneath them—I had this thing about ballet clothes. That little getup turned out to be such a hit Betsey made copies to sell in her boutique. I'm one-hundred-percent proof that wearing the right thing at the right moment can change your life. Eugenia Sheppard raved about my outfit in her syndicated column—she pronounced it the "dress of the evening."

I remember my mother looking very taken aback, very about-to-lay-down-the-law, when I descended the stairs to leave for the party. She looked really over-the-top herself—she was sprouting an awful lot of feathers of some sort on her head. Like a lot of women at the ball, she was absolutely magnificent. I, obviously, had felt that less would somehow be more—certainly for *that* occasion.

"Young" always helps, too, doesn't it. The other youngest person there was Mia Farrow, who might have been pushing twenty. She looked amazing, and she danced with her bodyguard while Frank Sinatra looked on furiously. Cecil Beaton was the only man who asked *me* to dance.

The next morning I got this summons from Diana Vreeland to come to lunch at *Vogue*. She said that Richard Avedon was all agog to meet me, having seen me at the ball. The second I walked into Diana's office I felt sort of at home with her. I had first seen her *at* home actually—mine, when I was thirteen or fourteen. At one of my parents' big dinner parties she was seated at a table in the entrance hall, and I was on the upstairs landing peering down through the balustrade. I just thought she was the most ridiculous-looking woman ever, not my type at all, but then four years later she became the absolute greatest as far as I was concerned. So, you never know . . .

Diana sent me directly to Dick for test shots. I adored him on sight. I mean, he was so *beautiful*. He would have been in his mid-forties then, and I was around eighteen, but it felt like he was my age, if not younger. He made you feel there was magic in the air, that you had

entered into a special world with him. And within a month we were doing a shoot together. The stylist was the fantastic Polly Mellen, and the equally fantastic Ara Gallant did my hair. I did my own makeup, and I really lashed on the old mascara.

I had this great yearning to break away from my stuffy establishment family. I had been flattened at home, and then stifled at boarding school, but there was still stuff way deep inside me that I needed to express, and I knew I had to get it out there, and fast. The irony is that when you look at Dick's pictures of me, you see that a lot of his work was inward. So inward. It wasn't about extroversion at all.

Dick and Diana picked Twiggy and me to do the '68 Paris collections. My personal life was in turmoil. I had met David Bailey the summer before—he had this dangerous, lion-king-on-the-savannah vibe, and I had this instant feeling that we were eventually going to be together, although he was married to Catherine Deneuve at the time. I told no one, of course, but Dick had this sort of sixth sense, because one day during the collections he suddenly said, "Get your coat on, you and I are going for a little walk." He took me by the arm and steered me around the block. He said, "You have a really good mind, you've got to forget all about Bailey and go back to college—he's twice your age and he's been with hundreds of girls and he'll only make you miserable in the end." I was absolutely livid—how *dare* Dick try to interfere in my private life! I mean, I had to do what I had to do. He felt responsible in a way, I suppose, because he was the one who had launched my career, and now I had taken a leave of absence from Sarah Lawrence in order to do the collections with him. My mother was horrified that I'd left school, which only made my not going back a necessity. But of course both she and Dick were right on the money—it probably would have been a lot better for me if I had stayed at Sarah Lawrence. But you know what they say: you live and maybe you learn. I went to the University of Bailey instead.

While we were doing the collections, Paloma and Claude Picasso came to the studio in Paris to be photographed. He was eighteen and she was a couple of years younger, and they were just the most glamorous two creatures I had ever seen. Claude I encountered again a little later when he was working as one of Dick's assistants in New York.

Once when I was working with Dick in the studio and having the

most wonderful time—it was very early days—Dovima dropped in un-announced, with a little stuffed elephant as a present for him. And he was cold to her, and after she left he was really foul about her to me. I remember thinking, I'm going to remember this. And *then* guess what: just a couple of years before Dick died I was having dinner at Orso one night after a Broadway show, and there he was. So naturally I went over to him, and then right away I wished I hadn't, because he was very re-moved. But then a week later I got a letter from him saying how sorry he was that he had been like that but that he had been just so over-whelmed at suddenly seeing me again, et cetera, et cetera. And he ended it, "And you're *blond!*"

I had seen him a bit, in passing, in the years between. He came to stay in my parents' house in Barbados in the early eighties when it was being rented by Mike Nichols and I was staying in our guest cottage, so we had quite a lot to do with each other then. It was very nice to see him, but it wasn't quite the same as when we were working together—in fact, it seemed very odd not to be doing that with him. Renata Adler was with him, and I'll never forget how perfectly she backstroked out to sea—it was just so classy.

I'm stopped on the street all the time by people who say, "Do you remember me from Dick's studio?" And I go, "Oh yeah, right. Of course. Of course I do!" What I do remember is how bloody hard they all had to work. And I remember the fabulous lunches. With people like Lartigue. There was a lot going on between *those* two. I cherish *Diary of a Century*, the beautiful book of Lartigue's work that Dick underwrote, masterminded, and micro-edited. I'm actually in it—the last or next-to-last picture. It's me in 1968, with oodles of makeup on, getting ready for a shoot in the Paris studio.

I have a couple of contact sheets Dick gave me at the very begin-ning of our time together that are very faded now. Look, they're at least *something*. I don't have anything from Bailey—I mean, it's one thing not having a proper Avedon, because I don't see why I should, but a Bailey I definitely should.

MARISA BERENSON: How I got to Richard Avedon was through Diana Vreeland—I mean, how else? She was a friend of my grandmother Elsa

Schiaparelli and had known me since I was knee-high to a whatever. Diana had these pet names for me and my sister. Berry, whose real name was Berinthia, she called Berengaria, and me she called Mauretania—after the deluxe Cunard liners. Berengaria, as you probably know, grew up to become a wonderful photographer and to marry Tony Perkins. As you also probably know, she was a passenger on American Airlines Flight 11 when it

MARISA BERENSON

crashed into the North Tower of the World Trade Center.

So anyway, when I was seventeen or eighteen, I ran into Diana at a debutante ball in New York; she hadn't seen me in years and she went, "Oh my God, you're divine! We have to photograph you! Beauty like yours belongs to the world!"—you know, her usual line when she saw someone she liked the looks of. I had done a few pictures with David Bailey for British *Vogue,* but I certainly wasn't modeling officially yet. It was a dream that I'd had since I was little, but I never really believed it would come true. And my grandmother was vehemently opposed to me doing it—she felt that girls from good families shouldn't become models, which was kind of a generational bias. And later, I would say, there was a bit of jealousy there, too, when I started becoming more famous in the fashion world than her. She accused Diana of ruining me by making me an instant star, and in fact she never spoke to her again. But friends of my grandmother's told me that she would clip my photographs out of magazines. After she died, Berry took pictures of me for French *Vogue* dressed in some of Granny Dearest's clothes.

Diana sent me to Paris with Bailey to do the collections, and when I got back she felt I was seasoned enough to be sent to Dick. The first thing he and I did together was a shoot with little black dresses with

white organdy, with my hair very pulled back. I used to fly across the set with him, and he always had that blasted umbrella with the lighting following you around. It was just so much fun, wasn't it! And the next year Diana sent me to Paris with him. He had my hair dyed jet-black, and then had Alexandre do very blond streaks. The trouble was I had always hated that my hair was naturally curly and I'd been having it straightened for years—I used to go up to Harlem to have it done, and I'd be the only white girl in the beauty parlor. So anyway, in Paris it all started to fall out—the dyeing, I guess, had been the last straw—and that was a big drama. I had to have it specially treated for months on end and, between us, it's been an ongoing struggle to have it sort of look like anything at all after that.

And as if *that* weren't enough, in the seventies Stanley Kubrick decided my teeth should be whitened for *Barry Lyndon*, to match my movie makeup, and that totally ruined them. In those days the technique was not as developed, and besides, I had to have it done in England, which is not exactly famous for its teeth. But you know, one does *anything* for art. One just puts oneself in the hands of a genius and lets oneself be molded into putty—probably better to say sculpted into clay, no?

Dick photographed me for Diana's "American Women of Style" show at the Costume Institute in 1975. And in the eighties I did a sitting with him for *Vogue* that was very Man Ray—he photographed me with bright red hair and a really red mouth lying on a red couch. One winter after that, he came to Klosters, where I was living, to do another *Vogue* shoot with me, and he had me standing in a bathing suit in powdered snow up to my hips. I hope I remembered to flash my super-white teeth for that.

The only proper portrait he ever did of me was with my boyfriend at the time, Baron David de Rothschild. You don't really see my hair in it, but believe me, it was straight. I've got this fur around my neck and my arm around David, and my finger practically in his mouth, and I'm wearing my own clothes—he told us to just come as who we were, you know.

Dick came to see me when I was in Noël Coward's *Design for Living* on Broadway in 2001—I was playing the rich New York sophisticate who the adulterous London couple visit. He came backstage to tell me how much he admired my performance, and he took me to

Sardi's, and that was the last time I ever saw him. I remember we sat in the darkest booth.

MIKE NICHOLS: I hesitate to talk deeply about Dick, because what's ours, his and mine, when all is said? Is nothing just ours? Remember at the end of *The House of Mirth* when Lily Bart burns the letters that

would stop her nemesis if she would only make them known and that would save her life, but she can't discuss the man she loves or bring him trouble so she burns them?

I met Dick early in 1960. He came to the Blue Angel, on East Fifty-fifth Street, to see me and Elaine May in our nightclub act, and he kept coming back, and bringing people like the Bernsteins and Comden and Green, but he never came backstage to introduce

MIKE NICHOLS

himself. Then one day he called me out of the blue, wanting to know if Elaine and I would be interested in writing a skit for Marilyn Monroe. Leland Hayward was producing a two-hour CBS special called *The Fabulous Fifties* and had promised Dick that if he could get Marilyn to do it he could direct the segment himself.

Our first meeting was in Dick's apartment at 625 Park. I remember all the books were covered in heavy white no-seam. There was a big white couch covered in a field-of-poppies fabric, and that's where we sat trying to come up with a Marilyn idea. At the end of the visit he put his arm around me and walked me to the elevator. He said, "I have the feeling we're going to be friends for life."

The next week he took us to Marilyn's apartment, around the corner from Sutton Place, so we could present what we'd worked out to

her and Arthur Miller. She had been in my acting class with Strasberg, so I knew the way she was, which was sweet and not saying much. She just sat on the floor at Arthur's feet—he had his hand on her shoulder. Dick and Elaine and I took turns acting out our rough little idea, whatever it was—after which Arthur said, "I don't think it's for Marilyn." So he nixed it, the jerk, although he and I became friends many years later when we were neighbors in Connecticut. I directed a successful Broadway revival of *Death of a Salesman* with Philip Seymour Hoffman in 2012, but of course Arthur was good and dead by then.

When Marilyn bailed, Hayward let Dick direct a segment with Suzy Parker doing takeoffs of famous bra and car and cosmetics ads, and Dick asked me to help him with it. He took me and my wife out to dinner a lot. This was my absolute first wife out of four, the singer Patricia Scott. He told me he could see that she and I weren't each other's time of day—he was good on things like that—and he invited me to Jamaica without her, to stay with him and his wife. Patricia and I split up right around then—basically over her not being able to handle my success. Elaine and I had suddenly become this big thing—"The New Comedians Are Here" and all that shit. We were a sell-out at the Golden for almost a year—*An Evening with Mike Nichols and Elaine May*, directed by Arthur Penn, Irving's brother. We were being compared to Lunt and Fontanne, which was ridiculous. Being famous was a new and very strange experience. Dick had been famous for a couple of decades, and he was the perfect cicerone for me.

One day a couple of years after this he said to me, "I've got a little idea . . ." Dick and his little ideas! He knew I was friends with Richard Burton, whom I'd gotten to know on the Alley—we'd been on Broadway at the same time, when he was doing *Camelot*—and later Richard invited me to visit the *Cleopatra* set in Rome. So I had had exposure to his and Elizabeth Taylor's extramarital drama and the whole tabloid nightmare that ensued. *Full* exposure to them both wouldn't come until 1966 when I cast Richard opposite Elizabeth in *Who's Afraid of Virginia Woolf?*, the first actual movie I directed. Anyway, Dick suddenly announced, "You're coming to Paris with me to do the collections." I said, "Gee, I don't know—I don't think I'd look so hot in a dress." He said, "You're a great social satirist and I need you to help me use fashion to

send up the whole culture of fame—so go and write a burlesque of Liz and Dick for me." Well, they were certainly nothing if not spoofable— their fights, their reconciliations, the over-the-top gifts they kept giving each other—and I knew I could feed everything I had witnessed first-hand into the script. He told me to go extra-broad on the high jinks—he was envisioning it like a kind of comic book. For added inspiration he handed me a thick folder of paparazzi photos he'd clipped from the European tabloids. He told me he planned to hire actual paparazzi as extras and that he was going to take some of the photos paparazzo-style himself, using paparazzi equipment—flashbulbs and telephoto lenses and the like. Then he hit me with this: "You and Suzy are going to 'play' Liz and Dick."

I hardly knew Suzy; I just knew I loved looking at her in magazines. Everybody jumped to the conclusion that she and I were having a real love affair, which for some reason we never got around to. I mean, I had my hands full creating mock-scandalous scenes for the two of us for Dick to photograph around the real world of the fashion shows. One scene I wrote had me throwing a glass of champagne in her face during a squabble we were supposedly having at dinner at Maxim's. It drenched the gold lamé Dior dress she was wearing, which I remember was called "Soirée à Beverly Hills"—*that* I could never have made up. She was dressed to the nines in all our scenes—in Saint Laurent, Nina Ricci, Patou, Laroche, Chanel . . . skirt suits, cocktail suits, late-day dresses, hooded evening dresses. And Dick photographed all of that shit as if he were covering it for *Paris Match* rather than *Harper's Bazaar*.

One scene I wrote called for me and a private nurse to escort Suzy out of the American Hospital in Paris after her suicide attempt. She had on movie-star dark glasses, and there were bandages on her wrists, and the paparazzi were going wild. Nobody could tell if the suicide attempt was for real or not—the nurse was convinced it was. I didn't know it at the time, but this was art imitating life—Dick told me later that Suzy had been rushed to the hospital in New York a few years back after some kind of overdose. Funnily enough, she told me that was her favorite scenario in the whole shoot.

The portfolio ran in the September '62 issue of the *Bazaar*, with the

title "We'll Always Have Paris." Dick thought it was one of his strongest magazine achievements—right up there with the ménage à trois he photographed in Ibiza a couple of years later. He was used to doing whatever he wanted and still being able to please his editors, but after those two subversive stories, Hearst accused him of being anti-fashion, of cynically trying to undermine everything the *Bazaar* stood for—an enemy-within kind of thing—because of course they couldn't deal with satire. It was very evident that Dick had evolved away from what they expected of him. They nevertheless offered him a ten-year contract renewal. But he felt it was high time he separated from the magazine.

Dick never considered any of the many pictures he took of me over the years a true portrait. A lot of those photographs were for things like album covers and publicity shots I needed done, and all he was trying for was to make me look as good as possible. He liked to quote his photographic idol, Nadar, who said that the portrait he did best was of the person he knew best, in order to say that he, Dick, was the exact opposite—whenever he took a picture of someone he really cared for, he could only think of how they wanted to be seen, and so it might as well be an ad. It could never succeed as a portrait if he had to please anyone other than himself—I'm remembering now how unsuccessful he felt his pictures of Lenny Bernstein were. The artificial little smile I always put on when I was having my picture taken drove him crazy—he would say, "A smile is a mask, it's the ultimate lie." He felt people should look as if having their portrait made was a very serious event. He did do a true portrait of the first Arabian horse I ever owned. He went out of his way to do it, too—the stable was in the depths of New Jersey.

One thing I'll never forget is that Paris ride Dick took me on. It was my first trip there, and my one-and-only foray into fashion, and he made it my absolute happiest professional participation outside of theater and film, although in a funny way you could say it *was* the first film I ever directed.

CHINA MACHADO: I was doing a Fashion Group show at the Waldorf in 1958—I had barely arrived here from Europe, where I was the highest-paid freelance runway model—a thousand dollars a day, my dear—and I

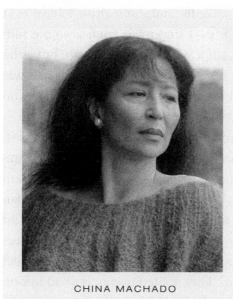

CHINA MACHADO

was wearing bat-wing Balenciaga hot-pink pajamas and had the good fortune to catch the Avedon eye. He and I had one of those six-degrees-of-separation connections, because when they were filming *Funny Face* in Paris the previous season, they picked me to preview Audrey Hepburn's Givenchy outfits on—we had similar figures. I got to know her in person the next year when Avedon did a whole Paris collection with her and took me along to use as an extra in some of the photographs.

Anyway, the day after the Waldorf show I was summoned to his studio. He told me that his first glimpse of me had had him "frothing at the eye"—imagine. There was a hairdresser on set, Ernie Adler, a real clown—he sang and danced up a storm. And a makeup person, a manicurist, and a fashion editor. I couldn't believe all the fuss—in Paris we had had to bring our own wigs and shoes to the set and do our own makeup. Plus we got paid next to nothing, and we would have to badger them for the pittance. But at the Avedon studio it was, you know, "Would you like another cup of coffee? And how about a delicious Danish?"

And then *he* appeared, this slim, shockingly handsome man—everything in perfect proportion. I was stunned by his beauty, and, let's not forget, I had been, shall we say, very close to men like William Holden and Dominguín, the bullfighter, who left me for Ava Gardner. Avedon was wearing dark-rimmed glasses and a silk shirt and low-slung, tight-fitting beige serge trousers. Oh, and sandals. And there was a crisp navy-blue blazer thrown over a chair or something. He later told me that he had understood very young how big he was going to make it and that he had then settled in his mind on what he should look like. I

mean, he had maybe the most nakedly ambitious drive I have ever encountered in anybody in my life—I never saw such absolute self-determination. His hair was very short when I first met him, but as he got older he wore it longer and it was all wavy and gray, and he was even *more* beautiful—he would have it cut by the hairdressers who came to the studio. He never lost his incredible *lumière*.

He told me right off that I didn't have it in me to be a successful *commercial* model, that I was too "special" for ads, the clients wouldn't understand me—he said he saw me as strictly editorial. Then he went ahead and turned me into the Western world's first non-Caucasian cover girl. As you can see, I'm a mix of Chinese, Portuguese, and East Indian—I can't give you exact proportions. The racial issue was something I blissfully knew nothing about at the time. All I knew was I didn't look like a blond all-American girl. Dick waited twenty years to inform me that the publisher of the *Bazaar* had told him, "If we run your pictures of the girl with the slanty eyes, all our readers in the South are going to cancel their subscriptions." Dick told me that he had been about to sign another seven-year contract and that he gave them an ultimatum: if they refused to run those pictures he took of me that first day, he was going to *Vogue*. So they used a couple of them, in the February '59 issue. Looking back, I can see that they tried to whitewash me: they described me as a woman whose "exotic Eurasian beauty is a serene blending of East and West." I mean, I was *all* East. And proud of it.

Anyway, it's the photograph he took of me where I'm holding the cigarette that's published all over the world all the time. That, and the one from '65 in London—me jumping all over the place in my Galitzine evening PJs. When the Whitney gave him the huge retrospective, they blew up that picture of me into an eight-by-ten-foot poster to put outside the entrance, and they used it in full-page newspaper ads. I was the cat's pajamas.

The last thing I did with Dick as a model was a 1962 shoot called— here we go again—"Beautiful Barbarians," which he always said was one of the five or six stories he was proudest of. That was the year Diana Vreeland left the *Bazaar* for *Vogue* and I got offered her job, senior fashion editor, by Nancy White. I asked Dick, "Is she out of her mind? I'm a model." He told me to take it—he insisted he could work better

with me than with anybody else. *Women's Wear Daily* did a big piece when I made the leap, and it opened with the most flattering quote from Dick: "China Machado is the most beautiful woman in the world." There may have been a "probably" in there somewhere, because, I mean, he had all his other models to think about. Anyway, I almost fainted when I read that.

The most exciting shoot I did with him as a fashion editor was the threesome in Spain in '64. At his Met show I couldn't get within ten feet of those pictures, there were so many people ogling them. I had discovered this fabulous pair of nineteen-year-old twins, Naty and Ana Maria Abascal, at the New York World's Fair. They were modeling for I can't remember which designer at the Spanish Pavilion. I'd never *seen* such a pair—big tits, big noses. The second I saw them I knew they were right up Dick's alley. He began immediately to search for a male model who would be equal to them. He felt it wouldn't work to put some cute American guy with these two Amazons, that they would chew him up and spit him out. One day he called me all out of breath from a phone booth: "China, I found him! He's a Brazilian diplomat who doesn't speak a word of English, and you and I are taking him to lunch tomorrow at '21.'"

Well, my dear, in walked the suavest Latin-lover-looking type ever! Helio Guerreiro—not to be confused with Heliogabalus, the Roman emperor who gave us the poo-poo cushion. Dick told me to lay it on thick, so I said—I was having to translate from English to Portuguese and then back into English—"Mr. Avedon is the world's most famous photographer, he always stays in the best hotels and dines in the finest restaurants, and you'll be in on everything." He ate it all up.

Helio arrived in Ibiza a bit after us, and Dick sent me to the airport to pick him up. He came bounding along the tarmac with a big erection and picked *me* up, clear off the ground. He kissed me smack on my mouth and shoved his tongue down my throat. I said to Dick when I got back to our hotel, "I don't want to do this—please don't make me," and he said, "China, I don't care *what* it takes, we've got to keep him here—you've got to keep him happy." Late that night there was a knock on my door—Heliogabalus in silk pajamas, with two tiny bottles of champagne and a hard-on as big as the Holy Roman Empire. My

whole professional relationship with Dick was on the line. I kept asking myself, Why *me*? Why not the beautiful young editor from the magazine who had come with us? The problem from *her* point of view was she was married. Come to think of it, I was, too! But why not Ana Maria? And why not Naty? The problem with the sisters was they were very Catholic, they may even have been virgins—never mind that they went out flamenco dancing every night. Naty of course went on to marry the nineteenth duke of Feria, a great catch except that *he* got caught—kidnapping a five-year-old girl, giving her a bath, and photographing her naked, and that must have been just for starters. He clearly had a thing for virgins.

I spent the entire two weeks we were in Spain trying to dodge Helio. I would have to keep my body flat against the wall at all times because he liked to come at you from behind. And because he only spoke Portuguese and the sisters only spoke Spanish and Enzo, the hairdresser, only spoke Italian, and Dick didn't speak anything to speak of, just English, I had to keep four languages going nonstop. Also, poor Dick had an amoeba that he'd caught nine months before and he was taking all kinds of powerful medication. He was so weak he had to be carried down the ravines and across the rocks on some of the locations and he had to lie down between shoots. By the end of the trip he couldn't afford to be more than a few feet from a bathroom. And yet, out of all this shit came his most sensual pictures.

I developed a very strong relationship with him—I mean, for years I had been going to Paris with him every six months for the collections. I wouldn't call it social exactly, because he was someone who pigeoned everything: with Dick, you did *this* in his life, and that was it, and then somebody else did something else in his life. I was basically someone he called when he needed me, and when he didn't, he didn't. So *I* didn't— I'm not much of a clinger. But whenever he saw me he would talk to me as if he had seen me yesterday. We were big foodies—we were both always eating—so most of our conversations were about that. He asked me to cook the traditional Brazilian dish *feijoada* for about fifty people for a wrap party on a shoot we did in Paris—I can still see him standing by the door of the studio with a tray of vodka shots while the two Russian girls who worked in the Paris office sang a native song. Much later on, when

I started a catering business in Sag Harbor where I live, he used to stop in on his way to or from his place in Montauk to stock up on my tomato sauces and ravioli—it seemed he could never get enough of them.

Look, Dick Avedon might not have been the easiest person in the world, but I adored him. He was the most important man in my life, *ever*, apart from a lover or a husband or two that I had. He was the witness at my first wedding, by the way, and afterward he took the bride and groom to lunch at Le Pavillon, then photographed us standing underneath the Fifty-ninth Street Bridge by the limo he'd laid on. And then, after all of *that*, he brought us to the studio and *again* photographed us, and he had his two choice pictures from that sitting framed in silver by Tiffany for us. When I heard he had died, I just went crazy and started painting my living room—blue. Pale blue. Aqua. I had to do *something*—I didn't want to dwell on it.

VERUSCHKA: China Machado was a friend of a friend of mine and referred me sight unseen to Avedon. She told our mutual friend, "I only hope she's beautiful enough for him." It was my first time to Paris—1963. The first thing Avedon said to me was he hadn't really wanted to see me, he had his own models that he worked with. He was looking at me but I felt not seeing me. So, I wasn't a hit for him—I was just a young pretty girl with a baby face, tall and so on, but I had not yet a personality.

Eileen Ford was in Paris and she told me, "We like tall blondes where I come from." So I followed her to New York, but when I went to see her, I saw on her face that all of a sudden she wasn't in the mood for me. So then I went with Stone Models, and after that with Zoli. And then I went back to Europe and became, you know, Veruschka.

I did *Blow-Up* and I got very famous. Unbelievable that somebody could get so famous from saying one silly little sentence! In the film the hot photographer played by David Hemmings says to me at a pot party in London, "I thought you were in Paris," and I say, because I'm smoking a joint, you know, "I *am* in Paris." For years people would come up to me all over the world and go, "I thought you were in Paris." Anyway, after that, Avedon looked at me again, and this time he *saw* me. And from there it went very fast with him.

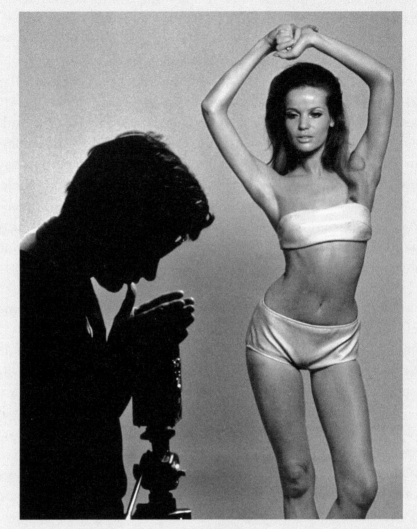

DICK AND VERUSCHKA.

What Antonioni had done with me in *Blow-Up*, Avedon did also—he *felt* with me. I never wound up on the floor with him on top, straddling me like the photographer in *Blow-Up*. But even without that, he got me to the point where he needed me to be—in the moment with him. Connected, you know.

The way he looked at me with those black X-ray eyes! A little like Picasso's, no? We got creative together right away. He would ask, "What

kind of woman does Veruschka feel like being today? An angel? A devil?" because he knew already she had so many personalities and she had always her own ideas how she wanted to appear. Veruschka was the only model he allowed to look at herself in the dressing-room mirror and make her own discoveries, and he would be studying her face. He might say, "I like who Veruschka just was—when she did *this* with the hair." Sometimes we went on for days, including nights.

Dick wrote once about me in *Vogue*, "Veruschka is the most beautiful woman in the whole world." Oh, I know, and I'm sick of hearing about it, he also once said somewhere that China Machado was the most beautiful woman in the world. But with Veruschka it was the *whole* world, and that is a very big difference, you know. Whenever people bring this up, I say, "It was not just about my superficial that he was writing, it was about Veruschka as a person." Because always he was trying to get the best inner out of me, although it was only fashion pictures we were doing. He still really loved fashion, but already he was starting to hate being called a fashion photographer.

For me, the most important work we did together were those 1967 jumping pictures. Such movement! Such expression! We would sit together, close, for hours in the studio looking at the Polaroids, and he would say, "Now let's change your foot a little bit, or maybe just the toe," or "Next time turn the arm a little more to the left," or "Lift the head a bit more up and turn a little to the side." We were always experimenting. Without that, we would never have gotten the picture of me almost falling over.

Or the pretzel picture! May 1972 it was. He hired this yoga master, a very high-up maharishi, all in orange, to give me instruction. He was droning on, and all of a sudden I said, "Now I'm going to put my feet behind my head." The guru cried, "No no no! You're not advanced enough to handle that position, it is far too dangerous for you to try and do." He kept going "No no no!" and Dick was going *"Yes yes yes!!!"* You see, *he* knew I could do anything with my body I set my mind on, and he was so excited, because all the other yoga positions compared to it were boring to photograph. That pretzel was a big hit, but then some stupid critic spoiled it for me by writing that it looked like bondage.

I went with Dick to Japan for *Vogue* in 1966—five weeks we were

there. Today I hate those pictures because I am so against fur, and that shooting was *only* fur, everything special-made. "The Great Fur Caravan"—twenty-six pages of it! Veruschka in the ermine boots, the white mink, the Argentine-goatskin cape, the guanaco cloak, the chinchilla toque and mittens, the silver fox, the white lamb, the Russian lynx, the snow leopard . . . It all looked and felt so great on her at the time—she didn't know the fur gets skinned off *alive* from the animals. Somebody had given her once a snow-leopard poncho as a present—huge, to the floor—and she used to walk around at home in that big thing looking like an African king or something. She still has it, but hidden away in a closet in Bavaria.

I was a very long person for Japan; the beds were too short for me, they had to push two of them together, sometimes I had even to sleep on the floor, on a tatami mat. Dick went crazy trying to find a Japanese man longer than Veruschka. He discovered in some training camp this nineteen-year-old sumo wrestler with a little topknot who was over seven feet high. Veruschka was like a shrimp next to him. He was so long they had to put him in the back of the car so all his legs would fit in front. His feet were too big for the biggest-size snowshoes—they had to wrap straw around them because we were going to be going into fifty-foot snowdrifts.

Dick told the interpreter to tell the sumo, "Just look at her and smile," but he was way too shy to look Veruschka in the eye.

ISABELLA ROSSELLINI: One day I was with Mama at Bloomingdale's and she and Charles Revson's wife were trying on the same blouse and it was the only one available. The Revlon lady was very kind and said, "Of course *you* must have it, Miss Bergman, and by the way you have a very beautiful daughter." And the next day, you know, there was a call from Richard Avedon. I had never had the slightest desire to be a model, I thought it was all too silly—I mean, my mother was an actress, my father was a director, my sister was a TV broadcaster. But I *had* studied the fashion photos of Avedon at the Academy of Costume and Fashion in Rome, where I was learning a métier, so now to be actually going to his studio was a bit like going to Michelangelo. I didn't go there with any *hopes*—I went just to live the fashion adventure for a day.

We did the test for Revlon, and he gave me a photo from it, and I brought it home to my mum. He had photographed her several times, and she was thrilled that he had now taken *my* picture. And yet I did not pass the Revlon test. But a few years later a photograph that Bruce Weber had taken of me nonprofessionally appeared in British *Vogue*,

ISABELLA ROSSELLINI AND DICK.

then Bill King photographed me, and finally Alex Liberman sent me to Avedon. And we got the cover of *Vogue* together, Dick and me, and that started this wave of enormous success that I had as a model: nine covers of American *Vogue*, four in one year, three in a row—September, October, November, bang bang bang. One with nine pages inside.

Dick understood that I had this prejudice against modeling. Also, my husband at the time, Marty Scorsese, was uncomfortable with the idea that I was needing to do something on my own. Dick said to me, "You know, modeling is not a big art, but it *is* an art—like embroidery." I learned so much from him—he was so intelligent and so original in his mind, like my mum and dad.

Whenever I modeled for other photographers, the camera went like a machine gun, but Dick would take only six, ten, stills of me. He was like a hunter, waiting for the right moment to shoot. He would say,

"Change your thought—I don't like what's going through your mind."
And I would quickly think of something more positive, like my dog.
And then these big eyes of mine would open to their peak of expres-
sion, and *that* would be the moment he would take. He taught me that
posing, in some ways, could be as legitimate as acting—everything we
did together felt like a scene. The result was always an image that left a
little bit of mystery so that each person who looked at it could complete
the picture with their own fantasy.

It was Dick who opened the door to my Lancôme contract. I was
afraid it would take away my freedom to be myself, the creativity that
by then I felt I had achieved in my editorial work. He told me, "Oh,
there's always ways around it. And it's very important to have a lot of
money." That was what my mother wished for me—a certain level of
financial comfort. I was just on the verge of it when she died, in 1982—
at least she died knowing I was in the very best hands, Dick's. I learned
of her death when being photographed by him for one of our first
Vogue covers. In a moment of enormous emotion for both of us he gave
me the contact sheets of a photo shoot he had done of her. I was fasci-
nated to see that what he had done with Mama was exactly what he was
doing with me—there wasn't one in-between expression on her face. I
gave four of the six sheets to Mama's archive at Wesleyan so they could
be properly refrigerated—the other two are up on my wall and I look at
them all the time. *Thank* you, Dick. From the heart.

And not only for that. You also wrote me the most wonderful condo-
lence letter ever. You said that words were failing you but, believe me,
you were most eloquent. You said you hoped I was suffering terribly,
because that was how it *should* be. And you wanted me to know that
quite soon after your father died you found him within yourself, and
you were certain I was going to find Mama—all the things I missed
about her—within myself. So I started doing everything the way *she*
had—the flowers, the housekeeping—and it was so true, Dick, what
you said. You showed me how to heal. And one day you did a portrait
of me for *Vogue* holding a photograph of Mama.

The last photo Dick took of me was more than twenty years after
this, when he was working with *The New Yorker*, and it was a real por-
trait. I had just done a surreal comic film where I played an amputee

baroness—she was missing both her legs. For the film I had plastic prostheses, but Dick said he wanted to do something even better. He ordered two slabs of roast beef as big as thighs from his Madison Avenue butcher. I had never seen pieces of meat cut like that in my life. They smelled to high heaven. He put them on top of my legs, which completely disappeared under them. What can I say—it was a pretty fantastic photo.

Working in Dick's studio again brought back memories of the tremendous times I had had with him and Polly Mellen. *She* was a trip. My God. You couldn't imagine anything in life that she could ever have done besides what she did. She was the most wonderful . . . well, twelve-year-old. She had this exaggerated way of talking—everything was followed by at least three exclamation points.

POLLY MELLEN: Japan!!! Japan with Veruschka!!!! Veruschka and her never-ending legs!!!!! That was the first shoot Dick and I did after following Mrs. Vreeland to *Vogue.* Mrs. Vreeland made me read the whole of the incredibly erotic *Tale of Genji*—she told me, "Enmesh yourself!" It was the longest, most luxurious, most expensive shoot in history. I had fifteen suitcases, great huge ones—we called them the coffins.

The greatest hair artist to appear in my lifetime was along, and there was simply nothing in the world that Ara Gallant couldn't and didn't do with Veruschka's hair—like twisting five yards of blond Dynel hairpieces into braids. He acquired his famous Japanese schoolboy cap on that trip. He was a gay, you know, and a drug user, and ultimately a suicide—in Las Vegas, of all tacky places. His real name was Ira Gallantz; he was just a little boy from the Bronx. Yet he was my twin—we had the same birthday. And he and Dick were so close—so closely associated professionally, I should say—that some people referred to them as Aradon.

In Hokkaido, Japan's northernmost island—deep snow country—Dick made us all go into one of those mixed-sex public baths. I wasn't comfortable with the idea of baring myself like that, to friends and strangers alike, even with the towel, but I thought I had to be a good sport. I was sitting next to Dick, and there was a Japanese gentleman

POLLY MELLEN AND DICK.

quite some distance away who I could see even through the mist inching closer and closer to me. And I was three months pregnant at the time! I said to Dick, "This man is getting too near, I'm getting nervous." So then what did Dick do? He egged the guy on, of course.

At *Vogue* I was responsible for picking the clothes for Dick's shoots—well, me and Mrs. Vreeland. Take Twiggy. She was too short, too skinny, too built like a boy, too Peter Pan. Not that I didn't fall insanely in love with how off-the-beaten-path she was. When Mrs. Vreeland asked me, "How do you propose we fit a misfit?" I said, "You go straight to the little-boys department at Brooks Brothers. And from there you just use your imagination." I don't want you to think I'm conceited or anything, because I'm just not, but Polly Mellen was the one who put Twiggy in that pink marabou jumpsuit of chicken feathers—nobody can take *that* away from Polly.

And then Penelope Tree came in—the ugliest girl I'd ever seen. So ungainly. But then, you know something, she grew on me. Dick saw right off that she was extraordinarily beautiful. Not that he ever ever ever made a move on any model that *I* know of, but if there ever *had* been one, it would have been Suzy, for sure.

Even after Mrs. Vreeland was replaced by Grace Mirabella in 1971, Dick refused to be limited. His work just went on being so *beyond*—he could take a picture to somewhere else like nobody else. He had a spirit that never stopped. And his friends were his friends. He didn't have that many, but then, do you really *need* a lot of friends?

I'll never forget the first time I laid eyes on him. My mother and I had gone one night in the late forties after dinner to an extremely chi-chi nightclub called One Two Three. We were in the bar section waiting for a table when in walked Richard Avedon, whom I knew only by sight, and he was with his first wife, the beautiful Doe. They were naturally seated immediately, on a prime banquette. Then they got up and danced, and I couldn't take my eyes off him. But then, I've been boy-crazy all my life. And I've always been partial to dark, short men—my first husband was dark and short. Actually I can go both ways—I've been swept off my feet by tall and fair, too. But there's something you have to understand: I've been a very good girl for a very very long time now. I married my Henry in '64, and for a wedding present Dick gave me a Gloria Vanderbilt painting called *Uptown Downtown* that he had had hanging in his house on Riverview Terrace.

I never *did* anything with Dick—you must believe me. There was no intercourse, no fucking. Dick was very easy to be in love with, and I was in love with him—just not physically. And yet, *yes* physically. Just not to the point where we had an affair. I was the only one he ever let get that physically close to him—he would let me lean over him or crouch down next to him while he was shooting.

We'd gotten off to such a shaky start, too. I was the youngster on the fashion block at the *Bazaar* back in '51, and when Mrs. Vreeland suggested he use me on a shoot, he refused—he told her I was too noisy. It turned out he had seen me clapping at a collection, with my hands way up over my head—clapping, and screaming bravo. You see, I'm someone who's never been afraid to express herself, and that came from my being the youngest of four sisters and having a mother who wanted me not to feel stifled—Mummy was the champion of Polly Speaking Out. And so I've always just let it fly. Anyway, Diana insisted that Dick give me a try.

Our first shoot was with Audrey Hepburn and I was terrified—I

walked into the Avedon studio literally on tiptoe. I showed Audrey the clothes I'd chosen for her, and she loved them on sight and said, "Shall we get Dick now?" I steeled myself. But he came in like a lamb and approved everything. So then I got Audrey dressed, and helped her with makeup and hair. A big part of my job was building up their confidence in the dressing room so they could go out and knock the socks off Dick. I would warm them up, then he would turn up the heat. I had yet to speak a word to him, mind you. But finally I couldn't keep it bottled up inside me any longer and I blurted out, "Oh, doesn't Audrey look beautiful!" He spun around, and he looked at me very intensely, as if he was going to dress me down, but instead he said, "She does look beautiful, doesn't she? Thank you." That was our true beginning, and a decade and a half later when we both went to *Vogue* we became the dream team of all time.

I'm remembering the day I went to his apartment over the studio to discuss a sitting that we had scheduled, and there were literally hundreds of his incredibly courageous photographs of his father staring me in the face. You can't imagine how painful it was for me to have to look at them — my mother was dying at the time. And also, remember, I was only there to talk about a sleeve, a seam, a button, *maybe* an earring . . . I mean, the contrast was positively killing.

Dick gave me the confidence to go down into my interior, my innermost depths. He made me feel I would never hit bottom. And that's what you see in that portrait he did of me, the one he put in both his Marlborough and his Met exhibitions. He photographed me in 1975 on the roof of his studio, not with his big camera but with his Hasselblad. He had given me three months' notice so I could get ready inside. He asked me, "Who do you want for hair and makeup?" I told him no makeup and I would do my own hair. When the sitting was over I couldn't speak for an entire day: me — can you imagine! He had totally drained me. The way he talked to me while he was taking my picture I can't even begin to describe. Yes, I let him dig *that* deep — like an archaeologist. It was his way of weaving into my portrait some of the torment that was his own truth. I trusted him, because I knew he loved me almost as much as I loved him. And I knew I would love whatever it was he decided he wanted to express *through* me.

When my husband saw the portrait for the first time, the night of the Marlborough opening, he said right away, "That's my Polly!" And our children all agreed it was me. *One* of the sides of me anyway—a side I try my hardest to hide, the serious side. Somebody later wrote that he gave me a face like nails. Well, I *am* a fighter, so maybe that's how he saw me. He gave me that portrait, as well as another one he took later on that he called the Jolly Polly, although it wasn't exactly a hoot, either. Alex Liberman's wife, the dreadful Tatiana, came up to me at Marlborough and said, "Polly, how do you like yourself in Dick's picture?" I said, "I love it!" and she said, "Then you must like looking like a cripple." That was Tatiana for you. Her own daughter, Francine Gray, had her mother's number, and wasn't afraid to share it with the world in that fabulous book she wrote about Tatiana and Alex after they were both safely dead. *Them*, it was called.

But it's *him* I want to talk about. Dick. He took me to L.A. with him in 1981 when he shot Nastassja Kinski for *Vogue*. He was renting the studio of an advertising photographer, who had all his own pictures up, naturally, and Dick turned them all around so they faced the wall. They were a distraction—I understood that—but I mean, the poor guy was right there.

We were trying to come up with a concept, so I asked Nastassja what she was interested in and she said animals—she had just finished starring in *Cat People*. I said, "Do you have a favorite?" and she said, "Reptiles." Dick was thrilled—he immediately rented a snake and a snake charmer, I mean handler. Nastassja asked to hold the boa, and you could see it was a natural fit. So then I asked if *I* could hold it, and it felt like, well, something unmentionable.

Dick said to Nastassja, "Would you do the picture naked?" She said yes right away, because when those black eyes of his were focused on you, you would do just about anything to please him. She lay down on the cement floor, and the handler started the snake at her ankles and it wound itself up her sinuous little body, till its tail was right between her legs. It stopped to investigate her tummy, and then it moved on up to her shoulder. She was rolling backward, forward—there was no mistaking how much she loved having that heavy gorgeous thing on top of her. Then without any warning it flicked its forked tongue out and

kissed her delicately on the ear, and that's when the shoot hit the high note—Dick got one of those split-second pictures of a lifetime. I had gooseflesh. There were tears streaming down my cheeks.

I just wish I hadn't put that Patricia Von Musulin ivory bracelet on her. But what choice did I have—it was a fashion shoot. It spoiled the picture for Dick, it made it somehow impure. He later reproduced the image in color as a poster titled *Nastassja Kinski and the Serpent*, which gave the snake Book of Genesis stature. It sold a couple of million copies.

I can't believe he's actually gone. I've blocked the date. I just remember I was in Connecticut and it was midmorning when that awfully nice man Bill, the secretary, called and said, "Polly, I have some very sad news." I said, "Oh God, no!" and I threw the phone down, and I started sobbing uncontrollably. Then I went round and round my bedroom hitting my head as hard as I could against the wall. Henry, my husband, grabbed me and held me till I was able to get hold of myself. And then I got myself into bed—the comfy old bed that Dick had thrown himself down on when he visited us and he joked, "I've just discovered where I'm going to have my nervous breakdown." I lay there very quietly the rest of that god-awful day thinking of all that Dick was to me. It's very hard to talk about him as a "was"—for me he will always be an "is." And all his pictures are an "are." They belong to the world, they belong to the children, they belong to tomorrow. I mean, tell me, where does a genius like that even come from?

5

THE HOUSE OF PAIN

—

ROM THE GET-GO—HIS EMERGENCE FROM THE WOMB SEVEN and a half pounds strong, on May 15, 1923, at the New York Nursery and Child's Hospital—Dick was special. Exceptional, in fact. One in a million. One in eighty thousand, to be exact: marked at birth with that legendary good-luck sign, a caul (David Copperfield was famously born with one). The thin, filmy, almost mystical membrane that covered his newbie head like a mask or shimmering veil was easily enough removed. The luck, however, stuck: Richard Avedon was a caulbearer who would find his calling. For all that, the umbilical cord would never quite be cut.

Family-wise, Dick had hit the jackpot: a full house—"material" enough for a lifetime. The menfolk on both sides all flew the coop sooner or later, leaving Dick primarily in female clutches. "I mean, the *craziness* of the three women Dick grew up with!" Renata Adler exclaims. "His overbearing mother. His 'tragic sister.' His too-close cousin. The sort of overtone or undertone—no, the *clear* tone—of incest all around."

The family name was originally Abaddon. "In Hebrew it means hell," Dick gleefully informed me. One afternoon around the millennium I heard a shriek of laughter issue from his office and I went tearing in. Leafing through an illustrated book, he had just come across a

red-hot demon astride, of all heaven-sent things, a tripod. "This is *me*!" he exclaimed. "I'm going to have it engraved on my personal stationery and note cards." He asked his creative director Ruth Ansel to play with it, and she had a devil of a job finding a red with the right rusty quality. The day the first batch of stationery arrived, Dick began dashing off wicked notes to friends. The first was to Mike Nichols, who sent it back with "Go to hell!" scrawled across it.

407 EAST SEVENTY FIFTH STREET
NEW YORK CITY 10021

THE DEVILISH LOGO ON DICK'S
PERSONAL STATIONERY.

Dick's father, Jacob Israel Avedon, whom everyone called Jack, was born this side of the River Styx, in the Russian town of Lomza, in 1889. *His* father, Israel, a tailor, had already made his way to the melting pot that was America, if only to settle in another ghetto, New York's Lower East Side. It was a year before he sent for the wife and five kids. A couple of years later he deserted them again, running off with the wife of either his brother or his first cousin (Dick was in the dark as to which). "My grandfather said he was just going out for a smoke, and he was never heard from again," he told me.

Jack and his two brothers were sent packing—to the Hebrew Orphan Asylum on the Lower East Side. It took their poor mother, Mathilda, four years of taking in wash to scrape together enough to get just one of her boys back. "It was a *Sophie's Choice* situation," Dick said. "She picked Jack." An excellent choice, as they say: he sailed

through elementary and high school, a boy who hit the books so hard his mother referred to him deferentially as "the professor." And he did manage to become one—a teacher, of math—however briefly. After earning a certificate from City College, he got a job as a sub—as irony would have it, in the Manhattan slum whose moniker, Hell's Kitchen, spoke to his original name, Abaddon.

To better himself, Jack graduated to the garment industry. In 1913, with his brother Sam, he set up shop at 110th Street and Broadway, selling "tailored and dressy" blouses manufactured by their sibling William. Avedon & Co. was the realization of every immigrant's dream—a family business. Within a few years they were flush enough to rent space at 448 Fifth Avenue, at Thirty-ninth Street. By 1920 they had taken a forty-two-year lease on the site and were in the throes of erecting a six-story limestone-clad structure, in the style of the Italian Renaissance, to house a women's specialty emporium called Avedon's Fifth Avenue.

The bible of the rag trade, *The American Cloak and Suit Review*, reported that the Carrara-marbled and mahogany-trimmed main floor would feature blouses; that the ivory-enameled five upper floors would be devoted, progressively, to dresses, suits and skirts, millinery, and furs; that, throughout, "buff colored carpets will contribute their soft richness to the general note of delicate charm"; and that the thirteen street-level display windows backed with Caen stone would scintillate at night with colored lights. On April 24, 1921, *The New York Times* published a photo of the building and a paean to the monumental arch through which shoppers would enter the circular rotunda leading into the store. In no time, Avedon's Fifth Avenue became, as Dick had it, "the Bendel's of its time."

Jack was now a merchant princeling. One Sunday, in 1923, his buyer's eye was caught by the cosseted daughter of a prosperous cloak-and-suiter whom her father was driving down Fifth Avenue in his horse-drawn carriage—trotting out the goods, so to speak. They got married a few months later. Ten years junior to her Jack of one trade, Anna Polonsky would remain forever young to life—and her son's abiding inspiration.

Dick came along within a matter of the requisite months, followed two years later by his sister, Louise. At which time the Avedons up-

wardly mobilized to the suburbs: a scenic village on the South Shore of Long Island called Cedarhurst. They purchased a fine stucco house on Villa Place, a street whose name struck Dick as being "straight out of Monopoly." Their plot boasted half a dozen trees.

Jack and Anna led quite the life. She took up tennis; he opted for golf (though as Dick liked to boast on his mother's behalf, it was Anna who scored the hole in one—and on her maiden round). The couple played bridge, drank mixed cocktails, and entertained with fancy candles and good china. Avedon's Fifth Avenue continued to click with the clientele. Dick would spend occasional Saturdays in his father's office, and some of his earliest memories were of Jack and Uncle Sam, who was in charge of sales, discussing which suits, skirts, coats, wraps, blouses, frocks, and furs to order and what the markup should be. "I come from a family where clothes meant everything, starting and ending with our bread and butter," Dick told me, adding with a laugh, "Any wonder I wound up in the dress trade?"

When the stock market crashed, in 1929, Dick was six. Villa Place ceased to be Easy Street—Avedon's Fifth Avenue was teetering on the brink. His parents' marriage was proportionately shaky. Jack sat Dick down and gave him his first life lesson: "When poverty comes in the door, love flies out the window." The couple quarreled relentlessly over money—"Do you have any idea how much electricity costs?" Jack would ask. Anna was reduced to reading by flashlight at night.

The day the business closed for good, in 1934, Dick's father pulled up outside the house and called for him to help unload the car. The boxes Dick lugged inside contained the pathetic remnants: engraved stationery, catalogues, swatch cards, ledgers, sales slips, dress labels, and glossy-magazine ads for the store, one of which he remembered featured Gertrude Lawrence, whom he liked to describe as the "feminine half of Noël Coward." When half a century later Dick learned that the old Avedon's Fifth Avenue building was to be razed, he considered purchasing the carved-stone letters on the façade that formed his last name—only to conclude, "That's my father, not me."

THE THREE-ROOM APARTMENT ON East Ninety-eighth Street between Fifth and Madison avenues that the Avedons moved to smacked

of straitened circumstances. Dick was made to sleep in the windowless dining alcove, whose walls and ceiling he covered with "a gleaning of five years' Christmas tuberculosis seals," three hundred Dixie cup tops, and twenty pictures he'd clipped from his parents' fashion magazines — "*Harper's Bazaar* became my window and Munkácsi's photographs my view." Jack had found employment, first as a door-to-door insurance salesman and then, more suitably, as a buyer for the New York specialty shop the Tailored Woman. Things were looking up, and Anna began looking for an apartment with a "more respectable" address — one that wasn't, in her unfortunate words, "this close to Harlem." She found it at 55 East Eighty-sixth Street, a then-ten-year-old fifteen-story building between Madison and Park avenues, and Dick was duly enrolled at nearby P.S. 6. Thanks to the thick glasses he wore for his myopia, his classmates taunted him with the tag "Four Eyes." His precocious retort: "I see twice as much as you do!" As Anna loved to tell people, Dick was already so visual he slept with his eyes half-open.

Anna's parents had also been hard-hit by the Depression but were managing to hold on to their West End Avenue apartment. She explained to Dick that his grandparents were putting up a "good front." (Dick pounced on the expression and ran with it. By the time I met him he had come up with a catchier phrase: "the pre*sent*" — pronounced like the verb, with the emphasis on the last syllable. His own, of course, was always perfection, his one shortcoming being his height — he topped out at only around five-seven.) Grandpa sat around all day now, reading a Yiddish newspaper, and whenever Dick was visiting and made a sound, he weaponized it, rolling it up and lashing out at his grandson. Grandma had become the breadwinner — she ran a weekly poker game for her cronies, one of whom was reputedly George Gershwin's mother, out of one of the bedrooms. Dick's aunt, Anna's sister, Sally, was back living at home, with her daughter, Margie; her husband had bailed out on them and she had had him arrested for nonpayment of alimony (the family's name for him was "the bum").

"To survive, I had to make a make-believe world," Dick told me. "I sang for my supper. I started acting out little stories. My father was desperate for me to be more of a boy — he was constantly giving me baseballs, baseball cards, a glove, a cap. I could never have made it through

my childhood if it hadn't been for Margie, my quote-unquote forbidden cousin."

Margie was two years older than Dick, and gifted to a fault. She was also ubiquitous to a fault, as far as Anna was concerned—before the Avedons moved back to Manhattan, Margie would spend every weekend with them in Cedarhurst. During the week Dick would normally have at least one sleepover at their grandparents'. In another doomed attempt to "make a man" out of a seven-year-old boy, Jack had Dick taking the train to Penn Station all by himself, and then the bus to West End Avenue.

When Margie and Dick were apart, they pleaded with their mothers for telephone time. "Every night my mother would put in a call to her mother and sister, and I would try to wrestle the phone away from her to talk to Margie," Dick recalled. "Finally my mother would cave in and hand me the phone—she would say, 'You have exactly two minutes, and I'm timing you. Talk is not cheap.' She was parroting my father."

Margie was "the source of my energy, the front-runner of everything intellectual, inventive, and original in our most formative years," Dick was quoted in her *New York Times* obituary, in 1999. To me he confided, "I fell hysterically and obsessively in love with her when I was four." To hear him tell it, they were the original hell-raisers—the spawn of Abaddon indeed. Their antics might begin in the Villa Place kitchen, with the juggling of dinner plates, then move on out to the garage, where, billing themselves as "The Two Incredibles," they would put on performances and puppet shows. Margie would finish her gig with a flourish, dragging Dick into the living room by his hair. There, on cue, he would spring free and swing onto the couch—"like Bomba the Jungle Boy," he boasted, adding, "We were practically feral." They played wrestling games as well, in which they took turns being the lion and the prey, and held dueling matches with wooden hangers. One night, listening on the extension, Dick heard his aunt Sally ask her sister, "What's the story with Margie's bruises?" Anna replied, "You should see the other guy."

"We were out of control," Dick proudly acknowledged. He told me that one of his early analysts, the renowned Dr. Edmund Bergler, had

DICK WITH HIS
"FORBIDDEN" COUSIN
MARGIE, STANDING,
AND HIS SISTER,
LOUISE, HIS
FIRST MUSE,
TO HER RIGHT,
1932.

DICK AND MARGIE,
1934.

MARGIE, 1936.

DICK IN FRONT
OF HIS GRAND-
PARENTS' WEST
END AVENUE
BUILDING, 1937.

MARGIE, LEFT,
WITH LOUISE
IN CENTRAL
PARK, 1938.

ANNA AVEDON
WITH HER
DAUGHTER, LOUISE,
AND SON, DICK,
CEDARHURST,
LONG ISLAND, 1926.

MARGIE WITH
HER MOTHER,
ANNA AVEDON'S
SISTER, SALLY
LEDERER, 1924.

diagnosed him as a prime example of a positive versus a negative exhibitionist. "I could never in a million years have grown up to be me if I had let my exhibitionism be inhibited when I was a kid," Dick maintained. Not long after I went to work for him he invited me to go with him and Mike Nichols to an art-house revival of Jean Cocteau's tragedy *Les Enfants Terribles* ("The Holy Terrors"); the film's teenage brother and sister live in a world of their own invention and indulge in secret games with a strong undertone of incest. Dick claimed to have seen it more than fifty times. "It's the story of Margie and me," he proclaimed, adding with a laugh, "Cocteau followed it up with a play about *mother-son* incest called *Les Parents Terribles*." (In 1958 Dick had photographed Cocteau, who, upon confronting his Avedon portrait for the first time, fired off a telegram to him: MERCI TERRIBLE ET MERVEILLEUX MIROIR—implying that he had seen himself as never before.)

One of the bedroom games that Dick and Margie played was called Making Baby. "She insisted she knew how," Dick recalled. "She peed in the bowl, then made *me* pee. She said, 'Now the toilet has a baby in its belly and all we have to do is wait for it to come up.' We waited all day—finally I just flushed. Margie said it was probably for the best—the baby might have been born with two heads since we were first cousins, and then the authorities would have taken it away and it might have wound up in a freak show, so we would have had to push it back down anyway with a toilet brush. I said, 'Now you tell me!'"

At Easter or Christmas, Jack and Anna would treat Dick and Margie to a Rogers and Astaire movie at Radio City Music Hall. "Fred Astaire was my hero from the time I was nine," Dick declared. "It was only through the artist in him that I was able to find the artist in me." And yet Dick's primordial enjoyment of dancing had an unlikelier source— his joyless father. "When I was small he taught me this little step that gave you the sensation of floating on air. He told me he had picked it up in his late teens when he was playing the violin at a Catskills resort for pocket money." One Easter, the moment the Music Hall lights came on in the wake of *Follow the Fleet*, the nine-year-old Dick got carried away and tap-danced up the aisle, kicking the seats, and blowing kisses right and left. (Dick, as I can well attest, would develop into

a "fellow of no mean foot," to quote Kenneth Tynan on Fred Astaire.)
"My mother kvelled," he recalled, "and my father cringed. On the way
home he accused her of ruining me by encouraging what he called my
'fancy theatrics.' My mother countered that I was just hyperactive."

Jack saw himself as being harsh only to be kind—he felt he needed
to prepare Dick for the "battle," his metaphor for life on earth. Dick's
allowance was a niggling nickel a week, which he supplemented by
collecting discarded soda bottles for their penny-apiece redemption
value ("Pennies matter," his father had drilled into him). "I was saving
up to run away," he told me. He then admitted that he had once stooped
to stealing a couple of dollars from the green suede box his father kept
hidden under the parental bed. He treated himself to an egg cream at
the drugstore and a couple of sticks of chocolate licorice at the candy
store. When his father discovered the money missing, he called Dick
in for "questioning." Such sessions were called "court" (it was not for
nothing that Jack was now called "the judge"). The verdict came down
swiftly: guilty as charged. He said, "You're going to get what's coming
to you": in the event, six lashes administered with a leather strop, with
Margie looking on. "While I was screaming in pain, she was screaming
with laughter," Dick recalled with a shudder. Small wonder that his
sobriquet for home (first Villa Place, then East Ninety-eighth, and fi-
nally East Eighty-sixth, street) was "The House of Pain." Margie's pet
name for West End Avenue was a variation of same: "The House of
Misery."

In the Avedon household, making money was understandably the
number-one preoccupation, but unaccountably it was also the family
expression for making number two—as in "Have you made money yet
today? You know you have to make money at least once a day. How
much money did you make? What color was the money you made?" "I
was allotted three squares of toilet paper per poop," Dick told me. "If I
used more than that, I could get the shit beaten right out of me. My
father said, 'We waste nothing.'" (Atavism, Avedon is thy name: the day
after Dick died, his family swooped down on the studio and scooped
up, in addition to other household sundries, our entire supply of
double-ply, including the rolls already on the rollers.)

The summer Dick turned thirteen, his father sent him to a survival

camp, to, again, "toughen him up." He chose one in the Catskills run by the Young Men's *Christian* Association, speciously reasoning that while Dick was learning to rough it, the "Gentiles would be experiencing and learning to appreciate a nice Jewish boy" and there would thereby be less anti-Semitism in the world.

The camp regimen was punishing: army-style hikes in all weathers, outhouses for "making money"; exercises in foraging for food, complete with instruction in snaring; and lessons in various methods of "self-rescue," to which Dick said he paid considerable attention. "I was the camp misfit," he told me. "I heard myself described as 'peculiar-looking, delicate'—I came to hate my face. I didn't do athletics; I wasn't any good at climbing mountains; the idea of trapping wildlife made me sick to my stomach; and I didn't know any dirty jokes—I didn't even know any Jewish jokes. There was one other Jewish boy there, and the counselors kept trying to get us to fight. My one reprieve: whenever nobody was looking, I would whip out my pen and notepad and write a poem or two."

Another diversion on the horizon was the camp play, an adaptation of that old chestnut "The Monkey's Paw." When Dick failed to land a part, he volunteered to entertain the troops during the entr'acte. He polished up his Fred Astaire routine and, sporting a cane and an improvised top hat, tap-danced his ardent little thirteen-year-old heart out. He was expecting bravos and encores, he told me, but heard only faint applause, and only from the counselors—and *then*, from somewhere in that wilderness of young Christian men, the unspeakable word *Jewboy*. "I executed an immediate self-rescue—I ran like hell to the nearest pay phone and called my father to come get me," he recounted. "The first thing he said when I got in the car was, 'You must have had it coming. What did you do—behave like a grade-A kike? I'm going to try and get my money back.' And then he sent me to the Young Men's *Hebrew* Association camp for the rest of the summer."

Dick was never going to be *his* kind of son, Jack feared, and blamed it all on Anna: "You're the reason he gives himself airs." A ravenous culture vulture—from her early teens a frequenter of art galleries, concert halls, bookshops, the ballet, and, inveterately, the theater—she had taken it as her mission to spoon-feed the fine arts to her fledgling.

(At the late-blooming age of seventy-five she would come into her own as an artist. The sculptures she created—birds and female torsos, in granite, bronze, mottled marble, and alabaster—had, astonishingly, some of the impress of Brancusis and Arps. "My mother's the real thing," Dick crowed, and he threw a party at the studio to unveil her first piece, a beautiful bird. Ron Perelman, the new chairman of Revlon, admired it and, I believe, subsequently acquired one of Anna's sculptures. On the occasion of the party Dick presented her with a luxurious fur coat. She pretended to be horrified, declaring, "Now that I'm an artist, I have to wear a cloth coat." No Laura Kanelous she!)

Unable to afford theater tickets when Dick was growing up, Anna developed a clever strategy: she would dress down, and have Dick put on what she laughingly dubbed his "ragamuffin stuff," before heading to Broadway, then plead poverty to the ticket taker, slipping him a few cents. The next hurdle was the usher, and there an additional nickel or dime would change hands, smoothing her and Dick's way to a couple of empty seats—if they were lucky. Sometimes they would have to wait until after intermission. Dick said he couldn't even estimate the number of first acts he missed, but that imagining what must have transpired was fun. And Anna made every outing feel like an adventure: *Saint Joan* with Katharine Cornell; *Peter Pan* with Eve Le Gallienne; Noël Coward . . . She also regularly sneaked them into concerts at Carnegie Hall and classic films at the Thalia.

For his fourteenth birthday Anna treated Dick to an orchestra seat for *Victoria Regina*, starring Helen Hayes. During intermission he spotted Toscanini and, greatly daring, asked him for his autograph. In the months ahead Dick became a rabid autograph pup, sniffing out the likes of Jascha Heifetz, Dorothy Parker, and Katharine Cornell. His father told him he would be better off collecting the autographs of ballplayers—"You want to be a man, don't you?"—but Dick's heroes were all in the arts. A dream day for the boy was when his father had left for work before he got up and returned home after he was in bed.

On West End Avenue, meanwhile, a seismic event was soon to take place—"the front" had developed a crack and would crumble. Grandpa Polonsky picked up sticks and walked out on the family. Margie's mother was relieved to see the last of her tyrannical father. But doughty

old Grandma Polonsky, now the abandoned wife of a cloak-and-suiter, fell apart at the seams. She pleaded with daughter Anna to take her in. "I got evicted from my room, which wasn't anything to write home about in the first place," Dick told me. "From then on, I had to sleep on the couch. I felt homeless, and that's when I decided to make the Met my refuge—the museum was only five blocks away and I began going there after school to do my homework."

By now Anna was beginning to feel that the house was no longer *her* own, either. There was friction between her and Grandma Polonsky, who kept accusing her of not feeding her "runt" enough. To placate her mother, Anna began putting a raw egg in Dick's Ovaltine, and cod liver oil in his orange juice. "I can still almost taste the putrid stuff," Dick stated half a century after the fact.

His only solace was Cousin Margie, and hers, Cousin Dick. One Sunday afternoon they rode the Fifth Avenue bus dressed in attention-getting garb—Margie in big movie-star dark glasses and her mother's ratty old silver-fox cape, and Dick, having turned it into an elegant foulard, sporting one of the woolen scarves Grandpa Polonsky had left behind in his mad dash to get away from his family (he was off to Florida where he wouldn't be needing it). Trying with all their little might to pass as a glamorous couple, they were put in their place when someone nicely inquired if they were brother and sister.

Margie's mother, Sally, had meanwhile turned the apartment inside out looking for the missing *schmateh*. Margie arrived home to a scene straight out of Bedlam: her mother was disheveled and, by turns, whimpered, moaned, cried, wailed, sobbed, prayed out loud, and screamed— "all for a miserable fox fur," Margie lamented to Dick. As time went on, Sally became more and more of a mental case (according to Dick, she once hurled a kitchen knife at Margie with such force it went on vibrating in the door frame just above her head; and according to Margie's son Robert, "Sally once asked her daughter if it would be okay if she, Sally, whored herself for money"), and eventually had to be institutionalized for the duration of her long life.

Margie continued to seek and find asylum in the Avedon household on Eighty-sixth Street—*that* madhouse. One afternoon she solemnly proposed to Dick that they make a blood pact. She drew up a docu-

ment on the spot that went something like, "Marjorie Lederer and Richard Avedon will hereafter be forever each other's *only* and each other's *one*. Their destiny is hereby twinned. From this moment they are officially two hearts beating as one, two minds thinking as one. May they always be crazy-creative *TOGETHER*!!!! To all of the above they this day hereunto set their hand and seal." Dick told me that Margie then marched to the stove and heated up a safety pin, with which she pricked his finger and then made him prick hers, so that the pact could be consecrated with droplets of their mingled blood.

Poor Margie was desperate to secure a family bond at any cost. Her father, the so-called "bum," whom, for her mother's sake, she had to pretend not to love, had just been incarcerated again for failing to pay alimony. To lift her niece's spirits, Anna offered to throw her a little party. But Grandma Polonsky put her fat foot down: Margie would have to wait to have her party until she was twenty and ready to get married. Anna accused her mother of trying to stunt Margie's social growth, the way she had succeeded in stunting Margie's mother's. When finally Margie was allowed to go to a "formal," it was Anna to whom she turned for help in shopping for her dress. When Anna corrected her posture and told her to tone down her Jewish accent, Margie was grateful. With all her heart, she wished her aunt was her mother.

But Anna's feelings about her niece were another story: they could best be described as conflicted. Something told Anna that Margie was a terrible influence on Dick. And that something was Anna's own mother. "Even a greenhorn like Grandma Polonsky had our number," Dick told me. "She was always going, 'What's up with those two no-goodniks?' From the age of nine I'd been hearing—*over*hearing—her apply the word *unnatural* to Margie and me. Thankfully nobody ever suspected what was going on between me and Louise, which was *everything*." Dick looked at me expectantly, and for the first and only time in our long relationship, I stopped him in his tracks. I told him, "I don't want to hear this." I still like to think he was just saying it to shock a prude like me.

"LOUISE." THE SONG OF SONGS in the Avedon household. Do people today still play Maurice Chevalier's delightful rendition of that

popular little melody? "Every little breeze seems to whisper 'Louise' / Birds in the trees seem to twitter 'Louise.'" "My father and mother would sing along with the record in unison, 'Beautiful, you're so beautiful, / You haunt me all day through,'" Dick recounted, "and Louise would make a face. But how could any of us possibly have realized at the time that all that unearned adulation was going to drive her crazy? Stark raving mad, in fact. I resented my little sister from Day One. I remember throwing a wad of dirt in her face, and hitting her on the legs with my lunch box—normal sibling stuff. When she got to be around six or seven, my mother started nagging Margie and me to take her everywhere we went and include her in whatever we were doing. But she couldn't keep up—she was a drag on us."

One day when Dick was nine and Louise seven, their father had come home holding a package tantalizingly above his head. "Get over here, Dickie, Anna, Louise!" he called. "I have a present for you." He unveiled a funny-looking cardboard contraption—a two-tone blue Eastman Kodak Box Brownie. All you had to do, "the professor" explained, was look through the glass and push the little button; and then, if you placed the negative against a piece of paper and left it in the window on a bright day, the picture would develop in no time. Dick grabbed it, looked through the glass at the nearest thing in sight, which happened to be his sister, and pushed the button. He decided to dispense with the window altogether and to substitute his own skin for the piece of paper. Affixing the negative to his shoulder with surgical tape, he repaired to the nearby beach to let the sun do the work. The next day, when he peeled off the tape, Louise could be seen imprinted— sunburned—onto his skin. "I could make her wiggle," he recalled, "by flexing my arm."

Dick took the Brownie with him on his next sleepover at his grandparents'. Sergei Rachmaninoff, the Russian pianist, composer, and conductor, lived upstairs, and Dick and Margie had often squatted on the garbage pails in the back stairwell to listen to him practice. "I bribed the doorman with a quarter to ask the great man if I could take his picture with my Kodak Brownie," Dick told me. "I posed him by the fire hydrant down the street from the building. He was my first famous face."

Anna, too, caught the Brownie bug. She would pose Dick in a little English suit and Louise in some finery from Loehmann's, in front of a house far fancier than their own, and with a more luxurious car in the driveway, preferably a Packard; to complete the haut-suburban picture, she would even borrow a dog, preferably pedigreed, from a neighbor or passerby (Dick counted twelve different dogs in the course of a year's worth of photographs). "These images were transparent [in that] they were built on some kind of lie about who we Avedons were, and revealed a truth about who we aspired to be," Dick would write years later, in a fine autobiographical essay titled "Borrowed Dogs." Lying, he maintained, could be considered "the first creative act" because "what it says is, 'I'm changing the world—I'm making it better, I'm making it better for *me*.'" ("Fashion work by definition is borrowed dogs," Owen Edwards pointed out, "in that the dress is borrowed, the model is borrowed, the situation is borrowed. Everybody goes home looking quite different than they did in the fashion photograph. In his portraiture, Avedon made the anti-matter of the borrowed dog. He created that challenge for himself, which was: I can do these things without borrowing dogs.")

Anna enrolled Dick in the YMHA Camera Club, reminding him that his loveliest subject by far could be found at home. Louise was a certified beauty who would become a certifiable one. For Dick's first sittings with her, Anna would dress her as a harlequin, or an English princess, or a Japanese princess complete with paper parasol, or a prima ballerina, or a bride, or a mermaid. "Louise didn't like to play, she didn't like to talk, the only thing she seemed to like was posing for me," Dick recalled.

He would tirelessly repeat to interviewers over the years that his whole notion of female beauty originated with the long legs, swan's throat, oval face, long dark hair, big dark eyes, white skin, and full lips of his sister. "Louise was the forerunner—the blueprint," he insisted, "the ghost behind so many of my subjects: Dorian, Dovima, Audrey Hepburn, Babe Paley, Fiona Thyssen, Elizabeth Taylor, Stephanie Seymour . . . Of course, none of them was Jewish except for Elizabeth Taylor," Dick laughed, adding, "almost everything I know about beauty I learned from photographing Louise." The incorrigible Suzy Parker

saw fit to inform a fashion journalist that "Richard Avedon photo-graphed *me* more than any other woman, and I couldn't have looked less like his sister, who wasn't even really that beautiful."

The lovelier Louise grew, the stranger she became. At one point she refused to consume anything hot, or even warm. One day shortly after she turned thirteen, she complained of feeling "funny in the stomach." Anna recognized that her little girl was about to have her first period. When Louise lingered in the bathroom that afternoon, Anna announced to Dick and Margie, "It's come." She sent the two of them to the five-and-dime for balloons and horns and party hats. Louise was still holed up in the bathroom when they got back. At one point she stuck her head out the door, looking scared and confused, and Anna, Dick, and Margie applauded. Then Dick popped a couple of the balloons, and Margie and Anna blew on their horns. Louise locked herself in the bathroom.

DICK WAS THE ONE WHO had something to celebrate. In 1937, he was set to enter the prestigious DeWitt Clinton High School in the Bronx. Its academic offerings would turn out to be largely wasted on him. His attention wandered; his mind drifted. His grades were miserable—he would claim to have even flunked hygiene. His father predicted he would end up in the "army of illiterates."

His only discernible aptitude was for writing poetry. "That didn't mean dick to my father," Dick recalled. "He would say, 'What do you want to be a starving artist for? I know from starving—it's no fun. Be a breadwinner—go into business and make a killing. Provide for your family. You're going to have mouths to feed.'"

Defying his father, Dick tried out for the DeWitt Clinton literary magazine, *The Magpie*, eventually making it all the way to the top of the masthead. He spent as much time as he could contrive in its office in the school's Gothic tower, and even hid out there at night whenever he could, sleeping under the worktable, on the hard floor—he would explain melodramatically to anyone who questioned him that he was "afraid to go home" because he had "an enemy" there.

Some forty-five years later Dick dug out his assorted contributions to *The Magpie* to show me. "Feel free to tell me how embarrassing they

are," he said. I must confess that on the whole they did strike my eye, and ear, as sophomoric. When I told him I thought the poems were "promising," he laughed—he said that the magazine's faculty adviser had made him promise to stop writing. "His name was Wilmer Stone, and I owe my whole career to him, because he convinced me I had no future as a poet and that flipped me into photography—I soon figured out how to express my feelings about life with a camera."

Stone's petrifying prediction notwithstanding, poetic justice lay ahead: Dick's "Wanderlust" won a Scholastic Art & Writing Award in 1940. This one, to my mind, was more like it—more like Dick. It was a poem that moved: it jumped around the way *he* did—his "glance is quick," things "swoop madly upward." And it was lyrical—the wind was wild, there was a bay, there were gulls. The protagonist was ready to spread his own wings more widely, while aiming to steer clear of security. I liked the poem so much I shared it with Renata. "Of course you can project onto it any side of the future maestro that you want," she elucidated, "but basically it remains an adolescent effort, by a kid who has not read much and who has no ear, and it seems to me unusually false even for an adolescent poem. I mean, what's he talking about? He never liked the outdoors, or the wind, or birds. And he certainly never shunned security—on the contrary! It is, in a premonitory way, a conformist's poem, even a businessman's." Her critique was all very apt, to be sure, but I still liked the poem.

In May 1941 Dick made *The New York Times*. The headline read, "STUDENT TOPS 32 IN POETRY CONTEST," and beneath it ran, "DeWitt Clinton Senior Takes First Prize in Inter-High School Competition/ Negro Girl Is Second/ She Attends Textile High." Dick won for his poem "Spring at Coventry," a paean to the historic British cathedral that had been catastrophically blitzed by the Luftwaffe the year before: "Spring will come, / And ivy crawl / Over our / Broken wall . . ." According to the article, Dick had his choice of six books that were offered as prizes and chose *Man and the Shadows*, a volume of poems by Dr. Elias Lieberman, assistant superintendent of high schools and chairman of the judges of the poetry contest—Dick's precocious tactical intelligence!

He told me that his favorite lines from all his juvenilia were these: "City snow, like sodden cotton / Is obviously good for notton." His father went on thinking of Dick as good for nothing—that is, until he succeeded in having a couple of poems published at twenty-five cents a line, in the *New York Journal-American*.

One of the editorial board members of *The Magpie* under Dick was no less than James Baldwin. The two quickly became fast friends, and Dick began frequenting Jimmy's house in Harlem after school—"In those days it was an adventure to go so far uptown," he told me. These visits came to a screeching halt when Jimmy's preacher father accused Dick to his face of being a "nigger lover" and "in league with the devil." Dick explained to me that David Baldwin was a diagnosed paranoid who in fact died in a mental ward a short time afterward. Dick's inviting Jimmy to East Eighty-sixth Street failed to solve the logistics problem: the vibe there turned out to be just as invidious. The doorman told Jimmy he had to use the back elevator. Anna marched down to the lobby and read the benighted guy the riot act, but Jimmy never darkened the Avedons' door again.

IT WAS DURING HIS senior year at DeWitt Clinton that Dick accomplished his first feat of self-invention. He didn't own up to it, however, until 1994. We had just arrived in London to discuss the upcoming Avedon exhibition at the National Portrait Gallery with its director, and I was sitting on the edge of Dick's bed in his suite at the Connaught when he lowered his voice dramatically. "Normie," he said, "I had my nose fixed when I was in high school. Did you suspect?" I told him, in all truthfulness, "I never for a second questioned your nose."

He explained what had impelled him to do it—his desperate desire to "look elegant and sophisticated, by which I mean not Jewish." Bear in mind that this was early-1940s America, where an abbreviated nose was inarguably better for business—for the business of life—and went hand in hand with a changed name. Dick's nose was his "front," after all: his figurative as well as his literal front. In his defense, he added that, when he was a kid cutting out photos from issues of *Vanity Fair*, *Harper's Bazaar*, and *Vogue* to pin on his wall, he had taken note of the fact that long Jewish noses were in short supply.

Dick also took the occasion to remind me that he was the son of an anti-Semitic Jew—a man who had taken elocution lessons to expunge any telltale intonation, who at some point jettisoned the names Jacob Israel and went by Allan Jack Avedon, and who never permitted a Jewish joke to be told at home. Dick's mother would sometimes put on a heavy Jewish accent to get his father's goat. "What really got him was when she uttered the word *schmateh*," Dick told me, laughing, and added, "but it wasn't like it wasn't okay to be Jewish—it was more like it was just better not to be *too* Jewish. Anyway, when I told my father I wanted to have my nose fixed, skinflint that he was, he said he'd foot the bill."

Dick insisted to me that nobody noticed the change in his appearance. I mean, maybe nobody said anything, but how could it not have been the talk of the DeWitt Clinton cafeteria?

That spring, he learned that due to his failing grades he wouldn't be graduating with his class—he was going to have to repeat the year. "That was humiliating, unthinkable," he said. "So I dropped out in January of '41. I didn't tell my parents." He got a job as an errand and darkroom boy at a small West Fifty-seventh Street photography studio run by brothers Mike and Steve Elliot. When Mike enlisted in the Merchant Marine that next spring and was assigned to set up a photography department, he invited Dick to come aboard, pointing out persuasively that it was a more palatable alternative to being drafted.

When Dick broke the news to his mother that he was "going to sea," the sky fell in. His ship was sure to be sunk, she wailed—or, failing that, he would be captured and tortured. He had to confess that he was going to be stationed only as far afield as Brooklyn, at the U.S. Maritime Service Training Station in Sheepshead Bay. She made him promise to call home regularly.

The morning of his momentous departure (to the next borough!) Louise became hysterical. "Don't leave me!" she pleaded, hurling herself onto the living room floor, kicking and twisting her body around. Then she caught sight of Dick's satchel standing in the corner. "That's mine!" she screamed. "You can't have it!" Dick repaired to the closet down the hall for another bag. During the minute or so he was gone, she had managed to fling his belongings all around the room. "To calm

her down I slapped her," he told me. "So then she started screaming that I had hurt her and she hated me." On that high note—the note of hysteria—Richard Avedon exited The House of Pain.

Margie was waiting at the bus stop to say goodbye to him, and Dick was anticipating yet another scene, complete with tears and remonstrations. The first thing he noticed was she was wearing one of his old shirts, the one with a missing button, and suddenly the tears were his. "She was standing there looking pitiful," he told me. "I reminded her that she had just won a full scholarship to Sarah Lawrence and had her whole life ahead of her. I knew I had to cut loose from her once and for all." His heart now sufficiently hardened, and without so much as a backward glance, Dick mounted the bus he had just thrown his cousin under.

6

FINDING LIFE
THROUGH A LENS

———

THE NIGHT BEFORE DICK "SAILED" FOR SHEEPSHEAD BAY, HIS father gave him a farewell present—a handheld, square-format, twin-lens Rolleiflex, with a waist-level finder. The only other present Dick remembered ever receiving from Jack directly was the money to pay for half of a new typewriter. The Rollei would turn out to be the gift that went on giving—it would be Dick's camera of choice for most of his fashion and portrait work until the late 1960s. "When I'm feeling charitable about my father," he said, "I like to think that that was his way of setting me up in business. The funny thing is, for several of my portraits of him, I used the Deardorff, because it was much more imposing and I wanted to impress him."

Dick's gig in the photographic division of the Merchant Marine consisted almost entirely of his taking pictures of the enlisted men for their military ID cards. As a kid he had been drawn to the Wanted posters in the post office, which showed felons both in profile and full-face. "I turned out to be a natural at it," he told me. "I just talked to each guy for a minute or two and clicked. Tens of thousands of times, I might add." Every photography critic worth his byline has pointed out that this minimal format—sitter head-on against stark-white background—became Richard Avedon's template: his trademark portrait style. One

critic cannily described Dick at the height of his career as "America's canniest mug-shot artist."

Chief Photographer's Mate Mike Elliot was also the editor of the two Merchant Marine house magazines, *The Helm* and *The Mast*, which covered the waterfront—life on the base and sailor life beyond it—dispensing, for instance, "training tips on how to live with maximum comfort on lifeboats, life rafts, and uninhabited islands." He promptly promoted his erstwhile errand boy—Photographer's Mate 2nd Class, USMS Richard Avedon—to second-in-command. Dick proceeded to contribute everything from photographs of rope climbs and judo-training sessions to proper portraits of sailors. His picture of a rain-splattered young salt was splashed across the full back cover of one issue—supplemented by an Avedon poem that reintroduced the raucous gulls from his Scholastic Award–winning effort. Dick was pleased, and no wonder: he was doing the two things he felt he was good at—writing verse and taking pictures.

Flash-forward fifty years to 1993. An elderly gentleman—Nathan J. Averick, a Chicago pathologist—appeared at the studio one morning asking to see Dick. By way of further introduction he produced a photo from his doctor's bag, identifying the two young men in it as himself and a Merchant Marine mate circa 1942. "My friend Vernon Beeson and I were so bored that one day we just decided to shave our heads for something to do," he filled in. "We were the only two baldies on base, and I guess Avedon just couldn't resist taking our picture. He got it published in *The Helm*." I took the photograph upstairs to Dick, who came bounding down to greet the good doctor. "This is exactly what I needed! I could kiss you!" he told him, explaining that he was in the process of collecting material for a comprehensive book called *Evidence* and that, until that very minute, "there was practically nothing from my Sheepshead Bay period."

Later that morning Dick buzzed me to stop whatever I was doing and come down to his office, saying he needed to talk. I found him sitting on his bed, tapping his foot, and his arm was twitching. He said, "Averick's visit has brought it all back—'the horror, the horror.'" I reminded him that he had always said what a swell time he had in the Merchant Marine—it got him away from home, it got his career

going. Dick inhaled deeply, then let it all out: how, though there were more than a hundred seamen in his "compartment," he was always the one who got the dirty end of the stick—the one who had to clean the toilets and swab the floors. "I didn't have to ask why me—I knew: I was the lone Jew. I couldn't even complain; that would have been *too* Jewish. I had to suffer in silence." I remember saying, "So unlike you!" He didn't laugh, which was so unlike *him*. "There's worse," he said. "One night when I crawled into my bunk there was a swastika, scrawled in black crayon on the wall. I managed to get most of it off, with spit and a corner of my pajama top. But then when I finally managed to get to sleep I had a dream about my father—he had jackboots on and he was chasing me with a German shepherd and a strop through the woods of that YMCA survival camp. And that night the swastika was back on the wall. I knew I had to get myself mustered out of the USMS ASAP."

A marine Dick knew who had cracked up the year before gave him the name of his psychiatrist, a Dr. Silverfenny. Dick ran to the nearest pay phone and talked her into seeing him the next day as an emergency case. "By the end of our second session," he told me, "she had heard more than enough to write me the kind of letter that would get me home free." It got him discharged all right, but free he was not—he was hooked on psychiatry for life. He continued seeing Dr. Silverfenny a couple of times a week for the next six or seven years.

"I was all out of whack," Dick acknowledged, "and Silverfenny helped me confront certain questions that I had about myself. She also helped me begin to sort out some of my relationships—the horrible guilt I felt about Louise, the bitter hatred I had for my father, my over-dependence on my mother, my resentment of Grandma Polonsky. Grandma kicked the bucket pretty early in my analysis, and I was struggling with my ambivalence about that—my *lack* of ambivalence. I told the doctor that I hoped Grandma was burning in hell very slowly. She said, 'Your harsh comment tells me that you must have loved her very much.'"

Another pressing issue for Dick at the time he entered therapy was his continuing entwinement—entwinment—with Margie. It was the love that came and went but never quite went away: she was still the

only and the one. She had by now achieved a level of success that Dick admitted made him "see green." While he was more or less treading water, publishing portraits and the odd poem in *The Helm*, she had left him in her wake, publishing not only poems but short stories in national magazines such as *Cosmopolitan, The Saturday Evening Post, Mademoiselle,* and *McCall's*. Anna, too, in solidarity with Dick, was envious of Margie's success, and referred to her writing as a "nice little outlet" (even as, years later, some of her poems were set to music and performed by two of Anna's favorite TV personalities, Dinah Shore and Martha Raye).

Then, to make matters worse, at the age of twenty-four Margie was appointed poetry editor of the women's magazine with the highest circulation in the country, the *Ladies' Home Journal*. It was in its pages that in 1957 she published her overwrought short story "First Cousin," based on guess who. She had taken care to change every character's first name except for Dick's.

Margie spent the following four years expanding the story into a novel (one of the five she was to write, in addition to eleven other books). In *The Eye of Summer* she did change Dick's name (to Spencer), presumably because he was a celebrity by then and the book touched on forbidden territory. The lip-smacking jacket copy read: "They had never been innocent . . . since the time they were children and had shared the long, hot, blood-stirring summers together. [Their love] threatened to destroy them in its all-consuming flame." In Margie's words, she and her first cousin were "love's criminals . . . Huddled there in the darkness, entangled inseparably as ivy in each other's limbs." *The New York Times Book Review* circumspectly described theirs as "a curiously exotic relationship between two little lost Katzenjammers."

When Dick gave me the novel to read, in 1994, he said simply, "Every single word of it is true." Eight years later, we were sitting at his desk reviewing contact sheets when he announced out of the blue, "Tonight I'm going to tell Margie's son John about his mother and me." I said, "Why? And why *now*? What's the point? Seriously, Dick, don't!"

Dick did.

"He had this habit of just sort of flying into your life at the last min-

ute, and then flying right back out," John Lee, a Manhattan art and photography dealer, remembers. "One evening about three years before he died I get this call from him: 'I'm in a cab, on my way over—we'll order in Chinese.' And five minutes later he shows up at our loft downtown and he's carrying a glass container with this weird-looking branch sticking out. At some point in the evening he says, 'There's something I've been planning to tell you for a long time—your mother and I were together. What I mean is *really* together. Lovers.' It was almost like he was saying, 'I had sex with your mom, so here, take this branch!' Like it was a peace offering from the Bible.

"Now, first-cousins incest is illegal in some states—it's a real fine line. He was clearly waiting for me to look shocked, but I wasn't. I already knew this, from a young age—I mean, my mother had written a whole book about it. Dedicated to her psychoanalyst, by the way. When I took Dick's mother, my great-aunt Anna, to lunch at a Chinese restaurant on East Seventy-ninth Street a couple of years before, she told me that Dick and my mother had been 'way too close' growing up, and I remember wondering if she knew what she was saying and was speaking in a kind of code. But then she said that clearly she had had nothing to worry about, since Dick had turned out so well. And then, because I was an art dealer, she invited me to her apartment after lunch to see the sculptures she had only started making when she was around seventy-five. I thought they were great.

"Anyway, when I didn't say anything in response to Dick's 'revelation,' he blurted out, 'Don't worry, I'm not your father or anything. Your mother and I stopped being together in that way long before you were born.' I asked him, 'Like around when would you say it ended?' And he said, 'I can tell you exactly—1965.' In 1965 I was six.

"The funny thing is, when my mother was sleeping with Dick in the sixties, it wasn't my father she was two-timing—she had basically checked out of the marriage, and Philadelphia, by then—it was her girlfriend in New York. Her first novel, *The Lion House*, was all about *that* relationship—it's listed on Amazon under 'Lesbian Pulp Fiction.'

"After our dinner that night, Dick took a lot of family pictures: my wife and I just sitting around, me with my quarter-mile-long sideburns; our daughter, who was wearing a tutu; and our year-old son, who was

in a bassinet on the dining table. He took them with just his point-and-shoot camera, and they're all really wonderful—they're Avedons. He didn't need the eight-by-ten and the lighting umbrella and all of that to make art.

"The few people I confided in about Dick's visit all said, 'Well maybe you *are* his son—maybe he came there intending to try to sort of tell you that but then got cold feet.' I mean, who knows—I'm in my late fifties and I do still have all my hair, which *could* be a legacy from Dick. That would mean that both of Dick's sons were named John. But seriously, I'm fine with *not* being Dick's son."

IF DR. SILVERFENNY FAILED to break Dick of his emotional dependence on Margie, she was immensely beneficial to him in practical ways. At the time he entered therapy with her, he aspired to be a Martha Graham dancer. She clarified his professional goals for him, recommending that he build on the strengths he was already demonstrating and become a full-time photographer. Dick had gotten wind of the workshops in both avant-garde photography and graphic design that were being offered at the New School in New York—ten three-hour evening sessions conducted by a White Russian émigré named Alexey Brodovitch, whose important day job was art director of *Harper's Bazaar*—and Silverfenny encouraged him to sign up for the classes.

The list of Brodovitch's students at the time added up for Dick to a preview of coming attractions. They included the future mother (Diane Arbus) of a future collaborator of his (Doon Arbus); the future husband (Martin Stevens) of a future studio director of his (me) who would go on to become worldwide creative director of one of Dick's most lucrative accounts (Revlon); and the future first husband (Milton Greene) of Dick's future second wife (Evelyn Franklin).

Irving Penn once said, "All photographers, whether they know it or not, are students of Brodovitch." Certainly an astonishing number of celebrated ones actually were: in addition to Avedon and Penn, there were Lillian Bassman, Ed Feingersh, William Helburn, Art Kane, Saul Leiter, Hans Namuth, Karl Bissinger, Karen Radkai, Eve Arnold, David Attie, Jerry Schatzberg, Mark Shaw, William Klein, Bert Stern, Ernst Beadle, Bruce Davidson, Eliot Elisofon, Louis Faurer, Lisette Model,

and Garry Winogrand, among others. They had gravitated to Brodovitch to hone their skills not only in photography but in advertising, design, and fashion.

Brodovitch was a veritable hero to them: he had given early magazine exposure to—and in some cases introduced to an American audience—Bill Brandt, Robert Frank, Lisette Model, Man Ray, André Kertész, Erwin Blumenfeld, Roman Vishniac, and Brassaï, not to mention Cartier-Bresson, whom he described as being "near to being a genius" (one could say that he got that *nearly* right). Many considered Brodovitch to be not far from a genius himself, including Cartier-Bresson, who permitted him, as opposed to every other art director he worked with, to occasionally crop his photographs.

This Czar of All the Graphics could be described as a very interesting case. Alexey Vyacheslavovich Brodovitch was born in his psychiatrist father's hunting lodge outside St. Petersburg in 1898—"in sub-zero temperature," he told an interviewer, adding that, when he was two weeks old, "my father took me and put me in the snow and shoveled over me, then took me to dry out in the open fire and gave me some vodka." Brodovitch's father also gave him a box camera fairly early on, the same as Dick's father would later be giving Dick.

Frozen out at home and further hardened by military school, Brodovitch went on to achieve the rank of captain in the cavalry of the White Army; but in the aftermath of the Bolshevik Revolution he wound up, like many another Russian aristocrat, poverty-stricken in 1920s Paris. Providentially for him, the city was awash in experimental art movements—Cubism, Purism, Constructivism, Surrealism, Futurism . . . Brodovitch began his climb as a lowly house painter, ascending to window displays and then to designing posters (he bested Picasso in a competition), catalogues, magazine layouts, books, and ads, and finally china, jewelry, and textiles (for couturiers such as Poiret and Patou). He operated out of his own studio, L'Atelier A.B., and at one and the same time headed the design studio and advertising department of a major Paris department store. In 1930 the Pennsylvania Museum and School of Industrial Art came courting, and he accepted the offer to establish and direct a department of advertising design in a major American city.

From his new Philadelphia base Brodovitch expanded in every imaginable—and hitherto unimaginable—graphic direction. He set up his first so-called Design Laboratory around 1933. Concurrently, he took on ad campaigns for Saks Fifth Avenue, Elizabeth Arden, Helena Rubinstein, Steinway, Sears Roebuck, DuPont, Shell, Bell Telephone, Bethlehem Steel, and the Red Cross. He also began designing furniture in a big way. His plywood, rope, and metal rocking chair went on to win third prize (out of three thousand entries) in the seating category in the Museum of Modern Art's international competition for low-cost furniture design. (It now sits comfortably in the permanent collection of the Metropolitan Museum of Art as well—donated in 2002 by Brodovitch's stellar student, Dick. It had languished in the Avedon studio for decades. I can attest to the fact that it was no easy chair: it was as hard to sit on as it was stunning to look at.)

In 1934 Brodovitch had a show of his graphic designs at the Art Directors Club in Rockefeller Center. The newly minted editor of *Harper's Bazaar*, Carmel Snow, stopped in and, astonished by how avant-garde the work was, made him an offer on the spot. For the next quarter century he and Snow would make fashion-magazine history together.

Loath to give up teaching, Brodovitch at some point arranged with the New School to conduct his Design Lab classes there. Tall, lean, stern, chain-smoking, he was an intimidating presence to generations of students. "My way of guiding people is by irritation," he forewarned them, adding, "I irritate to educate. I am not a teacher, I cannot give a recipe. What I am is a can opener—I open, so I can see if there is creativity inside."

English was not Brodovitch's strong suit. "His mastery of our language was like a charming disaster," a former student charmingly put it. He compensated by delivering his message so authoritatively that it had the force of law: "Resist imitation, originate, find a new language— your own visual ABC . . . Be clairvoyant, produce something for to-morrow . . . Move the cartwheel in your brain!"

Brodovitch was also a visionary photographer in his own right. In 1945 he would publish a groundbreaking book consisting of a hundred lyrical pictures of ballet performances, in which he pioneered the tech-

nique of blurred motion. *Ballet* went on to win the Book of the Year Award from the American Institute of Graphic Arts, and is today a highly coveted collectible. (Around the millennium the Manhattan photography dealer Howard Greenberg acquired eight vintage Brodovitch ballet photographs, and was in the process of successfully selling them to museums when he got a call from Dick, who had heard he had them. "Avedon said, 'You know how important he was to me, and they're so rare—it's incredible that you have them,'" Greenberg recalls. "I told him they were twenty-five thousand dollars each, and I then heard that pregnant pause on the phone. 'Wow,' he said. 'that's expensive.' I explained that I had already sold some at that price and that the book alone sells for around ten thousand. I said I was willing to trade. He said, 'Well, let me think about it,' and he never called back." I mean, Dick and money!)

Dick instantly and everlastingly fell under Brodovitch's spell. He would come to regard him as "a second father" (his *good* Russian-born father, as opposed to bad Jack), though he could never bring himself to address him as anything other than "Mr. Brodovitch." One of the earliest class assignments was to draw a neon sign for a Broadway show. Dick panicked, convinced he couldn't draw. "Then use spaghetti!" Brodovitch expostulated. "Or beer foam." Dick got the drift, and did it with pipe cleaners.

Other assignments included Halloween, parades, politics, juvenile delinquency, cafeterias, football, baseball, Harlem, jazz, graffiti, Dixie cups, housing projects, the United Nations, Central Park, zoos, antiques, Broadway, "Chinatown New Year," traffic, reflections, bridges, newsstands, Christmas trees, garbage dumps, soft drinks, lipstick, perfume, cellophane—the kitchen sink. "Astonish me!" Brodovitch exhorted the students, echoing the impresario Serge Diaghilev's famous injunction to Jean Cocteau. (The reference was pointed: in the twenties Brodovitch had worked for Diaghilev, painting Ballets Russes backdrops and stage sets designed by Picasso, Matisse, and Derain.)

The students would drop three or four examples of the week's work on Brodovitch's desk—no names attached—as they filed in. He would take a cursory look, then pass the work around for all to see, and then critique it publicly—mercilessly if need be. "Cliché," "passé," "junk," "rubbish—material for garbage can," he would grumble. He went so

far as to tell one student, "Your work disgusts me." Another he advised to "be a truck driver—on long distance." "Maybe I'm human, or maybe I'm unhuman—*you* judge," he said, adding, "Come on, let's fight! Defend yourselves."

Penn, who had been one of Brodovitch's first students back in the Philadelphia days, not to mention his unpaid intern at the *Bazaar* for two summers in the late 1930s, told Dick later in life that Brodovitch had once picked up a couple of his photographs and thrown them on the floor. "I've been vulnerable to the slightest word he has ever said," Penn confessed, adding that he regarded Brodovitch as "our father in a way . . . Without feeling much affection for him, you feel the greatest respect in the world and even a kind of love."

"A lot of the students couldn't take it," Dick told me. "I couldn't get enough of it. Brodovitch rattled my brain, which was a good thing. He taught me how to edit a picture and how to be my own art director. And photography was far from the only subject he discussed—he held forth on typography and newspaper and magazine design, and furniture and product packaging and display. And theater and film and art and literature and music and politics. One of his mantras was 'Be aware of everything that is happening.' Preferably, before it even happened." This was a lesson that Dick would pass on to generations of his assistants. "It's not just about taking pictures," he would drum into them. "It's an accumulation of things, including reading and going to the theater, that develops your style and your images." But the greatest lesson Dick learned from Brodovitch was to never be satisfied, that there is no such thing as good enough.

Dick attempted several times to trap Brodovitch's attention after class. His portfolio was at the ready. Its lead photograph was Louise in a one-piece bathing suit, followed by assorted other images of her, then by roughly twenty of his Merchant Marine "mugshots." Brodovitch would always dismiss him, literally wave him aside with "Good night, Mr. Avedon." Dick then tried another strategy: he made an appointment to see him at his office at the *Bazaar*—only to be told to come back another time. He stormed the Hearst citadel fifteen times in all, and all to no avail. Dick laughed when I pointed out that today this would be considered stalking.

"I was in the doldrums," he told me, "and then lightning struck." The bolt from the blue arrived in the form of a bank teller with aspirations to be a model: nineteen-year-old Dorcas Marie Nowell. Having heard that Dick was a beginner and presumably reasonably priced, she

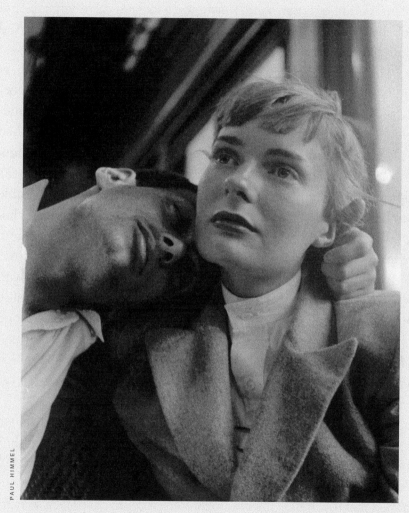

PAUL HIMMEL

DICK AND DOE, HIS FIRST WIFE, ON THE
FIRE ISLAND FERRY, CIRCA 1947.

went to him for test shots. "She was so beautiful I thought I must have dreamed her," he said. "I kept muttering to myself, 'Be still, my heart!'" He whisked her off to Central Park and photographed her against the

backdrop of the East Seventy-second Street sailing pond. This was the only time he ever fell in love through the lens, he said—"just like in a B movie"—as well as the only time he ever fell for a great beauty. "She was my second muse," he stated, "after my sister. And her hair and eyes were a lot like Louise's."

The eyes in question were brown, wide-set, and meltingly soft, and Dick instinctively called her Doe. That was it: Doe she became. And before the year was out, he would be changing her last name, too—to his. "The lucky thing," Dick said, "was she didn't have parents to object to her casting her lot with a penniless Jew who had the added distinction of being a high-school dropout." Doe was an orphan, her mother having died when she was three, her father nine years later. He had served as head butler to the Singer sewing machine heir and prominent horse breeder F. Ambrose Clark, and her mother had been the lady's maid to Florence Clark, who maintained a separate racing stable from her husband's. The Clarks divided their time between Broad Hollow, their estate in Old Westbury, Long Island, where Doe was born, and Warwick Lodge in Melton Mowbray, England, where "Brose" Clark had ridden to his own pack of hounds in the 1920s and '30s with his friend the Prince of Wales (later King Edward VIII and, later still, Dick's unwitting "victim" the Duke of Windsor). He was sorely proud of having broken nearly every bone in his body in pursuit of his passion. (When he finally bit the dust, in 1964, Dick learned from his *New York Times* obituary that he had "once put a hot potato under the tail of a balky horse to speed him along." Some sportsman.)

Brose took an avuncular interest in the beautiful Doe and underwrote her education, which, when Dick first met her, had just culminated with junior college. "He sent her the latest-model Singer," Dick told me, adding that, next to reading, Doe's favorite thing was sewing—he claimed that the dresses she ran up for herself could have given some of the couture numbers he would soon be photographing a run for their money.

For their second date Dick proposed a visit to the Central Park Zoo. As they tarried by the sea-lion pool he devised a *jeu d'amour*: "Let's see how far away from the noisy creatures we can get and still hear them." They ran hand in hand up the steps of the medieval-fortress-like Arse-

nal and out onto Fifth Avenue, achieving only the corner of Sixty-fourth Street and Madison Avenue before the seal honks were drowned out by car horns. It was their mutual infatuation that knew no bounds.

Doe was living in the Westchester County suburb of Pelham with a relative. Within a matter of weeks Dick had moved her into his place — a parlor-floor studio apartment with casement windows that he was renting, for the proverbial pittance, in a brownstone in the low East Sixties. He had plastered the walls with vintage fashion-magazine spreads by the Budapest-born street and sports photographer Martin Munkácsi. "His real name was Marton Mermelstein," Dick told me, "but at the *Bazaar* they called him *Munky*." As a teenager walking down Fifth Avenue one day with his father, Dick had seen the photographer in action, posing a model in front of the Plaza. (Some twenty years later he would pen a lyrical tribute to Munkácsi for the *Bazaar*, describing him as someone who had "brought a taste for happiness and honesty and a love of women to what was, before him, a joyless, loveless, lying art." He considered himself, he went on, one of "Munkácsi's babies, his heirs.")

The apartment had practically no amenities. "I made a darkroom in the john," Dick reminisced. "I put my trays over the bathtub and the enlarger sat on the toilet seat—I couldn't size and shit at the same time . . . I must say I got a kick out of living in so-called sin, which was something that was just not done in those days. But Doe had an uncle who was a cop and a great-uncle or something who was some kind of Episcopal muckety-muck and she lived in mortal fear that one or the other or both would discover our domestic arrangement. So I married her practically right away. I was proud as a peacock to have such a beautiful wife. My father typically said, 'Just how do you think you're going to support her?' My mother said, 'She doesn't talk much, I can't warm to her' and 'She's not as beautiful as Louise.' And Louise? She just glared—didn't say a word. Doe, good girl, put up with it all for my sake."

Emboldened by love, Dick one morning put on his snappy Merchant Marine uniform and swept into the public relations and advertising department of first Bonwit Teller and then Peck & Peck. He showed them a selection of his photographs of Doe and Louise and proposed

that they lend him clothes for his models in exchange for their choice of the prints he produced. He left with shopping bags full of the latest fashions. Then, blowing his Merchant Marine wad, he hired the highest-paid model in town, Bijou Barrington, to pose for him. Bonwit's displayed the pictures in their dressing rooms and elevators and, even better, commissioned Dick to photograph a girl in a bathing suit for a press release. "They paid me the going rate—$7.50," Dick said. "The first check I ever received for a photograph." Peck & Peck followed suit, also hiring him to do some publicity pictures. Dick's persistence was beginning to pay off.

Meanwhile his photos of Doe were striking an editorial chord. She was signed by the top-flight Harry Conover Agency, which sent her book with Dick's test shots to *Vogue*. One day the phone rang in the apartment—the caller introduced himself as the magazine's recently appointed art director, Alexander Liberman. The job he was offering was for Dick, though—not Doe. And Dick, still holding out for the *Bazaar*, turned him down. *Vogue* was flashier, to be sure, and had greater cachet, but the *Bazaar* was classier. Its coverage of fashion and society was more cutting-edge; its theater, film, and art reportage superior; and its literary and photographic fare far more substantial. Truman Capote, T. S. Eliot, D. H. Lawrence, W. H. Auden, W. Somerset Maugham, Evelyn Waugh, Virginia Woolf, Stephen Spender, Dorothy Parker, Jean Stafford, Carson McCullers, John O'Hara, Gertrude Stein, Edith Sitwell, Dylan Thomas, Kenneth Tynan, Eudora Welty, and Colette had all been published in its pages, which is where Dick first read many of these seminal writers. The *Bazaar* was also regularly graced with exceptional pictures. With some justification, then, it advertised itself as catering to the well-furnished mind as well as to the well-dressed woman.

The *Vogue* offer that Dick spurned had the effect on him of Brose Clark's smoldering potato on that malingering horse. He hotfooted it over to the *Bazaar*, and now, on his sixteenth try, he unaccountably succeeded in being shown into the small alcove that served as Brodovitch's office. The czar was on his hands and knees, laying out Photostats of varying sizes, shuffling them as if they were playing cards. "Young man," he mumbled, rising to his feet and offering his hand,

which Dick remembered was sticky with art gum, "you certainly know how to use your elbows, now let's see how you use your eyes." He then flipped impatiently through Dick's book. "He dismissed the Louises, Does, and Bijous as no more than catalogue material," Dick recounted. "He told me, 'There is a long distance between your receiver and my receiver.'" But then he came to a photograph Dick had taken of a set of twins in the Merchant Marine — the one in the foreground in sharp focus and the other blurry, impressionistic — followed by that photograph of Dr. Averick and his Merchant Marine mate, both of them shaven-pated. He exclaimed, "These two are real stoppers! It may be only a false pregnancy, but they give me some hope for you."

Brodovitch gave Dick an assignment to "do shoes" for *Junior Bazaar*, the small section in the back of the magazine that was soon to be launched as an independent offshoot aimed at the youth market, and that Brodovitch used as a testing ground for staff photographers. Dick put his best foot forward, but Brodovitch judged the results derivative and technically deficient. He pleaded for a chance to shoot Doe, and Brodovitch sent them to Mexico; though decidedly less than astonished by the pictures, he eventually published them, across two pages.

Dick didn't hit his early stride until he had the idea to spirit away a couple of natural-looking girls to Jones Beach, put them in horizontal-striped T-shirts and cotton shorts, and, mindful of Brodovitch's antipathy for the static, the stiff, and the posed, photograph them leapfrogging, skipping rope, and plowing through the sand on stilts. Brodovitch hailed these pictures of girls on the move as "a breath of fresh air" and ran them six pages strong. (More than half a century later, for the posthumous Avedon fashion retrospective at ICP, an enlarged black-and-white print from this shoot would serve as the opening image.) At the age of twenty-two Dick became the youngest photographer ever featured in the *Bazaar*, and Carmel Snow felt secure in promoting him as a "new, contemporary Munkácsi . . . a striking photographer" who "seems to have mastered gravity" as well as introduced "a lovely new fluency into the language of fashion photography." With that, Richard Avedon's legendary career was set in motion.

The wunderkind took instant wing. From the moment Dick reported to work in 1944, gliding into the art department in his Merchant

Marine uniform, he was a hit with the magazine's reigning triumvirate. "Brodovitch became my professional father, Carmel Snow my mother, and Diana Vreeland my fairy godmother," Dick said. "Diana's blood-red rouge and lacquered hair took a little getting used to, but it took me forever to get the hang of her upper-class patois. When I did, I understood that she was out of her mind for the good, cracked for the better, and that she was feeding into me a lot of stuff that I was going to be able to use in my work. But with her, fashion always trumped photography, which she never considered art—she couldn't see beyond the clothes in a photograph, and she saw photographers, she actually said, as 'necessary evils.' She lived fashion to the exclusion of everything else. I always wondered to what degree it isolated her from her—come to think of it—equally well-dressed husband."

For the first few years Diana persisted in calling Dick "Aberdeen," saying she didn't want to have to bother to remember his name—which he was only too ready to attribute to anti-Semitism. "Whatever it was, it wasn't an endearment," he told me. "I mean, imagine what my chances would have been if I had turned up at the *Bazaar* with the nose I was born with. I remember describing my sister to Diana as 'dark' and her saying, 'You mean Latin-looking.' I said, 'I mean Semitic,' and she recoiled. As a snob she was in a class by herself. To her, Carmel was just Irish underclass trash. One time when I was going over to Paris for the collections, Diana insisted I look up her old American friend the Baroness Pauline de Rothschild. She sat down and wrote one of those old-fashioned letters of introduction and handed it to me to drop in the mail when I got to France. A little bird told me to read it first. Well, she had described me as a 'colleague,' a 'business associate,' so no way was I going to send it. When Diana died, in '89, I was asked to deliver one of the eulogies at her memorial service, and I had to think twice about it. I couldn't help remembering how disloyal she could be—that back when she was professing to be this great mother figure to Marella, she sent me to photograph Gianni Agnelli's young mistress, Princess Domietta Hercolani."

In the end, Dick found it in him to salute Diana. In the august Medieval Sculpture Hall of the Metropolitan Museum of Art, before an invited audience of 450 that included Jacqueline Onassis in black and

THE LEGENDARY DIANA VREELAND, THEN THE FASHION EDITOR OF *HARPER'S BAZAAR*, GIVING DICK A PAT ON THE SHOULDER.

Lauren Bacall in Vreeland red, he extolled Diana for embracing "all kinds of beauty before other people did—Asian, African, Russian, Global," and lamented the loss of "the amazing gallery of her imagination." He ended on a note of nostalgia that could only have been ambivalent: "Goodbye from your Aberdeen." As we were leaving the Met, Dick kicked himself for neglecting to mention "the most wonderful thing I ever heard her say—that fashion was as evanescent as a kaleidoscope of butterflies gliding across a lawn. Or was it a charm of hummingbirds moving toward a jar of honey?"

"Carmel, on the other hand, was cozy," Dick recalled, "with the Irish-mist voice and the bluish hair and those coquettish Balenciaga hats. And *she* had a generous streak—I mean, she would give Evie her Mainbochers to have copied, and when our son was born she came to the hospital." For all that, Dick admitted to "wondering from time to

time what she might have said about Jews behind my back when she was drinking." He also acknowledged that her conception of elegance paled in comparison to Diana's, which was more original and imaginative.

The oft-told story goes that Carmel Snow dispatched Dick to Paris to photograph the collections in 1947 when the couture houses of legend reopened after the Liberation, and newcomer Christian Dior revolutionized fashion with his wasp-waisted New Look (it was Carmel who came up with that label)—saying, "I'm counting on you, young man, to reinvent prewar glamour and put all those poor fabric houses and seamstresses back to work." Not so, Dick told me: in order to secure this

DICK WITH THE *BAZAAR*'S LEGENDARY EDITOR-IN-CHIEF, CARMEL SNOW, AND THE MAGAZINE'S PARIS REPRESENTATIVE, MARIE-LOUISE BOUSQUET, AT THE COLLECTIONS.

career-making assignment he had had to threaten to go to *Vogue*—talk about elbow. It was not that Snow didn't think Dick was ready, but rather that the assignment properly belonged to Louise Dahl-Wolfe, the principal fashion photographer at the *Bazaar* since 1936.

Dick took Doe with him to Paris, to model as he saw fit. They hit

town in an open-roofed taxi, standing up, guzzling champagne. Their phrase books were at the ready—neither of them knew more than a few stilted expressions in French (Dick, hearing the word *verveine* for the first time, would mistake it for Yiddish). In those first heady days they made like good tourists, posing for each other on the Eiffel Tower, dancing in chic nightclubs, taking in a sex show in Pigalle. They donned evening clothes to attend their first Paris party, given for the American fashion press by the British designer Captain Edward Molyneux in his art-filled *garçonnière* overlooking the Seine. Food in Paris was short this side of the black market—rationing was still the order of the day—but Dick and Doe were on a roll: they stuffed themselves at the glamorous Grand Véfour, Paris's oldest grand restaurant, newly revived, where they tasted their first truffles, and at Prunier, the seafood restaurant designed by Brodovitch in the mid-twenties, right down to the menu and napkins.

Such divertissements, however, were few and far between. During the rush of openings Dick had to burn the midnight oil in the cramped *Bazaar* studio on the rue Jean-Goujon (it was just down from the San Régis where he was staying and directly behind Dior whose workroom he could see into—the omphalos of fine craftsmanship). Bicycle messengers old enough to be his grandfather would be constantly dropping off deluxe dressmakers' boxes; sometimes Dick had custody of the dresses for only an hour or two—then off they went, to buyers or clients or, worst of all, rival magazines.

The buyers, stylists, fashion reporters, photographers, and illustrators that Paris was crawling with during the collections operated like fifth-column spies. Whenever a model appeared on the street in a new-style outfit, someone would be quick to sketch its lines for hasty reproduction in a catalogue. The sketch would then be hawked to unscrupulous clothing manufacturers, who would knock it off to sell as ready-to-wear in stores like Gimbels, before the real McCoy—the licensed creation—could hit the market. This practice would become so prevalent that the French were forced to coin a word for it: *contrefaçon*, meaning forgery or patent infringement—in this case, *pattern* infringement. All this cloak-and-dagger intrigue was of course right up the young Dick's *allée*.

Carmel Snow had decided not to tell Dahl-Wolfe that she was also sending Dick to the collections. As Polly Mellen recalls, "It was done very sneakily, which was not my idea of a good idea. Carmel called it an undercover operation." Dick was cautioned to photograph on the sly and to otherwise lie low—a position that didn't sit well with him, even back then. Although he had had as many as two hundred photographs published in the *Bazaar* the previous year, it was those 1947 Paris pictures of his, in their multiple double-page spreads, that sealed his mastery of the field. From then on, until the end of her reign, he would accompany Carmel Snow to Paris twice a year, and be invited to sit beside her as she held court at the collections, chatting away to him but never missing a beat, be it a button or a seam. "She would give me tutorials on all the numbers," Dick explained, "not to mention the lowdown on everybody in the room—which French princess had been a sex trafficker in Fez, and so on. She opened the door for me to the beau monde, the enchanted world that I had read about in magazines, growing up—and she gave me the confidence to try and get a sense of that into my photographs. When she died, in 1961, and I was asked by the press to sum up her contribution to fashion, I told them without hesitation that she was the *only* editor, *ever*, that the rest of them were just business departments with legs on them. The *Bazaar's* tribute stated that she 'kindled the gifted toward excellence,' and that was certainly true in spades in my case."

For two decades, the *Bazaar* was Dick's editorial showcase (and from it, all things commercial flowed). Not a single issue of the magazine went to press without a photograph by Avedon, whether a fashion image or a portrait (starting with debutantes, he had quickly branched out into actors, dancers, writers, and world figures). In many issues, a third or more of the photographs would be Avedons, and for his swansong issue, April 1965, Dick took every single picture.

Over the years there had been the odd—in some cases truly odd—setback. For example, his great portraits of Charlie Chaplin, Marilyn Monroe and Arthur Miller, and Coco Chanel in front of that incriminating Hitler poster were rejected (Dick felt for political reasons), and his Duke and Duchess of Windsor was brushed off by Brodovitch as just a "cheap tabloid-type snapshot—not even a photograph" (Diana

Vreeland might have had something to do with that: a great friend of the Windsors, she had set up the portrait, and been outraged by it on their behalf).

No matter—from the mid to late forties and into at least the early fifties Brodovitch created star-turn sequences with Dick's pictures, often startlingly cropped and bled to the edges: montages consisting of close-ups, long shots, multiple images, and vertiginous shifts of scale. Moreover, his use of simple typography and abundant white space set standards for clarity in print. Brodovitch was riding so high astride the graphic arts that his counterpart at *Vogue* and fellow White Russian, Alexander Liberman, felt compelled to knock him down a notch or two, writing off his pages as "very attractive but not very interesting . . .

DICK'S MENTOR, THE *BAZAAR*'S LEGENDARY ART DIRECTOR ALEXEY BRODOVITCH, LAYING OUT AN ISSUE ON THE FLOOR OF CARMEL SNOW'S OFFICE.

a waste of space"—he himself, Liberman declared, would rather put "twenty pictures on two pages than make two elegant pages." The difference between them was that Brodovitch regarded photographs as

prized objects, while to Liberman they were little more than expendable pieces of paper.

Brodovitch was receiving so many lucrative offers to jump ship that in 1949 Carmel Snow, determined not to lose him, gave him leave to design a new, albeit noncompetitive, journal called *Portfolio*. Its first issue included ten-page portfolios by both Avedon and Penn (*Portfolio* died on the vine, after a mere three issues, but is today universally considered a landmark of the graphic arts). That same year Dick prevailed upon Mrs. Snow to let him moonlight: he illuminated the masthead of *Theatre Arts* magazine for a limited time, as both staff photographer and editorial associate.

Dick never ceased to pay homage to the man who had taught him that the cropping and printing and presentation of the work was as important as the work itself and, finally, that there was no difference between a camera and a paintbrush. To the end of his days Dick photographed, cropped, and made layouts as if Brodovitch was looking over his shoulder. And Brodovitch, for his part, never stopped teaching. In the late forties, wanting to give his students a glimpse of "the real thing," he began holding his classes in Dick's Fifty-eighth Street studio. Though he had to put the Design Lab on hold when he was appointed visiting critic in design at Yale in the mid-fifties, he later reestablished it under the auspices of the American Institute of Graphic Arts. In its last, vestigial incarnation—a few brief months in 1966—it was held once again in Dick's studio.

By the summer of 1958 Brodovitch's alcoholism had taken such a toll on his work that Hearst had no choice but to let him go (the previous year Carmel Snow had been kicked upstairs, to the do-nothing post of chairman of the *Bazaar*'s editorial board). "Was it right that they fired him?" Polly Mellen muses. "Probably. By that time he wasn't even bothering to show up at the office. But Carmel's successor, Nancy White, made a terrible, terrible mistake when she picked Henry Wolf, a Viennese émigré who was the head of graphics at *Esquire*, to replace him. For me, Wolf was totally bogus. He had zero feeling for photography—Dick once described him as a mass murderer of photographers. And what a vulgarian! One time he was showing Mrs. Vreeland and me some pictures from a shoot that had just come in and he nudged me to

look at his foot, which he had stuck out, and there, hidden in his shoe-laces, was a mirror that he was directing underneath Mrs. Vreeland's skirt—and, I'm pretty sure, when I wasn't looking, underneath mine. Henry left after a couple of years to become art director of Huntington Hartford's dead-end magazine, *Show*."

"It is painful and cruel when a giant like Brodovitch is cast out—there isn't a man of our time that hasn't felt his influence," Irving Penn reflected at the time. Typically, while Penn was busy reflecting, Dick was acting. He convened a meeting at his studio of the most commercially successful former members of Brodovitch's multifarious workshops. The objective was twofold: to keep the master usefully occupied—i.e., off the bottle—and to find a way to disseminate and perpetuate his precepts. Among the ideas floated: the establishment of a university chair for Brodovitch (the money to be raised from ad agencies, magazines, pub-lishing houses, and corporate art departments); a book; a symposium; a documentary film; and a traveling exhibition. The sad consensus was that, given the shape he was in, it would be "suicidal" for Brodovitch to attempt to take on any of the above strenuous endeavors.

Dick alone went the distance and began contributing substantially to his support. He also visited Brodovitch faithfully at the sanatoriums to which, starting around 1960, he was successively committed for the treatment of acute alcoholism and depression (he would discharge himself from each of them prematurely, after a stay of just a few weeks or, in some cases, days). For Dick, the most heartbreaking thing was seeing Brodovitch confined in the last of these ghastly institutions, Manhattan State Hospital, formerly known as the Wards Island Inebri-ate and Lunatic Asylum. He came up with one of his little ideas—that it would be therapeutic for Brodovitch to photograph his fellow pa-tients, surreptitiously of course, and to that end he smuggled a small Minox in to him. Years later, Dick did say to me, seriously, "He really *had* to have been crazy in a way—I mean, to turn down my portrait of the Windsors."

In the late sixties, Brodovitch fell and broke the hip that had previ-ously been injured when he was hit by a Hearst truck outside the *Ba-zaar* offices on West Fifty-seventh Street. At that point, financially as well as physically and mentally depleted, he moved back to France.

Dick visited him there in early 1970, in Le Thor, the picturesque town in the Vaucluse in which he had taken refuge. And it was there that he made the haunting, brokenhearted, broken-bordered portrait of the man who had in effect made *him*: the only person I ever heard Dick say he "worshipped" (Diana Vreeland confirmed that Dick's reverence for Brodovitch knew no bounds.) "He was a broken man in every way," Dick recalled. "During the sitting he was on crutches, and his hands were shaking as he tried to hold on to his cigarette holder. I'll never forget the tenacity—and the elegance—with which he was clutching it. He had become someone out of Dostoevsky. He told me he was making plans to return to the U.S. and revive his Design Lab, but I had the desolating feeling I would never see him again. He died that next year." Brodovitch had once described his protégé as a "photographer of emotion," and indeed, Dick's feeling for his mentor imbued the portrait with something ineffable—something almost unbearably personal.

7

ALL HELL
BREAKING LOOSE

—

OR DICK, ONE OF THE GREAT PLEASURES OF PHOTOGRAPHING the 1947 collections had been his success in transforming Doe from the "mould of form" into the "glass of fashion." She was now a model in some demand. One night at a Broadway opening, she was approached by a ferociously elegant middle-aged woman who introduced herself as Irene Mayer Selznick, saying, "I couldn't take my eyes off you," and offering to arrange a screen test. The second daughter of MGM founder Louis B. Mayer, the first wife of *Gone with the Wind* producer David O. Selznick, and the producer in her own right of the then-current Broadway smash hit *A Streetcar Named Desire*, Irene was in a triply privileged position to open the gated door to stardom. In due course David Selznick signed Doe to a movie contract, but she put Hollywood on hold, having just accepted a part in the Broadway-bound Harold Clurman–directed drama *The Young and Fair.* Happily, she would be commended by the *New York Times'* Brooks Atkinson for "acting the unscrupulous despot very ably indeed" and described by critic Richard Watts as "vivid and exciting," and she would go on to win a Theatre World Award for one of the most promising debut performances of 1948.

The next year Doe appeared in the Broadway comedy *My Name Is*

Aquilon, with Jean-Pierre Aumont and Lilli Palmer; in a film noir called *Jigsaw*, with Franchot Tone; and in a live television broadcast of Paddy Chayefsky's adaptation of the classic Budd Schulberg novel *What Makes Sammy Run?* opposite José Ferrer. Doe had really arrived. But she would soon be leaving—the marriage.

As Dick's second muse was ascending, his first, his sister Louise, was declining. "At the time, she seemed to me like Laura in *The Glass Menagerie*," Dick told me. He said he had hoped that some sort of gainful employment could amount to her salvation, and that he pulled every string—and ribbon—to make it happen. He got her a job at the department store J. Thorpe, which didn't work out. Finally, the color retoucher on his fashion photographs agreed to give her a try. Louise not only took to the work, she turned out to be good at it. "She loved making my models flawless," Dick told me, "but it didn't last long—one day she retouched-out the nose on one of my *Bazaar* cover girls."

Now, again, Louise had nothing but time on her hands, and she was driving her mother mad. To get her out of the house Dick gave her a set of keys to his apartment. She would have the place virtually to herself: Doe was either appearing in something or out on go-sees and auditions, and Dick was invariably at the studio or on location. They would come home to find the apartment practically surgically scrubbed; their bed would have been remade with hospital corners, and whatever loose change had been lying around would be neatly stacked in columns. Doe found the arrangement increasingly unsettling and asked Dick to get the keys back. He promised her he would, then couldn't bring himself to do it.

A few days later, Anna got Dick out of a client meeting and told him to get right over to Eighty-sixth Street. He found Louise sitting in the furthest corner of her room staring into space. "I couldn't get her to make eye contact," he said. "I kept asking what was wrong. Finally I got it out of her. She had gone to our apartment the day before and Doe was home and there was someone with her. At that point she clammed up again, but then she began making lewd gestures, and I began to get the picture. My first impulse was to dismiss what she'd just 'told' me as the ravings of a lunatic. But I had to know for sure. So I made a little plan. I told Doe I was going on location, and then I went to a couple of

movies, and after a few hours I crept home. There were two bodies lying on our bed—Doe was on top. I screamed at them to get the fuck out. Doe looked like . . . well, to coin a phrase, a deer caught in the headlights. The guy ran out the door pulling on his pants. She grabbed her dress and threw some toiletries into a bag and ran after him. I heaved a bunch of her stuff out the window. And that was the sorry end to the fairy tale called Dick and Doe. I divorced her in '49."

Doe's fancy man was called Dan. Daniel Matthews. He was a nice-looking boy from Pasadena she'd met in summer stock. Reader, she married him. In 1951. By that time they were appearing together in the national touring production of the Mae West revival of *Diamond Lil.* Sometime later she put her career on hold in order to play the great American female role of the fifties—the perfect housewife. While she contentedly made dresses for herself and cooked three squares a day for Dan, he was busy going nowhere, doing cameos in a couple of episodes of some anthology television series.

Then in 1952 came the great climacteric: Dan was offered a part in a movie, and he and Doe headed for Hollywood. On a desolate stretch of Colorado highway, with Doe at the wheel and Dan in the death seat, the car skidded and flipped over. Dan was decapitated. Doe, horrifically, was trapped in the vehicle for several hours with the severed head. She emerged intact but with lifelong guilt. For a long time she slept in Dan's pajamas.

Dick told me that when he learned of the tragic accident he felt "avenged." He said, "It had the feeling of biblical justice. I thought it served them right. But after a while the angel of my better nature kicked in and I decided to send Doe a sympathy note. I didn't know how to start it, so I just wrote, 'Words fail.' And then the words came." (When it came to condolence notes, the two words that never failed Dick were "words fail.")

With the reconciling passage of time, Doe came to feel that she should pursue the Hollywood Dream, not only for herself but for Dan in absentia. Good old Irene Selznick introduced her to Charles Feldman, the driving force behind the 1951 film of *Streetcar.* He in turn introduced Doe to John Wayne, who had a production company at Warner studio. America's biggest box-office draw had director William

Wellman screen-test her for a pivotal role in the airline near-disaster movie *The High and the Mighty,* which the two of them were about to embark on.

DOE AVEDON WITH HER CO-STAR JOHN WAYNE.

Wayne plays a copilot who, after the engine flames out, has to take over for the pilot, who has gone to pieces. The hitch is, the copilot is a nervous wreck himself: there's a crash in his past that he inadvertently caused, in which his wife and young son perished. Though elements of the plot had to have disturbed Doe, she acquitted herself nobly in the role of the stew, and John Wayne signed her to a seven-year contract. Dick told me that he went to see the film by himself, in a theater around the corner from his then studio. He said he thought Doe looked hard and that he found her performance wooden: "What I enjoyed was she kept having to say the copilot's name all through the movie—his name, believe it or not, was Dan. *That* Dan made it, he landed the plane safely. Lucky for him, Doe wasn't at the controls." Dick let out a bitter laugh. Still, he said, he dropped her a note congratulating her on an "Oscar-worthy performance."

Doe next landed a part in the musical extravaganza *Deep in My Heart,* a biopic of the American composer Sigmund Romberg di-

rected by Stanley Donen of future *Funny Face* fame. José Ferrer played Romberg, and Doe played his second wife (Merle Oberon, a tough act to follow in the beauty department, played his first). Two years later, she appeared in a film noir called *The Boss*, and that was it: The End. In 1956 she married the director Don Siegel, whose film *Invasion of the Body Snatchers* had just been released and who would go on to even greater acclaim with *Dirty Harry*. Doe and Don adopted four kids and for almost twenty years reportedly enjoyed an attractive domestic happiness, until he left her for Clint Eastwood's secretary: The End again.

Doe had been thrilled to receive Dick's letter about her performance in *The High and the Mighty*, and one night she picked up the phone and called him. He found himself warming to the old familiar sound of her voice, and the next time he was in L.A. he called her—there was really no reason they couldn't be friends after a fashion. Another time when he was out West he had his young son with him and he asked Doe if he could bring the boy by. "John developed a terrific crush on her—for days he went around chanting, 'Doe Doe Doe,'" Dick told me, adding with a laugh, "He always wanted everything *I* had." Renata remembers that as "a dear story, but then Dick said to me, 'Isn't it interesting—the sexuality of children.' I didn't think that was an example of the sexuality of children at all. I would have said that it was the romanticism of children. Whatever."

At least a couple of times in the years ahead, Doe flew to New York expressly for an Avedon museum opening. On one of those occasions Dick introduced her to the woman who had succeeded her, if not in his affections, at least as his wife. Doe took him aside to gush, "Oh Dick, she's utterly beautiful!" To which he said he replied, instantly regretting it, "People have said so."

Doe died in 2011, at the age of eighty-six, having held on to the Avedon name. The hall leading to her bedroom, her daughter Anney Siegel-Wamsat told me, boasted four of Dick's photographs of her. Foremost among them was the celebrated picture in which she's wearing a fur hat and fur-trimmed coat by Dior at the Gare du Nord—taken in the hot and heavy summer of 1947. Most of the lengthy obit of Doe in *The New York Times* was devoted to Dick. It can fairly be said that,

given the brevity of their married life, they each occupied a dispropor-
tionate space in the other's mythology. A little had gone a long way.

DICK'S SECOND MARRIAGE WOULD be longer-lived: the defini-
tion of wed-lock. It began, as the lyric goes, across a crowded room.
One night in 1950, the photographer Milton Greene was having one
of his Friday-night open houses in his penthouse studio, in the old
Grand Central Palace Building on Lexington Avenue. The room was
packed with art directors, admen, models, photographers, actors, and
dancers. Dick introduced himself to a fragile-looking blonde with
almond-shaped eyes who was standing alone against a wall of the
loggia—a wallflower. He broke the ice with, "How do you know Mil-
ton?" She said, "I was married to him," and she filled Dick in: They
were high-school sweethearts who had tied the knot in 1942 when she,
Evelyn Franklin, was only eighteen. Dick asked, "Any children?" She
answered, "One. Bobo." He asked, "Girl or boy?" She said, "Boy."
"How old?" "Two or three." Dick said, "He must be talking by now."
She said, "Sort of." Bobo turned out to be the springer spaniel that she
had bought from a couple named Storm who lived across the road
from her and Milton in Weston, Connecticut. He was destined to be
the first unborrowed dog in Dick's life (but far from the last: there were
to be three more springers, a beagle, and a miniature poodle, all of
which Dick felt free to totally ignore).

Dick said he was instantly taken by Evie's feyness and elusiveness.
And that he liked the simple, chic way she was dressed: navy-blue silk
skirt, white silk blouse, and navy bolero. He invited her to dinner that
night at the Oyster Bar in Grand Central Terminal. From there the
relationship took off like a choo-choo train, and the couple got hitched
at the end of January 1951.

Milton Greene had meanwhile taken up with a cute Cuban-born
model whom Dick had "discovered," Edilia Franco (Conover, the
modeling agency he sent her to, changed her first name to Amy and
her last to—in a nod to Dick—Richards). In the spring of 1952, the
year before he married Amy, Milton invited Dick and Evie to Sunday
lunch in the country. "I wasn't feeling so hot," Amy recalls. "I told Mil-
ton I wasn't up to coming down. 'Listen,' he said, 'I went through this

CECIL BEATON CAPTURED DICK AND HIS SECOND WIFE,
EVELYN, ARRIVING AT HIS COUNTRY HOUSE IN WILTSHIRE,
ENGLAND, COMPLETE WITH "BORROWED DOG," 1955.

shit for seven years with Evelyn, and I'm not going to put up with it
from you. So get the hell out of bed, put something decent on, and
make an effort!' He told me that one of the reasons he divorced Evelyn
was she would stay in bed for days on end. He said, 'I saw the writing
on the wall.'

"When Dick was in Hollywood for three months in 1956 consulting
for Paramount on *Funny Face*, Milton was there producing *Bus Stop*
for 20th with Marilyn, and Evelyn and I met for lunch," Amy recalls.
"She and Dick were renting Marilyn and Joe DiMaggio's old 'honey-
moon house' on North Palm Drive in Beverly Hills, and she com-
plained that the tour buses would drive by several times a day and the

guide would make a big thing over the megaphone about the master bedroom—she said it was sexually inhibiting. The minute Evie discovered that I detested Milton's mother as much as she did, she started giggling, and we became sort of friends. I remember her grousing that all Dick ever did was work. So I guess there wasn't much reason for her to *get* out of bed."

During the second year of their marriage, Evie presented Dick with a real son, John—no Bobo. "I'm going to be the most loving father," Dick vowed. "I'm never going to make him feel he's failed me—I'll value him for whoever he turns out to be, and support him in anything he wants to do." (Dick would live to regret that last promise; at the age of ten, John told him, "I deserve more than this," and it just went on from there.) Evie swore to Dick that she would be a storybook mother. But then, slowly but surely, overwhelmed by the pressures of motherhood—she told Dick she felt she lacked the maternal instinct—she retreated further into herself, and her bed. ("John always said his mother just didn't know how to nurture," his second wife, Maura Moynihan, offers. "I remember when she came over to visit—our son, Michael, was three or four weeks old, the war in Kuwait had just started, so it was very chaotic, and John's two vicious, dreadful, horrible mutts from his first marriage were barking, and the doorbell was ringing. I said, 'Oh, Evie, can you hold Michael for a minute while I go get the door?' I put him in her hands and she literally dropped him on the floor—she just didn't know how to hold a baby.")

Semiannually, in the early years, Evie would accompany Dick to the collections, sitting in the *Bazaar* studio in Paris all day while he was shooting, not saying a word that anyone can remember. She was always up for shopping: shoes, hats, cosmetics, and, mostly, designer fabrics, because when it came to the decoration of the Avedon houses, Evie called the shots—there were decades when she wouldn't have a photograph on the wall, including and especially any of Dick's.

"Evie was camera-shy," Dick told me. "She didn't want me photographing her, though I did manage to a few times and I got one great one. I caught her at a particularly vulnerable moment, the same as I would hope to do with anybody. She had this paranoid expression in her eyes and a pinched quality around the mouth, but she was also

ALEN MACWEENEY

making the most delicate gesture with her hands, and that was the
wonderful paradox. I put that picture in both my Marlborough and
Berkeley shows and not a peep out of her, but when I reproduced it in
one of my books she hit the roof—she went around telling people it
was the cruelest thing anybody had ever done to her." The critics have
always been kind to that particular image: one of them saw, in what he
described as Evie's "captured hesitation," no less than "Balzac's ex-
pressed fear of photography—that awful truthfulness," and another was
put in mind of the "guarded tenderness" in Nadar's mid-1850s portrait
of his eighteen-year-old wife, Ernestine, which Dick happened to own
a print of.

Five years into his marriage to Evie, a movie inspired by Dick's mar-
riage to Doe, conceived and written (first as an ill-starred play) by their
old friend Leonard Gershe, lit up screens across the country. Dick had
been in Jamaica when he received the telegram from the producer so-

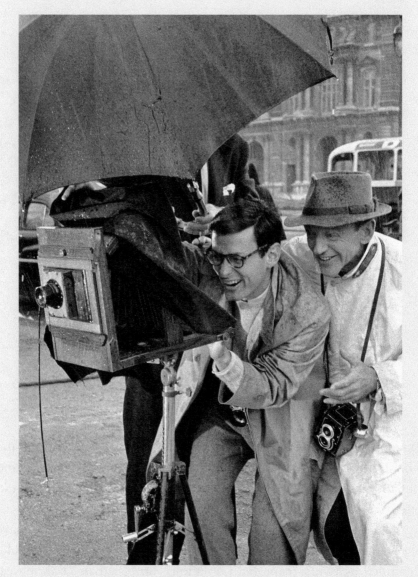

DICK "TEACHING FRED ASTAIRE HOW TO BE ME, AFTER WANTING TO BE HIM ALL MY LIFE." ON THE PARIS SET OF *FUNNY FACE*, 1956.

liciting his help. "Marlene Dietrich had had my horoscope done for me as a gift and it said my life would be changed by a telegram I received on a Caribbean island," Dick marveled. "*Funny Face*, by the way, wasn't really about *me*. They just used my early fashion escapades as a pretext

to make a glamorous musical extravaganza, but it was certainly an exciting thing for me, and good for business." Amazingly, Dick's boyhood idol, Fred Astaire, now an old boy of fifty-seven, played the twenty-five-year-old lead, named Dick; Audrey Hepburn played Doe, renamed Jo; Kay Thompson played a cartoon-strip Diana Vreeland (think "Think Pink!"). "Brodovitch" got truncated to "Dovitch"; and *Harper's Bazaar* was changed to *Quality* magazine. Dick leaned on director Stanley Donen, whose films by then included such classics as *On the Town, Seven Brides for Seven Brothers,* and *Singin' in the Rain,* to use Suzy Parker, as well as Sunny Harnett and Dovima, as a model in some of the fashion sequences, which led to Suzy's movie career.

Although Dick's official credit was "special visual consultant" (union policy dictated that he could only be hired to advise), Paramount wound up getting a lot more from him than they had bargained for. For his ten thousand dollars he furnished invaluable tips on light-

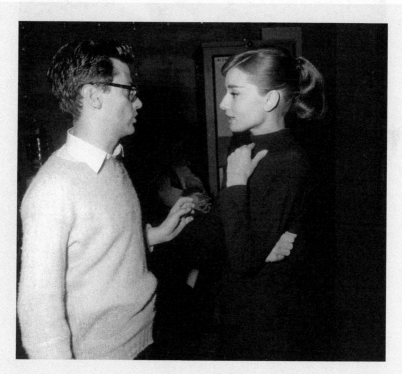

DICK AND AUDREY HEPBURN DURING *FUNNY FACE* TIME.

ing and on Audrey Hepburn's all-Givenchy wardrobe; he created the title credits and backgrounds plus a dazzling montage of freeze-framed fashion stills, which I've always thought would make a wonderful little Avedon show of their own; and he divulged some of his methods of working with models, for Stanley to translate into stylish sequences set to music.

"Dick told me that he wanted everything done his way and that Paramount wouldn't stand for it, their cameraman was going crazy, so

DICK AND AUDREY, 1989.

they gave him something toxic to eat in the editing room—he suspected poison, but maybe they only slipped him a mickey," fashion designer Isaac Mizrahi offers. "Anyway, the idea was to just get rid of him for three or four days so they could finish up. His enjoyment of the project was diluted. He said it ended up tasting like wine that had been watered down, but that the greatest gift, aside from getting to work with Fred, was working with Audrey. And by the way, I got to work with both Audrey and Dick. I made a black satin coat for her when Dick was shooting her for Revlon's 'Most Unforgettable Women in the World' campaign. That day he came to work in a suit and tie—every other time I had seen him in the studio he had just been in jeans—though he did put the jacket in the closet."

Dick could never get over having been played in a movie by Fred Astaire, and he couldn't get enough of watching him work—the seemingly effortless exactitude of every movement. He said he had to give himself daily reality checks. He would tell everyone, "I learned how to be me by pretending to be him and then I had to teach him how to pretend to be me." After Dick succeeded in showing Fred how to hold a Rollei properly, Fred turned around and showed *him* how he did the dance step with the umbrella, swinging it to and fro, bouncing it around. At the end of the filming he told Dick that his fashion pictures had always given him a lift, but when Dick returned the compliment, declaring that Fred had in fact been the wind at his back, Fred looked blank. An even greater disappointment for Dick was discovering that Fred indulged himself in the brothels of Paris during shooting. "I wondered if he really made love with his feet," Dick quipped to me. After the movie wrapped, Fred sent Dick a pair of suede moccasins from Bally on the Champs-Élysées, which turned out to be too big for him—Dick displayed them on his mantel as an art object.

The day Fred Astaire made the leap into death, some thirty years after *Funny Face*, Dick appeared in the doorway to my office with tears running down his cheeks. "I didn't cry when Marilyn died, I didn't cry when my father died, and I didn't cry when Brodovitch died," he told me. The next morning he had me order from Charvet, his elegant haberdasher on the Place Vendôme (he pronounced their shirts "pro-

found"), a number of made-to-measure heavy-silk evening shirts with the legend "Astaire Lives" embroidered in navy blue where the pocket would otherwise have been. All that week he watched the tapes of all of Astaire's old movies over and over again.

Funny Face made Dick an even bigger star. With its release in 1957 he was, if not on Mount Olympus, at least up on the ninetieth floor. But Evie was down in the dumps: she was inured to everyone always talking about Dick, but now they were talking about Doe as well. When Dick invited Fred and Audrey to dinner at home, they treated Evie warmly—Audrey even clowned around for her, donning Fred's trench coat and fedora (an ensemble that Dick later photographed her in). In return, Evie gave them the cold shoulder.

To make domestic matters worse, Dick was the subject of a long, fulsome *New Yorker* profile that November (his sole objection: being described in passing as an "aspirant to artistic prestige"). Now he was riding even higher, while Evie was lying even lower. Few were the occasions she bothered to rise to. Truman Capote's visits always got her up. He would sashay in around dusk, and Evie would run to make him a martini, then curl up on the couch beside him. They would hold hands, sip their drinks, and talk books (Truman had dubbed Evie the "human library" upon discovering that she was even more widely and deeply read than he)—until Dick dragged Truman away to discuss *their* book.

DICK AND TRUMAN HAD originally met through the fiction editor of the *Bazaar*, Mary Louise Aswell. It was 1948, and Truman had just published *Other Voices, Other Rooms*, which, thanks in no small measure to Harold Halma's homosexually provocative photograph of him on the back jacket, catapulted him to early literary stardom. He and Dick had two improbable things in common: they had both been passionate about tap-dancing as kids, and neither of them had bothered to graduate from high school. Dick was highly impressed by the guest list at a party the twenty-three-year-old Truman threw at his mother's Park Avenue apartment. "Every person there was a celebrity," he told me. "From W. H. Auden to Bea Lillie, whose autograph I had once gotten . . . It was like a preview of his Black and White Ball." Truman, for his part, was impressed with Dick's skills, writing a friend that Dick had

taken "a startling and fantastic photograph of Virgil [Thomson], Cecil [Beaton], and me. Virgil and I look like two little owls, and Cecil in a black bowler hat is leaning above us like a terribly hungry hawk."

A decade later Truman leapt at Dick's invitation to collaborate on a book project. He sent his text to Dick in stages, written in his fussy little hand on yellow legal pads and always accompanied by a note that endearingly began "Beloved collaborator." Dick was dazzled by Truman's lapidary descriptions of his portraits. For example, J. Robert Oppenheimer—"so choir-faced, boyishly holy . . . he gave us the atomic bomb"; Mae West—"that Big Ben of hour-glass figures, that convict's dream . . . sexless symbol of uninhibited sexuality"; Marilyn Monroe—"a waif-figure of saucy pathos . . . an untidy divinity—in the sense that a banana split or cherry jubilee is untidy but divine"; Jacques-Yves Cousteau—"a salt-seared merman with a hammerhead's grin and the undulating lankiness of an octopus." Though Truman's contributions would be billed as "comments," they added up to a composite portrait of their own and succeeded in making *Observations* as much a book with pictures as a picture book with text. (The title was Dick's, though Truman persisted in telling people it was his—it had been the name of Dick's poetry column in the DeWitt Clinton *Magpie*.)

Ironically it was Truman, the nonpareil chronicler of society beauties, who persuaded Dick to give them short shrift in *Observations*. "You have a lamentation of swans here," he pointed out, adding, "That's a correct description for a bevy of those birds." Together they pared them down to a precious few: Baroness Fiona Thyssen, Vicomtesse Jacqueline de Ribes, an entitled-looking Gloria Vanderbilt, Dolores Guinness, Marella Agnelli (whom Truman rated "the European swan numero uno"), and the "superb, unsurpassable Mrs. William S. Paley" (of whom he had wittily written elsewhere that she "had only one fault—she was perfect; otherwise, she was perfect"; Dick was no less wild about her, declaring that she made him feel he was in the presence of a work of art, a "fait accompli," but at the same time confessing that, photographing her, he had been so obsessed by her cheekbones he had never been able to penetrate beyond them).

The critical reception for *Observations* was mixed. *Newsweek* dismissed the book as a "bright bauble," but lauded Truman for "devising

images even more striking than any" of Avedon's. *Time*, on the other hand, chastised him for writing "in a style that combines the worst features of Henry James, Dorothy Kilgallen, and deb talk." The magazine went on to berate the book as "a sort of peeping tome," given that "the camera marks the most important advance in the technology of eavesdropping since the invention of the keyhole" and that "the prying eye can now record what it sees, and gossip has become a visual as well as a verbal art." Richard Avedon, in *Time's* eyes, was nothing more than "a determined celebrity chaser, and with *Observations* he establishes himself as an accomplished face-dropper." A face-saving review appeared in *The New York Times*, which deemed Dick's photographs "superb" and Truman's prose "sharp and rich—a bundle of needles in *pate de foie gras.*" And the London *Times Literary Supplement* summed the book up as "beautiful . . . eloquent of one man's use of his eyes and of another's use of his sensibility," while the London *Observer* proclaimed it "the photography book of the decade."

Brodovitch had designed *Observations*, which not surprisingly set a new standard for excellence in graphics. Truman had taken care to include an effervescent tribute to him in the text: "What Dom Perignon was to champagne, Mendel to genetics, so this over-keyed and quietly chaotic but always kindly mannered Russian-born American has been to the art of photographic design and editorial lay-out, a profession to which he brings boldness bordering on revolution." In short order, *Observations* became one of the first bestselling photography books.

Evie didn't take the success of the book lying down. "She was up in arms," Dick told me. "She became the poster wife for non-supportive— non-supportive, mind you, of the person who was supporting *her!*" By the early sixties, she was barely able to keep her unhappiness in-house. "She began taking it out on me in public, on the few occasions we went out together," Dick said. "She would wear a Mainbocher with a babushka and look like a street urchin, and she was popping every pill she could get her hands on, uppers, downers—in those days we called them the stop-and-go pills. Evie and I had his and hers medicine chests— I had to be 'up' all the time for my work, I couldn't *afford* to sag. Diana was giving her some of her 'pony pills,' the ones they gave racehorses to

make them go faster—she had a supplier at the track. At some point Evie stopped taking them, or they stopped working, and then she couldn't even hold a conversation. Anyway, the last thing she was interested in was how *my* day had gone. I gradually figured out what was up with the silent treatment—she was pulling a Louise on me."

ONE FRIGID JANUARY DICK announced to Evie, "I'm taking you to Jamaica for your birthday." Not only was it her favorite Caribbean island, it ranked high on Dick's roster of lucrative accounts. His first ad for its tourist board—"Come to Jamaica—it's no place like home"— had starred Noël Coward. Dick photographed him with the Deardorff one particularly fine morning: Coward standing on a rock in the sea in front of his bungalow at Port Maria, in crisp white ducks and a red blazer with gold buttons. "Deep down—to the marrow of his bones—he was shallow," Dick told me, "but surface never got any more perfect than that." Other stars of Dick's acclaimed Jamaica ads included his friend Leonard Bernstein, in a sugarcane field (in a switch, Dick shot him being conducted *to*—by the director of the Jamaica Military Band); Mary Martin, astride a donkey by the sea; and Joan Crawford, on top of a mountain, in white shorts, emeralds, and a big Mr. John hat, arm in arm with her husband, Pepsi-Cola CEO Alfred Steele (when he died suddenly a month later, she lobbied Dick to retouch him out, but Dick insisted on reshooting her, alone).

The Avedons' destination was the fashionable Round Hill resort in Montego Bay. On previous visits they had either been the guests of Babe Paley and her husband Bill, the chairman of CBS, at their cottage, or rented a cottage with the Bernstein family. This time Dick had rented one just for the Avedons, and he had made sure that two of Evie's favorite people would be on hand: he had invited their spanking new friend, Mike Nichols, to stay with them, while their old friend Truman was staying with the Paleys.

"The single biggest thing Dick and Evie and I ever disagreed on was Truman Capote," Mike told me. "I thought he was a vile, evil little twit, a really nasty piece of work, with that squeaky voice of his—the way he lisped *pouilly fuissé*—but I was forced to put up with him because he was part of the big Round Hill deal in which Dick was going to start

teaching me all about the good life, because remember, I was a young asshole, I didn't know anything, I wasn't from here, I had come from another place—I was an escapee from Nazi Germany, for Chrissake. Dick was instructing me on the right things to eat, such as caviar, and *how* to eat, and how to order in a restaurant, and how to travel, and where to travel, and how to dress. And how to get comfortable with people, which was a big thing—he said to me, 'Just ask them about themselves and they don't stop talking.' On that visit I had my first truly tropical drink, and my first-ever immersion in an infinity pool. And I guess by asking him about himself I got to be friendly with John Pringle, the wonderful, hilarious friend of Dick's who had founded Round Hill and who went around all day with his balls hanging out of his bathing suit and didn't even know it, he was so Britishly oblivious."

Evie's birthday fell on January 16, and Dick, having discerned—the Paleys and Bernsteins aside—Dorothy and Oscar Hammerstein, Jennifer Jones and David Selznick, Kitty Carlisle and Moss Hart, Phyllis and Bennett Cerf, and Fred Astaire's sister, Adele, realized he had on hand the ready-made ingredients for an A-plus-list surprise party. Having promised Evie that her birthday dinner would be a moonlit picnic *à deux* in a bamboo grove upriver, he then went ahead and organized what would amount to a bash, complete with a band from Kingston, a menu consisting of Senegalese soup, rock lobster *à l'américaine*, and curried goat, and a spectacular native bonfire.

On the big night, Dick steered Evie into the well-appointed hotel canoe, both of them in evening clothes. As they rounded a bend of the Great River, the glow from the bonfire illuminated the scene. The strains of "Happy Birthday" gave the plot away, and gave Evie the opening she always craved to tell Dick she hated him. Then she put on her party face. Within minutes it had turned into a scowl. Felicia Bernstein later said to Dick, rolling her eyes, "This was a pretty dopey idea, Dickie," after which she would often address him, affectionately, as Dopey Dickie.

"It was my mother more than my father who was Dick's really close friend," recalls the Bernsteins' older daughter, Jamie. "For a long time my father and Dick got on famously—they were both ridiculously

handsome and they had the same kind of electric-Jew energy—but then as they each got more and more famous they seemed to have less patience with each other. After my mother died, in 1978, Dick and Mike Nichols, who was also a better friend of my mother's than my father's, started something called the Felicia Appreciation Society, which consisted of their taking my brother and sister and me, plus their and our great friend Cynthia O'Neal, to dinner from time to time at some fabulous restaurant like Babbo or Craft so we could all talk about my mother together because we felt her absence so keenly."

"In Jamaica, Felicia looked out for Evie," Dick told me. "They both had this fragile kind of beauty—they wouldn't dream of setting foot in the sun without their Erno Laszlo oil, very expensive stuff. And Truman kept an eye on Evie, too." At the party he came running up to Dick to report that Bill Paley was "all over Evie" and that Babe, "a vision in Mainbocher," had seen him "rubbing Evie's ass" and was now convinced that they had been having an affair. Truman said that he had told her, "Don't be silly—she's not his type," and that Babe had mordantly replied, "What do you mean? They're *all* his type."

Half an hour and several rum punches later, Babe could be seen staggering toward the bonfire, which had reached its zenith—the sparks were flying, and the pyre was spasmodically exploding in gunfire-like blasts. Lit in both senses of the word, she turned and stretched out her arms to Dick, shouting, "Look at me! Look at me! Take my picture, Dick! I'm Joan of Arc!" Truman came up behind her, put his arm around her waist, and declared archly, "If you're Joan of Arc, I'm your stake."

Now, *The Passion of Joan of Arc* happened to be one of Dick's favorite films: a late-1920s silent masterpiece by the Danish director Carl Dreyer, whom he had photographed in 1958. Dick had arranged for the Museum of Modern Art to screen its impeccable print for the studio. No matter how many times he had seen it, he was transfixed anew by the extreme close-ups of the lead actress, reflecting her agony and then the ecstasy of her transcendence.

Mike remembered the incendiary event—Babe Paley's, not Joan of Arc's, trial by fire—with an alarming difference. "She tried to jump

right onto that bonfire and had to be restrained," he insisted. "Her husband had been pinching every ass at the party except hers. And the more asses he pinched, the more she laughed, hysterically. She looked absolutely gorgeous, it goes without saying—not a hair out of place. She somehow gave the impression of having changed her clothes several times during the course of that evening. And how about her Joan of Arc line! You couldn't make a script like that up. That scene has real staying power for me—as a matter of fact I considered making a movie out of it."

While Mike had seen the makings of a movie in Babe's injunction to Dick, Dick had had a flashback to a scene in a movie that had already famously been made: the moment in *Funny Face* when the ugly duckling becomes a beautiful swan. From behind the Winged Victory of Samothrace in the Louvre, Audrey Hepburn steps out in her strapless, flaming-red organdy Givenchy gown and swirling silk wrap, poised to fly down the Daru staircase to the waiting Astaire, exclaiming, her white-gloved arms stretched high above her head, "Take the picture! Take the picture!"

Bill Paley maneuvered Babe into the hotel canoe, and Truman and Dick, standing together by the angry flames, were left to reflect on her seemingly enviable life, which they agreed was in reality a kind of willed martyrdom to what Dick described as the "anxiety of being a great public beauty, given the ultimate failure of that beauty." Truman then recited Rilke to him: "Beauty's nothing but the start of terror we can hardly bear." Neither of them at that moment could possibly have imagined that a salacious expanded anecdote in the "nonfiction" fragment "La Côte Basque" that Truman would recklessly publish in *Esquire* in 1975 would cost him his relationship with Babe, and that she would be calling Dick to say, her voice breaking, "Promise me you'll never see that awful little man again."

Evie had long since disappeared by this point. She had left her own party—and her son, in the care of a minder—well before the cake came out. "She did it to humiliate me in front of the most distinguished people of our time," Dick complained to Truman, who replied, "Well, Dickaboo, what did you expect? When you expose a shrinking violet to

ultraviolet light, you get exactly what you deserve—a short circuit." Back in New York, Dick spent all of a dearly-paid-for forty-five-minute hour unloading to his analyst about Evie's ingratitude, at the end of which, Dick told me, the wise man explained that Evie secretly enjoyed playing the victim of Dick's celebrity and in fact used it as an excuse to justify her chronic bad behavior.

"I don't buy that theory," Mike reflected. "The thing about Evie was she always told the truth. For instance, she could see a piece of theater that everyone loved and see right away—and explain why—it was a piece of shit. She could also see through people, and be quite blunt about what she saw in there. There was a very particular moment when I found that I truly loved her, and one would have thought the exact opposite. A few months after Round Hill, they took me to Venice with them. And after Venice they introduced me to the mosaics in Ravenna, which is where I first learned to see, and I went back there later on my own, on my next honeymoon.

"In Venice I was still very much the Avedons' student, learning how you do all this social shit. We were staying at the Gritti, and one night they took me with them to dinner at some palazzo on the Grand Canal—I think the Brandolinis', the Brandolini d'Addas', in Dorsoduro—where there were fucking Giottos on the wall and a footman behind every chair and I was put next to Nancy Mitford, who didn't say a word, only made unintelligible British sounds—just sort of little moans—and after dinner the women retired and the men were on the balcony with their cigars. It turned out they did all know who I was—I was news on the Rialto.

"On our way back to the hotel I said to Dick and Evie, 'Well, *you* two may like this stuff, but I can't stand these counts and princesses, it's too much for me,' to which Evie replied, 'You're so full of shit, Mike— you love it, admit it. *I'm* the one who loathes it—having to talk to those people, having to smile at them. I only went because I wanted to see what they had on their walls.' And of course she was right—I did love it, *all* of it, I ate it all up. The irony is, the day would come when Dick would tell me that I had far surpassed my teacher in the art of living well and that he wasn't comfortable in *my* world anymore, that it was

all big-name and big-money people. He attacked me—affectionately—for collecting horses and Morandis and for not decorating my places spontaneously enough. And now I'm remembering the time he came up to Connecticut, unsuccessfully. To visit me and my third wife, Annabel, to whom I was not yet married, although we had one or two children by then. We were going to take him to a lunch party at Slim Keith's and then to Rose and Bill Styron's for dinner and he said we should go without him to both, and when we got home from lunch he was gone—he had taken himself back to New York. And much later on he visited me and Diane Sawyer at Chip Chop, our house on the Vineyard, and we had Steve Martin staying, and that was too much for him—he left without saying a word. He was a leaver—of the country, clearly. After that, he told me that he preferred for us to meet one-on-one.

"But back to when Evie called my bluff, because that's when I decided she was somebody to love and I developed a serious crush on her. She was beautiful in a way all her own, you know—delicate and stylish—and she had this great laugh. She was highly desirable, and, believe me, I was tempted—I was between girls at the time. But what could I do about her? I was already by then Dick's best non-strategic friend. I didn't know at the time that she was getting around. She told me later that she had slept with the psychoanalyst David Rubinfine—this was *before* he married Elaine May, who was one of his patients.

"It was when I was with Evie in Venice that I saw, with the insight of hindsight," Mike went on, "that that surprise birthday party in Jamaica must have been even more painful for her than I'd realized, and after she became seriously troubled I began thinking of her as Scott Fitzgerald's Nicole Diver. One of my favorite keepsakes is a snapshot Dick gave me that he'd taken of Evie going to bed, which more and more tended to be around seven o'clock. As we all know, she lived by Laszlo, and in the snap she was in whiteface, and in her beautiful white bathrobe. But here's the thing that really got me: in one hand she had Proust and in the other an apple. It reminded me of that line from *Miss Lonelyhearts*. I had done a reading for a theatrical adaptation of the novel when I was an undergraduate at the University of Chicago. I

played the cynical newspaper editor Shrike—he was a prick, and I was always good at playing pricks—and I had to say to my Miss Lonely-hearts columnist, who by the way was a man, 'You do not neglect the pleasures of the mind . . . you often spend an evening beside a roaring fire with Proust and an apple.'"

ONE NIGHT, EVIE WAS reading *Zelda* in bed and she put the biography down and said to Dick, "Do you think I'm going to become like her?" When Dick replied of course not, Evie said, "How do *you* know? Are you F. Scott?" "That was the night she told me she had been fantasizing about leaving me," Dick told me. "I decided to call her bluff. I said, 'Okay, let's give it a try,' and she said, 'There are men around who have given *me* a try.' She dropped the name Goddard Lieberson. He worked for Paley, he was the head of CBS Records—and married to one of the Balanchine wives, Vera Zorina. Evie said she had also slept with a couple of her shrinks. Who knows if any of it was true, but if it was, I was happy for her. And for myself—I mean, it let me off the hook."

Home had become next to impossible for Dick. Evie had taken to embarrassing him in front of their close friends, all of whom, Dick maintained, she disliked equally. One winter night in 1970 the Bernsteins were coming to dinner. Dick got home early and was pleased to find Evie fussing with the food—for the first course she had made one of her specialties, a hearty dish she called "prison soup," which consisted of potatoes, carrots, flanken, and the kitchen sink. As she was still in her nightgown, he innocently inquired, "What are you wearing tonight?" When she answered, "I'm dressed," he told her to go and *get* dressed. She ran upstairs, and half an hour later appeared in a housecoat hanging open over the nightgown, and with her hair uncombed and no makeup. Dick turned to Lenny and said, in front of Evie, "You see how my wife hates me. She blames me for the emptiness of her life and the fullness of mine." Evie was meanwhile saying to Felicia, "Dick dressed me tonight especially for you." Felicia looked away in distress, and Lenny quickly embarked on a riff about dinner the night before at Lillian Hellman's. Dick desperately chimed in, "I just photographed

her for a book jacket, the way I knew she wanted me to make her look, which was not the way I saw her—the hag." Lenny called Dick the next day: "What should we do about Evie?" Dick assured him that he was doing everything that could be done, that he was "paying for the works."

Evie at the time was primarily a patient of Dr. Lothar B. Kalinowsky, a psychiatrist who was a pioneer in electroconvulsive therapy, better known as electroshock treatment, or EST, for short. Dick found "Doctor K" both compassionate and helpful and, perhaps crossing an ethical boundary or two, made a portrait of him in 1970, which he included in his 2002 retrospective at the Metropolitan Museum (Dick's Doctor K put one critic in mind of a "Mannerist mortician").

"Around this time Evie became convinced that Dick was having an affair with Lee Radziwill," Renata Adler recalls. "I was certain that the only thing Dick had ever done with her was photograph her for *Bazaar*—as 'The Sphinx Within.' Then one day I saw her picture on the front page of *Women's Wear Daily* with Peter Beard, and then it was in all the gossip columns that *they* were the ones having the affair. So I thought, What kind of friend am I if I don't bring this to Evie's attention? So I brought her the clippings to comfort her, to relieve her of her pain, and she turned on me, and that's when I realized that what you cannot do is contradict a crazy person who has a fixed notion in their head. In her mind I became the enemy, part of a conspiracy to conceal from her the fact that her husband was indeed having an affair with Lee Radziwill.

"Then a week later she called and said, 'Will you come with me to my shock treatment today?' I said, 'With pleasure!' But then she called right back to say she would rather I met her at home after it. By the time I got to the house, she was already in bed. She was leafing through her diary, and she said, 'What's all this stuff I've written here about Dick and Lee Radziwill? I must have been *crazy*.' She kept repeating 'I must have been *crazy*.' So I thought, Here's Evie back again—she's sane enough to realize that she has in fact been crazy. From which I concluded that the shock treatment she'd just had must have really worked. Dick claimed that the treatments made Evie 'much more livable,' which was a bit of a joke, considering that he was about to leave her."

Dick, as he always put it, "ran away from home," to "live over the store." He moved into monastic quarters—a nine-foot-square room on the second floor of the twenty-five-foot-wide four-story brick carriage house on East Seventy-fifth Street between First and York avenues that he had purchased. The room contained only a platform bed built by his studio manager, a couple of telephones, and a couple of suitcases with his clothes spilling out. "I've never been happier," he proclaimed to visitors. "I'm free—free of the wear and tear of living with another person. I'm better at photography than marriage, and from now on I'm going to be married only to my work." (For all that, he never untied the knot with Evie: man and wife they remained till death did them part.) He sold the handsome five-story house at 5 Riverview Terrace, an enclave off Sutton Place, to which they had moved from 625 Park in 1964 (when Marvin Israel had once famously asked Dick, "How can an artist live on Park Avenue?" Dick had famously replied, "Very easily!"), and bought Evie a light-filled apartment on United Nations Plaza with a similar river view and continued to foot every bill. And for the rest of their lives, he saw her ritually once a week or so when he was in town, usually for Sunday dinner and a movie.

Mike Nichols, who remained devoted to Evie to the end, reminded me one day that she had had a damaged brother to whom she'd been particularly close in childhood. He suggested that this might even have been the key to her condition. "It seemed to me, as she just kept getting stranger and stranger over the years, that the past with that brother, whatever it was *exactly*, came and got her," he said, adding, as if it had only just occurred to him, "Isn't it fascinating that Dick and Evie both had those sicko siblings?"

DURING THE FIRST YEAR of Dick and Evie's marriage, Louise's condition had gone from bad to worse. She would sometimes refuse to eat on her own, and Anna would be reduced to spoon-feeding her. And occasionally she would remain mute for a week at a time. "My mother said about Louise from the day she was born that with eyes and skin like hers she would never have to open her mouth, and now look!" Dick lamented. Anna was just going to have to face the fact that her daughter needed to be put away for her own good.

Dick had his assistants do the research, then personally vetted a handful of institutions. In the end he and his mother settled on Rockland State Psychiatric Hospital, which was less than an hour's drive from Manhattan and specialized in electroshock treatment and lobotomization. "The setting couldn't have been more restorative—hundreds of bucolic acres," Dick told me. "And the ratio of doctors and nurses to patients was mind-boggling—a staff of two thousand for around ten thousand. I was aware that the place had been trashed as a hellhole, a dumping ground for nutcases, but that was all on account of a novel called *The Snake Pit* that was written by a former inmate—it got made into a harrowing movie and Olivia de Havilland got a best-actress Academy Award for it. Believe me, the Rockland State *I* knew couldn't have been more impressive."

Indeed: it was a completely self-sustaining facility, with a working farm, its own fire and police departments, its own bus depot, and even its own cemetery. "It was on a par with any of those fancy private places like Austen Riggs or McLean's that would have cost me an arm and a leg," Dick maintained.

Anna visited Louise every Sunday, as well as every other Wednesday, he told me. She would "drag herself" from the bus depot to the building on the north side of the complex where Louise was housed in the unit for "severe female cases." These included the screamers and the catatonics—some of them in straitjackets, others restrained by leather leg shackles fastened to rings on the wall, still others on leashes or tied down with iced sheets: images out of Bedlam. Anna would be led in to see her daughter by an attendant, who on the way out would lock the room from the outside with an oversize skeleton key.

As patients showed improvement they would be progressively graduated down the building until they reached the main floor. Louise got as far as the second floor, but when told that she might soon be ready for "Level One," she had an instant relapse, and right back up she went. Clearly she felt safe at Rockland State, and unable to face so-called reality. One day Anna called Dick at the studio in a panic, having heard on the radio that "a lunatic has escaped from Rockland State." "I assured her it couldn't possibly be Louise, because she was so happy there," Dick said. "And the funny thing was, she really was."

On one of Anna's visits Louise proudly presented her with a broom she had made in shop. "My mother said it was the most wonderful present she had ever received," Dick told me. "She saw it as a healthy sign. And maybe it was—one of Louise's fellow patients had made a coffin."

The first few years she was there, Louise was permitted occasional daylong visits home. Dick would send his mother up to Rockland State with a car and driver to fetch her. "I would meet them at Rumpelmayer's," he said, invoking the popular ice-cream parlor housed in the St. Moritz Hotel on Central Park South, now long-gone. "Louise always ordered the same thing—a banana split. My mother would sit there complaining that Louise hadn't even opened her mouth on the drive into town and that she had had to fill the awful silence herself. Sooner or later Louise would wander off to a corner to pet the store's stuffed elephant. Whenever she glanced over at us, my mother and I would reassure each other that that represented progress. Eventually she would wander back to the table to clean her plate, and I mean literally—she would put her face right down on it and lick and slurp away. Then we would take her for a little stroll in Central Park."

Dick was relieved, he confessed, when these painful visits were curtailed by Rockland State. By that point, even permission for Louise to walk unsupervised on the hospital grounds had been revoked— she'd been discovered roaming around in the tunnels that connected the buildings of the complex. In time she was diagnosed as "low functioning"—she had difficulty remembering basic things, such as how to turn on a faucet or a lamp. And now, whenever she did speak, it would often be only to spew a string of obscenities.

The last time Dick saw his sister, in mid-January 1968, her face was gray, her hair was thinning, and she looked bloated. They told him she was on Thorazine, Stelazine, and "half a dozen other zines." "Be a good girl," he told her as he waved goodbye. One morning a couple of weeks later, January 19, Louise failed to wake up, and Dick and Anna were notified that she must have suffered a heart attack. "She was only forty-two," Dick lamented. "They wanted my permission to perform an autopsy. Well, I had photographed a couple of those—from a stepladder with a heavy 4 X 5 Speed Graphic when I was in the Merchant Marine; my only forensic photographs, by the way—and I passed out

right afterward. The idea of authorizing anybody to cut into my own flesh and blood like that was unthinkable. I'd already done enough to Louise. I hadn't done enough *for* her. I don't think I ever really wanted to help her—I had my hands full trying to help myself."

AS ALWAYS WITH RICHARD AVEDON, everything was grist for the photographic mill. He had already found a way to use the tragedy of Louise in his work. By 1963, the point at which she had become more or less unreachable and when Evie was also "out to lunch," he had seized on insanity as the perfect metaphor for the craziness that was going on over civil rights in the South. At the time, he was collaborating with James Baldwin on a book envisioned as a report on the still-segregated places in the United States. (As far back as high school they had vowed to do a creative project together someday. But when Jimmy in 1946 proposed a study of "the streetscape of my native grounds," which he wanted to call *Harlem Doorways*, Dick brought the subject to a thudding close with, "Doorways are for Walker Evans." Later they briefly considered teaming up on another race-driven project, tentatively titled *On the Margin*.)

I once asked Dick to describe the nature of the collaboration on *Nothing Personal*. "That's easy," he answered. "We each went off and did our own thing. I didn't mind that Jimmy turned his back on my pictures—neither of us was the kind of purist who thought that the text had to have anything to do with the photographs. I just photographed whatever and whoever moved me, good and bad." Among those movers were the activist Julian Bond, Martin Luther King Jr.'s father and son, Joe Louis's fist, George Wallace with his lip curling, George Lincoln Rockwell, and Leander Perez. "I photographed the racists out of rage," Dick said, "and as a sorry consequence they ended up caricatures, cartoons—but then, so did Julian Bond, who came out a saint. This amounted to some of my worst work ever," he assessed, "because I was making my point with exclamation marks. I didn't want the Wallace picture in the book, but Jimmy insisted—he said, 'He *is* a cartoon.'" (Dick would photograph Wallace again, on the last day of July 1993, for *The New Yorker*—and again, at least to my mind, with an exclamation mark. The sitting took place in Montgomery, Alabama,

which happened to be the birthplace of Zelda Fitzgerald, a fact the city was hell-bent on never letting anyone forget: Dick delightedly registered that Wallace's house was on a street between Zelda and Fitzgerald roads, this side of Gatsby Lane and F. Scott Court. He proceeded to photograph the enfeebled, former four-term governor with tie askew. This, remember, was the man who had stood, back in the days when he *could* stand, in a schoolhouse doorway to prevent black students from entering. Wallace introduced his black caregiver to Dick as his valet, saying, "Some of my best friends are niggers—Jimmy Dallas here is my best nigger friend." Wallace insisted that Dallas be part of the picture, and the aide leaned into the frame—and *that* became the exclamation mark.)

"Baldwin wrote whatever came out of his heart or mind," Dick told me. "We worked together the way Walker Evans and James Agee had, on *Let Us Now Praise Famous Men*—in other words, apart." Later Dick showed me a passage he had found in a book where Evans spoke about that legendary collaboration: "We were friends, and we were both working rather defiantly really. Agee and I worked in distant harmony, paying no attention really, by agreement, to each other, but working on the same subject."

"The problem with Jimmy as far as I was concerned wasn't that he wrote whatever he felt like writing," Dick elaborated, "but that he wrote *whenever* he felt like it—he kept missing deadlines." Dick's studio manager at the time, Earl Steinbicker, recalls, "One day in the early sixties Dick came raging down the hallway into the office of his secretary, Sue Mosel, and I heard him yell, 'Fucking nigger!' I knew who he had to be referring to, and I was shocked. 'Fucking nigger hasn't done a lick of work! He's holed up in Finland with his boyfriend, and he's holding up our book.' Dick told Sue to get him on a flight to Helsinki that night. I remember he took his portable Olivetti and a ream of paper. A couple of days later he was back with the entire text of *Nothing Personal*, which he personally delivered to the publisher."

The Dick who reportedly uttered that racial slur was not the man *I* knew, although his old friend from the forties, the late fashion photographer Lillian Bassman, told me after he died that she and her family were renting a cottage at Round Hill in Jamaica one Easter in the fif-

ties at the same time as the Avedons and that Dick lit into her for letting her black nursemaid accompany her two young children into the water; John's nursemaid was made to stay onshore when John went in. Lillian claimed she never felt the same way about Dick after that. I knew from Dick that by that time he had dropped Lillian as a friend for all practical purposes (she was simply too good a fashion photographer!), and so her recollection may have been colored by resentment. All one has to do to dispel any vestigial suspicion of Dick's commitment to civil rights is gaze at his magnificent 1955 portrait of the great contralto Marian Anderson bursting into song (at the sitting he had asked her for a Verdi aria). He had proposed the portrait to the *Bazaar* as a way of celebrating her having just become the first black woman to sing at the Metropolitan Opera (sixteen years before, she had been prevented from singing at Philadelphia's Constitution Hall by Dick's future collective subject the Daughters of the American Revolution).

Dick told me he was shocked by the harshness and anti-Americanism of the Baldwin essay: "It read more like a scalding sermon, a diatribe. Jimmy had 'murder in his heart' — *his words.*" He saw his own contribution as a "comment on alienation and isolation, not a photographic polemic about racism." He was determined, then and ever after, to put as much distance as possible between his pictures and Baldwin's text. "What does the chic, diamond-brilliant fashion photographer Richard Avedon have in common with James Baldwin, the bitterly passionate rhapsodist of the American Negro's agony?" *Newsweek* would query. Around this time, as if in reply, Dick made a schizophrenic self-portrait in a photomat, covering half his face with one of his own images of Baldwin. (Never again would Dick feel the need to collaborate with a big-name writer—he was content to let his photographs speak for themselves.)

The publisher, however, was satisfied with the essay—it was the inclusion of photographs Dick had taken in a Southern mental institution that they questioned. Dick saved the day by explaining that they showed "just how fine the line of sanity is between 'them' and 'us,'" adding for good measure, "I almost went off the deep end myself, doing them." Entrée to the hospital, East Louisiana State (as well as to almost

everything else Dick wanted to photograph below the Mason-Dixon Line), had been arranged by his well-connected Southern-belle assistant Marguerite Lamkin—"through the husband of a third cousin of mine who was friends with the superintendent," she recalls.

Marguerite, who was Elizabeth Taylor's Southern-voice coach for *Raintree County* and *Cat on a Hot Tin Roof*, and who was purported to be one of the real-life models for Holly Golightly, would glide into the Avedon studio every weekday at three and stay till five, "telephoning people about being photographed." She is quick to add, "Dick's name was magical, so I didn't have to do too much, except maybe with the Daughters of the American Revolution, and my mother and grandmother were in it, so that helped." When Mark Littman, the brilliant barrister and future deputy chairman of British Steel, proposed to steel-magnolia Marguerite in 1965, "Dick told me, 'Just do it!'" she says. "He was very anxious for me to make a good life." (She did marry Mark, and went on to become one of the reigning hostesses in London. Dick replaced her with a young friend of hers who was an equally skilled facilitator, the Englishman Nicky Haslam.)

"Wouldn't you just know that the nut house would be in Louisiana!" Dick reminisced. "I mean, *Louisiana. Louise.* The birds in the trees. The cuckoo birds. The superintendent put Marguerite and me up in his house, but after a few days he let me stay in a tiny room right off of what was referred to as the 'untidy' ward, meaning—I got it— dangerous. My room didn't have a lock, so when I went to bed at night I pushed the chest of drawers against the door. I hardly slept a wink— the sounds were just what you would expect from a loony bin. But during the day, when I was working with the patients, using my 35mm camera, I felt safe, although the superintendent warned me that I could always be slugged from behind."

"I couldn't bear going into that ward, but Dick didn't mind one bit," Marguerite marvels. "And I didn't know what we were doing there in the first place—I gathered that the book was just going to be a bit of this and a bit of that, whatever was of the period. We went tearing around the South like Bonnie and Clyde, and later on, his great friend Mike Nichols, who was someone he really looked up to, met us in New Or-

leans, where we went to an all-black—we said 'colored' back then— cotillion ball and Dick photographed it. We stayed at the Royal Orleans in the Quarter. Dick and Mike went off by themselves a lot—lunches and dinners at Antoine's and Galatoire's, that kind of thing."

The portfolio that resulted from Dick's weeks in the asylum is for me one of his towering achievements. Those grainy portraits are as tender as they are harrowing. "The Mentals" (Dick's pet name for the portfolio) ended up having a section of their own in *Nothing Personal*, and were sympathetically received in some circles. The preeminent English theater critic Kenneth Tynan wrote that "in Avedon's terrible glimpses of life in a mental institution, rage and despair go naked before the lens: here is what Lear called 'the thing itself.' One thinks of Goya's *Caprichos*, those corrosive cartoons of debased and deformed humanity; and of the same artist's *Disasters of War*, etchings of atrocious pain bearing such laconic captions as: 'Nobody knows why,' 'That is how it happened,' 'Nobody could help them,' 'Do they belong to another race?'—all of which perfectly fit what Avedon shows us of life among society's rejects." Andrew Sinclair declared in *The Guardian* that "the certified insane appear the most human," adding that "*Nothing Personal* is the view of two . . . who see through a glass darkly." But *Time* took a dimmer view: "Avedon's lens" is a "subtler, cruder instrument of distortion than any caricaturist's pencil." *The New Statesman* put *Nothing Personal* down as "a coffee table book whose cardinal episode is a selection of slumped and staring lunatics" and Dick as a "virtuoso photographer who specializes in relentless portraits of ill-favored famous people." The book's "general effect," it continued, "is more than modishly sick, it is sinister and nearly emetic. Mr. Avedon is in the *Mondo Cane* tradition of a remunerative stress on human awfulness and degradation." Other journals summed the book up as "obscene," "dishonest," and "scarifying."

Even more disheartening, as far as Dick was concerned, Brodovitch announced to a Design Lab class that he "hated" the book, the photographs and the layout both (but then of course he hadn't been invited to design it). "I think it's vulgar in some ways," he said. "I think it's false. The way Avedon expressed himself is very insincere." The impresario, connoisseur, and all-around cultural avatar Lincoln Kirstein pro-

nounced *Nothing Personal* "the coffee-table horror supreme." Dismissed by these two arbiters of art, Dick was helplessly amused that Sammy Davis Jr., someone who was routinely billed as "the greatest living entertainer in the world," favorably reviewed the book for a trade journal in his capacity as an amateur photographer.

When Dick heard that the book was to be reviewed in the December 17, 1964, issue of *The New York Review of Books*, he was hopeful — "my first review in an intellectual journal." "Of all the superfluous non-books being published this winter for the Christmas luxury trade, there is none more demoralizingly significant than a monster volume called *Nothing Personal*," the theater critic and public intellectual Robert Brustein began his savage pan of what he would sum up as a "hypocritical charade": "It pretends to be a ruthless indictment of contemporary America, but the people likely to buy this extravagant volume are the subscribers to fashion magazines, while the moralistic authors of the work are themselves pretty fashionable, affluent, and chic. Such show-biz moralists have for some time now been a fixture of our cultural life, ever since it became apparent that Americans were eager to reward certain critics who abused them (the reception of Baldwin's *The Fire Next Time*, not to mention its publication in *The New Yorker*, did a lot to make this apparent) . . . Now comes Richard Avedon, high fashion photographer for *Harper's Bazaar*, to join these other outrage exploiters, giving the suburban club woman a titillating peek into the obscene and ugly faces of the mad, the dispossessed, and the great and near great—with James Baldwin interrupting from time to time, like a punchy and pugnacious drunk awakening from a boozy doze during a stag movie, to introduce his garrulous, irrelevant, and by now predictable comments on how to live, how to love, and how to build Jerusalem. The book, however, is mainly Avedon's . . ."

The Brustein blow was softened somewhat when the *Review* published a letter from Truman Capote in Dick and Jimmy's defense. He was "startled," he wrote, that an "intelligent man and critic of the first quality" such as Brustein could pen something as "distorted and cruel as he seems to find Avedon's photographs . . . Of Brustein's many injustices, the most unjust is in his depicting Avedon as merely an affluent fashion photographer whose main motivation in assembling this book

was to exploit the American desire for self-denigration and, so to say, cash in. Balls . . . Brustein is quite mistaken when he suggests that Avedon and Baldwin are a pair of emotional and financial opportunists."

"Of the three names that Capote mentions in that letter—Avedon, Baldwin, and Brustein—which is the one least likely to be remembered?" *New Yorker* editor David Remnick asks today, rhetorically. "That said, I understand Avedon's reaction—with even the best artists, a wounding review can cause *creatus interruptus.*" Dick confessed to me that he cried actual tears when he read the review. "I should have just burned it in the toilet, but I didn't know then that that was what you do. It disabled me—incapacitated me. It took four years to recover from it. That man robbed me of the confidence to go on with my serious work. Even my advertising work slipped a bit. I was professionally down but not out."

Brustein's rant was so extreme that I found myself wondering if he felt the same way about Dick and his work today as he had in 1964. So I asked him point-blank if he was proud of having deprived the world of four years' worth of Avedon portraits. "The short answer," he replied, "is that I regret the review . . . I was under the illusion that I was helping to preserve standards and keep middlebrow pretense from encroaching on the domain of earned achievement. Today, when the one criterion of value regarding art seems to be its financial possibilities, that enterprise almost seems quixotic. And if, thinking I was essentially an unheard minority voice, I employed a tone that hurt Avedon, I am very remorseful indeed. I had no idea of the effect my review had on him. Baldwin was an old acquaintance from Fulbright days—we had met on the steamship *United States* returning from Europe in 1955—and I was regretting in print what had happened to his purpose as well. The U.S. then was offering large rewards to turn artists into celebrities—a process that has been totally completed today—and I was trying to send up warning flares." For Dick they amounted to a seven-alarm inferno.

"*Nothing Personal* was a coffee table book, which made its harsh critical posture seem hypocritical to me," Brustein told me recently. "There was no question in my mind when I wrote the piece that Avedon was one of our greatest living photographic artists. I wasn't com-

menting on his artistry but rather on his direction. If I *was* responsible for his giving up serious photography for years, then I feel very badly indeed . . . I am ashamed of [the review's] tone. I was not thinking compassionately enough about the feelings of my subjects. A typical critical failing. My first wife, an actress, died five days after taking a critical drubbing in the *Times,* partly, I believe, as a result."

Brustein was far from the only critic to accuse Dick of political posturing. There were detractors and disparagers in his innermost circle, among them the designer of the book's choppy, jumpy, oversize layout—none other than Marvin Israel. He told me that he considered *Nothing Personal* an "ill-considered, highly politicized diatribe . . . a totally absurd polemic," and that in his opinion Dick "didn't have a political bone in his body. And frankly," he concluded, "I thought it was crazy of him to include the crazies in the Louisiana snake pit— what were *they* doing in our book?" And what—pray tell, Marvin—was Lana Turner's daughter, Cheryl Crane, who killed Lana's lover, Johnny Stompanato, doing on the page facing Martin Luther King III? Believe it or not, she was the one who complained about the placement.

"Something that struck me about Dick from the very first," Renata Adler adds, "was that he was just not political—he just wasn't. I even discussed this with him—in a non-accusatory way, of course—and he acknowledged it. For instance, during the McCarthy period he was completely silent, when all the Lauren Bacalls of this world went left. Look, I didn't believe in all those fellow travelers, either, but it was very striking that, with all his friends signing on to every leftist thing, *he* never did—speaking out would have been bad for business. In the McCarthy period the only thing that would be good for business was to shut up, and that's what he did. He said, 'At least I didn't rat out my friends the way Jerry Robbins ratted out his.' He did do that thing of going to Vietnam and doing those pictures that people took to be antiwar but that were just fashionable—nothing that would have required any business risk." Indeed, Dick was regularly described as "radical chic" and "chic" but never as "radical."

To me, this view of his politics, or lack thereof, is too categorical. When he was growing up, his mother idolized Eleanor Roosevelt and attended political rallies and feminist gatherings, and surely some of

that rubbed off on him. He genuinely saw himself as having been a foot soldier in the civil rights movement, although he did once admit to me that one of the reasons he embarked on documenting social injustices in the South was that he wanted his son to "see that I did my part and not be ashamed of me."

DICK IN VIETNAM, 1972.

Dick felt strongly about the Vietnam War. Witness his portraits of political prisoners in cages, his Chicago Seven mural, his monumental American Mission Council tableau, which has been described as an antiwar portrait right up there with *Guernica* (even Dick's father got the message; he told Dick, "Be careful—those Republicans will eat you for breakfast!"), and his pictures of female napalm victims, which he felt he didn't make "searing" enough. "They should have been *scorching*," he admitted. "Instead they were beautiful and glamorous, in an unutterably appalling way." He long refused to even print them, in the stated belief that they would only serve to contribute to the sum of brutality in the world, though many in the antiwar movement, Susan Sontag foremost among them, urged him to publish and exhibit them as a "deter-

rent." He relented in 1994, for the purposes of his Whitney retrospective, but on the eve of the opening he considered asking the museum to take them down. In the end he made a truce with his conscience by having the lights in the gallery they were in dimmed to the point where the images were half in shadow and the room felt "private."

And what, if not political, were Dick's iconographic portraits of roughly seventy members of the American establishment collectively titled "The Family," which took up the entire central section of the bicentennial-year pre–presidential-election issue of *Rolling Stone*? For perhaps the first time in his by then already considerable career, Dick was content to simply photograph his subjects as they were, and the images speak for themselves, and they speak volumes. Dick must have been doing something right, or rather—politically speaking—left, be-

RICHARD AVEDON IN THE HANDS OF THE LAW—
ARRESTED FOR CIVIL DISOBEDIENCE AT AN ANTIWAR
DEMONSTRATION, WASHINGTON, D.C., 1972.

cause sixteen years later the benighted arch-conservative Hilton Kramer was still questioning his motivations. "With his flawless sense of chic, which in the 1970s was all but indistinguishable from what Tom Wolfe had dubbed 'radical chic,' Avedon's move into *Rolling Stone* proved to be a masterstroke," he wrote. "Subscribers to this flagship publication of the youth movement at the time were as much a pushover for his style of seductive artifice as the readers of *Vogue* had always been. Overnight, it seemed, this celebrated functionary of the high-fashion industry was washed in the blood of the lamb, and in his new purified state was, astonishingly, now being sold to us as a born-again acolyte of the counter-culture, which was, of course, already the most fashionable culture of the day."

DICK COULD ALWAYS MOVE nimbly from what was going on in the great world to what was going on in his own life. The latter consisted of a number of discrete watertight compartments, or "pockets," as he liked to put it. By the end of the sixties the deepest unexamined pocket remained his father. Jack had deserted Anna around 1952, emptying their joint bank account of all but a few hundred dollars and absconding with their bonds. He had, moreover, left without leaving a forwarding address—it turned out he had moved to Florida and was selling mutual funds. "We couldn't even reach him when there were crucial decisions to be made about Louise's care," Dick told me. "As for my mother, he knew I would step up to the bat—one of his pet phrases—and take care of her financially. By this point he respected me as a successful small businessman—rather than as a rather important photographer, mind you.

"I tried to get him to contribute something to my mother's support, and when he refused, I told him that he disgusted me. He said it was all none of my business. *I* begged to differ. I told him, 'If you want to run away from home, that's *your* business, but expecting *me* to support *your* wife makes it *my* business.' And to think that his definition of a man had always been 'someone who supports his family'!"

Dick and his father were in touch only sporadically over the succeeding years, and even then only by telephone and always on Dick's nickel. At some point his analyst warned him that the only way he

could "outgrow" his father was to make peace with him, and that, until he did, his own masculinity would continue to be "disoriented." But how to forge a relationship with this penny-dreadful father? That was the question—and the germinal moment of one of Dick's most significant bodies of work.

During the summer of 1967 he had one of what he called his "little epiphs." He composed a letter to his father, making the labored point that his way of getting close to people was through taking their picture. He proposed taking a series of photographs of Jack over time—in other words, over whatever time remained to him—and he made a persuasive case that this mutual undertaking could bring them together as father and son at long last. He went on to echo his analyst, to the effect that a reconciliation would also be a good thing for his relationship with his own son (John was now fifteen and his need for a father was down-to-earth and diurnal, while Dick's sense of fatherhood remained high-keyed and occasional). Dick showed me a passage he had underlined in a book by the fifteenth-century Florentine humanist Poggio Bracciolini: "If we want our own deeds to be praised and remembered by our posterity, the recollection and praise of parents must shine—as their portraits would—on sons."

Jack responded that he was willing to "give the photography thing the old college try." He said, "You'll make me handsome?" Dick told him, "Sure, Dad, leave it to me." Over the next six years, Dick photographed his father relentlessly. The sittings were fraught. And there were as many as fifty of them—Jack Avedon can be counted the sitter to whom Dick returned the most often.

The first sitting took place in late March 1969 in Sarasota, where Dick had gone to be best man at his father's remarriage. The bride was a widow, a Gentile of Swedish extraction, and the ceremony was conducted by a priest. She had her own means of support, his father assured him, so even as a married couple they would go Dutch. He showed Dick the wedding present he attached the most value to. "It was a reproduction of a Van Gogh sunflower, but he was convinced it was the original, considering the source—Cousin Margie," Dick told me, breaking up.

The next year Jack asked if he could see some of the pictures, and

Dick did something he had never done before—he let a sitter see the photographs. "My father was frightened by what he saw," Dick told me. "He said, 'I look like hell—I don't even have my teeth in. You didn't keep your promise.'" Years later Dick got out those photographs of his father to show me—they looked a lot like his 1959 series of the skeletal remains in the catacombs of Palermo—and these were pictures taken *before* his father became ill. I reminded him of the description of Avedon portraits in general by the French semiotician Roland Barthes: "corpses that have living eyes which look out at you, which think." I asked, "What could *you* have been thinking? What did you think your father was going to think?" He said, "Clearly I *wasn't.*"

The upshot at the time was that Dick had to sit down and write Jack a second earnest letter, painstakingly explaining that he was not the kind of photographer who flattered, ennobled, and idealized his subjects—he was no Bachrach. The reference was sure to resonate with Jack who, in the swanky days of Avedon's Fifth Avenue, had commissioned a Bachrach photograph of himself—in a vest, yet. In it, he looked prosperous, dignified, and wise, and it enjoyed pride of place on the piano in the Avedon living room when Dick was growing up. (Full disclosure: in the mid-1950s Dick lent himself to a Bachrach ad. The copy read: "When Richard Avedon, great fashion photographer, wants portraits for his personal use he comes to Bachrach." If nothing else, this goes to show that there was practically nothing Dick wouldn't do for money.) The Jack Avedon *he* wanted to capture, he wrote his father, was a man of courage, pride, and *elbow.* "I needed to tell him that photographing him the way I was doing was the single biggest emotional experience of my life," Dick told me, adding, "It worked. He kept that letter in the breast pocket of his favorite sports jacket. I found it when I was going through his closet after he died."

Four years into the project Jack began to visibly shrink before his son's eyes—and camera. During one of the sittings, he whispered, "How long, Dickie?" In 1973 Dick had to fly from the Paris collections to his father's bedside in Sarasota. While they awaited test results, Dick spirited him off to the Fontainebleau in Miami Beach for the weekend. It was a hotel that Dick had been frequenting for years, and where he

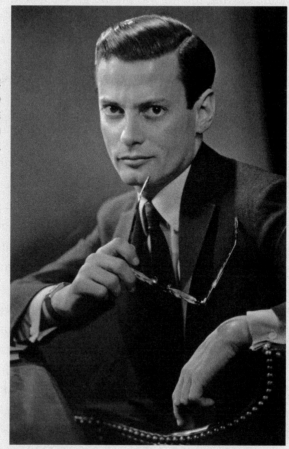

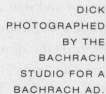

DICK
PHOTOGRAPHED
BY THE
BACHRACH
STUDIO FOR A
BACHRACH AD.

was always given the same suite and the same greeting, "Welcome to the Blue, Mr. A." Dick loved the place, he said, for the sincerity of its vulgarity—something he knew his father, who, after all, had made a point of settling on what he described as "the less Jewish coast," would not appreciate. This most garishly Jewish of Jewish hotels was a place that normally this dying man would never have been caught dead in. Now, however, he was simply grateful to Dick for springing him from the hospital.

Their first night in town, Dick took him to a famous Jewish restaurant (actually *called* The Famous). He had arranged for the preparation of dishes not on the menu—ones that his father had recently confessed

he had a craving for. "It was all the grease-laden, artery-clogging food he was given to eat as a kid," Dick explained. "I was providing a whole Jewish Proustian feast for him—what my mother would have called a *ganza megillah*, to get his goat."

"*Gribenes!*" Jack exulted, as balls of fried chicken fat and skin arrived at the table. "It looked like popcorn to me," Dick said. Next up was tzimmes, a mush of prunes, carrots, and potatoes. Over the steaming bowl his father tearfully confided that the tenement apartment on the Lower East Side where he went to live with his mother when she took him back from the orphanage didn't even have a stove; at night she was allowed to use the one in the bakery on the ground floor for her tzimmes. Jack would have to get up at the crack of dawn to bring the pot upstairs before the bakers began their day. Dick said, "He ate the bowlful," and added, in the way of too much information, "That night, as you can probably imagine, there were noises of every description coming from my father's every orifice. I didn't sleep a wink."

On Monday morning the news was delivered: primary cancer of the liver—prognosis negative. Two days later, Dick was helping to wheel his father into the O.R. As he recalled, "His eyes locked on mine—he said, 'Dickie, is is isn't isn't.' I mean, the greatest writer of our time, Samuel Beckett, couldn't have put it any better." Confounding the doctors' prediction, Jack lived another—if mostly miserable—six months. On August 25, 1973, in Sarasota, Dick took what he fully realized would be the final photographs of his father. "I understood that there were always going to be those who would say, 'How could you do it?'" he told me. "And I knew that my answer would always be, 'How could I not!'" After the sitting Jack began refusing nourishment, and a week later he expired. "On Labor Day weekend," Dick pointed out. "Requiem for a workhorse."

At the crematorium Dick was shown a variety of high-end urns, vases, boxes, and the like, but settled on the cheapest receptacle—a tin can. "My father would have appreciated that I had taken his lessons to heart," he rationalized. But then—contradiction!—he had the container transported to the cemetery by limo. He left Sarasota the next day, taking with him his father's dark paisley silk bathrobe from Sulka, which he proceeded to wear to death. Dick felt that he had given Jacob

Israel Avedon the priceless gift of immortality: thanks to his artistry, his old man now belonged to the ages.

The most painful of all the attacks provoked by those photographs over the years occurred twenty years later and originated agonizingly close to home. For the 1994 PBS *American Masters* documentary on Richard Avedon, *Darkness and Light*, filmmaker Helen Whitney interviewed scores of Dick's sitters, colleagues, friends, admirers, and detractors—and, naturally, his son. As the date of the broadcast neared, somebody sneaked us a tape and, fingers crossed, hearts in mouths, nuts and cheeses at hand, Dick and I sat down on his bed to watch it. From time to time he would ask, "How do you think I look? How's my hair?" He would nod his head, or shake it, or roll his eyes at some of the things being said about him, or beam.

Then John Avedon appeared on the screen, in the context of a discussion of the photographs of his grandfather. "I was upset by them," he stated, "because I felt it was an invasion of privacy." Dick looked shocked. He was shaken to the core, cut to the quick—to the very lining of his pericarditic heart. He was struggling to take in that his own son, his only child, hadn't gotten it. As Dick himself explained, passionately, on the program, "It's just strange to me that anyone would *ever* think that a work of art *shouldn't* be invasive. That's the property of a work of art, the arena of a work of art—it's to disturb, it's to make you think, to make you feel . . . It's meant to disturb in a positive way." He had further maintained that when it came to an assessment of his work he preferred "disturbing" and "upsetting" to "beautiful." Throughout his career, he stressed, "I have never invaded the privacy of strangers, never whipped out my camera and taken a picture unbeknownst—I always have the decency to ask. I'm not a sneak, a grabber, I'm just not aggressive in that way. I'm not a voyeur—I don't steal photos the way Garry Winogrand and Danny Lyon and Robert Frank do, slinking around and watching and waiting. And even, when you come right down to it, Cartier-Bresson, who's probably the greatest photographer who ever lived—he would do things like hide behind a tree!" (Cartier-Bresson admired Dick, to the point of intoning, "Your eyes observed with such acuteness the curious and wondrous people you photographed that they became the inhabitants of an Avedon world.")

When Susan Sontag declared that "there is aggression implicit in every use of the camera" and that "to photograph people is to violate them," Dick had retorted, "There's an aggression implicit in the vicious use of her pen," and gone on to accuse her of "visual ignorance." But that was Susan Sontag—this was John Avedon. Dick said to me, "The only word for what he did is *patricidal*." The very word Dr. Kleinschmidt had used to describe Dick's photographs of his father! I remembered this snippet from *The Little Wisdoms of Richard Avedon*, the pale-blue booklet of Dick's apothegms compiled by his first agent, Laura Kanelous, and privately printed in a limited edition: "If you wouldn't do it to your own father, you're no son of mine." Talk about coming full circle!

"John's *never* gotten me," Dick railed. "And he certainly doesn't get my work—it's now clear that he doesn't even really like it very much. Or *me*, for that matter. Maybe it's payback for all the times I leaned out the window when we lived at 625 Park and yelled down to him as he was going off to Dalton, 'Be creative!' Mike always said that that was like a hex, that it was wrong to try to hold Johnny to *my* standards. It was just that 'be creative' was the exact opposite of what my father used to yell at *me*—you know, be a ballplayer, be a breadwinner, be a man. As a father, I tried to be as little like my own father as possible, but maybe I wound up being just as destructive."

Laura Kanelous used to tell interviewers that the only thing more important to Dick than his work was his son. Not true: nothing on earth was more important to Dick than his work. The work was all-consuming, and his best parental intentions got swept away by the velocity of his career.

8

EAST MEETS WEST

—

DICK'S DOCTORS HAD WARNED HIM AFTER HIS FIRST ATtack of pericarditis in 1974 that it was literally a matter of life and death that he take a "good long breather." He nevertheless immediately accepted what he admitted was a "heart-attack assignment"—a three-week shoot for *Vogue* of a galaxy of Hollywood stars kicking up their heels for the Christmas issue: Cybill Shepherd, Donald Sutherland, Jack Nicholson, Liza Minnelli, Fred Astaire, Burt Reynolds, Barbra Streisand, Warren Beatty, Cher, and Elizabeth Taylor. His own exertions triggered another attack of pericarditis, landing him back in New York Hospital for another hellish month.

A couple of years had passed since this last hospitalization, and he was again running himself ragged, in aid of his upcoming fashion exhibition at the Met. The result was predictable—except that this time, after a couple of weeks, he took matters into his own hands and disconnected himself from the electrodes attached to his upper torso, checked out of the hospital, and returned to the studio, where he proceeded to work, from a hospital bed, on his second Bloomingdale's catalogue, with the model Rosie Vela. When, early in 1978, his friend Alfred R. Stern, the grandson of a founder of Sears, Roebuck, approached him about an investment opportunity, Dick saw it as poten-

DICK SHOOTING A BLOOMINGDALE'S CHRISTMAS CATALOGUE
FROM A HOSPITAL BED IN HIS STUDIO, 1977; STUDIO MANAGER
GIDEON LEWIN HOLDING THE LIGHT AND ROSIE VELA MODELING.

tially paying dividends on the health front as well. Mutual friends of his and Al's—the art and photography collector Barbara Jakobson among them—had already gone in on it, "it" consisting of the thirty-five thousand acres that made up the fabled Bar 7 Ranch in Ennis, Montana. The spread was a picture-postcard vision of hills, dales, dells, trails, and overarching sky. Dick had been reading Henry James, to the effect that age was a "considerably reluctant march into the enemy's country, the country of the general lost freshness." He told Al, "Count me in," and wrote himself a prescription for five weeks of R&R: hiking, riding, and reading till the cows came home (he had filled a suitcase with Proust, Chekhov, Nabokov, Turgenev, Dosto-evsky, and Swift, not to mention James).

At the Bar 7 Dick was recalled to life. He struck up one of those little lightning friendships with the foreman, Wilbur Powell, who was

right out of central casting—weather-beaten, lean, laconic. "Let's just say he isn't a verbal—about the longest words out of his mouth are 'yup' and 'nope,'" Dick reported. "In other words, he's the perfect un-me. He's the salt-of-the-earth type—he's got a heart as big as the Western sky. He's in charge of our nine hundred head of cattle, and he treats me like part of his herd—checks on me first thing in the morning and last thing at night." Dick added that Wilbur had worked for the previous owners, an old land-rich New York family called Gerard, and that when their house caught fire he ran in, saying, "I gotta get the Picasso." He rescued it, then sat outside cradling it as the place proceeded to burn down. Dick now envisioned Wilbur taking his own masterpiece, John, in hand, turning him into something of a cowpoke, making him into even more of a man.

When Dick returned to New York, it was with his energies replenished for the final push on the Met installation and the accompanying book. He went back to the ranch for the Fourth of July weekend, where he tried to keep his mind off work but couldn't help obsessively rearranging that last room at the Met in his mind's eye. One day when he and Wilbur were talking—or rather, when Dick was talking—"something just clicked" and he asked if he could take Wilbur's picture. Wilbur said, after a long pause, "Yup," and Dick ran to get his camera before Wilbur changed his mind.

Dick was surprised when *Newsweek* wanted to include the photograph of Wilbur in his polka-dot shirt and cowboy hat in its Avedon cover story. In the event, Wilbur looked woefully out of place, keeping company with Elizabeth Taylor, Brigitte Bardot, Janis Joplin, Marella Agnelli, and the like. "I'm looking at [the portrait] to learn from it," Dick was quoted in the article, "to see where I can go with it if I go back to Wilbur. He's an uncommon common man. He's a victim, and he's completely heroic."

That last utterance of Dick's would, appallingly, prove out. We were working at his kitchen table, reviewing contacts from his latest sitting, when the phone rang. "Al Stern," he whispered to me. Then I heard "Oh no!"—followed by "When?" and "How?" One of Wilbur's Hereford cows had taken sick and he had refused to leave its side, sitting up with it all night in an outlying pasture. The vet arrived to find both

of them dead. "They think it was a heart attack," Dick said. "I'll never feel the same way about Montana." Later that afternoon I helped him find the right place for the Wilbur picture in his living room.

That photograph was shortly to change Dick's life. On the strength of the image published in *Newsweek*, Mitchell Wilder, the founding director of the Philip Johnson–designed Amon Carter Museum of American Art in Fort Worth, a major repository of photography, proposed to Dick a five-year Western-centric project culminating in a major exhibition. It would be underwritten to the tune of half a million dollars (to be raised by the museum from corporations and foundations), payable to Dick at the rate of one hundred thousand dollars a year beginning in May 1979. Dick for his part would be obligated to contribute the original negatives plus a full set of large-scale signed prints of any and all photographs eventually shown at the museum.

It was a wild idea that Wilder was suggesting. Dick responded that he wasn't a hundred percent sure he was capable of doing justice to a part of the American experience that he had not shared. But before long he was fortifying himself with both Diane Arbus's axiom "It's what I've never seen before that I recognize" and a favorite line from Renata Adler's novel *Speedboat:* "When you have stood still in the same spot for too long, you throw a grenade in exactly the spot you were standing in, and jump, and pray." Without a prayer, Dick jumped.

Being the shapeshifter that he was, he bought himself a suede jacket, a leather work vest, a pair of distressed cowboy boots, and a secondhand cowboy hat, and, hi ho Silver, Richard Avedon rode off into the sunset to blaze some new trails. Essentially he would be devoting most of each summer between 1979 and 1984, as well as assorted times in between, to the marathon endeavor.

The collective portrait of the Last Frontier that he was shooting for would be "no more conclusive than the West of John Wayne," or Ansel Adams, or *Dallas*, or Marlboro Country—it would be his alone, nothing if not subjective. It would serve the purpose of expanding his group portrait of America—a grand ambition that he now realized could never be fulfilled "until it included the man in the street." For the first time Dick would be working with the working class, though, as always,

looking for the grist in the run-of-the-mill. He considered titling the project "Heartland," then settled on "In the American West."

Wilder's original concept was for Dick to photograph only Western women. "I said fine," Dick recalled, "in the mistaken belief that they were all going to look like June Leaf." By 1984, 68,000 square feet of paper and over a million gallons of water later, he had taken 17,000 portraits of men, women, and children. His 752 sitters included cowboys, motel maids, factory workers, carnival workers, migrant workers, oil-field workers, slaughterhouse workers, cotton farmers, ex–prize fighters, unemployed blackjack dealers, pawnbrokers, grifters, drifters, drillers, waitresses, gypsum and coal miners, copper smelters, murderers serving time, ex-cons, pig men, sheep men, cow men, chicken men, meat-packers, state-hospital patients, grain threshers, gravediggers, hay haulers, female bartenders, janitors, cashiers, crop dusters, nuclear-fallout victims, Hutterites, and a rodeo contestant named Joe College. Dick took inordinate pride in the fact that no gesture in any of the pictures was repeated and no two heads were in exactly the same alignment.

Whenever feasible, Dick photographed his sitters embodying the trademarks of their labor—be it coal dust, oil, soot, grit, grease, blood . . . Though the majestic Western landscape would remain a huge absent presence in the photographs, its effect was nevertheless legibly etched, in fact writ large, on the only landscape that ever interested Dick—the human face. He was out to capture, in the words of Wallace Stevens's "The American Sublime," "The empty spirit / In vacant space."

The portraits were taken in a thumping 189 cities and towns across seventeen states. Places with the names Reliance, Gallup, Faith, Crystal City, Miles City, Church Rock, Shiprock, Show Low, Ten Sleep, Two Dot, Eagle Pass, Bitterroot Range, Surprise Creek, Wolf Creek Pass, Shepherd's Peak, Wildhorse, Alamosa, Encampment, Priest Lake, Jackpot, Big Timber, Deadwood, Thermopolis, Chloride, Yukon, and Stanton, whose corny road sign read: "Welcome to a town of 3000 friendly people and a few old soreheads." Richard Avedon, whose old stamping grounds were theaters, movie houses, and expensive restau-

rants, spent the better part of five years attending steer roping and fiddling contests, Frontier Day rodeos, threshing bees, fat stock shows, watermelon derbies, woodchoppers' jamborees, cantaloupe festivals, livestock parades, and greased pig contests—on the prowl for faces that were "heartbreaking" or "beautiful in a terrifying way."

Dick had hired a woman from Dallas by the name of Laura Wilson as his project coordinator and scout. She had an Early American kind of loveliness—in fact she looked like a frontier lady. And she dressed the part: blue-jean skirts, cowboy belts, Western boots. When she called me early in their relationship for advice on how to handle Dick, I told her she would just have to learn for herself, by trial and error, what things *didn't* bother him. Dick took to Laura, and with his encouragement and help she went on to become a fine photographer. The only fault he said he ever found in her was that she saw only the bright side of things. She was the second major Laura in his life.

Come to think of it, I did give Laura one potentially lifesaving bit of guidance: "Never let him drive if you can help it." At first, Dick rented a twenty-six-foot Winnebago motor home, which he nicknamed "Winnie." It functioned as a studio on wheels, being commodious enough to

DICK DOFFING HIS COWBOY HAT TO HIS
WESTERN RESEARCHER, LAURA WILSON, CIRCA 1980.

sleep in, and the white seamless paper that Dick used for the portraits could easily be hung from its side. Eventually he purchased a Chevrolet Silverado Suburban, where the seamless, packed in special tubes, rode on the roof.

Laura was such an accomplished people-person that only a handful of the hundreds of characters she approached on Dick's behalf said nothing doing, even though hardly any of them had ever heard of him. She would show them the *Newsweek* issue with Dick's picture on the cover and watch their eyes grow wide. Then she would promise them an original print and a signed copy of the book if theirs turned out to be one of the portraits in the Amon Carter exhibition. Things tended to go awry whenever Laura for some reason couldn't be around. For example, at a café in Burley, Idaho, Dick spotted a waitress who had an Avedon face, and in Laura's absence asked his two assistants to approach her, wielding the *Newsweek*. The girl said she wanted to sleep on it. When they returned the next day the sheriff was waiting to question them. She was claiming that they had solicited her—offered to put her on the cover of a national magazine in exchange for certain favors. "It was high time to get the hell out of Dodge," Dick recalled.

For each sitting an assistant would tape a thick nine-by-twelve-foot sheet of the seamless to a barn wall, or the side of a cattle truck or trailer or the Suburban. Dick would stand to the left of the lens of his trusty Deardorff, about four feet from his subject, preferably in the early morning or late afternoon. One assistant would load the film and the other would check the aperture, and Dick would proceed to work as fast with the Deardorff as with a 35mm camera. Each day the film would be rushed to the nearest town that had a FedEx facility, thence to the Avedon studio for processing. The rough contacts would then be FedExed back out to Dick.

During the five years that Dick worked in the West, I stayed back East, minding the store: vetting advertising requests, making budgets with the bookkeeper, babysitting staff, and, wonder of wonders, getting to spend a little more time with Martin and our two children. Dick would be calling constantly for updates on everything. I would often have to tell him how disappointed clients were that they were going to have to wait for his services—till, say, after the fat stock show in Dallas!

We would schedule the sittings, discuss how high we could go on the fees without killing the job, and make a tentative choice of hairdresser, makeup artist, and stylist. He would always want to be filled in on all the New York gossip: Had I talked to Renata? Had I run into Twyla? Had I heard from Mike? He would end by asking, "Is everyone at the studio glad I'm gone? Does anybody miss me?"

Dick's first shoot in the West was triggered by an item in an old *New York Times* that had lodged in his memory—the annual three-day Jaycees' Rattlesnake Round-Up in Sweetwater, Texas. He had the assistants put together a bunch of research material for him, which came to include tomes like *Rattlesnakes: Their Habits, Life Histories, and Influence on Mankind*; *Serpent Worship*; *Snake Cults*; *Serpents in Literature*; and *Snake Handler*; and articles like "I've Caught 900 Deadly Snakes"; "If You Love or Walk in Rattler Country"; "Warning: Death Might Not Rattle"; "Blowjob on a Rattlesnake" (by James Dickey, the author of *Deliverance*); "Why Does the Rattlesnake Rattle?"; "Death in My Hand"; and "Peaceful Coexistence with Rattlesnakes." Dick had no intention of going into that round-up cold.

The first image that he registered in the Sweetwater coliseum early in the morning of March 10, 1979, seemed made in herpetological heaven: a western diamondback in the process of being skinned and gutted by a boy in a bloodstained butcher smock. Dick asked the kid, a thirteen-year-old eighth grader by the name of Boyd Fortin, what he was being paid. The answer: all the French fries and deep-fried snake meat he could eat. Within minutes Dick had Boyd in front of the seamless, which the assistants hastily taped to the outside wall of the coliseum. It took three sittings, spread out over two days, to accomplish what is universally acknowledged to be a remarkable photograph.

The boy was innately photogenic: his lips were full, cherubic, almost like a girl's; his curly golden hair was girlish, too. But his eyes were cold and his pose macho, and the snake he was holding was, after all, a classic phallic symbol. "The picture is all about contradiction— male vs. female," Dick explained. "It's a portrait of androgyny, of sexual ambiguity—of the rite of passage into manhood. I wanted it to address the whole vexed issue of masculinity. You can almost see the boy grappling with which sex he is, or wants to be, which so many of us do at

some point in our lives. Everything I've struggled with in my own life went into that picture. I had to go into my most private feelings to be able to photograph what I was most afraid of, and then not be afraid to contemplate my terror. I was shooting for a mythic image—I even had the boy hold the snake in the configuration of a lyre, something out of ancient Greece." Before taking leave of Sweetwater, Dick wanted me to know, he took in the Rattlesnake Queen Pageant (twenty-four local girls were competing for the crown) and the Rattlesnake Dance, which featured a fetching Miss Snake Charmer—he also sampled the snake meat, which he said tasted just like chicken.

DICK THOUGHT SO MUCH of the Boyd Fortin photograph that he decided to use it right away—blown up to an epic 56.25 x 45 inches—to preview the Western Project. He had the perfect venue for it: "Avedon: Retrospective 1946–1980" was scheduled to open on March 5, 1980, at Berkeley's University Art Museum. The *New York Times* art critic John Russell described its Mario Ciampi–designed Brutalist-style building as a "grim, granitic affair," with "battlements from which boiling oil could be poured, huge foursquare cells in which sentence of death could plausibly be passed, and long stony corridors from which no fugitive could escape." Dick had recognized at once its "extraordinary space potential," and told the museum's chief curator, David Ross, "I feel strongly about pulling out all the stops and doing what will become legendary." And that they did: the four-hundred-photographs-strong omnibus would have something of everything and everything of some things, including the MoMA-exhibition pictures of his father and the Metropolitan Museum fashion exhibition.

Dick and I established ourselves in Berkeley, at Gramma's Bed and Breakfast Inn on Telegraph Avenue, which David had heartily recommended, saying that they bring you hot chocolate and cookies at bedtime. Most nights, we dined at Berkeley's gift to the culinary world, Alice Waters's organically driven Chez Panisse. There, one evening, Dick grabbed an umbrella from the stand in the entrance and took off on a Fred Astaire *Funny Face* number—only, when he threw the brolly up in the air, hoping to catch it behind his back, it put a hole in the ceiling. (Dick went on to photograph Gene Kelly in February 1980, and got him

to demonstrate for him his "Fella with an Umbrella" number from *Singin' in the Rain*—"I'll take Fred's studiously unstudied style over Gene's preening athleticism any day," Dick concluded.) Fortunately we had a fallback place to eat—a local frankfurter joint called Top Dog.

For the night before the gala opening, Dick had wanted to do "something small, simple, and special" for about a dozen of his friends who had flown in from all over the country. He hit on the idea of a pajama-cum-poker party, and booked a suite at the posh Stanford Court hotel on Nob Hill for the evening, then went out and bought a new pair of pajamas (white cotton, with navy-blue piping). I decided to make do with the ones I had brought with me (red flannel, with feet).

When the bell to the suite rang at the appointed hour, I opened it—to find nobody standing there. Then, looking down, I saw Walter Matthau playing dead, in a silk bathrobe and slippers. His wife, Carol, swept grandly in, over his dead body. She looked almost supernatural, what with her white-powdered face and platinum-blond hair. She theatrically flipped off her coat to reveal a lacy blue negligee. With her was her actress daughter, Lucy, from her first marriage, to the writer William Saroyan. Yvette Mimieux, who was married to Stanley Donen at the time, came dressed against her sexy screen persona, in a prudish flannel Lanz nightgown, and was going around being very sweet. Dick always maintained that a true star should act against type at someone else's party. Stanley, on the other hand, was holding sway in elegant silk pajamas. He had flown up from L.A. a couple of days before for a screening of *Funny Face*, followed by a discussion that Dick had arranged for the museum gala committee, at Francis Ford Coppola's Pacific Heights mansion, promising David Ross that "Stanley and I will dance for them."

David was in cowboy pajamas. His sprightly wife, Peggy, changed into Lily Pulitzer pajamas in the suite. Oh, and Marvin Israel was there, sporting, wouldn't you know it, corduroy PJs, with patches yet. (He and Dick were still somewhat at odds. It was a very pregnant Betti Avedon who was designing the show—"I want to get as much work out of her as I can before the birth," Dick told David—and Marvin was in Berkeley merely to advise.) It was a party to end all parties, and *the party*—the gala—hadn't even begun.

The next night, March 3, every swell in the Bay Area washed up at the museum for the sold-out black-tie dinner dance. The swank orchestra had been set up in front of a blowup of Dick's group photograph of the Chicago Seven—Dick's idea of a sight gag. At my table I had the Matthaus; Francis Ford Coppola, in rumpled brown corduroys (he was even more informally dressed than the sculptor Scott Burton, who was there in leather, studded belt, and black tie); Francis's two-doors-down-Broadway Pacific Heights neighbors Ann and Gordon Getty (they had given a "simple luncheon" for Dick a few days before, at which the tables were set with solid-gold service and Dick resented being seated with "all the short people"); Lyn Revson, the by now well-divorced wife of Charles; and my old pal Danielle Steel (her kids had gone to nursery school in New York with mine).

Between the starter and the entrée Dick was presented with the Berkeley Citation for Distinguished Achievement by the school's chancellor. In his acceptance speech he decided to play the high-school dropout—he announced that he was reminded of the scene in *The Wizard of Oz* where the wizard gives the scarecrow a diploma and confers upon him the honorary degree of Doctor of Thinkology. "I would now just like to say to the chancellor what the scarecrow said to the wizard," Dick intoned. "'Oh joy! Rapture! I got a brain.'"

Carol Matthau came over and whispered in my ear, "I need your help in getting to the ladies' room. I have ophidiophobia." I innocently asked, "Is that something to do with your stomach?" "It's fear of snakes," she hissed, gesturing in the direction of the gigantic Boyd Fortin photograph. I took Carol's hand and guided her, this strange, ghostly presence, from one side of the vast room to the other, and thence to the powder room. The whole long way she kept her eyes shut tight, but as we skirted the wall where the noxious photograph was hanging, she started to shake uncontrollably.

This, incidentally, was not the last occasion I was present at when Carol had one of her outlandish reactions. A little more than a decade later, in September 1993, Tina Brown, Dick's self-described "number-one fan in the world," who had recently hired him as *The New Yorker*'s first-ever staff photographer, and her husband, Harold Evans, the president and publisher of Random House, who had just signed Dick to a

DICK ENGAGED BY MIKE NICHOLS AT THE PARTY AT THE
NEW YORK PUBLIC LIBRARY JOINTLY THROWN BY *THE NEW
YORKER* AND RANDOM HOUSE TO CELEBRATE THEIR RESPECTIVE
AVEDON AFFILIATIONS, 1993; RANDOM HOUSE PRESIDENT HARRY
EVANS STANDING; *NEW YORKER* EDITOR TINA BROWN AND
PICASSO BIOGRAPHER JOHN RICHARDSON SEATED.

ten-book multimillion-dollar contract, cohosted a big black-tie dinner at the New York Public Library to celebrate all things Avedon. Mike Nichols, one of the evening's featured speakers, regaled the guests with an off-color story whose protagonists were none other than Carol and Dick. Carol had been detected in flagrante delicto in Madrid with Kenneth Tynan by Tynan's then wife, the novelist Elaine Dundy, and had fled to Paris to hide out with Dick, to whom she proclaimed, hilariously, "The pain in Spain was mainly from Elaine." Carol was at

the library bash that night and fainted into her soup as if on cue and had to be carried out. She was meant to be coming to my apartment for a drink a couple of days later, but called to cancel at the last minute, pleading food poisoning. A lucky thing for us both, I realized as I put the phone down and glanced up: there, on my very living room wall, hung the photograph of good old Boyd Fortin and his snake. Martin and I had bought it from Dick after the Amon Carter show. I now remembered having read an interview with Boyd in which he said he kept the signed print Dick had given him in his gun safe because it was "not something you want to hang over your fireplace." I thought, Speak for yourself, Boyd! His own mother had been quoted saying, "At first I couldn't understand why anyone would want to take a picture of a boy with bloody overalls holding a skinned snake, but every parent should experience for their child what we've experienced as a result of it." Boyd was indeed the local boy made good.

During the run of the Berkeley show—on April 30, to be exact, at approximately 4:45 p.m.—the face and showing hand of Andy Warhol in Dick's great mural *Andy Warhol and Members of the Factory* were sprayed with a discoloring orange-colored chemical substance. The perpetrator was apprehended as he jumped a barrier on his flight out of the museum, and, asked what had possessed him to commit his act of vandalism, replied, "Do you know anything about art?" Dick promptly issued a statement: "I can understand that a picture about gender confusion might upset someone fragile. But it was a kind of masterpiece and he killed it. It's not replaceable. In six months' time I can achieve a print in that scale, but never of that quality, and anyway, I don't have the six months."

DICK WAS ALREADY BACK in the mines, going full blast on the Western Project. At the Miles City, Montana, bucking horse sale, he and Laura "discovered" a handsome young buckaroo by the name of Richard Wheatcroft. "I was sitting in the bleachers and I noticed this couple down in front walking back and forth, like trying to find a face in the crowd," Wheatcroft recalls. "Turned out that's exactly what they were doing. All of a sudden the woman was in my face, asking if her friend could take my picture. She showed me this magazine and she

said that was him on the cover. He set up behind the fairgrounds, and they put duct tape down in the dirt for where he wanted me to stand. He told me to be sure not to move or I would wind up out of focus. The whole thing took maybe ten minutes."

Wheatcroft was one of the few Western subjects Dick returned to. "There were always a lot of things going on in Richard's eyes," Dick explained. "He looked like a different man to me each time." That first image shows a confident twenty-four-year-old—there was a real glow to him. But when Dick photographed him a few months later, Wheatcroft's face was a "relief map of petulant and bewildered unhappiness," to quote Scott Fitzgerald. Two years later, he made another portrait of him, and then another the next year when he attended the christening of Wheatcroft's son. At their last meeting, in Montana in 2003, Dick decided not to take a picture.

DICK PHOTOGRAPHING RANCHER
RICHARD WHEATCROFT.

The Western portrait of Dick's that created the most buzz came wholly out of his imagination—the Bee Man. Texas novelist Larry McMurtry has described it as a "picture designed to make Robert Mapplethorpe eat his heart out." Laura Wilson was indirectly—though

genetically speaking, directly—responsible for it, in that it originated with the oldest of her three sons. Dick was sitting on a kitchen stool in her house in Dallas when her son Andrew came home from school raving about a photograph of a man with a bee beard that his seventh-grade science teacher had shown the class. Dick "got the picture" right away and had Laura contact the teacher to see if he knew of somebody who might do something similar for *his* camera. The teacher suggested that Dick place an ad in a beekeeper journal.

The ad we ran stated simply that a "world-famous photographer" was looking for a man to pose with bees on his body, and invited any interested party to send a Polaroid. (Full disclosure: Dick had zero interest in bees, but he sure loved his honey, and was constantly bringing jars of it home from his travels. Early in our working relationship, I had suggested he think about developing a product of his own, and he immediately said honey. He came up with the name "Honey Boy," and designed the packaging himself. But he lost the taste for the project after digesting the marketing study we commissioned.)

We were surprised to receive more than fifty replies to our ad. Many of the responders had defeated the purpose—which was, after all, for Dick to be able to see their faces—by sending pictures of themselves in beekeeper gear: helmets, masks, veils. Several of those who did send distinguishable pictures of themselves looked more like book-keepers than beekeepers. But there was this one Polaroid of an odd-looking fellow in a three-piece suit. Dick was drawn both to the guy's facelessness—he was dead-white, almost albino; hairless and soft-featured—and to the self-effacing note that accompanied the photograph: "I'm sure I don't look anything like what you're looking for . . ." He identified himself as Ronald Fischer, a six-foot-three accountant with a Chicago bank and a Sunday beekeeper with his own honeybee hive. He was Dick's honey boy all right.

The schema for the photograph appeared to Dick in a dream, and in May 1981 he traveled with Laura and his Deardorff to Sacramento to meet with the chairman of the department of entomology at the University of California at Davis, who was also a professional bee wrangler. He had meanwhile had Fischer flown to California, where he was waiting on a nearby tomato farm. Dick arrived with the entomologist,

who was carrying thirteen wire-mesh packages of mature bees, ten thousand to a package, and the crucial pheromone, a fluid infused with the scent of the queen bee in order to attract drones. Dick for his part was carrying the sketch he had made of Fischer with T-shirt off and bees on.

The subject was getting cold feet. He confessed that the only honeybees he had ever worked with were newborns that didn't yet have stingers. These were the kind of bees normally used for bee beards, and the kind he assumed Dick would be unloosing on him. Even as Fischer was balking, the entomologist/wrangler was applying the pheromone to his head, neck, chest, and arms with a dropper. He then proceeded to release the contents of all thirteen packages onto sugar-water-soaked boards, and shovel them into the air. A grist of seasoned bees, stingers all, swarmed over Fischer's head while Dick's two macho assistants ran

DICK PREPARING THE BEE MAN FOR HIS PHOTOGRAPH.

for cover. Fischer, who was now additionally admitting to never having had more than three or four bees on him at any given moment, steeled himself for the onslaught.

The two sittings, spaced a day apart, were torturous. The bees refused to sit still for Dick's Deardorff. A few of them insinuated themselves into Fischer's nostrils and had to be snorted out. Others migrated into his ears, their buzzing magnified to a roar; still others dive-bombed his armpits. They all tickled, but what could he do—Dick had warned him not to move a muscle, on pain of blurring the picture, and, above all, not to open his mouth. In the end he got stung just a couple of times—under and above the lip. Dick got stung a couple of times, too, but carried on. Later, at a symposium sponsored by the Amon Carter, Dick would entertain the audience with the story of how, the instant he and the entomologist dropped the pheromone-saturated Fischer off at the nearest Trailways station so he could catch a bus to San Francisco to visit friends, a small swarm of bees pursued him. Running practically the length of the terminal, he managed to outdistance them enough to jump on board.

When it came time for Dick to select the print for the exhibition, there were two that worked for him on the desired level of mythic association. One had a Buddhist feeling: Fischer stoically enduring the stings and arrows of outrageous fortune ("like a Lazarus indifferent to his worms," Arthur Danto would write in *The Nation*, going so far as to say the picture belonged to the genre of religious photography). In the other, he was the spit and image of a Christian martyr—you felt his pain. Dick went for the Buddhist. Martin and I bought a print for ourselves.

Marvin Israel was already at work on the design of both the museum exhibition and the book that was to be published in conjunction with it. He had already had a miniature replica of the museum built, but felt that in order to work most usefully with the small scale he needed to take the measure of the actual galleries. To that end—and, as it turned out, to Marvin's—he and Dick paid a visit to Fort Worth together in the spring of 1984. "He was so excited to be in Texas for the first time," Laura Wilson recalls. "Like any American kid, he had this romantic image of the West. His very first day in town he asked me to

arrange for him to go riding. When I reminded him that Dick was expecting him to be at the museum, he said, 'I don't care, I want to ride—not everything is about Mr. Avedon.'"

Marvin did spend the entire following day at the Amon Carter with Dick, but the day after that, he got back in the saddle. It was evidently as hard for Dick and Laura to get Marvin off his horse in Texas as it had always been for me to get him off his high horse—his superiority kick. "He rode for hours on end, in pouring-down rain, and late that afternoon he complained of chest pains," Laura recounts. "Bob, my husband, drove him to Presbyterian Hospital—they said he was going to have to stay there for at least a week. Dick had had to return to New York to finish shooting a Bonjour Jeans commercial, which Marvin was supposed to be art-directing. He sent him a get-well greeting in the form of a photo he took of the entire studio, signed by one and all.

"Bob and I and our boys went over to visit him every day," Laura reports. "He would always get up to talk to us, and the minute he did, the boys would hop onto the bed to watch TV, because we didn't have one at home—we didn't want them watching it all the time. Marvin was both amused and irritated by their antics. He thought nothing of whacking Luke and Owen. [Reader, meet the young Luke and Owen *Wilson.*] They were more formal with Dick, and I remember him saying to them, 'Why do you call me Mr. Avedon when you call Marvin Marvin?' Later, when one of them was causing a lot of turmoil in his teenage years and I was despondent over this, Dick gave me the best advice. He said, 'Leave it alone, Laura, it will all flatten out—he'll go back to being the good boy he was at eleven.'

"Anyway, I made them cut it out—after a couple of visits they stopped using Marvin's sickbed as a trampoline. And I made Marvin get back into bed—he needed his rest. He said he was dying to get back to work on the jeans commercial. The last thing I ever heard him say was 'Au revoir, Bonjour.' He died in the middle of that night—May seventh. He was only sixty-one."

My phone rang at the crack of dawn, and when I picked up, there was a long, audible sigh. I was about to hang up when I heard Dick's voice. "Marvin died, I can't talk," he said.

I, too, was dumbstruck. Marvin was all the things everybody said:

impossible, feisty, angry—*really* angry, all the time. On the other hand: smart and gifted and full of value. "The last time I saw him, which was right before he left for Texas," recalled the photographer Deborah Tur- beville, whose 1975 photographs in *Vogue* of etiolated women in seedy bathhouses had caused a sensation and whose first book Marvin de- signed, "all he wanted to talk about was his horse, the one he kept in the Central Park stables—he insisted it was the only thing that had never let him down. I miss Marvin to this day. He always shook you up and got you going. He set you free. He was the truth teller of all time."

MARVIN ISRAEL AND DOON ARBUS.

Yup, Marvin was one of a kind, like him or not. He didn't like *me* very much—frankly, he couldn't stand me. And he disapproved of Martin as well. He looked down on us as "commercial." We weren't "fine," like him and Doon. The two of them went through life being self-righteous together, although everyone knew they had a thing going (despite Marvin's not only being long married but having been the longtime lover of Doon's doomed mother).

And, let's face it, Marvin deeply resented the influence I had with Dick.

When I got to the studio that morning, everybody was sitting around

listening to Dick tell story after Marvin story, which I could see made him feel better. He had brought the 1962 self-portrait that Marvin had given him down from his living quarters—an oil annoyingly titled *Portrait of a Man, Said to Be the Artist*. Dick announced that he had decided to accompany Doon to Dallas and that they were taking Marvin's favorite suit with them—the khaki corduroy number with leather elbow patches, I presumed—for him to wear in the hold on the flight home.

I felt it only fitting to go with Dick's driver to meet them at the airport on their return. They were the last two off the plane—which seemed odd, given that they were in first class. Wobbling down the steps they came, hardly able to stand on their own by the time they reached the tarmac. Dick looked disheveled—his pre*sent* was absent. And he was giddy. And Doon was giggling. They had had a bit to drink, they said. I chalked it all up to shock.

I went with Dick to Marvin's funeral at Frank Campbell's. He said he felt an enormous vacuum, that he had almost never felt so empty. Marvin had left a big hole not only for Dick and Doon but for that long-suffering wife of his, not to mention his elderly parents, his cat Mouse, his eponymous cur (to hear Marvin calling "Marvin!" was always good for a laugh), and his horse whose name escapes me—was it Israel?

How odd that both Marvin and Dick ended up dying in Texas—I mean, these Jewish guys from New York? Interesting, too, somehow, that their two deathbeds were attended by one Laura Wilson.

Dick said, "I'm sick about Marvin, but the show must go on." As he had done for his Met show six years before, when he and Marvin were on the outs, he co-opted his designing daughter-in-law Betti to help with the exhibition, which was only a year or so away, and the book, which he and Marvin had determined would end where the project had begun, with the portrait of Wilbur.

Several of the Western pictures were previewed in *Texas Monthly*. The mother of one of Dick's oil-field-worker subjects called to complain: "I raised Roberto to be a clean boy, and you show him with a face full of dirt." She threatened, in the event that Dick went ahead and put the picture up, to send one of her other strapping sons to rip it right down.

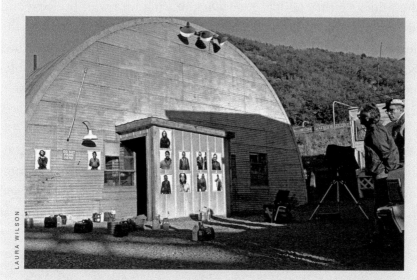

DICK'S MAKESHIFT EXHIBITION, ON THE SIDE OF A
COLORADO MINE, OF SOME OF HIS COAL-MINER PORTRAITS.

The only other time before the exhibition itself that any of the Western work was extended to public scrutiny was when Dick tacked up several coal-miner portraits on the wall of a bathhouse in a mine in Paonia, Colorado—they were objects of some curiosity to their subjects as they arrived for their shifts with their lunch pails. Dick viewed those photographs as "Black Goyas" (when he wasn't viewing them as El Grecos and Caravaggios). And in a way they were—the miners went down deep, into Stygian darkness, and eight hours later came up dirty, coated with the coal dust that produced the lines on their faces that Dick considered more beautiful than the most professionally applied makeup. Whenever any of them offered to clean up for their portrait, he stopped them.

One of the Colorado miners, James Story, had a "beautiful baby face" that Dick was eager to photograph, only it wasn't sufficiently be-grimed. "He covered the miner's face with coal dust that we'd picked up from the side of Route 133," an assistant recalls. "Then he squeezed a wet rag on the miner's forehead, and drops of moisture rolled down his face, hitting his lips. The effect was like the crown of thorns, almost like blood. Then Dick cut up an onion to make the guy's eyes water.

The miner's girlfriend had seen Dick dusting him with the coal and she said to Laura Wilson, 'That's obscene.' I guess she didn't like the idea of anybody messing with her boyfriend's face. Dick was concerned about her strong reaction and hoped she wasn't going to be a trouble-maker. If she was, he just wouldn't use the picture, he said." She wasn't, so he did.

Dick flew the entire studio to Fort Worth for the September 13, 1985, opening. He had invited all of the 120 subjects whose gelatin-silver portraits, mounted on aluminum and free of mats and frames, now spanned the walls of ten museum galleries. Boyd Fortin showed up with his parents and siblings. He was now a premed student at

THE AMON CARTER MUSEUM OF AMERICAN ART,
FORT WORTH, WITH DICK'S WESTERN PORTRAITS
SHINING THROUGH THE WINDOWS.

Southwest Texas State, and Dick commented to me that he looked "much more masculine." (A while back Boyd had written him a thank-you letter for taking his picture and had enclosed a photograph "to show you that I don't always look mean, serious, and, most of all, bloody," so Dick had had a preview of the coming attraction.) Billy Mudd, a trucker, of whom Dick had once said, "He's the guy Sam Shepard wants to be," was taking in the scene with his piercing blue

eyes. "They're all sayin' I'm gonna be goin' down in art history, and it feels kinda great," he said.

"There was a whole line of people wanting me to sign their book on the page that had my picture," Richard Wheatcroft recalls, adding, "but Ron Fischer was being asked for his autograph a whole lot more than me." In the years ahead, museum and gallery goers would always make a beeline for the skin-crawling Bee Man picture. Kids would try to pick the insects off the print, until finally we had to have a special Plexiglas frame made to protect it. Ron Fischer could be counted on to attend every Avedon opening that featured his photograph, and he enjoyed nothing better than to be photographed alongside it in all his apiarian glory. "Fame," Emily Dickinson wrote, "is a bee."

Both the exhibition and the book took a critical beating. "Callous," "unfeeling," "unsympathetic," "unempathetic," "harsh," "cruel," "condescending," "belittling," "victimizing," "bludgeoning," "malignant," "objectifying," "empty," "chilling," and "cold" were just some of the pejoratives hurled in Dick's direction. The subjects as pictured were characterized as "life's losers unforgivably exploited," "specimens examined by a visiting scientist," "innocents led to slaughter," and "a sickening sideshow." ARTnews summed up the exhibition as "Richard Avedon's nightmare vision of the West, filled with monsters," while Art

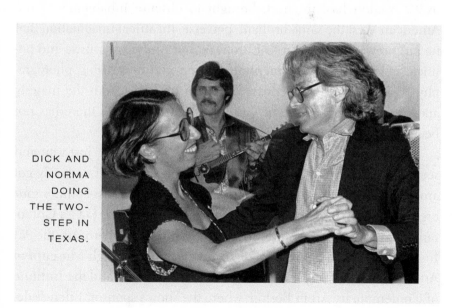

DICK AND NORMA DOING THE TWO-STEP IN TEXAS.

in America castigated Dick for a "failure of decency." When a reporter asked him why he had photographed "so many grotesques," he unwisely fired back: "Look at the person sitting next to you. Or better yet, take a look in the mirror."

New York magazine's art critic Mark Stevens found the portraits to be "flawed by self-congratulation . . . They are so immodest in their portrayal of modest or broken lives—completely without the tact, like perfect pitch in music, of a Walker Evans or Robert Frank." Then he let Dick have it right between the eyes: "It is Avedon's finely honed fashion sensibility at work here." Kay Larson's declaration to the contrary, that "an intensity of moral engagement separates these pictures from his fashion work," brought Dick scant comfort since it was made in the pages of a fashion magazine (*Vogue*).

During the subsequent run of a reduced version of the exhibition, at New York's Pace Gallery, Dick's nemesis Gene Thornton propounded in *The New York Times* that Avedon "seems . . . to be possessed by an artistic vision of the American West as purgatory, if not hell, on earth . . . Most of [his Westerners] seem to be suffering from some sort of metaphysical anxiety, or perhaps it is just from difficult, boring jobs and too much television. Many of them are dirty and misshapen in ways that are often associated with degradation and depravity . . . Avedon has, in short, brought to obscure inhabitants of the American West the same brilliant, perverse, theatrical imagination that he has previously brought to European and American artistic and political celebrities, not to mention fashion and advertising photography . . . [His] 'In the American West' is a long way from the majesty and nobility of Ansel Adams, but for a horrifying thrill there has not been such a good show since *Frankenstein*."

"Nothing has changed," Dick lamented. I told him, "Just wait and see—they're all going to come around." The show itself certainly got around, traveling to seven museums on a two-year cross-country tour organized and tightly controlled by Dick (Washington, D.C.'s Corcoran Gallery of Art, the San Francisco Museum of Modern Art, the Art Institute of Chicago, the Phoenix Art Museum, the High Museum of Art in Atlanta, the Madison Art Center in Wisconsin, and the Institute of Contemporary Art in Boston, where the show's sponsor, Filene's de-

partment store, raised more than a few eyebrows when it used the des-
ignated exhibition poster of a freckled twelve-year-old girl in denim
coveralls to advertise its Western wear). Tellingly, the show had no New
York museum venue. Today is another story: Dick's Western pictures
are considered to be among his strongest, attested to by the high prices
they command at auction. And so, like Theodore Roosevelt, Dick in
the end owed "more than I can ever express to the West."

"He gave me a print of two of the photos he did of me put together,
and he wrote this interesting thing on the back, 'Yours in the struggle,'"
Richard Wheatcroft says. "In 2007—it was spring, I think—this big
Sotheby's thing came in the mail and it had one of his pictures of me
on the front cover and another one of me on the back." The diptych in
question was one of only four ever produced, and it went on to sell for
$192,000. Wheatcroft's reaction to the price was priceless: "I'll be
darned!"

The seller who hit pay dirt—who, in other words, cleaned up—was
Ruedi Hofmann, Dick's assistant on the multiple Wheatcroft shoots. "I
needed to sell it to pay for my kids' college educations, which I knew
was something Dick would have understood," he explains, adding, "I
printed most of the negatives for 'In the American West,' for both the
exhibition and the book, and it was a physical as well as mental ordeal
to get the emotional feeling that Dick wanted in each print—the shad-
ings and the rich tonalities—and the Wheatcroft pictures were the
ones that felt the most personal to me, because I had spent a lot of time
on that ranch of his over the years.

"For the most part, when we were out West," Ruedi goes on, "it was
Dick I was working with, not Richard Avedon—the mask would just
peel away. But then on the plane coming back it would start to take
hold again, and by the time we got to New York it would have stuck. In
the West he was relaxed—downright loose. He had picked up expres-
sions like 'sixty miles off the tar'—Highway 12 was all dirt at the time.
We smoked dope together, played songs in the car—a lot of country
western. He loved *Der Rosenkavalier*—we always had to have that tape
ready. One day we were driving through Montana at sunset, doing
ninety-five—there were no speed limits there in those days—and we
had the volume of *Der Rosenkavalier* turned all the way up. And that's

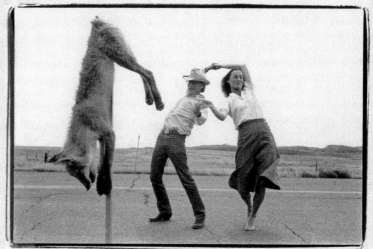

RUEDI HOFMANN

DICK DOING THE "DEAD FOX-TROT" WITH LAURA WILSON
ON A HIGHWAY IN MONTANA.

when we saw this dead fox draped over a metal mile-marker post. Dick said to stop. I had my camera and, I don't know, the combination of the *Rosenkavalier* blaring and the glaring sunset, I just couldn't resist shooting that fox. It was in the foreground, so it's real small in the frame. And then Dick did the most spontaneous thing—he took Laura Wilson by

the hand and led her out to the middle of the two-lane highway and danced with her. They both always referred to this as the dead fox-trot.

"We were en route to Kansas, and as we were passing through this one-horse town Dick saw a sign for a bookstore and made us pull over. He turned up a used hardcover copy of *In Cold Blood*. He couldn't believe that neither I nor Richard Corman, the other assistant on the trip, had ever read it, so he put aside the Raymond Carver he was in the middle of and began reading *In Cold Blood* aloud to us from the back seat. Every ten pages or so, he would stop and share stories about the time he spent with Capote in Kansas. He said he met the entire cast of characters during his first few hours in town. He told us how he and Truman were sitting in a booth in the coffee shop and he was talking nonstop and Truman scrawled a note on a napkin and shoved it over to him. It said, 'Shut up! I'm eavesdropping. This is material.'"

Dick explained to the two transfixed assistants that the impetus for his original spring 1960 visit to Kansas was an irresistible photo op. Truman had wrangled permission for him to shoot the killers of the Clutters, who by consensus were "the last people you would ever want to murder"—he had assured Alvin Dewey, the head investigator from the Kansas Bureau of Investigation, who had cracked the case, that Richard Avedon was "easily the world's greatest photographer" and his pictures were "all marvelous." The sitting took place in the jail-house—in Truman parlance, the cooler—and Perry Smith and Dick Hickock were led in in shackles. Dick soon had them unbuttoning their shirts and rolling up their sleeves (the big reveals were a dancing-dragon tattoo on Dick's biceps and a tiger on Perry's). And later that same day he photographed Hickock's father, who was dying of cancer—there was no time to lose there. He also shot the slain Clutter daughter's white horse, which was going up for auction that week.

Six years later, Dick told them, he revisited Kansas with Truman. He had been commissioned by *Life* to take a series of pictures for an article on the impending publication of *In Cold Blood*—"Horror Spawns a Masterpiece." As the assignment was to fill in the background to the horror story, Dick photographed the farmhouse where the murders had taken place, the postmistress, patrons of the local diner, the Clutter daughter's bereaved beau, and the family friend who had dis-

covered the bodies. And of course the man himself, Truman, topped by a high-crowned, wide-brimmed Stetson. He insisted on accompanying Dick when he photographed the graves of the killers, who were buried side by side in a cemetery near the penitentiary. "After all," Truman reminded him, "I paid for their headstones out of my own pocket— seventy dollars and fifty cents apiece." "He was crying," Dick told the assistants, "all the way to the bank."

"After about sixteen hours of road time, Dick reached the last word of *In Cold Blood*," Ruedi recalls. "At which point he announced, 'I'm going to show you the crime scene.' Just like Dick to have timed the reading so we would end up right nearby. While we stopped at a gas station for directions to the Clutter farm, Dick located the passage in the book where the killers are trying to find the house. He read it to us as if it were a scene he was directing: '"This is it, this is it, this has to be it, there's the school, there's the garage, now we turn south." To Perry, it seemed as though Dick [Hickock] were muttering jubilant mumbo-jumbo. They left the highway, sped through a deserted Holcomb, and crossed the Santa Fe tracks. "The bank, that must be the bank, now we turn west—see the trees? This is it, this has to be it." The headlights disclosed a lane of Chinese elms; bundles of wind-blown thistle scurried across it. Dick [Hickock] doused the headlights, slowed down, and stopped until his eyes were adjusted to the moon-illuminated night. Presently, the car crept forward.'

"We did exactly as Dick directed," Ruedi remembers. "Doused our headlights and slowed down. And damned if there wasn't a full moon that night! Then Dick broke the spell—he said, 'Let's get the hell out of here!' That night he took us to dinner in Garden City with Alvin Dewey and his wife, Marie. He told us he had last seen them the night of Truman's big Black and White Ball where they'd been honored guests along with Katharine Graham. I remember Dewey asking Dick at some point in our evening how 'Little T' was doing, and Dick said, 'You don't want to know.'"

Dick must have been thinking of the last time he heard from him. Truman had called with a proposition that he described as "your next beauty bonanza—picture a cross between Rita Hayworth and Holly Golightly." The girl turned out to be Dick's cross to bear: Kerry O'Shea,

whom Truman had renamed Kate Harrington, and who Dick belatedly discovered was the daughter of Truman's married suburban boyfriend. Dick used her in a toothpaste ad and took some pictures for her portfolio, which succeeded in getting her a modeling agency. Truman then went on to make a colossal fool of himself trying to launch her in Hollywood—he got his and Dick's old friend Carol Matthau to give a celebrity-studded party for her. Dick referred Truman to Dr. Kleinschmidt, who, crossing a professional boundary, as was his wont, told Dick that Truman was constantly threatening to commit suicide. "He's been killing himself for years," Dick said.

Truman would die in 1984 at the age of fifty-nine, of "liver disease complicated by phlebitis and multiple drug intoxication," according to the coroner's report: a death that Gore Vidal heartlessly described as a "good career move." Almost two decades later, the actor who had been cast as Truman in the movie based on Gerald Clarke's bestselling biography *Capote* approached Dick for help in channeling the man that Truman had been in the now-distant days of *Observations* and *In Cold Blood.*

After his last dinner meeting with Philip Seymour Hoffman, in September 2004, Dick said to me, "He's got Truman down—to a T. I see Oscar." Dick didn't live to see it.

9

FRESH AFFILIATIONS

—

URING THE YEARS WHEN DICK WAS EXPLORING THE American West, from 1979 to 1985, literally working in the mines (he even ventured a mile or so underground on a couple of occasions, braving high levels of methane) and the slaughterhouses (he secured permission to photograph on the kill floor, where three hundred head of bawling cattle were dispatched every hour), he was having to fly cross-country every few weeks to shoot the cover of *Vogue*. That amounted to a psychological roller-coaster ride: Dick resented having to leave his personal work in the dust to tend to his commercial work, which sustained him in one sense but not the other. By this point he could do the commercial jobs with his eyes closed. On one occasion he had started a sitting, then realized he'd left his glasses on his bed; when I offered to run up and get them, he said, "Don't bother, I don't need to be able to see for this."

When Dick had belatedly followed Diana Vreeland to *Vogue* in 1965 (having been passed over for the editorship of the *Bazaar*, she had bolted to its rival three years earlier), he was confident that he was still fully capable of expressing his feelings and ideas about life and about women through the prism of fashion. He had been easily enough seduced by the sheer number of zeroes in the *Vogue* offer—a sexy mil-

lion dollars a year. And by the unprecedented guarantee that he would have final say on choice of image and layout. Even more gratifying was the fact that this arrangement effectively cut Alex Liberman out of the process, cropped him right out of the picture — Dick would be working only with his longtime co-conspirator Diana. Condé Nast was also permitting Dick to retain the copyright on all his photographs. It was a clean sweep. And yet, the *Bazaar* had been his editorial home for two decades, and the sundering affected him physically — he was sick to his stomach for two weeks running. Irving Penn for his part confided in friends that he "felt as though he had been kicked in the gut" and was sick to *his* stomach, for three days, after learning that Dick was coming to *Vogue*. (The two greatest photographers in America puking their guts out at the same frozen moment in time does not make for a pretty picture.)

Buoyed by Diana's ever-escalating flights of *fantaisie*, Dick's work expressed the esprit and ethos of the sixties. The star turns he delivered in issue after issue often featured stars, beginning with his first cover, March 1, 1966: Barbra Streisand at the Paris collections, swathed in Dior, her lips sprouting a daffodil. (Later that year she commissioned Dick to photograph her for the cover of her signature album *Je m'appelle Barbra*.)

By 1970, however, *Vogue*'s circulation was down — the magazine was no longer speaking to the subscriber and had ceased to be a must-read. Diana in her arrogance had also been ignoring the advertisers and merchandisers — to her peril: She was axed. Dick had seen it coming. He was apprehensive for himself and also sad for Diana. ("Don't cry for me, Aberdeen," one can almost hear her saying, for within a couple of years she would be fully resurrected — as special consultant to the Metropolitan Museum's Costume Institute.) She was replaced posthaste by her polar opposite, the wonderfully misnamed Grace Mirabella, whose mantra was "real clothes for real women." Grace's favorite color was beige — a non-color. And beige was what the bright red office that Billy Baldwin had dreamed up for Diana got repainted. And what *Vogue* soon became — in Dick's words, "a catalogue for stewardesses."

With the advent of Mirabella, a disillusioned Ara Gallant stopped

DICK BETWEEN LEGENDARY *VOGUE* FASHION EDITOR
BABS SIMPSON AND LEGEND BARBRA STREISAND AT
THE COLLECTIONS, PARIS, 1966. STREISAND WAS DICK'S
FIRST *VOGUE* COVER AFTER HE LEFT *HARPER'S BAZAAR.*

styling hair for photographs. Dick, too, soon lost the joy of working for *Vogue.* "Grace never understood or appreciated my sense of style and beauty, and she put the lid on a lot of my ideas," Dick told me. "Suddenly, there were as many ground rules and restrictions in editorial as in advertising. I no longer had freedom of expression. I just went through the motions—doing the best job I could, given the new realities."

To make matters worse, Alex, now that Diana was no longer around to protect Dick's work, began cropping his photographs and even running type over some of them. At a certain point in the early eighties, Dick informed him that he was only interested in doing covers for *Vogue* and wanted to do *all* of them. Alex was thrilled—Dick's covers

"pulled," they sold like crazy—and he immediately suggested that Dick also do all the covers for GQ, *Mademoiselle,* and *Self.* Dick thereby got to maintain his power base at Condé Nast, and his big fat salary.

For GQ, Dick shot big shots only—Stallone, Schwarzenegger, Woody Allen, Bruce Willis, Dustin Hoffman, and Michael J. Fox, all of whom, coached by GQ's twentysomething photo editor and celebrity wrangler Lisa Atkin to fully engage in the process, seemed to appreciate the fact that they were being photographed by Richard Avedon. But then along came David Letterman. There was something surly about the way he arrived, dressed in just a T-shirt and khakis. To everything the GQ stylist showed him, he said, "I'm not putting *that* on." He was chewing gum, and Dick asked him politely to get rid of it—"I'm trying to photograph you"—but he went right on chewing. Dick tried again, no longer Mr. Nice—"Give me that gum!"—and Letterman defiantly pushed it to the side of his mouth, then turned and walked out the door. Dick said, "Good riddance." GQ prevailed on Letterman to come back a couple of weeks later, and Dick took an upbeat picture of him. Letterman later held the cover up on TV and bantered to Paul Shaffer that he had had to go to the Avedon studio not once but twice, and, hey, this "terrible" picture was the result. (The only other subject who ever dared to chew gum at a sitting was Frank Sinatra. On that occasion, Dick put his hand out for the gum. Sinatra swallowed his wad instead.)

Dick also photographed a surfeit of sports stars for GQ, most of whom he had never heard of—sports was a total blind spot. But the pictures all turned out great, especially of Michael Jordan, who was a really good sport. For the most part, getting the athletes out of the studio as quickly as possible was Dick's objective—those GQ shoots would take half an hour tops. At one point I had to remind him that he was going to have to start making the sessions last longer. "Just continue working even after you're sure you've gotten it, so it looks like you're spending enough time," I told him. "Otherwise they're going to make you give the money back! For the serious portraits, needless to say, you can go on taking as little time as you need to." We both laughed. But after that, it was mutually agreed on with the GQ crew that they would hang out at the studio for a couple of extra hours, rather than return

directly to the office and risk having the editor-in-chief think the magazine was being stinted.

By 1988 Grace Mirabella had been supplanted at *Vogue* by Anna Wintour, *her* polar opposite. In one of those iconic firing stories, she had learned of her demise while watching Liz Smith's gossip roundup on *Live at Five*. Dick, who had known instinctively how to handle every editor he'd ever worked with, was nervous. "We're in the Wintour season now, it's a whole new Ice Age," he remarked. "She's a very frosty concoction. She knows what she wants, and I may very well not be her glass of iced tea." Truer words: Dick's first Anna cover would also be his last.

For starters, Anna insisted that Dick shoot outdoors—no more studio. He was understandably unhappy about that: he wanted to go on knocking out the covers the way he had been doing for years—why tamper with a winning formula? The location was downtown—some nondescript plaza. The temperature was in the mid-nineties, and everyone was drooping. The editor on set, Carlyne Cerf de Dudzeele, recalls, "I didn't have the heart to tell Dick what I knew Anna wanted— a happy Patrick Demarchelier–type picture." Anna rejected Dick's with "It's a reshoot." He said to me, "We have a real adversarial on our hands."

She sent him back downtown, to some other godforsaken plaza. "Halfway through the shoot," Carlyne says, "Dick threw his arms around me and said, 'Carlyne, this is all wrong.'" Sure enough, the upshot of the reshoot was a re-reshoot. Dick predicted, "Anything I do she's going to kill."

This time she sent him to the beach—in other words, packing. She rejected those pictures, too. Oribe, the hairdresser on the shoot, the reshoot, and the re-reshoot, sums it up: "She wouldn't let Dick do Dick." (The young German photographer Peter Lindbergh was handed the assignment and, working with Carlyne, produced a smash cover. It was the first where haute couture was mixed with low. They put the fresh, blond one-name model Michaela in Guess jeans, with a bit of belly showing, and a Christian Lacroix velvet sweater accessorized with an oversize cross of multicolored stones, and they told her to smile widely—happy happy happy.)

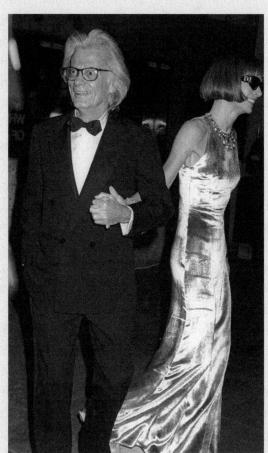

DICK AND *VOGUE* EDITOR ANNA WINTOUR QUICKLY CAME TO A PARTING OF THE WAYS.

Condé Nast bought out the remaining two years on Dick's contract. Taking something for nothing wasn't his style, but he learned to live with it—in a snap. He never took another picture for *Vogue*, and in all his subsequent exhibitions and books he made sure to give short shrift to his work for the magazine (there were only four *Vogue* photographs in *An Autobiography*, ten in *Evidence*, and twelve in *Woman in the Mirror*).

DICK HAD MEANWHILE BEEN making waves, tidal ones—veritable tsunamis—with his advertising work. For Calvin Klein he had created both print and television jeans ads that were the talk of the industry and

beyond (Brooke Shields: "You want to know what comes between me and my Calvins? Nothing"). Then Gianni Versace gave Dick the freedom—and the budget—to pivot from glamour to glitz. He was working now with a new generation of models, and making them all into supermodels, first-name recognizables: Linda, Claudia, Kate, Naomi, Stephanie . . .

The renewed fame and fortune that his advertising work was bringing him notwithstanding, Dick felt homeless without a mainstream magazine. Enter the visionary—and very visual—Tina Brown. Immediately upon assuming the editorship of *The New Yorker* in 1992, she hired Dick as the first staff photographer in the magazine's history. Its readership was aging and declining, and she recognized that the introduction of photography would attract a younger generation. The announcement of Dick's new affiliation made national news—one paper commented that to describe Richard Avedon as a staff photographer was akin to calling Michelangelo a house painter. Dick loved flashing his press pass: a pink medallion with his picture and the words "Working Press Number 01117 Richard Avedon New Yorker magazine is entitled to pass police and fire lines wherever formed."

"You can do anything you want," Tina told him. "One great image an issue or a run of images together. You can do reportage, theater pictures, action pictures, a dance piece . . ." The formal arrangement specified that Dick would provide roughly one black-and-white full-page photograph a week, either on assignment or from his vast archive. He was to have approval of layout and even engraving.

We also extracted from the magazine—and this was handshake stuff—the promise that no other photographer's work would appear in its pages for at least the first couple of years (after that, Dick would continue indefinitely to be the only photographer used for full-page portraits and for portfolios). The stated exception was for the students in the master class he'd been teaching since January 1992, under the aegis of the International Center of Photography. By the end of the year Dick was ready to introduce these young photographers to *The New Yorker* as "my stable of sixteen thoroughbreds . . . a new generation of talent." Selected by Dick from more than three hundred applicants, the class, for as long as it lasted (which was, formally, four

scheduled weekends and, informally, something like five years), amounted to yet another surrogate family for Dick. (He had taught officially only one other time—a weekly advanced master class in photography, conducted with Marvin Israel, for ten weeks a quarter of a century before; among the students were Peter Hujar, Deborah Turbeville, and Caterine Milinaire.)

The New Yorker announced that Dick would "work closely with the editors in assigning these photographers and would oversee their projects through to completion." "He gave me my first professional assignments, and for The New Yorker, no less," says class member Barry Munger, adding, "The Avedon workshop was miraculous. I was not as experienced a photographer as many of the other students, but I was ready to step up a level and he created the perfect environment for that. If all he had done was share his anecdotes, he would have given us plenty, but he also opened his studio to us and let us watch him work, flattered us with his attention to our work, fed us brilliantly, brought in prominent guests from the arts, invited us out to his place in Montauk, and continued the workshop for years after it was slated to end. An additional bonus: when I think back on the class I think of us all laughing." Another member described the class another way: "ass kissing, ego stroking, idol worship, game playing, and work hustling."

For Dick, The New Yorker was both a re-berth and a rebirth. Having to "perform" on an almost weekly basis for the magazine made him feel, he said, as if he were "tap-dancing on Mount Rushmore." His point person was Pamela Maffei McCarthy, the deputy editor, whom he hailed as "a perfect partner—a combination of patience and brilliance." "He required somebody to bounce ideas off," she says. "He would call me at exactly one minute past nine every morning. It was always an exhausting call—his level of energy was superhuman. He would usually want to talk about whatever piece of theater he'd seen the night before, and his ideas for the critics' section. He supplied so many of them he was like an unofficial editor of the theater pages."

Once again, people were talking about Dick's work on a regular basis. "His photographs, in their epigrammatic compression of a whole subject into a single black-and-white image, were New Yorker profiles in miniature," as Adam Gopnik put it with characteristic concinnity.

Week after week, year in and year out for the rest of his life (it was while on assignment for the magazine that he died—out West and with his boots on), *The New Yorker* published image after extraordinary Avedon image. The first—a 1963 photograph of Malcolm X—ran full-page in the October 12, 1992, issue. W. H. Auden followed a couple of weeks later, and then: Alger Hiss, Jasper Johns, Giacometti, Nureyev, Marian Anderson, George Balanchine, Montgomery Clift, Cole Porter, Edmund Wilson, Cyril Connolly, James Baldwin, Jerome Robbins, Harold Brodkey, Bob Dylan, Norman Mailer, Mandy Patinkin, Bert Lahr, Dorothy Parker, Susan Sontag, Katharine Graham, Elizabeth Taylor, Sly Stone, Gus Grissom, Janis Joplin, Bertrand Russell, Allen Ginsberg, Bernardine Dohrn, the Beatles . . .

Not to mention Tilda Swinton and Charlize Theron (both topless), Ricky Jay, Senator Daniel Patrick Moynihan, Diana Trilling, Stephen Spender, Stephen Sondheim, Steven Spielberg, Alan Bennett, Robert Mitchum, Edward Albee, Calvin Klein, Isaac Mizrahi, John Currin (with his infant son, the one as naked as the other), Christopher Reeve (post–riding accident) . . .

In April 1993, Dick flew to Los Angeles to photograph the Reagans. "The former president shuffled in like a zombie—there was *really* no there there," Dick's assistant on the shoot, Marc Royce, recalls. "But then a wonderful thing happened. As Reagan doddered by the makeup and hair area he turned and looked at himself in the mirror, then smoothly reached into his back pocket, pulled out a comb, and went swoosh, swoosh, swoosh through his hair—he made it look all perfect. And then he gave himself a little mirror face. After that, he went back to being a zombie. Nancy said up front to Dick, 'You're going to retouch me, right?' And of course he said of course. The picture was Reagan standing there and Nancy holding his hand. After they left, Dick said, 'I'm going to make a political statement. Hands betray people's age, and I'm going to use the hand of hers that shows to really sock it to her.' He left it looking like crocodile skin." (Dick paid rapt attention to First Family hands. When he was photographing an impassive-looking Gerald Ford in the White House for his *Rolling Stone* "Family" portfolio, he noticed that "his hands were twisted and tense. And I thought, That's it, that's the contradiction in the photograph that will

tell what it's like to be who he is at this moment. And I made the mistake of telling him. I said, 'President Ford, your hands are beautiful. Just don't move.' And as I went back to lower the camera to include them, his hands became benign and perfect and boring and revealing of nothing.")

Dick spent eight intensive weeks that summer photographing a medley of still-living figures from the Camelot era for a forty-page portfolio titled "Exiles: The Kennedy Court at the End of the American Century," to be supplemented by photographs from his archive. The courtiers pictured included Eunice and Sargent Shriver, John Glenn, Dave Powers, Julian Bond, Evelyn Lincoln, Frank Sinatra, James Meredith, Ethel Kennedy, John Lewis, Robert McNamara, Ben Bradlee, Tip O'Neill, Pierre Salinger, Theodore Sorensen, McGeorge Bundy, John Kenneth Galbraith, Tom Hayden, James Reston, Arthur Schlesinger Jr., a trinity of Martin Luther Kings (Sr., Jr., and III), and Rose Kennedy. (The latter portrait, inexplicably, had just been singled out for abuse in a *Washington Post* review of the 1993 exhibition of Dick's *Rolling Stone* "Family" portfolio at the National Portrait Gallery: "Rose Kennedy stands before us as living proof of something you'd rather not talk about . . . Her hands hang at her sides, they are festooned with liver spots. She is sad, puzzled, and small. She looks angry and resigned at the same time, as if she were posing for a going-away picture taken by a servant she never really liked.")

Dick had toyed with the idea of calling attention to the machinery behind the phenomenon that was Jacqueline Kennedy, by photographing her hairdresser, Kenneth; her official dress designer, Oleg Cassini; and her social secretary, Tish Baldrige. "I decided it would have made her look superficial," he said, adding, "That goes to show what a forgiving guy I am." Dick was alluding less to The Jackie's no-show at the opening of his Met fashion exhibition back in 1978 and more to the fact that six years later she sued over a print ad in a zany campaign that he created for Dior's U.S. licensees ("Meet the Diors: the Wizard, the Mouth, and Oliver—when they were good they were very, very good and when they were bad they were gorgeous"; Liz Smith described them in her syndicated column as "too too *too* Diorable" and dubbed them "*quelle* threesome!"). He had used a Jackie look-alike, provided

by a celebrity-look-alike agency, in a wedding-reception scene he staged. Among the other guests he photographed for it were the real-life Andy Warhol; a look-alike Queen Mother; Charles de Gaulle impersonated by a cabdriver with a big nose whom Dick had hailed by chance the week before; and a Harry Belafonte look-alike, in the person of his daughter Shari, a favorite model of Dick's. The judge ultimately ruled that the ad amounted to "an appropriation without consent for such nefarious purposes as advertising and trade," and that The Jackie's "civil rights" had been "trampled upon." The ad had to be scrapped. Dick got even: there came the day when Jackie personally called him for permission to use a couple of his photographs in a book she was editing and he turned her down flat. She remarked on the refusal to their mutual friend Karen Lerner, "Dick Avedon no longer knows what's good for him."

But if Dick could sometimes hold a grudge, he also had his moments of generosity. One of them involved Saul Bellow. He photographed the near-nonagenarian Nobel laureate in Vermont in 2003, and didn't notice in the contacts that there were piss stains on Bellow's pants. He had them retouched out on the prints. "Not that a mensch like Remnick ever would have published it," he acknowledged, adding, "Tina would have."

THE NEW YORKER WOULD SURELY HAVE drawn the line at Dick's May 9, 1992, photograph of Stephanie Seymour. The image in question was a questionable one: Stephanie hiking up her black Comme des Garçons sheer body stocking to expose a beautifully manicured bush. "The world at that point was ready for anything Stephanie — they were champing at the bit to See More, so I gave her to them below the belt," Dick said. He regarded what quickly came to be called the "crotch shot" as both a fashion picture and a portrait: his *Naked Maja*. The image is confrontational and erotic, but not voyeuristic. "She's in complete command," Dick said. "It's a statement about power and control — in its own way it's even a feminist picture. What she's saying is, 'You've all been wondering what a supermodel's vagina looks like — so here, look your fill. Then look me in the eye.'"

It took a lot of guts for Dick to be able to do this. For Stephanie as well. Especially when you consider that the photograph was taken in front of an audience: Dick's master class. The students' first assignment had been to do a self-portrait. Amy Arbus, Doon's younger sister, did a nude of herself in a bathtub, which cried out to be interpreted as a replay of her mother's suicide. (This was a picture calculated to get a visceral reaction from Dick, one way or the other. After all, he was not uninvolved: Marvin Israel had called him from Diane Arbus's West Village apartment after discovering her body in the bathtub on July 26, 1971. Dick had rushed over there, and then insisted on going into the bathroom to see for himself. The next day he flew to Paris to break the news to Doon—she was there working for him on a Chanel ad with Catherine Deneuve—and bring her home.) Dick saw Amy's photograph as a breakthrough for her, both professional and emotional.

After exposing the class to the lubricious watercolors of Egon Schiele, including *Self-Portrait in Black Cloak, Masturbating,* which Dick felt Schiele had conceived as a performance, he suggested to a male member that he take a portrait of himself masturbating. "I sort of gulped—I said, 'I'll think about it, yeah,'" the man recalls. "I actually did do the picture, but small, as a four-by-five Polaroid, and I shared it privately with Dick. He put it in front of his eyes, but it didn't seem to me that he really looked at it either content-wise or aesthetically, which was kind of a relief. I knew he considered me uptight, and I came to feel that his asking me to do that picture was more a provocation than anything to be gained as a photographic project. Because what would have been the point—I was up against Schiele!"

The class member's double-pronged selfie and Amy Arbus's bathtub reveal were water under the bridge by the time Stephanie entered the class picture. All that the students were told was that that weekend they were going to be treated to a fashion sitting with a "fantastic, very emotionally complex and responsive model that I've done a few jobs with—a very beautiful girl who looks a lot like my sister." He told them he hoped it would be beneficial to them to witness close-up how he worked. "I'll never forget it," Barry Munger recalls. "Any time

you're in a studio with Stephanie Seymour and she doesn't have clothes on, it's memorable, but what remains indelible is the way Dick ran the show."

Stephanie swept in at eight-thirty in the morning, in overalls and no makeup, half an hour before the others (the classes were all-day affairs, often going on until ten at night). She had in tow her three-year-old son, Dylan Thomas Andrews, from her short-lived first marriage to guitarist Tommy Andrews. "I didn't want to leave him at home, it's the day before Mother's Day," she explained to me. Dick parked the kid with an assistant and whisked Stephanie upstairs. He told me afterward that almost without knowing it he began telling her that he wanted her to do "something pretty uninhibited" with her body, exactly what he didn't know. "Then suddenly I had this thought, which I couldn't defend intellectually, that I was going to flash the crotch instead of the breast. She said she was up for it and she gave me a little preview. I had no idea whether any photographer had ever done anything like that with a big model before—all I knew was I had never seen *that* kind of picture. But I still didn't know if I could make it happen."

He led Stephanie downstairs. By this time the class was fully assembled, along with Dick's coterie, Polly Mellen, Oribe, and the makeup artist Kevyn Aucoin. He asked Polly to explain to the class how she planned to style Stephanie. She showed them the clothes she had chosen for Stephanie to try on, even putting on a couple of the items herself. Polly would find the mood of the model unforgettable. "I saw Stephanie as being more than merely free," she recalls. "She was clearly a woman who had learned the word *abandon*, which I learned myself when I was twenty-two, obviously from a man. It's when you believe in somebody so completely you let yourself go, as Stephanie was getting ready to do with Dick. And you get back something that enriches your life forever, like that photograph he took of her."

Dick instructed Kevyn to keep the makeup to a minimum—"I don't want her to look like she's wearing a mask." He then told Oribe that he wanted Stephanie's hair "simplified," that he wanted to be able to see the natural shape of her head—"Maybe even leave it a little greasy, I don't want it to look like Hollywood and Vine." Then he motioned for Oribe to follow him upstairs.

DICK'S "CROTCH-
SHOT" SHOOT WITH
STEPHANIE SEYMOUR.
MAKEUP ARTIST
KEVYN AUCOIN,
STEPHANIE, AND
POLLY MELLEN IN
THE AVEDON STUDIO.

POLLY MODELING A SWEATER
FOR STEPHANIE TO WEAR.

POLLY SHOWING
A BIT OF BODY
STOCKING.

POLLY PERFORMING
FOR KEVYN AND
STEPHANIE.

"Dick sat me down and explained what he wanted me to do with her," Oribe recalls. "He said, 'I've seen it and it's not pretty down there. You're going to have to pretty it up, so just go in there and groom it.' And I'm like, 'Oh my goodness—go in *there?*' He was really pushing it, and he made me feel that it was going to be a real important picture. And it *is* such a great picture to have worked on! It will be shocking forever, and forever beautiful. And what's even more shocking is that it came from a guy who was seventy at the time—and I mean, I thought *I* was wild. Anyway, there I was, about to be doing my first crotch haircut. Later I got to do one for Lady Gaga, for a Mario Testino shoot for V magazine. She said to make it good and hairy, so I did a big fuzzy standard-poodle pink one made out of wigs. But getting back to Stephanie, Dick wanted it to have a particular shape, just clean and square— not natural, more like a V. I discovered to my horror that she was wearing a fur coat down there—it was not shaved, she didn't have a French cut. She got her leg up on the counter and she was just being so great about it, laughing and spurring me on, 'Go right ahead, Oribe!' Dick kept popping in to inspect it. I would probably be able to do it much better today, by the way—now that I have experience."

Stephanie emerged from the dressing room in a turtleneck, which came down like a dress. Dick shook his head no. Polly then held out her closed fist to him, dramatically opening it to reveal a black mesh body stocking. "It's from the Rei Kawakubo collection for Comme des Garçons," she crowed. "It's the newest thing I've seen—so feminine, so non-fashion, so *real*. It will completely cover her and yet at the same time it's sheer—so you see, you'll be getting the best of both worlds." Dick said, "Polly, great work. Just make sure both her nipples are showing."

With it on, Stephanie might just as well have been naked. "She made the walk from the makeup room to the studio proper in front of the entire class—we were all huddled in a corner of the entranceway, and we were gaping," recalls class member Nina Drapacz. "I had my cousin's wedding to go to that day, but I stuck around for the crotch shot and I missed the ceremony." Barry Munger adds, "I just assumed Dick would have had a really closed set for this, because I knew he did close the set for certain things, like the Pirelli calendar, but he obviously felt he didn't have to do that with Stephanie."

Finally, at two p.m., Dick was ready to roll. He put on some chamber music — Schumann. The fun music — Broadway, disco, soul, rock 'n' roll, jazz, blues — he reserved for when the models were moving, and Stephanie was hardly even going to budge for this. He took a bunch of eight-by-ten Polaroids of her, and put them up on the wall to study. Then he began shooting for real, standing next to the Deardorff and making small talk with her, working toward what he wanted. At one point she tugged at her waist, and he made the snap decision to go with that gesture. He said, "Do that again! . . . Do it *more. Emphasize* it." And then: "Lift it up! Higher! *Hold* it!"

Class member Lizzie Himmel marvels, "Dick's assistant Marc Royce was the lighting arm, and he let me hold the reflector for the pussy picture, swear to God." According to Marc, "Dick was worried that the light would fall off the crotch. He was directing the hell out of Stephanie, but it felt like it was a spontaneous thing that just happened. She was completely unself-conscious about her body. And what a body — I mean, she had those fake tits but, other than that, she was amazing."

"I was trying to get the single most astonishing image of Stephanie's face at that moment," Dick said. "Something just so simple it would make what she was doing with her hand seem like a lovely gesture. And the exposed nipples and breasts, the skin showing through, would work to intensify the elegance." Polly, who was crouching down behind Dick when he got the picture, adds, "I was looking at Stephanie's face, because the face is more important than the crotch — I mean, if it isn't on the face, what good is it — and it *was* on her face, and it was just a very moving moment. But if you ask most people what they think of that photograph, they don't know what to say. Because they don't have the knowledge, they haven't brought themselves up to that level in an intellectual way."

There were at least fifteen pictures where the lift of Stephanie's eyebrows and chin, the tilt of her head, and the expression in her eyes were all perfect. I was in on the final choice. Two years later that photograph was hanging life-size on the walls of a major museum — part of Dick's 1994 Whitney retrospective.

The year after the crotch shot, Polly received a prestigious award

from the Council of Fashion Designers of America. Dick, who had been asked to present it, insisted that the photograph of Stephanie appear as part of the slide show accompanying his tribute to Polly. "Avedon rattled on for fifteen minutes about a marvelous shoot they did with Seymour, and then projected onscreen an enormous image of the model baring her crotch," one fashion editor later wrote, adding, "Even in the fashion world, which is beyond outrage, people were appalled." Polly among them, unaccountably enough. "Right now I hope they don't publish it anymore," she told me recently. "For Stephanie's sake. And for the sake of her children. I'm proud I did the picture, but there *have* been a couple of times when I would have liked it not to be shown—I mean, Stephanie and her husband were in the audience the night I got my award." I informed Polly that Stephanie's newsprint tycoon–cum–art collector husband Peter Brant had purchased a print of the crotch shot and that it reportedly hung in all its full-frontality in the living room of their Greenwich, Connecticut, mansion. And as for their two boys, Dick had heard that it was their favorite photograph of their mother. Be that as it may, in October 2012 a print sold at Christie's New York for $230,500. "That's a lot of scratch for a snatch," someone couldn't keep himself from quipping.

When Stephanie became pregnant, shortly after the crotch shot, Dick's immediate reaction was, "How could she do this to me!" He came to terms with her condition by photographing what he called her "pregnancy belly" in a mesh dress by Karl Lagerfeld. "She was a little more self-conscious that time," Marc Royce observed.

As no respectable American magazine would touch the crotch-shot photograph, it had to make its debut abroad, in an independently owned and irregularly published French cult journal of photography and the arts called *Égoïste*. Since 1985 it had served as the repository for much of Dick's most imaginative editorial work, and it must be said that its oversize format, heavy paper, and exquisite printing did full justice to his portraits.

"He couldn't wait to show me the picture of Stephanie exhibiting her sex," says Nicole Wisniak, *Égoïste*'s founder, editor, and publisher. "He met me at the airport with a photostat of it. He said, 'Look! I've done it again!' He meant: produced another masterpiece. The oppor-

tunity to publish it was a great gift. There was no reaction in France beyond that people thought it was beautiful. No scandal, because, you know, we are the country where *L'Origine du monde* of Courbet was painted, 150 years ago, and everybody knows the image — a very graphic view of the genitalia of a faceless female lying spread-eagled on a bed. We don't have this prudery about sex in the same way that Americans do, so it was not a brave act on my part to publish the Stephanie picture. It was far more audacious of me to republish Dick's mural of the Warhol Factory, which had frontal *male* nudity."

After getting a load of Stephanie in *Égoïste*, Suzy Parker called Dick to complain that "it was not very ladylike for that girl, who I refuse to

DICK WITH
NICOLE
WISNIAK,
FOUNDER
AND EDITOR
OF THE
FRENCH
ARTS
JOURNAL
ÉGOÏSTE,
1994.

name, to expose herself that intimately." She told Dick that she now thought less of him, not to mention Polly, for enabling "such a thing." On the other hand, a far less vintage supermodel of Dick's thought more of him. "I fuckin' loved it," Janice Dickinson says. "I just wish he'd shot *my* crotch. Or even shot me pregnant, the way he did Stephanie."

Nicole proceeded to publish Dick's lavish portfolio of Stephanie modeling various decades of fashion (couture from the great days of Dior, Chanel, Balenciaga, and so on), with her hair, makeup, and attitude styled to set off each dress. Dick enjoyed a special relationship with Nicole—they were very much each other's time of day. She was adventurous, eccentric, exotic, fun. Most important, she frequented the highest social and intellectual circles in Paris. At the time they first met (the occasion was an interview she did with him for her magazine in 1984) she was married to a French journalist and pregnant with her daughter. From that moment on she was always willing to drop anything for Dick, and anybody—starting with, for all practical purposes, Helmut Newton, her first star photographer. One of the original attractions of *Égoïste* for Dick was that he would be largely displacing Helmut, whose work he admired enough to feel jealous of it.

Nicole would constantly pump me for information about the "other women" in Dick's life—Doe, Suzy, Evie, Felicia Bernstein, Tina Brown (Nicole referred to her snidely as Tina *Marron*), and especially Renata, whose choice word for Nicole was *predatory*. Renata had admittedly met Nicole only once, with Dick, at a small dinner at Joan Didion and John Gregory Dunne's, from which she came away feeling that Dick wanted—needed—Nicole to believe that he and Renata had been romantically involved. For one of Dick's lectures Nicole asked me to save her a seat in the front row, and I could hardly believe my eyes when I saw her coming down the aisle sporting a Dynel Renata-like braid. She had thought, I can only surmise, that this would somehow spoil Renata for Dick. He was just about to begin when he caught sight of her, and from the podium he asked her to leave. Within fifteen minutes she had wiggled her way back in. She tried desperately to make me her ally. That didn't work, but it didn't have to: Dick bought the act. To the point where, when we were negotiating his contract with *The New Yorker* and Tina wanted to enjoin him from accepting

DICK FLANKED
BY NICOLE
AND NORMA
IN VENICE.

NORMA AND
NICOLE IN COLOGNE.

NORMA AND
NICOLE IN PARIS.

photo assignments from any other magazine, Dick insisted he be allowed to photograph for *Égoïste*.

"Richard Avedon had always been my god," Nicole declares. "The first time I ever saw a book of his—it was *Observations*—I must have been only sixteen, yet I knew he was the greatest photographer alive. One May fifteenth I took a bouquet to his marvelous mother. I said, 'I know today is your son's birthday, not yours, but, after all, it's you who made him.' The first work of Dick's I published was a self-portrait, and I put it on the cover. It wasn't a picture that he did expressly for *me*—it already existed. But we did do a lot of original work together. I was sort of like a midwife, constantly trying to marry my needs for *Égoïste* with his own passionate interests. I wanted also for him to do for me things he had never done for anyone else. For instance, I brought him to Berlin on the first New Year's Eve since the collapse of the wall—1989. It was a frigid night, and he was holding his camera with his right hand, and with his left he was holding on to my arm; it was sheer chaos—we were in the middle of the jostling, screaming crowds and so terribly afraid to lose each other. East and West were supposed to have become one, but what he saw in the crowds was not hope for the unification but hopelessness and fear, and the photographs he took were absolutely devastating.

"It was I who suggested the Volpi Ball in Venice to him. I knew he wanted to go back and photograph high society, but deeper, in a more Proustian way than he had done in the fifties. And I knew it would be a wonderful opportunity to make a sort of social criticism of the combination of vanity, hysteria, and beauty that you always found in that world. He took a photo of me at the ball, with my strands of pearls floating around me—he told me to run in the middle of the guests, *fuir*. I must have a hundred pictures that Dick took of me over the twenty years we were together. The one he did when he was doing an Isabelle Adjani cover for me I look sort of tough in. When I told him I didn't like myself in that picture, he said, 'But one day when I'm not here it will remind you that I knew you were strong.'

"When I asked him to photograph Gérard Depardieu, he said he didn't know what to do with him, and at some point I mentioned Rodin. So before flying to Paris he rehearsed in his studio a picture of his as-

sistant in the position of *The Thinker*. The big thing was to get Depardieu naked for it, which Depardieu accepted as a fellow artist, and the picture was done in under two minutes.

"Dick had as much the eye of a painter as a photographer, and the point of view of a writer. And everything with Dick was an adventure, always—something very intense, magical. It's not for me to say what I might have meant to *him*, but there's this Cole Porter song, 'You're the Top,' that he adapted especially for me: 'You're the top, you invented laughter / You're the top, you're the rain but after / You're a sight to see, sipping breakfast tea / You're a flight, you're that long day's journey into night / You're a breeze in the hottest places, you're carte blanche / You're Shakespeare's wig, you're the dream of a midnight swimmer . . .' I quote not exactly, but you can see it's a very nice song anyhow. I don't know if I was *the* top for him, but surely I was up there, no?"

Nicole tried in vain to convince Dick to move to Paris to be with her. I'm not saying they weren't extremely close—when they traveled together, they shared hotel beds—just that I'm positive that theirs was an *amitié amoureuse* rather than a *roman d'amour*. There were admittedly others who saw the situation differently. David Bailey, for one. As the real-life model for the hot young photographer who straddled Veruschka in *Blow-Up*, he was certainly in a position or two to pick up on a sexual vibe. "The last time I ever saw Dick was in Seville," he recalls. "I was sitting with my wife in the fake-Moorish lobby of the Hotel Alfonso, which I was renting most of for a perfume commercial with Christy Turlington. Dick came in and he was with that woman who had that magazine, what's it called, and they were screaming at each other. I said to my wife, 'Get down in your chair—I don't want Avedon to notice us.' They got in the wobbly old lift, and we continued to hear the two of them having a real go at each other the whole way up. I just naturally assumed he was having a big affair with her—I mean, you wouldn't argue that passionately if it wasn't personal like that. It was Dick who was doing most of the screaming, by the way." (When he called me late that night from Spain he mentioned that he and Nicole had had an argument over where to go for dinner.)

Marisa Berenson was another one who swallowed the fairy tale hook, line, and sinker. "They seemed so in love," she sighs. "Nicole

would be lying at his feet at dinners and things in Paris." Carlyne Cerf de Dudzeele also saw them as a concupiscent couple. "Nicole and I were related, sort of, you know," she volunteers. "Her late husband was the brother of the husband of the sister of my mother. The last time I ran into her with Dick I was exiting Central Park at East Seventy-ninth Street. He told me they had each just gotten a massage. On a park bench—can you imagine! From that little woman who was always working there. I smelled happiness on them. Truly!"

I smelled business. If Nicole hadn't had an artsy magazine, forget it. It wasn't a love affair, period, and please don't anybody ask me again. Yet Dick passionately wanted everyone to think it was. I told him, "Dick, it's not necessary."

He said, coldly, "It is."

10

FORBIDDEN AFFINITIES

—

A FEW MONTHS AFTER DICK DIED, IN 2004, MIKE NICHOLS said to me, "The first thing everyone asks me about Dick is was he gay." I said, "It's the first thing anybody asks me, too." Mike said, "How do you handle that?" I said, "I always say, 'Don't ask *me*, I'm not the mattress—Dick was a monk as far as I know.'" "That's great," Mike said. "I'm going to start using that."

Of course I knew. And Mike knew that I knew.

"The question remains: who *was* he?" says Dick's friend Charles Michener, who wrote the 1978 *Newsweek* cover story on him. "He made it seem like there was nothing he wouldn't talk about, but there *was* something—his sex life. I have no idea what it was—I certainly never saw any evidence of anything one way or the other. He was probably very complicated on that score. The women he was involved with throughout his life, starting with his precocious first cousin Margie and going on to include Renata Adler and Twyla Tharp and ending with that French woman he was so close to who had the magazine, Nicole Wisniak, were all striking-looking and a tad neurasthenic and had some offbeat talent or other. What I'm saying is, there were shadows in his life, which probably accounted for his moodiness and extreme volatility and occasional vindictiveness."

Dick liked to end his letters with a catchphrase he'd picked up during the civil rights era—"Yours in the struggle." But his own struggle wasn't political, it was agonizingly personal, and it was lifelong. His homosexuality remained a deep, dark secret, although in the late nineties he did say to me, "I know it's no big deal anymore—now everybody's gay. The thing is, I don't want it defining me—'the gay photographer,' as if I were a professional homosexual."

The secret Dick guarded with his life was not something he confided to me in our first years of working together. But whenever we were out of town installing a museum or gallery exhibition or meeting with a client, we would wander in and out of each other's hotel rooms, sit on the edge of the bed, and talk. There came the time when we felt we could tell each other anything without fear of being judged.

In the spring of 1979 we flew to Berkeley to make preparations for the huge Avedon retrospective at the University Art Museum that was to open the following March. One night, after a four-star dinner at Chez Panisse, we returned to Dick's room at Gramma's B and B. Ensconced on his bed, on one of the eponymous grandmother's handmade quilts, Dick asked, out of the blue, "Remember the YMCA survival camp I told you about that my miserable father made me go to when I was thirteen?" What I mostly remembered was how physically inadequate Dick had said he felt there: too short, too skinny, too myopic, Jewish—not a happy camper. Now he was confessing to me that he had had "feelings for one of the boys in my cabin—Patrick. More than feelings—stirrings." He was searching my eyes.

I said, "Oh!" If I was surprised, it was because I had just suddenly realized that this was something I already half-knew. He was saying that I was the only person he felt he could tell. "Patrick was a *double* no-no—a goy and a boy," he went on. "A boy with freckles and butterscotch hair. My other bunkmates made fun of me, they said I threw a ball like a girl. One Sunday I was lying on my bunk and he came over and whispered, 'I said a prayer for you this morning.' My heart turned over. I needed to find a way to make him proud to be my friend, so I talked the drama counselor into letting me do my Fred routine at intermission during the camp play. On the big night, after I finished, I took a deep bow, then blew a big fat kiss to the audience—only, without

even thinking, I aimed it directly at my butterscotch boy. He stood up, looked straight at me on the stage, and—it still hurts to remember—he mimicked throwing up, as my eyes pleaded with him for mercy. And then he walked out. I knew I could never go back to my bunk. Committing suicide wasn't an option, so I did the next best thing and called home. I told my father a terrible lie—I said I had just been called every dirty Jewish name in the book. I had to say something that would make him get right in the car and drive up and get me—I wasn't going to stick around to be called a fruitcake."

"You had no choice," I offered. "And not only did you survive, you're *you*—Richard Avedon."

"I've got a secret," Dick said, and paused. "Mike Nichols."

"Mike?" This time I *was* shocked.

Dick said, "We had so much going for us. He's above me intellectually, of course, the way Renata is, but I'm the artist, so it evens out. And we're equally corrupt. We were made for each other. At one point we even thought about running away together. Eloping, we called it— leaving our wives and our lives and moving to Gay Paree. I was the one who introduced Mike to Paris, that time when we shot the collections for the *Bazaar*—he loved it as much as me. We chickened out, but we were together for years, till Mike met someone else and moved on— someone not worthy of him, I might add. Later on we started things up again—there were sparks, but no fire. But we've stayed best friends. And we'll always have Paris."

I asked Dick, hesitantly, "Does Evie know?" He said, "Who knows *what* Evie knows? If she does, she's never put it into words." He told me then that he felt he had done a very selfish thing in marrying her. He said he hadn't been "sexually strong enough" for Doe, either—and that he had spent most of their honeymoon photographing her. "After a couple of years Doe asked if there was another woman. I swore on my mother's life there wasn't, and you know that I love my mother more than life itself. Finally Doe asked if it was another man. I remember I said, 'What an idea!' Not long after that, my fairy-tale marriage ended like a B movie—like one of the ones Doe was beginning to be in. The summer after I kicked her out I was in Hollywood doing a shoot and I screwed up enough courage to go to one of George Cukor's 'boys'

nights.' The minute I walked in the door I had an attack of what Auden called HP, homosexual panic, and ran out.

"I felt naked without a wife, and I married Evie for cover," he confessed. "But some nights, after she'd fallen asleep I would slip out of bed and hit a bathhouse or the forest in Central Park for a little recreational sex. My heart would be pounding just like before a sitting, pounding as if it were going to explode—sex with a total stranger was the same kind of charged exchange. It was dangerous, too, and that was part of the thrill—you could wind up getting killed. Or worse, arrested—one night the police raided the scene. Another time, I saw a married client of mine on his knees in the bushes and I had to lie low until he finished his business. After I finished mine, I would slink home and slip back into bed.

"The night before I ran away from home for good, in 1972, I sat Evie down and tried to make her understand that we were over. I trotted out one of the biggest clichés in the book: 'Our marriage has no legs.' She seemed to accept it—I was surprised. But then she called the next day to say she had something very important to show me, so I went running over to the house—and she had had a carpenter saw the legs off our bed! She was off her rocker."

Now, eight years later, Dick was reaching across the bed in Berkeley for my hand. He said, "So, Norma, what do you think of your golden boy now? Do you hate me?" I said what came naturally: "No, Dick, I love you." He said, "It feels good to let it all out. Normie, there's more." I said, "You can tell me anything." He said, "I never did anything with Jimmy Baldwin—except for some innocent kissing, which his father caught us at. But Jerry Robbins put the moves on me a whole bunch of times. I put the brakes on there—too many ripples—and now I'm sorry. He went and took up with one of my assistants, Jesse Gerstein." I remember sitting there thinking, What a couple Dick and Jerry would have made! "And Lenny. That ended in another big nothing. I didn't feel I could do it, because I was such good friends with Felicia." I sat there thinking, What a couple *they* would have made! I asked Dick directly about Harold Brodkey. "Harold?" he said. "I don't want to go there." Renata has no qualms about going there: "Harold and I used to have breakfast all the time with Dick and Evie in the early seventies in

their house on Riverview Terrace, and they were delicious breakfasts and everything was wonderful, and then one day, overnight, Dick wasn't there, he had moved out, maybe sort of gone another way completely, and Harold was gone at the same time. Do you understand what I'm saying? Suddenly we weren't having breakfast, all four of us, anymore! I remember thinking at the time that Dick had left Evie, more or less, whether he knew it or not, for Harold, who'd been pretending to be heterosexual all those years, too, don't forget." When pressed, Dick said to me only, "There was something about Harold . . ."

It was now midnight in Berkeley, long past Gramma's bedtime, and Dick and I had an early-morning breakfast meeting at the university museum. I said to him, "Sweet dreams. You're a great artist and a great guy. Tomorrow you will rise and shine."

A couple of hours later he was knocking on my door. He looked terrible. "I just had the worst nightmare," he said desperately. "I have to get it off my chest." What he had dreamed was truly unspeakable—that he was having strenuous sex with the leper he'd photographed in 1971: "I've been having fantasies about the guy for years—*that* was a dream. *This* was a nightmare—I became a leper, and people were stoning me."

Dick had gone a long way out of his way to get the picture. He had been looking for the outcast of his dreams, and found him in Saigon, in the ward of a municipal hospital for the diseased and insane—the man had been a tailor. Dick was then faced with the problem of how to sneak him into the luxury hotel where he'd set up his studio. Dark sunglasses, a fedora with a turned-down brim, and a knee-length raincoat did the trick—the staff at the Continental Palace Hotel assumed it was some movie star or head of state outfitted for showy anonymity. The photograph of that poor unfortunate soul that Dick took that day wasn't even in the studio files—he kept it in a safe. Although he saw the image as a metaphor for an abominated war, in hindsight he had decided it would be wrong to capitalize in any way on a picture made out of somebody's "atrocious physical condition." I said to Dick, in those wee small hours at Gramma's, "The problem is, you don't accept a certain part of yourself, so your subconscious is punishing you by making it all ugly. This is Dr. Stevens talking." The next night he had a comparatively comforting nightmare about baseball.

We returned to Berkeley a number of times in the months ahead, and thankfully Dick's scaly nightmare never recurred. After the exhausting Berkeley opening, he told me he needed a few days to catch his breath and that he was planning to "take in some serious tree trunks," by which I naturally assumed he meant redwoods. But on the plane going home, after he had knocked back a vodka or two and was into the white wine, he put his hand gently on mine and said, "I've been naughty again. I spent the weekend in the Russian River Valley—the California version of the Fire Island Pines." I remembered now a letter he had written the Berkeley museum director a couple of months before, in which he said he was planning to enjoy "a little sex" while in San Francisco. I had thought he was just being funny. "A guy came running up to me to say he'd met me at the opening," Dick continued. "I told him, 'I'm sorry, I'm not who you think I am.' You don't think he's going to blab, do you?" I said, "Of course he is—he's going to tell everyone. And nobody's going to believe it."

Dick's life soon took a turn for the better—he fell in love. At a theater benefit at the Waldorf he locked eyes with a promising man. "He'd never heard of me—can you believe it? I had to spell my name for him," Dick told me the next morning. "I gave him my number, but he's never going to call—I'm an old crow, and he's a spring chicken." I said, "Don't worry, he's going to call. And if he doesn't, *you* call *him*." That was what Dick needed to hear: he took a lover's leap up the stairs to his bedroom and made the nervous-making call.

The young man's name was Bob—Robert J. Reicher, Esq., to give him his full due. He was just out of law school and working as an associate at the white-shoe firm Proskauer Rose. I said to Dick, "Congratulations—a Jewish lawyer yet! He can support you in your dotage."

Dick called me first thing the morning after their first date. "This you're not going to believe—he grew up in Cedarhurst, same as me. And he was taking the train to Penn Station all by himself at the same age I was. And going to matinees and eating hotdogs at Nathan's the same as me. And guess what—when his family left Cedarhurst, they moved to East Eighty-sixth Street, like mine. This was meant to be." (Dick, it should be pointed out, was often drawn to people who reminded him of himself. Later, when he met the writer Adam Gopnik,

he said to me, "I see myself in him—he's exactly like me when I was his age." *Their* relationship, rest assured, was strictly platonic and Socratic.)

Dick couldn't wait for me to meet Bob, and made a lunch date for the three of us a few days later—at some out-of-the-way spot, I couldn't help registering. I knew not to expect a male beauty—that was the last thing Dick would be attracted to. Bob turned out to be a cute enough guy: short (surely one of his selling points where Dick was concerned), dark, and callipygian. A bit of a smart-ass, too, which was refreshing. But, I felt, deep-down-nice. I predicted a future for this fling.

"There was someone in my high-school class with the name Avedon, only they spelled it with an *i*," Bob recalls, "so I just assumed that was how *he* spelled it. He liked it that he had to correct me—that's when he really believed that I had had no idea who he was. He seemed impressed that I'd graduated Penn and Columbia Law and been on the *Law Review*. When I got to know him he told me that he always felt at a loss for not even having graduated high school. He sure could have fooled *me*—I never knew anyone who was better read. He was very conversant with most of the classics, and he always had a serious book going. He kept pushing me to read that old French guy—you know, the one who wrote all those volumes after being turned on by a cookie."

I said, "Proust!" Clever me.

"Yeah, that's the name," Bob confirms. "And the cookie had a name, too—a girl's name, Madeleine. Oh, and I couldn't have cared less about clothes. I got my shirts from Costco. Which I think he also got a charge out of, although he did get very defensive once and explain that fashion was a multibillion-dollar industry and I shouldn't pooh-pooh it. But I'm a very unfashionable person, so it didn't move me."

The most auspicious thing for their relationship from Dick's point of view was that Bob lived and breathed theater. He'd been collecting *Playbills* since he was thirteen—he had amassed seventy-nine binders' worth and had a closet dedicated to them. Dick and Bob began going to the theater together a couple of nights a week. "He did something that used to drive me nuts," Bob says. "He had seen many of what are considered the great performances of the twentieth century, such as Laurette Taylor in the original production of *The Glass Menagerie* and

Lee J. Cobb in the original *Death of a Salesman.* So when we went to
see Dustin Hoffman in the 1984 revival of *Salesman,* Dick insisted he
wasn't as good as Lee J. Cobb. Maybe so, but this was *my* time to see
Willy Loman, and he kind of spoiled it for me. And that's what hap-
pened every time we went to a revival of something he had seen the
original production of, years before I was even born—his was always
better."

When Dick and Bob attended the theater together, unless I was
there as the beard Dick had Bob sit a few rows behind him. When I
expressed how unfair to Bob I thought that was, Dick snapped at me,
"Let *me* be the judge of *that*! I have my image to consider." If they hap-
pened to be standing together at intermission, in the lobby or in front
of the theater, and someone Dick knew came over, he would introduce
Bob as his lawyer (which, after a certain point, was true enough, in that
Dick had him doing occasional work for him—at, need I add, a very
friendly discount). Bob would shake hands with Dick's acquaintance,
and then, while the two of *them* made conversation, he would bury his
face in his *Playbill.*

Bob put up with this. But whenever we met for lunch, just us, he
would vent about how Dick, in addition to keeping him segregated at
plays, would take him only to under-the-radar restaurants and, when
they traveled, make him sit in the back of the plane. He also minded
that Dick would never permit a photograph to be taken of the two of
them together.

"Another thing—Dick would walk out of any play the minute he
began not liking it and I would have to follow him, even if I was loving
it," Bob adds. "I could have killed him when he walked out on the re-
vival of *Zorba* with Anthony Quinn—I'd been listening to the album
since I was a kid. He would always say, 'I get it,' which meant that he
got where the play or the performance was going, to the point where he
didn't see any point in staying."

Dick got tickets for Larry Kramer's *The Normal Heart* shortly after it
opened in the spring of 1985 at the Public Theater. Bob had already
seen it—with his grandmother, of all things. She and the playwright
had apartments on the same floor of their lower Fifth Avenue co-op,
and she had explained to her grandson, "I don't *care* what it's about—

I'm a good neighbor and I have to go see it." "When it was over I asked her what she'd gotten out of it," Bob recalls, "and she went, 'That Koch was a real stinker.' She missed everything else in the play. He happened to live in her building, too."

Bob was only too happy to see the play again, with Dick. "It opened with these three young guys in a doctor's waiting room, one of whom said, 'I know something's wrong'—that was the first line of the play, so it was pretty clear where this was going," he says. "Then a patient with big purple lesions all over his face came stumbling out of the office in a daze and announced that the doctor had just informed him that he was probably going to die of it. I say 'it,' because the play is set in '81 and 'it' didn't even have a name yet. Anyway, I was enjoying it all for the second time, until Dick got to his feet and began shooting up the aisle. I caught up with him and he grabbed my arm and said, 'We have to leave! Right now!' That was a very frightening experience for me—it was the most upset I ever saw him. The minute we got outside I asked what was wrong. Well, it wasn't just another case of 'I get it'—he said he had a cousin, Keith, who had just been diagnosed with it and that he couldn't bear watching all these guys die throughout the play. He told me he had known what the play was about, but didn't know how it was going to affect him. I don't know if he ever went back to see it." (Reader, he did: Dick would attend a performance of the 2004 revival with his friend Cynthia O'Neal, the co-founder with Mike Nichols of the AIDS nonprofit Friends in Deed. To help raise money for the cause, he contributed a print of *Dovima with Elephants*, his most famous and most valuable photograph.)

At six-thirty the next morning my phone rang. "Do you think maybe *I* could have it?" a panicky Dick asked. I said, "Have what?" He said, "The plague! I woke up with the night sweats. What will you tell people if I get the purple blotches on my face? How would you cover for me then?" "I'd just tell everyone you're a drug addict," I told him, adding hopefully, "But you *don't* have it, and you're *not* going to get it— now try to get back to sleep." Later that day he went to the doctor for the first of what would turn out to be many AIDS tests over the years. Dick was confused about how to handle the unmentionable subject in relation to the studio—everyone was. AIDS paranoia had set in: people

were at a loss as to what it was exactly, or how you contracted it, and rumors were rife. The models were terrified to have anyone who was suspect (nobody suspected Dick) touch their face or comb their hair. The great makeup artist Way Bandy succumbed, then the celebrity hairdresser Suga, then the model Gia—and so many talented, irreplaceable others in the fashion industry.

The week before "In the American West" opened at the Amon Carter Museum in Fort Worth, Dick said to me, "I'd really like for Bob to be there. I think it would be good for our relationship if someone who had never even heard of me could see my adoring public in action. I'll get him a room in a hotel in another part of town. And if anybody from the studio or anything asks who he is, I'll just tell them the truth—that he's the lawyer who drew up the contracts for the museum tour." Dick proceeded to blithely ignore Bob at the opening. And when I said to him, "Talk to Bob!" he ignored *me*.

Normally Dick would go to Bob's place, a starter apartment in a postwar building on First Avenue in the Nineties. By the time I got to work in the morning, he would be back in the studio, having his breakfast upstairs. Early one flex Friday in August I was heading for the country, driving up First toward the Triborough Bridge, when I spotted Dick hurrying out of Bob's building. Something told me to steer clear of him—not to pull over or even honk.

Not once in the years they were together did Dick include Bob in his professional or social life. By the end of the eighties, Bob had had it. What he wanted was to step out from the shadows, into the sunlight, and be officially acknowledged by Dick. At one of our tête-à-tête lunches he told me that he was prepared to give Dick an ultimatum: whenever they went to the theater, or traveled somewhere together, they would have to sit together—and Dick was going to have to agree to meet his parents. I said, "Bob, I hate to tell you this but it's never going to happen."

The night Bob finally got to have his say, Dick called me from a pay phone on his way home from dinner. "This is what I was afraid of," he said. "I'm about to lose the most important person in my life, and there's not one thing I can do about it." I was divided—I felt for Dick as well as for Bob. It was the Dark Ages as far as widespread acceptance

of homosexuality went, and Dick feared that his embracing Bob pub-
licly would be not only bad for business but disastrous for his relation-
ship with his son.

The cutoff with Bob was sharp, but not acrimonious. Eventually
they were able to enjoy an occasional theater date (sitting together!). In
1992 Bob met an age-appropriate partner—a psychiatrist named Mike
who was doing research on eating disorders and worked at Columbia
Presbyterian and taught at Columbia Medical School. "We would all
three of us go out to dinner," Bob says, "and some of his books Dick
would inscribe to both me *and* Mike, which always made Mike feel
good. Dick was so happy for me that my Mike was a doctor. We had a
share in a summerhouse on Shelter Island and he invited us to come
by Montauk for an afternoon. He gave us a nice lunch and we got the
grand tour up and down the rocks."

When, after knowing each other for only a year or so, Bob and Mike
decided to "informally commit to each other," Dick had a cake made
with two meringue grooms on top (much later the couple would marry
officially, in California). The celebration took place in Dick's kitchen
on a Saturday afternoon when none of his assistants were around. "He
took a snapshot of me and Mike and the wedding cake with his Kodak,"
Bob says. "I put it on my bookshelf where it's the first thing I see every
day when I get into the office."

When Bob opened his own law practice in 1996, Dick said to him,
"Pick any print you like," Bob recalls. "I didn't have to think twice: I
not only liked, I *loved*, that photograph he did for the cover of *Égoïste*—
two Cirque du Soleil clowns looking like they were trying to walk in a
windstorm. He printed it especially for me, so it's a one-of-a-kind
item—it wasn't till later that he decided to print editions of it. I possess
one other Avedon. About three years before Dick died, I was on the
committee for a GLAAD fundraiser and I asked him to donate a photo
for the silent auction. He gave me the one that had run in *The New
Yorker* of the board of directors of Friends in Deed. But, I mean, who
would want *that* . . . in their *home*? It didn't sell, which I never told
him, so I bought it myself, at the reserve price, and I had it nicely
framed. The frame cost me as much as the photo."

I asked Bob what he felt he learned from Dick. "I guess to always

have a bottle of champagne on ice and a bottle of vodka in the freezer," he says, laughing. "But seriously, aside from opening my eyes to a lot of great literature, Dick always gave me terrific business advice. I'm mainly a corporate entertainment lawyer, but I have also personally represented some really difficult Broadway stars and he would coach me in how to handle them. I really miss Dick." To this day, Bob emails me touchingly every May fifteenth: "Happy Dick's birthday!"

Bob was one of the first people I called when Dick was rushed to the hospital in Texas that late-September day in 2004. "I'm a realist—I knew the odds were I'd never see him again," he says. "His son called me later that afternoon. I had passed him on the street once and recognized him from pictures that Dick had up around his living space, not that I was there all that often, and frankly, they looked alike. Later I was introduced to him for a second at the Amon Carter opening in 1985, and again for a second at the opening of Dick's portraits show at the Met in 2002. Anyway, there he was, on the phone, the day Dick went down, and he had his business hat on. He wanted to know what impact his father's incapacitation could have on the real-estate transaction I was handling for him—Evelyn Avedon had died about six months previous and Dick was selling her U.N. Plaza apartment. I explained that if Dick expired we would have to wait for the transfer of certain papers before being able to close any deal. He died a week later, on October first, and we sold the place before Christmas—it was an unremarkable transaction, everything went very smoothly."

Dick and Bob had a theater date for the week after Dick died, to see Mandy Patinkin in concert. Dick had already seen Mandy's one-man show at least thirty times, no exaggeration—when he loved something he could never get enough of it. "He had taken me to see Mandy the night before 9/11," Bob recalls, "and afterward he took me to that Russian restaurant and piano bar he loved, Samovar." Mandy was one performer Dick felt he could always learn something from. He explained it this way: "He's a different Mandy every time I see him. That's how he's able to keep it alive for himself and the audience night after night. I know how hard that is, whether we're talking about a theatrical performance or a photographic sitting. Or an erection, for that matter."

Next to Mike, Bob had been the love of Dick's life. Yet not one of

Dick's close friends was even aware of his existence and, as Alan Hollinghurst astutely noted in his Man Booker Prize–winning gay novel *The Line of Beauty*, "People take it very personally when they find they've been kept out of a secret." When Dick's affair with Bob ended, he was only in his sixties, yet never again did he enjoy a physical relationship with another human being. "For me," he declared, "work is an equally ardent form of arousal—it's photography that gets me up in the morning."

Dick went on playing it straight till his dying day. Despite having lived into an age when what he could never accept in himself was largely accepted, he still felt the need to hide in plain sight. I was therefore stunned when, one day shortly after 9/11, he announced to me that he was considering coming out. "I'm sick and tired of living like this . . . repression isn't good for the heart," he said. "I'm a very lonely little person. Everybody thinks they know me, but nobody *really* knows me." That was true enough: Dick drew everyone out and never let anyone in. "I'll be doing it for Bob, too," he said. I said, "Dick, just *do* it."

At the time, he was grappling with the problem of which pictures to hang in the defining final room of his upcoming portraits retrospective at the Met. He had decided to place John Cheever in that pantheon, and he read me these lines from the writer's journals: " 'I was determined not to have this love crushed by the stupid prejudices of a procreative society. Lunching with friends who talked about their tedious careers in lechery, I thought: I am gay, I am gay, I am at last free of all this.' " When I responded, "That's great," he said, "Not so fast! There's one additional line: 'This did not last for long.' You *see*! You can feel free for a minute, and then for the rest of your life everyone's calling you a faggot."

Poor tortured Dick. He was simply too consumed by homosexual shame to turn the key in his self-made prison lock. His mindset, it must be remembered, was from a time when you could be ostracized, blackmailed, and even arrested—not to say murdered—for homosexual acts conducted even in private. He also still had his son and his wife to consider. He said, "The skeleton stays in the closet—I just can't do it. Let somebody else do it." And then he looked at me: "*You* do it, after I'm gone."

"You do it": something more easily said than done. During the five

years that I ran the Richard Avedon Foundation I had to officially pro-
tect the Avedon image and brand. Once I stepped down, I agonized
over whether revealing Dick's homosexuality would be an incitement
to critics to reinterpret his work—color it all lavender. In the end, in
deciding to write about him in his totality, I chose to be guided by Dick
himself, who had said to me, "The best portrait is always the truth."

11

DARKROOM RIVALRY

———

WHAT DICK LONGED FOR, DESPITE HIS PROTESTATIONS to the contrary ("I want to be free of the wear and tear of having to deal with a domestic situation . . . I'm married only to my work"), he knew he could never have: the everydayness of an open, loving relationship—what he liked to call the kitchen of life. He had tried it twice, with Doe and then Evie, but he was working with the wrong ingredients and ended up merely playing house.

In Dick's eyes, the perfect marriage was the one enjoyed by Irving Penn. "I'm jealous," he told me. "Not envious—*jealous. Green.*" From the moment Penn had laid eyes on the Swedish beauty Lisa Fonssagrives, in 1947, on the set of his celebrated *Vogue* sitting "Twelve Beauties: The Most Photographed Models in America," she became the focus of his life—Penn Central, as it were. They married in 1950, a couple of months after she had starred as his model at the Paris collections (the year before, she had graced no less than the cover of *Time* as "the new goddess of plenty"). Lisa became an essential part of Penn's creative as well as his emotional life, collaborating on some of his seminal fashion images, including *Mermaid Dress* and *Woman with Roses on Her Arm.*

The couple's legendary domestic happiness aside, what continued

"A COMMUNITY OF TWO."

to hit home with Dick was the fact that Avedon and Penn, as aestheti-
cally diverse as they were, had become professionally inextricable. And
for Dick, the field of photographic fame they shared was not big enough
for two.

Comparisons are always invidious. Olivier and Gielgud. Beckett
and Pinter. Hemingway and Fitzgerald. Tolstoy and Dostoevsky. Pi-
casso and Matisse. Ali and Frazier. Paris and London. Apples and or-
anges. Fire and ice.

Avedon and Penn are as un-comparable as they are incomparable.
And as distinguishable as hot from cold, night from day.

They are, as Penn once pithily put it to Avedon, "poles apart."

The two of them began photographing the Paris collections—and,
often enough, the same dresses—at the same point in historic time:
Avedon for *Harper's Bazaar*, Penn for *Vogue*, in the mid-1940s. They
also took portraits of many of the same cultural luminaries. "It was like
a never-ending contest—I was always looking over my shoulder," Dick
told me. "But the competition was beneficial to us both—we could
never get complacent about our place in the sun. The standards Penn
set, in composition and proportion, were exhilaratingly high—you

couldn't catch your breath up there in his stratosphere. I was going in the exact opposite direction—I made straight for the emotional deeps. I used the surface to get under the skin, while Penn made exquisite sculpture that was cold to the touch—icy, if you ask me."

Dick had the perfect anecdote to illustrate the difference between him and Penn. They had run into each other in Paris in the late sixties, when Dick was working with Lartigue on Lartigue's book and Penn was on assignment for *Vogue*. As it was the last day in town for each of them, they arranged to share a car to the airport. It was the time of the student uprisings, and at the intersection of the rue de Rivoli and the feeder street to the Pont Neuf the vehicle was stormed by a group of revolting youths, some of them brandishing torn-up paving stones. The driver blurted out a word that needed no translation: *"Revolution!"* "I leapt out of the car with my camera, but Irving stayed put," Dick said. "When I looked back he was cravenly closing the windows and locking the doors."

One of Dick's abiding beefs was that Penn had been accepted by the art world a full generation before he even began to be. But Penn had credentials Dick didn't, and a head start: before Dick even surfaced from the depths of the Merchant Marine, Penn had graduated from art school and tried his hand at painting, as well as worked in graphic and industrial design. To the art snobs, Dick was too high-profile, too flashy—easy to pigeonhole as just Fashion and Advertising.

By the time he became Penn's colleague at *Vogue* in 1966, they had both been shooting stars for so long that, according to Dick, "there was no need to shoot at each other." And yet . . . and yet . . . During a 1964 Design Lab workshop that Penn was conducting in lieu of Brodovitch, whose assistant he had once been, he witheringly dismissed *Nothing Personal*. "It's a book which I think nobody but Dick Avedon would have *wanted* to do," he said. "I think it's probably the pressure of Revlon ads that produced that book." He then accurately predicted that it was going to be a "financial disaster on a very serious scale," despite its adorning "every coffee table in Paris."

He told Dick to his face that there were portraits in the book that he considered "cheap" as well as "cruel," singling out the one of a vacant-looking, bleary-eyed ex-President Eisenhower, unrecognizable minus

his five-star grin. In Penn's opinion, Dick had clearly taken advantage of a fragmentary moment in order to make a point at his helpless subject's expense—"almost what the newspapers do when they show the gangster or the dope addict with his eyes half closed every time the flash goes off"—whereas he, Penn, always tried to find "something timeless" in the person he was photographing. Dick's unassailable riposte was that that was his own truth of the moment—no matter that it might not have been Eisenhower's. "The face that moves *you* is the face to photograph," he maintained, adding that a photographer was "nothing but a machine *unless* he editorializes." Penn himself, Dick pointed out, was no stranger to editorializing.

Penn spoke with undisguised distaste to the Design Lab class of Dick's "strong taste for high living—someone told me that he and Baldwin mapped that book on a yacht in the Mediterranean." "It was just going to be a little cabin cruiser, but the day before we were set to embark, it sank, same as the book would," Dick told me. "Instead I went with Jimmy to a Freedom March meeting for Americans in Paris held at a nightclub called the Living Room, and that same night I told him about Mike and me, and those bug eyes of his got even bigger. He said, 'I hope you're going to tell the world.' I told him, 'Bad for business. I don't want to queer the pitch.' He laughed—he knew I meant the advertising pitch."

Dick got his own back with Penn by poking mild fun at his deadpan images of cigarette butts, the subject of his 1975 solo show at MoMA, describing them as "the most emotionally powerful photographs I think I've ever seen . . . apocalyptic, intense." They had been received with incomprehension, suspicion, and hostility by most critics, the maddening exception being Dick's *New York Times* nemesis, Gene Thornton, who hailed them as works of art. Dick, however uneasily, recognized them as such himself, and later purchased all fifteen from Marlborough, each one the number-one print (an example of his canny collecting). They remained in his possession until his death.

In the 1978 *Newsweek* Avedon cover story, Penn brushed Dick off as "the greatest of fashion photographers." He further described him as a "seismograph" and a "wonderful reporter of what is in the wind . . . what's in vogue . . . the latest thing, the next thing . . . a wonderful re-

corder of what's what . . . Much more powerful [than me] in setting the pace of our times." What Penn neglected to add was that Dick's renditions of what was out there were never at the expense of what was *in* there: he was able to have it both ways.

But if the two shooting stars did indeed shoot at each other, they never actually shot each other. At least, Dick never photographed Penn. "He wouldn't have wanted me to—I would have wanted him rumpled, a bit of a mess, and he would never have stood still for that," Dick mused. "I mean, the last thing I was going to do was take a Penn of Penn. As far as I know, the only name photographer he ever posed for was Karsh, and that sort of says it all."

Newsweek had commissioned Penn to take Dick's portrait for the cover. When Dick saw the picture, he dissuaded the magazine from using it, on the grounds that Penn had made him look "too poetic, almost godlike." He then proceeded to take his own portrait. (After printing it in both color and black-and-white, he compared the two images in the mirror and concluded that the black-and-white was the more striking, "less Karsh-and-Bachrach-like," but then went ahead and picked the color one—it was bound to be "more of a standout" on the newsstands.)

Penn had also been assigned by Alex Liberman to take Dick's portrait for *Vogue*, in connection with the opening of the Avedon fashion retrospective at the Met. This time, Dick was determined to call the shot. The day before the sitting, he spent the better part of an hour studying himself in the bathroom mirror, making faces and rehearsing poses and gestures. But then as he walked into his living room he was jolted anew by an image on the wall: the surreal circa-1865 *Game of Madness* portrait of the pathologically vain Countess de Castiglione, of which he owned one of the only two early prints in existence (Dick had purchased it directly from the brilliant French stage designer Christian Bérard, an early Paris subject of his). The countess is holding a small oval picture frame around one of her eyes, the better to accentuate it, and this gave Dick the idea to focus on just one of his own—he covered the left side of his face with his hand and came running into my office to try it out on me. "It's a perfect parody of a Penn portrait—he's going to love it," Dick accurately predicted.

"Penn kept excusing himself to go to the john," Dick recalled of the sitting, adding, "I had noticed a crust of Kaopectate on the corner of his lip." Dick was relieved that his rival had the runs—it was prima facie evidence that Penn had been even more nervous than he was.

Seven years later, in 1985, to promote Dick's Western show and book, *Vogue* ran five pages of the photographs accompanied by a Penn portrait of Avedon. In this one, Dick also had his hand over one eye, and around the other was a colossal lens. "A parody of a parody of a Penn," Dick pronounced it.

In 1993 *Vogue* again assigned Penn to take a portrait of Avedon, for an article heralding the opening of Dick's Whitney retrospective (as a way of "burying the lipstick with Anna Wintour," who five years before had rejected his three cover tries, Dick had consented to an interview with the veteran journalist Dodie Kazanjian). The day of the shoot Dick had a stomach virus—gallingly, it was *his* turn to take Kaopectate, though he made sure to leave no telltale trace on his lips. He asked me what he should wear to the sitting, and I suggested the beat-up-looking shearling coat that he practically lived in. It was quasi-historic by this point: he had had Marilyn Monroe put it on over sequins, and, another time, over nothing; he had talked Judy Garland into posing in it, too, after he'd finished shooting her for Blackglama. But Penn preferred to photograph Dick wearing just his work shirt.

"I kept taking my glasses off and putting them back on," Dick reported after the sitting. "And my hair was a total mess for some reason. I was going to sweep it back with my fingers so it would look leonine— this was for *Vogue*, remember. But Penn, aware of my objection to his *Newsweek* photo, said he wasn't interested in doing another pretty-boy picture of me I wasn't going to like." Dick loved his latest Penn portrait: "He took a great Avedon of me—I look ravaged, like a French Resistance fighter."

That, however, was not the image Anna Wintour had envisioned. She didn't think Dick looked good enough, and she offered a reshoot (her wont, it would seem, where anything to do with Dick was concerned). Dick told her to run it, and took the occasion to ask what *Vogue* had against age. In her editor's letter some twenty years later, Wintour acknowledged that Dick's remark had started her thinking.

"[He] certainly made me question my attitudes and assumptions about the aging process, informing how we tackle the subject year after year in ways that are meant to be empowering and uplifting," she wrote, adding, "As for me when I look at Penn's Avedon portrait today, I see only a magnificent lion in winter."

There were always photographers swarming around Dick eager— anxious—to take his picture. "I fight other photographers' cameras," he said. "I have it down pat. I push my glasses up to my brow and I try to look absolutely expressionless; I want a photograph of me to reveal nothing. I effectively efface myself. Until that last Penn, practically no-body had ever taken anything but a fashion photograph of me. It took Penn to bring me forward. Which is funny, because he usually does the opposite: he squeezes his subjects into those goddamn constricted cor-ners—he *pens* them in. That's his way of capturing them."

Dick and Penn had once enjoyed regular Sunday-morning phone conversations in which they collegially discussed their work. But by the early 1990s their fellowship had been reduced to a single catch-up meal every winter, from which Dick would inevitably return to the studio out of sorts. "All Irving ever wants to talk about is how awful the clients are, how he hates all admen—his word for them is whipper-snappers," Dick reported. "I told him, 'Irving, you should get down on your knees to them like I do.'" Another time, Dick was annoyed by Penn's touting of Alex Liberman as a genius. And another, when Penn mentioned how much pleasure he got out of handling his platinum prints, which he made himself—"they're so soft, it's like stroking a puppy." I said to Dick, "What's wrong with that?" He said, "You know I've never liked dogs."

For all that, whenever Dick's eye lit on a certain photograph above his living-room mantel, he felt a genuine sense of friendship and affec-tion for both Penns. In 1976, while out walking with Lisa in Paris, Penn, who for his found-object series had spent a great deal of time looking in gutters, spotted a dead bog mouse in one and, mindful of how much Dick had admired his 1947 photograph *Still Life with Mouse*, took a picture of it for him. Upon his return to New York, he made an exquisite platinum print for Dick, pressing the negative di-rectly onto the palladium paper (it remains the only print of the image

in existence: one of one). Dick prized the photograph not only for its velvety voluptuousness but for its provenance—it had originated in "the Paris that Irving and I had in common."

Penn had earlier made Dick a gift of his 1951 portrait of one of the legendary writers Dick had met on his first trip to Paris ("Cocteau presented me to her and she in turn introduced me to Proust—his work, I mean"). Dick felt that, of the legion of portraits taken of Colette, Penn's was the only one that lived up to Cocteau's indelible description of her: "Between the dust-cloud of her hair and the scarf knotted around her neck, set in that triangular face with its pointed nose and its mouth like a circumflex accent, were eyes of a lioness at the zoo who becomes the audience instead of the show, watching those who watch her, with folded paws, and a sovereign disdain." It was a photograph—taken, literally, on Colette's deathbed—that Dick felt "you could spend a lifetime looking at." (I know what he meant—I own a print of it myself, and every time I pass it on my landing I stop and stare in wonderment.)

The differences between Avedon and Penn can be framed as follows:

Avedon maintained that the least important part of photography was the camera and that he wished he could take pictures just with his eyes, whereas Penn stated, "I myself have always stood in awe of the camera; I recognize it for the instrument that it is, part Stradivarius, part scalpel."

Avedon never played ball; Penn as a boy dreamed of becoming a professional baseball player.

Avedon retained his full head of hair to the end; Penn had long since lost most of his, but was taller.

Avedon was voluble, self-dramatizing, and seemingly open; Penn, reticent, formal, and bottled-up.

Avedon was hyperkinetic; Penn, still.

Avedon was full-throatedly arrogant; Penn, seemingly modest.

Avedon basked in the limelight; Penn avoided it.

Avedon courted advertising clients; Penn could take them or leave them, preferably leave them.

Avedon was a people person's people person; Penn admitted that he

wasn't "completely comfortable taking pictures of people," as opposed to objects.

Avedon operated out of a far-flung five-story brick carriage house on the Upper East Side, with six bathrooms; Penn worked out of a suite of rooms in an office building on lower Fifth Avenue, with the bathroom in the outer hallway. People referred to Penn's studio as "the hospital," owing to its frosty-white walls and his insistence on silence. Avedon's studio was a hotbed of activity, often centered around a hot plate.

Avedon was interested in everything; Penn, in his own runic words, only in "the thingness of the thing."

Avedon, Penn observed, liked to "reach a high point very fast on the curve," while Penn, Avedon observed, liked to slow the process down "to his own, deliberate pace" and wait the sitter out.

Avedon had Alexey (Brodovitch) for a lifelong mentor; Penn had Alex (Liberman).

Avedon made his early mark in fashion by making pictures that had narratives and were action-packed; Penn's fashion photographs were plotless and pared-down. Avedon expressed his models, having encouraged them to express themselves; Penn stated, "I don't think the girl's personality should ever intrude in a fashion picture."

Avedon, in a word, was about life; Penn, in two words, about still life.

PETER GALASSI: Those guys! Those poor guys! They were just fated to end up in the same sentence all the time. What a horrible burden for both of them. Each of them deserves his *own* sentence.

I worked for John Szarkowski at the Museum of Modern Art forever, first as an intern in 1974–75, and in 1991 I finally succeeded him as chief curator. John was a testosterone giant, and he and Dick had a difficult relationship—it was just bad chemistry. And of course John was devoted to Penn, which didn't help matters any—he gave Penn shows, including a major one. All you had to do was mention John's name to Dick for the fur to fly.

I happen to love the picture Dick took of John in 1975—the vertical portrait where his seersucker jacket is draped casually over his arm and

he's got his eyeglasses in his hands and he's looking away from the camera. At that time, John was at the height of his career and just full of beans, and actually very funny, but Dick made him look like he was about to commit suicide. It was clear to me that Dick was beginning to equate serious photography with getting people to look depressed. Because after that, everybody in his pictures started looking the same—at least that's what it looked like to me. Whereas Penn went on evolving.

Look, I never gave Avedon a show myself. I didn't think it was necessary—he had had so many. The one show John did give him, in '74, was the eight photographs of his father, which I think are very powerful and moving. Of course they were controversial—photography has this matchless capacity to disclose intimacy in a brutal public way. But I don't see that as being morally incorrect. The intimacy is part and parcel of the meaning of the work, and you judge a picture on whether it's artistically successful or not. I remember that Gene Thornton review very well. I don't know how someone that shallow and boneheaded ever became the photography critic for *The New York Times*. And he wasn't the only dumb one—it was a big club.

OWEN EDWARDS: I was interviewing Avedon way back in 1973 for an article for *New York* magazine, and we were talking about Penn, and he said, "Well, yes, Irving lives out on Long Island and he's semi-retired." And of course it wasn't true at the time. And in fact it was *never* true—Penn worked right up till almost the end. Maybe Dick, with his phenomenal energy and incredible work ethic, equated Penn's phlegmatism and contemplativeness with semiretirement; maybe *anybody* who worked at a slower pace than Dick did would have seemed semi-retired to him. Years later, Penn told me that when he read what Dick had said about him in my piece, including that he was "the greatest and the last of the Victorian photographers," he just gritted his teeth.

The title of my article was "Blow-Out: The Decline and Fall of the Fashion Photographer," which was the tack that Clay Felker, *New York's* founding editor, had insisted I take. The minute I met Dick I realized that that was not going to be an argument I could persuasively make. He was my first encounter in my long career of writing about photography, and that would be akin to someone writing about physics and their first

interview is Stephen Hawking. I took everything he said as gospel. He was profoundly charming, never mind the contradiction—if he wanted you to think something, it was hard not to. When I got to know him better, I saw that he was an artist who operated in an ancient political tradition—he was someone who would have been entirely at home in the Florence of the Medicis or the Versailles of the Sun King. There was nothing he didn't weigh in advance or, if he was taken by surprise, couldn't quickly turn to his advantage. And he made it all seem so natural. I think Penn was truly fascinated by him—the way a Martian might be by a Venusian.

Penn once told me that Alex Liberman had considered him uncivilized and sent him to Paris the first time so he could figure out which forks to use. Dick, in contrast, seemed to have been born with a worldly air.

Together Avedon and Penn represented an age we'll never see again. I don't think there has ever been anybody like either of them not only in fashion photography but also, and more important, in portrait photography. Penn was more like a Renaissance painter—like Bellini— and Dick was more like Caravaggio. They worked entirely differently, and they had very different personalities. They were both Jewish, of course, but Penn, you could say, was the WASPy one and Dick more the noodge. Both of them were enormously pleasing to be around, Penn in a rather more formal way, and Dick—well, he could captivate you, pull you into his gravitational field in three seconds. It goes without saying that both of them were immensely intelligent, and I've always held that the greatest photographers were the most intelligent ones.

PENELOPE TREE: In my humble, or rather, arrogant, opinion, Richard Avedon was the greatest photographer who ever lived, and I'm not just saying that because he discovered me. I love every single era of his work—he never stopped astonishing me.

Penn thought I was a total joke. He actually said that to Dick, who couldn't wait to tell me—I'm not sure confidence-keeping was Dick's greatest virtue. But then, in all fairness to Penn, there were a lot of photographers who thought I was a freak, that I looked like a bug—a

praying mantis. Or something out of *Close Encounters of the Third Kind.*

Working with Dick was likc having a love affair—only better, because it was between our two psyches. It was always so sparky when we were together. Then I went with David Bailey, and learned that it's probably better not to work with your lover—he and I certainly did our best work together after we stopped being together in that way.

DAVID BAILEY: Dick paid me my first professional insult—he said, "David Bailey is a Penn without ink." He said it to one of those poncy newspapers like *Women's Wear Daily.* It was kind of a weak joke, but in a way I was flattered, because it meant he had noticed me. I mean, for Richard Avedon to say something like that for publication, he had to have been a bit worried about David Bailey. A little later, but still fairly early on, he asked to shoot me, but when he said nude I said no.

Avedon had gotten there first with Penelope, and I thought his photos of her were absolutely great. But I had gotten there first with Shrimpton, and when she made the move to him, I didn't mind, because it was a great move for her. Jean was quite difficult, by the way. It was a myth that she was shy and overmodest—a myth that grew up because she sometimes used her shoulder-length hair to hide her face in public. Anyway, we're still friends: all my ex-girlfriends and ex-wives I'm friends with. I got there first with the Chanel commercials of Deneuve, too—hell, I was married to her—and when *he* began doing them, I was happy for her. Why wouldn't I be?

I had originally met Avedon in New York in the late sixties, at the house of Goddard Lieberson, the president of Columbia Records, and his wife, the ballerina Zorina—that was the royal court in New York. I'm not going to say I didn't get a kick out of meeting Richard Avedon. A short time before, John French, a photographer I'd briefly worked for, had taken me to see a revival of *Funny Face,* which I just thought was a bit of icing on the old fame cake—the same way my being associated with *Blow-Up* was for me.

I used to see Avedon in Paris, too—at Dior. He was by far the greatest fashion photographer of all time, and I say this as someone who himself shot eight hundred pages of *Vogue* editorial in a single year.

After which, by the way, I decided I never wanted to look at another fucking dress in my life. I also prefer Avedon's pictures of people to Penn's—Penn's are too emotionless for me. I knew Penn better, because when I first started out we both used to shoot in the *Vogue* studio in Paris. I can't remember now who it was who said Penn's studio was like a cathedral and Bailey's was like a nightclub. And Avedon's? I guess you could say a playground or a summer camp.

I had some Avedons at one point. Nureyev gave me five of the ones Dick took of him, including the famous foot. I gave them all away—to, I don't know, models and different people if I liked them. Definitely to someone called Pat Booth. Do you remember Pat Booth? I think I gave her two. You know, they were only photographs—in those days they had no monetary value to speak of. I've still got at least twenty good Penns. I got them from Hamiltons, where we both showed. When the gallery wouldn't pay me what they owed me, I used to just take the Penns off the wall.

CARMEN DELL'OREFICE: The first time I laid eyes on Irving Penn, he hadn't even been mustered out, he was still in his American Field Service uniform, with his little doughboy hat and the short jacket—a real Yank. I was part of a still life he was doing, along with a melon, a butterfly, and a shoe. He said, "Now my little Carmen, you must be utterly still, try not to even blink." Penn knew my mother needed the money, so even if he was only going to be using me for an hour or two, he would book me for the whole day, which added up to thirty bucks, the monthly rent on our cold-water fifth-floor walk-up—we didn't even have a telephone. The last time I worked for him was about forty years later—an ad for Nikon. I was in the hospital recovering from an operation when he called, but I got right up and left, with the stitches still in me, because nothing was going to keep me from doing a job with Penn.

The last time I worked with Dick, it was for a commercial, too. Sometime in the nineties. One of those big studios, with a cast of thousands. The minute he walked in, he made a beeline for me. Now, you have to understand something—he had gone off me completely when I married my second husband, Richard Heimann, a fabulous fashion photographer that Eileen Ford sent me to who I ended up totally sup-

porting. Dick had only recently started talking to me again like a human being, because I had remarried wealthy.

Penn I had always had a human connection with. Back when I was just a kid he was worried that I was too skinny—he said he wanted to build me up. He had a cot just outside his cubbyhole, and he would make me lie down and rest; then he would come and pull me up to go get dressed for the sitting. Beaton and Blumenfeld, too—they nurtured me. I never got any of that from Richard Avedon, which is why, although he and I had this very long story line, when I heard that he'd died I felt nothing in particular.

GARREN: I did the hair for both Dick and Mr. Penn on the Versace campaigns they each did. Gianni showered them with freebies. For Dick he even made something *sua misura*, a short shearling coat, and Dick sent it back because it was tan, which he didn't think was chic. Gianni then made it for him in black, with a mink lining, and *that* Dick wore all the time.

But, I mean, Mr. Penn—what was *he* going to do with a Versace outfit? I was in his studio when he was thumbing through a catalogue, and he asked me what I thought he should pick. I told him to take the navy-blue cashmere blazer, the gray flannel slacks, and the crew-neck sweater. When they arrived, they were way too big. Being that I'd been schooled by Polly Mellen, I had some tricks up my sleeve: I got some pins and I tapered the jacket, adjusted the shoulders, marked where the sleeves needed to be shortened, and fitted the pants on him. And then I went out and got some plain buttons to replace the flashy ones. Penn was just in awe of my process. I told him, "Now I'm going to take them to my tailor for you, and it's on me." Well, he wound up wearing that jacket and those pants into work every day, then he changed into his blue jeans and work shirt, then put them back on to go home. I even saw him in this outfit at art openings, including his own. This was of course before he began photographing the Issey Miyake ad campaigns in the mid-eighties, which he went on doing right up to the millennium. And he actually wore Miyaki—Penn was finally getting the hang of fashion!

DAVID ROSS: Penn had been *the* photographer for Estée Lauder campaigns for years: all those incredibly beautiful still lifes on glass shelves that everybody remembers, all the Clinique stuff. So when I became the director of the Whitney Museum, where Leonard Lauder was the head of the board, people were really surprised when Avedon was the first major exhibition, the first show of any kind, that I put on the books. Leonard said to me—in his own way, of course, because he never would have presumed to tell any director what to show—"You couldn't do Penn?" Don't get me wrong, I thought Penn was a wonderful photographer and a great artist, but I didn't, and don't, think his career had the emotional range, the over-the-top passion, that Dick's had.

BARBARA ROSE: I used to think that those photographs of his father dying were his most important body of work, because there he really tried to feel something. I don't think he was ever fooling himself—*he* knew that he was essentially anesthetized. But he *wanted* to feel—he wanted desperately to be able to—and he just couldn't. And there's a lot of pathos to be found in the combination of his inability to feel and his desperation to feel. He had a wall around him, and a moat around the wall.

I reviewed the MoMA show for *Vogue,* and my article was titled "Fathers and Sons: Breaking the Barriers of Isolation." I remember making the decision to suspend judgment and believe what he kept saying to me about those photographs—that they showed his love for his father. But of course that was bullshit. He had simply decided that these were the pictures he was going to use to finally get respected like Penn. These were the ones that were meant to prove that he was a profound and feeling person—they were to be his legacy as a great humanistic artist. Of all his series of photographs, they're still my favorite—they're phony, but they represent the limit of what he could do, and he could just never outdo Penn.

I met Dick in the late sixties through Alex Liberman, whose protégée I had become—he thought I was just this scintillating thing—and later I wrote the art book on him. He was *another* person of strange

sexuality. Because I don't think Dick ever came to terms with *his* sexuality, whatever it was; that was just *too* much to contemplate, he couldn't even begin to entertain that idea. I actually thought he was interested in *me* at one point—he told me I reminded him of his French girlfriend, whatever her name was. He liked very smart women, obviously. But I wasn't interested in *him* that way in the slightest—sexually he was just not compelling.

Jittery was my first impression of Dick—he had manic energy, he kept looking around, and I thought, Why is this famous guy so nervous? His opportunism was just out of sight. When I could be useful to Dick, which I learned was all it was ever about with him, he was my best friend, and when I had no more power, in his eyes, he disappeared from my life. It was always around the time of one of his museum shows that he would decide to let me be his friend again. I took it very personally, because I liked him—unlike most people, who either loved him or hated him. He did take a glamorous picture of me for *Vogue*, but it was a commission from Alex, who was trying to turn me into a personality. By the way, Alex used to complain to me that Dick had this insanity about money—the incredible amounts he was always demanding.

I found Dick intellectually seductive. He was one of the smartest people I ever met—brilliant, probably a genius. But he was not a great artist. Did all the museum shows really convince him that he *was* who he wanted to be? I don't think so. I think that the absolute center of his dilemma was that he knew exactly what he was as a photographer, compared to Irving Penn, and he couldn't stand it. *That* was his tragedy.

PETER GALASSI: Dick's tragedy—well, maybe *tragedy* is too strong a word, but let's use it as the placeholder—has nothing whatever to do with Penn. The tragedy is that Richard Avedon was a really great commercial artist, and I don't mean that in a negative way, who wanted to be Diane Arbus. His "In the American West" series is a very large transparent failure *because* it's him wanting to be her.

DEBORAH TURBEVILLE: He would always say, "You have to have your influences, everybody starts from them, and then you take it from

there, you *push* it." In 1970, he said to me, "This is the year of Arbus, but she better watch out, I'm going to get her, I'm going to get her good."

PETER GALASSI: Why couldn't he have been satisfied just doing what he was absolutely great at, which was the fashion stuff and certain of the portraits? They were both basically made for the printed page, but they were also brilliant on the wall. The fashion work with all the movement, from the mid-forties right up through Twiggy in the late sixties, is an indispensable part of the history of photography. Those pictures were all about excitement, pizzazz, personality—not deep, intimate psychology. Dick misunderstood himself, I'm afraid. In a profound way. He misjudged his greatest gifts and thus ended up misusing them. That's why I said *tragedy*.

PETER MACGILL: Dick may never have had more at MoMA than that small show of portraits of his father, in a small space off the lobby, but he sure had more than his fair share of the high-paying advertising work. Whereas Penn, in 1973, found himself with no commercial work to speak of and had to close his New York studio. Lisa suggested they go live on their farm on the North Shore of Long Island and just be artists. But before clearing out, Penn invited John Szarkowski to come see his recent work. John told him up front that the schedule was booked for the next seven years. By this point in the Penns' move, their apartment had been emptied of everything but two chairs, one of which was occupied by the plates of the cigarette photographs. After examining the third plate, Szarkowski said, "Show!" And the exhibition that resulted in 1975, of fourteen large platinum prints, was the beginning of the deep, rich, supportive history with MoMA that Penn had and Dick didn't, and that culminated in Penn's major retrospective in 1984, for which John himself wrote the catalogue.

When Penn came to Pace/MacGill in '87 from Marlborough, where he'd been since '76, he said, "This is it for me," and I said, "For me, too, Mr. Penn." We represented him exclusively, and I worked with him very closely right up until his death. It was one of the greatest experiences I've had in working directly with a great artist. I called him

"Mr. Penn" into the late nineties anyway, when I presumably became the first person outside of his inner-inner circle who he ever invited to call him Irving. Whenever people new to the game would call him Irving, he would go, "It's Mr. Penn." I never really felt that comfortable calling him Irving, and I don't think I ever did it in front of anybody.

At one point Dick had good regard for Pace/MacGill—notice I said *good*, not *high*. He consigned his great *Rolling Stone* portfolio, "The Family," to us for a summer show we were doing called "Family Pictures." We were careful not to corrupt the portfolio—we hung it like a grid and made sure it was dominant in the gallery. We wound up selling it to the National Portrait Gallery, and that gave us a little bit of credibility with Dick, because it was a very important body of work and we had steered it to the perfect place.

When he was in the middle of "In the American West," one of us approached the other about doing a show. I introduced him to my partner, Arne Glimcher, and it was love at first sight—they were both glamorous, super-successful, incredibly cultured guys, and they knew all the same people. I think that what Dick immediately and expediently saw in Arne was the potential transitioning and transporting of his life's work from a photography to an art platform. And Arne did sincerely see the Western photographs as having a presence much bigger than photography. He and I made a representative selection of forty-five of them during two or three visits to the studio—Dick had said he preferred to stand aside. It was a beautiful exhibition—it opened in our second-floor gallery at 37 East Fifty-seventh Street, our painting floor, which was unheard of—and it got a two-page review in *Time*.

Arne had taken stock of Dick's expectations and promised to try to sell the pictures to his great collectors. And he did in fact promote them to his clients as great works of art that should be hung with other great works of art; and indeed a number of the clients did buy them for Christmas presents. We sold a *ton* of pictures—thirty-two, to be exact. At $14,000 apiece—a very serious price at a time when you could buy a vintage Cartier-Bresson for $5,500 and a Paul Strand for $10,000. We always knew at Pace/MacGill when to push the price—how much we could sell things for. I mean, we sold the first hundred-thousand-dollar

photograph, the first million-dollar photograph, and the first three-million-dollar photograph—we've set all the records.

So with Dick's pictures, we were going like, Holy shit! We'd never seen anything like it. And yet the result radically disappointed Dick. He was upset that a lot of the sales were to the Avedon studio list and that Arne hadn't been able to place more of the work in the hands of Pace's prestigious art clients.

I maintain, by the way, that, contrary to legend, "In the American West" was born not with the photograph of Wilbur the ranch foreman but with the great, ennobling June Leaf photograph wherein Dick created—there's no question about it—a whole new approach to portraiture. My wife and I have that picture up in our house in the country—the big print. And here's something funny: about twenty years ago June spent the night with us, and the next morning our daughter, Mary, who was in kindergarten, was eating her porridge when into the kitchen walked June. And Mary, who had grown up with that picture, did a double take.

It's not often that a dealer has nice things to say about an artist's relationship with another dealer, but Dick's with the San Francisco–based Jeffrey Fraenkel was exemplary—in part because by the time Jeffrey started representing him, at the end of the nineties, Dick was enlightened enough to let good work happen for him. After he died, Jeffrey arranged for Pace/MacGill to do a reprise of the show he had organized at his gallery of Dick's personal collection of photographs by people other than himself, including a world-class group of Peter Hujars and of course the Penn cigarettes that he'd purchased in a group from Marlborough.

ANDREA BLANCH: Penn had his show of cigarette butts at MoMA when I was working at the Avedon studio, and Dick sent me over to check it out for him. The minute I got back he pounced on me: what did I think? I said, "I think it's art," and you could see him just deflate.

SAM SHAHID: I remember seeing Dick at a Penn exhibition at Marlborough—this was before I ever met him, let alone worked with

him. We happened to be the only two people there. I was just a kid going to see a show, but I thought, I'm going to stand here and watch Avedon looking at Penns.

CHRISTY TURLINGTON: Mr. Penn looked through my book and said, "How old are you?" I was sixteen, which after all was a pretty average age to be beginning modeling, and he said very gruffly, "Well, that's very young." He photographed me that day, and we went on to do quite a bit of beauty together over the years. *Vogue* would send him the models they wanted him to work with, and he was generally happy to photograph them, whereas Dick was much fussier—he discovered a lot of the girls himself, and he didn't particularly care what *Vogue* thought of them.

Vogue was very pushy, always. Certainly with us models. They would say, like, "We're holding these days and you're going to work with Steven Meisel," but then they would switch the photographer on you at the last minute, and they would take it out on you if you protested—if you exhibited any free will. Eventually the group of women that I modeled with began speaking up—we emerged as sort of personalities, and we got ourselves some power. The press invented a name for Naomi Campbell, Linda Evangelista, and me—the Trinity.

So: Dick and Mr. Penn. It was, I would say, a healthy competition. Like when you play tennis, you want your partner to challenge you—it improves your game.

FRANCINE DU PLESSIX GRAY: I called him Uncle Irving when I first met him, which was, naturally, through my mother and stepfather, Tatiana and Alex Liberman—I was around eleven at the time. And I never stopped calling him Uncle Irving—you know, playfully. I think he and Dick were on equal footing—I can't say one was greater than the other, and if anyone tried to make me, I would cry uncle. But I know there are a lot of people who would argue that Uncle Irving was the greater.

He and Lisa led a very reclusive life, mostly in the country. He would rush home to her at six p.m. I had dinner with them maybe once during the whole time my parents were alive.

Dick was another story. My husband, the painter Cleve Gray, and I knew him totally apart from Alex and my mother. He was extremely critical of Alex. And vice versa: I remember Alex saying he hated Dick's photographs of his father, which I thought were absolutely marvelous—I couldn't imagine anybody not appreciating them. Alex said he didn't think it was right to show one's parent in decline. A pity Dick didn't live to read my book about Alex and my mother—it's called *Them.*

Alex adored Penn, openly. Dick he secretly admired—I say secretly because Alex knew how little Dick thought of *him.* Alex had a way of charming just about everybody else, he was used to being completely irresistible to people—I mean, Grace Mirabella, right up until he sacked her, was just sort of in love with him.

One of my first memories of Dick is him sitting behind me at the trial of the Chicago Seven, which I was covering for *The New York Review of Books.* Four years later, in '72, we were arrested together for civil disobedience during an antiwar demonstration at the Capitol Building—Cleve and Dick wound up in adjoining cells in the central cell block at Washington's Metropolitan Police headquarters. Dick had gone to that demonstration, number one, because he had strong feelings against the war and, number two—to be truthful—because he knew quite a few people in the upper intellectual elite were going: the Nobel laureate George Wald, Benjamin Spock, Kenneth Koch, Garry Wills, Noam Chomsky, Joe Papp, Felicia Bernstein . . . Felicia—now *there* was a very close friend of Dick's. And of mine. I mean, Lenny was a genius, but it was impossible to keep up with him emotionally, he was so volatile, but Felicia was a rock.

A few years later, when my novel *Lovers and Tyrants* was being published, Dick did a portrait of me for *Vogue,* and he gave me a print. Being Alex Liberman's stepdaughter, I had been photographed by them all, from the time I was eleven: Penn, Horst, Beaton, you name it.

When you live two hours out of town, as Cleve and I did, and you love a friend, you want the whole time to talk when you see them, so you don't go to the theater with them. Dick always cooked for us in his apartment—quite simple things. I considered him as close a friend as Cleve and I shared—what I mean is he was equally our friend. I can't

think of really anybody we were closer to in the last ten years of his life. I learned many things from him—above all, that one could carry fame with grace. He was always the same adorable, affectionate, ebullient Dick with whom I could talk about anything. I was so open with him about everything in my life that almost every time I saw him I found a reason to cry—it was a great joke between us.

Dick was totally open with us about his love affairs. I always just sort of assumed he had had a romantic relationship with Renata. And then, of course, with his lady friend in Paris—that Nicole woman. I met her with him a couple of times and they certainly always acted very enamored. I mean, if *that* wasn't an actual love affair, who *did* he have sex with, I wonder.

He was wonderful with our sons—they remember him with great affection. He felt his own son wasn't amounting to anything, and that was a great source of sorrow in his life. And after he died, didn't the son sell all Dick's personal property at Sotheby's within a year or two? Was he just materialistic, or what? Was it something else?

Dick came to stay with us for a week in August of '78 in the house we were renting on Nantucket. I don't remember him ever holding a camera, he was just cozy and he read a lot. Our sixteen-year-old son, Luke, had just finished a painting of the beach, and Dick bought it on the spot, for twenty-five dollars. Luke's first sale. One night Dick took us to the best restaurant on the island, but he found the atmosphere pretentious and when the Grand Marnier soufflé didn't arrive after forty-five minutes, he said, "C'mon, family, let's go!" We ended up having the most hysterical time at some simpatico bistro. I somehow can't imagine hysterical with Uncle Irving.

RENATA ADLER: Dick admired what Penn did, but he also felt threatened by it. In his mind, and maybe also in everybody else's, there was something absolutely pure about Penn's work. By the way, I was photographed by Penn, in 1970, and he made me look like Maria Callas. But then, nobody ever truly enjoys seeing a photograph of themselves—it's like hearing your voice on a tape recorder.

The competitive streak in Dick extended incredibly far—to virtually any photographer living or dead, however obscure. He once said to

me about Diane Arbus, "I was doing those pictures long before *she* was." Right? And who cares, you know—who cares if it *was* long before? I mean, he was just the bigger of the two. And when Charles Michener's wife, Diana, who worshipped Dick, had an exhibition of people's beds, he said to me, "*I* was doing beds long before Diana Michener." I don't know if he was or not, but this was a little person. The implication was, "I did everything before everyone else." And of course to a certain extent he had.

OWEN EDWARDS: Dick took much greater risks than Penn artistically—he was the more adventurous of the two. For all his discipline, he always seemed ready to try just about anything. He had the restlessness that's the hallmark of a truly great artist. Avedon and Penn were the two pillars of Hercules, really. The biggest difference between them was that Penn stood at a distance from things and Dick stood nose to nose. And that's what makes Dick's pictures somewhat harder to live with, although, unfortunately, I don't live with any. I do, however, live with three of Penn's exquisite platinum prints of cigarette butts, which I bought in the seventies when they were cheap—I think of them as my Rothkos.

One year in the early seventies after Dick had finished doing the Paris collections, he visited me and my wife at the time at our house on the Greek island of Patmos. He arrived with one of the first SX-70s, and he was like a kid, just having great fun with the thing. I've always kicked myself that I didn't, you know, just scoop up any of the pictures he discarded. He spent a lot of time collecting stones on Lambi Beach—what he was doing, of course, was collecting faces in the form of stone. He swiped a few from us, actually—my ex-wife told me that when she saw that *American Masters* documentary on him a good twenty years later, she recognized some of them immediately and yelled at the TV screen, "Those are *our* stones!"

Having Richard Avedon to stay was a big feather in my sombrero. It was like hosting Fellini—suddenly everything was like 8½. Dick was full of superhuman energy, and he energized everybody else. After lunch one day, he said, "I don't think you fully appreciate what a paradise you have here. Tonight's the night of the full moon, and I've made

arrangements to get us up to the highest point on the island so we can dance." At the stroke of seven, a small army of men with donkeys appeared. The beasts were loaded up with baskets of food fit for a feast. And off we went on a long, steep, stony trek to the thousand-year-old monastery at the top, which was almost always empty since the monks were busy leading a fine life down in the town. That night we had ourselves a kind of Dionysian—well, it wasn't an orgy but it was definitely a revel. And Dick was directing it all. Like Prospero, with a magic wand. Penn was Apollonian—I just don't see *him* up there on the heights, do you?

POLLY MELLEN: I enjoyed working with Penn, but I bent toward where Dick went—with reality. Truth to tell, I had a little crush on Penn. I liked to needle him, affectionately. To make Penn smile, to make Penn laugh, made you feel so good. And his forty-five-year love affair with Lisa was enough to make you just draw a deep breath.

GARREN: When I did the collections with Penn, Lisa would usually accompany him and she and I became very close, the way you do when you cut someone's hair. She would say, "I'm ready for my Garren haircut," and I would do it at the *Vogue* studio or else in their suite at the Crillon, of course for free. At some point Penn said to me, because he knew I normally charged several hundred dollars for a cut, "I would like to do something for *you* for a change—just tell me what." I said I would love for him to do my portrait. He got all stone-faced and he went, "I really have to think about that. I work so closely with you I don't know if I could remove myself enough to take a picture of you that would go beyond Garren the hair genius." So the idea went away.

Later, Penn booked me to do Paloma Picasso for a portrait he said he wanted to echo the one he'd done of her father. That day I walked in wearing a long navy-blue cashmere Yves Saint Laurent coat and a blue cashmere scarf and gray flannel pants. He gave me a sweeping look and announced, "Good morning, Garren—I'm taking your portrait today, after we're done with Paloma." My knees got weak.

As soon as she left he said, "Your turn. Shave your head." I said, "Well, um, umm, wow—that's like, you know . . ." I was wondering

how a hairdresser would feel when he looked at himself in the mirror suddenly without hair. And another thing: I had no clippers with me, only women's equipment, because I was there just to do Paloma—I had cut Penn's hair only the week before so I knew *he* didn't need anything done.

When he saw me hesitating, he said, "Okay, I can you tell you're a little uncomfortable with this. So just slick your hair down real tight and we'll see if it works." I got the gel out and got my hair all flat, and then François Nars, who Penn had asked to stay, did my makeup. Then Penn got going. He kept telling me, "Sit up straight. Straighter. Turn your head. I said *turn* it!" I turned it till it felt like it was going to break off. Then he put the beam of light on me exactly where I had seen him put it on Paloma—across one of the eyes.

A couple of days later he showed me four contact prints. He pointed to one and said, "This is *you*, Maestro"—that's what he called me sometimes. And he had a print of it delivered to my house. My mother was visiting and she got spooked by it—she said, "That eye is following me around the room."

The funny thing is, I ended up shaving my head. A long time later. I looked at myself in the mirror and said, "You know something, Garren, Mr. Penn was right."

Dick never offered to take my picture. But then, I wasn't cutting his wife's hair. Although I *was* cutting *his* hair every couple of months or so, before we started a shoot. He told me he felt that I really understood his hair.

JAMES KALIARDOS: I worked on shoots for Dick, starting in 1994, mostly doing makeup but sometimes also hair—when he would introduce me to the sitter he would say, "James can do anything." He always built me up. And he trusted me to cut his own hair, his beautiful silver hair. He liked it to look lush. His hair was really important to him—look, Dick was a hot sexy man, like up until the day he died. He gave me a print of Nureyev's foot to thank me for all the haircuts I gave him.

I worked a lot with Penn, too. For *Vogue*. Weird pictures. I did the makeup for his famous 2001 photograph of the candied fruit all over the face of the model with the bloodshot eye. Usually he would make

a little sketch for me, but that day for some reason he just said, "Go for it, James," and I did—I really went to town. He plastered that picture on the cover of one of his books, and it wound up in the collection of the Museum of Modern Art.

The most artistic makeup I ever did for Dick was for his portrait of John Galliano in 1999, for *Égoïste*. I painted Galliano as his own shadow—I contoured his body in black, and I silhouetted the face as well. It was Jungian—Dick and I had discussed the concept a bit beforehand. The image went viral in 2011 after Galliano went on that drunken anti-Semitic tirade in a Paris bar and was suspended by Dior— I remember him back at Dick's disappearing into the bathroom a lot. And speaking of *Égoïste*, Dick confided something romantic to me. I had been photographed by Annie Leibovitz for a couples story for *Vogue*—me and my boyfriend at the time, Nicolas Ghesquière, the head designer for Balenciaga. He lived in Paris, and I was having to fly back and forth all the time to do jobs for Dick, so when that story on Nicolas and me came out Dick left a message on my machine: "*You* now know what *I've* been experiencing for years—that love across the ocean is just as strong." The reference was clearly to his French squeeze.

These days almost every job I go to, the photographer comes with a layout or an idea that originated with Dick, sometimes something he did like sixty years ago. I was in his studio the day he saw the cover of *Vanity Fair* with Annie Leibovitz's photo of some big celeb with a colony of ants or flies crawling around their face. It was a total steal of his Bee Man, and he was horrified. He said to me, "When it's Penn who gets ripped off, they say it's an outrage; when it's me, they call it an homage."

SAM SHAHID: Grace Coddington was working for Calvin Klein in advertising when I was the art director of Calvin's in-house ad agency, and one day on a shoot she asked Penn if he would sign one of his books for her boyfriend, Didier Malige, the hairdresser, if she brought it in the next day. He said sure. So, hearing that, I brought in one of *my* Penn books and at lunchtime I got him to sign it. Then Grace produced this big shopping bag that was bulging at the seams with books. Penn just stared at it for a long minute, and then very deliberately

signed the bag, which was just so brilliant of him. Whenever any of us asked Dick to sign his books for us, it was always the more the merrier.

Calvin was always very nervous about Penn—freaked out, even. He would say things like, "Maybe the bottle for my fragrance isn't beautiful enough for him to photograph." I happened to be with Penn, by the way, when Dick called to congratulate him on his photograph of that bottle, and after they hung up Penn said to me, "My God, he got carried away—it was just a product shot. But you know, Dick is much more emotional than I am."

CALVIN KLEIN: I bought some Penns at Sotheby's or Christie's and he actually called to thank me—he said, "You paid more than anyone's ever paid for one of my photographs at auction." Between us, it wasn't all that much.

I've had a few Avedons, too. One disappeared. *The* one, you would have to say—*Dovima with Elephants.* I had it in my bedroom when I lived over on Fifty-ninth Street in the early eighties. I never knew where things went—there were a lot of people in and out of my apartment in those days, and all of a sudden one day it just wasn't there. I guess Avedon was more popular, because none of my Penns ever went missing.

SAM SHAHID: Dick was not a big one for giving you things, but he did give Calvin a black-and-white Audrey Hepburn, I think the one with the polka-dot hat. Calvin had it in his office for a while, but then he put it up for auction, and Dick found out and was pissed.

RENE RUSSO: For me, Avedon photographs transcend Penns. There's just something about them—they're light, they've got a spiritual quality to them. Penn didn't have Dick's compassion *at all.* The one time I sat for Penn I fell asleep, and he would never work with me again. If *I* had been that photographer, I would have looked at that—child, really—and thought, Maybe she's having a hard time. Because I *was.* In those days I was asleep even when I was awake—a walking zombie. Dick, on the other hand, saw that I was in trouble, and he was very fatherly with me.

He had spotted a little picture of me in a Clairol group ad in Beverly Hills and had Revlon fly me to New York. My mom—a single

mom, God bless her—drove me to the airport with my red cardboard suitcase with big Xs in electrical tape all across it so I would know it was mine. It was freezing cold in New York and I didn't even have a coat when I walked into the Avedon studio carrying all that baggage. I was crying, I was afraid of everything. He said, "Why the tears?" I said, "Well, I've never been to New York, and the cabdriver was so rude to me . . ." He said, "Forget it, you're perfect."

CINDY CRAWFORD: My first time with Dick was an all-day shoot, and it was like being in the presence of royalty. The first thing he did was make me see how important it was to have a thought. He kept saying, "Get a little idea in your head, Cindy." You see, the reason even his head-shot covers were so dynamic was because he wouldn't tolerate a blank stare—hollow beauty just didn't do it for him. And I use that little trick of his to this day, especially when I'm doing a head shot. After practically every click I look away from the camera, and when I turn back it's with a different thought in my head. I mean, it's not all that hard—you can think about the guy you're dating, or a pair of nice shoes that you saw. It can be absolutely anything—the readers will never know what it is—just so long as your eyes are saying *some*thing.

I actually remember what I was thinking that first day with Dick. It was 1986 and I had just come to New York from DeKalb, Illinois, having had a long professional relationship with the photographer Victor Skrebneski in Chicago—that was my training ground. When I broke the news to him that I was leaving town, he told me I was making the biggest mistake of my life—he insisted he was the only photographer who could make me look good. And so when Richard Avedon was shooting me for a *Vogue* cover try, the big thought in my head was, Take that, Victor! I walked out of the studio not knowing if I was going to get that cover or not, but feeling good anyway.

I did at least twenty shoots with Penn. We talked some, yeah, but it wasn't really what I'd call chitty-chat. He had a vision and if he told you to put your arm out, you had better leave it there till he said it was okay to move it. You were more like a coat hanger for him, a mannequin. Yeah, a still life.

MARISA BERENSON: Whenever I set foot in Penn's studio it felt like I had entered a church—a temple, I guess I should say. After every session, I would call Diana Vreeland and plead, "When can I work with Dick again?" and she would go, "Someday over the rainbow, Marisa. For now I'm liking the way Penn photographs you better—crisp, clean."

MIKHAIL BARYSHNIKOV: Mr. Penn photographed me when I was doing *Metamorphosis* on Broadway, and also we had mutual friends, including Alex Liberman. With Mr. Penn I talked photography more than I did with Dick—Mr. Penn was more about the process.

With Dick, it was always more about people—what Jerry Robbins was doing, what Twyla was up to . . . We traded Astaire stories. I told him how, when I was asked to say a few words about Fred when he was receiving his American Film Institute award, I quoted what Ilie Năstase had said about Björn Borg, "We're playing tennis, he's playing something else," and then I said, "*I* dance, but Fred Astaire . . . I don't know what he's doing, but it's something else." He came over to my table afterward to shake my hand and thank me.

When Dick photographed me, he zeroed in on my fingers, of all things. I later got to photograph *him*—but, again, *I* take photographs, what *he* was doing was something else. I mean, his single-image portrait of Stravinsky is, for me, the equivalent of an in-depth biography. Mr. Penn was a genius and a giant, too. They were both monsters of perfection.

CAMERON STERLING: A couple of days after I started interning at the Avedon studio, an assistant came running up to tell me, "The red light on line four is Dick talking to Penn!" We both thought, like, Wow! Legend to legend.

CARLYNE CERF DE DUDZEELE: There was a special phone in Dick's studio to connect him directly to Alex Liberman. Like a Batphone. You dialed four digits—an extension. And Mr. Penn, he had the same. A red phone. Like between Washington and Moscow.

Mr. Penn said to me, "Carlyne, please, can I ask you something?

Don't call me Mr. Penn, call me Penn." And I said, "Mr. Penn, I can't."
I always felt there was something sad inside Mr. Penn. He told me the
story of how Alex had sent him once to Africa to take pictures of two
flowers, and how always he could go to Paris at the drop of a hat, and
all this he was telling me in a way that said maybe he wasn't enjoying
himself so much anymore.

I shot many times the couture with Mr. Penn in Paris, and not once
did he take the Concorde. Dick took it always, because he liked fast.
Mr. Penn flew with his wife in first class because he liked it slower, and
he stayed always at the Crillon, never the Ritz like Dick, because it was
less Hollywood. He would eat a lot at the Russian restaurant Domi-
nique, where he told me he used to go when he was young—I was so
touched by his *simplicité* I would cry. *Simplicité* is the most sympa-
thetic thing in the world, no? I cried a lot with Mr. Penn.

MAŁGOSIA BELA: I never got to actually work with Mr. Penn. I was
sent to his studio for *Vogue*, and the fashion editor Phyllis Posnick put
a strange Yohji Yamamoto dress on me and a huge Yohji hat, and when
Mr. Penn saw me he made a face. I thought he was going to ask me to
change into something he liked, but with Mr. Penn evidently you got
only one shot—if he didn't like what they put on you, you were out the
door. Phyllis told me, "Now you have to go and say, like a good girl,
'Goodbye, Mr. Penn, and thank you very much.'" So I did that, but
with tears in my eyes because my ego was hurting me.

When I got home I found a message from my agency saying that
Mr. Penn wanted to talk to me right away. I thought, I am already so
mortified, how much worse can it get? I called his studio, and he had
left already for the day, and so I had to sleep with that. The next day I
was working with Steven Klein and they put this black makeup on me,
and on my break I called Mr. Penn. He said, "Ah, it's you! From yester-
day. You know, when you were leaving, you had a look on your face I
didn't like. I didn't like it for *your* sake—it was the look of a trapped
animal. Now let me give you a little piece of advice—you mustn't take
these things so personally. I didn't like the dress, that was all." It was
beautiful of him to do that. My makeup was running in a black river
down my cheeks I was crying so much.

The first time I went to Richard's studio was for a casting. And I took a copy of *In the American West* for him to sign. My legs were shaking because I had never really felt much like a model and I was terrified he was going to see right through me. I had my modeling book with me—I had done a Jil Sander campaign, and a Versace with Steven Meisel the year before. Richard said straight off, "I don't want to look at your book, I want to look at *you.*" Then he told me, "You're not really a model," and my heart sank. But then he explained what he meant by that—that there was much more to me. So naturally I fell totally in love.

The casting was for Égoïste—five girls. He sent the other four home, one by one, till it was only him and me. And when I was leaving he gave me a book on the Countess of Castiglione, and also his incredible *Alice in Wonderland* book, which he signed "For Małgosia, born too late—but not too soon."

We did a Harry Winston shoot, and he let me pick the music. I went through all his CDs, and found the Dusty Springfield where she sings that old Burt Bacharach song "The Look of Love." It became *our* song, Richard's and mine. He played it every time I came to the studio, and that was a lot—we did Club Monaco five times together. The last time I saw him he told me that there had been beautiful girls for him before me, but "never a Małgosia." He told me that I broke and healed his heart at the same time.

Richard was a fantastic psychologist. He was always giving me very useful life advice. I happened to be in Paris in 2000 when the all-Avedon issue of Égoïste came out, and he invited me to a drinks party in his honor at the American embassy, hosted by Madame Rohatyn, the wife of the U.S. ambassador, and then to a very private dinner afterward at the apartment of some Rothschild organized by his lady friend Nicole. I ended up spending the whole evening talking with a very important publisher who was very old, compared to me—in his late sixties, at least. He asked me where I was staying, and by the time I got back to my hotel, there was already a letter from him. He wrote something like, "It was love at first sight. I didn't think it existed. And yet now it has happened. This is my cell number—I await your call." The letter was so romantic, so *French*. But basically what we call in Polish *lanie wody*—bullshit. Still, I was thinking of calling him just to say thank you

for thinking of me but no thank you. Because, with my upbringing and education, that was how you responded.

The next day I was seeing Richard—he was staying with Nicole, in her apartment—so I asked him if I should call the guy. He said, "If you go to the trouble of calling to say no, he's going to think that what you really mean is yes. But you might actually want to think about this a little more—he's someone you can probably learn a lot from. Maybe it's worth a shot." Nicole also was saying that I could maybe get something out of it—meet famous people, go fancy places. But I've always been someone who would need to be in love.

It was Richard who told me to audition for the Actors Studio, and I ended up doing five movies. But in 2004 I decided to go back to Poland and finish my M.A. at the University of Warsaw. When he died, later that year, I felt such emptiness that I decided to write my thesis on him—I felt I had to do it *for* him. It's called *Richard Avedon's Art of Photography: A Case Study,* and it includes my own experiences with him, but in highly academic terms. Mr. Penn is mentioned only in passing, since that was all that my one little encounter with him amounted to.

You know who I work with now a lot? Tim Walker. What an amazing photographer! Did you see in his latest book, *Story Teller,* how many pictures there are of Małgosia inside? He inscribed it, "To a true collaborator in emotion." Something Richard might have written. When Tim told me he had once been an Avedon assistant, it made total sense. The pictures he creates are like the Bee Man—something fantastic from the vectors of the imagination.

KELLY LE BROCK: Dick motivated me into a place I don't think I could have gotten to otherwise, and he was right there *with* me—*in* the photograph. The first thing I ever said to him was, "I'm rude, crude, and vulgar." Which was something Mrs. Mulligan, the matron of my English boarding school, had said to *me.* Anyway, it made Dick laugh. I was like the class clown. He picked me to be one of the effete trio of Diors in that crazy ad campaign—I was "The Mouth." Working with him was like being back in the playground.

I was good at my job—when I showed up, that is. I wasn't going through a very good time in the crazy eighties, I was hanging with the wrong crowd. Dick got me a big advertising contract, but then they couldn't find me to sign it: I wasn't taking calls, I was taking drugs. The company wanted to move on without me, but Dick told them, "I'm not doing it with anybody but Kelly." He stuck his neck out for me in so many ways. I always knew that if and when I made it to the studio he'd take care of me. If I didn't seem well, he would say, "Okay, Kell," and send me upstairs to go sleep in his bed. That little monk's bed. It was so beautiful of him to share it with me when he wasn't in it.

The day he photographed me and Iman for Revlon I had the worst hangover of my life. I had bumped into her the night before at Studio 54, and now here we were, standing in *Dick's* studio, in our red chiffon dresses, with these big stupid pink flowers in our hair because the campaign was called "Revlon in Bloom." We were just wishing we were dead and swearing to God we would never stay out late again. And then that night we ran into each other again at Studio.

I was working with Penn a lot as well. He made me do it myself; he wasn't going to lift a finger to help me get there. And God, was he strict! We were shooting something for *Vogue*, and I was kind of not paying attention, not doing my job, and he came over to me until he was literally in my face, and he slapped me. His hand . . . it was like a quick breeze. It woke me right up, and he got his shot. I mean, I understood where he was coming from: I was getting paid to do this—not a whole lot, mind you—and I was there with a master and just not engaging.

NAOMI CAMPBELL: I was always on my best behavior with Richard, because I didn't want to get slapped. Because if you acted like a prima diva, he slapped you, and that is all I will say. So on the set I always toed a fine line—and remember, I used to be a dancer.

He would come into the makeup room, and if I was getting my calls out of the way he would be like, "Put that phone back in your bag!" One of the things I loved is he would always want me to tell him what was going on with everyone, like with Christy and Linda. And I would ask *him* things—like what was the Stork Club like, tell me about all the

eras. I mean, he'd shot everybody on earth. I couldn't get over all the history. I loved working with Richard, because I prefer direction to freestyle—I want to be told where to stand and how high to jump.

Penn let me pose how *I* felt I looked best. One day in the studio he surprised me with the gift of a platinum print. I would dearly love to have had even a Polaroid from Richard, because an Avedon Polaroid is like gold, but I was too afraid to ask. I don't know of too many girls who got one. I think Stephanie. Maybe Linda. I do have one Avedon. It's of Nureyev—a nude. And I had to buy it. I wanted a Nureyev because of my dance background, and because I had met him once, on the Concorde.

Richard photographed me nude, too. For his first Pirelli calendar, 1995. It was a closed set, so I felt safe. He said, "Just trust me," and I always did.

SAM SHAHID: One time we were shooting Naomi for Bally, and Dick had just gotten her into the most gorgeous position, and I couldn't help going, "Ah, God! Genius!" He stopped what he was doing and turned and glared at me with fire in his eyes. I had heard stories about how he'd thrown people out of the studio for less. Joe McKenna, for one, and even Donatella. And they had only been whispering.

Well, every photographer has his own way of operating. With Bruce it was the same old Janet Jackson record all the time, and there was all this craziness going on, right? I mean, hysteria! And with Penn there was dead silence, you didn't dare draw a breath—God forbid you sneezed.

INGRID DROTMAN: When I was working in Mr. Penn's studio, I once giggled about something and he put his finger to his lips and went "*Sshh!*" He wanted us to speak in whispers, and my expressing pleasure for a second in his presence he took as some sort of terrible affront. The other big difference between him and Dick was Mr. Penn relished printing—he brushed every print himself. Dick referred to the darkroom as "the dungeon"—he made you bring the prints up to him.

ADAM GOPNIK: Dick once said to me, "I could teach you everything I know technically about photography in less than twenty minutes—

the fundamentals." He publicly admitted that he didn't know the pre-
cise difference between a 30mm, a 50mm, and a 90mm lens, and that
he couldn't even read a strobe meter. He maintained that he could
take as compelling a picture with a Box Brownie or in a Fotomat as he
could with his Deardorff or Rollei. The claim was an exaggeration, to
be sure, but it was the emotional truth: he didn't value technique at all.
In fact, he felt it could be a dead end.

CAMERON STERLING: In the middle of my unpaid internship with
Avedon, the possibility of landing a paying job assisting Penn came up.
I sat down and made a little list for myself of the pros and cons of work-
ing in each studio: "AVEDON: the pluses are I enjoy the people I work
with; and the facilities and resources are great. The minus is more stu-
dio upkeep with twelve-plus people and five floors. PENN: the pluses
are less studio upkeep—fewer wastebaskets to empty and lightbulbs to
change—and more responsibility, thanks to less people. The minus is
the slower pace."

Then Dick offered me an actual job, and I jumped at it.

ORIBE: I worked with Mr. Penn doing hair, and I traveled with Mr.
Penn, and Mr. Penn, if he liked you, would eat lunch with you, and if
he didn't like you, he would steer clear of you. Me he liked.

If you did something Mr. Penn didn't like, he would say, "Oh, okay,
that's fine," and then walk out. My friend François Nars, the great
makeup artist, once said to him, "I'm not going to make her up like
that," and Mr. Penn said, "Very well." Then he went and lowered the
light and shot the girl in the dark. He was very like that. You couldn't
go against him. I was scared of Mr. Penn. I wasn't scared of Dick.

Dick you could challenge—he wanted you to challenge him, he
didn't like it if you felt stifled. He made you feel that it was *your* picture,
too. He was into teamwork.

Mr. Penn and Dick, they both liked hairstyles to be a little on the
weird side. But with Dick, the weird was more obtainable.

Nobody I worked with, and I worked with them all, had the pa-
nache of Dick. Annie, well, she needs to go to finishing school, what
can I say. Stay out of her eye line—that's the trick. Helmut was a mon-

ster, he yelled at everybody—I couldn't wait to get out of there. When you left Dick's studio you couldn't wait to come back.

GARREN: Something Dick sometimes did that Penn never did was show you pictures from his archive to inspire you—Deneuve maybe, or Bardot or Twiggy or Sophia Loren. I was never one to feel crushed if I'd spent hours doing great hair for Dick, with maybe even something surprising happening with the bangs, and then all of a sudden he wants it spritzed down to make the model look like she's just come out of the water. Or, God forbid, he wants a hat on the head—a baseball cap or a beret or something. A couple of times after I'd put a fall on a girl and gotten her all teased up, he said, "The hair's taking over the picture." I would say fine, and I would take the fall off, brush the hair out, maybe squish it a bit and move it around with my hands till the girl became real-looking. Sometimes he would tweak her hair himself, but that would have nothing to do with how it looked—it was to pull her in and focus her attention on *him* again.

With Dick, in contrast to Mr. Penn, it was always a group effort. I remember one advertising sitting we were doing for an African-fabric house, and Dick had the idea to use Iman. He said, "Let's bring her *home.*" He said he was remembering the day in the mid-seventies when Peter Beard brought her to the studio, claiming to have discovered her walking through the African bush, and she was dressed to the teeth in ethnic. So from that, I got the idea to do her kind of Zulu. The texture was wild, and Dick was wild about it—he said, "Now tie turbans in there." Ariella had done the makeup like war paint, and Iman was going, "Make this side of my face more orange, make the other side more yellow . . ." She looked like a macaw—gorgeous. And we had gotten there thanks to collaboration. Mr. Penn, on the other hand, was about deliberation—with himself.

Sometime after Dick died, I got booked to work with Annie Leibovitz on a Tina Fey *Vanity Fair* shoot. Tina came out on the cover with my hair, but looking ridiculous because Annie had styled her as a majorette when, I mean, she'd gotten famous from doing Sarah Palin. But you can't mess with Annie—too much ego there. The night before the shoot, her assistant had faxed me the address of the studio Annie was

renting, and I'm like, Mmm, this seems familiar. And then the next morning when my taxi pulled up in front I was like, Oh no . . . it *can't* be . . . this is not right . . . this is *wrong*. Then I thought, Well, maybe the studio has been renovated, or stripped out. But the new owner hadn't changed nothin'—the dressing room, the lunch table, even the refrigerator was the same. The only thing different was Annie had put up her own pictures on one side—her tear sheets. And on the facing wall there were Avedon work prints. I am now totally freaked out, I'm having a real anxiety attack. And Annie is actually saying things like "There's a presence here" and "I feel his presence."

I finished the day, which I can without exaggeration describe as the single worst of my professional life. She tried to book me for the next day, 'cause she couldn't get her picture. But that's Annie for you—she can't ever get it the first time around. She should have stayed in her own backyard, because at Dick's she was doing it ass-backward—toward the door—and she couldn't get the light. And she turned that studio upside down *trying* to get it.

RUEDI HOFMANN: All Penn cared about was the image. With Dick, it was more about pushing to be first—to break ground, break barriers. A big Dick first was when he got that astronomical salary to go to *Vogue*, at a time when Penn was probably only getting the $2,500 cover rate. Somehow I don't think Penn would have minded being first in *that* department.

JEFFREY FRAENKEL: I visited Mr. Penn in his studio the afternoon of October 14, 2004, two weeks after Dick died. He was reminiscing about the day Alexander Liberman, to whom he had been so close, called him to his office, which was uncharacteristic because when he wanted to see Penn they would usually get together for lunch. Penn knew something was wrong when he walked in. Liberman was brief and to the point: Avedon was coming to *Vogue*. Penn was stunned and humiliated. He didn't say a thing, turned around, walked out of the office, and roamed the city late into the night. "That was the day my life began," he said—the day he realized he had to have a professional life outside of *Vogue*. And that's when he began to travel and make the

now-well-known pictures he didn't think he would've made if he'd not been asked to share *Vogue* with Dick.

DODIE KAZANJIAN: Alex's bringing Avedon in didn't mean Penn was out or anything drastic like that—in fact he increased Penn's annual guarantee to two hundred pages. It was just that Dick's arrival was going to change the balance. And it was true that nobody had ever gotten the kind of money Dick was getting at *Vogue*—a million a year or something, and this was 1965. But let's not forget that Penn's dedicated studio was being essentially underwritten by Condé Nast, which was a deal—and a big deal—that no other staff photographer had.

Penn and Alex were a great creative team. The former wouldn't really have been possible without the latter. Alex not only suggested ideas for Penn's still lifes and fashion pictures, he sketched many of them for him. And Penn trusted Alex to make the choice from his contact sheets, whereas Dick and Diana Vreeland simply sent Alex *their* choice. Dick's being hired by *Vogue* had all been Diana's doing. She needed him, he was part of her vision for the magazine: they were going to cook it up together, the way they had at the *Bazaar*. Alex of course finally had to rein her in. I remember him saying, "The horse was running out of control." It was time, in other words, for Grace Mirabella.

GRACE MIRABELLA: Penn was so much more up my alley: think the three Cs—calm, cool, and collected. He was a perennial seeker of truths. And Dick was always just nonstop Dick—a royal pain. The minute I replaced Diana, in 1971, he invited me to lunch, during the course of which he interviewed *me:* was I really up to the job and did I realize that he would accept only the best assignments? Arrogance at this level was something new to me, but anyway, thanks to Alex and eventually to Dick himself, we were able to move along.

Shortly after I married Bill Cahan in '74, I received a communication in the mail notifying me that I had won a prize: I could take my pick of four well-known portrait photographers to do a picture of my husband and me. One was Karsh, but we would have to hie ourselves to Canada for him; another was Helmut Newton, for whom we were going to have to go all the way to Paris; another was Victor Skrebneski,

and he was in Chicago; and then there was Richard Avedon, who was basically around the corner. It suddenly dawned on me that this was Dick's prankish way of offering to take our portrait as a wedding present. And he did do some wonderful pictures—I'm still thrilled by them.

One of the things that always galled me about him was that whenever he photographed a personage like Princess Grace for us, or even just a supermodel, he would submit, along with a couple of choices, an array of runner-up prints that he had very aggressively cut into pieces. I thought that was a terrible thing to do, given the quality of *all* of his photographs, but if it had been just work he was making for himself, that would be up to him. However, it was work he was doing, and being lavishly paid to do, for *us*. At some point I felt I had to put my foot down, but when I did, he stepped on my toes. Everything always had to be his way.

DAVID REMNICK: There was a great difference between Avedon and Penn not only in their temperament but in their way of working. Penn had this Vermeer-like sense of if I only make fifteen photographs in my life, it's okay. Not that Dick was a short-order cook, but with him there was this kind of effulgence—there was a desire for all *kinds* of success in his work. And he loved the fact that he was operating out of this carriage house with all these gifted kids, who wanted to be *him*, running around. Penn I don't think could have stood that sense of disorder for twenty minutes. At *The New Yorker*, it was very clear to me not to screw around in *those* waters—the only Penns I ever really ran were things from his library archive, like Alfred Hitchcock in a corner. We published one or two of his archival shots, and I don't know that Dick loved that.

LINDA EVANGELISTA: Penn was a great master—the model always came out looking totally objectified. But here's an interesting thing: growing up in St. Catharines, Ontario, I worked two or three jobs at a time in order to buy clothes and fashion magazines, and I would cut out *Vogue* covers and Revlon and Versace ads and put them up on my bedroom wall—I had absolutely no idea who had shot them, so it's

just very telling that not a one turned out to be a Penn, they were all Avedons.

My first experience with Dick was a *Vogue* cover try. He made me feel right at home with his enthusiasm. The stylist was Carlyne Cerf, and she was having a very hard time getting these heavy blue earrings to stay on my ears. In the end she used Super Glue, and I modeled a blue jacket with these big blue balls glued to my ears.

My boyfriend bought me the most beautiful antique full-length mirror from the auction of Dick's stuff. So I get to see myself all the time in Richard Avedon's personal looking-glass. It's a little like seeing myself through his eyes.

VERUSCHKA: With Dick I could always propose the idea of how I wanted to appear. Penn was someone Veruschka could never in her life have gone to and said, "I have an idea"—I had to have nothing to say to him when I went to a sitting. I come from the arts, so that was hard, almost impossible—I need to be able to have a voice. And *he* usually had nothing to say to *me*. His attitude was I should just pose in the clothes and take the money and go—I might as well have been a bottle. In one Penn you see only the back of my neck—of my face, nothing. When he showed it to me he said, "This looks *nifty*, don't you think?" *Nein!*

The last picture Penn did of Veruschka he did specially *for* her. Around 2008 I had the idea he should photograph me like a painting, so I could hang in the gallery in Bavaria with portraits of my noble ancestors. I had in mind to wear a very beautiful black dress, with shoulders open. He said, "Yes! I like that. I want you severe and disturbing." I said, "Can we put a little bit of light on my eyelids, because that will look so good in black-and-white—what do you think?" and he answered, "Bullshit." I laughed, you know—"bullshit" was so funny coming from *him*. He said, "I want pale-blue baby powder," and his assistants, they all told him, "That doesn't exist, Mr. Penn—only in white." So they went out and got some, and he threw it all over me. And after it was over, he held my hand, and it was a little bit the feeling of this was the last time.

The last time with Dick, he invited Veruschka to his studio, he said he wanted to discuss with her a book he wanted to do on his great muses—he mentioned also Jean Shrimpton, Penelope Tree, Anjelica Huston. We sat around his apartment looking at some of his pictures of me and talking deeply, about the old creative times. I think by then he had almost gotten over being horrified to be called the best fashion photographer, but it had taken him so long. He said it was a terrible crime that his most beautiful pictures of Veruschka hadn't always been the ones that got published, because in advertising the biggest consideration was of course the dress. He said, "Veruschka, know that we could have gone so much further and so much deeper than we did." Then he hugged me goodbye and I walked down the stairs, but when I got to the bottom I had this strange feeling and I looked back up and he was standing there looking down at me *so* seriously, with those eyes. No words— there was nothing we needed to say. And a few months later he's dead. It makes Veruschka even today a little bit melancholic, you know.

PETER MACGILL: Penn and Dick's relationship was up and down and hot and cold. To be perfectly frank, it was pretty much Ice Age for most of it, although I think they were ready to put down their battle-axes at the very *very* end.

JEFFREY FRAENKEL: It goes without saying that Avedon and Penn had a complicated relationship, that there were periods of difficulty. In 1994, at the time of Dick's retrospective at the Whitney, he arranged for the museum to let Penn in early one morning to see the exhibition before the museum opened. Penn didn't like the show, and when he came downstairs Dick and Norma were waiting. He tried to say something honest but not offensive, he told me, and he felt he'd gotten away with it. But not long after that, at a party at Si Newhouse's, some woman he was talking to asked him what he thought of Dick's exhibition. In reply he found himself telling her a story, an old Swedish tale, about a man walking alone through the woods who comes across a woman so beautiful he can't help embracing her, but as he wraps his arms around her he discovers that she "has no ass." That, Penn explained to the

woman at the party, was what Dick's exhibition had felt like to him. Just then, he heard from somewhere behind him "*I beg your pardon!*" and when he turned around Dick was standing there. Dick insisted that Penn repeat the story to his face, after which he declared, "I've never been so insulted in my life," and walked around the party repeating it to anyone who would listen. Penn said that, after that, they didn't speak for a year, and that he felt bad about it, "but what could I do?" Then one day he got a call from Dick, who said simply, "Let's move on," and invited him to dinner at his apartment. Dick cooked. Penn said it was a good dinner in every sense.

MARIA MORRIS HAMBOURG: I had this wonderful, unbelievable moment when I was chief photography curator at the Met: I had Penn and Avedon shows at just about the same time—Penn's 2001 show of the female nudes he'd photographed in 1949 and '50, and then Dick's big portraits show the next year.

Each of them was the ultimate professional. Privately, of course, their lives were vastly different. Penn had that storybook marriage, and Dick didn't have the good fortune to have a wife who was solid enough to carry through. I had a personal relationship with Penn and I miss him, but it wasn't a patch on what I had with Dick, which was a true friendship that enveloped my whole family.

I'm writing a book now on a small, particular cut of Penn's oeuvre that Dick will come into: the body of work that Penn made in 1948, in Europe, working with a young editor at French *Vogue*, Edmonde Charles-Roux. It started out with his taking portraits just in Paris, and expanded to Milan, Rome, and Naples, where he photographed Italians reemerging after the disaster of the world war. Dick also went to Rome, as well as to Sicily, during this postwar period, and I'm going to contrast Penn's pictures of life in those teeming streets with Dick's. Dick of course created, fabricated, and staged his pictures, which amounted to theater, or scenes out of movies or the circus—Zazi the toothless street performer and the man on stilts and so on. Penn's were more about trying to find a way to control something that was intrinsically uncontrollable. For Dick, the setting was perfect, but for Penn it

had to have been sheer misery, because after that, with very few exceptions, he worked only in the studio. The impossibility of Italy had taught him that it was in the studio that his needs could best be satisfied and his gifts served. The contrast between Penn and Dick in this regard was very dramatic.

PETER MACGILL: I put the question, What would twentieth-century photography be without those two? For sure, it wouldn't be what it is. The axis of the two of them was just extraordinary—they were a community unto themselves, a community of two. Penn's career was longer: he lasted, by which I mean lived, longer than Dick. And he did more *stuff* than Dick—he was more prolific. When you look past Penn's fashion, there are the still lifes, the cigarettes and the street material, the dead flowers, the food, the tradespeople, the tribal people, the archaeology and underfoot series, the cultural figures, the movie stars, the fleshy female nudes, the animal skulls . . .

Also, technically there was no comparison between them. Penn not only made each and every one of his platinum prints himself, he mixed the chemicals and brushed the coating on the paper—he even made his own paper. He was able to achieve incredible tonal range, experimenting in the lab in his barn in Huntington, Long Island. He quit making prints only after Lisa died, in 1992—he told me he couldn't bear being in the country for those prolonged periods of time without her. By chance I'd been the first person who arrived to comfort him the day she died. I hugged him, and he said, "Don't squeeze too hard, the drops might all come out."

Penn had his last show at Pace/MacGill in 2008, the year before he died. I had persuaded the curator of European paintings at the Met, *the* great Vermeer and Rembrandt scholar, to write the introduction to the catalogue, and that pleased Penn a lot. The exhibition was called "Vessels," and it consisted of ten superb gelatin-silver still lifes of the ceramics that he and Lisa had collected in Europe. One of the images, a vessel that was cracked and on its side, struck me as a sort of Penn self-portrait in extreme old age.

He was a great warrior and he worked till just about the end—when

he saw that maybe he couldn't take a next step artistically, he retired. Dick, on the other hand, pushed himself over the edge—he died actually working.

LIZZIE HIMMEL: As someone who knew Dick since the day I was born—he was a very old friend of my parents, Paul Himmel and Lillian Bassman—and as a working photographer myself, I want to say how much I hated the installation of the posthumous 2012 Gagosian-downtown show of his murals. Anyone with the slightest knowledge of contemporary photography would have recognized as a total Penn thing the reverse-triangle walls with the sharp angles that had been built to separate the space by David Adjaye, the English architect du jour who designed the installation, at I can only imagine what cost. It was deeply creepy for me to find some of my favorite Avedons trapped in—locked into—those claustrophobic Penn corners. It's unconscionable for a serious art gallery to alter how an artist wanted his work to be seen. Dick would have had a fucking fit.

TWYLA THARP: I was not prepared to go to the Gagosian—I didn't need to see for myself how badly they curated it.

BILL BACHMANN: John Avedon came over to me at the dinner after the opening and said, "Bill, tell me the truth—you were my dad's right hand for so many years—do you think he would have liked the way these pictures are hung?" I tactfully replied, "John, I think your dad would be happy that this show has brought together so many of the people in his life, including the two of *us*—happy that you and I are standing here sharing this moment."

JOHN POST LEE: It was one of the most beautiful shows I've ever seen. I felt that the gimmicky installation actually worked—it definitely competed with the material, but in the end the material won in a big way. To my eye, Dick's photographs, displayed the way they were, reached the threshold of great Renaissance painting and sculpture—Donatello, Piero della Francesca . . .

DR. ROBERT MILLMAN: There's no question that Richard's greatest nightmare was Irving Penn. Richard was great, but he didn't appreciate *how* great he was—he rated himself only the *second*-best photographer in the world. He would say to me again and again, "I'm more famous, but Penn is *really* an artist—this guy is really fantastic." I would have to champion him to himself, which I was in the perfect position to do, as both his analyst and his friend—I would reassure him that his work was getting stronger and deeper all the time, more profound, more important. And *still* he would say, "No no, Penn is really better." One of the running arguments we had was that he dismissed all of his advertising work out of hand, and most of his fashion stuff. I would argue that Shakespeare was commercial, and how about Dickens, who wrote as much as he did because he got paid by the word—and hey, *they* were both pretty great, too, wouldn't you say.

12

ASSISTED LIVING

———

I COULD NEVER HAVE WORKED WITH PENN. I NEEDED NOISE and laughter, and being in on everything. I needed a nut like Dick to crack me up, not a monitor to keep me in check; a maniac to fan the flames, not a fireman to put them out.

Dick's studio was always staffed to the hilt: a receptionist, an office manager, an in-house archivist, an art director, a full-time accountant, a housekeeper, print spotters, and assistants, speaking of which . . . Over the decades, he overworked, underpaid, and to a greater or lesser degree exploited—but also exponentially encouraged and inspired—a schoolful of aspiring young photographers. We were constantly being bombarded with résumés. Kids would often simply show up on our doorstep, with their cameras around their necks, their portfolios in their hands, and their tongues hanging out. For Dick, the ideal helper was someone who had—Brodovitch's undying expression—elbow; who was a Jack, or Jill, of all trades, and could make lunch as well as construct props; who would beam when asked to perform the most menial task (every assistant starting out would begin the workday by sweeping the sidewalk in front of the studio); who had a veneer of culture and a "look" of some sort (tall was not a plus!); who was outgoing off-set and invisible on; and who was prepared for his life to cease to be

his own. Assistants not only had to report to work early but might be called upon to stay late (on occasion all night). And Dick didn't believe in weekends, and paid mere lip service to holidays.

Before getting to meet Dick, applicants had to pass muster with the studio manager, who himself would have risen from the ranks. Dick never needed to see a résumé—he could tell at a glance not only who someone was but who they had it in them to become. The decision to hire or not to hire was therefore often made the minute Dick laid eyes on the aspirant. But there were times when he wanted his intuition confirmed by mine. I would wander into the dressing room and exchange enough pleasantries to get a little feeling about them. Dick and I had worked out a system of signals, reminiscent of the arrangement he had had with Stanley Donen during the filming of *Funny Face* (after Paramount forbade them to confer on set, they communicated by manipulating their neckties). Our eyes would meet in the mirror and the determination on whether to take things any further would be made via a blink, or a wink, or the arching of a brow. Or Dick might cough discreetly, twice, or put his hand to his throat, or run his fingers through his hair.

Having good people around led to having more good people around. Some of the assistants, according to Dick's lights, were "more good" than others. Harvey Mattison, for instance: stunningly handsome, highly articulate, and uncannily sensitive to what Dick was feeling at any given moment. Ruedi Hofmann, with his sterling Swiss work ethic and sense of excellence, was another favorite. Sebastian Kim, who Dick predicted would be a great fashion photographer but who went on to commit high treason as far as the Avedon studio was concerned, was another. Dick fostered competition among the assistants for his favor, having long ago discovered that a bit of sibling rivalry worked to his advantage. So the studio had its pecking order, but for the most part camaraderie prevailed.

The assistants weren't always homegrown—they came from France, Japan, Holland, Germany, Sweden, England, Italy, Ireland, and Israel. A few were born with silver spoons, like Freddie Eberstadt and Cameron Sterling. A handful were the bearers of famous names: Picasso, Vreeland, Donen (Dick would bring in these well-connected kids as

extra pairs of hands, to give them a little experience while they figured out what to do with themselves). Some were even women. One didn't even officially exist: he was in the Witness Protection Program, thanks, he told us, to his father's having once "seen something he wasn't supposed to."

THE STUDIO'S PATRES FAMILIAS.

These young men and women had to be ready at a second's notice to hand Dick the camera with film loaded and, as soon as the roll was used up, pass him another loaded camera. Dick was the ringmaster, prodding them to go faster, faster. His arms would be flailing and he might accidentally strike an assistant in the frenzy of it all. Most of them understood that it was nothing personal, that it was just part of the process, and rolled with the punches. But one sensitive soul took it the wrong way, of which more later.

In the absence of his actual family, Dick treated his assistants and staff like family, and if Dick was the paterfamilias, I was the mater, sitting next to him at the lunch table, keeping the family together, working both sides of the Avedon aisle. Dick loved his long-serving

(1963–1991!) in-house bookkeeper, Sebastian "Chick" Chieco. He had all of Chick's milestone birthdays celebrated at the studio; invited Chick's twelve-year-old daughter to his 1967 sitting with her idol, Twiggy, and twelve years later not only danced the "bump" with her at her wedding but all but bumped uglies with her roly-poly great-aunt Angelina; treated Chick and his wife to a sky-is-the-limit trip to Italy; inscribed the note on the floral arrangement he personally carried to Chick's funeral in 1992, "Chick, see you later . . . Dick"; and ensured lifetime financial support for the widow, "Mrs. Chick." "The studio was home as well as workplace," curator Peter Galassi wisely observed, "and became an all-encompassing aesthetic environment—an embodiment of a unique artistic identity and perhaps an instrument for realizing it."

Work was not the only four-letter word that made the studio tick— *food* was the other (Dick told me that his psychoanalyst had diagnosed "orality" as a major ingredient in his makeup). Every morning on his way to work, Chick would stop at the neighborhood Hungarian bakery for babka, and one of the assistants would bring schnecken and coffee cake from William Greenberg. Dick would usually pop downstairs in time to pick most of the pecans off everybody's pastries, then help himself to a spoonful or two of jam straight from the jar that he had brought back from Paris and to a couple of slices of apple slathered with Skippy peanut butter, which Diana Vreeland had touted as "the greatest invention since Christianity."

What to have for lunch was the subject of vigorous group discussion. In the really old days (that is, B.N.—Before Norma), the cheesecake came from Reuben's, the herring from Old Denmark, and the steak from Manny Wolf's downstairs from what was then the studio. In my day, lunch would often come from a little catering place called Babbington, right across the street, next to the Sicilian shoemaker. The eponymous owner/cook would deliver the food himself, wearing his trademark food-stained apron. He had a big round face with a Jimmy Durante schnozzola that Dick loved. He did a portrait of Mr. Babbington, and included it in his 2002 Met retrospective.

From time to time an assistant would volunteer, or be delegated, to make lunch, according to his or her cooking chops. Some made do

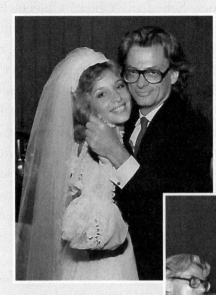

DICK DANCING WITH
LONGTIME BOOKKEEPER
CHICK CHIECO'S
DAUGHTER, SUSAN,
AT HER WEDDING,
THE JUMPING BROOK
COUNTRY CLUB,
NEW JERSEY, 1979.

DICK AND
THE FATHER
OF THE
BRIDE.

DICK AND NORMA.

DICK EXTENDING
HIMSELF TO
HIS EXTENDED
FAMILY'S FAMILY—
DANCING WITH
CHICK'S AUNT
ANGELINA.

with whatever ingredients were on hand; others spent part of the morning shopping. The budget was pretty unbudgeable and if an assistant overspent one day, he would have to make up for it the next. Whenever Asian food was in the offing, the assistants knew to order me a tuna-fish sandwich from the deli around the corner. My darkest culinary suspicions were confirmed the day one of our retouchers encountered a two-inch black screw in a forkful of Chinese rice. Dick put the screws on the restaurant's owner, threatening to personally call the New York City health commissioner if a respectable donation to Citymeals on Wheels was not immediately made.

Dick was food-crazy—to the point of near-insanity. At least a couple of times when a restaurant he wanted a recipe from was reluctant to part with it, he bartered a print for it—something he never would have done for an artwork or for services rendered. Once, when his taste buds were ravished by an Indochinese chicken dish with leeks at a Washington, D.C., restaurant we were dining at, he offered the owner's wife a vintage Avedon in exchange for the recipe.

Dick rarely came back from a summer weekend in Montauk empty-handed. The back seat of the car would be filled with baskets of heirloom tomatoes, fresh mozzarella, basil from his garden, and teeny-tiny blueberries, plus dozens of ears of the sweet white corn with the minuscule kernels called Silver Queen ("Corn is in the details," Dick was fond of saying). With the advent of car and cell phones, he would call the studio as he gained on Seventy-fifth Street, and Bill Bachmann would announce over the intercom: "Dick is three blocks away . . . two blocks . . . Stop what you're doing and get yourselves outside to greet him."

Dick himself would occasionally put on an apron and whip up something simple, delicious, and unfailingly Italian. He had a soft spot for risotto and one summer enrolled the two of us in a risotto class at the New School for Social Research. Within the first ten minutes of the first session, he had taken over from the instructor, winging it on the strength of the single lesson in Risotto Milanese Con Donno Versace we'd been given the summer before by Gianni Versace's chef at his Villa Fontanelle on Lake Como (the next night Dick and I made the dish for Gianni, who pronounced it *perfezione*). Dick was also seriously

addicted to the tomato sauce at his favorite neighborhood restaurant, Primavera, and had the chef come to the studio to teach us how to make it (the so-called secret was a bit of a letdown: extra salt).

"Lunch is ready" would be announced, and there would be just enough time to wash your hands, scoot downstairs or up, grab a plate, and squeeze in wherever there was room on the picnic benches that flanked all four sides of the big square butcher-block table in the studio kitchen. The working premise was that the family that eats together works better together.

Everyone on the premises was invited to partake: hairdressers, stylists, makeup artists, supermodels (the latter sitting around in varying states of undress). Dick's housekeeper Verlie Fisher also ate with us — an endearingly outspoken lady from Guyana, which Dick persisted in calling the Kool-Aid country. She called him Boss and treated him like a baby. Doon, with her inimitable high-pitched laugh and flowing black Issey Miyake robes, would be chowing down with us as well, if she and Dick were collaborating on copy for an ad campaign that day. Occasionally Dick's mother would join us, having walked over from her nearby apartment in her leather pumps, her blond hair held in check by an old-fashioned hairnet. Sometimes she would come bearing the gift of what Dick referred to as "the royal pot roast" for her son's studio family.

Dick naturally felt right at home and thought nothing of eating from everybody's plates as well as his own. He would be laughing, or giggling, or saying something deep, or taking a call, or dictating a note — or all of the above. He set the tone: if he was having a good day, we all had a blast.

When lunch was done, slam bang, back to work. It wasn't like a Paris lunch, no — it was a lunch *hour*. When clients came (and, needless to say, paid), we duked it up: the food was fancier — poached salmon from William Poll or lobster salad from Rosedale — and the table would be dressed with one of Dick's blue Native American cloths. No booze, with the exception of champagne on someone's birthday and at Christmas. The holiday was always celebrated at the studio the day before, with an all-out traditional lunch. The table would be seasonally decorated, yuletide Sinatra songs would be playing on the stereo, and every-

body would be taking Polaroids of everybody else. Dick always insisted on curating the tree himself, but gave the assistants the green light to further embellish it. They would make Christmas-tree balls out of discarded negatives and cut-up Polaroids—you could come across the body of a famous model or the face of a world figure festively hanging there. One holiday Dick gave everyone a long, skinny, brown box of Teuscher chocolates, each one in the form of a tool: it was fun to sink your teeth with impunity into a hammer, saw, or screwdriver. Whenever Dick found something he liked, he wanted to share it in spades, chocolate or otherwise.

As nourishing as working at the studio was, the assistants all eventually had to begin thinking about establishing studios of their own. Every time someone decided to move on, there would be a farewell lunch and a parting gift. When our English studio manager Peter Waldman was leaving to go out on his own, Dick served expensive champagne, and later followed Peter out the door, took off his Cartier watch and threw it to him, and Peter caught it midair on the street. The most elaborate of all the valedictory in-house shindigs was for Alicia Grant Longwell, the studio's first archivist. The party took place in Dick's living quarters, and featured both a male striptease artist, of which more (or rather, less) presently, and an all-girl string quartet that played an all-Mendelssohn program (he was Alicia's favorite Romantic composer).

A few weeks before, Dick had decided that he and I should "do a Fred and Ginger" for Alicia. He asked Twyla Tharp, whom he considered the world's greatest living choreographer, to create a ballroom number for us. More than that, she sent a couple of members of her company to train and rehearse us—to, as Dick instructed *them*, "make us look good." We made sure we would look good to begin with. Dick decided to wear black tie. I had a dress made for the occasion: geranium-red, with spaghetti straps and a billowing handkerchief skirt cut on the bias. Six hundred dollars, if you please, which wasn't petty cash (and didn't come out of it).

The two of us danced sublimely to the strains of "Isn't This a Lovely Day?" from the scene in *Top Hat* where Fred and Ginger get caught in a rainstorm, which gave Dick the opportunity to twirl an umbrella à la

DICK AND NORMA ENTERTAINING AS "FRED AND GINGER" AT
THE FAREWELL PARTY FOR A STUDIO ASSISTANT.

Fred. Alicia took in our performance from a throne-like chair that Dick
had just had re-covered in Louis-something tapestry. On her "early-
laureled" head she was wearing a wreath Dick had commissioned from
the tony Rhinelander Florist. When we took our bows, she shouted
"Encore!" and her wish was our command—Dick and I did it again.
Does anybody have fun like this anymore?

To mark another assistant's leave-taking, Dick rented the gilded
ballroom at Primorski, a restaurant in the Brighton Beach section of
Brooklyn known as "Little Odessa," and had two busloads of studio as-
sistants and alumni transported there. A rollicking wedding celebration
was taking place in another part of the restaurant, and Dick got the two
parties to merge, and everybody to dance. He made a point of waltzing
with the bride, then snapped some pictures of her with the groom's
camera. Of course they had no clue as to just who the impromptu shut-
terbug was.

Dick picked Brooklyn again as the venue for a surprise bash to cel-
ebrate the twenty-year tenure of his private secretary in 2004. (Bill
wasn't going anywhere; he loved his job, which defied description—as
Dick himself put it, "There is no explaining the full range of Bill Bach-

mann's duties and contributions.") For weeks before the event, after Bill had left the studio for the day, Dick rehearsed the assistants in "You're the Top," with the Bill-related lyrics that he and I had written. In the event they performed in full voice—dressed like a barbershop quartet. After which I belted out "Bill," from *Show Boat*. Dick announced, "She was better in rehearsal." No, I wasn't—I was equally bad.

Among the revenants at the restaurant that day was a woman who had fallen unbalancingly in love with Dick when she worked at the studio a quarter of a century before. One day she came into my office and closed the door behind her. "I had a sex dream about him last night," she confided. I immediately shut the conversation down, and advised her to get over it or get going. She proceeded to do neither. Anyway, I was glad to see her again and to hear how well she was doing as a commercial photographer.

DICK "CUTTING UP" WITH HIS PERSONAL ASSISTANT, BILL BACH-MANN, AND NORMA.

A little later (Dick had died in the meantime), she invited me to her studio downtown, saying she had some Avedon memorabilia she wanted to show me. "I'm a keeper—I keep things," she explained. By

this point, I thought, I had seen it all. Evidently not: Laid out neatly on her daybed were Dick's custom-made caramel suede trousers, which she said he had given her during the Western Project "one day after we jumped rope twosies." I laughed at that—the jump rope had been my gift to Dick "for the road" (a high-end item, as I recall: leather, with wooden handles). "Dig in," she said, indicating the huge carton of material that she had set aside for my perusal. The trove consisted of old articles and publicity releases on Dick, some scrawled notes from him to her, a batch of candid studio photographs, and a few excruciatingly embarrassing diary entries detailing the "very involved" sex dreams she had continued to have about him.

There was a legal-size manila envelope in the mix that looked to be of no interest, and I was putting it aside when it fell to the floor. Out spilled strands, then whole hanks, of what, with a sick feeling, I recognized as Dick's hair: the last surviving tufts from his much-lionized mane. I looked at her in utter astonishment. She enthusiastically confessed to having scooped them up from the dressing-room floor when no one was looking. In Dick's words, "Words fail." Except for one, that is: to borrow the name of the Calvin Klein perfume that he helped to brand—obsession.

"I think it's time to let go," I said gently. "Toss the hair."

"Never! I'm conserving it," she replied, and carefully put it back in the envelope.

Look, none of Dick's assistants ever fully got over him, personally and/or professionally. Nearly every assistant who was at Bill's anniversary party came over to me to say that working for Dick was "the best job I ever had." As one of them, Junichi Izumi, put it, beguilingly, "In one's life, I was the happiest."

I suddenly found myself wanting to hear more—*everything*—about the assistants' times with Dick: the lows as well as the highs. At first I followed up with just a few of them, but each of their accounts was so compelling I wound up collecting as many as I could. Listen, then, as I did, fascinated and sometimes even astonished. Their voices ring independently, and resonate in response to one another.

13

FIRST SERVING

—

E ARL STEINBICKER (STUDIO ASSISTANT: 1952–56 AND 1959–65): I wrote to a bunch of New York photographers during my last year in high school in Allentown, Pennsylvania, and Richard Avedon was the only one who answered, and I'm sure it was because I enclosed a picture of myself—I was one great-looking kid.

He paid me my weekly salary in cash that he just pulled out of his wallet—it was no more than twenty bucks. My father had offered to supplement it on the grounds that it was education. But the next year I went on the books. In those days the studio was on the second floor of a block-long two-story building at 640 Madison, between Fifty-ninth and Sixtieth streets. It had been the studio of George Platt Lynes, before he moved out to L.A. in '46. The ceilings were high and there was a skylight—it was a heck of a nice place. The only problem was the building was slated for demolition.

A couple of years later we moved to another high-ceilinged, skylit space: seven rooms on the second floor of a two-story building on the northeast corner of Third Avenue and Forty-ninth Street, above Manny Wolf's Chop House, which is Smith & Wollensky now. And then in 1958, while I was in the army, Dick moved the studio to the top floor and penthouse half-floor of a five-story building on Fifty-eighth off Park

that eventually became a fifty-seven-story luxury condominium called the Galleria. The first thing he did there was install a pay phone in front of the studio door.

Right away when I went to work for him he suggested I take some night classes. He said, "Go where I went—Columbia." Only it turned out he hadn't gone there, or anywhere else. Anyway, Columbia was too far uptown for me, so I enrolled at NYU, and took the two classes he recommended—writing and art history. Culture was always one of the biggest things with him.

When he took his six-week summer vacation after the Paris collections, he would close the studio so he wouldn't have to pay people. The studio manager, George Thompson, who had been with him since '47, got so fed up with this that one day in '53 he just upped and left, never to be seen again—by anyone, including his wife, so far as I know. Dick hired a Sicilian by the name of Frank Finocchio to replace him.

Dick always took me with him on location. Sometimes when we would be sitting together on a plane and I would have my hand on the armrest between us, he would put his hand over mine. Whenever we were working in Hollywood and London, he would put me in a different hotel from him—he would stay at the Beverly Hills and I'd be at the Beverly Wilshire, and in London he'd be at Claridge's or the Ritz and I'd be at Brown's. Everywhere else in the world we went he always had me staying at the same hotel as him. I guess in those two cities he must have had people coming and going that he didn't want me to know about.

In the summer of 1955 I traveled with him to San Francisco to photograph Suzy Parker with Dave Brubeck and his quartet at the hungry i nightclub—the ad was Suzy in a flaming red gown leaning over Brubeck who takes his eyes off the piano keys to ogle her. It was a joint promo by Helena Rubinstein and Columbia Records: Brubeck's EP *Jazz, Red Hot and Cool* had just come out, with the image from the ad on the cover, and if you bought the lipstick of the same name, you would get the record for free. One of my jobs on that shoot was to keep Helena Rubinstein's son, Horace Titus, away from Dick.

On the last leg of this trip Dick was scheduled to meet with Stanley Donen to work out some of the details of *Funny Face*. He wanted this

movie to happen in the worst way, so, to impress Donen, he arranged to have their conference take place at the Hearst Castle at San Simeon—he had had to go over the head of Carmel Snow to the honchos at the Hearst Corporation and tell them he wanted to photograph the castle and that Stanley was his assistant. They were even allowed to spend the night there, and they had that huge place all to themselves—Dick did take a handful of pictures, and a couple of them eventually appeared in the *Bazaar*. Dick's wife was along for the ride. She always seemed just in a cloud, wandering around. She never got in our way.

My first encounter with Brodovitch left a bad taste in the mouth. Dick had sent me over to the *Bazaar* to deliver some prints. The art department was on the seventh floor, and the desk where he worked faced the window, and he didn't even turn around when I said, "Mr. Brodovitch, these are from Richard Avedon." He just pointed over his shoulder to a place somewhere on the desk and said, "Put there." So I put there and fled. A few years later, when he was down-and-out, Dick let him use the penthouse space in the studio for the once-a-week Design Lab night classes in graphics that he was teaching. His assistant berated me for using our elevator to haul things up and down when the students were about to arrive. He said, "Mr. Brodovitch would not like this." I told him where to get off.

I was alone in the studio one day when Diana Vreeland came stomping in. This was the only time she ever set foot in the place. She said she hated the way the dress looked in the picture I'd delivered to her office that morning, and she charged into the darkroom. There was a big plastic waste can under the sink, full of the wet rejects, and she rummaged around in there. She found one she liked and ordered me to get it printed immediately. When I reported this to Dick, he said, "I'm going to let her win this round."

He and his wife were renting a three-story townhouse on Beekman Place when I first went to work for him. In the late fifties they moved to a "classic six" at 625 Park Avenue, the building where Helena Rubinstein, and later Charles Revson, occupied the penthouse triplex. Around 1964 Dick bought a big house on Riverview Terrace, off Sutton Place. By that time he had a butler in addition to a maid and cook. I mean, this was supposed to be a left-wing kind of guy. He

always dressed very well, too—like a little British lord. Everything he wore in those days came from Chipp or J. Press. And he was big on accessories—he had his initials embossed in gold on the front lens of his Deardorff, and the cases for his two Rolleis custom-made by Louis Vuitton. He sold me one of those Rolleis, by the way—for a hundred bucks or something, about five weeks' salary. I still have it, though it no longer works.

In 1956 Yasuhiro Wakabayashi, who'd come from Japan a couple of years before and for commercial reasons shortened his name to Hiro, joined the studio, and the next year when I got drafted he took my place as second assistant. By the time I came back from the army, three years later, he was established in Dick's studio as a photographer in his own right. The arrangement was that Dick would cover his expenses and the overhead and get him jobs in exchange for a cut. Dick told me to keep a close watch on Hiro because he felt he had a tendency to use way too much film.

Dick wanted to get rid of Frank Finocchio, but was waiting till he was sure I could handle the job. Frank ran the studio well and made beautiful prints and was great with lighting, but he was always badgering Dick for more compensation and greater recognition. When Dick finally did fire him, in '61—for "lack of subservience," as he put it— Frank simply disappeared. His sister called the studio several times trying to locate him.

I met a helluva lot of famous people with Dick. One day Leonard Bernstein came by and Dick introduced us using a German accent: "Lenny, I'd like you to meet Earl *Steinbicker*." Bernstein responded by clicking his heels and giving me a *sieg heil*. I was there for the first sitting Dick ever did with Marilyn Monroe. The *Daily News* had sent a photographer to photograph him photographing her. I worked the fan blowing her hair, and at the end of the sitting she came over and said, "Wouldn't you like a picture of me?" When Cousteau came, he brought that underwater-breather device he'd designed, and he demonstrated it on me. Louis Armstrong let me fondle his trumpet. When Christine Jorgensen was coming, Dick clued me in that she used to be a guy. She couldn't have been more bubbly.

I was right there with Dick when he took that photograph of the

one-hundred-year-old colored gentleman who'd been born into slavery—we set up in front of his cabin on the other side of the Mississippi from New Orleans. Earlier that day we were run out of Atlanta, where we'd gone to take a picture of Julian Bond and his SNCC group. Dick stayed cool when the state police showed up and demanded our film. Luckily I had it hidden real good—in one of the camera cases. We gave them blanks instead. They thanked us and escorted us to the airport.

We photographed former president Eisenhower in Palm Springs, on the patio of the Eisenhower house, which was right on the golf course, and he was super-friendly. If you look at the portrait closely, you can see a reflection of me in his eyes. As we were leaving, Mamie, who had just finished playing Solitaire, was setting up the Monopoly board and she asked me to stay and play with her. I didn't dare—Dick would not have liked that.

Ike wasn't the only general we photographed—we did a portrait of some lady generals. Well, generals of the Daughters of the American Revolution. They were having their annual convention, in the ballroom of the Mayflower Hotel in Washington, D.C., and they were all dolled up—gowns with sashes and stuff. We had just come from photographing George Lincoln Rockwell, the commander of the American Nazi Party, in Virginia, so we were good and ready for those dames. Dick had his hands full arranging them for a group shot—he was trying to get the one with the biggest ass to be the furthest away from the lens. He told me to pretend to be adjusting the camera but to actually take pictures. At some point he got behind the lens himself and took a few, but it was one of the ones *I* took that wound up as the choice. I had to laugh when I read an interview he gave years later where he was spouting off about some of his landmark pictures—he said, "The person who took the DAR picture is not who I am now." I remember the generals wrote him an effusive thank-you note—they obviously didn't get it.

The Fifty-eighth Street studio had white walls and a battleship-gray concrete floor. Mike Nichols had bought a classic Eames lounge chair and ottoman, and when they didn't work in his apartment he gave them to Dick, who put them in the rear of the studio. There was a big picnic table and benches, and a few black director's chairs. For lunch I would order piles of sandwiches from Roger's Bar around the corner,

on Lexington between Fifty-seventh and Fifty-eighth—it's now a Star-bucks, like everything else. Allen Ginsberg and his boyfriend, Orlov-sky, would always show up just when the free lunch was about to arrive. Truman Capote came around a fair bit, too, in the early sixties. He had bought an identical Rollei to Dick's in the hope that the master would teach him how to use it. I was the one who had to show him how to put the film in and stuff. I remember him saying, "Ah'm beside myself."

I loved Dick's rep, Laura Kanelous. She had one of the two offices in the penthouse part of the setup. Dick had the other one, except he never used it—he was almost always down on the floor below. Laura had a bit of flash, for sure—I'm remembering that mink coat of hers—and she and Dick made a great fun team. Dick and his kid were an-other kind of team. When John was about nine and just getting interested in American history, Dick had me drive them to Valley Forge and Gettysburg. I took a picture of Johnny standing next to a Civil War cannon, with his arm on the barrel.

One year after the collections Dick and I flew from Paris to Spain to shoot an ad for Maidenform bras at the Alhambra in Granada—the copy was going to read something like "I dreamed I was living in a castle in Spain in my Maidenform bra." The Alhambra is like a shrine—plus this was during the Franco regime—so one of my jobs that day was to get rid of the guard long enough for Dick to take a ris-qué picture. So while he was busy pretending to be shooting straight fashion, I slipped the guy a few pesetas to go out and get us something we didn't need. Then off came the model's dress, Dick did his thing, and back on it went. By the time the guard returned, Dick was back to pretend-shooting. He had a cab waiting at the gate to speed us to Ma-drid, where we put the film on a plane to New York.

In January of '65 I flew with Dick to London to do fashion spreads for the April issue of the *Bazaar* that he was guest-editing and taking all the pictures for. We were using Antony Armstrong-Jones's studio, which was the penthouse of the London *Sunday Times* building. Dick photo-graphed Paul McCartney there—he had already photographed him with the other Beatles for a cover and special foldout section of *Look* magazine. Later that day Paul ambled back in, with Ringo, and Dick got him to pose in the NASA suit we had just photographed Shrimpton in.

After Paul left, Ringo lingered, and at some point he challenged Dick to a drinking contest. Well, they proceeded to drink each other under the table. Ringo had this 35mm Pentax camera with him and took pictures of Dick getting progressively smashed on scotch and wine, until he finally passed out himself on the studio floor. Dick had gone into the bathroom to pass out. Meanwhile there was a huge crowd of Beatles fans waiting out front. China Machado, the stylist for the entire April issue, quickly arranged for a car to come to the back entrance of the adjoining building. I had to carry Ringo up to the roof and drag him clear across it and then down in the freight elevator. The driver took it from there.

Then back I went for Dick. I dragged *him* down to the main entrance and then through the sea of Beatles fans—nobody knew who he was—and into a cab and then up to his room at the Ritz and I laid him down on the bed. When I saw him late the next day, which by the way was the day of Winston Churchill's state funeral, he seemed none the worse for wear, and I must say I never saw him inebriated again. Those famous solarized pictures he did of the Beatles came later—after my time.

Two years before I left the studio for the second time, Dick hired Gideon Lewin, who became the longest-lasting of all his assistants, making me the next longest. Dick was impressed with Gideon because he was an Israeli. My job was to train him—which wasn't hard, since he already knew a lot—so there would be a line of succession to the position of studio manager.

After I left to go on my own, Dick would sometimes call me very late at night for advice on his relations with his assistants. He never asked how I was doing.

HIRO (1956-58): I'd been in America since the early 1950s and I was working for a couple of commercial still-life photographers and taking Brodovitch's class. I heard from Avedon's studio manager at the time, Frank Finocchio, that there was an opening for an assistant. He presented me to Dick, and Dick and I talked a little. He asked about salary and I said it didn't matter, and right after I got back to the studio where

I was working I had a call from him to come back and start work immediately. Fate had smiled on me.

He told me one day that he had hired me because he felt I would know my place. But then later when he saw the still lifes I was doing, he said I should get him out of my system and follow my own bent exclusively, that I was sui generis. He said, "You're already too good to just be working for me," and he invited me to formally share his studio and work independently from it. After a time he encouraged me to open my own studio. I also began working for the *Bazaar*.

Dick was the most brilliant of all the flashes that illuminated my professional path. His impatience was an inspiration in itself. The preparation he made for each sitting, the perfectionism—sharp, like a scalpel. And then the way he directed. His personality, which helped him clinch every shot. His timing. This man created the modern woman—the Avedon Woman. Eventually he turned against glamour, except for when he had to photograph for *Vogue*, and he embraced all aspects of human anguish. Like his father dying. He had to suffer people's bourgeois reactions to that.

In 1985 I made a portrait of Dick for *Vanity Fair*. It was one of the most difficult assignments I ever had, *because* I knew him so well. I felt that I captured at least the intensity in his eyes. *He* felt I should have been rougher on him. Yet when he was editing the book of my photographs in 1998—doing for me what he had done so many years before for Lartigue—he included that portrait. Contradiction? That was Dick all over.

FREDERICK EBERSTADT (1958-60): Harold Brodkey, a friend of both of ours, talked Dick into taking me on. There was a salary attached, but not what you could call a living wage. Dick's liberal tendencies did not include supporting his staff, and I would soon discover that this was also true for the staff he had at home. Every summer when he and Evie went to Paris for the collections, followed by a honeymoon-length vacation, he would not only suspend studio salaries but fire his domestic servants so he wouldn't have to pay them, then hire a new staff when he got back. One of the things Dick found interesting about

my life is that when I married the poet Ogden Nash's daughter Isabel, we inherited her grandmother's housemaid and her great-grandmother's butler, who had originally been her shoeshine boy and who died still working for us in his eighties. Dick was very much intrigued by the idea of indentured labor but was too cheap to underwrite it. My father's name for him was Richard Avarice. Dick's generosity brought tears to his own eyes alone—I remember him welling up when he kicked in $150 for the Student Nonviolent Coordinating Committee.

When Dick was doing the publicity photographs for *Some Like It Hot,* Tony Curtis came in carrying the most elaborate camera you ever saw. He said to Dick, "You're the perfect person to show me how to use this thing." Dick took one panicked look and said, "My studio manager Frank will be happy to help you out." One of the first things he said to me when I went to work for him was, "Don't bother to learn any technique—you can always hire some guy for a few bucks a week." Dick simply did not know how he did what he did. Learning to photograph from him would have been like trying to learn to sing from somebody who has perfect pitch and just can't help hitting the right note.

At noon on the day he was to shoot Marilyn, a woman with a doughy face and a babushka, who I presumed to be her maid, dropped off some clothes for her at the studio. It turned out to be the star herself— that was what she looked like when she was not in full drag. She was supposed to come back at three, but Dick had booked somebody else in that slot, knowing she most likely wouldn't show up until six and wouldn't be ready to work till nine. He told me to stick around, that my job would be to make sure her vodka was diluted enough so she didn't get too drunk but not so much that she realized it was mostly water.

The experience Dick provided on the set was an exciting, almost intoxicating fantasy. Off-set, too. Absolutely everything was calculated for effect. He paid elaborate court to Marie-Louise Bousquet, who represented the *Bazaar* in Paris and presided over a famous Thursday-afternoon literary/theatrical/intellectual/social salon in her little top-floor flat on the Place du Palais-Bourbon. That's where Dick got his first taste of *le tout Paris* and encountered personages on the exalted order of Picasso, Cocteau, Gide, Colette, and Gertrude Stein. One night when she was visiting New York he invited me and Henry Wolf,

the *Bazaar*'s new art director, to dinner with her. His idea was that, when we picked her up, the minute she came out of the building where she was staying, we would all fall down on the sidewalk in mock obeisance. This was the kind of goof that Dick was better at than anybody. So Marie-Louise, who looked like an old ape and slept with a stuffed monkey—Dick took a photograph of the pair of them in bed that's in *Observations*—came lumbering out, and we three guys went down on all fours in worship, which she lapped right up, as Dick had known she would. She said, "Where are all the *other* men?" and laughed coquettishly. It was pretty grotesque.

Everybody on the planet was entranced with Dick. He said to me once, "My personality is my business." I remember him telling me how much he admired Elsa Maxwell, the professional hostess, and when I asked why, he said, "Because she's all business." He was not unlike a professional hostess himself, one who lays on caviar and champagne and waltzes, but then when you wake up with a hangover in the morning you discover that she's flitted off to her next engagement. Dick was heartless—in my view just as heartless as Andy Warhol, which is saying something.

Dick was a star, but what he desperately wished for was to be a star *among* stars, and that yearning is what passed for emotion in his life. He didn't connect with people on a human level, and I think that must have been a very difficult thing for his wife and young son. My feeling about him as a photographer is that the more he became a celebrity, the weaker his work got. I think that his truly valuable and beautiful stuff was the work he did for Brodovitch at the *Bazaar*, as a purely decorative artist. Dick was like Fragonard. Or Christian Bérard. But like many decorative artists, he despised his gift. He had the ability to express a kind of ineffable joy, but he was in love with gloom—gloom to him was profound. Only, *he* was about as profound as a plate; that was all an act. And the more profound he tried to be, the more deeply superficial it seemed to me his work became. The entrance of Marvin Israel sealed Dick's artistic doom. Marvin in a sense cut Dick's throat. He was someone who insisted that *everything* have a deep meaning. And since now you had two people with no moral sense whatsoever, the work was not likely to be very deep, was it?

I was occasionally used as a rainy-day nanny for John. I would take him to the park and buy him a hotdog or an ice-cream cone and a balloon. He was, as you might expect, a lonely little boy, looked after by a succession of nannies. His father was off being a star, and his mother . . . Well, I bumped into Evie one day on Park Avenue and recommended she take in some art show or other around the corner, and she said, in utter seriousness, "I don't have time—I have to go home and daydream." I mean, she was already staring into space.

Dick's agent, Laura Kanelous, who was based upstairs in the studio, was a real hoot. She called me Cecil Beatnik. And she used to kid about Dick. She'd say to me, "Would you ask Mr. Avedon whether he's Jewish today?" But as a businesswoman, she was strictly no-nonsense. One time Dick was in the middle of doing an especially complicated campaign for a big ad agency and when the client said to Laura, "I don't know how we're going to pay for all this," she said, "That's easy— through the nose!" She and Dick, if I'm remembering right, went to the same shrink. Dick sent *me* there once, and I thought the guy was just a hot-air artist and I never went back.

Dick ultimately fired me. At five o'clock on a Friday. Some last-minute thing had come up and he said he needed me to stay really late. I explained that I had family obligations, and he said, "Well then, don't bother to ever come around again." Hiro took me on, practically the next day.

I ran into Dick again at Diane Arbus's service at Frank Campbell's— she had been a great friend of my wife's and photographed us and our children. He said, "Oh Freddie, wouldn't you give *any*thing to have her talent? I know *I* would!" I told him I wasn't wild about her work, and that I also wouldn't have wanted to have what I considered to be her curse. He got very pissed off. Dick and Diane had this extremely peculiar relationship. They knew each other personally mainly through Marvin Israel, and they really didn't like each other all that much. Dick was very envious of Diane's reputation, and Diane was very, *very* envious of Dick's bank account.

There was talk that Dick was gay. The story that *I* was told involved a successful model that Dick occasionally used, named Tom Stokes—he was a good model, too, because he had a great sense of fun. I ran into

him out in Santa Fe many years later—he was living with another man and painting or something. I asked him point-blank if he had had a fling with Dick, and he said, "Oh well, Dick and I had a lot of fun together." So. Whatever that means.

ALEN MACWEENEY (1961-62): When I was eighteen and living in Dublin, I got up the courage to write Richard Avedon about the possibility of working for him. I admired Irving Penn's work, too—just as much, in fact. To be chauvinistic and drop only Irish names, Penn struck me as being more like Yeats—austere, reserved—and Avedon more like Joyce—jumpy, emotional. Almost immediately I received a telegram from Avedon summoning me to Paris where he was photographing the collections for *Harper's Bazaar*. I presented myself, as instructed, at his hotel room, which turned out to be the penthouse duplex of the San Régis—I remember going up in the open-cage elevator. He wasn't in, but his wife said to wait, so we sat in the living room together while she made no conversation whatsoever for an hour or so. She was like a chair, she was . . . just *there*, and in fact, in all my subsequent experience of her, which included living in their apartment in New York for around a month, she always took a back seat to whatever was going on.

At some point he came swaggering in—it was a best-boy-in-class walk—and his thumbs and the middle fingers of both hands were going snap snap snap. He was with a fellow called Marvin Israel, and they were discussing a *Bazaar* layout. He was dictating copy, and even the young, green me could see that he was elevating things out of the area of just caption description. He went on talking only to Marvin for the next twenty minutes or so, and finally he turned to me as though he had only just noticed I was sitting there. He said, "Come to the *Bazaar* studio tonight and try to make yourself useful to my studio manager from New York, Frank Finocchio."

I noted what he was wearing: brown slip-on Italian driving shoes, tight-fitting gray slacks, blue-checked shirt with the sleeves rolled halfway up. Years later he told me that he had never forgotten what I was wearing, either. I had arrived in my three-piece Irish tweed suit—it was cool in Dublin that morning when I put it on, but in Paris it was swel-

tering. He said I looked like a refugee from the Russian steppes from a century before.

Frank was a stocky Italian who could have passed for a truck driver or a machinist, and he put me to work rolling up paper and loading cameras. The models that night were China Machado and Margot McKendry, and the stylist was Polly Mellen—Polly Bell, as she was then. This was the summer that Nureyev defected to the West during a Kirov Ballet tour, and he was now dancing in Paris with the de Cuevas ballet. One night Dick took me to see him, because the next day he was coming to the studio to be photographed. Dick took twenty-six rolls, as opposed to the three or four he would normally take, according to Frank. I would never see Dick so drawn to one person as he was to Nureyev during that sitting.

Soon after he returned to New York, Dick sent me a telegram saying he had just fired Frank and could I come right away. When I got there, he explained that Frank had lost focus and had been spending too much time doing silly housekeeping things like cleaning the brass corners on the Louis Vuitton camera cases. There would be no gainsaying that Frank had been very useful to Dick in his day. He invented—either with or without Dick—the so-called Beauty Light, which did wonders for bone structure. It was a big 1,500-watt Saltzman flood with two scrims of spun fiberglass across the front, and it was like sun—it bathed the model in a constant light. An assistant would be holding it on its aluminum stand and following the model's every movement with it. You had to keep the distance right for exposure so the background would go just the right shade of gray and the model's features would stand out. This was light that reproduced extremely well in magazines, giving Dick's pictures their high contrast. One of the earliest beneficiaries of this invention was his iconic 1953 portrait of Marella Agnelli.

The Beauty Light could also do the opposite and give you the deep lines on people's faces, as it did in Dick's portraits of the Windsors and Father D'Arcy. That said, the most beautiful light I ever saw Dick use was in that tiny Paris studio—just a channel of pure daylight pouring down the skylight.

Anyway, Dick had now replaced Frank with Earl Steinbicker, who was very German, very rigid, a rather heavy-handed person. But he

worked unstintingly and gave his all to Dick. And now I was taking *his* place as second assistant. My starting salary was sixty dollars a week, and when I first came over, Dick invited me to stay in his apartment, at 625 Park, in the spare room in the back. Dick at home was only a little more relaxed than Dick at the studio—you always felt, in his presence, that he was on the stage. There was an Irish maid named Rose, and a miniature white poodle named Piffles that it often fell to me to walk. I remember thinking how funny it was that he wanted to live in this sort of ultra-conventional Upper East Side Jewish-taste way. The apartment looked very decorator-done, something out of a magazine—shiny Parsons tables with lots of brass on top, that type of thing. The rent was $1,250 a month. That's what Polly Hatch, the bookkeeper, told me—she was his first wife Doe's step-aunt, by the way.

Dick included me on an excursion to Coney Island on Easter Sunday, with his son Johnny and Marvin Israel, and we all had our photos taken in a Fotomat booth. He introduced me to other exotic American places as well, like Nathan's Hot Dogs in Times Square and Hubert's Dime Museum and Flea Circus, a freak show, which Marvin said had been Diane Arbus's introduction to that world. I still have a photo of myself entering 625 Park for Johnny's tenth birthday costumed as a Morlock from *The Time Machine*.

Marvin would occasionally grumble about Dick, and even claim that Penn was the greater photographer. His immediate predecessor as art director at the *Bazaar*, Henry Wolf, had been like a lapdog to Dick, and Marvin, who was ornery and relished his orneriness, in turn became a combative type of dog to him. Combative, too, where everybody else was concerned. Over his boss Nancy White's strenuous objections that the model looked like a man in drag, he put on the January 1963 cover a girl he had had styled, down to her snood, to look like Diana Vreeland, who had recently gone over to *Vogue*. This was perhaps his perverse way of saying goodbye to her, but in the heat of the moment he had told prim old Nancy to go fuck herself, and she said goodbye to *him*. He was replaced by his slaves, Ruth Ansel and Bea Feitler, who had been his prize student at Parsons—both of whom Dick completely controlled. I got along with Marvin well enough. He later visited me in Ireland with his wife, Margie, an accomplished

MARVIN ISRAEL IN THE ARAN ISLANDS,
OFF THE WEST COAST OF IRELAND.

ceramicist—he once paid me the princely sum of twenty-five dollars to photograph a whole shitload of her work.

Dick and I flew to Bangor, Maine, to photograph the renowned classical scholar Edith Hamilton. That was the most nervous I ever saw him at a sitting. She brought out all his insecurities, she was so damn learned. He felt he didn't have any ground on which to even begin a conversation. I certainly never saw him clam up like that around anybody who was in showbiz. In any case, he took such a bad picture of her that I considered pretending I'd exposed a roll of film so he would have to do a reshoot.

We went to Antigua for ten days in 1962 to do a swimwear story for the *Bazaar* with Suzy Parker, who was in the middle of her failure, in the middle of its being all over—both the modeling and the acting. Watching him direct her was like watching somebody build a sand

castle—he would start off very simply, with a little idea, and then add bits incrementally—it was an indescribable progression. We were staying at a place called the Hawksbill. Gianni Agnelli had his huge sailing yacht in the harbor, but for some reason he was staying in the room next to ours, with his girlfriend, the Swedish actress Anita Ekberg—this would have been only a year or so after she cavorted in the Trevi Fountain with Marcello Mastroianni in *La Dolce Vita*. One night we overheard Agnelli saying, "Back to bed, Anita!" and that became a joke forever between Dick and me.

I did wonder that time in Antigua with him if he was going to make a move on me. The atmosphere felt a little charged. I remember in particular one night after dinner and lots of drinks when we were lying on the twin beds in either his room or mine. We were talking about photography, and yet it was occurring to me to wonder, Is this something that's going to happen? What will I do if he . . . ? I remember some phrase coming out of him, something oblique—what he seemed to me to be saying was that he could be homosexual or not, as the mood took him. That night, thankfully, the mood didn't—nothing happened.

Later that year Dick made me the monitor at the design class Brodovitch was teaching in Dick's studio, which Dick came to only once. My job was basically to collect the money, and I was replaced halfway through because I wasn't ferocious enough—I let people get away with owing. Brodovitch's barn in East Hampton had recently caught fire—all his Picassos and Matisses, plus all the furniture he'd designed, plus his whole library, including the negatives for his ballet book, went up in smoke. So he was burnt out, in both senses of the word. He seemed uninterested in the class, and deeply bored with all of life, and as far as I could see, he himself was completely finished as far as being interesting was concerned. When class members projected their photos for him, without even looking at them he would say, "Next!" Not that he couldn't occasionally summon a caustic, and pretty much unhelpful, thing to say. He glossed over photographers like Bill Brandt and Robert Frank, saying only that they printed well. The only photographer he seemed to have any respect for was the one he had invented—Richard Avedon.

Dick fell in love with a photograph I had taken of my girlfriend in the bathtub. Marvin also thought it striking and wanted to run it in the *Bazaar*, but Dick discouraged him from using it—he didn't like that an upstart assistant of his had done what he considered a first-rate photograph. Mind you, he did want you to be good—just not *too* good. Then he had my girlfriend come to the studio to be photographed by *him* for the *Bazaar*. My only consolation was that his picture wasn't nearly as good as mine. The trouble was, people never stopped telling him how wonderful he was. But not *all* of his work was so wonderful. His seventies fashion photographs were prone to excess, shinier than shiny—like Jewish chocolate box covers.

MAGGY GEIGER (1963-71): It's always who you know, isn't it? My mother was a children's book buyer for the old Scribner's bookstore on Fifth Avenue, and her assistant was going out with Earl Steinbicker, and that's how I heard there was an opening. The studio secretary, Sue Mosel, said to me, "All you're going to be doing is making coffee and manning the switchboard, and I'm telling you now, if you ever cut Mr. Avedon off, you're fired."

Amazingly, because I was only nineteen, I never screwed up a call. I loved the switchboard. It was totally *Bells Are Ringing*, pure Judy Holliday: "Just a minute please." We had black phones for incoming calls, and white for outgoing. But then after a couple of years they got rid of the switchboard, but at least I got to have a desk of my own.

Right away he said to call him Dick, but I was so awed to be in his aura I couldn't call him anything but Mr. Avedon. Then one day, after about a year, I made a slip and called him Dick, and he said, "Maggy, at last!"

He had me teaching his twelve-year-old son to type. I used to go to the house on Riverview Terrace for that. I never saw such floors—they'd been stenciled by Billy Baldwin. I would see Evie vaguely, and vague was the word for her. I don't know what the story was there—whether it was drugs or just phobias. Whenever she dropped by the studio, she would go into the closet for a while, and come back out kind of staring, then go sit on the couch. Dick never seemed to get irritated with her. Maybe because she looked so good. She used a lot of

Laszlo, like Laura Kanelous, so she had this iridescent skin. And very good hair. And she always wore Jean Schlumberger bracelets. She left one in a cab once, but Dick didn't do a flip-out. He had a lifelong commitment to his own sense of responsibility to her.

Working for Dick was so glamorous, except for the bums, and I mean Bowery-type bums. They were usually sprawled on the floor by the elevator, just a few feet from the studio door—sometimes they even went to the bathroom there. When Sophia Loren came in, she had to step over them in her spike heels—fortunately she had very big feet. Another one I remember having to straddle them was Audrey Hepburn. I could never figure out how they kept getting into the building.

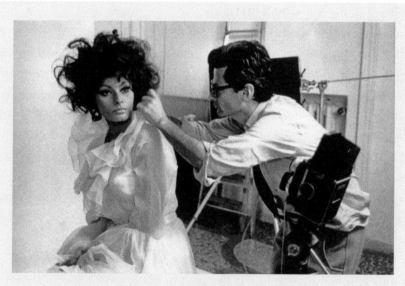

DICK PRIMPING SOPHIA LOREN.

Everybody was coming in. Even the Black Panthers. Smack in the middle of that sitting the strobes exploded and Dick and the assistants and I all hit the ground—we just assumed we were being shot at. Which was just such a terribly telling thing to think—telling of the times, that is. The saddest-ever sitting was Judy Garland. She came in to do the mink-coat gig, the Blackglama ad, and she stole some hairbrushes from the makeup room. And that just killed me. I mean, wasn't it enough that she was getting the fur coat for free? Dick used *me* one

time for Blackglama—for a test shot. He gave me the picture, and scrawled on it, "Maggy is beautiful!"

Jim Morrison came in. But for Hiro, not Dick. He started coming on to me, doing his creepy Doors thing. I wasn't responding—I was just trying to get him upstairs to the sitting. Afterward, Dick said, "Never just send somebody like that up—always introduce them to me first." So then a little later, when those albino brothers Johnny Winter and Edgar came in, also for Hiro, and they started playing and stuff, and Paul Simon dropped by, I went running to find Dick.

Another time, Janis Joplin came in. For Dick. I remember her sitting on the big tufted black couch drinking Southern Comfort. To get her in front of his camera, he had to play her version of "Summertime." That got her going—she sang along.

One weekend, fairly early on, I went to an art fair on Eighth Street and I saw Dick standing there alone, maybe waiting for somebody, maybe not, and I suddenly wondered if he was lonely. It had never occurred to me until that moment that Richard Avedon *could* be lonely.

I only really messed up once. I sent the psychedelic solarized prints of the Beatles to England by regular mail, and I had to tell Laura Kanelous that they hadn't yet gotten there. She had just finished making her calls and was reaching for Dick's portfolio to take on the road— that is, on the avenue. She said, "You did *what?*" in a way that the blood drained out of my body. When I heard they'd arrived, it was like a transfusion.

Four or five years after I left Dick to work full-time for Hiro, I got an invitation to a party for Laura that was being given by her husband. I guess it was a case of me not reading the invitation carefully enough due to being so excited about going to an affair at the St. Regis and getting to see Laura and Dick again—what it was was Laura's memorial service.

I always accompanied Hiro to the collections, and one of the things he had me do was send flowers to the French editors. I would go into the Madeleine and pick out these gorgeous bouquets. I had always been flower-crazy, and later on I started a business in Manhattan called the Window Box, which grew to terraces and gardens. At some point Dick hired me to do a party for my old typing student Johnny. I used

garden flowers, and weed kind of things, grasses, nothing floristy, and Dick loved it. In 1990 he asked me to do Johnny's wedding to the daughter of Senator Moynihan. It was at Dick's place in Montauk, so naturally I did it very Montauky, with rocks from the beach and wild roses.

After that, Dick hired me to take care of his terrace in town—he said he wanted it to look overgrown and *gemütlich*, as if the wind had just blown it all in. Whenever he called about something, I stopped the presses, even though he was far from my most famous client—I mean, I had Barbra Streisand and Madonna.

As our relationship got older, one of the things we had in common was our mothers going down. Suddenly we had the same problems that all children have with a parent who's dissolving. He just couldn't believe that his mother could no longer sculpt, couldn't even go out.

I bought a portrait from Dick—the one of Braque and his wife— and he threw in the entire sitting, all the contact sheets. I was incredibly touched. He told me that Mme. Braque had looked so dowdy and jowly he felt he had to do *some*thing for her, so he draped a scarf around her neck. Toward the end, I got up the nerve to ask if he would take a portrait of me and my husband and son in exchange for a whole year of free greenery. He did seven eight-by-tens of us—a triptych and four singles. I do like them, don't get me wrong. Only I'd somehow hoped he was going to make me look like one of his models. But as my sister said, "The older you get, the better you'll like yourself in them."

GIDEON LEWIN (1964-80): Earl Steinbicker took one look at my book and brought it to Dick, who was on the phone. He glanced at it and looked over at me and raised his thumb and said, "You're on!" A year later when Earl was leaving, Dick took me aside and said, "You'll be taking over."

I was making sixty-five bucks a week—for working at least twelve hours a day most of the time. Dick sincerely felt that people should work for him for basically nothing. I got really good at keeping the Beauty Light moving with the girls—it was like choreography. I was good with all the technical stuff. The ideas all came from Dick, but I was the one who executed them. He had the most exacting standards

of anybody you could imagine, but he would allow you to break all the rules in order to achieve the effect he wanted.

Dick let me use the studio at night for advertising assignments of my own, in exchange for 60 percent of whatever I earned. One day Laura Kanelous looked at my work and said, "Watch out for Dick—you're getting too good." She was laughing, but I knew she was serious. Through the studio I had access to all the top models. I only screwed up once, but it was a big one—Lauren Hutton. I photographed her for one of my clients, and the ad unfortunately came out the same time and in the same magazine as one of Dick's ads with her for Revlon's Ultima II, and the styling was very similar. He took me into the back room and let me have it—"How *dare* you copy me!"

Dick let me take his portrait many times. He had this fixed idea of what he wanted to look like—intense, a bit remote. He would give you that set look of his, which was not what I was after. I was after the eyes, and I got them. He had eyes like Picasso. And that same kind of 24/7 passion for work.

In 1970 the landlord put the building our studio was in up for sale. From a logistical point of view, we never thought of going as far uptown as Seventy-fifth Street, but after three months of scouting I found this great seven-thousand-square-foot carriage house, between First and York avenues. It was the New York studio of the L.A.-based graphic designer and photographer—and car nut—Reid Miles, and it even had a cyc, the curved walls. We got the place for $147,500. Dick brought in an architect and a contractor, and Billy Baldwin as a consultant. He wanted everything stark and practical: coffee-colored tiles, coffee-colored carpeting . . . I made the shelves myself, with my own two hands. And I built the darkroom—not that he ever went into it.

One morning in the early seventies he showed up at the studio with his suitcase, saying, "I'm here to stay." He told me he had left his wife—he said he needed to live on his own and that he was putting 5 Riverview Terrace on the market. He moved into a room on the second floor, and rented out the rest of the floor, along with the third and fourth floors, to the married actors Richard Benjamin and Paula Prentiss.

In 1980 Dick pulled the coffee-colored rug out from under me—he

said he wanted somebody fresh in my job. I was just finishing making the last print for his Berkeley show: the first portrait from his Western Project—Boyd Fortin and the snake. I had to walk around the block to calm myself. I'd walked that walk before, believe me—whenever we had a little disagreement. Leaving the studio was like leaving home. At my going-away party everyone took turns reading a testimonial poem they had written to me, and a while later I had them all over to my new studio and read them a poem I'd written for *them*. It was called "To My Family," and one of the lines went, "With you around, / All the doin' can be done without Lewin." Of course that wasn't true. Dick had put me on a retainer to be available to him for a year, and he was already calling me a lot.

At the opening of his 2002 show at the Met, one of his assistants came running up to tell me that that morning Dick had called him by my name. I told him that that wasn't the first time that had happened. Apparently whenever Dick needed some important work done, he would call, "Gideon!"

I bumped into him at a movie screening a couple of months before he died. He looked frail to me. He was there alone, and he seemed glad to see me—I mean, we hugged. He said, "I want to go to Iraq, and I need someone to go with me." I said, "Dick, I didn't go to Vietnam with you when you asked me, and I'm not going to Iraq with you." He laughed.

CLAUDE PICASSO (1968-69): Dick had photographed me with my sister, Paloma, in Paris, in the *Vogue* studio on the rue de Bourgogne, in 1966—he had just started doing that thing of draping multiple subjects with the black sweater so they would blend into each other. All I knew about him was that he was part of the gang of fashion people that used to stay always at the San Régis, which was owned by childhood friends of my mother's. I certainly didn't know that he had photographed my father, but later he told me that he felt the picture didn't work—he'd been furious to discover when he arrived at my father's house in Cannes that some other famous photographer had been invited to come the same day.

At some point I decided I wanted to become a photographer for

some reason. And a bit after that, as luck would have it, I ran into him in London where he was shooting a Mary Quant ad. He said right off the bat, "Come work for me, Claude—New York is the place to be."

On my second day in the studio, he took me for dinner to the Dover Deli around the corner. He ordered for me—matzoh ball soup, hot pastrami, exotic stuff like that—and he made a list of restaurants I should eat at. He also gave me the names of some clubs. I was already living over one—I was renting a room in a flophouse on East Sixtieth Street called the Hotel Fourteen, where the ground floor was the Copacabana, "the hottest spot north of Havana." Does anyone besides me remember the Copa?

I got to be good friends with one of the studio assistants, Sakata. Everybody would make jokes about us, because he didn't speak a word of either English or French and I certainly didn't speak his language. Laura Kanelous gave me the Berlitz Method for Christmas so I could learn Japanese, and she gave the same to Sakata to learn French. One morning the two of us were standing at the long table with all the Danish and coffee, and Sakata says, "Claude, voulez-vous le gâteau?" which came out sounding Japanese. By this time I was able to answer in serviceable Japanese, although it came out sounding French. I was the only person at the studio who spoke French, by the way, so when letters came for Dick from Lartigue, who I happened to know, I would be asked to translate. I mean, I was there to do anything and everything—including cleaning up after the bums at seven-thirty in the morning.

I had started at the studio a couple of weeks after he did those great Beatles solarizations, but I was there for the solarized Revlon Moon Drops campaign, and that was a bitch—Sakata and I were printing till two every morning. We were breaking in a monster color-processing machine, quite experimental for its time, and it would go on the fritz six times out of ten and we would have to start over. I christened it La Belle Dame sans Merci—I even made a name tag and stuck it on.

When Dick went to Paris to do the collections, Sakata and I were left behind, and we had to work even harder. The film and contact sheets were hand-delivered by a TWA stew, and we would immediately have to start printing—sometimes for twenty-four hours straight. Sakata would do the printing under the enlarger, and I would process, then

we would change places. One night I was printing so fast I didn't even bother to turn when I handed him the big sheet to brush, and I heard it fall on the floor. It was dark, of course, and when I looked around I could only just make out his folded-up body under the processing trays. He had conked out. I didn't have the heart to wake him. And shortly after, I also went down. When the staff got in in the morning, they found no Danish on the table, only a Japanese and a French on the floor, sleeping peacefully—and the prints all scattered around.

Like young people did then, I dressed kind of funny. Diana Vreeland was always plucking things off me to take to designers to copy—I mean literally pulling them off my neck, lifting them off my shoulders . . . I remember particularly a long denim coat she took off me that I had had someone make—very tailored, with the stitching showing. She gave it to Giorgio di Sant'Angelo to knock off for her. The models of the time were all Penelope Tree, Twiggy, Lauren Hutton . . . And *the* hairdresser was Ara, such a sweetie pie, pushing till the last second to make each strand count. Dear old Ara with his cap and rings and bangles.

I would occasionally do stupid things. Like with Donovan, the singer. He showed up extremely late one day at the studio, and I actually said to him, "You know, it's really rather irresponsible of you to put drug-taking first." I mean, who did I think I was? I was a bit of a number sometimes, but little by little I learned to *fermer* my *bouche*.

The year I was there was an election year, so we had McGovern and a lot of people like that coming in. Dick wanted each political figure to be holding a dove, to symbolize the peace movement. So a bevy of nice, trained, perfectly lovely doves was brought into the studio, and every single one of the sitters turned out to be terrified of those harmless little creatures. I would have to calm them down and then place the dove on their finger and show them how to hold it. The problem was the sitters could never stay still, they would move a little bit, and the dove would start flapping and then fly off, and I would have to climb up on a ladder to capture it.

I left the studio to try to become a photographer in my own right. For many years I took pictures for French *Vogue*. Alex Liberman I always found a bit pretentious, I must say. Whenever I would come into

the Condé Nast offices, he would address me as *mon cher ami*—like we had been schoolmates, or herded sheep or something together. I photographed also for *Interview, Saturday Review, House & Garden, Life*—*any*thing. *Brides.* There I was responsible for the bestselling-est issue ever, simply by persuading them to put a nice homely girl on the cover. I wanted to do a black girl for them next—it was the moment when you would try to shake the coconut tree any which way you could—but good luck.

I didn't see anything of Dick after I left the studio. I was shy about that, maybe stupid. Was he, people ask, a true artist, or merely a great photographer? I mean, nowadays every photographer considers himself an artist. And what exactly is an artist anyway? It's just a word. It means nothing. Let's just let Dick be the fantastic photographer that he was.

HARVEY MATTISON (1968–71): I was friends with Dick's son, who was sixteen, three years younger than me, and still at Dalton. We had commandeered Dick's study on the top floor of the Riverview Terrace house and were mapping out plans for a free school that John wanted to start and that we were going to call Robin Hood Relearning. This was the time of post-Summerhill educational effervescence—the idea of a different kind of pedagogy was in the air. John was really on to something and raring to go. But then his father stepped in and took it over—the whole thing, not just the fundraising part—and that took the wind out of John. It wasn't easy to be the son of such a famous man—I mean, how and where in the world do you make your own place?

John's parents insisted I call them by their first names. From the beginning there was a deep connection between me and Dick, and a different strong connection between me and Evie. She was incredible-looking. She had a wonderful wispy voice that asked only the important questions, and a gentleness, and clairvoyant intuition. And what a reader she was. She put me onto Pushkin, and Chekhov, and I remember walking all the way around the Central Park reservoir with her where she talked only about Yevtushenko and Andrei Voznesensky.

Dick also had an extraordinary mother, whom he adored, and she him—she was the be-all and end-all of doting mothers. The only other artist's mother I can think of where the relationship was that strong is

Dolly Sinatra. Dick and Anna had that same kind of very old-world thing going.

I was attending Fordham at night and I needed a day job. Dick offered me a studio assistantship at $48.59 a week. The first time I walked into the studio I was dazzled by all the white—it was like walking into a frosted lightbulb. There were rolls of paper on the floor everywhere, and Dick was shooting and the soft explosions of the flash were like that final spray of fireworks on the Fourth of July.

Often I would have to work until midnight. Dick was good for a dial-a-steak, and around nine we photo trolls would come up from the basement and sit ourselves down at the butcher-block table and eat like millionaires, under the gaze of Charlie Chaplin or Marian Anderson or whoever—he was constantly moving the photographs around.

In the beginning I did the most menial tasks, like cleaning the cyc with Fantastik. I was eventually allowed to dip my hand in photography, like roll up maybe twenty rolls of film, put them on the spools, and then drop them into these black tanks, or measure the temperature with a Kodak one-percent thermometer. At one juncture I accidentally dropped the thing and it shattered, and that could have been two weeks' salary right there, but mercifully Dick didn't make me pay and the earth returned under my feet.

My first year at the studio Dick took some portraits of me, and it was on the basis of those that he invited me to Ireland that summer to be the model for a *Vogue* shoot with Anjelica Huston. He told me that she had chosen me over James Taylor after he showed her his photo of me with my head thrown back and my long dirty-blond hair half-covering a smile.

For the shoot, Dick rented a brightly painted tinker's wagon drawn by a white draft horse. There were all sorts of costumes I had to put on. He directed us as if we were in a film. For me it was more like play— the romance of the countryside and the beauty of the young Anjelica, who Dick told me reminded him of Dorian Leigh in her glory days. I remember driving with her on country roads in Galway and Oughterard and listening to music as diverse as Vivaldi's *Four Seasons* and Dylan's "Lay, Lady, Lay." Anjelica and I played tag in the hayricks, carrying on like the children we had been not so very long before. At night I would go to her room, where she had draped colored scarves

over the lampshades, and we would listen to the husky plaint of Nina Simone singing "Tom Thumb's Blues." On the twentieth of July we went down to the pub with Dick to drink shots of Irish whisky with the locals and watch Neil Armstrong land on the moon.

There was one jarring moment on that trip. Dick had rented a falcon for one of the pictures and we went to check it out at the house of the falconer, and there in a glass case in his living room was a glaring display of Nazi memorabilia. As soon as we got outside, Dick said, "I need to get Simon Wiesenthal on the phone right away."

In Ireland, Dick shared with me a lot of his terrible ambivalence about his marriage. He told me that he was suffering, and that Evie was, too, which I already knew from her. I don't mean to imply that he spoke to me in the most *intimate* terms about the inside of his marriage—I don't think that was ever his way. He just wanted me to know that he was trying to come to a decision and that it was very difficult. And in fact he didn't leave Evie until a couple of years later.

Lartigue was hanging around the studio a lot in those days—this almost historical personage who behaved like an imp. Since I spoke French, Dick had me translate—he was editing Lartigue's book of photographs, *Diary of a Century*. Later on, things soured between them. Lartigue's wife, Florette, accused Dick of only caring about money, and he accused her and her husband of being spongers.

Because I also spoke fluent Spanish, Dick asked me to come with him to Buenos Aires to photograph Borges. He was disappointed with the result, but I was left with the indelible image of the two of them sitting together on the couch sharing stories: the blind genius and the sighted one.

One Christmas Dick sent me as a gift a self-portrait signed with a single word—"Me." That was so Dick. He also gave me one of the portraits of his father and a large portrait of June Leaf, which I later donated to ICP, and some contact sheets of the portraits he made of me in Ireland. When I was getting married, in 1984, he gave the prenuptial dinner, at Primavera, and a week later he flew to Washington to be my best man. My wife and I still have the present he sent our son when he was born—a mobile with little blue rabbits that play Tchaikovsky's *Swan Lake* when you pull the string. The last time I saw Dick I had my

by-then-grown-up son with me. We lunched upstairs in the studio, and afterward the three of us walked out into the street together. The late-spring sunlight was pouring down on my son and my second father. I took a photograph. Dick has his arm around Sean and is leaning into the light—as always, in my memory.

INGRID DROTMAN (1971–75): Dick's secretary Betti Paul was friends with my dearest friend. I had moved to New York from California and was working at a small ad agency and hating it, and Betti was kind of hating *her* job and hoping to move up in the studio hierarchy, and when she met me she thought I would be a good fit. So a couple of days before Christmas I went in for my interview. He just let me talk, and when I was all talked out and he still said nothing, I said, "So, Richard"—I didn't even know enough to say "Mr. Avedon"—"tell me a little bit about *yourself.*" He looked at me with those big boogity eyes of his and said, "I'm a portrait and fashion photographer. You might want to pick up a copy of *Vogue* and notice my name." I said, "Okay, I'll do that"—just as California-casual as could be. I was evidently an entirely different bird from what he was used to. He said, "Can you start the day after New Year's?"

I never gussied up to go to work. I didn't wear makeup or nail polish. I went in there just fresh and scrubbed, with only the tiniest little bit of lipstick. I was trying to stay the person he had liked enough to hire: the girl on the natch, as they say—natural. Oh, it's such a pleasure to talk about him—and I've worked for people who it's not a pleasure to talk about, believe me. I have a frame of reference by now.

I sat at a desk facing out the glass doors to the street. Dick would often sit down across from me, with his back to the door. Whenever I saw a cab pulling up with his next appointment, I would say, "Dick, they're here," and he would scurry upstairs, so he could keep them waiting. I'd then go through the motions of buzzing him—"Dick, your guest is here"—and a few minutes later he would make his entrance.

When Renata Adler came in with her braid, I went over and said something harmless like "I love your hair that way." Dick overheard, and as soon as she left he marched me into the makeup room: "Don't ever get familiar with any of my friends!" So I knew better than to try to

get chummy with Way Bandy or Ara Gallant, adorable as they were. Dick wasn't the only one to lash out at me like that in the studio. One day I was chewing gum, and Polly Mellen was standing there with Dick and she looked at me and said, "Don't you ever chew Juicy Fruit in my presence! I hate the smell." I was smart enough to figure out that it wasn't about the gum—it was about her wanting to put me in my place in front of Dick. But you want to know something, I can't chew Juicy Fruit to this day.

Dick liked it when people would tell him how cute his little secretary was, because he felt a certain degree of ownership. I remember how pleased he looked the day one of his friends complimented him on my body. But *I* was embarrassed, thinking of the legions of truly beautiful women who had come through that door.

I often wondered if he preferred men or women, and I really couldn't ever nail it. All I know for a fact is he preferred his work to either. It came first, and then there was everything and everybody else. Evelyn, to me, always looked a little used—like a washcloth that was a bit not white, that was starting to turn gray at the edges, and I'm not referring to her hair. There were two kinds of people in Dick's life: the ones who got larger from having this powerhouse generator in their midst, and then those who were so eclipsed by him they got dimmer and dimmer, and I had the feeling that that's what had happened in the case of his wife and son. John didn't come to the studio very often, and when he did he seemed angry.

It was what I would call a very diversified job. I had to do everything from making sure the practically identical shirts that he was always having made at Charvet in Paris were lined up in his closet just right—like little soldiers on parade, all facing a certain way on the hangers—to confronting the craziness that was going on in America at the time, drugs and whatnot. I mean, when Sly & the Family Stone came in, and started right away living up to their name, going straight to the makeup room and smoking up a storm, I had to keep tabs on the situation for Dick. Finally he smoked them out—he cranked up "A Family Affair," the studio became a disco, and Sly in his aluminum foil and hot pants and wild-looking cap did his thing for the camera.

After a while a celebrity, even a legend, was no big deal for me—it

was just, "Bob Dylan is coming in today." The only people who seemed to make Dick nervous were the writers—Susan Sontag, for sure, and Harold Brodkey for some reason.

One day out of the blue Laura said to me, very straight-on, "You've gone as far as you can go here, you should try to break out and have a career of your own. You could be an agent. You *should* be an agent." She was right about at least one thing—it was time to leave. Dick sent her to Tiffany's to get one of those platinum chains with the little diamond for my going-away present.

I started representing a talented Japanese photographer by the name of Jeff Niki, who had assisted Dick for quite a few years, and Dick was very nice about it all, because Jeff and I were like his children. And later, way later, I went to work for Mr. Penn.

DICK CRITIQUING A FUJI CAMERA FOR COMPANY
EXECUTIVES, TOKYO, MID-1980S. NORMA FORCES A SMILE.

KAZ NAKAMURA (1973–78): I never got Berlitz from Laura, so I don't have English vocabulary to express feelings about Dick—only can say he was my New York father. Taste of life I learn from him. Technique learned from him wouldn't have kept me this long in business. He say, "Kaz prints a better black than anyone." I used to bow to

East—to studio—from Tokyo, thanking Dick. Now I bow to sky, thanking Him for Dick.

When he come to Tokyo to photograph Shiseido cosmetic, he ask me to be translator and restaurant guide. I take him to favorite sushi restaurant to meet Issey Miyake. He come back to Tokyo to do Fuji campaign. I go with him to president of company, who greet him with "Avedon Sensei." Dick say hi, then tell big boss what's wrong with Fuji film—shutter not right, film turn yellow. President of Fuji say, "*Domo arigato, Mr. Roboto. Sayonara.*"

DICK AND NORMA IN KYOTO, WITH DICK'S FORMER
ASSISTANT KAZ NAKAMURA.

My dick had only energy for one-time intercourse and needed to rest for overnight, but my big boss Dick seemed to have energy forever—never was able to catch him up. When he die I fly to New York—go to studio, put flowers in front of Dovima, visit darkroom. Leave same day.

ANDREA BLANCH (1975): Ingrid Drotman was 150 percent instrumental in getting my foot in the studio door. I kept calling like crazy, until finally, after more than a year, she got Dick to take me to lunch. I had had to pursue him the way *he* had pursued Alexey Brodovitch—he

even told me that one of the reasons he agreed to meet me was my initials were A.B. and that was symbolic for him. I had basically had to stalk him, and I think he recognized and respected that—I mean, how else do you get something?

One time I was talking to Ingrid at the reception desk and I overheard him saying to someone on the phone, "Oh, my slave Andrea will do that." As I recall, he was just rushing off to a therapy session and he was in a really bad mood. Frankly I couldn't have cared less how he referred to me—I was just an unpaid intern, so I guess I *was* a slave. Anyway, everyone knew I was the one he liked the best. I had made real sacrifices for him—like giving up my boyfriend. You couldn't work for Dick and have a boyfriend at the same time. Of course I knew, going in, that five minutes with Dick would be more stimulating than a lifetime with Hank.

The one summer I was there, he had put most of his commercial work on hold because of the pressures of the upcoming Marlborough show. The only client I remember him having was Joni Mitchell, for an album cover. She was coming to him for an ultra-glamorous Avedon portrait and he had just put the larger-than-life June Leaf up on the wall—the earth-mother picture of all time. When Joni walked in, the first thing he did was point to it and say, "Now *this* is my idea of a truly beautiful woman." When the prints came back, he knew at a glance that they were definitely not what she wanted. So instead of having her come in to review them, he had me deliver them. She looked at them, and then she looked at me like she could have attacked me—you know, the messenger.

Five months into my internship, Dick's master printer, Kaz Nakamura, pulled a gun on me. I was an unending frustration to him because I knew next to nothing, and he kept wanting me to read all these instruction manuals and stuff, but I don't learn that way. Or maybe he just had a big crush on me.

He had just gotten back from assisting Dick on a Revlon shoot with Rene Russo and Tony Spinelli in Philip Johnson's Fort Worth Water Gardens. One of those pictures—the one where it looks like Tony is slapping Rene across the face—became wildly controversial. Tony told me later that when he walked into his hotel room Kaz was stand-

ing there with his back to him and then spun around and pointed a Colt .45 at him. He said he didn't want to make waves by mentioning it to Dick and that he liked to imagine Kaz was just playing cowboys and Indians. Anyway, there *I* was, alone with him in the darkroom, and I was freaking out. But I'm a very cool customer, so I was able to not show fear. He had the thing pointed right at me for probably three minutes, and he wasn't uttering a word. When I couldn't take it any longer, I broke away and ran upstairs to Dick. I naturally assumed Kaz's head would roll—right away. Naïve little me: Dick loved me, but he *needed* Kaz. He admitted not knowing how to handle the situation. He said, "I think I'd better call Hiro"—probably for insights into the Japanese mentality. Hiro advised him to fire Kaz, but it was me he fired.

But then he felt so guilty he mentored me exclusively for nine months. He encouraged me to try color—he gave me a book of William Eggleston. And a book of Matisse, and that Ed Ruscha book of gas stations. He worked with me on building up my portfolio. Richard Avedon totally made my career, which is something he never did for any other assistant, before or since, and that is a fact, plain and simple. He called Alexander Liberman at *Vogue*, which became the first magazine to publish one of my photographs—girls running down the street eating fruit. Dick gave me fair warning: "Alex is not a photographer maker, he's a photographer breaker." But Alex found my pictures very refreshing and went on using me. So that gun in my face was probably the best thing that ever happened to me.

And speaking of gifts, I never forgot Dick's birthday—every May fifteenth I would send him flowers or orchids. And he would send me these beautiful notes back: "Oh, Andrea, by not seeing each other we will remain beautiful to each other . . ." He was the only man who never disappointed me.

ALICIA GRANT LONGWELL (1975-80): I was working as a cataloguer at MoMA and Pierre Apraxine at Marlborough recommended me to Dick, who was looking for someone to make an archive of all his prints. So, presto magico, I became his one-woman fine-arts department. He had a huge inventory of fascinating portrait work from *Har-*

per's *Bazaar* and *Vogue* and from the brief time he worked for *Theatre Arts* magazine. I just followed numerical logic and put everything in job numbers and sequences. He insisted that the fashion and the portraits be labeled as such—he had already fallen into that way of thinking, that they were two very separate realms, commercial vs. art. He was just starting to put together his fashion book, and we went through every possible image together.

The studio and his personal life were seamless—and pretty transparent, as far as I could see. Except, come to think of it, he did have a couple of private compartments. One of them was "Dick and Renata," which may or may not have been happening after hours. Anyway, we weren't supposed to think about Daddy that way.

Right after I came to the studio, I eloped with a photography curator at MoMA, and then six years later I left Dick to have a baby. The day of my farewell party I got to the studio late and Dick was standing by the door with a vodka shot for me. What was the name of the cute little Japanese boy with the long wavy hair who was Hiro's assistant? Anyway, he jumped out of the cake in his jockstrap. Dick was egging everyone on to put money in it—a Chippendales-type thing, and we all got into it. The two studios, Dick's and Hiro's, were very friendly, although normally not *this* friendly. What I mean is, Hiro's assistant didn't generally take off his clothes. I was naked, too—in a manner of speaking: There was a big blowup of Baby Alicia in her birthday suit that Dick had gotten from my mother unbeknownst to me. The highlight was Dick and Norma tripping the light fantastic. The lunch went on till four o'clock.

A couple of years later I had a call from Dick wanting to know if I wanted to be a nun—he thought I would make a very convincing-looking one. This was for the campaign based on those crazy characters he invented, the Diors. I got to wear an authentic habit and cotton stockings and shoes—B. Altman's sold nun's clothing at the time. I had my work as a sister cut out for me: the script called for me to put the children in the orphanage to bed while they were having a pillow fight and the feathers were flying. I got a fee for the day, and I didn't even have to be there the *whole* day, because, as a nun, I didn't have to have hair and makeup.

PAT KNACK (1976-81): I had been working as a production person for a television and animation studio, and I came to Dick through one of his assistants, Jesse Gerstein, a good-looking narcissistic kid who eventually left Dick to go live with Jerry Robbins and whose dad was a friend of mine. Dick told Maggy Geiger, who was doing his flowers by then, that he was thrilled to have found such a nice, ordinary person for the job. I started out just making his phone calls and arranging for the daily lunch, but as time went by he gave me more responsibility and even let me help produce his TV commercials. Everything was great, until one day when he was walking by my desk while I was on the phone conducting some business for him, and I guess he didn't like something I was saying, or how I was saying it, because he kicked me — real hard. I think he only kicked me that once, though.

The high point for this nice, ordinary little person was the day Jackie Onassis came to lunch — she must have been trying to butter him up for a book. He sent me out to get lobsters and tomatoes and beets, and strawberries and raspberries, and we served it all on red dishes, and the napkins and candles were red as well. She ate it up — the whole chic red combo.

I left Dick right after I got married — I wanted to go to social-work school. As a parting gift he took my wedding pictures. I was still working at the studio but he gave me the day off. My husband and I love our portraits. They're more flattering than Maggy Geiger's, but then, hers were family — not wedding — pictures, so she was older at the time.

SHONNA VALESKA (1978-81): I had certainly known of Richard Avedon since I was *this big*. My parents had his book *Nothing Personal* in the house, and my sister and I sneaked a look at the pictures of the people in the mental institution — we thought we were doing something bad so we went under the bed to do it.

I had dropped out of my second year at Skidmore to be a dancer with the Harkness Ballet in New York, but one day I just picked up a camera and started shooting my class and realized that it was photography I loved. A bit later I heard somebody say something about an opening at the Avedon studio.

The studio manager, Gideon, took me into the dressing room to

preview me. The first assistant, Adrian Panaro, was sitting in, and he and I looked at each other and went, "Gee, *you* look familiar." And then twenty minutes into the interview, one of us said, "Oh my God, that was you on the metro!" It was a couple of years before, and he was coming to the city for his first day of work at the studio, and I was coming in for my first day at Harkness, and they were both located on East Seventy-fifth Street. So that added to the comfort level I already felt since Gideon was clearly Jewish and maybe even from the same tribe as me.

Then in walks this leprechaun, and I had been expecting a jolly green giant or something. He was wearing a gray cashmere sweater. He had them in every color, it turned out. They were from Andre Oliver, and after Dick died I always meant to ask his son if I could have one. And he had these gorgeous shoes on, which were highly polished, and I noticed what small feet he had—he'd come in almost like a dancer. He took a quick look at my portfolio and said, "Enough of this—tell me what your parents do. And if you like to cook, because we do lunches here." I said, "I love to cook." Then he asked me if I was married. "No? Good. You're hired." And he gave me a hug and a kiss on the forehead. I said, "Is all this for real?"

When he left the room, Gideon explained that it was just a two-week trial period, and even if I made it through I wouldn't be getting paid for at least the first six months. So it was like I was in but not really in. And I really wanted in! There had been only one female assistant before me, he said: Andrea Blanch, and she was short-lived—in and out.

One of my first chores was to take a tube of a new Revlon lipstick to Dick's dear friend Felicia Bernstein in the hospital. He told me that she was dying and he couldn't bear to see her in that condition.

From Day One I waited on that man hand and foot. I was there in half a second when I saw his water glass was empty. That was my way of getting on the set. The first sitting he let me in on was for *Vogue*— Patti Hansen, Rene Russo, Rosie Vela, and Janice Dickinson. Kaz was there, and I heard him tell Dick he didn't want to be on the set anymore, he wanted to be left alone to print the large-scale editions in the darkroom. You know, all alone in that Japanese way. Junichi, another

assistant, was the same way. So that was my opening—that's where *I* came in.

Dick was working on his fashion show at the Met, and he let me print all the thumbnail pictures that were going in the back of the book for identification purposes. After six weeks I went to Gideon and said, "Do you think I could possibly start getting paid now?" and a few days later my trainee salary began—$63.46 a week after taxes.

I was with Dick a lot during the Western Project. I was present at the creation, you could say—the Rattlesnake Round-Up in Sweetwater where he photographed the teenage snake skinner. I also assisted at the slaughterhouse sitting in Omaha, where the guys had scythes and sabers and were in rubber all the way up to here, and the moo-cows kept coming up on the conveyor belt and the blood was splattering way out to *there*. They explained to us what was going to be done with everything, right down to where it becomes cat and dog food. That night I ordered fish for dinner. You would think that Dick and the assistants would have done the same, but no, all three of them had two-pound steaks.

Dick's secretary Pat Knack came down for a week to lend a hand. She told me she was on the verge of telling him that she was going to be leaving to get married. That night I had this dream that he was behind her in the car with a machete and that after he was done hacking her to pieces he turned on me and accused me of not knowing how to put myself together.

He took me and Jim Varriale to Paris with him on the Concorde to do the collections, with Brooke Shields, Paloma Picasso, and Way Bandy, may he rest in peace. And I was around for the beginning of the Versace extravaganzas—the gorgeous men and women and all the sexuality and sensuality—which I didn't let go to my head.

I thought of Dick as my second father. He was always touching me in a very fatherly way, which as you can imagine was my idea of seventh heaven. I was twenty-one-ish, but I was still my daddy's little girl, and now here was this other man, an amazing, colorful human being who I looked up to and loved. My father was always jealous of my relationship with Dick—he held it all inside, but I knew. Daddy used to say to me, "Honey, I'm your boyfriend, you don't need any others." And guess what? I wound up never getting married. Daddy died several

months before Dick, and a whole lot younger. I was very angry with Dick for dying the same year as Daddy—I was like, Couldn't you have waited twelve weeks? Couldn't this just have been Daddy's year to die? Why did it have to be *both* your years?

When I told Dick I was leaving to become a visual articulator in my own right, he was mad at me, so my farewell party was a simple thing, just the studio—you could call it a family affair. I wouldn't have wanted it any other way. The cake came from Greenberg, and it was yummy. And he presented me with a diploma that said "The Avedon College of Hard Knocks." It came complete with a little photo of him that he signed.

JIM VARRIALE (1978–81): Shonna and I were hired within a couple of weeks of each other. Both of us had been dancers, and dancers understand each other. I ended up marrying one—the well-known seventies ballerina Christine Sarry.

I had been working for a year as an assistant to a still-life photographer, so I had a bit of experience. The only advice Dick gave me when he hired me was "Think ahead!" My first day in the studio Gideon put me to work in the darkroom, but Kaz was there and insisted on making all the prints himself. So I thought ahead and just started cleaning everything in sight. Later in the day Dick came down to the basement to welcome me, and we had a nice little talk through the slat between the darkroom door and the hall.

I guess I performed well, because a couple of years later when he asked Gideon to leave he promoted me to studio manager. I remember when Jimmy Carter came in Dick had all of us line up to be introduced and shake the glad hand. Dick had photographed him before, with his mother, wife, and daughter, for the *Rolling Stone* "Family" portfolio. He would sometimes want things left very still in a sitting to generate a certain kind of tension—no conversation to speak of—and Jimmy Carter was one of those times. But when Ed Koch came in, it was a regular gabfest—neither of them ever stopped yakking. The mayor kept asking, "How am I doing?" It was like he was campaigning for the camera. And who was the girl who danced up a storm in *Urban Cowboy*? Debra Winger? When she came in, Dick had us all dance

two-step with her, which was a tricky thing for me, having been trained in ballet.

I went to Paris with Dick a couple of times. Once for the collections. Grace Mirabella happened to be on our flight, and she said something snippy to Dick, like, "How generous of you to take your assistants on the Concorde." The other time we went to Paris, it was to photograph Samuel Beckett and Francis Bacon. They took half an hour each maybe. Bacon showed up in a very natty outfit—striped shirt and plaid jacket. Dick wordlessly handed him his own solid dark turtleneck to put on, then asked him to do something with his hand; then he shot him outdoors, against the side of the Musée de l'Art Moderne. On that trip Dick went out of his way to show me *his* Paris, starting with his haberdasher, Charvet, where they took us into a back room that had thousands of swatches of fabric, hundreds of bolts of blue alone, all in subtly different shades. Dick spent two, maybe three, minutes in there, going, "This . . . That . . . These . . . Those."

By the time I moved on, he had begun mentoring me a little, giving me personal assignments to shoot. He would review my contact sheets, and he always seemed to choose something where I had made a mistake, like when the strobe didn't fire. He would go, "Yeah, it's blurry, but that's good, it's got some energy to it."

My farewell lunch took place in the kitchen—we had ribs. He gave me a pair of $400 Lucchese cowboy boots that he said he'd bought for me one afternoon in San Antonio when my back was turned. The real present was he called the art director at *Rolling Stone*, his friend Bea Feitler, and I got my first big portrait assignment—a cover, Carly Simon. He also got on the phone to Alex Liberman, and in about two seconds I was doing a beauty feature for *Vogue* with Isabella Rossellini.

RUEDI HOFMANN (1978–85 AND 1988–90): I had just graduated from that great photography school Brooks Institute in Santa Barbara, and I came to New York to get my dream job—with Richard Avedon. It was the time of his fashion show at the Met, and I had bought the book and studied the pictures trying to figure out how he did it. You know, I'm *still* trying.

My first two interviews were with the studio manager, Jim Varriale.

As I was leaving for the second time, without having gotten to meet Avedon, I heard his secretary telling someone on the phone that he would be back shortly, so I went and stood across the street and waited to get a glimpse of him. When I finally got to have my interview with him, a few days later, in the dressing room, I noticed that he made a point of sitting on the table so I would have to be looking up at him from my chair. Stagecraft was always all.

I began the next day, doing what beginning assistants did—mopping the floors. The short of it is that I ultimately rose to studio manager. And from that point on, everything Dick did, I was right there with him, whether it was advertising or editorial or portraiture, in the studio or on location, or laying out a museum show or a book. My salary was $250 a week, before taxes.

I accompanied Dick to L.A. in 1981 for the Nastassja Kinski *Vogue* shoot with the snake—I mean, I was pinching myself. One of the assistants almost stepped on it, and the handler told him, "It's already been fed, so it doesn't need to eat you." I learned something from that that's probably never going to come in handy—always make sure the snake has eaten before a shoot. Dick had the handler place it on Nastassja and he got ready to photograph them. The studio manager, Jon Edelmann, whispered to me, "Get a load of her from behind"—there was a wad of blue toilet paper coming out her ass. Dick caught the moment—the second—when the snake stuck its tongue in her ear. The bracelet Polly Mellen added was a genius touch because that's what made a picture of a naked girl with a reptile acceptable to readers of an American fashion magazine.

Before I came, there had been a tradition of Japanese assistants—one had just led to the next. The reason, I was told, was that the Japanese made great slaves—different times, different trends. Kaz Nakamura, who was now just freelancing for the studio, printing the fashion editions, would have thrown himself under a bus for Dick, and that was the kind of commitment Dick required. One day I was drying prints in the darkroom and I saw an object on top of the dryer—I reached up and it was a gun. The real McCoy. I put it right back. The next time I saw Kaz, I confronted him about it. I said, "I found a gun in there, what do you know about it?" He said, "It's mine."

The angriest I ever saw Dick get was one day when he appeared in the darkroom, which was something he almost never did. I had taken some of the prints we were working on—a Dovima, a Suzy Parker— and put them up on the walls because I loved them, and when Dick saw them hanging there he just exploded: "I don't want anyone decorating with my pictures down here!" He ripped them down. They weren't choice prints, but still . . .

Dick loved to play people against each other. And he would play favorites. He hired Stanley Donen's son Mark, who quickly became his pet. Which made him untouchable. And Mark took advantage of that to shirk his duties, and meanwhile the rest of us had to carry his load: the day of reckoning was at hand, however. He had been elevated to the point where he was responsible for the film. There was a big all-day advertising job going on in the studio, involving a lot of different sets of pictures, and you had the eight-by-ten holders that had to be loaded for each set. But when the film came back from the lab, it turned out Mark had failed to put any in any of the fifty holders. He was out running a personal errand when I informed Dick, who said to me, "I don't want him walking back in here, *ever*." He told me to stand outside in the street and head him off, so I gathered up his pencils and some other stuff from his desk to hand him. It was all Dick's fault, of course: his assistants were invariably, to one degree or another, craftsmen, educated and trained, but then he would go upset the cart by bringing in some extraneous bad apple.

For my farewell dinner, Dick took my wife and me to dinner at Primavera. I was flabbergasted to find the big downstairs room filled with all the people from the studio plus some of the suppliers and outside printers I worked with. There was this enormous crate way over in a corner, at least ten feet by ten, with a red ribbon tied around it. Dick said to open it right away. I would have bet anything it was my going-away print. But, oh my God, it was my parents in there! My father was sitting in a little chair, with my mother on his lap. Dick had brought them up from South Carolina and, it goes without saying, directed them how to sit. The next day he presented me with the print I had told him I wanted—his 1947 picture of the smiling Sicilian boy in the

shabby wool jacket and the cap, with the tree in the background that people like to interpret as a mushroom cloud.

Usually with Dick, once you had closed the door, it was please, whatever you do, don't try to come back. But *me* he did bring back—to steer the technical aspects of the studio for a couple of years—and on this go-round he paid me very well. The glamour high point of my second tour of duty was the Sinatra sitting. It was one of those celebrity-couples ads for "the most unforgettable women in the world wear Revlon" campaign. The studio went whole hog—Dick rented a red carpet to roll out for Frank and Barbara. Dick had told her to bring her whole stash of jewels from California so he could pick and choose. The day before the sitting she made her entrance with two suitcase-sized jewelry boxes and a couple of outsize bodyguards. Dick said to her, "I'm sure you had to work very hard for these baubles, Barbara," and she was laughing and they were carrying on like mad. There were diamonds and emeralds in there, but Dick chose a strand of pearls, real big ones, and a pair of pearl earrings, for simplicity's sake.

The next day Barbara came in with a suitcase full of hairpieces, and Oribe pulled one out and just stuck it on her head and combed her hair over it. Then Kevyn Aucoin did her makeup. Then she slipped into this sensational low-cut red satin dress. Frank swept in a couple of hours later. Dick was nervous, more like anxious, even though he had photographed him before, beginning in 1955 with publicity shots of him and Brando for *Guys and Dolls*. Sinatra was in a snit—he was grumpy and gruff, telegraphing that he didn't want to be there and was just doing it for Barbara. He was downright rude to Dick—he said, "Okay, let's get on with it." Dick said, because he wasn't going to take that lying down, he wasn't going to let even Frank Sinatra walk all over him, "Excuse me, sir, this is my studio." From that, Sinatra understood that Dick was like *him*, a fighter, because then immediately there was some kind of respect. He had brought his own hair person, even though he was clearly wearing a piece. On his way to the dressing room to change into his tux he passed the desk of our bookkeeper, Chick, who was from New Jersey, like Sinatra, and Chick reached out to touch him as though he were the pope. The ad turned out great: Sinatra reaching

for Barbara's necklace and giving her a kiss. It was plastered on the sides of city buses for weeks.

The other day I was working on my computer and Dick popped up. I had never been able to bring myself to delete him from my contacts. The message said, "Today is Richard Avedon's birthday. Want to send him a card?"

SHELLEY DOWELL (1980–91): He was in San Francisco, at the tail end of his Berkeley museum show, and our job interview took place in his suite at the Stanford Court Hotel and continued in the car to the airport—it was the first time I had ever been in a limo. He told me he was looking for strictly a fine-art person, and I wasn't even a photography person per se, I was just an assistant curator in art education at the de Young Museum. Later, much later, he told me it was my shoes that clinched the deal—the low heels. This was May, right around the time Mount Saint Helens erupted, and I started at the studio in July. The first day I walked in, he was shooting Brooke Shields for Calvin Klein jeans—she was whistling "Oh My Darling Clementine" as the camera panned up her leg to her crotch and then her incredible face.

Kaz was working there freelance. There was a period of two years when he out-and-out refused to speak to me and we had to talk through other people. Whatever, we ended up becoming close friends. Alicia Longwell had already laid the groundwork for me—she had set up a cataloguing system for Dick's negatives, starting with his Marlborough show, which was really the beginning of photography as an art market. I re-sleeved the prints and got them into acid-free boxes.

Dick's whole life, just about, took place in that building, and to that extent it was transparent. His apartment wasn't like the sacred space—it wasn't off-limits, you didn't even have to knock. There was nothing to knock on, in fact, when I was there; it was open, like a loft. And the things he had inside! Not to mention the way he put them together.

The world is littered with people who I'm sure thought Dick was their best friend. It was a very heady thing to have someone who was such a great talent and such an incredible charmer come on as completely devoted to you. And he *was* sincerely curious about you and interested in you, if only for that minute or hour or two—it was no act.

I remember when I was about to get my teeth bonded how he sat down and helped me pick the color and decide how far they should be filed down, so I would have a perfect smile.

In 1989 Dick and Norma negotiated a deal with the Center for Creative Photography at the University of Arizona—a state-of-the-art research and storage facility and the repository of the archives of Ansel Adams, Edward Weston, Paul Strand, W. Eugene Smith, and Harry Callahan—you get the picture. In exchange for their preserving and conserving all things Avedon from here to eternity, he gave and/or promised them one print of every eight-by-ten portrait that existed in an edition—with the exception of the Western Project. He threw in assorted negatives, preparatory sketches, correspondence, books, and memorabilia. It was a relief, he insisted, to say goodbye to all that— fewer warehouse bills, no more cardboard boxes and mothballs. And his work—at least the paper it was printed on—would be breathing and contracting in a stable, even-temperature environment. I stayed until the transfer of most of it to Tucson had taken place. Then all of a sudden there were no more prints for me to archive.

PENNY COBBS (1980-84): I trained with Pat Knack, who was very conservative—soft-spoken and matronly. She said to just make sure I kept everything confidential. When I arrived, Gideon was in the middle of leaving, and everyone said his successor, Jim Varriale, was a definite departure—a former ballet dancer.

You could almost see the energy flowing inside Dick, and if you couldn't see it you could certainly feel it. It was contagious—I always answered the telephone "Studi-O!" But whenever I called a restaurant or anything like that, I used a very dignified voice, "This is Penny from the Avedon studio." And of course the seas parted—it didn't matter what I was asking for, I was going to get it.

The first thing I did in the morning was make the pot of coffee, to go with the pastries, and I would be making it all day long for the studio family. Because we *were* a family—I mean, if Ruedi called me tomorrow, we would still be like sister and brother. Some of it was good family stuff—some not so good, by which I mean all the jockeying to be Dick's favorite.

Whenever his son called, no matter what Dick was involved in, even if he was on set, he would take the call. He wouldn't interrupt his work for Renata or Twyla, not even for Mike Nichols—not even for his mother!

I was close with her—we would go to dinner and the theater together. She was a very strong woman, Mrs. Avedon. Very independent. A real feminist, I think—I mean, she gave me a book by Simone de Beauvoir. And she was artistic. I could see how Dick, you know, *came* from there. She respected his privacy like nobody's business—she wasn't one of those "I don't see enough of you" mothers. She would never drop in unannounced, and it wasn't like she couldn't have—he would have been thrilled.

Everyone wondered if Renata was really his girlfriend. *I* didn't think so. That wasn't Dick's focus—he wasn't interested in any of that. I don't think he ever even went on an actual date. All he did was work—work work work. And go to the theater.

Dick's was a very small world: people like Isabella Rossellini would come in and he knew her mother, or Shari Belafonte and he knew her father. Almost everyone was on their best behavior at the studio. The tone of the place was basically serious. And really, one of the most important things he wanted to teach his assistants was the business side. After a while I was promoted to work in his poster company upstairs— Andrew Grenshaw *Limited*. Dick liked the veddy English-blueblood sound of that—he hadn't wanted to use his own name.

We started with four posters: Nastassja Kinski and the snake, Lauren Hutton with one of her nipples showing, Brooke Shields with a Keith Haring heart, and John Lennon. And then we did four Marilyns— her impersonating the old-time sex symbols Jean Harlow, Theda Bara, Clara Bow, and Lillian Russell—he'd done those pictures for *Life* in 1958. But since nobody could recognize Marilyn, they didn't go over well. We sold our posters through galleries all over the country. Dick was like a little kid, wanting to know every time a poster sold. We put a map of the U.S. up across from his desk and when we told him the places where the posters were selling out he stuck a pin in, and when people visited the studio, he would show them the map. They went for

$25 unsigned and $50 signed. The posters with Lauren's nipple he signed at the bottom in silver—big, all across. The same with the Kinskis, and he signed at least half of *them*—like maybe a million all told.

The night of the "In the American West" opening, in Fort Worth, Dick took us all to this great barbecue place after the big dinner at the museum. There was a huge cake, which I can't imagine wouldn't have been in the form of something Western, and he pulled me up onto the table and we danced around it. I was wearing cowboy boots and a sparkly little skirt and my hair was flying, we were bopping up and down and twisting, but somehow that cake stayed in one piece. That year for his birthday I gave him a snow globe with a cake in it.

Every Christmas my mother would send him cans of his favorite popcorn, and he would write to thank her immediately: "It wouldn't be the holidays without Penny's mother's popcorn." He just always knew the thing to say. One time he wrote her that the popcorn was all gone but not to worry, her daughter was keeping the studio popping.

I was working so hard I felt I deserved to be making more money, so I decided to leave. My father said, "Penny, you should think of it this way: you are working for somebody who people might actually *pay* to work for." After Dick I went to work as a liaison between the jeanswear company that was putting out a Brooke Shields line and her mother, Teri, and godmother, Lila—those two really did raise a nice girl.

Dick said he was sorry to see me go. He took me to Primavera for dinner, and then on to Danceteria, where it turned out he'd arranged a big surprise party. He was in cahoots with my mother—she had sent him a picture of me at the age of three on a pony and he'd blown it up wall-size and hung a pair of cowboy boots from it. The whole floor was strewn with pennies—pennies for Penny. It was a big production, but then, that was Dick. He and I danced—he was such a fabulous dancer that any occasion I could dance with him I did. At the end of the evening he gifted me with an eight-by-ten print of *Dovima with Elephants*. And a few years later, when Chick retired, Dick sent me a ticket to come from Miami where I was living to his farewell party.

When my father died, Dick wrote me the most beautiful letter. He said that grief was something he understood firsthand, having suffered

the deaths of his first agent, Laura Kanelous, and his second cousin, Keith Avedon — losses he said he still hadn't recovered from.

DREW CAROLAN (1982-83): I came on as a freelance utility person, someone imported for advertising shoots. If you needed coffee, or there was a spill, I was just kind of the guy with a lot of energy. About six months later something at the studio opened up, and Dick said to his second assistant, Richard Corman, "What about that utility kid?" Corman told me it could amount to more than just a studio gig, that Avedon was working on a big exhibition and book called "In the American West" and I might be getting to go on the road — "seeing the blue highways of America" was how he put it. You can imagine what that meant to a kid from the Lower East Side. The running joke was that the furthest west I'd ever been was Fourth Street.

My first day at the studio, Shelley Dowell handed me a pair of white cotton gloves to put on to help her roll out some print — she explained that oil from fingers was very destructive to photographic emulsions. Well, that really *was* some print. As we were rolling it out, it was being revealed six inches at a time. It was a close-up of Andy Warhol's torso with all the scars and stitches, and his hand holding his chest, and I thought, Wow, it's only nine a.m. on Day One, this is going to be some ride.

Ruedi gave me my first piece of advice in the studio: "Everything you know, forget, because there's a certain way we do things here." He and I became good friends, he even named his son after me.

We hit the road in late May.

DAVID LIITTSCHWAGER (1983-86): When Dick told me ten minutes into our interview that I had the job, it was four-thirty exactly — I remember looking at my watch. It was my twenty-second birthday, so it would've been June 10, 1983. From the time I was fourteen or fifteen, living in Eugene, Oregon, and skipping school to hang out at the local camera store, I had wanted to work for Richard Avedon.

The studio was my education. Assisting Dick was better than going to college, it was like entering into a traditional European apprenticeship. I thought and still think he was the greatest photographer who

ever lived, but I also witnessed him use every tactic in the book, from charm to oppression. Let's start with the charm. We were all sitting around the table one day at lunch. He had just put up the ad he'd done for Avon to promote Catherine Deneuve's perfume Deneuve—it showed only her face, black-and-white, very stark, with her hair slicked back. And then suddenly in walks this vision of loveliness, the quote-unquote most beautiful woman in the world, Deneuve in the flesh. And she sits down with us. Dick then asked his four unsophisticated young assistants to stand up, one at a time, and explain to her why they each went into photography. When we finished our tongue-tied little stories, he said, "Come off it, guys—admit it was just to get girls!" That got Deneuve laughing. It was all a little show he was putting on just for her.

I worked at the studio at the height of the production of the Western Project, and figuring out the technique for making the big prints the best they could be was very challenging. I made only one mistake during my time at the studio, but it was a whopper—I let a sitter see a Polaroid of himself before showing it to Dick. He whacked me on the back of the head. For which, I might add, he later apologized.

When I left the studio to start taking pictures of endangered species, he gave me from the Western series his only non-human subject—the 1983 diptych of the heads of three slaughtered *un*endangered sheep, taken in a Montana slaughterhouse. The email saying that he'd died found me in one of the most remote places on earth—Midway Atoll in the North Pacific—photographing an incredibly rare snail. The training I got from Dick had everything to do with why I was where I was. And am where I am.

BILL BACHMANN (1984–2004): A Condé Nast editor my wife knew mentioned to her that Richard Avedon was looking for a secretary/office manager, and my wife called me at home to ask, "Is this for you?" Coincidentally, I had just finished putting an Avedon fashion picture up on our refrigerator. I decided to apply for the job: I was someone who was super-organized, plus I liked photography—I had a darkroom when I was little.

There was a long line of people at the studio waiting to be inter-

viewed. When my turn came, Avedon gave me a dictation test. He rattled off a letter in what was the fastest I'd ever heard anyone speak—it was like a vocal attack. I was scribbling away like my life depended on it. I then had to take what I'd managed to get down and go to a typewriter in another room and turn it into something coherent. And that was the first of the literally thousands of letters Dick dictated to me over the years.

My first day at the studio was just insane. He was shooting not one but two *Vogue* covers and it was a circus: he was screaming at the top of his lungs, and Polly Mellen, a scream to begin with, was screaming back, and people were running around like crazy, in and out the front door, up and down the stairs, and the phones were going nonstop, and messengers were wheeling in racks of clothes. It was an assault on every one of my senses. And every single day of my twenty years with Dick was more or less like that—a madhouse—and I loved every minute of it. I'm six-one-and-a-half, by the way—one of the few exceptions to the unwritten no-tall-assistants rule—and all those years, whenever I saw him coming over to sit next to me, I would put a pillow on his chair to make us a little more equal in stature.

Dick was *in the moment* all the time. I mean, if he wanted to thank somebody for sending, let's say, a great bottle of wine for Christmas, he would stage a whole scene—he would have some of us drinking a glass of the wine and looking punch-drunk, and he might be lying on the table with his head on a plate and his tongue hanging out.

When I had been at the studio fifteen years, he took me and my wife to dinner at Restaurant Daniel, and he gave me his fashion portfolio. I sold it at Sotheby's after he died—I had to, my daughter was going off to college. In the summer of 2004, my twentieth anniversary with him was coming up, and he conspired with my wife to get me all the way out to Brooklyn for lunch. He had arranged for practically everybody who had ever worked at the studio to be there. Plus people like his son, Doon, Twyla, China Machado, and Adam Gopnik with his two kids— the whole extended Avedon family.

He had taken the entire restaurant, Locanda Vini e Olii, northern Italian, reportedly one of the best in the New York area—it had originally been a pharmacy, and all the old curios were still on the shelves.

The son of Toshi, one of our freelance assistants, performed two classical guitar songs. And various people put on skits and sang songs and read limericks at my expense. I was in tears throughout—I'm an emotional guy to begin with, you know.

The moment Dick went into the coma in San Antonio, my life froze. It's funny because I was always saying things like, "If *I* die before him . . ." I mean, *he* was the one with the trainer, the one with all the energy, all the power, all the money, all the . . . everything. I had instructed my wife that if I did go before Dick and he wrote her his standard condolence line, "Words fail," she should burst out laughing. But now it was Dick who was going.

The week that he lingered I spent preparing not only myself for the worst but all the other people who loved him. I had to explain to scores of them over and over what was happening, and it never got easy—each time it felt just as bad. Still does.

Not that working for Dick was ever easy—you could never call what he was going to do. By the time I was there a year, I had seen such a wide spectrum of actions and behaviors from him that nothing could shock me, good or bad—I knew that he was capable of anything. But there was always a method to his madness.

14

ASSORTED NUTS

—

"**D**ICK'S AT HIS SHRINK," I WAS HORRIFIED TO HEAR AN assistant once say to a client who was calling. I told him, "That's a no-no—just say Dick's out." His analyst, even more than his cardiologist (the world-famous Isadore Rosenfeld, no less), was a doctor after Dick's heart. He harkened to Dr. Kleinschmidt's words of wisdom. To wit: "A dollar is a dollar—an artist should never be shy about asking for more money"; "Don't trust your friends, or your relatives—always watch out for Number One"; and, most helpful to Dick, who used it to assuage his persistent guilt over leaving Evie, "Never surrender to feminine pressure." Kleinschmidt took a further load off Dick's conscience by quoting him a line from a letter by Kandinsky: "Art is very jealous and permits no rivals."

Kleinschmidt didn't brook any rivals, either. He confirmed and encouraged Dick's antipathy toward his previous analyst. "Edmund Bergler I went into treatment with around 1950," Dick told me. "He explained that my photography was just a form of infantile peeping, thanks a lot. I hadn't gone to him to hear that. He was known for his 90 percent cure rate for homosexuality. I discovered at some point that he had discussed my case with another patient—he described him as a 'queer fish,' and other things, using my name. And then, not using it,

but feebly disguising my identity by making me French and deceased, he wrote about me as a 'famous photographer' in his book *The Super-ego*. I went running to Kleinschmidt."

Dr. Kleinschmidt, first name Hans, was a German-born Freudian complete with heavy accent who had fled the Nazis. His specialty was creativity, and he numbered among his patients Philip Roth and Leonard Bernstein. It was Lenny, in fact, who referred Dick to him, or was it Dick who referred Lenny? And was it Philip who referred my husband, or was it Martin, who employed Philip's brother, Sandy, as an art director at Revlon, who referred Philip? Roth divulged to an interviewer that it was Kleinschmidt who had "given me *Portnoy's Complaint*" — that is, by unwittingly serving as the model for Dr. Otto Spielvogel of "So, now vee may perhaps to begin" immortality. To have been credited — on the record yet — as the inspiration for one Roth character was not enough for Dr. Kleinschmidt. "I'm Klinger, too," he boasted to a literary critic, instancing the psychiatrist in two other Roth novels, *The Breast* and *The Professor of Desire*. (Soon the analyst was trying his hand at thinly veiled portraiture. His article "The Angry Act," on "the interplay of narcissism and aggression" in creativity, published in the late sixties in a psychoanalytic journal, included the case history of a writer "in his early forties who had come into therapy because of anxiety states experienced as a result of his tremendous ambivalence about leaving his wife, three years his senior." The similarities to the backstory of one Philip Roth did not go unnoticed — by Philip Roth, for one.)

As far as Dick was concerned, however, Kleinschmidt could do no wrong. He would occasionally give a session with him as a gift to a friend, or even an assistant in perceived need. "When I told Dick that my father had just died," Kara Glynn, the studio manager in the early nineties, reminds me, "he sent me to his psychiatrist without passing go. He was this really old guy on Park Avenue who fell asleep and started snoring. Naturally I told Dick that the visit did the trick — I'm not stupid."

Dick underwrote several Kleinschmidt sessions for Harold Brodkey, with whom he had such a complicated relationship. (Complicating matters even further was the fact that Dick had hired Harold's brainy and beautiful first wife, Joanna Brown, who suspected a relationship

between them, as his secretary—and, further still, that through Dick she met, fell in love with, and became engaged to Mike Nichols. Mike eventually broke it off, but it was Dick who had broken it up—Joanna and Mike had to return all the presents.) Kleinschmidt warned Dick that Harold was "insanely jealous" of him and that he should be very careful: "Brodkey is like barbed wire—if you get too close, he will cut you." Dick told me he was touched that his psychiatrist was so protective of him he had been willing to cross the professional line to give him that piece of advice. I said, "What are you doing going to an analyst who has such a big mouth?"

Harold was not the only person close to Dick whom Kleinschmidt tarred with the jealousy brush. Dick's successive secretaries were instructed to leave two four-by-six-inch white index cards with his daily schedule typed up (one for that evening, the other for the next day) at the foot of the stairs to his apartment when they went home. Pat Knack, his secretary in the late seventies, would from time to time forget to do this. Kleinschmidt diagnosed this minor dereliction for Dick as "a pathological acting out of envy." Armed with this piece of shrinkage, Dick hurried back to the studio to confront Pat: "I depend on those cards! I'm practically helpless without them. And don't think I don't know why you did this. My doctor told me that . . ." Pat came running into my office with a you'll-never-believe-*this* look on her face. "He gave me such a load of Freudian crap," she fumed. I reassured her with a "Dick really loves you." Which happened to be true.

Another time, Dick came running into my office directly after a Kleinschmidt appointment. He told me, "As I was going out the door and his next patient was going in, Kleinschmidt said to me, 'You can tell your friend Renata Adler that I know all about her.' What do you think he meant by that?" Dick being another one who couldn't keep his mouth shut, he passed the message on to Renata. She says today, "I had actually met Kleinschmidt, at one of Dick's openings. But still, it was highly improper of him to send me a communication via a patient. My interpretation is that he wanted Dick to know that he was familiar with what he perceived as my category of being—my so-called type, ethnically and culturally. And maybe he even thought I was making advances to Dick, and that my object was marriage and that that was

the middle-class game I was playing. You have to understand that although Dick and I loved each other in a way, we were never involved sexually at all—we were not at any time, *ever*, that kind of couple. But Dick wouldn't necessarily have told it that way even to his analyst, would he?

"The time we went to Mustique together, I was involved with someone else, but I thought, All right, this is it, this is the deal, Dick and I are both grown-ups—dammit, I suppose this has to be an affair. I mean, it's very peculiar to go to Mustique with someone of the opposite sex and *not* have an affair. Later I came to realize that he was dreading that I was expecting a pass as much as *I* was that *he* was. Neither of us wanted to, so there would have been nothing at all to worry about, but who knew? It actually worked out just fine, because on that trip I introduced him to Princess Margaret, and for him that was better than sex.

"There was a funny sort of paradoxical reversal in my relationship with Dick—that this sort of intellectual, this wallflower, *me*, would be in a position to introduce *him* to people like Princess Margaret and Brooke Astor. What are the odds of that? He, after all, was the much more social, presentable—*sortable*—person. You would have thought that those people would be his natural constituency, and yet, though they knew who he was of course, they didn't know *him*. One of the triggers of bitterness in him was the way Grace Kelly had supposedly treated him at a sitting—like a servant—not even offering him a glass of water. He said he didn't consider her beautiful, that her features were too perfect for anything much to ever happen on her face. When he was telling me this he had the look of the hangdog Dick that I had met at that Sidney Lumet screening of *The Pawnbroker*. Grace Kelly was a very long time ago, to be sure, but it seemed to be his abiding notion of what society people were like—never mind that nobody had treated him that way for many, many years. So you see, Dick and Dr. Kleinschmidt had a lot of ground to cover without bringing *me* into the picture."

Kleinschmidt retired in 1996, forcing Dick to shop around for a new shrink. He found Dr. Robert Millman. Let me put it a better way: they found each other.

When a psychiatrist tells tales out of school about a patient, even a

dead one, it raises an ethical question. "I love to talk about my pa-
tients," Dr. Millman protests. "I consider them the most interesting
people I know. I used to be able to talk about them freely all the time
to my wife, who's also a psychiatrist, but ever since she decided to only
work in clinics and take care of crazy poor patients, she doesn't want to
hear about a lot of rich entitled crazy people. To be fair to her, she had
had a couple of private-patient suicides, and it got to her. Whereas *I*
feel nothing—I can handle any kind of thing in my practice without
the slightest emotion. Real life I can totally handle, but I hate watching
television because if by accident I happen to see a commercial and it's
Prudential or something and they show old people walking off into the
sunset, I start getting teary. And I *hate* myself for it—it's disgusting. But
anyhow that kind of thing gets through my defense system: So I just try
not to watch commercials.

"About Richard—I never called him Dick, by the way; to my ear,
'Richard' was nicer—I did feel something, a lot actually. He was so
much more than just a patient to me. I don't know of too many other
people who died who've left such a gap in my life. He was startlingly
interesting to me, and he enriched my life immensely. Socially. Edu-
cationally. He gave me some of the best books I ever read, although I
never believed that he actually read that many of them himself, be-
cause he wasn't a good reader, he read very slowly—oh, maybe he
waded through a couple of them."

Dr. Millman stresses at the outset that he isn't one of those old-
fangled psychiatrists who blindly follow regulations. "The rules of strict
psychiatry going back to 1907," he explains, "state that you should
never have anything to do with your patients socially and that you
should never accept anything from them—not a theater ticket, not a
meal. Surgeons, on the other hand, can get country-club member-
ships, houses, clinics—they can get anything from rich patients. This
stupid rule is called the boundary violation. I boundary-violate a lot—
not so much taking things as much as socializing." (I now remembered
having read in a bylined story in the *New York Post* that Michael Doug-
las's junkie son, Cameron, had been "inadvertently exposed as a turn-
coat by his shrink during a bail hearing in 2010 . . . Dr. Robert Millman

let slip that Douglas agreed to testify against his suppliers." That was a slip with potential life-and-death consequences for the patient.)

Whenever Dick had a museum opening, Millman came. And whenever he invited Millman to the theater, Millman went—"He would usually have gone to the play already five times, and I'd go and not like it, but you know . . ." Dick had Millman and his wife to dinner with Renata, both in his apartment and at the Upper East Side restaurant Café Boulud. And sometimes I would be leaving the studio at the end of a long day and Millman would be arriving to have dinner with Dick alone upstairs. He was also an occasional weekend houseguest of Dick's in Montauk, and I do remember feeling that that was going too far. "I know that the Montauk place was a big money pit and that he didn't even use it all that much, but I think the real reason he sold it a few years before he died was he didn't want his son to have it," Dr. Millman offers. When I say, "I'm not so sure that was the case," he responds sharply, "Well, I am."

The patient-doctor socialization was sadly one-sided. "I would like to have reciprocated," Dr. Millman explains. "I was the medical director of Major League Baseball, all of it, but Richard never expressed the slightest interest in going to a game. I would have had him in Steinbrenner's box—and Steinbrenner would have been thrilled, you know."

Dr. Millman recalls for me the story of how he and Dick hooked up in the first place: "We were both involved with the same woman, Twyla Tharp—she was my girlfriend for a moment years ago. She and I were such an unlikely pairing. I had never met anyone that intensely focused. Or that helpless with mundane things—I had to teach her to swim, I had to teach her to drive . . . She was older than most of my other girlfriends had been, but hey, she was famous, and amazingly interesting. One of her ballets was having its premier at Lincoln Center, followed by a black-tie gala, and she sent a limo for me. And inside the car was Richard Avedon, with his beautiful mane, looking like he'd been born in a tuxedo. When we got out in front of Lincoln Center, the photographers swooped in to take our picture. At the opening there were a bunch of people I knew—psychiatrists—and I was there with Richard Avedon and I was preening. Subtly. And it felt really great."

I take a moment to savor the image of Dr. Millman looking like a penguin and behaving like a peacock.

"We talked all through the evening and, to put it mildly, I fell in love with the guy—you couldn't help it," he says. "Then months and months later he called me. He told me that his previous analyst had died and that he wanted to see me professionally. I explained to him that mine was a very different style of psychiatry from Kleinschmidt's. He was an old-world analyst, very distant, very formal in manner. I, on the other hand, would talk as much as Richard—maybe not *as* much as Richard, but a lot. And actually, that theory is catching up with the practice—they're now saying there's more progress to be made when the therapist is active, talkative. I don't encourage dependency, and I think the secret of my success is, my patients realize I'm as crazy as they are—crazier. So if *I'm* getting along with a smile, and humor, they can, too: something like that—no kidding. They see how flawed I am and they feel like they can get better.

"I saw Richard right up until his death. Several times a week. He was a strange combination of narcissism and interest in others. And of insecurity and power, and of . . . I don't know what. Actually, I do know what. Among other things, Richard was having problems getting to sleep. I explained to him that as you get older it's harder to sleep and you sleep less. My theory, and I wrote a paper about it, is that a young animal—a tiger, for instance—or a young boy, sleeps soundly and deeply because he knows that if there's a predator he can spring up and either eat it or outrun it; he has that power. But as animals and people age, they lose their power, and evolution has programmed in them a lighter sleep—they sleep only at intervals throughout the night, because they need to be vigilant. That's the reason it's harder for them to fall back to sleep—they're afraid. And three o'clock in the morning when you wake up, no one thinks good thoughts. I'm an expert at helping people to stay asleep—I know more about sleep than anybody on earth. Anyway, I gave Richard a prescription for Ambien, but because in older people it can really screw up their memory and he was afraid of forgetting things, I was careful with it—I switched him around a lot. The game is to never take the same pill every day for a long time. I took Ambien myself for a long time, and in the morning things would happen to me and by the

afternoon I would have no memory of them—I'd see a patient and then forget what happened with them. I mean, a lot of people dissociate on Ambien. I still take Ambien, but now, to keep it moving around, I vary it with Valium, Klonopin, Trazodone, Lunesta . . . I've taken every drug on earth."

At some point while he was being treated by Dr. Millman, Dick had a nocturnal fantasy in which he experienced what he described to me the next morning as "an unpleasant animal moment." He had struggled out of sleep feeling as if his chest had been crushed, and with the sensation of an indeterminate creature's breath on his neck. In an access of self-analysis, Dick declared that the predator must have been his neck-and-neck competitor Irving Penn.

I have a quick question for Dr. Millman, but first I need to tell him a couple of short stories. One summer in the sixties when Dick and Evie were renting on Fire Island, in the family community of Seaview, a neighbor called to him from her porch—she had someone there she was eager for him to meet and he wasn't going to believe his eyes. Dick found himself face-to-face with his doppelgänger (except for the galling fact that the guy was considerably taller). His name was Charles, which was Dick's middle name, and Dick felt the urgent need to know everything about him. He arranged to do a sitting later that week in his studio.

For the picture, Dick asked the subject to take his shirt off, unbuckle his belt, and unbutton the top button of his trousers. "I didn't have the balls to ask him to take off his pants and underpants," he told me. "I was dying to see whose was bigger." He took his own shirt off and had one of the assistants take a photograph of the two of them.

Fast-forward to the summer of 1974. Dick was recovering from his first attack of pericarditis—floating obliviously in the swimming pool at the Bernsteins' estate in Connecticut—when he was summoned to the phone. The sex-crimes division of the Washington, D.C., police department was calling to inquire if he had been in the capital the day before when a young woman was raped, and did he answer to the description of a six-foot-six white male weighing 250 pounds, with a scar above his left eye and two missing front teeth, and was he wearing a gray two-piece polyester suit. It turned out that thirty-three young women in twenty-

five cities in the United States and Canada had been methodically raped in Dick's name, not to mention swindled, by a man armed with a calling card engraved "Richard Avedon, Fashion Photographer." His m.o. was to stop women on the street or approach them in shopping malls, airports, or cocktail lounges, and ask if they had ever done any modeling. Then he would tell them they had beautiful skin and great bone structure and walked like a princess, and offer to provide introductions and arrange for modeling jobs. All they would have to do was furnish him with the money to class them up (via new clothes, an apartment in Manhattan . . .). He would make his proposition around noon, which would give them a couple of hours to finesse the bank withdrawals. Once they had done so, and many of them took out their entire life savings, he would take them to his hotel, snap pictures of them topless and sometimes bottomless with their own cameras, violate them, and abscond with their money. . . . All this in the name of Richard Avedon!

This story had what Dick loved more than anything—high drama— and he inveigled a member of the police force into sharing the victims' harrowing confidential statements with him. He felt bad for all those poor deluded girls, but on another level he was fascinated by the concept of identity that the episode exposed, and secretly thrilled to have his notion of his own fame and power reified.

Now I am ready with my question for Dr. Millman: "Where Dick was concerned, would you diagnose these as cases of narcissistic duplication?"

"For sure," he replies. "And yet, Richard was nothing compared to most of the other world-class malignant narcissists I see—that's my term, by the way; I made it up—because he was also interested in what was going on with *me*. The stars I treat—the billionaires, the politicians, the amazing athletes—they aren't interested in anybody but themselves. They *act* like they think I'm as fascinating as they are, but it's just a façade. Everybody is always looking at *them*, and so what happens is that at some point they stop being able to look back, though they continue to have the nice smile on their face when they're talking to you. But Richard was a bit different—he sincerely wanted to know what thoughts *I* had about subjects other than *him*. There were even times when I felt *he* was observing *me*."

"That must have been a little unnerving," I say.

"Very, because he wasn't afraid to really criticize me, and a couple of times he wounded me, correctly. For example, he had given me all those incredible books of his, and I'd grouped them together on the shelf in my office, whereas all the other books up there were disorganized. In the middle of one of our sessions he pointed to the shelf and said, 'You're trading on my name, and I won't have it.' He was accusing me of using him, of *deliberately* displaying the books in a group in order to reveal to my other patients that *he* was a patient. The minute he left, I got up on a ladder and started separating them—I spaced them all really far apart. Because he was right. I have no trouble admitting that. I admitted it to him then and there. Well, I could hardly have denied it, could I?

"Here's a *really* crazy thing: when he was working on his big portrait retrospective at the Met, a couple of years before he died, he would always ask my opinion on which of his photographs to include, and where I thought they should go in the show. I finally had to tell him, 'You don't want my advice on issues like this. For *two* reasons.' And I explained them to him. One was I'm someone who has to be told what's good—only *then* do I get it. What I mean is I have good taste but only after I've been shown what it is. Funnily enough, the only photographer I ever appreciated on my own is the French guy that Richard really went to bat for—Lartigue. I could see for myself that Lartigue was great: the pictures of his parents, so sweet, and also how elegant it was to be upper class in French. The other reason I didn't want to get involved in a discussion with Richard about his pictures is that I had already learned my lesson about giving artistic advice to geniuses."

I fasten my seatbelt: another artist patient is about to be betrayed.

"For many years, every time Miles Davis came in," Dr. Millman begins, "he would sit across from me at the partner's desk I use in my practice and right away begin doodling. Now, a good psychiatrist would have glommed on to every single doodle he did and analyzed it, right? But I'm so bad I never even bothered to look at them. I would just stick them in the Miles folder and forget about it. But I must have looked at one or two without meaning to, because one day I said to him, without really thinking, 'You ought to take a few art lessons, it might give you

some tools to play with. I can see that you don't have any perspective—they're all in silhouette, they're kind of Martian-like.' And he just looked at me like, Where do you get off, telling me about my art, I'm Miles Davis and you're not, you're nobody. I *meant* well, and I was right, but I guess I put it pretty primitively.

"When he died, I got out his file, and it was *this thick* with doodles. One of them was a silhouette of two women, a black one and a white one, sexually intertwined, and on top of the black girl he had written 'Miles' and on top of the white girl it said 'Robert'—*me*. So I framed that. Because suddenly I saw that it was really very good. And from that I sort of got some humility—I turned in my license to practice as an art critic."

The room in Dr. Millman's house where he hung that Miles Davis doodle is home also, he tells me, to his Avedon collection. As he proceeds to explain how he happens to possess so many of Dick's greatest photographs, I recall how his distinguished predecessor and fellow boundary-blurrer, Dr. Kleinschmidt, also had no qualms about accepting art from his artist patients. "I was in Richard's apartment one day when he was cutting up some of his photographs, getting rid of the prints he felt didn't measure up to his impossible standards of perfection—you know, trying to protect his legacy," Dr. Millman recounts. "I was pleading with him, 'No, Richard, no! Stop it this minute!' And then, just kidding around, I said, 'Give 'em all to *me*—*I'll* take 'em!' And he said, 'Go right ahead, pick some pictures.' I have a lot of regrets in this life but one of the biggest is that I didn't pick more—it *kills* me.

"I grabbed a couple of Bob Dylans—real beauties, little ones, twenty by twenty-four. One is Dylan in jeans when he was just a kid, and the other's from when he was as big as the Beatles. I also took one of Richard's self-portraits—the one that was on the back cover of the 2002 Met catalogue. The print was really small, and he said, 'Don't take that one, I'll send you a bigger one.' And sure enough, what he sent over the next day was a gigantic one-of-a-kind—bigger than life, and mounted on steel. It dominates my house to the point where I can truly say that Richard Avedon is always with me. I didn't care that he never offered to take my picture. Because I knew that when he did someone's portrait

they could come out real ugly, they often didn't want the picture that he did of them, although *I* would have accepted an Avedon of myself. One day, out of nowhere, he gave me the whole series of his father dying—all eight. His secretary, Bill, delivered them to me in a gray archival box."

I laugh to myself, remembering what Dick said when he told me he had decided to make that particular gift: "I'm perfectly aware that most people would prefer not to have to look at them—my analyst is going to go nuts trying to figure out where to hang my father."

"I can't put them up, they're such downers," Dr. Millman confesses. "I mean, *not pretty*. I put them in a drawer. They're in the box they came in, and lying flat, but the edges are a little . . . But there's a piece of light paper between each one. I hope they're okay in there. I'm afraid to look at them—I'm afraid they have creases. I wonder how much they're worth now. Will you give me his dealer's number?"

I inform Dr. Millman that he can consider giving up his day job.

"Richard was the gift," he says. "I should have been paying *him*."

In a way, yes. Dick was innately theatrical, a born performer—he made scenes, he played to the gallery, the curtain never came down. He trusted in performance, and, to the degree that the essence of him was to be found in his own, Richard Avedon *was* his performing self. The couch was just another stage, and a psychiatrist just another audience to capture. And, I mean, show me the shrink Dick couldn't have left rapt!

15

SECOND HELPING

—

ANN GIORDANO (1985–90): ONE OF THE INCREDIBLE PERKS of working at the studio was getting to hear Dick's spellbinding stories—Paris in the forties, Charlie Chaplin hiding out in the Avedon studio, Vietnam, the night he spent in jail in Washington—and he *performed* them. I mean, he could easily have made it as a professional entertainer.

I came to the studio through an assistant of Dick's that I'd gone to Parsons with—Paul Chan. I was trying to be a fine-art photographer, but I was making my living as a spotter, a retoucher. I remember the first time I used the private entrance—going up the staircase to his apartment, which I always thought of as the Anne Frank staircase, because it looked like it would lead to a secret attic.

I quickly learned to do things the Avedon Way. If you were carrying a negative down to Modernage for printing, you had to use the car service that had the best insurance in case of an accident. Speed was also the Avedon Way. And all of us having lunch together every day.

The spotters were up on the third floor. We started out as three and then he hired two more—it was a regular spotting factory. For some reason we were all girls, but the two mounters were guys. The giant mounting presses he rented for the production of the Western Project had had to be brought in through the window.

We cut up quite a bit—one of the mounters took a discarded print of a truck driver named Billy Mudd who Dick had photographed in Texas in 1981 and cut out the eyes and put elastic around it to make it into a mask. We would put on that mask whenever we were feeling silly or irreverent and parade around in it. This only took place upstairs, in the kind of playpen we worked in, where Dick never set foot, except for the time he brought Baryshnikov up for us to meet. I actually got to meet the real Billy Mudd—*after* I had worn his mask, which was kind of creepy. He came over to me at the opening-night party at the Amon Carter Museum and introduced himself, and I didn't know whether to laugh or faint. He said, "Mah name is Mudd," and the voice was surprisingly soft, coming out of this very tall man. He had to stoop real low to talk to me, and I remember he kept his hands behind his back.

One Halloween at the studio I decided I would dress up as another of the Western Project prints—Petra Alvarado. She was the Mexican woman Dick photographed in 1982 wearing a corsage of dollar bills that had supposedly been pinned on her by her blue-jeans factory co-workers in El Paso on her birthday. That's supposedly some sort of Latino tradition—and *I'm* Hispanic, at least according to the census, since my mother is. In actual fact, that was one of the pictures that Dick totally created: somebody had mentioned the custom to him and he went out and had a corsage fabricated in New York and then carried it around to various factories in Texas until he found a woman with the right face. I had gotten myself a wig, and done my lips and eyebrows like Petra's, and put on similar mascara and her trademark beauty mark, and I was wearing the same kind of striped shirt. Then I pinned on the pièce de résistance—a corsage that I had made myself, out of fake money. One of the mounters, the minute he saw me, ran to put on the Billy Mudd mask, and the other one took a Polaroid of us.

I was in a holiday mood and took the risk of going downstairs to lunch as Petra. There was no way to predict how Dick would react. He was sitting at the kitchen table, so I stood off to the side, and it was a good couple of minutes before he noticed me. He went, "I love it! Somebody photograph her!" After work, David Liittschwager, or maybe it was Ruedi, took me into the cyc—they said they wanted to do something different, and they asked me to hold the corsage so they could set it on fire.

I think Dick truly cared if you were happy. He wanted happy people around at work, people with good morale. And he was interested in you—interested in people's lives. Once, when we were on the final lap of a trip to Montauk in his Suburban, he asked me who I was dating. It would always take something like seven hours to get there, because he would want to stop for a hotdog at that special place just off the exit that became a bank, then at Loaves & Fishes to pick up pies, and then the Seafood Shop for chowder, and someplace else for tuna burgers. I had driven most of the way; not until the Quiet Clam, in East Hampton, did he get behind the wheel, and that was truly terrifying. Anyway, he wanted to know about *me*, so I told him about the love of my life, Barry Valentino.

A couple of years later he was killed in the Lockerbie disaster. He was an exhibit designer at a museum in San Francisco and he'd been in England visiting some of the artists he worked with—he was flying to New York on Pan Am flight 103 to see me on his way home. He had a letter from me in his jacket pocket that I'd written him on Richard Avedon stationery just before he left San Francisco, and I'd enclosed a test-shot Polaroid taken of me in the studio. The State Department eventually released it to his parents, and his mother sent it on to me—a Polaroid of me in pieces, along with the pieces of the letter.

I came into the studio a couple of days after the incident—it was right before the holidays—and the second I walked in the door Dick got up from what he was doing, which he usually did not, and he ran over and hugged me. He said, "Unbelievable!" I mean, what *do* you say? It's the hug that I really do remember. And he immediately came up with a project for me, something to keep me busy: spotting one of everything he was giving to the Center for Creative Photography in Tucson. It wound up taking around two years.

I eventually went to work for Irving Penn. And I retouched for Hiro, too. But I continued doing freelance spotting for Dick—some of it for *The New Yorker* and some commercial—right up to his final Met show, in 2002.

MARC ROYCE (1989-94): I had just graduated from Kenyon College and was interested in fashion photography. Probably for the wrong

reason—to get girls. So I moved to New York and started freelance assisting. I heard through the grapevine that Richard Avedon was looking for a bottom-of-the-totem-pole assistant. The only photograph of his I really knew was Nastassja Kinski and the snake—that poster was on every guy's wall in college.

I interviewed with the studio manager, Ling Li, who had succeeded Ruedi Hofmann. He gave me a once-over in the makeup room, then told me to come back in half an hour to meet with Avedon. Forty-five minutes later, this bright little ball bounced in. He shook my hand—a strong handshake—and my hands were sweaty, which he remarked on. I said, "I'm sorry, but I'm really nervous," and he said, "Well, don't be." He asked me where I came from, and I told him my mother was French and my father was English and a professor at Princeton, and he seemed to like all that. And especially that I spoke fluent French.

Part of my responsibilities was ordering the lunch, but since my mother was a great cook and had passed some of her expertise on to me, I thought, you know, I'll *make* lunch for everybody. Dick could never get enough of my salad dressing and had me make a vat of it every week just for him. I also did a nice rice dish, baked with Gruyère, that he had me make a lot—Bill Bachmann named it "Rice Royce." All of us, because we weren't getting paid enough to subsist, divided up the leftovers to take home.

One morning around seven, after I'd been there about a year, I was getting ready to sweep the sidewalk when Dick buzzed me to meet him in the kitchen. He invited me to sit down at the table, and he poured me out a cup of coffee and offered me cookies. He told me that he had just discovered that Ling had been "disloyal"—he said he didn't want to go into it, but that he was going to fire him the minute he came in. "Marc," he said, "I want *you* to be my studio manager. I know I'm throwing you into the fire, but I'll make it work—I'll get Ruedi to come in and give you a crash course in lighting." Which Ruedi did, and not very long after that, I was able to handle a big IBM print campaign, and everything just rolled from there.

When Dick first described his process to me, he compared it to a Japanese ballet, where everybody knows his role, knows exactly what he's doing and does it silently and with agility and finesse. Lighting was

the most important part of Dick's dance. The first assistant would hold the umbrella, which was the light source, on a single boom arm, and then keep moving that arm to keep pace with the subject. Opposite him and working in tandem would be the second assistant, holding a twelve-inch-square show card, a silver-and-white piece of cardboard, to reflect into the subject's eyes. If you enlarge into the eyeball in any Avedon picture, you'll see the umbrella and, if you look really closely, a hint of silver underneath the eyes, which is the reflector. If you squint you can even see Dick reflected.

Dick took happy pills before every shoot. You knew that his mood came from them, because it was not the Dick *we* knew, you know—it was this other guy. It was a different *kind* of bouncing—it was *flying*. His bathroom drawers were full of medications—just *packed*. I remember the two *F*s: Fiorinal and Fioricet.

As studio manager I had the responsibility of hiring assistants—with Dick's approval, of course. I began picking people from my alma mater, Kenyon. Douglas Mott only lasted a year in the third-assistant slot, and Jonathan Mannion, a white guy from Cleveland who's since become *the* go-to dude for hip-hop photography, moved on out pretty quickly, too. But Kara Glynn held fast, and she ended up replacing me. She and I didn't get along so great—stupid kid stuff. I did a ton of growing up while I was at the studio; it was much more than photography that I learned.

I spent a lot of my time at the studio printing. It could be a multiple-day process to make a single image. I would lock myself in the darkroom and print six different exposures and maybe three different contrasts, with variations in burning and dodging, so Dick could cut out things from each of the prints and paste them on a piece of paper. He would hand it to me and go, "*This* is what I want." Then I would have to make a new engraver's print, composed of a face from one image, a face from another, and a body from yet another. If all that was needed after all that was retouching, he would write what he wanted directly on the image with a red grease pencil—"eye" or "neck," or he might even draw in the neck he wanted.

Bob Bishop was an indispensable part of the Avedon System. Dick had met him back in 1945, his very first week at *Harper's Bazaar*. Bob

was the only retoucher Dick totally trusted to translate what he wanted. I guess you could describe him as Mr. Photoshop of that earlier time. He airbrushed, bleached, dyed, enlarged pupils, stretched legs, lengthened necks, slenderized bodies, switched body parts, and stripped in hair, like with Dick's multiple image of Donatella Versace for her perfume Blonde. He was particularly proud of having "cleaned Andy Warhol up a lot after he was shot." Bob worked only on the black-and-white prints—Scott Norkin did the color—and he worked on Dick's portraits as well as the commercial stuff, including plenty of the American West photographs. And everything was done with such artistry that there was no hint of meddling. Dick called Bob his Rembrandt.

At first I was a little disillusioned to learn that a lot of Dick's pictures were created after the fact, that he *post*-visualized as well as pre-visualized them. But now I appreciate how much ahead of the curve he was in that, too—I mean, when you look at the nature and extent of digital today.

Dick went through a phase where he was actively searching for a new way to do things. In 1991 he used a reportage style to shoot the Volpi Ball in Venice for *Égoïste*. Anybody who was still anybody in Europe was there. It was over-the-top decadent—wall-to-wall princes and princesses and archdukes in their full-on gear, some of them wearing masks, which Dick said were probably not all that different from their real faces. He had rented tuxes from A. T. Harris Formalwear in New York for me and the second assistant, John Delaney. We ended up wearing them with black sneakers, since assistants have to move fast.

Nicole Wisniak of course was there, with *her* assistant, and that crazy-ass hair of hers—she was just acting like a crazy, pushy monster. She and Dick were staying at the Gritti, in the same room, and John and I were sharing a room at a nice enough hotel around the corner. We were always questioning whether they were a couple-couple or not—we didn't know what was up with them.

We rolled in on the afternoon of the ball. The palazzo was on the Grand Canal, so we had to take the equipment over on a vaporetto, unload it on the dock, and then haul ten cases' worth of stuff up four flights. We set up a studio on the top floor for Dick to shoot some eight-by-ten portraits—the reportage stuff he would be shooting downstairs

at the party with a 35mm Nikon. I'll never forget that climb—those stone staircases were exceptionally wide, and the steps were slippery because the stone had been worn down by people treading on it for centuries. And it was the last day of August and it was pretty darn hot.

It was really low ceilings on the top floor, so we had to come up with a new way for Dick to work, since he would be shooting from low—the twin-lens Rollei uses a waist-level finder, so he was going to have to be a little bit below the subject. We wound up taping a roll of nine-foot-wide seamless to the ceiling, and it made an egg-shaped cove going down to the ground.

The plan was that Dick and Nicole would breeze through the ball and pick out a few beautiful young girls to take upstairs for him to shoot. We shot Tatiana von Furstenberg. She was around twenty, with tight curly hair and a real angelic quality. He did portraits of only about four girls in all. I was disappointed—I'd been looking forward to shooting a whole lot of hot Italian princesses. He did get them all pretty much naked. He'd start off slowly, shoot them in their full outfit, and *then* he'd say, "It would be so beautiful if you would just put your top down." I don't remember any of them balking—I mean, come on, it's Richard Avedon! Most of the dresses were strapless, so they just unzipped the back and kind of wedged them down.

Whenever Dick went back downstairs I was by his side, hand-holding the flash plus a strobe battery kit. He was taking what I would call hip shots—he wasn't even looking through the lens. He would see a great face or something and just snap away. He called these his paparazzi pictures. At some point in the festivities Jack Nicholson came up to Dick—they knew each other—and he shook my hand and John Delaney's and said, "Hey boys!" I mean, *hey* is right, it was Jack Nicholson! And he had two great-looking women with him. As Dick and I were walking around I could tell that word had gotten out that Richard Avedon was there, because there was so much peacocking going on. I think I remember Carla Bruni walking by and doing a peacock thing.

The portraits all turned out fine—he was really excited by Tatiana's picture. But the weird-style hip-shot ball pictures weren't so hot, and he knew it. He got out his trusty old nail scissors and began cutting them up. He took a sinister face from one negative and then a goblet and

another face from another—he was working from maybe five negatives. It was essentially collage.

We went back to Italy the next spring, to Rome—to photograph the French tennis player Yannick Noah for the cover of *Égoïste*. Dick got him naked right off the bat. He basically said to him, "What's going to make this picture great is your taking all your clothes off. Don't worry about your private parts, we're not going to light them." Then Dick, after a little powwow off in the corner with Nicole, whispered to me to make sure and light Yannick's dick. I mean, why not—the idea was to have a sensational picture and get some press out of it. First, we did the eight-by-ten Polaroids, and on those I made sure the dick was in shadow because I knew Dick might want to show them to him. In the choice, Yannick is jumping up in the air with his arms out kind of like a cross, and there's this beautiful, floating Black Jesus quality to him. In the end, though, we had to tone down his dick, because it had somehow gotten *too* lit.

He used to try with almost everybody—if he could get 'em naked, he would get 'em naked. He photographed Twyla and her company naked. I remember him wanting to do a nude shoot with his trainer and the trainer wouldn't do it. He tried to get *me* naked—he was working out an idea in the studio and said he needed to see what the light would do on bare flesh. Then he remembered that I was there to do the lighting, so he got the third assistant to strip—everything would always fall on the third assistant, you know. Not too many of the assistants would get full-out naked for him, but they *would* take their shirts off.

Then it was back to collage-making. We went to L.A. in March 1993 to shoot the Academy Awards for *The New Yorker*. We started out just in the paparazzi line, and then all the photographers turned around in unison and started taking Dick's picture because of course he was a star. Pretty quickly we were ushered under the rope and onto the red carpet. Dick was shooting every star in sight, many of whom seemed to know him, and doing it reportage-style with the big flash and nighttime. He wanted the background black so that, after he cut and pasted, it would look like a single, seamless picture of about half a dozen of the biggest stars all talking together. He said he was going to just put them where he thought they should have put themselves. Dick's fabricated

lineup consisted of Elizabeth Taylor, Jack Nicholson, Clint Eastwood, Dennis Hopper, Sharon Stone, and Al Pacino, who won best actor that night for *Scent of a Woman*, all talking to each other.

After the red carpet, Dick and I went to Spago for what Swifty Lazar had announced was his last Oscar party. It was a big sit-down dinner, with everybody watching the awards on a huge screen. I was seated between Gene Kelly and his much younger wife, Pat, who had a great rack. When everybody started arriving from the awards ceremony, Dick got up to take pictures again, with me assisting with the big handheld flash. We were the only photographers allowed in the room.

Dick took me to London with him to do a bunch of shoots for *The New Yorker*. The day before we left he ordered the biggest tin of caviar you ever saw, from Petrossian, and he had Verlie, his housekeeper, make those little blini things. So we sat on the Concorde pigging out on fish eggs. Dick stayed at the Connaught, with Nicole, and I was at Brown's—not too shabby.

The next morning I found a suitable studio to rent and hired a couple of assistants. Our first sitting was Tilda Swinton, and Dick had her taking her shirt off in no time. She invited him to dinner at Harry's Bar, and he had me come along—he said they made the best white-truffle risotto in the world and it was something I had to experience at least once before I died.

One day he asked me what pictures I was taking for myself. I told him I was working on an abstract series of roller skaters, and he asked to see them. He told me he loved them, and he really must have, because he got five of them published in *Égoïste*, and that led to *The New Yorker* commissioning a skater picture from me and running it as a full page.

In 1993, Dick got awarded an honorary degree from my alma mater and he invited me to the ceremony. He went around telling everyone the reason he got it was that he had let me hire so many Kenyon graduates. He was happy that he was getting to keep the mortarboard—he said he had had to give it back when he was awarded his only other honorary doctorate, by the Royal College of Art in London. He did get another degree later on, from the Parsons School of Design, but I don't know what happened with the hood.

I left the studio because I needed to begin figuring out how to make it on my own. Remember, I didn't know anything but the Avedon Way. I live in L.A. now, so naturally a lot of my work is photographing celebrities, like for the cover of *People*. I have no assistants, and I don't really need any—out here there's no Japanese dance going on.

JOHN DELANEY (1989-91): Like everyone else, I only wanted to work for Avedon. I happened to hit the studio just right—someone was leaving. My interview with him lasted maybe ten minutes. He asked me about my grandparents and what books I was reading. He must just have assumed I knew enough to assist him, since I had graduated from the Rochester Institute of Technology. My first day on the job I opened the door at eight on the dot and he was standing at his desk in his underwear, and it was like, All right, Richard Avedon is now Dick. Then I went back out to spray down the sidewalk.

I was commuting from Far Rockaway—*very* far Rockaway. I had to get up at five-thirty to get a bus to Flatbush and then a train, and then work all day until ten at night. My first Christmas at the studio he bought forty or fifty trees and made a whole forest in his apartment, and after the holidays I had to haul them all out and sweep up the mountain of pine needles. On the upside I was getting to work with superprofessionals like Ruedi Hofmann and David Liittschwager, and my printing chops just went through the roof.

En route to the Volpi Ball in Venice, which remains the high-water mark of my life, we stopped in Paris, and he took Marc Royce and me to dinner at a Moroccan restaurant. It had these ornately painted wineglasses, and I mentioned how cool I thought they were. As soon as we got out on the street Dick handed me two of them—he had tucked them under his jacket and just walked out with them. One broke a little while ago, so I'm grateful he pinched two. You could never tell what Dick would do.

One time in the wilds of Montauk, Marc Royce, Ann Giordano, Dick's art director Mary Shanahan, and I went on a hike to the lighthouse on the point while Dick stayed behind to organize dinner. We took a wrong turn somewhere in the woods, and we were gone so long Dick got into that big tank of his where he could barely see over the

steering wheel and went weaving all over the back roads beeping his horn trying to find us, which he never did. He was waiting with a tray of vodka shots when we finally staggered in the door. He had laid on a banquet of goat, and after dinner we sat around the fire telling riddles and playing word games.

After I left the studio, I went to the Himalayas with my Rollei. Ironically, the portraits of mountain people I took were more like Penns than Avedons. Dick commented only on how beautifully I had printed them. In 1994 when he was doing his Whitney retrospective he asked me to print for him—I did the smaller ones in Ruedi's darkroom on Gansevoort Street, and the murals at Modernage. Later I also printed freelance for Penn—his *Vogue* stuff. And for Annie Leibovitz—her women's book.

Some years later, when Dick's studio manager Marc McClish left, the two of us opened a lab called SilverWorks. We could never have had the success we had without Dick's encouragement and patronage. I was in our darkroom there, in one of the old printing buildings on Twenty-fourth and Eleventh Avenue, when I got a call from the studio that Dick had been taken to the hospital in San Antonio. The second I got off the line I ran to find Marc. He was in his office and I remember he was leaning against a wall, and when I told him he just sort of slid down.

MARY SHANAHAN (1990-95): I had first worked with Dick on covers at *Rolling Stone*, then again at GQ. During that time he asked me to work on a few freelance projects—create a layout for his Egon Schiele essay for *Grand Street*, and later, Versace and Revlon campaigns. I was in Paris working for French *Vogue* when he called to ask me to return to New York and work at the studio on his books and exhibitions, and everything else that came through.

Dick had an irrepressible desire to express himself through his photographs—an unsuccessful picture was not only better than a repetition of past work, it was even better than no picture at all. And the process of making books was similar to creating music in that it was a pure sensory experience, unbound to words. We edited through his entire archive, finding overlooked work of merit as well as the master-

pieces. It was a revelation of his artistic process, and I tried to bring that understanding to his books. Putting photographs in sequence was an instinctual effort, doing what our eyes told us was right before the thought had composed itself in our heads.

Dick's work was never sentimental, which I think allowed him to see precisely the performance taking place in front of his lens. While he may have started with an idea about the picture he wanted to take, he was readily open to responding in the moment. Because Richard Avedon saw everything very, very clearly.

KARA GLYNN (1991-94): A friend of mine happened to be sitting in front of some guy at a Squeeze concert and heard him tell whoever he was with that they were looking for an assistant at the Avedon studio. I was attending a photographic workshop in Camden, Maine, but I rushed back to town to offer myself. The studio manager, Marc Royce, gave me an interview when he saw that we had gone to the same college, but afterward he told me, "I don't know exactly what we're looking for but I know it's not you." I said, "If you don't know what you're looking for, how can you be so sure it's not me? What if I tell you it *is* me?" Well, that was a bummer, and I went running back to Maine, but I wrote him a thank-you note anyway, because everybody told me I should. And then an amazing thing happened—Avedon picked up the letter and then picked up the phone and called me. I flew back down the next day. My head was spinning.

Marc Royce and another assistant, John Delaney, sat in on the interview, and at a certain point I was asked to leave the room. I learned later that that was so they could vote on me. Both boys voted against me. But Dick overrode them, and *boy* were those boys ever mad—they were adamant about not having a girl in the job. Because of that, I always wore Levi's, a T-shirt, tube socks, and sneakers to work—that was my little uniform. I didn't dare put on anything feminine, lest they make fun of me. It was better to try to be one of the boys. When I became first assistant and had to hold the heavy lights, I understood why it had always been a guy.

I started like the next day, doing the normal third-assistant things— sweeping the sidewalk, mopping the floors, getting the breakfast, tak-

ing the garbage out . . . The crazy thing was that in a couple of days we were leaving for Camden, where I'd just come down from, because Dick was giving a lecture up there. I had been assigned to clean and re-sleeve all his slides for it, and it was taking forever, and Marc was yelling at me to hurry up and get them done.

Then Bill Bachmann came over to tell me that Dick's mother had just called needing someone to get her groceries. He explained that Dick had been trying to introduce a permanent helper into the situation but that his mother was resisting the idea. The bookkeeper gave me a wad of cash, and I abandoned the slides and hotfooted it over to Mrs. Avedon's at 201 East Seventy-seventh Street.

It was just a one-bedroom, so the companion would have had to sleep on the living-room couch—probably one of the reasons Mrs. Avedon wanted to go it alone as long as she could. She was very well dressed, very formal—a real lady. When I told her my name, she thought I had said Karl, so that's what she always called me. She said she wanted a roast chicken cut up in five pieces, Birds Eye Mixed Vegetables, and the latest thing in margarine—she gave me the name. There was a Gristedes right next door. I found the frozen vegetables right away, and I got the chicken cut up without too much trouble. But no one there had heard of her margarine, so I got some other brand. When she saw it, she shook her head. And she said it was the wrong chicken, too. I hit the streets again, and managed to find a promising-looking chicken. She tore open the bag and took a whiff of the fowl, and said, "No good, Karl." And Karl is thinking, Three strikes and you're out.

As I was sprinting down Third Avenue I saw a Chinese place, Tang Tang, and I went in and bought a takeout chicken. She said, "Take it back, Karl." So I did. Then on Third and Seventy-sixth I marched defiantly into David's Chicken, where they recommended I try the so-called "Hot One." Mission accomplished: it melted in her mouth. While I was gone, though, she had called the studio to report that I was having trouble finding the right brand of margarine, and Bill had thought to call her cardiologist, who was the one who had recommended it. Turned out the product wasn't even on the market yet.

I returned to the studio with a bunch of receipts, hardly any of the

cash, and the three chicken rejects. A few weeks later the margarine hit the shelves. I wasn't taking any chances, in case there was a run on it: I bought twenty boxes and put them in the studio deep-freeze, so that every time Mrs. Avedon called wanting her heart-healthy margarine I could just put one in my bag and hop on over.

One night Dick was having dinner somewhere upstate with his son's in-laws, Senator Moynihan and his wife, Liz, when Mrs. Avedon called the studio to announce that she was having a heart attack. I ran all the way there with Marc Royce. The paramedics said, "She seems to be fine, but she's insisting on going to the hospital to be checked out." So I rode in the ambulance with her. Bill meanwhile had gotten through to Dick, who said he wanted me to spend the night in the hospital with her. At two in the morning the diagnosis came down: gas.

Mrs. Avedon's doctor became my doctor—Goldberg, an associate of Dick's cardiologist, Izzy Rosenfeld. I used to have terrible coughing fits that sounded even worse than they were, and Dick would be like, "Right now, out the door! Go to Goldberg!" One time I had full-on bronchitis and needed antibiotics in a hurry and Goldberg wasn't available, so I barged my way into Izzy's examining room. He was nice about it—he took my pulse, then wandered off, leaving me to stare at the four walls. I found myself staring at photographs of his kids, all of which I recognized as Avedons—the pictures, not the kids. Izzy told me that Dick had initially signed only one of them, saying that he had just done them as a favor and had no intention of giving them added value as portraits; so then the next time Dick requested refills on his prescriptions, Izzy dutifully wrote them all out but signed only the top one. "He got the message and came in and signed the rest of the photographs," Izzy told me, chuckling.

The other Mrs. Avedon, Evie, I had a lot less truck with. She was still kind of beautiful, but fragile, shall we say. She would answer the door in just her underwear and a buttoned-down shirt. Every time I went there, which would be to change the needle on her record player or bring her some gourmet treat from E.A.T. she wanted, she was kind of out to lunch.

Dick's life was all work, because if he wasn't working, what would he do? Watch television? He did watch movies on television. Con-

stantly. Old movies. And of course he loved theater. He always had twofers, and occasionally whoever he had invited would be unable to go at the last minute and he would ask *me*, which was another thing that ticked the boys off. Dick and I saw everything Sondheim probably five or six times each, and a lot of off-off-Broadway stuff. And afterward he would take me to the Russian Tea Room or Orso.

We did a Spanish liquor ad in the studio, with Stephanie Seymour draped naked over the back of a live bull, à la *The Rape of Europa*. And this was *before* the crotch shot! While Dick was warming her up before the sitting—shooting the bull—*it* was bullshitting all over the floor. I thanked God, because this was just one week after John Delaney left and I had gone from third to second assistant, so it was the new third assistant, Doug Mott, who had to clean up. Stephanie at the time was living with Axl Rose, the lead singer of Guns N' Roses—she had appeared in his video "Don't Cry," but during the shoot she was on the phone with him every other minute crying. She told us afterward that he had just thrown all her clothes out the window. Dick sent an assistant over to photograph Stephanie's stuff lying in the gutter—he thought she might need it one day as "evidence."

During a sitting Dick would never speak to you, and you were not allowed to make eye contact with him or the sitter. And he would hit you, smack you in the head basically, when he wanted you to go faster. I would be on the floor, crouching and taking the hits. I was studio manager during many of the Versace campaigns and for a lot of the *Égoïste* and *New Yorker* stuff. I remember a Saturday when Mayor Giuliani was on the books to be photographed for *The New Yorker* and he was a no-show. One of the assistants found a note sticking out of the studio mailbox: "Sorry, my dad can't make it today"—written in, like, first-grade handwriting. Dick was fighting mad. The shoot got rescheduled, and Dick photographed Giuliani as a political hack stretching his hand out, the way he would later shoot Tony Blair. He told me that the only politician he photographed that he had a soft spot for was Eugene McCarthy—"a good man, too good for politics."

One time Dick was incredibly mean to me for absolutely no reason. I was in the hot seat for nothing, and the tears started streaming down my face. He said, "Studio managers don't cry." What the hell, I learned

so much more from him than from any other person I worked for. Not that he ever sat down with you and said, "This is how I want you to do it"—he left it up to you. What he did was, any question you asked he would answer with a little story, he would give you an anecdote, and he had one for every occasion. And *that's* how you learned from Dick: Jean Renoir said this, or Jean Cocteau did that, or some model got fat or moved to Connecticut or died in a fire.

For my farewell dinner, he took me to San Domenico. He ordered for me, and that was just fine—he gave me a *Dovima with Elephants*.

JULIE KAVANAGH (1992-98): One of my duties as the London editor of *The New Yorker* was to scout suitable subjects for Avedon to shoot. Nobody I approached ever needed the slightest convincing. I consider those amazing days with Dick the high point of my journalistic career. Absolutely.

The studio he was renting was out in the sticks—Clapham. There was a cushioned area where he would sit and have his little social ritual with the subject before he photographed them—he would always spend a good twenty minutes just talking to them over tea and biscuits. There were times when he would be processing four, five, six in a day—it could feel like a production line at times—and that would mean a lot of tea. He was incredibly good at small talk, and if they were actors or writers he could talk shop with them, because he would have made sure to see them perform or read their books. I tended to be part of this chatting-up routine, and if they were writers, I would usually be able to introduce bits of topics that I thought they would be comfortable being drawn out about. And all during these warm-ups you could see Dick's mind whirring, deciding what the picture should be.

I arranged a sitting with the critic John Bayley and his wife, Iris Murdoch, who was in the quite late stages of her Alzheimer's. That, without question, was the single most emotional sitting I ever witnessed. Afterward Iris kept impatiently twisting the fingers of her right hand, which John explained was an unconscious mimicking of the car key in the ignition—a signal to him that she wanted to go home. Dick's picture captured not only her vulnerability but also whatever self-possession she had left—she's half-smiling in it.

For the playwright Alan Bennett, we forsook the studio, for the one and only time. We drove to Hyde Park, because Alan had struck Dick as looking like an owl—you know, with those eyeglasses of his—and Dick wanted to try and shoot him up a tree. The assistants followed in another car, with the ladder. It was getting dark and Dick was worried that Alan might balk at the last minute, but he's so English and polite I knew he was going to do what he was told, like a little boy. And in fact he clambered right up, and he sat there on his branch for about three-quarters of an hour for Dick.

Dick wasn't too thrilled with the picture he took of Julian Barnes, who happened to be my brother-in-law. But he couldn't have been happier with his portrait of Salman Rushdie. He photographed him post-fatwa, in '94, and worked the lighting so Salman in close-up looked satanic. Martin Amis, someone I had lived with in the seventies, buttonholed me at a dinner party to tell me how furious he was with Dick about that picture. As for Salman, he said he was shocked and depressed by it—he felt he had been tricked, and he described Dick in print as both a sorcerer and a predator. But he also blamed his own face. He went and had his sort of droopy-looking eyes pinned up, what I believe is called an eyelid job.

A lot of the subjects I came up with were actors, because theater was Dick's passion. We went to quite a few plays together, though if he wasn't enjoying something we would have to leave. Afterward he would always take me to that Chinese restaurant near the Connaught that had the best crispy beef. So we had all these great actors coming and going, and the only time I ever saw him nervous—I mean wound-up, pacing-up-and-down nervous—was when we were waiting for Sir John Gielgud to arrive. He was like a god to Dick, who told me he hadn't felt so jumpy about a sitting since Jean Renoir—and that was 1972! He kept watching for him out the window, and then finally, because Gielgud was so tall, we saw just his head bobbing along.

The other time he sort of panicked was when he had to photograph Colin Firth, who's got such a bland face Dick felt he might not be able to do anything with it—a woman friend of mine once compared it to a scone. He certainly did wonders with Colin's much less famous baby brother, Jonathan, who has a prettier—a slightly more feminine—face.

Jonathan was playing Henry VI at the time, and Dick took an incredible full-length photograph of him dressed in a billowing sort of nightshirt. He got Nigel Hawthorne into a billowing nightshirt, too, at the time he was embodying the madness of George III. Billowing nightshirts were obviously the default thing when Dick wanted to create a highly theatrical atmosphere.

He told Judi Dench straight off he wanted her to cry for him. The tears came pretty easily. Tilda Swinton was someone he really bonded with—he did love intelligent women. So actresses like her and Cate Blanchett and Helen Mirren he would spend a lot more time with.

I brought Dick a Royal Danish Ballet principal dancer called Kenneth Greve, who was of a beauty you could just not imagine. He would come out onstage and the audience would collectively gasp—Dick himself later described him as a Nordic god. Kenneth was in my life at that point because I was writing a biography of Nureyev, who had been obsessively in love with him, and I just thought, Dick *has* to photograph this guy. It took him about two seconds to get Kenneth to completely disrobe. He was able to pull off the most extraordinarily powerful nude. It may be worth noting that he spent longer on that portrait than on any of the others, over an hour and a half—perhaps it seemed to him like a reincarnation of his glorious first Nureyev sitting. And nobody—I repeat nobody—ever photographed Nureyev better than Dick did.

The day he took so long shooting Kenneth, Dick's girlfriend, or mistress, or however you want to describe Nicole, was in the studio waiting for him to finish. She was pacing up and down, wondering, Is he never going to come out? She was probably wanting to get him back to the Connaught, where they were certainly sharing a bed. He did talk an awful lot about taking Viagra.

MIKE DAVIS (1993): Avedon told me right off that he was involved with a much younger woman. It wasn't a boast—I had asked him about his personal life. I'm just about the same age now as he was when I met him, and he was jumping around like a twenty-five-year-old. He had the body and the light movements of a dancer.

I had written this book *City of Quartz: Excavating the Future in Los*

Angeles, on the basis of which I was hired by CalArts to teach in their photography program. The course consisted of my taking the students on location all over Southern California. We would do things like go crawling through tunnels in downtown L.A. at midnight—it was an urban boot camp I was running. I became kind of notorious for leading people on these expeditions. A couple of years after this, I got one of those MacArthur "genius" grants, and somebody there told me that part of the reason was those crazy tours of L.A. So anyway, *The New Yorker* hired me to show Avedon parts of L.A. that he might never have seen before—to be his tour guide and driver for three or four days in the spring of '93.

I was thrilled at the prospect of showing Richard Avedon around. I thought that, of all the attempts to document the wrongheadedness of the Vietnam War, his long linear foldout of the U.S. command, *The Mission Council,* was arguably the most important—it was a photograph that changed people's minds, and it should hang permanently in the Oval Office as a cautionary tale. I also felt that his were probably the most acid and revealing portraits of wealth and power in America ever taken.

He told me he had been out here a couple of weeks before, photographing the Oscars, but that what he was intensely interested in seeing now was the alternate realities. I saw right away that for him this wasn't an assignment where he was going slumming in the lowlands, it was more like an adventure in understanding. I gave him a menu of things that had rarely been represented or photographed that I thought he might find interesting. And speaking of menus, he wanted to only eat at soul-food places—there were no hot Hollywood restaurants on our agenda. An awful lot of white people in L.A., the last place in the world they would want to go is South Central. But Avedon was avid—he told me he used to venture uptown to Harlem quite a lot when he was a teenager, to visit his high-school buddy James Baldwin.

I set up a meeting between him and a Shia imam by the name of Mujahid Abdul-Karim who'd been a Black Panther in Chicago named Benjamin Farmer. He had recently brokered the Watts Peace Treaty, the truce between the four rival gangs, which amounted to something of a social miracle. I took Dick down to his mosque, and within about

five minutes the imam was saying to me, "This is a good man—this is in fact one of the best men I have ever met."

After that, we went up the street to the various housing projects so Dick could meet some Crips and Bloods who were now responsible leaders of their community. He instantly put them at their ease, and a couple of days later we went back so he could handpick the ones he wanted for a group photo—one of the guys he chose had this great name, Twilight Bey. They followed us in their cars to the studio that Dick was renting on Melrose, or was it Beverly, where he had shot Nancy and Ronald Reagan not long before.

MARC ROYCE

DICK IN LOS ANGELES, WITH *CITY OF QUARTZ* AUTHOR MIKE DAVIS AND A LOCAL GANG MEMBER, WHOSE PAINTING DICK IS BUSY EXAMINING.

This was less than a year after the Rodney King riots, and the image of Watts that people had was guys with sequoia-circumference biceps holding Uzis, guys who could literally do a thousand push-ups at a time, as well as other things that were off the scale of what you would think humanly possible. I watched Dick compose the guys for his picture like Rodin's *Burghers of Calais*. It was like a heroic frieze—he caught the civic *dignitas* of each one of them. Everybody had been

kind of stunned to see that big Mathew Brady–like camera on the tripod, but when he stood in front of it holding the shutter and talking to them they didn't even realize half the time that they were being photographed.

He also wanted to do a shot of this group of women whose kids were in jail, Mothers Reclaiming Our Children. These were hardworking women who were now spending half their lives on endless bus trips to prisons in Northern California. He photographed them standing in the debris of a burned-out mini-mall—they had heard somehow that he was a fashion photographer so they had all come dressed in their Sunday best. And what he did was, after he'd gotten his group picture he took the time to take a photograph of each woman, which was, to me, a singular act of democracy and kindness—the very opposite of the image of the photographer who raids the neighborhood to get his image and then runs with it. The women were all incredibly self-conscious, so as he photographed them he told them how gorgeous they were—"You have a fantastic smile," or "Your hair looks great." Then he went around getting all their names and addresses so he could send them each their photograph. And all his dealings with the people I introduced him to in South Central were conducted like that.

I usually don't like being around famous people, it makes me nervous. But this was one of the few occasions in my life where actually meeting somebody I'd always thought of as a hero surpassed expectations. He made you feel . . . not in awe exactly, just glad that there was such a brilliant guy out there who kind of had your politics.

MARC MCCLISH (1994–99): One of my professors at Brooks was Paul Meyer, who was like a one-man employment agency for Richard Avedon. He steered me to Ruedi Hofmann, who recommended me to Kara Glynn, who gave me eight hours in which to decide whether I wanted to quit school and work for Avedon. I went in as the fourth assistant and before I knew it I was the second and in a little over a year the studio manager. The first week I was there, he photographed Uma Thurman for *Égoïste*, and after he looked at all the film and the contacts he called her to say he was sorry, he hadn't gotten it, he must have been having an off day, and he was going to have to reshoot. It was

probably only three or four times that I ever saw him make a call like that.

I would always load as fast as I could, and that was fast, but still he would like hit me on the leg or whatever he could reach. Not hard— just, you know, to motivate me. I had to be ready for anything. He called me once on Christmas Day—"I can't get my TV on." I had to run down to the studio and get it working for him. He had hit the input button by mistake, so instead of pulling from the cable it was looking for the VCR. He never had to learn how to do any of these things— that's what he had *us* for.

I stayed at his house in Montauk for around six weeks while we were shooting a big portfolio for *The New Yorker.* One of my nicest memories of Dick in terms of something personal was when my fiancée, Dorin, moved to New York from California after graduating from nursing school, and he invited us to Montauk for a "non-working weekend." I expected it would still be like, if he needed something, I would have to respond on the double. But no, he encouraged us to go for walks and read books, and he cooked *us* dinner and served it to us and poured our wine.

He got Dorin a job at New York Hospital, on one of the cancer floors. But after a year or so, she went to work for a doctor who specialized in natural-health stuff and who later died in a car accident. Dorin brought him into the studio fold to provide and administer the B-12 shots on the Avedon sets. I remember those shots—they gave you this quick little high, but then later in the day you were peeing red.

I stayed with Dick through the end of the *New Yorker* religion project, which just sort of fizzled out. He let me choose a print when I left, and I picked the sad Marilyn. I had fallen in love with that picture when I was emptying wastebaskets every night as fourth assistant—I was all alone in the building and so was she, somehow, and, I don't know, she spoke to me. Dick did one of his smiley faces on the archival paper he wrapped her in for me—except he gave the face a frown and put tears in the eyes, which I'm not embarrassed to admit brought tears to mine. I still have my Marilyn—I haven't had to sell it, my kids aren't in college yet. And by the way, when they were born he sent baskets of baby's breath that were probably a foot and a half around.

When John Delaney and I opened SilverWorks, he gave us all his mural prints to do for his upcoming shows, and he had us make digital negatives for him of the original portraits from his earlier shows. We printed all his new things, too, like his portrait of Roy Lichtenstein, with the broken border. Since we weren't out there being photographers, he could afford to be genuinely happy that we were successful.

These days I'm living at 8,200 feet in the Rocky Mountains and I'm just a stay-at-home dad. I think of Dick often. My kids hear stories.

TIM WALKER (1994-95): I came to New York fresh out of art college in London to assist a British photographer on a shampoo ad at Industria Studios. But I aspired to work for the best of the best, and so, very neatly, and in real ink, I penned a letter to Kara Glynn, which resulted eventually in my meeting with Richard Avedon for approximately three minutes. He asked what my mother and father did for jobs and whether I had any brothers and sisters, period. I became fourth assistant forthwith—the bottom of the barrel. I was like a human broom. I was the Cinderella in the cellar. One of my chores was to open up in the morning, and on my first day I accidentally set off the alarm. He screamed at me so loud he drowned it out.

The whole studio was preparing to leave for London, to help set up his "Evidence" show at the National Portrait Gallery, where he was going to be personally taking Princess Di around. I pleaded with him, "I'm English, let me be your guide." And the answer came back, "You have to stay here and clear out the cellar." So the broom was left in New York, with only the mop for company. And I really did have to clear out the basement, which was full of all sorts of shit, including rats.

When they came back, my role expanded—I got to order lunch for everyone, empty their trash cans, change their lightbulbs, and paint the cyc white every day. I was the run-around, and I was good at that—brilliant, in fact, at getting people lunch. That part of it was actually kind of jolly. In fact, I was much better at homemaking than at light readings.

When we were on a shoot, my job was to turn on the light on the focusing lamp as Steve Wylie loaded the film in the camera, and then switch it off. Another of my roles was, when Dick raised his hand, to

pull him up from the floor where he would be sitting cross-legged shooting. One time my mind wandered—I was staring at a luscious model who was contorting her beautiful body all over the place for him—and my hand slipped and he fell back over the camera, and he went crazy on me: "Wake up, stop dreaming, concentrate!" But you know, I deserved that. Hot and cold Dick ran, like a tap: that's how I remember him. These very dramatic contrasts—distant, warm, funny, mean, cruel . . .

Kara was the overseer and her I really liked. But the assistant just above me, Marc McClish, was all about speed; if the phone rang, you couldn't walk to get it, you had to run, which just wasn't in my nature. He told me I should think of assisting at the studio as being like a stint in the army. He was certainly always marching around being very army. One day when I didn't pick up the phone quickly enough for him, he started shoving me around, and that just pressed the wrong button in me and we ended up having a punch-up. The whole mood there was pretty intense.

Dick had put up this huge bubble-jet poster of a sequence of pictures he'd taken of Marilyn Monroe in a tight sequined dress: she was laughing in one of them, she had her hands on her hips in another one, in another her head was down, then up . . . One morning the first thing, when I was making the coffee, I observed him standing in front of the poster mimicking all her poses, reliving the shoot in a way— almost asking, with his own body, "Did I get all I could?" And of course he had!

I got fired for not moving around the studio fast enough. The firing itself was very friendly. Kara made it seem more like a windup—you know, "I think it's time . . ." It was *high* time. Every day I would write down in this scrapbook I kept in my apartment in the East Village an idea for a photograph I was itching to take, which would then never get taken. And besides, I was dreadfully homesick for England.

Having worked for the Avedon studio was a big point of reference for me professionally once I was back in London. Photographers I met would take me aside and ask stuff like, "So how many flash setups does Avedon have?" I mean, his technical setup was actually incredibly simple, and the importance of keeping things simple was something he

stressed—it was his golden rule in photography. And I must say I follow it to this day. I don't even use flashes, I just shoot with daylight, and I have only one assistant.

I saw him in Paris, around 2003. Across a crowded room, at the Café de Flore. He was wearing a black puffer jacket and he was with Nicole Wisniak, and I just froze with fear: "There's my old boss," you know. I do kind of regret that I didn't approach him, because by that point I had achieved some recognition and Nicole had even tried to book me to do some pictures for *Égoïste*. But would I even have twigged with him? It might have been like it was with his old art director Ruth Ansel—when I approached her to design my last book, *Story Teller*, she didn't remember little Cinderella, who had emptied her bins and changed her bulbs.

I ran into another studio stalwart a few years later, at the Avedon fashion retrospective at ICP. She was someone whose little cups of tea I had cleared away more times than I can number. I respected her as a true partner with Dick in creating some of the narratives for his ad campaigns, and let's face it, I was also always very impressed with whose daughter she was. So I went up to her and said, "Oh hi, Doon, you won't remember me, but I was an assistant of Dick's and . . ." And she was like, "You're right, I don't remember you," and she turned in her little flat shoes and marched off.

A lot of the models Dick worked with I've now worked with myself: Kate Moss, Małgosia Bela, Kristen McMenamy, Stella Tennant . . . We talk a lot about Dick. Dick, Dick, Dick . . .

GRANT DELIN (1994-96): I was brought on originally to key up the crew on the big, complicated *New Yorker* fashion shoot in Montauk. So many of Dick's assistants had gone to Brooks, which offers an extremely technical education, along with courses in the business practice of photography, but for this highly imaginative project he felt he needed someone who wasn't necessarily so literal and practical—someone who understood the creative process.

The funny thing is that just a couple of years before, I had traveled to New York from London expressly for an interview with the studio, and been passed over by Dick in favor of Kara Glynn, I gathered be-

cause she was a woman. I ended up staying in town and going to work for the documentary photographer Mary Ellen Mark. She in turn introduced me to Ruedi Hofmann, and when he got hired to help out on the extensive shoot in Montauk, he thought of me.

I functioned as kind of an executive studio manager. I got to have my own caravan, complete with a darkroom, and that was great. My stated aim was to try and bring socialism to the regime, you could say. I was a big advocate for revolving roles—I wanted everyone to learn how to do what each of the others did.

When the gig was over, Dick asked me to come work for him for a year as a consultant. I had told him that my dad was seriously ill, in London, so he made me an offer that was generous enough to underwrite quality nursing care at home. It was simply the best assistant's salary I had ever heard of—100K.

He could be Adorable Dick, and he could turn on a dime and be Richard Avedon to the Max. But even then, two minutes after an outburst, he would be inviting you to have guava jam and cream cheese and crackers at this Spanish restaurant he loved around the corner from the studio. Occasionally he would have me up to his apartment after work for spaghetti with caviar. He considered that the ultimate delicacy, but to me it was positively abhorrent. The apartment itself was amazing. Like an Aladdin's cave. The assistants referred to it as the Dicksonian.

I also supervised the shredding of a lot of Dick's old commercial and advertising work—the stuff he called the "grant money" because it had underwritten his really serious work. It amused me to think of that phrase as a pun on my name, since the shredding was enabling *me* to do *my* personal work. I was based out at Fortress, our warehouse in Long Island City. Part of my job consisted of wheeling the boxes to a professional shredding vehicle the size of a municipal garbage truck that was stationed outside. It had a monitor mounted on its side for easy viewing. As I watched Dick's work turn into confetti, I sometimes had the feeling that this was maybe not the right thing he was doing.

One box of discards contained the transparencies of some of his early Western Project pictures, and when I noticed they were in color I called him to propose a stay of execution. He was adamant that no

trace of them remain—he said they represented an experiment that had failed. So it was off to the guillotine with them! A couple of times he asked me to gather up some of the shredded material and stuff it into one of the big industrial garbage bags and bring it in to him at the studio. He would run his fingers through the shreds and throw them up in the air, like a little kid.

On one occasion he asked to see some of my own work. It was all very classical—landscapes, platinum prints. He looked at them and said, "You should do pornography." I think that was just his way of encouraging me to ratchet up the subject matter—to find an edge.

Just before I left him, there was some talk of his giving me a print. But I didn't want to push it, since I was getting such a whacking great salary. And also, I didn't know if a print was something you got only after slaving away for him for years for nothing.

BRIAN HETHERINGTON (1995-98): I fully enjoyed working for Dick, but I also had to work nights as a waiter in Chelsea to make ends meet. Part of my duties was to put everything that was still left in the studio archive in alphabetical order and then into the big black portfolio boxes. I mean, when I think of the photographs I got to handle, to actually get my hands on! Like Nureyev's cock—*semi*-erect. I wasn't looking for it. It just popped up, so to speak—so *not* to speak. And Oscar De La Hoya—topless. And Greg Louganis—not nude, just wet, but still pretty hot.

I also worked at the warehouse with Grant. I had to follow the shredding truck to the dump—in a Skyline car with a driver, mind you—to make sure every shredlet got incinerated. We had a big flood—one of the major pipes in the warehouse burst. It happened on a Sunday, and Bill Bachmann called me at home and told me to get right out to Long Island City. The trouble was it wasn't just any ordinary Sunday, it was Gay Pride Sunday, and I had a bunch of friends in my apartment and we were just out the door to go parading. I explained to Bill that it was, like, *my* holiday and that I had never missed a single Gay Pride Parade in the nineteen years I'd lived in New York City. The flood, by the way, impacted only the solarized Beatles posters, but they were very rare. They all got ruined, and Dick ended up getting hundreds of thousands

of dollars from the insurance company. Nobody begrudged me my day at the parade. In fact, when I left to go work for Fabien Baron, who had been the art director for Dick on both the Calvin Klein CK Be perfume campaign and the Pirelli calendars, the whole studio collaborated on an ode to me:

> His precision there was no denyin',
> He was quick as a deer,
> Direct, focused, and clear,
> An arrow, not straight, that was Brian . . .

SEBASTIAN KIM (1996–2000): When I was in my second year at Brooks, one of my professors, Paul Meyer, recommended me to Marc McClish for the position of fourth assistant. Marc's going off to New York to work for the great Richard Avedon was a school legend. A couple of other students who had left school to work for big-name photographers came back to lecture about their experiences, and some of the stories they told were horror stories: I mean, the way they were treated, like tripods. One of them painted such an awful picture of a photographer he'd worked for who he wouldn't name that afterward I went to my teacher and begged him to tell me who it was. So then there were two photographers I knew for sure I never wanted to work for—one was *that* guy, and the other was Richard Avedon because he was just too big a deal. And the irony is I wound up working for both of them. One right after the other.

I met Dick the first day of my one-week tryout, and I was really surprised by how short he was. I'm only five-eight, but I was taller than him. He asked me where I was staying, and I told him with my mother in Flushing, sleeping on the couch because she had just a one-bedroom, so then he began asking me all these personal questions about her. I told him she was passionate about ballroom dancing, and he seemed fascinated by that.

One night when I was at Brooks, *Funny Face* was on TV and even though I'm not a big fan of musicals I stayed up late to watch it, because of the subject matter. And then, my first summer with Dick, it was shown in the Bryant Park free movie night series where you sit on

the lawn, and the whole studio went. All I could think as I watched the movie for the second time was that Richard Avedon was right there on my blanket. He left early, though—he said he was bored.

When Kara Glynn left, I got to be on set and change the film and run the Polaroids back and forth. During important shoots and campaigns I would have sleepless nights because you could never know for sure if the camera had been in focus or the exposure was right—there were so many variables. I would say, "Dick, we need to recheck focus," and he would say no, because he only wanted to keep going.

Psychologically it was very hard for me to get used to calling Dick Dick. I was timid by nature. I didn't think I had the personality to work for somebody like Richard Avedon. But a lot of that had to do with my relationship with Marc McClish, who ruled with an iron fist. He had come on the hot seat very young, and he didn't have that much experience, so he overcompensated by working incredibly hard and working everybody under him practically to death.

Dick had the most respect for Grant Delin, because every summer he would travel to Poland and places to make Holocaust photographs, or Prague to take pictures in tunnels. Dick liked you if you were cultured, and if you knew theater he *loved* you. I wasn't cultured enough for him—I mean, coming from California.

Marc told me, "If Dick ever invites you to Montauk, you should go, because he's not going to be like Dick there—he will make you eggs in the morning and take you out to lunch and cook dinner for you." So when Dick did ask me, I went—and then the problem was that he had asked *me* instead of Marc.

It was the job of the first assistant, when he gave notice, to prepare the next-in-line to take his place, which I would later do myself with Daymion and Dirk, both of whom I hired. The dynamic between Marc and me totally changed when he realized that I was his ticket out of the studio on good terms—he was going to have to break me in and make me shine for Dick. Plus he knew I would be having some say when it came to giving him and John Delaney jobs to print at their new lab.

After I had been at the studio three years, Dick told me I could choose any print I wanted for Christmas. I wasn't going to be greedy and ask for Dovima, so I picked his 1968 photograph of Lauren Hutton

in the Bahamas with the nipple sticking way out—*big*, twenty by twenty-four.

In my fifth year with Dick I got a call from Steven Meisel's assistant who said he was moving on to become a cinematographer and he wondered if I would be interested in replacing him. I was, even though it was Steven who was the monster in that lecture I attended at Brooks by one of his former assistants. And the more I thought about it, the more I saw that I needed to be on set in a different type of environment from Dick's and learn different things—things that were super-contemporary. The work for Dick was mostly galleries and museums, personal projects, big private commissions like the sheikh from Qatar, and editorial for *The New Yorker*—not a whole lot of commercial stuff. To work for Steven was the right next step for me. But I knew Dick would freak out if his number-one assistant left to assist the enemy.

Dick had been the ultimate fashion photographer from the fifties through the eighties, but around the nineties Steven took over shooting *Vogue* covers from him, while also shooting Italian *Vogue* and Calvin Klein. *The New York Times* once asked Dick what he thought of Steven, and he said something dismissive like, "I'm not familiar with his serious work." Dick felt strongly that Steven had made his name by copying him. I would put it another way: Steven had studied Dick about as hard as anybody could.

In 1997 we were shooting a Versace campaign with Kate Moss at Pier 59. This was a little before Steven took Versace away from Dick, too, his biggest account—I mean, he wound up sucking the blood out of him. Whenever Dick shot Versace at the pier he would rent the three back studios that interconnected: one for shooting, one for the clients, and one for wardrobe and catering. But this time Steven had gotten there first and reserved one of them, and Dick was forced to rent a third studio that was a little out of the way. One morning he and I and the stylist, Nicoletta Santoro, were walking from the catering studio to the shooting studio at the same time that Steven was walking out of the studio he'd rented right out from under Dick, and they came face-to-face—for the first time ever, according to Dick. Nicoletta, who had worked with Steven, said hi to him, and he said hi back, and then he nodded courteously to Dick, and Dick *sort* of nodded back. I mean,

talk about a brief encounter! Anyway, in the middle of the shoot Dick became very distracted, and he turned to Nicoletta and said, "Maybe I should have tried to talk to Steven—tried to connect."

So now I didn't know how to break the news to Dick that I wanted to go work for Steven. That spring we did a shoot for *Égoïste*, and Nicole Wisniak kept telling me how high Dick was on me, and I had noticed myself that he was being friendlier and more expressive than ever. Another assistant, Jos Schmid, was the only person who knew about me and Steven, and he was sitting next to me when Nicole said all this, so I felt sick to my stomach. I thought the best way to handle it was to say nothing to Dick and just let it play out. I was like, you know, a child—if you don't tell your mom the bad thing you've done, maybe she won't find out. I was planning to tell him *after* I'd left the studio— say that I had *just* gotten the offer.

But then on my second-to-last day—I was almost at the finish line—a friend who worked for Fabien Baron called me at the studio the first thing in the morning. He said, "Sebastian, congratulations! I heard last night that you're going to work for Steven. How did Dick take it when you told him?" I realized then how stupid I was not to have told Steven not to tell anyone. I had been thinking it was okay, because he was in a different world—he was downtown and we were uptown.

So while I'm on the phone with my friend, I hear Dick screaming, "Sebastian! Sebastian!" Everyone is having breakfast, and Dick, who hardly ever comes down this early, is heading over to me in his slippers, looking frazzled. He says, "I just received word that you're going to Meisel. I need you to tell me that this is *not true*." When I don't say anything, he shouts, "How could you do this to me, betray me like this, after everything I've done for you?" I say, "Dick, I can explain everything but I need to talk to you in private," and I practically drag him into the hair-and-makeup room and I sit him down, and he's twitching and I'm squirming, and I'm physically unable to get a word out, and he keeps saying, "Is this true or *not?*" Finally I break down and tell him, "*Yes*, Dick, it's true!" And he says, "This is just despicable. I can't believe it. You of all people, stabbing me in the back!" It was the most upset I'd ever seen him. I knew there was nothing I could say that

would make any difference, there was no point in even trying. I *had* done everything he was accusing me of.

He immediately called a meeting. It was everybody around the kitchen table: the housekeeper, the bookkeeper, the interns, the assistants, the archivist . . . He made an announcement: "I want all you guys to know that Sebastian has done something unforgivable. I was so ambitious for him, I was pushing him the way I haven't pushed anybody in years, and *this* is how he repays me. And he didn't even have the decency or courage to tell me himself. I had to hear it from Marla Weinhoff." And then he started in on Steven, and when he finished with that, he turned to Bill and said, "Cancel Sebastian's farewell party!" And then he turned to me. "Sebastian," he said, "pack up your stuff and get the fuck out! *Now! This minute!*"

Dick went upstairs, and everybody tried to go back to what they were doing. I asked Bill to come into the bathroom with me, and I just cried uncontrollably. He said, "How could this have happened?" and I told him, "I wanted to eat my cake and keep it, too." He was being so nice, trying to calm me down. He said, "Don't worry, this is just how things end sometimes." Then I gathered up what I had there, which wasn't much, and I walked over to Central Park and spent the day punishing myself for doing bad. I felt like my relationship with Jos was kind of strained now, too—I was afraid Dick would look at him like he had been an accomplice or something. Two weeks later I started working for Steven.

I did write Dick a heartfelt letter, and after about three months I got a short note back—two or three sentences. I read it with tears in my eyes. It said to please come back to the studio for the farewell lunch. That was a big gesture on his part—one that I would never have thought him capable of.

It wasn't one of those big elaborate goodbye lunches—the food came from Blue Moon, a crummy Mexican place. But it served its purpose—it was just a better ending to the whole thing. There were a couple of awkward moments for sure: somebody stupidly asked me in front of Dick what it was like to work for Steven, and then somebody else wanted to know if it was Steven's real hair under the bandanna.

Dick took me upstairs afterward, and he said, "I don't want to go on being upset with you, it's not healthy—you did what you felt you had to. But you also have to understand that as far as I'm concerned you're on the other side of the fence *permanently* now." I never saw him again.

I stayed with Steven seven years. I had been brought in as a contractor to do the lighting and camera work, and I was treated accordingly—I didn't once have to get him coffee. Dick I had had to do everything for. But I had also enjoyed a personal relationship with him, unlike with Steven. I was first assistant by the time I left Steven to pursue fashion photography on my own. I mostly do advertising and editorial portraits— for Calvin Klein, Uniqlo, *Vogue, Time, T, Interview* . . . My studio is in the Brooklyn Navy Yard. Like with Dick, everything is done in-house. I have two full-time assistants, two retouchers, and two interns.

DAYMION MARDEL (1999–2004): When I told my teacher at Brooks, Paul Meyer, that Richard Avedon's pictures spoke to me more than any other photographer's, he encouraged me to apply at the studio. I was hired by Sebastian as an intern, to work with the archivist out at the Long Island City warehouse, for which I would be getting college credit—I would be able to go back to Brooks and graduate. My roommate, Joe Cooie, got hired at the same time, as third assistant, but he didn't make it past the fourth day. He's six-nine was the problem—that didn't sit too well with Dick. Meanwhile Sebastian had noticed how well I was doing with the archivist and he thought I would fit in at the studio. He urged me to quit school and take the third-assistant job.

First I had to pass muster with Dick. He asked me just one question— where my name came from. I hesitated a second, then I said, "From Saint Damien of Molokai, the patron saint of lepers," and I could tell he thought that was cool. I had made it up—I had no idea how I got my name. All I knew was I couldn't afford to have him not be interested in me. He gave me one week to go back to California to pack up my stuff and sell my car. I would be making seventeen thousand dollars a year, which would leave me with around twelve after taxes—try living in New York City on that! But I moved up very quickly, because Jos Schmid went back to his native Switzerland, and Sebastian—well! I

was standing right there when the shit hit the fan. Then Dirk Kikstra was brought in, because he had had a lot of experience.

I'm six-one. My mom is real short, so I must have gotten my height from my dad—his side of the family are all over seven feet. I'm not going to tell you I was on my knees the whole time at the studio, but I did adopt a hunch, and any time I had to approach Dick at his desk or at a table, I crouched so he could be looking down on me.

I had noticed pretty early on that when Dick got excited about something he would get explosive, and so, no matter what it was about, I made sure to stay real calm. Because Jos had very nervous energy, too, and when both of *their* energies collided, it would get really crazy. One of the first assignments Dick gave me was arranging his flowers—lilacs and magnolias mostly. I didn't realize that this was, like, his little test to see how much aesthetic intelligence I had—until I saw him studying other assistants when they were doing his branches. Anything he gave me to do I did my utmost, starting with mopping the floors and making them smell good.

I was kept downstairs—out of sight pretty much—for the first couple of years. My first time on set I walked in holding a reflector and not really knowing what to do with it. I was wearing a baseball cap, and earrings. After a couple of sittings I knew enough to take all that stuff off. Today I look back at the kids I hired when I was studio manager and I think, Oh, they were just so young—and that was *me*, too. Luckily, Dirk was there to teach me things like printing. I think he and I ended up the best team in that whole generation of assistants—we realized right off that we were going to either drown together or win gold medals.

Dick's apartment was like a genie bottle. It was such a fantasy for me every time I went up there. There was always something new I learned about him, and so many new things to see. He would sometimes make me food. Runny scrambled eggs. God, they were terrible—he was a perfectly awful cook—but I ate them with relish. And I did just love watching him cook for me. Most of the time, though, he would take me out to dinner. And he took me to more plays than I can shake a finger at. A lot of it was business—we would be photographing the cast the next day or something and he would want me to have seen what *he* saw, because he might decide to re-create a moment from the piece.

DICK'S LOFT-LIKE LIVING QUARTERS AT 407 EAST 75TH STREET.

DICK'S PRIVATE KITCHEN/DINING ROOM—THINK GOOD FOOD,
GOOD TIMES, AND BIG BUSINESS.

The big commercial stuff we worked on was Hermès, Jil Sander, and Dior with Hedi Slimane. The major portraits were President Carter, Kofi Annan, and Obama when he was just an Illinois state sen-

ator. Oh, and Hillary Clinton. Dick had asked her to come as she was, but she showed up with hair and makeup *really done*, and wearing big earrings and a black power pantsuit. He very politely said, "Come with me," and whisked her upstairs. She came back down in one of his simple silk Charvet shirts, with the "RA" monogram, and his pale-blue cashmere cardigan, looking all relaxed. He had gotten her to wipe off the caked makeup and the too-red lipstick, and he had mussed her hair a bit to make her "look more like a real person." Then he put on Chet Baker and began shooting her. Another thrill was getting to meet Laura Wilson's sons Owen and Luke when we were photographing the cast of *The Royal Tenenbaums* for the movie poster.

Some of the assistants didn't understand at first what was going on when Dick planted his hand in their face, that all it meant was "Put the film in faster!" Look, he punched *me* all the time. And how! But it was no big deal. When we were shooting Savion Glover, the dancer with the dreadlocks, he was doing all these mile-a-minute moves and Dick couldn't shoot him fast enough. I was lighting him, and Dick was fisting me in the face the whole time, and I was laughing—I was actually enjoying it. It was something just in the moment—he didn't even realize he was doing it. I mean, Dick wouldn't hurt a fly. After the Glover shoot, I did say to him, "Dick, you punched me in the face an awful lot today," and he went, "What are you talking about?"

One morning he woke up with the feeling that there was stuff in his archive at the Center for Creative Photography that he wouldn't want anyone to ever be able to see. So he sent me to Tucson to start making preliminary piles for him to review for shredding. I was there for half a year, and Dick flew out and stayed for half of that. We were super-productive—you can do an awful lot of damage in a few months. Between the two of us we probably destroyed half of what was there. I mean the three of us—we poached an incredibly diligent CCP employee named Jennifer Landwehr. It wasn't all work by a long shot—we had movie night every Monday in Dick's suite at the Marriott. He would order in Mexican food, and he let Jennifer and me pick the movie, provided it was a classic.

A few months after we returned to New York, he wanted the remaining negatives and contact sheets shipped from Arizona to the studio to

be vetted there. I told him it would take a few weeks for all that stuff to arrive, and he said, "I want it by tomorrow." He said it again, emphatically, so I said, "Okay, okay, I'll get it here!" and I had it FedExed overnight. Two weeks later Bonnie the bookkeeper came charging down the stairs with the reddest face I'd ever seen. She waved a piece of paper in my face, and she screamed at me, "Do you know what this is? It's a FedEx bill for fifty thousand dollars!" I explained that Dick had absolutely insisted on overnight delivery — of over a million negatives!

Later that day, Dick called me into his office. He said, "Daymion, Daymion, what were you thinking? You didn't get an estimate? I mean, when I said overnight, I didn't mean *overnight*, I just meant as soon as possible." I said, "Dick, you were yelling, you *meant* overnight." He said, "Then you shouldn't have listened to me." He transferred me to the warehouse in Long Island City to continue the bulk of the shredding out there. Destroying his work went against every fiber in my body. I was even having to shred some of his sister. He had initialed the envelopes that contained what he wanted killed, and he trusted me to carry out his wishes. But if I felt strongly that something he ordered me to shred was really important and maybe even historic, I didn't do it — and I didn't tell him. I had my principles.

Oh, this is bringing up a lot of emotions. I miss Dick. I totally do. I loved every minute of working for him, even the bad days. He would call me up on my day off — "The coffeemaker is broken . . . There's a leak — I hear dripping" — and I would go running over. I would have stayed with him till he was a hundred. I thought he would live another twenty years for sure.

At the end of August 2004 I wrote him a five-page letter that basically said, "I have definitely put in my time — five years — and I promise I won't ever leave you and that I'll go on doing everything for you that you want done, but I do need a raise." I mean, I could barely make my rent. I left the letter at the top of his stairs. He never mentioned it, but two weeks later he quietly doubled my salary. There was only one paycheck before he died.

For about a year Annie Leibovitz rented the studio a lot from the building's new owners. She called me once, freaking out, wanting to know what formula — what exact ratio of this paint to that — Dick had

used for the cyc. I told her, "Benjamin Moore, matte, off-white, from the hardware store." It was hard to keep from laughing.

I credit Dick for whatever skills I've developed. Today I'm a working photographer, with clients like J. Crew, Coach, Neiman Marcus, Fossil, Macy's, the Gap, and Target. I just took a client away from Sebastian—he was up for a national campaign for Gillette razors and I beat him out of it. How Dick would have loved that!

DIRK KIKSTRA (1999–2004): My first month at Brooks, Avedon's *Autobiography* came out, and I didn't eat out for like a week in order to buy it. I was an industrial-advertising major and an automotive minor—I thought I might want to be a car photographer. At some point the dean noticed I had never taken a single photograph of a human being. He suggested I take a fashion-photography class, in the course of which I discovered that that was the kind of photographer I wanted to be. I asked Paul Meyer I don't know how many times to recommend me to the Avedon studio, and he wouldn't lift a finger.

I moved to New York anyway, and rolled into freelance-assisting for various fashion photographers. Seven months into a stint with Patrick Demarchelier I was contacted by the Avedon studio. Sebastian, who I'd known at Brooks, told me he was leaving and that Jos Schmid was moving up to first assistant. Daymion Mardel had started a few weeks before and in theory should have become second assistant, but, according to Sebastian, Daymion and Jos didn't gel and Jos was really keen for me to come there. They were worried on account of me being six-three— they felt that if Dick saw me cold he would turn against me, that he needed to be eased into my height. It was Sebastian who thought up this great idea of how to sell me to him—he said, "We're going to present you as the Gentle Viking." Well, I mean, I *am* Swedish.

Dick took me into the famous makeup room, just the two of us in there, and it was all just general questions. Except he did ask if I thought I could handle the long hours, because I had a wife. Salary was an issue, too. But my wife was working at Estée Lauder at the time, so we could manage.

As second assistant, I was learning how to do the Avedon lighting, how to make master prints, how to crop, how to follow through on the

NORMA WITH DICK'S ASSISTANTS DAYMION MARDEL (LEFT)
AND DIRK KIKSTRA, MONTAUK, LONG ISLAND.

DICK AND NORMA ENJOYING A LAST LUNCH AT DICK'S HOUSE,
WHICH HAD JUST BEEN SOLD, WITH DAYMION, DIRK,
AND DIRK'S WIFE, MARA.

framing . . . We assistants all lived in fear of Dick, and I saw how that collective insecurity generated nervous energy that he was able to use to his advantage. He also took different things that he needed from each of us. Daymion was very much the *caring* assistant. I was the *technical* protector. Sebastian had the sensibility thing, but hey, deep down he was just like Dick, he didn't make career mistakes—he played the innocent kid, but he always knew what was up.

The first time I was thrown on the camera, it was for an all-day shoot and I was nervous: had everything been in focus? I left the proofs for Dick that night, and the next morning when he came strutting into

Industria—up the plank, because it was like a garage—I rushed over to him and said, "Dick, I don't know, I think—I *hope*—they're pretty great." I was shaking so much I didn't realize I had lifted him clear off the floor until I heard someone say, "Dirk just picked Dick up!"

Within a year and a half I was studio manager. We were shooting campaigns like Hermès, Oscar de la Renta, and Dior, and I was print-ing Dick's books *Portraits* and *Made in France*, and working on his Met portraits retrospective. We shot a lot of celebrities, too—we went to Atlanta, to Emory University, to photograph Desmond Tutu for one of Dick's biggest clients, an insurance company called Winterthur. It was a real short warm-up conversation between Dick and the archbishop, and the shoot was over in under six minutes.

Which models did we shoot? Małgosia, Małgosia, and Małgosia. He really loved that Małgosia. She was intellectual, see. Beautiful, too, of course, just not in a classical way—Dick didn't like *boring* beautiful. He was an amazing fashion photographer—he did frocks better than anyone, and personalities—but he just couldn't do sex. The Stephanie Seymour crotch shot to me is just a fashion picture.

Dick had this phenomenal visual memory—say a picture he took didn't show up on the contact sheet, he would remember having shot it, even if he'd done five or six rolls. He only used the Rolleiflex for one out of every thirty sittings we did, I'd say—when he wanted to get some-thing really lively—and he would be, like, dancing with it.

The best experience I had with Dick in toto was in the fall of 2000—Château Lafite Rothschild, in the Médoc region of Bordeaux. It was a private commission, although some of the pictures did eventu-ally appear in *Égoïste*. Every few years Baron Éric de Rothschild would pick an artist to render the place for him. Dick told us that Lartigue had done it. The baron put Dick up in his château, and Jos and me in a mini château across the road which had its own wine cellar. I wasn't a big wine drinker—till then!

Dick did pictures of the workers in the vineyards, that kind of thing, and then some portraits of the baron—one was of him deep in conver-sation with his head vegetable gardener. When Dick was finished, he told them, "Okay, you guys, you don't have to talk to each other any-more." They both turned to look at him like, What are you talking

about? This isn't playacting—we always have plenty to talk about. He was very impressive, the baron. He played it down—he wore a Swatch and drove a Volvo, all of which I liked. And he showed us the line of showers that the Nazi officers installed when they occupied the château during World War II.

Jos and I really tied on the old feedbag there. Breakfast was just baguettes at our château, but lunch was a five-course, three-wine deal over at the main château with Dick and Éric. Dick had given us money to buy good suits before we left New York, and he made us put them on for the first lunch. Éric was in a baggy old sweater and he just looked at Jos and me like we were out of place, and afterward Dick told us we didn't have to dress for lunch anymore.

Éric talked about things that Dick had absolutely no interest in. Like hunting. I would have loved to go hunting with Baron Éric, but it wasn't in the cards—it wasn't the season. Plus Dick's eyes were saying to me, Don't try to get chummy-chummy with him. One day for lunch they served oysters, which I don't eat, and I nudged Josh, "You want mine?" Dick heard me and he said under his breath, "You don't do that here! You don't shovel food back and forth at Château Lafite!" He was so uptight, but Éric made up for it by being so super-relaxed. The next time he came to New York, he visited the studio. Dick was in a quandary about whether to serve fish or chicken for lunch. A bigger worry was what wine to offer him. The baron solved the problem elegantly by asking for beer.

Dick had the kind of personality where he could make you feel he really cared about you. When my wife was in labor with our daughter, Chloe, he kept calling the birthing center in the West Village every half hour, "Is she here yet?" My parents weren't even calling; neither were my wife's.

I could never do an Avedon—even if I had worked for him for a hundred *more* years. I could do it technically—obviously, because I did—but nobody but Dick himself could pull it off. What I appreciated about him—and about photographers like Penn and Peter Beard and Helmut Newton, and what's missing in a huge sense from the field today—is that he lived his photographs. He was photographing his own realities—he *was* his pictures.

When you left as studio manager, the unwritten rule was you got a print. When Jos was leaving to go home to Switzerland, I mentioned to Dick that I knew he would especially cherish a Charlie Chaplin, because Chaplin ended up there, and Dick gave it to him. The print he gave *me* when I told him I was leaving was the self-portrait he did for the Met show—maybe because I was the one who tripped the shutter and took the picture essentially. It was a triptych, too—*three* pictures of Dick! I would have rather had one of those iconic Avedons from the American West.

The last real conversation I ever had with him was late in the summer of 2004, about a month before he died. We were doing a job for H&M at Industria. The big story playing in the world at that point was Iraq, and Dick told me he was dying to go there and wanted me to go with him—it turned out a lot of people had turned him down. I had my kid now, so I told him my terms—a three-million-dollar insurance policy and ten thousand dollars a day. He said, "No problem—*The New Yorker* will take care of it." So I said okay I would go. I knew that, being with Richard Avedon, you weren't going to be running through a combat field—you would be with the press corps, within a certain bubble of safety. But in the end he decided not to do it.

On Saturday, September twenty-fifth, I was packing the van to drive to Washington to build a studio for Dick at the Pentagon—he was going to be shooting Rumsfeld and Rehnquist, and maybe even Cheney, for *The New Yorker* in a couple of days—when I got the call from one of the assistants in San Antonio: "Dick's bleeding out of his ears, what should we do?" I was, like, "Get him to the hospital!"

ROBERT GABRIEL (2000–2002): My mother gave me a camera when I was in high school and I loved taking pictures, and after graduation I took courses at ICP. But I needed a job, and a friend of hers, who was like the dean of flower arrangement in New York for events and private homes, took me on, and I turned out to have a real knack for it.

I was also freelance-assisting for photographers like Craig McDean, Michael Thompson, and Patrick Demarchelier. Then a photographer I met at ICP told me the Avedon studio was looking for someone. Dirk

and Jos gave me a twenty-minute written test on photography. It was highly technical—stuff like, "How do you compensate for color temperature in the shade as opposed to the sun?" Well, that was a breeze— you just use a yellow filter, or a blue. And there were questions about film exposure index, bellows compensation, and background density. They graded it right there, and they told me I had gotten the highest score of anybody ever. When they were wrapping up the interview, they asked if there was anything else I could do that they should know about, and I told them I worked as an assistant to an important flower designer. And they went, *"Really??!!!!"* They wrote across the top of my test the word *flowers*, with three stars, and I got called back later that afternoon to meet with Dick.

He took me into the makeup room—I'm not claustrophobic but it felt like a box. He said he could really use someone who knew as much as I reputedly did about flower arranging. He asked if I had a girlfriend and I told him I was married, so then he wanted to know if that would be an issue and I said no. But the truth of the matter is I did not see very much of my wife for the next three years. I worked a minimum of twelve hours a day six days a week, and the days we were shooting I'd have to be in the darkroom till two or three in the morning—then I'd go home and sleep for a couple of hours and be back at the studio by eight. I was making $450 a week, around the minimum wage, but I was so fortunate to be working for this freight train of creativity, with a history behind him that was staggering.

When I was first doing his arrangements he would order the flowers himself, but after a while he developed enough confidence in me to let me get him whatever I wanted. I knew he loved—what's the yellow flower called? forsythia?—so one morning I did a huge tree of it in his living room, in a tall cylinder. Then I went down to the darkroom to print. Half an hour later he buzzed me: "Robert, get back up here immediately!" I was naturally imagining the worst. But he pointed to my forsythia tree and said, "How did you *do* this? It's brilliant." I said, "Dick, how do *you* take photographs?" He said, "Robert, you have a real eye for beauty." Another time, I had gone to the Agata & Valentina emporium on First Avenue for cold cuts and tomatoes and I'd made this big picnic kind of presentation for lunch, and he said to me, in

front of the whole studio, "Robert, you're as good as Martha Stewart." I could see that the others were pissed off when he praised me.

He had me working on three of his books, including *Made in France*, and on the portraits for the Met show. After a year and two months—Jos had left, and Dirk and Daymion had both moved up—I became second assistant in a way. The high point for me—it was literally way up there—was the *Angels in America* sitting. Dick was shooting the ad, at Silvercup Studios, to promote the *Angels* HBO miniseries directed by Mike Nichols. Emma Thompson was the angel, and Dick asked me to stand in for her for the Polaroid test shot. I had to be hoisted up on a pulley. I had a shoulder harness on, and the wings I was wearing had a spread of eight or ten feet—I had had to take off my horns for the picture and tuck in my tail, ha-ha. It was such a beautiful image, and Dick let me keep it. At the shoot Al Pacino was racing around the studio, haranguing, trying to get in character as Roy Cohn. He and Dick had a big tug-of-war, and finally he stormed off, with Dick running after him to get him back. He photographed him and Emma Thompson separately, then collaged them.

The low point for me was a pro bono shoot that we also did at Silvercup—a TV and print ad for an antismoking campaign. The models were real people in various stages of their cancer, and Dick wanted to film them telling their personal stories. He asked them each, "If you could live your life over again, would you still smoke?" and that was usually enough to get them to open up about the kids they were going to be leaving behind, who they were never going to live to see graduate high school or go down the aisle. One woman had shown up with a breathing tube which at some point she removed so she could smoke a cigarette through the hole in her throat. Another one was wearing a wig, but from the sides you could make out a little bit of fuzzy weird hair growth. When Dick asked her to take the wig off, I assumed he wanted to photograph her just with the fuzz, but no, he wanted the hairdresser on set, James Kaliardos, to shave it down. James refused—he stood up to Dick and told him that someone very close to him had recently died of cancer and that there'd been a whole hair thing with them, so it was personal for him. So Dick had no choice but to go with the fuzz. Ironically, he had the poster person for lung cancer right in

the studio—Bonnie the bookkeeper. She would always be sneaking a smoke outside—huddling in the doorway type thing—and when she came back in she would have the shakes. He told me he had thought of using her. Sadly, she did succumb. But the funny thing is Dick went first.

I did some of his shredding down in the basement, and then I got transferred out to Long Island City to shred under Daymion. There were a lot of celluloid negatives of the Beatles from the sixties, and I thought, Oh no, I'm annihilating my idols. I cut up a lot of beautiful models, too. Certain models it was a big thrill to see in the flesh. I mean, I was a young man. It was a little like collecting baseball cards. Cindy Crawford, Stephanie Seymour . . . But Naomi Campbell, forget it! She was just a monster—she marched into the dressing room and got right on the phone and started screaming at the top of her lungs at her boyfriend or her assistant or whoever. She was cursing away and throwing stuff around. Dick came this close to throwing her off the set.

I was getting a little burned out at the studio, emotionally and physically, and eventually there was a mutual parting of the ways. I worked practically till the day the Met show opened—I remember loading the huge prints into the crates and onto the truck. After I left I wrote a poem for Dick called "All in a Day's Work." These days I work at my mother's eyebrow-design boutique, Eliza's Eyes. I personally did Oprah's eyebrows. And then she had me on her show. I wish Dick had lived to see that.

JENNIFER LANDWEHR (2002-3): Dick would sit beside me at the Center for Creative Photography in Tucson and we would page through his old contact sheets together and he would tell me his stories—it was just him and me and the shredder, and it was wonderful. He would circle on the sheets with a red grease pencil the ones he wanted to keep, and I would cut them out to save, and later I would match them up with their negatives. You couldn't question anything he wanted you to do, which meant you were sticking an awful lot of pictures you loved into the killing machine. I was killing some of his earliest stuff—his first shoots for *Junior Bazaar* and *Harper's Bazaar*, and it

ripped my heart out to do it. My biggest fear was that one day he would ask for something he had had me kill.

A couple of times I couldn't keep from speaking up—I'd say, "Oh no, *please*! Not this one!" We were going through a sitting of Judy Garland, one of my all-time favorite stars, and I expressed reservations over having to shred her, and he said, "Don't give it a second thought—she wouldn't have wanted to be remembered this way." I asked him how he thought she *would* want to be remembered, and he said probably by his photograph of her looking adorable in top hat and tails and carrying an armful of roses but that he considered that the most "lying" of all his celebrity photographs.

We had just been shredding his sitting with John Huston, so for our next movie night I picked *The Treasure of the Sierra Madre*. You could basically take any old classic and he had photographed the stars or the director. The night we saw the Huston movie he wanted to eat out afterward. My sister was with us, and we were walking through the Marriott lobby on our way to this taco-truck kind of place, because my original restaurant suggestion was too chichi for him—he wanted to eat someplace "authentic." By the front desk he saw an announcement that a senior prom was being held in the ballroom. He said, "Hold your horses!" He told us he had never gone to a prom and the next thing I knew we were crashing one. He danced with my sister, and they truly could have passed for high-school seniors. There was a group of popular-looking girls in fancy dresses all clustered together, and then way over in left field was this girl standing alone who had something really funky on, and Dick went up to her and said, "I love your dress." She just beamed.

MICHAEL WRIGHT (2002–4): After a couple of classes at Brooks, I got totally hooked on Richard Avedon's work, and I told my professor, Paul Meyer, that my dream was to work for him. He arranged for me to leave school early and do an internship at the studio that would count as credit.

Working there was the coolest thing—you learned not only what was old and what was current but what was coming next. Twyla Tharp

came in—Dick had made us read one of her books—and it turned into a group-counseling session. She said to me, "You seem to have a hard time getting to the point—jump!" Cat Power came in and right away started doing shots of champagne in the dressing room. Charlize Theron came in to be photographed for *Égoïste*, and Dick got her naked. She was hot, of course, but when you're on camera like I was—I was second assistant by then—you're not ogling T and A, what you're looking at is film.

The Christopher Reeve shoot for *The New Yorker* was super-memorable. It was up at his house in Westchester. We never got inside, because Dick wanted to do it with daylight, against the white canvas. So Mr. Reeve got wheeled out to the driveway, and from there it took ten minutes for his nurses and support people to maneuver him into the right spot. I was not on camera—I was just handing film to Day-mion. Dick was talking to Mr. Reeve and his wife, Dana—not small talk, more appreciation talk, because he was obviously feeling pity for someone who had once been Superman. On the drive back to town, he said, "Let's face it, it was a stupid thing he did when he tried to do that jump with his horse—he just wasn't advanced enough for it. It was about macho and narcissism—how good he looked in his riding clothes. But that was *then*—*now* he is noble." The photograph was, too, and it could so easily have been grotesque.

My mother passed away while I was working for Dick, and I had to go back to California for a few months. He couldn't have been more understanding—he told me to take as long as I needed. During her last days he had written her a wonderful letter about me that I have framed: "You've achieved immortality in Michael . . ." This goes to show that Richard Avedon gave a shit about Michael Wright—oops, my girl-friend doesn't like it when I swear. And on my twenty-second birthday he gave me a signed copy of *Observations*.

When clients got in Dick's face, he wasn't afraid to let them know it. One client, I think it was H&M, suggested he try doing a photograph another way, and he shoved the cable release he was holding in the guy's face. He said, "Why don't *you* take the fucking picture?" and walked off the set and out of Industria Studios. He was back fifteen

minutes later, all cooled off. He might not have taken client input well, but he would never leave a job undone.

We were doing a high-stress job—portraits of top CEOs—at some private club on Park Avenue, and I was on camera. When Dick went to push the button on the cable release to fire the shutter, he discovered that I hadn't loaded the eight-by-ten holder and he spun around and hit me on my arm real hard. I thought, What the hell's going on here? I shouldn't be getting hit by my boss, my mentor, the person I'm doing everything I can for and more—he has no business treating me like a bad child. I was too scared to say anything, but I heard the head of AT&T say to the CEOs on either side of him, "Did you just see what I saw? He hit that kid. That's *wrong*."

My first day on set, back when I was just an intern, I had witnessed Al Pacino yelling at the top of his lungs and gesticulating wildly as he tried to turn himself into Roy Cohn. And now, as far as I was concerned, Richard Avedon was channeling Al Pacino—acting like a raging bull. I confided my anger and confusion to Daymion, who told me to just forget it, that Dick hit everyone and not to take it personally.

Six months after that first punch Dick struck again. I wasn't loading the camera fast enough for him and he hit me in the same damn spot—karate-chopped me a few times on the arm. It was very childish behavior on his part. Now that I'd seen for the second time who my idol *really* was, I said to myself, That's not who *I* want to be. We had all experienced up close his reaction to Sebastian going to work for Steven Meisel. I mean, there was clearly a maturity thing going on with him. Or maybe it was just all those pills he was taking. I was one of the two people responsible for organizing them when he was going on location—putting them in the blue plastic container. He had different ones for each day of the week, and different ones for day and night. He had had a chart made for quick reference, with photographs of all the pills.

He never apologized for hitting me, but he did write me the greatest letter of recommendation you ever saw. He said I was one of the finest assistants he had ever had, that I was like one of his own arms. He might have been afraid I was going to sue. I wound up freelance-

assisting for Annie Leibovitz and Patrick Demarchelier, and then I went to work for Irving Penn. In the job interview Mr. Penn asked why I had left Avedon. I'd rather not say what his reaction was when I told him.

CAMERON STERLING (2003-4): I was attending the feeder school for Richard Avedon—Brooks Institute. I had graduated from the other feeder school for him, Kenyon College, with a B.A. in history. Now I was working toward a second B.A., in advertising photography, and I had half a year to go before graduation. My six-month unpaid internship at the studio was going to count as credit.

I started on November first, and I remember I wore my good-luck shirt to work. It had belonged to my grandfather, who had given me my first really good camera, and wearing it was like bringing him along to see how far in life his encouragement had taken me. There was a lot of excitement at the studio that day. Dick had assigned the staff to take pictures of the Halloween Parade in Greenwich Village, and they were going to be getting feedback from him—he was trying to find his old issues of Brodovitch's *Portfolio* magazine, which he wanted to use to illustrate various points of criticism. I had missed out on the assignment by one day, but then a couple of months later he assigned us to photograph "the Halloween in Christmas."

I was living with my mother in Greenwich, Connecticut, in the house I'd grown up in, so it was a big help when after only a couple of weeks the studio offered to pick up my train fare, which came to around three hundred dollars a month—now at least it wouldn't be *costing* me money to work there. I was having to wake up at 5:15 to catch the 6:27, and sometimes on the ride home I would fall asleep and miss my stop. Halfway into my internship, Dick hired me as fourth assistant, which would also count toward my graduation requirements. The only downside was that my train fare subsidy came to a screeching halt.

I would open up the studio at 7:45. I would pick up Dick's newspaper from under the mail slot and bring it to the threshold of his apartment. Sometimes he'd already be up, puttering around in his T-shirt and boxer briefs—or his black running shorts, or his blue pajamas and faded pink terry-cloth robe. I would see him with bedhead—what I'm

trying to say is I saw him in a very human way. As I got to know the full spectrum of his personality, he became less of a myth and more of a reality. The first thing in the morning he was often groggy, and then he might call me "Carleton" instead of "Cameron." There were mornings when I approached his door and his lights were off and there was no music playing, that I couldn't help wondering . . . I mean, he *was* eighty years old.

In the course of my roughly thirteen-hour workday—I usually closed the studio around 9:30, after emptying the eighteen trash cans—I might be called on to do pretty much anything, from taking his glasses to the optician to be repaired after he sat on them, to picking up his meds from the pharmacy, to finding bamboo poles to keep his orchids from flopping over, to unpacking about a hundred individually bubble-wrapped wooden coat hangers, to organizing all his ties and belts. I was always having to arrange his branches—forsythia, dogwood, cherry, lilac, whatever—and when they were finished, I had to sweep up the sticky petals. I was almost never not sweeping something up— the sidewalk in front of the studio or the trimmings from the Christmas tree or even his hairs from the floor of the dressing room after he'd had a haircut.

When the electrician left wires dangling inside the storage space above the kitchen, I had to crawl in there and fiddle with them without getting electrocuted or setting the studio on fire. Then I might have to clean out the silt in the basement pipes that supplied water for the processing and printing. He also asked me to disassemble all the cardboard boxes that he had had set up in order to try out his new bed environment, because he had decided to go ahead and have them made out of mahogany. Then when his new bed arrived and he saw that the legs were too long, he had me pick up shorter ones at some shop in Harlem. Another day he sent me to pick up a bunch of books on New Zealand—he explained that he was thinking seriously about moving the studio there because he was sure New York was past due for another 9/11.

Another thing he had me do was put all his recipes in a bound book. I slipped them into acetate sleeves and organized them in sections, like "Pastas" and "Veal." He had more recipes for risotto than

anything else—they could have been an album unto themselves. I was constantly having to update the book, because he was collecting recipes nonstop. He wanted to include one of the dishes I'd made for a studio lunch; I had to quickly come up with a name for it, so I just put "Cameron's Crunch Salad."

I had to fix the phone for his wife at U.N. Plaza, and later when she was moved to the hospice in the Bronx he had me take some of her things up to her, and then after she died he asked me to accompany the appraiser to her apartment. And not so long after that, *he* died. It struck me as kind of cosmic that a husband and wife both died around the same time.

One day Dick and I were on our way back to the studio from downtown and he told the driver to make a detour to the Sutton Place neighborhood—he wanted me to see the townhouse where he and his wife had lived for most of the sixties. It was an impressive-looking building right by the river, with a private park behind it. We stood on the cobblestoned street in front and he gave me a virtual tour of the house.

Dick said he thought I had a knack for graphics, and he asked me for my design ideas for the invitation for Bill Bachmann's surprise party. Then he wanted to know if I had any ideas for the cover of his book *Woman in the Mirror*. He also told me that he wanted me to work on the design for a series of small books he was thinking of doing on his early models. This was very heady stuff. He asked me once, "What kind of parents do you have—to raise someone like you?" I took it as a compliment.

Daymion thought it would be a good thing for me to learn about client etiquette and he suggested I stand in the corner of the doorway leading from the basement and listen in on a sitting. The boiler was so noisy I wasn't able to catch every word, but I got the gist of it. He also allowed me to *observe* a sitting, through a crack in the door of the utility closet adjacent to the cyc.

Dick liked to use me as a model for lighting and composition tests. I was the stand-in for Isabella Rossellini for a *New Yorker* sitting, and for the artist John Currin, and also the model when a couple of techs from Hasselblad came to the studio to give Dick a demo of their latest digital

camera. Unfortunately I had a zit on my forehead, which came up again and again—gigantic—on the cinema display. He took sixteen rapid-fire exposures, and he sent the choice image to friends and art directors and editors to commemorate his first photograph with a digital camera—I guess that makes me historic. He said he was put off by the speed of the thing, the immediacy of it. He also thought that technologically made images always looked it.

One of the most valuable things I learned from being around Dick so much is what I call the spirit of a photograph—the poetry and mystery. Sometimes he created it by a sort of controlled overexposure. He always knew when a picture should be even-contrast and when it should be really high-key. In this regard I particularly remember the photographs he took of his three-year-old granddaughter cavorting on a beach in the Caribbean. Michael Wright printed them normally and Dick asked him to go back and continuously overexpose them until they became ethereal, what with the little girl's blond hair and the platinum sand. The light just overpowered the picture—all you saw, really, were her paper-white footprints and her billowing dress. The image had become dreamlike—it had the same fantasy quality as Dick's famous photograph of the little boy in Sicily. On an even lighter level—in another sense—I'm remembering how one day during that Caribbean holiday he called the studio wanting to know how to work the 35mm camera that Daymion had FedExed him.

When Dick died, my overwhelming emotion was gratitude—gratitude that I had gotten to experience him, if only for a fleeting while. The whole ethos of the studio changed overnight. Bill was instructed to padlock the door to Dick's apartment, which everyone who worked in the studio had always had access to—to find or fix things—whether or not Dick was there. Now it was like a crime scene. There had been a kind of family trust that we all enjoyed, and now suddenly we were being treated like potential looters.

I got a job right away, freelancing for a fashion photographer on a Victoria's Secret underwear/bathing-suit shoot in St. Bart's. Hey, a beach location with models! The photographer encouraged me to interact socially with everyone on the set. With Dick you had had to be-

have the exact opposite, you had to be unseen—a supporting player. The interesting thing was that this photographer's operation was like a family, too—only a wildly different kind of family.

I'm not going to say I didn't enjoy the much more open environment. I'm glad I got to experience that element of the photography world, where everything doesn't have to be so serious the whole time. I mean, the guy was photographing catalogue stuff, it wasn't about trying to make art. It was about having a good time yourself while you were getting the job done and making the client happy. The photographer, by the way, offered me a full-time job, but I went to work instead for Dick's old assistant, Hiro. I've been with him going on thirteen years now, wearing different hats.

And sometimes wearing something of Dick's! Like the green corduroy jacket he gave me. Or his black jeans. He once asked me to take eight pairs of them to a thrift shop and I asked if I could keep a pair or two for myself.

PAUL MEYER: I had been Ruedi Hofmann's roommate at Brooks, and I went to visit him in New York in 1981 when he was working at the Avedon studio. He mentioned that Hiro was looking for an assistant, and when I told him I was interested he typed up my résumé himself, then called Hiro and arranged for me to be interviewed that afternoon. He pointed me in the direction of his studio, across Central Park.

After my interview, I doubled back to the Avedon studio. As I walked in the door the secretary, Penny Cobbs, who was talking to Dick, stopped mid-sentence to ask, "How did it go?" Then Chick the bookkeeper popped out from his little area behind her and said, "How did it go?" and now Dick was looking quizzically from one to the other. And then the first assistant, who had come up from the basement, chimed in, "Well, how *did* it go?" Dick was turning in a little circle, and finally he took me in. He was kind of frowning, maybe because nobody was paying attention to him. Penny formally introduced us: "Oh Dick, this is Paul Meyer, Ruedi's old friend from Brooks—he just interviewed with Hiro." So then it was Dick's turn to go, "How did it go?"

It had gone very well, and I ended up working for Hiro for a year.

After which I freelance-assisted for some of the biggest commercial photographers in New York. At some point Ruedi brought me into the Avedon studio for a few days to do gift prints of the Hutterites from the "In the American West" series—I was just the guy that came in the side door, went downstairs to the darkroom, and did the work. Eventually I went back to California, and in the early nineties I started teaching at Brooks.

In 1994, Dick's studio manager Kara Glynn asked Ruedi if he knew of anybody good to assist, and Ruedi asked me, and I recommended a student of mine, Marc McClish. And that kind of opened the flood-gates from Brooks to the Avedon studio. And as for Marc, he ended up taking Kara's place when she moved over to Annie Leibovitz.

I next sent Sebastian Kim to Dick, then Michael Wright, and then Daymion Mardel, who started out there as a mere intern. I did *not* send either Dirk Kikstra or Jos Schmid. Jos they picked up on their own, from Switzerland, and Dirk—well, he had asked me to help him get to Avedon, but I felt his ego was too big. It was only after he moved to New York and got knocked down a peg or two that he was able to come in and be a great assistant to Dick. He came back to Brooks to speak to my class and publicly thanked me for *not* sending him to the Avedon studio directly after school—he admitted he hadn't had the right mindset. I also sent Matt Olson, Jamie Peachy, and Cameron Sterling.

You can predict only so far, because a lot of it is chemistry. That said, I only really missed on one guy. I sent him the same time as Day-mion, and I thought he was going to be great—Joe Cooie. It didn't occur to me that he was way too tall to work for Dick.

What was wonderful for me was that the assistants I sent would al-ways fill me in on life in the studio, and thanks to that I became even better at prepping the kids I would recommend. I'd tell them, you know, "You're going to be expected to do tasks you won't think you're ready for, and it's going to be how you approach them that determines how successful you are there." And I would remind them, especially the ones who were going in as interns, that they would be the lowest form of photographic life on the planet, that they would be doing things like Dick's dishes and picking up his dry cleaning and that they

certainly wouldn't be getting on set right away—they were going to have to earn that privilege.

I was always looking for kids who would understand that their primary job was to be part of Dick's team and make his life as easy and smooth as possible. I came across some great technical shooters, but they weren't team players—you know on your elementary-school report card where it said "works well with others"? The job was about supporting the effort. It was kind of like the Tour de France, where it takes a whole slew of riders to get one person across the finish line first.

My kids got Dick to sign most of his books for me, with personalized inscriptions. And then, around 1998, Dick left me an absolutely wonderful voice message that I saved. I play it occasionally for myself: "Paul, it's Dick Avedon. I'm so grateful to you I can't tell you. You should be here. It will be like a class reunion. Every intern and the entire staff comes from you. Dirk, Daymion, the great Sebastian . . . And I just want to thank you with all my heart. It's a joy to be surrounded by your children, who are turning into, who are really, men. Bye-bye."

Probably the biggest thrill of my life, next to the birth of my two sons, was seeing the Avedon portraits show at the Met in 2002 and then walking over to the studio to have lunch with Dick and the whole crew at the big square butcher-block. Just sitting on that bench imagining the people who had sat on it before me was overwhelming. Every item I ate was placed on my plate by Dick—he was standing up dishing. "Oh Paul," he said, "you have to try *this*!" And this. And that. In no time I was filled to capacity. And, I mean, to be personally served by Richard Avedon! I get goose bumps just thinking about it.

I talk to Daymion pretty often and oh boy is he doing well. And Sebastian is huge in New York right now—*huge*. Some of the others are doing fine, too. I'm proud of my boys. Dick's boys.

16

THE CALVIN CAMPAIGNS

FOR BOTH HIS COMMERCIAL AND, TO A LESSER DEGREE, HIS editorial work (the latter often served to spark the former) Dick earned millions. The lion's share went toward footing the studio expenses and financing his personal projects, including the making of his gigantic prints and landmark books. Emotionally it was all a balancing act—when it came to advertising, he did what he had to do, but with ever-diminishing enthusiasm. That is, until the advent of Calvin Klein.

One day not so long ago I was having lunch at Sant Ambroeus in the West Village, and there he was—the man himself, looking more like a boy. I hadn't seen Calvin in, well, an eternity. He was still skinny, still with the spiky hair, and still with the cashmere sweater thrown over the shoulder. Mr. Cool. Mr. Clean. Mr. Less-Is-More.

He saw me and waved. Simultaneously we got up from our tables and met in the middle of the room in a hug. He said, "I miss you, I love you, you look great." Fashion people: how I love *them*, and miss them. As I was returning to my table he called out after me, "We made history together!"

The next morning he called to make a lunch date at Sant Ambroeus. In the event we had plenty to gossip about but nothing to really talk about. We were just babbling away, doing our best to keep from

missing Dick. Then Calvin said, "He always ordered the same dish—the risotto agli asparagi." "The risotto di mare mediterraneo," I corrected him. Calvin sighed. "Those were the days—the best of times. Dick and you and Doon and me. We were all in this crazy thing together. I loved working with Dick more than anyone, though I was always a little afraid of him."

I said, "Then let me tell you something—Dick was a little intimidated by *you*."

"Richard Avedon intimidated by *me*? I can't even begin to grasp that."

"You were known to be one tough customer—or should I say client. Dick would always have clients come to *him* for meetings; *you* we went all the way downtown for. I remember how he obsessed over what to wear to your first meeting—he was as nervous as if he were dressing for a first date."

"Well," Calvin said, "*that* I can certainly understand—I think about that sort of thing all the time myself. Only I never had a sense of that in *him*. What *did* he wear that day, by the way? Do you happen to recall?"

I recounted to Calvin how Dick had tried on and taken off a couple of his bespoke suits, and as many as half a dozen shirts and ties. "In the end we decided he should just come as he was—go as himself," I told Calvin.

"Always a good idea," he agreed. "Dick really had a look all his own. Did he put a lot of thought into it, I'm wondering."

I said, "He didn't want it to look like he did, but yes." Richard Avedon's age-old pre*sent*. I found myself telling Calvin the story of the blue-denim jacket and matching trousers that Dick had made back in the sixties. It arrived too blue to suit him, so that weekend he took it with him to the house he was renting on Fire Island and soaked it in the sea until the salt had done its job, then he gave it a loving sunbath. Calvin was nodding appreciatively.

There was a sobering coda to the tale, however. When Revlon's founder and chairman, Charles Revson, asked to meet Dick after his sensationally successful "Fire and Ice" campaign, he proudly wore that suit to the meeting. After giving him the once-over, the cosmetics ty-

coon said, "This is what you wear to a business conference? Dunga-rees?" "But Mr. Revson," Dick weakly protested, "it's couture—I had it made to order." After this comeuppance, whenever Dick attended a meeting at Revlon, he took care to dress like Revson—in a gray or black flannel suit, blue or purple shirt, and black or olive tie. It worked like a charm—he always returned to the studio having gotten every-thing he had gone in there to get. Calvin laughed and said, "So now I'm wondering how come on *our* first meeting he didn't come dressed like *me*. If he had shown up dressed like Revson I probably would have thrown him out."

"That's only the half of it," I continued. "After Dick got his million-dollar advance-against-work contract from *Vogue* in 1966, whenever he had a meeting at Condé Nast with Alex Liberman he went in dressed like *him*—white shirt, dark tie, shiny black shoes; gray flannel suit in winter, light tan suit in summer. The time he experienced chest pains in the middle of the night he made a point of putting on his Alex Liber-man suit to go to the emergency room. He said to me, 'I figured I would get better treatment if I came in looking like a serious business-man. Only I forgot to put socks on.'"

The irony is that over the years a lot of people coming in to see Dick had—you couldn't help noticing—tried to dress like *him*. His dealer, Jef-frey Fraenkel, recalls, "When our first appointment to meet and discuss working together was made, I sensed that if I wore the wrong thing it could easily be over, just like that: after all, one of the subjects of his work was the understanding that whatever one put on in the morning sent out unconscious signals, about one's sense of security, or insecurities—the codes embedded in attire. So naturally I gave some thought to what I would wear, and concluded that, A, it would not be a suit, it was a warm day anyway, and B, I wouldn't wear anything that might make me look like someone who was trying too hard. That meant jeans and a white shirt, and when my cab pulled up to the studio, Dick was standing out-side, wearing exactly jeans and a white shirt. Good sign, I thought."

Sitting at Sant Ambroeus now, with Calvin a whiff away, I remem-bered something that one of his top executives had shared with Dick: Calvin's employees thought it politic not only to dress like him but to

smell like him, so they began scenting themselves, as well as their offices, with the glandular secretion of the rutting musk deer.

"Norma," Calvin interrupted my sylvan reverie, "how did we ever do it? Remember the moment I decided to call them Calvins?" Amour propre prompted me to remind him that that was *our* idea—collectively Dick's, mine, and Doon's. Dick thought those skinny high-waisted denims that Calvin wanted to sell millions of needed a less generic name than jeans. When I came up with "Calvins," Dick and Doon looked at each other and went, "Yeah! Calvins!" It was as simple as that. Almost—it turned out Calvin had never liked his name, and Dick had his work cut out convincing him that it was as appealing as it was distinctive.

As for the campaign's famous tagline, the way it worked creatively at the studio was one of us would express an idea and then someone else would swoop in with a word or phrase that would make it work. When we were tossing around concepts for the Brooke Shields commercial, the words "You want to know what comes between me and my Calvins?" freewheeled into my head, triggered no doubt by some copy I had written back in my pre-Avedon working life. It was for an under-makeup moisturizer one of my clients was introducing, and it went something like "What comes between me and my makeup? My moisturizer." Doon, who had crawled under the table, where she often retreated when she was waiting for something to come to her, shot back, "What comes between me and my Calvins? Nothing." Well, that nothing was really something—in short order it became one of the most successful taglines in the history of retail.

CALVIN KLEIN: Dick just seemed like the most natural fit for my jeans commercials. Most jeans ads that you saw were boring and tacky, but with Dick, everything always had amazing style—a sophistication, a real intelligence, a certain edginess . . . And he brought me Brooke Shields, whom he had photographed for *Vogue.* After we finished the first set of commercials, I did a showing for the chairman of the company I had the licensing partnership with to make the Calvins, and he was just in shock. But *loving* them. And laughing. And before we were through, laughing all the way to the bank.

Barry Diller is a good friend of mine, and at that time he was the chairman of Paramount, and when I told him how much it had cost to make those commercials, he said, "I never heard of such a thing—you can make a film for that kind of money." I explained that I had wanted the best piece of creative I could get, I didn't care what it cost, which was three million 1980 dollars, by the way. But it wasn't like it was *my* money.

After CBS banned the ads, I was having to spend my whole life going around to the networks, trying to talk them into airing them, then negotiating whether they'd give us nine o'clock, ten o'clock—you know, after the children were in bed. The trouble was Brooke was so young. Dick and I looked at her simply as an actress playing a role, but a lot of people were going, "Wait a second, how old is she? She's barely legal. Take a listen to what she's saying, and get a load of what she's doing with her body!"

They were reading things into it that just weren't there. Dick and I were coming from a creatively exciting, artistically thought-provoking point of view—we weren't pandering to base instincts or anything like that. But the whole puritanical world came down on us. Leave it to Dick to point out that that was good for business! One day most of the front page of the *Daily News* was a picture of Brooke in her Calvins, and then way up in the right-hand corner, real small, was "DOW BREAKS 1000" or whatever number was a big deal at the time. What I'm saying is, Brooke was a bigger deal. Sales skyrocketed—kids were watching those ads and saying to themselves, "Our parents hate it? We're going right out and buying it." Forget about Brooke, their parents probably hated jeans to begin with.

BROOKE SHIELDS: The famous ad! Or should I say infamous. By the end of it I was in that sort of salacious pose. Dick wanted it to be shown in movie theaters, and I remember the powers-that-be telling him, "You'll never see a commercial in a movie theater." And now look! Commercials are practically *all* they show.

All we were trying to do was something that was fresh. The copy was so good. You always hope an ad campaign will hit the public psyche, but it's a crapshoot. That ad was revolutionary—I don't think even Cal-

vin anticipated just how big it was all going to get. But then, despite its unbelievable success, he made the decision not to do a second round. I think that was because the jeans had such an identification with *me:* people were thinking of them as Brooke Shields jeans rather than Calvin Kleins. It was a brand clash.

SAM SHAHID: The big blowup came when *The Wall Street Journal* did a story about Dick and Brooke. When you worked for Calvin, and I was the art and creative director of his company, you had to always stay in his shadow. He put us all on notice to never take credit for any of the creative. I was sitting in his office when he read that article, which made Dick and Brooke seem more important than him, and he was shouting, "I've never had this and I *won't* have it! *I* am the creative overall—I mastermind the campaigns just like I design the clothes." That was funny—I mean, he can't even draw! But to his everlasting credit, he did invent it all—it was totally his sensibility.

BROOKE SHIELDS: Calvin and I made the cover of *People* together— I'm straddling his shoulders. The copy read: "Her bottoms-up commercials have made Klein the best-known name in U.S. fashion." Sales had jumped by more than 300 percent by then—we were selling half a million pairs of jeans a week. A few years later I started a jeans line of my own, "Brookes," about which the less said the better.

I know nobody's going to believe this, but believe me, I was naïve as to the possible other meaning of "nothing comes between me and my Calvins"—remember, I was only fifteen, so how could I possibly have been aware of any double entendre? It was just an expression I would always use myself, like, "Listen, nothing comes between me and my mom," or "Nothing comes between me and my dog." A lot of people must have had dirty minds back then, or maybe they were remembering me in *Pretty Baby* where I played a child prostitute when I was twelve. Anyway, at the time nobody thought to clue me in on the innuendo in those ads, so thanks to my ignorance I never felt like I was being exploited or anything.

They only quote that one line—it's the only thing they pull out. I mean, we did eleven other pretty memorable thirty-second jeans spots—

DICK WITH THE GIRL BETWEEN WHOM AND
HER CALVINS NOTHING CAME.

only nobody remembers them. In the one called the "Giggler" I almost split my Calvins trying to recite a limerick, and then there was the "Flirt" and the "Fashion Freak" and the "Teenager"—we kept them coming. The spot I liked the best was the "Bookworm," because I got to read aloud some lines from one of my favorite novels, *Great Expectations*, after which I say, "Reading is to the mind what Calvins are to the body." Why doesn't anybody quote *that* line? What's wrong with people?

The jeans *were* pretty snug, I'll admit, but they came up over my belly button, and my shirt was only a little open, so it wasn't like we were doing a kiddie porn or anything.

POLLY MELLEN: Fashion advertising was never the same after Dick's Brooke Shields commercials. And neither was editorial—*Vogue* was now forced to compete in terms of raciness. We commissioned Helmut Newton to do a perfume feature called "The Story of O"—o for odor, of course—and his photographs, needless to say, were very s, for suggestive.

BROOKE SHIELDS: I was only thirteen when I first met Dick, but don't forget, I had done my first ad when I was just eleven months

old—Ivory soap, shot by Scavullo. I lived with my mother on East Seventy-third Street and my school was on East Seventy-seventh and Dick was right in between on East Seventy-fifth, and I would always walk the two blocks to the studio with my mom.

That first meeting lasted only around five minutes, and as I was leaving he said to me, "So nice to meet you, Drake," and I said, getting *his* name just as mixed up, "Oh, thank you, Mr. Don." When we got out on the street my mom started laughing hysterically.

My first job with Dick was a *Vogue* cover. I can still remember what it felt like that first time to be shut up in that hot little dressing room with some terrified assistant of Polly Mellen's. Then I was allowed into the studio proper, and finally into this all-white cocoon. He drew that big curtain behind us, and nobody but nobody could come in—not even my famously pushy mom.

Everybody seemed to truly appreciate how determined my mom was to never let me become a model casualty—an industry statistic. I mean, when you reached my level of sort of super-recognition, it could have been really devastating. She did a great job keeping me normal, and if she had to be the crazy stage mother to pull that off, so be it. Everybody had seen what happened with the Gias of this world, girls who *didn't* have a stage mom. Dick wasn't one of those my mom felt she had to protect me from. She would only ever be out there fighting the mama-bear fight when someone was trying to screw us over, and it would usually be a client trying to get more time out of me without pay.

Dick was pretty minimal in his direction, but there was definitely an intensity in the communication. It was always just real and serious—I mean, it was *work*. But he was also a father figure to me insofar as I was a little kid who wanted his approval and was willing to work her little ass off to get it. I happened to have been born with a strong work ethic, which was then nurtured by my mom. And being in Dick's studio, in that ultra-focused environment, and having so much pressure on me to deliver, helped sustain it. And I carried it to school, and on to college— that's just the way I'm programmed.

When he asked me what music I liked, I told him, "I said upside down / You're turning me," and he always had it blaring. I was like a mascot to the studio—it felt like I was his personal pet in a way. I always

behaved myself. I'd been taught manners by my mom and dad, and I'm a monster with my own kids about that—I mean, I couldn't see Dick having a whole lot of patience with some brat that came in there.

I could never get to the studio till after school let out, and that was infuriating to him, he definitely did not like having to start a photo shoot that late in the day. My mom would tell him, "Brooke is only available to model for you after class." She wasn't going to allow my education to be jeopardized even by a big photo shoot. He would sometimes keep me working till three in the morning, five hours past my curfew. And yet . . . I find myself sometimes pining for the days when I would be sitting in his studio waiting breathlessly for that Polaroid he had just taken of me to come out. He let me keep the ones from our important sittings.

I was always doing homework at the studio—all through every hair and makeup session. I wrote a paper on genes there—that's genes, not jeans! I distinctly remember sitting in the dressing room, under all those bright lights, and writing the words "a gene is a fundamental that determines the characteristics of an individual." There were so many crazy characters running around in there that, for me, maybe doing homework was a way to sort of not soak any of that up. I'm just now remembering that he helped me write a paper on *King Lear* that I got an A on.

By the time I got to Princeton, I wasn't really modeling that much, at least not in the same way—I was acting more. And I was twenty pounds heavier—from eating pizza and mocha chocolate chip ice cream at three in the morning like all the other college kids. I hardly ever saw Dick anymore, but also his own work was becoming less and less about the glossy advertising world—he was pouring his all into his portraits and books. What came between Dick and me wasn't nothing—it was the new paths in our careers.

SHARI BELAFONTE: I was part of the next wave—three years later. The Brooke Shields commercials had run their course, and I guess they figured it was going to take five girls to fill her jeans. I had done some *Vogue* covers with Richard, and he auditioned me for the new jeans ads—he did some tapes of me running off at the mouth.

I got to spend three whole days in his apartment, and that was the best of times and the worst of times. The best of times because I had such a crush on him, from having grown up looking at his covers and then seeing pictures of what *he* looked like. My stepmother once pointed him out to me on the street and I immediately started daydreaming that I was going to marry the guy. First of all, that hair! *All* of that hair! Let's face it, it was really all about that hair. For me, it was always the sexiest head of hair in the world, so thick and so long, and naturally it was darker when I first saw it in person, that time on the street, when I was eleven. I had just seen *Funny Face* and I fantasized that it was *my* story with Richard, the Richard Avedon and Shari Belafonte Story; that it was me up there instead of Audrey Hepburn. And since I also absolutely adored Fred Astaire, it was like a double orgasm — one great big wet dream. So when years later I got called in by Richard for that first go-see, I was positively melting.

He right away had me doing what I call "catharting" — like in *catharsis*. And that was the worst of times, because he was wanting to know all the dark stuff. You know, the very intimate things that happen in your family, like your parents divorcing. I mean, my father moved out on my mom while she was pregnant with me. I had blanked out those things. But Richard wouldn't let up — he was shooting for honest, I guess. Out of that he created a slew of thirty-second spontaneous-sounding spots for me, the same as he did for the four other Calvin Girls — Andie MacDowell, Martha Plimpton, Lauren Helm, and the one-name model Antonia. We were Richard Avedon's talking airheads.

"When you lose your mind, it's good to have a body to fall back on." That was one of the better lines he had me saying. None of us had to say a thing about the jeans — we just had to wear them. *Saturday Night Live* did a skit on those commercials, but you know something, they were serious — painfully serious. What truly surprised and excited people was their depth.

Whenever I came to New York from L.A., even if I was only going to be there a couple of days, I would go to the studio with a bouquet of purple flowers. I had once heard him telling someone that that was his favorite flower color, so I always brought him whatever purple was in season. And if he was around, I would kiss him hello. And then quickly

bid him adieu. Because the studio wasn't a place you went to just hang for a few hours—it was run like a Swiss watch. Plus I didn't want him starting to think, Okay, she's coming over a little too much now, staying a little too long—beware of stalkers bearing blooms.

LAUREN HELM: He told me up front that the copy was going to be written from the things I actually said when he interviewed me with the tape recorder. But first he told me a little story—how he had a best friend and they saw a very rare butterfly on this walk they took in Greece, and then years later in New York, at her funeral, the butterfly was there. Then he sat me down at the kitchen table upstairs and started asking me all these questions, like what kind of water would I prefer to be. I'm sure I just said Perrier. But maybe I said Poland Spring.

He wanted to probe, so the questions got very nosy—you know, biographical in nature. And there were a couple of philosophical ones, too, that were just as potentially embarrassing, like how do you really see yourself. I remember saying something to the effect that I could never see myself the way other people said they saw me, and he said that Marilyn Monroe had said practically the exact same thing to him. I admitted that when I looked in the mirror I couldn't see whatever it was that had made Eileen Ford send me to Polly Mellen and that then made Polly summon everybody at *Vogue* to take a good look at me. I stood there frozen in place as she proclaimed, "This is the most modern girl I've ever seen."

It was Polly who sent me to Dick. I was only eighteen, and he was so archetypal that in all honesty I had thought he was dead. And now it was three *Vogue* covers later, and here we were—he was taping me making all these very critical comments about my face. He let Andie MacDowell in *her* thirty-second spot get away with just going on and on in her irresistible Southern accent about this bar in her rural hometown called the Firefly where all the "real men" hung out and how "someday, someday, I'm gonna see Atlanta." Atlanta! Can you imagine! Martha Plimpton got to talk about her experience being born, how it was all squishy and cold and dark down in there, and how relieved she was to have gotten out alive.

I recently showed one of my spots to the man I live with. It's just my

face in real tight close-up, and I'm talking about not really knowing who I am. After just a few seconds of watching myself I became so emotional I had to leave the room—someone could do a clinical analysis of my reaction if they wanted. Actually I could do it myself—I'm a practicing psychiatrist. My specialty is personality and eating disorders. I stayed in modeling till I was comfortable with what I looked like, and then I looked for a way to be challenged in a more non-narcissistic way—I needed it to stop being about me.

SANTO LOQUASTO: The best thing Twyla Tharp ever did for me was introduce me to Dick—she had me put together some things for her dancers to wear, little black teddies and whatever, for when he was shooting her company in his studio. And that led to his hiring me to do the sets for one of the series of Calvin Girls commercials—four spots. Anyway, without just endless sentiment, I can say that working with him was truly just "one of those things." He pushed me, but always in the best way—he was never tyrannous in his requests. And of course you only wanted to please him.

When you worked with Jerry Robbins, you also wanted to please *him*, but it was an excruciating experience—he enjoyed making you feel that you were disappointing him. Dick could get whatever you had in you out of you in a *positive* way—there wasn't any of that sort of frustration with himself that was always the case with Jerry, not to go on about him. When people ask me if I ever do commercials, I say, "Well, not really, but I did once do a few with Richard Avedon," and that always gets a big "Oh!"

For the Calvin Girls set I did a Greenwich Village–type coffeehouse. I covered the windows in hazy, semi-transparent organza, and I made a very nice table for them to sit around, because in the ads you would only be seeing their legs.

CALVIN KLEIN: The jeans commercials Dick did for me were all great, but let's go back in time a minute. Let's not forget his work on my fragrance campaigns. They came first. I had designed the gorgeous bottle for my first fragrance, Calvin Klein, myself, in 1978, and I hired

Penn to shoot it. The trouble was the scent was way too subtle for America—it bombed, it stink-bombed. So I sold that business and entered into a partnership with a company that specialized in marketing fragrances, and in 1985 we launched our first fragrance together.

I had a sixth sense that Dick was the one to put it over. I brought with me to his studio the woman I was sold on to represent what I was trying to convey to the world—Josie Borain, from South Africa. I had just signed her to an exclusive contract, and I distinctly remember saying to Dick, "This woman is my obsession." Because that's how we got the name—don't believe anything else you hear or read.

Now, I always insisted that the woman in any fragrance ad of mine have company. Fragrance ads were traditionally just a woman alone: a double-page spread might show her running through a wheat field by herself. Even when Dick photographed Catherine Deneuve for Chanel, it was just her speaking. I wanted a man in the picture—preferably more than one. Or at least another woman. I mean, you have to try and get it to the point where it stimulates. And besides, what sort of woman wants to be alone? Isn't the whole reason she's putting on perfume in the first place to attract someone?

When Dick presented an ad to me, he would play every part—the girl, the guy, whatever. He would put on a real show, and I would react accordingly. Sometimes I would have to hold back because it was a little too weird. But by the end he and his copywriting collaborator Doon Arbus always managed to come up with something you couldn't get anything better than. When I first went with Dick, I had wanted him to use a different writer, Fran Lebowitz. But it turned out he had in mind a kind of writing that was definitely not Fran— something that was fun but not negative. He had the vision to realize that the copy could be positive and still have an edge. Doon was talented, but she could go off in her moods—well, I mean, look at her mother and all of that. But then, I'm creative and I'm pretty crazy, too. And Dick certainly had his little fits, or whatever you want to call them.

I mostly left him to his own devices, especially when we did film, because he was as good a director as he was a photographer. I had

learned by then that if you want to get the best out of an artist you really have to leave them alone.

SAM SHAHID: Calvin put us under unbearable pressure for Obsession. Dick was doing the commercials, and Bruce Weber was shooting the stills. When Bruce and I were about to leave for Puerto Vallarta with Josie Borain, Calvin said to me, "I want you to think of this as the most important thing you will ever do for me, because I have yet to have a success with a fragrance." When he reviewed Bruce's stills he decided he wanted Dick to shoot some, too. So Dick photographed Josie, and then Calvin compared his pictures with Bruce's, which were steamy—they showed Josie with a couple of guys in a hot tub. Meanwhile neither Bruce nor Dick realized that they were in a competition, and Bruce to this day does not know. Normally it didn't happen that way with Calvin. He was very straight, he wasn't someone who played those kinds of games: it was always one photographer or another from the get-go—Dick or Penn or Bruce or Herb Ritts or Patrick Demarchelier. In the end Calvin chose Bruce's stills over Dick's because he knew they would get Obsession talked about more. But it was really Dick's commercials that did the trick.

CALVIN KLEIN: Dick had the insanely great idea to do four thirty-second spots with Josie—her with a boy, then with a young man, then with an older man, and finally with a woman, and they would be like overlapping love stories, mini psychodramas. And I mean, the lines he would come up with for them to say! All with abrupt cuts. The fragrance-company people thought we were out of our minds—"What does any of this have to do with our product?" I explained to them that they didn't have to understand it. I was coming from slaving over making this product, and I believed in it with all my heart and soul, and when Calvin Klein really believed in something he was unstoppable. I got the company to do blockbuster advertising, and at a time—the mid-eighties—when people weren't taking out multiple pages or going on the air with breakthrough imaging.

The tagline for our first ad was, "Ah, the smell of it!" When Dick tried it out on me, I just looked at him and said, "Oh my God, *no!*

Smell is a bad word, it makes you think *stink*. *Scent* is a much nicer word—so is *aroma*. Naturally I prefer *fragrance*." But then, somehow, you know, that *smell* stayed with me. And I quickly forgot whatever the hell else he had Josie talking about. "Ah, the smell of it!"—that's all I was left with. That, and that he had the wit to have the great Nestor Almendros doing the cinematography.

"SCENT OF CHEKHOV MAY CONFUSE THE SENSES," THE-ATER REVIEW BY BEN BRANTLEY, *THE NEW YORK TIMES,* **JANUARY 16, 2013:** Remember those much-parodied Calvin Klein fragrance commercials that Richard Avedon did in the mid-1980s? The ones with glamorous, sexually ambiguous young creatures in stark rooms, striking languorous poses and speaking enigmatic nonsense? Well, that's kind of what Tina Satter's 'Seagull (Thinking of You),' feels like, at least at first. The stage is a rhapsody in white, with billowing, diaphanous curtains and small columns on which cunning little bibe-lots are perched. As wind chimes and bird song delicately drift through the air, you half expect to hear a breathless voice whisper, 'Chekhov: The Perfume. Smell the melancholy.' Inside, six glamorous, sexually ambiguous young creatures in cocktail outfits and silly headgear drift onto the stage and start chattering irritably and competitively in what appears to be Russian. They're a lot more animated than the poseurs from those Obsession ads. But they too speak in what is likely to sound like enigmatic gibberish . . .

SAM SHAHID: Obsession was a mega-bestseller; it saturated the per-fume market. Dick gave a little dinner in his studio to celebrate. He served baked potato with caviar, which I naturally assumed was the appetizer, but then it turned out to be dinner, and later I thought, How chic! As Calvin and I were leaving, Dick picked up a copy of that French magazine that his girlfriend published and he handed it to Cal-vin, saying ever so casually, "Oh, do you know the French literary and art journal *Égoïste*? It's all the rage." He told us that his self-portrait was going to be on the cover of the next issue, Spring '85, and that they were running some of his Western pictures inside. The second we got outside, Calvin said, "Get me the first spread in that issue." We ran an

ad with a huge picture of Calvin in a Calvin Klein white double-breasted suit—it was the first thing you saw when you opened the magazine.

Calvin waited a couple of years before introducing a new perfume. He called it Eternity, after the eternity ring he'd bought his wife Kelly at the sale of the Duchess of Windsor's jewels. The scent was supposed to suggest lifetime commitment—the exact opposite of those decadent Obsession commercials.

CALVIN KLEIN: The face of Eternity was Christy Turlington, who I had just signed to an exclusive three-million-dollar-a-year contract. For me, she was the epitome of the fine young woman, someone who other girls would look up to and who even adults could relate to—she comes from a really nice family, by the way. And she was smart. I mean, this was somebody I could have seen myself even marrying. Dick meanwhile—probably because I had always more or less trusted him with the casting—was laboring under the illusion that *he* was going to be picking the Eternity girl.

SAM SHAHID: Calvin went to the studio to break the news to Dick himself about Christy, and Dick just flipped out—he carried on that she didn't have enough range. We left very quickly, and I remember looking up from the street and seeing Dick standing at the window glaring down at us. Calvin got in the car and slammed the door and said to me, "I don't believe it—I am Calvin Klein, Eternity is my perfume, and Christy Turlington is my choice for its face. How dare Dick not be wild about her!"

Dick called Calvin the first thing the next morning still trying to get him to change his mind. He argued that Christy sounded too much like the teen she was. In the end he did get Calvin to spend something like eighty-five thousand dollars on voice lessons for her.

ORIBE: Dick was distraught, because he had gone ahead prematurely and done his own casting for Eternity. He had imported this really good German actress who had a great voice—very intellectual, very cool, a blonde. The problem from my standpoint as a hairdresser was

she had only about three hairs on her head. Dick had me set them on tiny rods—more like toothpicks really—so we could get as much volume out of them as possible. But two hours later we still just had fuzz. Whatever, Dick loved the test he did with her.

What he never understood was that Christy was *always* going to be the girl for Calvin. And, I mean, she was perfect for Eternity. I did her with her hair just pulled back, because this wasn't supposed to be too much about the hair. She has become quite the woman, but at the time she was just a really delightful little girl—we used to laugh so hard together it actually hurt.

Dick had also imported a French actor by the name of Lambert Wilson, who's still around, by the way—he's been the emcee for the Cannes Film Festival lately. He stayed in the picture, but the funny thing is he developed a boil on his face—this humongous thing that just wouldn't go away, no matter how many times they took him to Dr. Orentreich to have it lanced. In fact, it just kept getting worse, so in all the commercials Dick had to shoot him in profile. He had gorgeous hair, which I also did just back—very classic.

SAM SHAHID: Bruce was doing the Eternity stills, and he was pissed at having to use Lambert, who was definitely not a Bruce Weber type. He kept saying, "I don't appreciate being forced to use Avedon's choice." We were shooting in Martha's Vineyard, and Bruce went out and found a guy he liked, on the streets—actually, he did a lot of his casting that way—and he shot him with Christy, and I was freaking out. I finally said, "Can you do at least some with Lambert?" In the end I was able to persuade him to not show Calvin any of the ones he'd taken of Christy with the street guy. I mean, he looked really rough, like trailer-park trash. Bruce said, "Christy *needs* a guy like that."

SANTO LOQUASTO: I did a series of rooms for the sets of one of Dick's Eternity campaigns. He told me to envision them as love chambers, or confessionals—places where secrets were revealed. I made each room a different color, based on the mood of the commercial and the season they represented—the walls, the platform double beds, the bedcoverings, the big pillows . . .

ORIBE: Santo's gorgeous sets—autumn-orange, snow-white, summer-blue . . . I remember deep-red, too. And a room *so* dark it was like Before the Creation. He built on the stories that Dick had created with Doon. The dialogue was pretty outrageous: "Who were you before this room . . ." "If you were me and I were you . . ." Very esoteric stuff, right? Very ahead of its time.

CHRISTY TURLINGTON: Those Eternity commercials sure lived up to their name—they took forever. We were at Silvercup for a whole month and a half. There were ten spots, and they revolved around the cyclical life of this couple—they had squabbles, they made up, they became parents, I don't know . . . It was all very confusing to me, but I did get to meet two all-time greats—Santo, of course, and also Sven Nykvist, who was Ingmar Bergman's favorite cinematographer. To have had exposure to creatives like those so early on was amazing.

There were weeks of rehearsals, upstairs in Dick's apartment. He had me doing all kinds of limbering-up exercises so he could choreograph different postures, and I was also going to a voice coach. He introduced me to all these various components, and had I wanted to become an actress, that would have been really great training—he showed me how it wasn't just the way you looked, it was also the energy you created.

I was pretty much living in his studio, and one evening he surprised me by inviting me out with him socially—me and Lambert Wilson. He took us to see Madonna in that David Mamet play she did on Broadway, *Speed-the-Plow*. They were the best seats in the house, and Madonna, I was told, was very cognizant of the fact that Dick was in the audience. I guess they always tell them who's out front: "Richard Avedon is in the house tonight." He's still out front for me.

SAM SHAHID: One morning during those endless Eternity commercials Dick showed up at Silvercup wearing a black armband. When I asked him what was up, he told me with tears in his eyes that Fred Astaire had passed the day before. It was a strange time all around. Calvin had come back from Hazelden a different person. Penn photographed him for *Vogue* around this time, and he took me aside and

THE SET FOR AN ETERNITY PERFUME COMMERCIAL,
WITH CHRISTY TURLINGTON, THE ETERNITY GIRL;
MODEL LAMBERT WILSON; DOON ARBUS; DICK;
AND CINEMATOGRAPHER SVEN NYKVIST.

ETERNITY SET DESIGNER SANTO LOQUASTO
AND NYKVIST.

said, "Calvin has lost his soul." I mean, he didn't even recognize his own clothes that season. He had told me before he left, "Make sure Penn shoots only my white things"—and there was nothing white in the show! He hated the photos Penn took and only used about three.

Finally he asked to see Dick's Eternity commercials. He had a strange reaction to them, he said, "They're a caricature of everything I stand for, which is sexuality and sensuality." But eventually he came around.

CALVIN KLEIN: I hired Steven Meisel to shoot the commercials for my new fragrance in 1994—CK One, a light citrusy unisex scent. Kate Moss was the model. Shortly after they aired, I ran into Dick someplace, and he started screaming at me, "How could you use *him*! He's just a Xerox machine. That campaign he did for you looks just like my group pictures—it's a total rip-off of my Warhol Factory mural." I thought it was some sort of joke, and then when I realized it wasn't, I told Dick he should be ashamed of himself. I said, "You're, like, the greatest photographer in the world, and here's this much younger guy who worships you and is inspired by you and you're standing here bitching that I gave him some work. You should be flattered that people want to imitate you, and by the way it's not just an imitation—Steven did bring something of himself to it."

ISABELLA ROSSELLINI: I remember Dick having not a feeling of complete pleasure when Steven copied him—being quite offended, as a matter of fact—and I remember Steven feeling lost when he heard that. He said he hadn't realized that he was copying somebody who was a living human being, that Dick was so iconic it felt more like he was doing an homage to somebody who had lived five hundred years before. At the beginning, you know, Steven was an illustrator. He would come every Sunday to our "open house" when I was married to Martin Scorsese, because Marty's mother liked to cook. Then he started to photograph, but he never asked to photograph me. He told me one day, "I haven't been able to because the pictures that Avedon did of you were so incredible—I needed to really get to know you so I could see you through my own eyes, not his." The photographs that Steven eventually did take of me were beautiful but, frankly, they looked like the Avedons.

GUIDO: Ultimately Calvin hired Dick to photograph Kate Moss for CK One, and I did the hair. Dick did her in kind of "In the American

West" mode—he said he wanted to bring out her character rather than glamorize her. And a couple of years later he got to photograph her again, for Calvin's CK Be perfume—print and TV both. Those ads were a mix of models and people off the street, and they all had white lettering on a black background. It was a be-all: "Be a Saint. Be a Sinner. Just be . . . Be good. Be bad. Just be . . . Be shy. Be bold. Just be . . . Be hot. Be cool. Just be . . ." Unfortunately, Dick no longer is.

CALVIN KLEIN: For me, Dick lives. I mean, when you've been through Obsession and Eternity with someone, you just go on connecting.

17

VENI, VIDI . . . VERSACE!

—

IF THE CALVIN KLEIN CAMPAIGNS WERE BONANZAS FOR DICK, the Versace campaigns were lollapaloozas—we wallowed in the lap of luxe. They were also a cauldron of energy, anarchy, and creative freedom. Gianni put it this way to Dick: "We are the family and sometimes the family go crazy." The Versaces *were* Dick's Italian family: in loco parentis, emphasis on *loco*.

Almost inconceivably, Dick and Gianni had something in common from birth—they had each been born with a caul. They were both mama's boys, too. And both from families heavily into clothes (Gianni's mother was a seamstress and boutique owner). Each of them had one parent who was practical and one who was artistically inclined. And they each had a sister who figured disproportionately in his chosen profession (Gianni had begun bedecking Donatella at about the same age that Dick had started photographing Louise). They were equally knowledgeable and passionate about Italian film: Fellini, Visconti, De Sica, Rossellini, Bertolucci, Antonioni . . . Not to mention Italian food: spaghetti, risotto, sorbetto, tartufo . . . They were also both workaholics and perfectionists.

Gianni had embroidered his backstory the same way the Avedons had theirs: he too had put on the borrowed dog. For a 1977 feature in

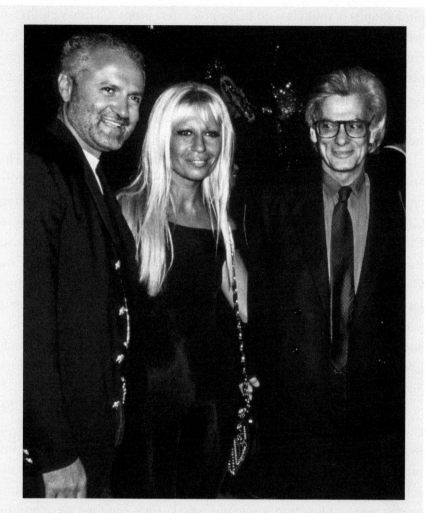

DICK MAKING EYES AT TWO OF HIS FAVORITE CLIENTS.

Italian *Vogue* he had posed with a pair of Neapolitan mastiffs belonging to a friend, on the loggia of another friend's villa, wearing a borrowed Calabrian costume, but alongside his authentic parents and siblings. Dick and Gianni were clearly made for each other—cut from the same exorbitant cloth.

When Dick started working for Versace, in 1979, the company was only a year old. Gianni knew he needed what he described as "the artistic Avedon touch" to enhance and advance the Versace image and help turn it into a deluxe brand. In the early years Dick provided tame

photographs of models—no tricky poses, few props. Gianni's clothes at the time were relatively understated, often historically derived. He had cut his tailoring teeth on the measured and the traditional; as he explained to Dick, "You have to understand the classic before you can do the very fun things." Diana Vreeland claimed that she had never seen anyone drape a dress as aesthetically or as quickly as Gianni—she considered him a true couturier.

One day Gianni exhorted Dick, "Maestro, let's rock 'n' roll!" His ambition now was to "dress egos," to which end he began extravagantly courting celebrities to wear his creations. Soon to be seen strutting Gianni's stuff, along with their own, in the front row at his shows were Elton John, Sting, Liza Minnelli, Madonna, Duran Duran, David Bowie, Jon Bon Jovi, Freddie Mercury, Don Johnson, Sean Penn, Eric Clapton, Bruce Springsteen, George Michael, Prince, Princess Diana, Jane Fonda, Faye Dunaway, Joan Collins, Tina Turner, Jennifer Lopez (she would preview Gianni's "Jungle" dress for the civilized world), and Elizabeth Hurley (she would introduce Gianni's black silk-and-Lycra oversized-gold-safety-pin dress at the premier of *Four Weddings and a Funeral*).

Dick delivered the goods. The campaigns—"our explosions," he called them—were as flamboyant as the clothes. Every Avedon ad set trends. Gianni soon felt confident enough to publicly disparage his more successful competitor Giorgio Armani as "Mr. Beige." The pressure of having to conceive and execute increasingly elaborate campaigns turned Dick into a nervous wreck. One time we were on our way to a shoot at Industria when he suddenly nodded off. I had to shake him awake. He mumbled, "Must've taken the sleeping pills." Meaning, instead of the uppers. The shoot had to be canceled.

The pills were definitely bad for business, not to mention bad for Dick—he flew off the handle and over the top; he would talk too fast, and what he said to clients . . . I mean, he insulted Rita of Revlon. As Renata Adler puts it, "Somebody had once told him half of one was better than a whole, so, being Dick, he took two, and it went on from there. The sad thing was, the manufactured energy was never up to snuff—it didn't hold a candle to his own natural energy." Mike Nichols

put it another way: "He felt he had to keep up that Richard Avedon persona at all costs, that he had to be up all the time, appear tireless, put on a show. He never gave it a rest. 'Sagging is catching,' he would say." Not long before nodding off on the way to that shoot, Dick had run out of doctors willing to write prescriptions for him. We were about to leave for Japan for four days of back-to-back meetings with a client, and he appealed to his heart doctor, Izzy Rosenfeld, who told him, "You've come to the wrong place, I'm not a drug dealer. I can give you a prescription for coffee." At that point Dick made me his pill pimp and sent me scurrying to *my* doctor, who said, "You know I can't do that." In desperation I repaired to my dentist, who told me the same thing. Dick eventually found a biddable doctor. There was a stiff price to pay: his legs would twitch—his arms—even his precious eyes; his voice would become thick, his words slurry. "I need the extra energy sometimes," he maintained, adding, "Luckily, most of the time I can produce enough on my own."

The temperature of the images he was creating for Gianni kept going up (think kink: threesomes, foursomes, fetishes, increasingly scant attire). When Gianni introduced his revolutionary *maglia metallica* collection in 1982, Dick devised an ad featuring male and female models in chain mail on four squeezed-together mattresses the size of a life raft. He grandiosely announced that the inspiration for the image was Delacroix's action-packed masterpiece *The Death of Sardanapalus*. The name of the campaign: "The Pile of Beautiful People."

In the early years the creative collaboration was solely between Dick and Gianni. The business stuff was all left to me and the Versace executive Paul Beck. As personable as he was classically handsome, Paul had started with the company the same year as Dick—as Gianni's "exclusive" fall model. Then, in relatively short order, he became Donatella's lover, and the two of them eventually ran off together. Gianni banished the transgressing pair. Happily, only briefly: he was soon designing Donatella's wedding dress and promoting Paul to head of men's collections—family was family. Paul's new responsibilities embraced advertising and promotion, for which he was exceptionally well suited—no one could have been better at handling celebrities. (Sepa-

rated from Donatella since around the millennium, he went on to triumph over the notion of nepotism by remaining with the company, most recently as a communications consultant.)

Paul and I would work backward from the budget, eventually reaching the point where both Dick's and Gianni's financial expectations were met. With Gianni now designing—in addition to couture—celebrity, home, and men's as well as women's ready-to-wear collections, the House of Versace had become both the client Dick did the most work for and, arguably, the client he did the most for.

Dick realized that his photographs for the men's campaigns were a little too elegant for their own good—the muscles looked more like marble and the penises were shadowed too artistically. But he had no desire to shoot men the sexual way Bruce Weber did—in part because it would have played havoc with his psyche. (Though Dick liked him well enough, on one occasion even referring to him as "an angel," he was envious of Bruce's commercial success. Also, he could never quite get past what he called "the goddamn bandanna," not to mention all those unborrowed dogs—the golden retrievers and Newfoundlands.) Whenever Dick photographed male models in the nude, we had a closed set: only Paul was allowed in. Slowly but surely, he got the hang of it, to the point where, when Gianni proposed an ad with five girls, Dick suggested including five naked guys. "Men even more than women can now be shown as pieces of ass," he needlessly assured Gianni.

Dick got carried away. He proposed photographing Madonna carrying a marble phallic symbol that would echo the colossal Dionysus penis in Delos. He envisioned her "talking to it like a friend, riding it like a rocket." Gianni said an immediate yes. Madonna, surprisingly, declined.

When Gianni insisted Dick use one of his boyfriends in a campaign, Dick stuck him in a group behind a couple of supermodels. But Gianni wanted him frontal and center—"Maestro," he pushed, "make him a star!" Dick reluctantly inched the boy closer to the center of the composition, but by the time Gianni saw the new layout, the old lay was ancient history. (On Dick's Rolodex under "Versace" was a thickly peopled subcategory labeled "Lovers.")

The clothes were all the time getting flashier, racier, harder-edged.

They had crossed the line from opulence into excess—critics were now describing them as raunchy, gaudy, tawdry, tacky, campy, hedonistic, nouveau riche, "gypsy-ritzy," and "tacky-tarty." *Time* nailed the "chain-mail combos" as looking like "rough-trade rigging that Prince Valiant might have worn to go cruising." All this was to miss the point, which was fantasy, plain and simple. Nor was Gianni being given his due as a pioneer of fabric combinations: silk and leather, leather and rubber, rubber and tweed, wool and lace, neoprene and Lurex . . .

By this time Donatella was parading around *con panache* in her big brother's most outlandish creations, accentuated with her signature 20-carat canary diamond. Say what you will about how she looked, she was impossible to *overlook*, stiletto-heeled, short-skirted, perpetually bronzed, and platinum-bleached as she was. "I'm a real blonde," she declared to us, adding with a laugh, "in my head, that is—I have a blond attitude." Hard to believe that the woman who would one day be inducted into the Rodeo Drive Walk of Style had started out on the shy side, hiding her face in her hair, seldom speaking, just quietly going about her job overseeing accessories. From there she moved on to assisting—with Paul—on styling the photo shoots, and little by little she insinuated herself into the design process. Gianni discerned the shape of things to come: he strategically began describing his sister to fashion journalists as "my first customer" and "my perfect woman," which in a way she was—being a fabulous mix of rock and La Scala. She became his sounding board, and he came to rely on her sound judgment. Now, at the climax of his runway shows, she was right up there onstage with him, bowing away.

Donatella would call Gianni in Milan countless times a day from the Avedon set in New York, stage-whispering in Italian. To Dick and me she spoke in the equivalent of speed-dial, wildly mixing the two languages. Her English was admittedly poor, but Dick and I had picked up enough working Italian to get the gist. Every season she would fasten on to a new superlative: *fantastico, magnifico, bellissimo, bravissimo, modernissimo* . . . and before we knew it, Dick and I were Italianizing everything ourselves. Donatella laughed a lot—a deep, throaty, chain-smoker's laugh—and she gesticulated frenetically. The *Saturday Night Live* skit based on her wasn't all that far removed from the truth.

By the time Dick and I first met her, she had already had a lot of what is euphemistically called "work" done. A good deal more was in store on our watch. And watch we did: after each procedure, she would treat Dick and me to a show of the putative improvement. He would invariably tell her how beautiful she looked, but the day came when, as she was explaining what more she intended to do, he blurted out, "*Basta!*" "Just one more!" she protested, adding ominously, "I promise—on my brother's life!"

A couple of weeks later she was summoning us to Gianni's house for the latest reveal. She made her usual theatrical entrance, descending the staircase very, very slowly, like Norma Desmond anticipating her close-up in that sad, surreal scene of *Sunset Boulevard*. "*Bellissima!*" Dick roared. Donatella laughed her raucous laugh—she was in stitches.

On our way back to the studio that day I found myself asking Dick if he thought I needed a lift. I was hardly expecting him to say yes, but not only did he, he said do it right away—that it would be "good for business." He recommended the fashionable plastic surgeon Sherrell Aston, and insisted on accompanying me to the consultation. The doctor was visibly impressed to have the ne-plus-ultra arbiter of beauty Richard Avedon sitting there in the flesh. Dick took over, as usual. Taking my face in his hands, he instructed Dr. Aston, "Don't do *too* much . . . Just take *that* out . . . And make sure you leave *this* . . ." The doctor was all ears. As we were leaving, Dick handed him a sketch of the new me.

Postop, I was lying in my hospital room, face swathed in bandages. It was after visiting hours, but suddenly there was Dick—disguised as a doctor! He told me that he had lifted the white coat from the laundry room, then pilfered the stethoscope from a tray in the nurse's station. When Donatella inspected the results a couple of weeks later, she gave me a big hug and exclaimed, "Welcome to the club! The next one will be even better!" Dick cut in, "She's not doing it again!" To *me* he said, "Don't you dare!" (Reader, I didn't.)

By now Donatella was in full charge of the one-name wonder women in Dick's campaigns: Christy, Cindy, Linda, Janice, Jerry, Naomi, Stella, and Stephanie. Kate was being groomed for Versace stardom. After photographing her for the first time, Dick promised

Gianni he would turn her into an Anna Magnani. Gianni, however, had something a little more contemporary than Mamma Roma in mind. Donatella had hired stylist Joe McKenna from London, and the two of them had bombarded him with the word *modernity* and he was now bombarding Dick with it. Dick was a past master of modernism but modernity left him perplexed. He was nevertheless quick to reassure Gianni that he was all for the new. So when it was suggested he photograph a Christmas tableau consisting of a lesbian mother, a homosexual father, an incestuous brother and sister, and a transsexual grandfather and grandmother, Dick upped the ante, counter-proposing a series of "modernity weddings," such as the grandfather marrying his grandson. Gianni replied that that would be going too far, even for him.

Grasping at straws, Dick began promoting Linda Evangelista to Gianni as the spit and image of modernity. The sixteen-page spread that resulted featured her in varying states of Versace undress. Gianni meanwhile had taken a shine to Amber Valletta and was pressing Dick to photograph her in a see-through dress times three—as triplets. Dick suggested doing Nadja Auermann instead, as quintuplets. Thankfully, this all added up to nothing, and modernity went the way of all flesh.

Dick turned abruptly in the opposite direction, and for a Versace home furnishings campaign he went biblical—with Gianni's blessing. Inspired by the Leonardo da Vinci mural of the Last Supper, he conceived various scenes around a groaning board loaded with Versace dishes, glasses, vases, candlesticks, and napkins: twelve settings, one for each disciple. For a follow-up home furnishings campaign he mined the Book of Genesis and hit pay dirt in the form of the Tower of Babel. He sold the concept to Gianni as a cautionary tale for the high and mighty. The set consisted of a wooden structure sturdy enough to support a veritable mountain of mattresses, replete, it goes without saying, with Versace sheets and bedcoverings.

To celebrate the end of each shoot, Gianni would send a towering over-the-top cake from Sant Ambroeus decorated with the campaign theme (the *motivo*, he called it). It would be rolled out onto the set the minute Dick shouted, "It's a wrap!" Gianni would be waiting on the

phone in Milan to congratulate him: "Maestro, bravissimo!" Then Dick and I would eat our Versace cake, and have it, too.

Throughout our Versace years, Gianni was outfitting Dick from head to toe, and Donatella was taking good care of me, showering me with everything from swimwear to evening gowns. One day she sent over a silver-and-gold metallic-mesh short dress. The sharp links, sewn together with metal threads, turned out to be almost as lethal as they looked—by the time I wriggled out of the thing, my pantyhose was in shreds and my legs were bloody. I immediately donated it to the Met's Costume Institute, which eventually exhibited it, along with other medievally inspired works of fashion.

Gianni was heaven on earth. The best host in the world, bar none, with the best houses in the world. Take his twenty-five-thousand-square-foot Casa Casuarina, on Ocean Drive in South Beach. It was glorious, in that Italian way: it boasted marble floors, onyx toilet seats, mosaics and frescoes galore, wrought-iron Medusa-head gates, and a fifty-five-foot-long pool lined with 24-karat gold. Whenever Dick and I went to Miami to present the choice photographs to him, Gianni would have a

DICK AND NORMA CELEBRATING THE CONCLUSION
OF A VERSACE CAMPAIGN, THE RAINBOW ROOM, NEW YORK.
NORMA'S DRESS WAS A GIFT FROM DONATELLA.

trainer lined up for each of us every day, followed by an equally dedi-
cated masseuse. I always stayed in Donatella's room on the second
floor—she said I could wear anything in her closet (we're the same
size) and keep whatever I wore.

On the morning of July 15, 1997, I was in the studio drafting a letter
to *The New Yorker* confirming Dick's upcoming assignments when the
first reports of the shooting trickled in—one of them had Gianni still
alive but "hemodynamically unstable." Dick immediately remem-
bered something Gianni had once said to him—that the only truly
shocking thing in life is violence. We spent the next couple of hours
frantically trying to reach Paul and Donatella. We were especially con-
cerned for their eleven-year-old daughter, Allegra, who was *there*—
visiting her uncle at Casa Casuarina. When we finally managed to get
hold of Paul, he could barely speak—except to confirm the worst. I
shut down so I wouldn't feel anything, but then of course I felt every-
thing. That night we heard on the news that some ghoul had breached
the crime-scene yellow tape to dip torn-out Avedon-Versace magazine
pages in Gianni's blood. Dick said, in a stricken voice, "Poor Gianni.
And poor *us*, because now we *are* going to be poor."

In early September, Dick and I attended the "commemoration of
an extraordinary life" held for Gianni at the Metropolitan Museum (I
took care to wear the short-skirted blue-green tweed suit with grosgrain
notched collar that Gianni had given me). Elton John spoke from the
heart, and he was followed in kind by Madonna and Anna Wintour.
When Dick's turn came, he likened his dashing, darting, flashing,
rainbow-hued friend and client to the visionary of the insect world, the
dragonfly. (I had pointed out to him that dragonflies were also well
known to be prime predators that attack passing fruit flies from behind
and below, but no matter.) Dick over the years had been likened to one
himself.

Within the year—as a tribute to "the impassioned shameless opu-
lent titillating seamanship of that daredevil magician of art and artifice
who was and will always be Gianni Versace," as the book's flap copy
read—the House of Random published a lavish retrospective of the
eighteen-year collaboration between the House of Versace and the Stu-
dio of Avedon.

SAM SHAHID: Dick hated that Versace book so much he refused to sign my copy. He said he objected to the slick color reproduction, which I thought was great. What he really didn't like was having his name all over a book that was about advertising and nothing else.

KRISTEN MCMENAMY: My first Versace with Richard Avedon was at Silvercup and it happened to be on his birthday—there was this humorous cake with a picture of him in vanilla icing. The set was sand, tons of sand, plus a gigantic tree trunk. The other girls on the shoot were all supermodels—Christy, Linda, Naomi, Kate, Stephanie. I didn't understand what *I* was doing there, because I was kind of, which I remain to this day, an alternative-looking person. I was real skinny, with really short hair, and I felt so insecure next to all those Big Girls. Dick showed me a picture he had just taken of Stephanie, with her big eyes and huge breasts, and he said, "See how amazing she is!" Believe me, I saw! But I thought, This is how he's trying to *help* me? I can never be that. I didn't realize he meant her attitude, not her boobs.

I went straight into the dressing room, put my own clothes on, and walked off the set in tears. *Yes,* I walked out on Richard Avedon and a Versace shoot! But when I got to my hotel room the phone was ringing and it was him saying, "Kristen, I understand what you're feeling—your sensitivity about the other girls. Trust me, *you* are key to this shoot." I went running back.

NAOMI CAMPBELL: Poor Kristen had thought she wasn't sexy enough for Richard. She'd gone up to him and said, "I feel like a eunuch," which was the first time I ever heard that word—I had to go and look it up. She called me from the street and she was crying, "Oh my God, what did I just do, he's never going to work with me again." I told her, "He loves you." And in fact he called her fifteen minutes later and told her so himself. He loved me, too. I mean, I was in his Versace campaign, wasn't I, which was *the* campaign to be in.

Richard worked with Kristen many times after that little kerfuffle, and she was always beautiful and brilliant for him. In one of the Versace home furnishings campaigns we did he put Kristen and me at the tippity top of a tower of mattresses—naked. We were scary-high off the

ground, twenty-five feet maybe, and all the other models were squished in between, with their heads or legs hanging over the sides. I was having fun way up there — Richard brought out, like, I don't know, the child in me. A certain innocence. I'm not saying I *was* innocent, just that he brought that out.

KRISTEN MCMENAMY: By the time I did the "Two Tall Women" Versace campaign, I was on fire. And Dick was on fire. We were both sizzling-hot. He got the most electricity out of me of all the photographers I ever worked with, including Helmut Newton. The other tall woman was Nadja Auermann. Dick told the two of us to really go at it — thrust our necks out, make angry faces, threaten each other with our spiky Versace heels. Then he had me stand on one foot, and my ankle went *pfft!* and all I could do was wobble. Twyla Tharp was on set and she gave me an exercise to do, and I was back on my feet, both of them, in no time.

NADJA AUERMANN: "Two Tall Women" was a very dynamic shooting. The images stayed in people's heads forever, and they inspired a lot of knock-offs. For some of the fighting pictures Dick told Kristen and me to pretend we had a love situation going. So one of us was going to have to be the guy, and Kristen had short hair so she was it. But after a while she complained that it was her turn to be a girl, and Dick switched us and I became the boy. There's one image where she has a dress on and I'm nude, standing behind her. You see only my leg and my silhouette — I have my hair combed back and I've got a little hat on and I'm looking . . . well, not exactly like a boy. More *zwitterartige* — how do you say? Androgynous.

I was in another Versace shooting with Kristen that had also Elton John. I had on a very glamorous gown, but Elton was outshining me with his semiprecious jewels and chain-mail dress specially made for a big male.

KRISTEN MCMENAMY: He was playing the piano and I was supposed to step on his fingers on the keyboard with my bare foot, without squishing them too hard.

TIM WALKER: I was the lowliest assistant on "Two Tall Women," and I was so impressed with Dick's technique of directing Kristen and Nadja that I swiped it for my own subsequent work. They would be standing in front of his camera in, let's say, little black suits, and he'd go, "You're both crows, and you're sitting on this branch, and it's winter so there are no leaves, and . . . oh look! you've just fallen out of the tree. But oooh, there's a worm. Quick! Go grab it! It's going to taste *so good*." For each shot he cast them in a different role—as animals, or insects, or characters from history or fiction. This was so much richer than the usual photographer's put-your-hands-on-your-hips-and-look-gorgeous-for-me shtick. Dick treated them like actresses, and that's what they became for him.

The third night of that shoot I was working late in the studio, and Dick called down to me to bring him a box of red grease pencils. He had just spent a very strenuous day getting the girls to contort themselves into all these shapes for him and dealing with their vulnerabilities, especially Kristen's, and yet there he was, sitting up in bed with the wet contact prints and a couple of pairs of scissors, editing. I found that very touching somehow. And now, you know, I do the same thing—I wouldn't dream of not taking the contact sheets to bed with me.

The only time I ever saw anything not work for Dick was with Prince. He had had me cover the walls of a small chapel-like room at Industria with purple Colorama backdrop paper, and then hang little nightlights all around, so it would be like a greenroom where Prince could go chill. His bodyguards swept in en masse and frisked the lot of us. Then we stood at attention and watched the whole circus of Prince's arrival, which was as Hollywood-glittery-baubly as things could get.

He was wearing a little red suit that Versace had made for him, along with a matching pair of little red shoes with zippers, and he had the word *slave* written on his cheekbone in eyeliner. Dick tried everything to warm him up—you know, "I saw you at Radio City last night and you were fantastic, now if you would just stand a bit like this . . ." But whatever he told Prince to do, Prince did the reverse. When Dick said, "Put your walking stick on the floor," Prince brandished it in the air. And when he said, "Just make believe you're marooned on an island in the middle of the ocean and you're hungry and tired and scared

and lost," Prince began jumping up and down laughing. It was nothing short of a rebellion. Dick with all his genius for communication and direction couldn't cut through to him. There was a reshoot—Prince showed up in black leather and mesh, and somehow Dick got him to behave.

KRISTEN MCMENAMY: I went running up to Prince with my hand out—"Hiiiiiii!" Nobody had clued me in that you weren't supposed to approach him. He looked up at me—*way* up. He was tiny, seriously tiny, and I'm five-ten and I had ten-inch Versace heels on. He said, "*Wow!*" So I guess it was all right.

STELLA TENNANT: The first Versace campaign I did with Dick, spring '96, Kristen was supposed to do, but she was evidently going through a very wild, crazy time, and they were afraid she might not turn up. So they flew me in from London on the Concorde. I was over the moon—I mean, what model wouldn't have killed to be in one of those high-voltage Avedon/Versace campaigns?

I had never worked with him before—he was this other generation, and he had this sort of great groaning load of work behind him, which was all quite intimidating. Thankfully I knew the stylist, Joe McKenna, and the hairdresser, Guido. And the fabulous Kevyn Aucoin, with his enormous hands—he called them his mitts. It was always a little scary having your makeup done by someone who had hands that big. He spent a lot of time that first day making sure *he* looked good; when he was holding my face and we were looking into the mirror together I could see he was concentrating more on *his* makeup than mine. On the previous shoot I'd done with Kevyn, he tried on all the women's clothes, and that was such fun for all of us. In a way a shoot was like a country-house party, a grouse-shooting weekend where you're all *doing* something together, getting off on the same thing. And in our case getting paid.

I had just assumed I was going to be modeling Versace couture in a very couture-like way, because, let's face it, I'm the couture type. But Avedon started yelling at me to pick up the green dress I was wearing and chuck it around so my green panties would show, and, added to

that, there was a whole lot of nerve-racking wind machine. He was wanting me to go against type, and the trouble was, I was having a particularly shy moment—I suddenly just couldn't do this in front of a whole group of people. I mean, I'm not an entertainer.

At the end of that first day I was so full of rage and frustration that I went up to him and said, "Y'know, Dick, I *hate* you." It was very brave of me to say that, you must admit, to someone like Richard Avedon. But it's what needed to be said at that moment in time. He said, "*Why?* What have I done?" I told him, "You've been trying to get me to be someone I'm just not." And after that, he was much more understanding about where I was coming from, and we started really cranking it out.

It was a four-day shoot. That's a lifetime—a lot of dresses. At some point he showed me one of the prints and said, "Your legs look too short here, so I'm going to give you six inches." I thought, What *is* he talking about? I'd never been known for short legs. Luckily, I'm not at all vain—my mother and my grandmother, and later my children, had always made sure I stayed totally grounded, so there was no chance of my having any inflated ideas of self-beauty. I mean, when I was chosen to be one of nine British models in the fashion segment in the closing ceremony of the 2012 Olympic Games in London, my mum said to my dad, "God, I'm not going to watch this rubbish," and on the big night she went to bed before I came on. And I came on strong. As the event was starting, I suddenly heard this huge roar from the crowd, which got my blood kind of hot. I felt like I was going into the Colosseum—like the lion was waiting for me! Then I walked out on the runway in front of forty thousand people in my gold and bronze chain-mail two-piece suit and sky-high heels.

GUIDO: I felt, and remember, I'm speaking as a hairdresser, that Stella's violent reaction to Dick must have had something to do with her hair. She had come in the previous day with black hair, and he had had it dyed orange, and then she had been up all night, and then in the morning Dick really pushed her into a sort of modeling she wasn't used to. She started crying, and he carried on shooting her, and then she just lost it and there were words said. But you know, he admired women

who had a point of view. I mean, he did cause reactions in people, and that was often how he got his pictures.

JOE MCKENNA: We did Stella again a year later with Jon Bon Jovi—the Versaces were really the first to do celebrities for fashion. She had this fantastic range—she fit all the Avedon Girl boxes. Elegant and classical—Madame Lady, being that she was the granddaughter of "Debo," Duchess of Devonshire; funny and smart; crazy and punk . . . I'm sure that if Dick were alive and working today, he would still be photographing Stella.

My first Versace campaign with Dick was with Amber Valletta, who was new to both of us. It was the period when minimalism in fashion was fashionable, and Gianni had started simplifying his clothes. But Dick still had to create unforgettable images with them. It wasn't the easiest collection for him, because he was used to working with very embellished and outlandish creations, yet the pictures that resulted are some of my favorites that I did with him. We decided to go with a classic Avedon approach—the old gray background—because there was no other photographer on earth who could do that kind of picture the way he did. We did Amber with a very fresh face and her hair just tied back and a feather sticking up from it, which was Guido's bright touch. And the following season, we did a similar minimal thing with Kate Moss.

I think Kate reminded Dick of some of those girls he had famously photographed in the sixties. Here again, the clothes were much simpler than they had been in the past, but she really carried them for him. While he was shooting her he had a lot of the funky tunes of the time blasting out, like Blondie. To show her how he wanted her to jump, he would, like, dance into position—get right out there next to her in front of the camera and do the jump himself. And then he'd duck back behind the camera and shoot *her* doing it. I had just seen an old clip of him on TV showing Lauren Hutton how to leap around, and now here we were, all these years later, and he was still at it and at the top of his form.

He also demonstrated to Kate how to fall onto a mattress: what to do with her body, from the tip of her toes right out to her extended finger-

tips. And he did it repeatedly—this was not a case of just once upon a mattress! The end result was this beautiful triptych of her in different stages of free fall, with the mattress airbrushed out, of course, and her Guido hair flying.

I had brought Guido in, having worked with him for Prada and Calvin Klein, and he gave Kate this huge thatch, which he put a wind machine on to create all those volumes and shapes that Dick so loved photographing. Guido came from the streets of London and had a punk sensibility and accent, and he traveled light. A lot of hairdressers traveled with five, six, eight huge suitcases full of falls and hairpieces and equipment, but Guido arrived with only a brush and comb and a handful of pins. Dick was surprised by that at first, but he found it refreshing, because the hair Guido did always had an edge to it.

I functioned as sort of a go-between for Dick and Donatella. I was the one who would have to say to him stuff like, "Oh, maybe we could try it with a little bit more movement." Imagine having to say that to someone who had done all those incredible things with motion that *he* had in his fashion pictures from the fifties through the seventies. He threw me off the set once, when I was pushing a little *too* hard, I guess, for something Donatella wanted redone. I thought that was the worst, most humiliating thing that could happen to me and that I was through, my career was ended. But half an hour later he sent someone out to bring me back, and soon we were laughing and back on a roll.

My last Versace collaboration with Dick was Courtney Love, and that was a tough one. It was at the height of grunge, and she'd been married to Kurt Cobain and all that and had this very obsessive rock-'n'-roll lifestyle. The problem was she didn't trust Dick's vision—she felt she knew how to look her best in front of the camera better than Dick knew, and she had just as strong a personality as him. She didn't quite understand that he wasn't just photographing *her*, he was also photographing the dress. But apart from Courtney Love, I don't think he ever took a picture where a model didn't look her most absolute beautiful.

Anyway, Gianni died that July, and that's around when I stopped working for Versace. And around the time Donatella changed photographers, too.

GUIDO: When Donatella flew me from London on the Concorde to be the new Versace hair guy, fashion was transitioning away from high glamour into a kind of English-sensibility thing—what would get labeled heroin chic. I was hired to help Versace tamp down its version of glamour, which had always included super loads of hair. And that was a challenge, because Versace anti-glamour was still going to have to look glamorous. Donatella still laughs when she talks about that first job I did with Dick, because the only thing I brought with me was my fingers.

The hair was allowed to get a little more complicated when Kate Moss came along. Dick wanted to give her a whole new identity for Versace, and those curls I did for her was how I first proved my worth to him. Seven mornings in a row I wrapped sections of her hair around pipe cleaners, which took like forever and a day, and then I baked them, basically. It was a very fiddly procedure, and painful for Kate, but well worth it in the long run—Dick's pictures were revolutionary. Hair was a critical part of his picture-making, and fortunately for me, he wasn't stuck in any path—he was as open to new things as any young photographer.

Sometimes before we shot a campaign he'd have me up to his studio to discuss an idea. He might show me part of a movie and point out the way the actress's hair moved when she jumped from a step in a certain way. That was how he brought me into what inspired him—into the process.

It was a real honor when he invited me to cut his own hair. I worshipped his hair. He was very proud of still having it all. Most days the first thing he would ask me was, "How does my hair look? Am I having a good hair day or a bad hair day?" For me, it was a charming side of him that the minute he came into the dressing room he would begin obsessing about his hair just like, you know, any of the models would. He said to me once, "How did you learn to do hair this good?" and I said, "By looking at your pictures!" I mean, I had grown up studying his pages in magazines and books.

TIM WALKER: I learned another invaluable lesson from Dick. When he was working on the campaign for Blonde, the bombshell perfume

Gianni created for Donatella, Dick had me blow up three of the prints to billboard size. He merged them into a triptych so you saw her full-face and then in left and right profile, all with masses of yellow hair. He told me to get it up on the wall. Then he made us all, by which I mean the three freelance assistants he was using, in addition to his four full-timers, stand in a row underneath it, with our hands behind our backs, while he ran to the client room to get the Versaces.

They were high-drama to begin with, but to view this monumental composite portrait of Donatella they walked in like fucking Italian no-bility, not just fashion royalty. And that's when I got it, when I realized why Dick had had us stand there like that and applaud their arrival. It was to give a flourish, like at a fancy gala where the waiters are all lined up. That taught me the psychological importance of theater in presentation. I began recognizing it as something Dick used in every aspect of his work. Like if he was sending a print to Tina what's-her-face at *The New Yorker,* he would say, "Don't just stick it in an envelope, make it look presentable—wrap it like a present."

GRANT DELIN: Gianni commissioned Dick to do a portrait of him in his mansion on East Sixty-fourth Street off Fifth Avenue. He wanted to be shot standing in front of this huge horrible portrait of him that Julian Schnabel had made out of Versace plates. Dick whispered to me, "I'm not having that thing in the background." So we spent the afternoon exploring alternatives—luckily the pressure wasn't on to walk away with finished goods that day. Dick ended up simply photographing Gianni behind his desk, surrounded by his trademark Medusa heads.

MARC ROYCE: He wanted Dick to do a second portrait of him, with one of his boyfriends. Dick's concept was to model the picture after that famous photograph he'd taken in the early sixties of Allen Ginsberg and his boyfriend, naked—you know, the one where they have their arms around each other and they're sort of semierect. Gianni was totally up for it, but then an embarrassing thing happened: he couldn't get it up, hard as he tried, and, I mean, he was manipulating his dick

like crazy. The boyfriend had gotten hard right away, but Dick needed two to tango.

One time when we were in Milan, Gianni invited Dick *and* me for a weekend at his villa on Como. After a fabulous risotto lunch, his longtime, thirtysomething companion, Antonio d'Amico, invited me to work out with him in the gym at the five-star Villa d'Este next door. I didn't particularly want to go, but Dick took me aside and told me that I had to. Antonio ran upstairs to get me a bathing suit, and returned with this bikini thing with the gilded Versace Medusa head on the crotch. At the hotel we indulged in every steam bath and whirlpool going, and Antonio was very flirtatious—he asked if I had ever considered modeling. When we got back to the villa, Gianni had this annoying little smile on his face.

LAUREN HELM: Versace was the second campaign Dick and I did together, after the Calvin Girls. It was the one with all the wood scaffolding, where the set looked like children's blocks but on a giant scale. Jerry Hall was in it. Also Janice Dickinson and Iman, and at one point I was stuck in the dressing room with the two of them naked. They were sneaking a smoke and chatting away, just having the time of their lives. And I was curled up in the corner, on the floor. Eileen Ford once told me I didn't have the right personality for a model, and she was probably right. But I always tried to do a great job for Dick, because I needed his approval so badly. The only other time this kind of disproportion occurs in life is when you fall in love.

JERRY HALL: Everybody had a big crush on Dick. The boys and girls both. We couldn't decide if he was straight or gay, because nothing was ever reciprocated. I never really knew him outside the studio—I was "out there," far out there with Mick, and Dick stayed way in there.

I'll never forget those wild beds that Bob Currie designed for one of the Versace sets. They were covered in satin, velvet, denim . . . The satin was difficult, especially when you were wearing one of those heavy chain-mail dresses—you kept sliding off or slipping down. Dick told you what to do on the bed—whether to cuddle or just strike a spe-

cial attitude. There were three girls or something on one side of me and two on the other, plus wherever the boys were, and my hair would always be getting caught on something and having to be redone.

Anything he asked, I was only too happy to do. Except when I was pregnant, I guess with Jade, and he asked to photograph me naked, and I didn't want people seeing me looking fat. But whenever he wanted me to stick out my tongue, I did it. I yanked on my hair for him, too, and I leapt all over the fucking place—my legs tangled into the strangest shapes, and he liked that. To me, modeling was like finger painting—you made a shape, and kept on remaking it until it looked right.

Dick loved gossip, and he was in and out of the dressing room all the time, getting an earful from everyone. I never did tell him what Way Bandy told me one time in the studio while he was slathering makeup on my face. He bet me I couldn't guess what the secret ingredient was. I screamed when he told me.

PAUL CAVACO: Jerry was part of the first Versace shoot I styled for Dick—spring/summer 1980. The other girls were Patti Hansen, Rene Russo, Janice Dickinson, and Rosie Vela. Dick said, "We need somebody new," so I recommended using Gia—I'd been knocked out by the big spread on her in *Vogue* by Dick's old protégée Andrea Blanch. There were six or seven guys on the shoot, but they were only being used as props—furniture for the girls to sit on—and they would just be wearing Versace sweat suits.

Jerry had just had one of her periodic breakups with Mick, and as she was walking into the dressing room, Janice was walking out and turned to her and said really loud, "I like to lick Mick's dick." We were all in shock—like are we going to have a cat fight now or what. But Jerry was totally cool and didn't respond.

About five o'clock the first day, Gia emerged from the dressing room where she'd been sitting all by herself since nine in the morning, and mumbled, "I have to move my car." We all knew she didn't *have* a car. She was very insecure, very shy, and I guess she got totally freaked that Dick hadn't been using her and went out to do a score. She was one of those models who the minute they get in front of a camera just lift. But sitting around was mostly what she got to do in this campaign.

She did a little sitting, too—she sat on a couple of the guys. Dick photographed her again six months later, for a *Vogue* cover, and she climbed out a bathroom window. But even after that, he used her again for Versace—she was one of the girls on the famous Delacroix bed. She died in 1986, and ended up being played by Angelina Jolie in the TV biopic.

JANICE DICKINSON: I'd seen Gia chopping up heroin with a switchblade in the studio bathroom—I mean, to be fair, everyone was always in the bathroom back in the day. But I never saw her actually snorting it or shooting up, although she was always happy to show you the track marks on her arms. One time she passed out and we couldn't wake her up. Way Bandy was shaking her foot and I was pulling on her ears, and Jerry Hall was doing something to her, too. Then Dick popped in, and he goes, "Don't hit her—I mean, *do* hit her, just don't hit her in the face." And Gianni, come to think of it, was there also, screaming, "Deek, Deek, *fantastico*—shoot this!" I mean, I could see where he was coming from—he loved drama and he was paying for everything and he just wanted to get his money's worth.

Donatella was taking cocaine all during that shoot. She invited me to join her in the bathroom, and when she started tapping it out on the toilet seat, what was I supposed to do? Refuse her? By the time I came out, we had really bonded: I felt totally accepted by the designer's sister. But whenever I wasn't shall we say lucid on set, Dick would say, "Come on, Janice, knock it off! Let's get to work! I don't have all day."

You have to understand one thing: from childhood, all I had ever wanted out of life was to be in an Avedon photograph. I couldn't wait for some agent to send me to him, I knocked on the door myself. He saw right away that I didn't look like anybody else, and I didn't act like anybody else, either—I was a wild child. He was able to tap into a side of my soul that nobody else could see, and he shot me into a stratosphere of art that people normally have to go to art galleries or the opera to experience. From our first moment, I had a fantastic relationship with him in front of the camera. Dick was everything to me—father, priest, yogi . . . And he did everything for me, except have sex with me, and that's what should be etched on my gravestone.

CARLYNE CERF DE DUDZEELE: No fashion editor at *Vogue* was al-
lowed to do advertising, but a special exception was made for me to
work with Monsieur Gianni Versace, first on a couture collection and
then on a campaign. After his show in Paris, I went to London to meet
with Dick at the Hotel Connaught, and the first thing he did was pull
out this big penis to show me—a drawing. I said nothing, because it
didn't matter if *I* liked or didn't—a penis was a decision for the client
only. But believe me, there was nothing *to* like about *this* penis.

Dick told me, "This is an idea from Nicole." I never asked who
drew the prick. He said he wanted it built out of foam rubber and
papier-mâché like the lethal phallus in *Clockwork Orange*. His idea
was the model would be holding on to it like a branch on a tree, and
then climbing it. In evening clothes! I was just shaking the head. I
mean, this kind of concept—it's trying too hard. Fortunately, Donatella
and Paul—and even in the end, Gianni—were dead against it.

The two Versace campaigns I did with Dick were Elton John and
Stallone. Stallone in the nude, with Claudia Schiffer, for home furnish-
ings. I had to cover his genitals with a cup, or maybe an ashtray. Fortu-
nately I had met him already, in Paris, at the Versace couture show at
the Ritz—he came backstage after. He had with him Janice Dickinson,
his fiancée at that moment, and when Gianni saw her from behind—
the posterior décolleté—he said, *"Ma chi è questa puttana di vacca?"*
Who is this cow of a whore? I was in *tears*. Donatella, too. Both of us
were laughing so hard we were crying. Janice would no way have under-
stood the Italian. And even if she had, she would never have imagined
Gianni was referring to her, although she was very far from a model by
then—she had gone the way of, how do you say, all flesh. The most
beautiful women in the world, it's a crime what they do to their asses,
not to mention their faces.

I was in my garden in the south of France, near Saint-Tropez, when
I heard that Gianni had been assassinated. I thought, *Non, non, non, et
non! Ce n'est pas possible!* I was asking everybody, *Qu'est-ce que c'est un
spree killer?* So then Donatella became the big boss of the label. And
tout de suite she began doing the antithesis of Gianni—*pas d'élégance.*
At which point I actually said to her, "You are killing your name."

NICOLETTA SANTORO: When I was in Paris working for French *Vogue*, I was doing work also for *Égoïste*. The editor of that journal, Nicole Wisniak, is a great matchmaker and suggested to her good friend Richard Avedon that he engage me to style the spring/summer '94 Versace campaign with Linda Evangelista. I felt with Dick an instant affinity, and indeed it turned out we were both Tauruses—he was born May the fifteenth and I the sixteenth. And my father the seventeenth—and when I dream about Dick, I very often confuse the two men.

It was Linda's first time with Dick, too. A challenge—I should say nearly a tragedy—occurred on the first day. We lost our hairdresser, Oribe. Or should I say he lost himself. He poured gasoline in Linda's hair, and immediately after, he was shipped off to rehab. Linda was screaming, and we took her upstairs to shower in Dick's bathroom, and still it did not all come out. Dick and Donatella made the executive decision to not bring in another professional hairdresser, and so we were left—Oribe's assistant and the makeup artist François Nars and myself—to fix Linda's hair ourselves.

It was a godsend that she had come in with a very short, boyish cut. The whole spirit of the campaign was a little bit minimal—distressed, underground, punkish, grungy. This was of course not at all Dick's aesthetic—his previous Versace campaigns had had a much richer sensibility. This one was all black-and-white, and it was, by the way, very well received on the fashionista level, as something highly unexpected and avant-garde.

ORIBE: It was Suga, who I had never met, who recommended me to both Dick and Gianni as someone they should hire if anything ever happened to him. Which it did—it was called AIDS.

Dick got my career spinning. I was just so excited to be working with him. He called me Rafael for years, and I was fine with that. Every once in a while, when you got him going on the past, he would run downstairs, where the gold was, and bring up the most amazing photographs—the Marilyns, Shrimpton in the space helmet, the Lauren Huttons, the Dovimas . . .

Whenever I went to his studio, I would right away go upstairs and attend to his hair. He was someone who looked really good with hair. He didn't want like your perfect haircut, so I could do it in ten minutes. There was always a little volume I left on the side. I do mine like that, too, kind of, now, if I want to look a little crazy—slick it back, but leave it long here and there.

He didn't like the models to have your conventional kind of hair, there had to be something that would really stand out beyond what was going on at the moment in fashion. I was in my thirties and scared of nothing, and that fearlessness was one of the things that allowed me to make Dick—make *us*—phenomenal.

Sometimes on a Versace shoot he would say, "I want flying hair." And we would go wild with the wind machines—I'm talking gale force! I would position one in the back of the model's head and center the other in front, and that would give Dick hair that would normally take twenty wigs on a girl to get. Even with all that double wind blowing, I was always able to suspend the hair just long enough for him to take a few incredible frames.

We took Gianni's Medusa logo as the inspiration for the hair in our first campaign together. I looked up the original Medusa, and what she had on her head was live snakes—so, I mean, forget *that*. I still wound up doing the wildest hair with the craziest texture you ever saw. And on Stephanie Seymour. It was Versace to the max. Because it wasn't just fashion—it was more like an art piece that included fashion. And it was something that came out of this bravery of mine that I was telling you about. The male supermodel was Marcus Schenkenberg, and I did him all curly, too—and, I mean, you didn't curl boys' hair at the time. And I curled his real tight—very, very Roman.

Another amazing Versace shoot was those sand pictures with Kate and Naomi. Dick was obsessed with Kate's face—she was just a baby, just coming up then, and he made her into an international star. He wanted the two girls to have real fuzzy hair—he was going to bury Naomi in the sand, a pharaoh kind of thing, so all you would see was her frizzed head.

She and I got into a huge fight on set that made it into the papers and everything. You know, once Richard Avedon came up with a con-

cept, that was it—you couldn't send the girl out looking like anything else. I had to put something in Naomi's hair to crank it up, and she made a face, so I said to her, "Look, this is the hair you've got to wear." And all of a sudden she kicked me. She had a heavy shoe on, too, and it hurt like hell. I mean, how dare she! I had done her for her first pictures in the United States, and I thought we were friends. Clients would hire me because I was the only one who could even remotely control her. She's gotten better, by the way—she's a really good girl now, a great humanitarian. Anyway, I started chasing her, and she ran ran ran, and the next thing I knew, Dick was going, "What's going on here?" I said, "Dick, I came here to do hair for you, not to get kicked in the shin." He was totally on my side, and when he caught up with Naomi he told her where to get off. Anyway, by the end of the shoot she and I were best friends again.

Donatella and I became very close—maybe you could say too close. We would hang out at night, often at Gianni's house, although the last season he was alive he separated her and me. She and I had things in common, which seemed to really fascinate Dick—he would be like, "What do you guys do together?" And that was a bit weird—I mean, how could he not have known? I was really, really wild—it was the times and everything—and I kind of spiraled out of control. I mean, I went crazy. But I was always polite.

Linda Evangelista comes into the studio with practically no hair, so I'm not understanding what it is I'm supposed to be doing with her. I did two days of trying to find another look for her, but she was fighting it tooth and nail. She was wanting to look a way that I didn't get—grungy. All of a sudden, like overnight, the beautifulness of beautiful girls was out as far as fashion was concerned—all the gorgeous supermodels had to look awful, at least in the sense of don't do the hair. I used to do the Calvin Klein shows, too, and even he . . . I would hear him say things like, "Leave the pimple, it's beautiful." People were going crazy like that. It was a really confusing time for me.

I had been hoping that, with Linda, things could maybe be different. Especially since Dick never went in for trends. But Linda wanted the trend, and she was being a real pain to me and, I don't know, instead of just slicking it back with hair product, I put petroleum in. I

went straight to rehab after that. I was in Hazelden for fifty-three days, a pretty good chunk of time, but it took me much longer to completely sober up—to learn that you just gotta stay away from certain things for good. To have to be put away in the middle of a big campaign was a really unforgivable thing, you would think, but Dick, amazingly, forgave me. He had to do his next campaign without me, obviously, but then we did one of the most sensational Versace sittings of all time, "Two Tall Women."

Dick was super-loyal to me, and the only reason I didn't go on working with him was Jennifer Lopez, because I jumped on her bandwagon and traveled all over the world with her for seven years, creating J.Lo. She was the thing that saved me—by refusing to go with the flow and look ugly and pimply she showed the world there was life after grunge.

LINDA EVANGELISTA: Getting to work with Richard Avedon on a Versace campaign was like winning a gold medal at the Olympics. I did the one where you had to stand on the balls, and I also did a lying-down one, and I did the desert one—the sand dunes . . . For our first campaign I was hoping he would shoot me on the white backdrop, because he always shot his portraity pictures—the ones of real people, not models—that way, while his fashion ones were mostly on gray. I wanted to be considered a portrait. And happily that's how he photographed me. He had me styled in a very undone, natural kind of way—practically no makeup and not a lot of hair.

That was the campaign where Oribe got sent away on the first day. I think it was Murray Oil he put in my hair, which supposedly doesn't really ever come out. By that point in my career, I had had a lot of different stuff put in my hair: dirt, beer, sugar water—you know, whatever they wanted to do to you, you had to let them. My hair at the time was quite short, and it got really greasy from all the oil Oribe dumped in. We had to proceed without a hairdresser, and amazingly it actually looks very clean in Dick's photos.

My favorite character that I met on an Avedon set was something I never knew existed. I don't think I even knew her name—I just called her Handy, because she was the hand model. And the funny thing was she wouldn't give you her hand to shake when she met you—I guess

she felt she had to protect her big asset when she wasn't actually working. She'd just sit there under the table during a shoot, and then her hand with all these elongated perfect fingers would come up into the picture whenever it was called for and touch your chin or wherever. Not that I was someone who needed a helping hand—my own hands were perfectly okay. Finally Dick noticed that and stopped booking Handy. I'm not sure Handys even exist anymore.

Nowadays everything just gets magically rejuvenated on the computer. But none of *those* images has the magic that Dick was able to create. Every single one of his Versace pictures is unforgettable. I mean, how many campaigns can you reference from decades ago where people can visualize exactly what you're talking about?

SEBASTIAN KIM: Dick was preparing to do a picture of Erin O'Connor in a slinky Versace chemise made of silver and gold chain mail that looked like full-on armor, and he had me stand in for her in the test shot. He liked the Polaroid he took of me so much he asked to photograph me in the dress for real, and he wanted me naked underneath. I was really nervous. He said, "Don't worry, it's just for myself."

NICOLETTA SANTORO: Erin O'Connor was the last sitting I styled for Dick. He told Guido to give her a very masculine cut—just buzz her in back. Later I learned that her agent was furious with Dick, feeling, as she had every right to, that this could interfere with her client's ability to get other jobs in the short run.

SEBASTIAN KIM: He promised me that that picture would absolutely never be published anywhere. But then he put it in the big Versace book—a full page, right opposite the page with Erin in the same dress and with my exact same hairstyle. All I feel comfortable saying about it now is that finding myself in that book like that was a very big surprise. I just pray my mom never sees it.

GRANT DELIN: The day my mum and dad arrived from England to visit me, we were shooting Versace at Pier 59. They were champing at the bit to see the set. Dick stopped the shoot and made such a fuss over

them. He did a beautiful thing for me—he dragged my dad out of his wheelchair and positioned him next to Stella Tennant, and then he put my mum next to one of the hot male models. It was so funny, because my parents looked like people from the old country—refugees. Dick got in the picture himself, but Donatella refused to. This was the first shoot after Gianni had been shot, the first shoot on her watch, and she looked annoyed that Dick had interrupted it for the likes of the little Delins. She was standoffish to begin with—she had had the workmen at the pier make her a private little alcove so she wouldn't have to be with us the whole time. Those photos made my parents' entire trip. And Dick gave them prints. But my mum, wouldn't you know it, had blinked on both frames.

Whenever I called her in England after that, the first thing she would ask was never "How are you?" but rather, "How's Dick?" And when I told her I was leaving the studio to go back to working on my own, she said, "Why would anyone ever quit Dick?" She had those photos right up there on her wall till the day she died. My sister has them now: my dad making eyes at Stella Tennant, and my mum blinking.

MARC ROYCE: I can still see Stephanie Seymour being driven in her then-boyfriend Axl Rose's stretch limo up the ramp at Industria toward the waiting Versace campaign. A couple of months previous, as first assistant, I had had the high honor and distinct privilege of lighting her crotch for that amazing shot. That was editorial, of course, but Dick also took some equally incredible pictures of her for Versace, like the one where she's riding Marcus Schenkenberg like a rodeo horse. That time she had all her clothes on—it was Marcus who was buck-naked. Dick told me to be sure and light his dick, though later he reversed himself and had me shadow it.

SAM SHAHID: Dick shot Marcus for Versace with nothing on, but it was Bruce who made him, with Calvin Klein jeans. The Marcus in Dick's pictures was beautiful, perfect, clean—*too* clean, almost sterilized. Bruce did him in the shower really hot—holding the jeans in front of his private part. They clearly saw Marcus very differently. Well, Bruce was always better with men.

ISAAC MIZRAHI: The women Dick photographed have all this life to them—he really knew how to blow a woman out. But his men came across as more like objects. Could it be that he had homosexual kind of tendencies? And if he did, would anyone have ever known that? Not that it even matters. Or does it? It must have mattered to *him*. He was asexual in a way. Like Andy, somehow. Although I did see him at the theater one night with Twyla Tharp, sitting together real close, like lovers.

SAM SHAHID: Abercrombie & Fitch was one of my accounts, and Dick asked me to send him their latest catalogue. It had hundreds of pages of Bruce photos that were awash in nudity, and he said, "Let me just tell you how *I* see it: I think you're using far too many Bruce Weber photographs." He was saying this tongue in cheek, *sort* of, because he knew he could never do it the way Bruce did.

I confided in Dick that I was breaking up with someone and having a really rough time, and he gave me the perfect thing—Colm Tóibín's *Love in a Dark Time: And Other Explorations of Gay Lives and Literature*. He was very good to me, too, when I had a sexual harassment case against me. He told me that he had had a similar type thing happen to him—courtesy of his ex-daughter-in-law. Which I already knew about, of course—it was all over the papers and everything at the time. He said, "Sam, there wasn't a word of truth to any of it. It was just the case of a woman I'd been very generous to trying to euchre more money out of me." On the first day of my trial he called me the first thing in the morning to say he was thinking of me. And Bruce did *not* call, and that really upset me, though he had quipped to me at some point, "I've got a guy who can take your accuser out, just tell me when you need him," which was so cute of him.

Bruce used to ask me about Dick all the time, and I remember how nervous he was when he was assigned to photograph him for *Vogue*. And Dick would ask me what Bruce was like, too—just not as much. One time, he said, "I hear you guys work till three or four in the morning over there—does Bruce take anything?" I told him no, and he said, "*I* have to sometimes." I thought it was adorable of him to admit it, but I also thought, *Sometimes?*

RUEDI HOFMANN: One time in the early eighties when we were in Montana for the Western Project, Dick mentioned some pictures he had recently seen in GQ by Bruce Weber as examples of something really fresh. So after lunch when he went back to the motel to take one of his twenty-minute naps to rest his eyes, I decided to play a practical joke and I drove into town to pick up a couple of copies of the magazine. I ripped out all the Bruce Weber pictures of boys and taped them to the back seat and inside roof of the Suburban. When Dick got in the car he blew his top and ripped them all down. I hadn't done it to get his goat or anything; I had just gotten a little carried away hearing him say something not negative for a change about the work of a living photographer. The only exception to that rule was Nick Waplington, whose work he compared to Bruegel's. Anyway I had momentarily forgotten how competitive Dick was, how worried about being displaced—he was constantly looking over his shoulder at anybody who was younger and coming up behind him.

BRUCE WEBER: Dick and I shared two very special experiences— working with Calvin and working with the Versaces. He mostly did the women's and I mostly did the men's. I loved all his pictures for Versace. They were so much fun, so crazy—he really got all that Italian drama in there. There are so many art directors walking around today with those tear sheets saying to young photographers, "Do *this*." Like, good luck!

I got a little bit close to him when I photographed him for *Vogue* in 1993. I went to his apartment, which was kind of a beautiful mess— books all around, and his own pictures up everywhere. And that was interesting to me, because if you come to my loft in Tribeca you'll see *my* pictures only in my bedroom, and just of my family and animals and close friends—nothing up on the walls. That was a decision I made when I got my first studio, on West Twenty-sixth Street—to only put up a few photos, like the Heunes I had of Johnny Weissmuller. But Dick was this great theatrical person—he could get away with displaying his work all over his place. He handled it in such a way that it wasn't a turnoff. It came across as a joyous self-celebration, and you just had to love that big ego of his—he had always been just so in love with being

who he was. Or maybe, for all I know, he had all his photos up there to give him courage to do the next one.

The day I was photographing him I talked him into going to Central Park, and it was like we were playing hooky from school. He was like the wild child in the Truffaut movie, or like the madcap kid from art school, running around. Afterward I did something I'd never done before, or since: I called *Vogue* and said I had to go back, I wasn't sure I'd gotten the picture. And of course I did have the picture, I just wanted to be with him some more. And in fact I went *three* times.

CINDY CRAWFORD: The mega personality of Dick combined with the personalities of the two Versaces made those the most fun campaigns of all. I did three or four with him, always at Industria, and they were the epitome of what you would think a nineties photo shoot would be: Christy, Stephanie, just every top girl, and top boy, and all the stylists and seamstresses, some from Italy, and, I mean, a whole separate studio for the wardrobe.

My teenage daughter recently did something for Versace's kids' line, and Joe McKenna was there, and Guido, and it was old home week. The only thing missing was Dick. *The* thing.

MARLA WEINHOFF: I lived in the same building in the West Village as Robert Currie, the great set designer, and one day he stopped me in the lobby and asked if I would be interested in painting some props for Richard Avedon for a Versace campaign. I said, "Avedon? You've got to be kidding!" I mean, I was addicted to his ads featuring the Diors— they were always the first thing I looked for in the Sunday *Times*.

My job was to touch up the giant black fiberglass spheres covered with silver leaf that Bob had made for the models to balance themselves on. The set was at Silvercup Studios in Long Island City—Bob explained that there were no studios in Manhattan big enough to accommodate Avedon's concepts—so I grabbed my little paint kit and hightailed it out there. An assistant told me to just sit and watch for a while. A couple of the models were practicing how to balance on the balls, and Linda Evangelista was lying on the floor entwined with somebody, and Avedon was test-shooting from overhead, calling out

directions like "Move your hand to the right . . ." and "Go in and fix her hair." It was Suga who was doing the hair—that's how long ago this was. The very early eighties. It was my first time at a photo shoot, and I said to myself, "This is the world for *me*."

Bob hired me to help on the next Versace campaign, but by that time he was dying of AIDS, so I graduated to being Dick's designer. Now I was the one responsible for coming up with the set and getting it made. This one was like a Cecil B. DeMille production. Dick wanted me to create a beach for him—he said, "Think Saint Bart's." The sand dunes I did were *better* than real ones. And to top it all off I had this huge piece of driftwood I found on his property in Montauk hauled to Long Island City.

I did the sets for a lot of the Versace Home collections, too. Everything that wasn't clothing, I got. Or got made: the stacked-up mattresses, which were right out of "The Princess and the Pea"; the piano for Elton John; the colossal chair that had to withstand fifteen models climbing up it and hanging off it; the flying carpet for Naomi Campbell . . .

NAOMI CAMPBELL: A funny thing just happened—Versace asked me to approve the image of me on the flying carpet to put on a plate. I said fine, provided they give me the whole set of thirty-six. It's Rosenthal china. Gorgeous.

AMBER VALLETTA: The first campaign I did with Dick was for Donatella's Versus—the younger line. I was a little bit scared, because it was Richard Avedon and I knew how important he was not just to photography but to pop culture, and there were just so many levels of what he meant historically. And then he was just so *not* scary. But I was disappointed that he used only two or three pictures of me in a group shot.

But the next season! He picked me to be the only model in the campaign. He did all these test shots of me—some with dark makeup, some light, then none. Some with my hair pulled back, and for those he wanted my ears pinned back, too—I do have kind of elfin ears. And then with my hair unkempt, and finally with very Versace hair—big,

super-glamorous. The concept was very involved—he was going to have a mask of my face made from a photograph and I would be holding it in front of my real face.

But then the next day he told me, "We're not doing the mask idea, after all," and he gave me the contact sheets of all the pictures. I didn't have them framed until maybe two years ago, when I finally felt I had enough distance from my career to appreciate them.

I was a fairly natural blonde at the time, and he didn't like my hair color. So the colorist, Christopher, added some red tones. It turned out so cool I kept it that color. Guido planted a feather in my hair, to stand straight up. I must have told him I was part Cherokee. I remember dancing around the studio like a regular little Indian with that feather, whooping it up. And when I got in front of the camera, Dick encouraged me to be the kind of energetic, rebellious, bright young girl I had always been afraid to let myself be.

Midway through the shoot, he said he needed a couple of young guys for some of the jeans pictures, and I mentioned that I had two brothers, ages seventeen and fifteen—one from my mom's second marriage and one from my dad's. He went, "Perfect!" The only obstacle was they lived in Oklahoma and California, but he said he would fly them in. He got really excited when I told him they had never laid eyes on each other. But why should they have? *They* weren't related or anything.

The boys were thrilled that they would finally be getting to meet. Not to mention see New York for the first time. And do a fashion shoot. And for Versace. And even make some money. Five hundred bucks apiece, I think. Which was a lot in the early nineties, especially for guys who weren't making *any*thing. And they would be getting to keep their Versace jeans.

Well, they had the time of their young lives. They had their hair cut by Guido. And they modeled the three-million-dollar tiara that I'd worn in some of my pictures—I had gently explained to them that Versace was a bit into gender bending—and they looked just like little princes with it on. I'm not sure any of the photos with the boys got used in any of the print ads, but they definitely made it into the big glossy catalogue.

CHRISTY TURLINGTON: When I first worked with Dick for Versace, I was still in high school and commuting to New York from the Bay Area. There was a fair amount of terror involved in meeting such a big name, but he turned out to be such a personal person, and so talkative, I didn't even feel the fifty-plus-year age difference between us. The first time, my mother came with me to the studio. She had really prepared me—she made me watch *Funny Face*, and she showed me the picture of Dovima and the elephants in a book. She'd been a flight attendant in the sixties for Pan Am, where my father was a pilot, and traveling around with me and meeting interesting people was a close equivalent for her occupation-wise.

Years later in Paris I got to meet Dovima in person, at a Ford Agency anniversary party at Maxim's, and she looked so different from her pictures. She told me she was currently working at a pizzeria in Florida, and she pulled out a picture of herself standing next to a row of pies. It was pretty cute—she could still do a pose—and the pies looked yummy.

The Versace campaigns I did with Dick in the beginning were just straight fashion—with Estelle Lefébure, Cindy, and Paulina—and we did them in his studio. But then they began getting more and more elaborate—with Naomi, Linda, Kristen, Kate, and Stephanie—and we had to do them way out at Silvercup. The last Versace I did with him, the one with the really short skirts and the bobby socks—with Nadja, Cindy, Claudia, and Stephanie, at Industria—was the last shoot Dick and I ever did.

When I finally got to go to college—NYU—at the very late age of twenty-five, I took a history-of-photography course. The professor would occasionally show slides of different fashion images, and during one class a picture of me appeared on the screen. I was in a bright-red Versace, leaning on a naked Adonis who was posing as a piece of furniture. I squirmed in my seat. The professor lingered on that frame for the longest time, going on about what a great master Richard Avedon was; and then suddenly he launched into how terrible it must have been for that model to be in such a horribly degrading position. That stimulated a group discussion of the big change in notions of female exploitation since those days. I don't think there were that many people there who realized it was me: it was a big class, and we had never had

to get up and say our names or anything—plus, mercifully, since we were watching slides, the room was dark. I mean, my own kids know me more as a student, as someone who went back to school, and as an advocate for underprivileged moms in underdeveloped countries. They see me as a role model more than an ex-model. My daughter hates having her picture taken—*so* far.

I do think Dick brought out the greatest things in me, but I would love for us to have done something together that wasn't just advertising. He never did do a portrait of me—you know, with just the clean background, and without all the bells and whistles. That was a real rite of passage: it meant you had made it. Stephanie got that from him.

KELLY LE BROCK: I had been the Pantene shampoo girl—you know, "Don't hate me because I'm beautiful." But guess what, a lot of people did! I was photographed by everybody that mattered, all the masters, but there was only one Dick. And he loved me. I mean, you can ask him yourself. Yes you can! You *can* talk to them. They're all still around us.

There was nothing like those Versace campaigns. *Ever.* They flew twelve of us to Milan for one of them, and at about three in the morning the phone in my hotel room rings and it's one of the male models going, "Wake up, Kell, the hotel's on fire!" I thought he was playing a trick and hung up. The next thing I knew, the room was filling with smoke and I had to crawl along the corridor on my hands and knees. The Italians who were staying there were dragging their suitcases behind them, and there was all this jangling because they'd emptied the mini-bars and taken all the ashtrays. When I got outside I just stood there staring at the burning hotel—the whole scene was just *so* Versace, so operatic and chaotic. One of the stylists was going, "Look at that *orange*! Do you believe that *yellow*!"

The shoot must go on, and a couple of hours later it did. We were all still coughing up black stuff, and our eyes were bright red from the smoke and the makeup people were trying to neutralize the red with green eye shadow. I remember one shot Dick took where everybody's eyes came out totally closed. He was staying in Gianni's villa, forty minutes away, on the shores of Lake Como, and had missed out on all

the excitement. He would have been in his element. And fire *is* an element, my friend—a classical one.

It was Dick who encouraged me to go into movies. I wound up doing two big ones: *The Woman in Red* with Gene Wilder, and *Weird Science*. Then at age twenty-four I more or less ran away. I didn't want to be in the limelight anymore—I had had it with being stared at.

I've lived on a ranch in the wilderness in California for about twenty years now. I have no television, and my friends are all four-legged. I can get on one of my herd of beautiful horses and ride for untold miles and never see a living soul. I have a lot of water stored, and propane, and I make my own cheese and yogurt, and I slaughter my own animals. I sleep with a .44. I also have a .45. And a sniper rifle.

DONATELLA VERSACE: After Gianni got gunned down, I died myself and had to be born again. Continuing working like I had was not possible—too painful to try and do the same thing! I had to get detached from the past, which was gone with my biggest love and my biggest heartbreak, my brother. I missed so much Gianni that I changed most of the things around me. But no longer my face so much. I mean, I was now the face of the label.

From Dick I learned everything I still don't know. To be never satisfied! The first day of work he would always produce nothing—it was downtime, preparation. Gianni would say, "How can there be nothing? There must be one Polaroid you can show me." But nothing till the third day or the fourth, because Dick was super-perfectionist, he was experimenting with the *punti*. But when he was ready to show, there would be incredible pictures beyond anybody. They could run today, every one of them—after thirty-five years!

Nobody was on the level of Richard Avedon. He was such a super-intelligent person, Dick, that I would have to say to people, "What the fuck is he talking about?" Once I heard him asking Paul the same thing about *me*.

Dick would stop photographing the minute Gianni came around. But Gianni was naughty, and he tried to put a mirror up in a corner of the studio to secretly watch. Dick caught him and told him, "Out!" But Gianni only pretended to leave—he went and hid behind some pillar

or something. He tried this I think twice, then he gave up and left Dick alone.

Every girl was dying to be photographed for Versace by Avedon. From all of them he wanted only one thing—attitude. There was a very intense supermodel moment, of Linda, Naomi, Christy, Kristen, and Kate all together, and that was the best time for fashion *ever*, in history. But let me say something about supermodels: they were hell to work with. They had way *too* much attitude—for *me*. They had bodies and faces, sure, but some of them even thought they had brains.

Dick gave them always a very precise, a very concentrated, direction. He made them hold the most impossible positions—twisting off beds, balancing on glass balls, Linda upside down, Kristen and Naomi way up on the top of the mattress mountain. The only time Naomi behaved—followed direction exactly—was on the set of Richard Avedon. She's a troublemaker, that girl, but a very good person inside.

Such a helluva lot of fun we had, too! When Oribe poured the diesel oil in Linda's hair she screamed and he started to cry and Dick laughed and I said, "Quick! Dishwashing fluid!"

I hate to get nostalgic, but I miss everything.

PAUL BECK: Gianni from childhood liked nothing better than flipping through the pages of a magazine or book and discovering a picture. He loved photography, and he courted the photographers he loved. As a very young man he had idolized Richard Avedon, and it was always his dream to one day be able to work with him. And when that day came he was willing to pay Dick anything Dick wanted.

Gianni eventually got the message that Dick didn't want him on set, so he usually stayed in Milan when Dick was shooting in New York. He was just so grateful for how completely Dick understood his clothing, that Dick treated the dresses like pieces of art.

Dick would often have a favorite outfit to photograph, and every once in a while there would be one he would rather *not* shoot. But there was always room for compromise—he might say, "I'll do that horrible red thing if you let me do one more mesh." He was instrumental in making bestsellers out of a lot of our dresses and jackets and jeans.

What Dick loved more than anything was presenting the finished

product to Gianni. Practically every photo would be a masterpiece. Today they all have to use Photoshop to make it work, but even in this era of higher-than-high technology the end result never looks as good as it did when Dick did it.

Donatella and Dick understood each other pretty much. They were a really good balancing act. He trusted her on a lot of what was going on at the moment as far as the girls and their makeup and hair went. And *she* knew that only Richard Avedon could get a dozen or so larger-than-life models in a shot where the hair on each would stand out perfectly—again, his grasp of the *punti*. And I don't know how many of them would have done all those climbs up ladders and things, and held all those difficult poses, for anyone but Dick.

One of my favorite campaigns featured our workers in Milan—Dick and Gianni worked out the concept for that together. Dick went to our factory in Novara to handpick them. He photographed the bosses and head seamstresses in their black uniforms and the underlings in their blue and white. He told some of them to pretend they were examining the *punti* on the lapels, and others he posed holding tape measures and pincushions. To me, those photographs are very reminiscent of his greatest creative stuff, like his "In the American West" work where he was shooting real people. It was great to have that sensibility in a fashion ad. It got us a lot of attention.

Dick and Doon were quite the pair on set—a team within a team. He liked to have some sort of little narrative or tagline, and she was pretty good at coming up with these quirky little things for acting out the visuals. She was like one of those Aborigines—the way they just sit in the desert. She would stay right next to Dick, practically immobile, a mountain of black cashmere, and whisper to him.

Between you and me, we had a lot of difficult personalities working together. I mean, we weren't all getting those B-12 shots in the ass on set for nothing: bend over, flash a cheek—everybody was lining up. The doctor was behind a little curtain, some sort of screen, and he would call "Next!"

GRANT DELIN: I remember Kate Moss getting the shot and immediately needing to lie down, which was too much, because it wasn't like

it was even a drug. It was originally supposed to be only for the VIPs, but then Dick urged everyone to get it. Right in the butt. I only did it once, and my mouth tasted of yeast afterward. The doctor giving the shots was an Indian, and we had a running joke that he was just a cabdriver who happened to have a syringe. The studio manager Marc McClish's wife was a nurse and she eventually took over doing it.

PAUL BECK: We had our fair share of dramas, for sure. Oribe putting all that petroleum in Linda's hair, or whatever it was—some kind of gunk, something you get in a motor shop, so it was just not the right product to use. But he wasn't himself, because he would never have consciously planned on destroying a supermodel's hair. Anyway, in the photographs it looked really great.

Oribe came back from rehab stronger than ever. Like so many people that have gone through the drug mill, myself included. Back in 2000 I had to take a sabbatical to go to Silver Hill. I stayed the twenty-eight days, then did another two months outpatient. And look at me today! And look at Donatella—she entered rehab for cocaine addiction in 2004 and came out a new woman in every way.

Our daughter Allegra remembers Dick from way back when she was just an infant and he first photographed her. And now she's thirty-something and working full-time with the company. Gianni left her half of it outright, with 20 percent going to her mother and 30 to her uncle, Santo, who runs the business part of the business.

NAOMI CAMPBELL: I talk to Allegra all the time—she's like my little sister. Since she inherited the biggest share of the company, whenever I need a Versace dress for an occasion and they don't get back to me right away, I just tell them, "I'm calling Allegra," and I get it *pronto.* It's all fun and games at the end of the day.

PAUL BECK: The decision to replace Dick after Gianni died was just normal. Fashion is cyclical. It's a merry-go-round—that's the nature of the business. People come and go after a few seasons; they move on and there are never any hard feelings. There were about eight collections to shoot—we had a whole world of Versace going—and we

needed to have other photographers on tap. Over the years we also used Steven Meisel, and we used Penn a little, and Herb Ritts and Horst once each, I think. And Mario Testino. And Bruce Weber, of course, a lot. But Dick was there for most of the span. He had the longest and best run of all—he ran rings around practically everyone else.

18

BACK IN (EDITORIAL) FASHION

—

WHEN TINA BROWN HIRED DICK IN 1992 AS *THE NEW Yorker*'s first staff photographer, it was with the sweeping directive to do anything that interested him. The one thing he knew he didn't want to do was fashion: he'd *done* it—he'd had it all sewn up for decades, it had worn itself out as far as he was concerned. Besides, he felt that fashion these days was unimaginative, middle-class, boring: both the clothes themselves and the way they were presented in the magazines. He was happy to have gone out of fashion, in that sense.

It took a postapocalyptic dream Dick had—in other words, a nightmare—to make plain as day to him what his aversion to fashion was really about. In the dream, the only two people in the world to have survived a nuclear holocaust are a photographer and his supermodel wife. She emerges unscathed, with even her wardrobe intact. He, on the other hand, has become a living skeleton, with the bare-bones wardrobe that that implies. "It's fashion's last gasp," Dick explained to me. "And it has to be done full-color."

Dick saw the feature as filling the whole magazine. When I reminded him that the last, not to mention first, time *The New Yorker* had ever devoted an entire issue to a single story was for John Hersey's 1946 journalistic coup "Hiroshima," he said, "Well, there you have it—there

are parallels." But even with Dick trying to sell Tina on how much fashion and fragrance advertising the feature would generate, the best she was willing to offer was most of the well. Hey, it was the center of the magazine.

For the supermodel, Dick chose Nadja Auermann, with whom he had collaborated on four Versace campaigns. He had recently used her exclusively for a twenty-six-page Neiman Marcus advertising portfolio in *Harper's Bazaar*, and she had succeeded in transforming herself into a startlingly different creature in each of the outfits by the thirty major designers. And in the seasons-themed calendar for 1995 that he had just created for Pirelli, Nadja, partially masked by fabricated icicles, radiated heat as the face of Winter. "I represented three months— December, January, and February," she says. "He told me that the *New Yorker* piece was going to be very different, more like an art project, and that the outfits would not be the focus of interest. He promised I would have the freedom to express my innermost self."

Dick perversely decided to call the couple the Comforts, and he and Doon, with their combined imaginations of disaster, scared up a doomsday scenario to end all doomsdays. Their script called for the beleaguered supermodel to climb blistered and flaking walls, sweep biblical-scale floodwaters from floors, and dance around an infernal ring of fire—all the aforementioned actions to be performed, needless to say, in haute couture. Before she was through, she would be draping her size-zero husband in some of her clothes—the moment Dick thought that one up, he began referring to the skeleton as "Nan Kempner," after the late Manhattan social X-ray. "I felt the whole thing was getting *too* stylish—too pageanty," recalls Polly Mellen, the fashion editor on the shoot. "And to be perfectly frank, I wasn't a hundred per-cent for the skeleton. Dick had told me he wanted to develop deep ideas here, but then he went flying off in too many directions at once, for *my* taste." Polly's misgivings evaporated when Dick charged her to assemble a vast wardrobe of French couture and a safe's worth of genu-ine jewels.

Dick quickly settled on Montauk for the location, less because he had a house there than that the place exuded the right otherworldly, land's-end feeling. He put together a crew consisting of production

manager Kara Glynn, assistant Marc McClish, studio alumni Ruedi Hofmann and Grant Delin, and scenic designer Marla Weinhoff, who was in the middle of refurbishing his apartment. So spectacular was the project he envisioned that Dick ended up having to hire an entire art squad to work under Marla. It was his idea to have them all uniformly dressed, in khakis and camouflage jackets, so they would look like a small private army—"There's beauty in homogeneity," he offered.

I spent a three-day weekend scouting locations with Dick. On the outskirts of Montauk, in an overgrown field somewhere between the fire and train stations, an abandoned building caught my wondering eye. We had to claw our way through thickets, at one point crawling on our hands and knees. The place lived up to Dick's nightmare: it was a dream of dereliction, complete with broken windowpanes, vine-choked doors with hinges askew, and a blitzed-out interior. "This is it!" he exclaimed. "And Marla will make it look even worse for us." Her first purchase would be right on the mark—a dilapidated love seat from Buzz Scrap Metal in East Hampton.

Finding a suitable skeleton, one preferably scrubbed and flensed, was another story. Dick was adamant that it be human, not a plastic replica—he claimed he could tell the difference "a mile away," thanks to his having taken an osteology class back in the Merchant Marine. Marla, having clearly boned up on mortuary archaeology, cautioned that the bones would have lost their cartilage and connective tissue. To which Dick replied, "I'm sure you can flesh them out somehow." The skeleton she eventually unearthed was a shorty—not nearly tall enough for Nadja, whom you could bet your boots Polly would be putting in designer heels. The enterprising Marla solved the elongation problem with armature wire.

Joint articulation lay ahead—the thing had to be made mobile for posing. A member of the art squad, Brian Tolle, came in handy here, functioning as a one-man skeleton crew. Dick would say, "Can you get him so he can move his pinky a quarter of an inch to the left?" and *presto magico*, Brian would accomplish the digital feat. Dick would occasionally ask Brian to pose as the skeleton and, once or twice, as Nadja. And when he wanted an icon-like sculptural form to hang over one of the mantelpieces, he pressed Brian into service—a crucifix fash-

ioned from a rusted-out Venetian blind that he had literally stumbled on was the arresting result. The skeleton was hardly the only working stiff on set.

In the lengthy list of credits published in the back of the issue of *The New Yorker* in which the portfolio would appear, under "Cast and Crew" Brian received fitting credit, but the skeleton was stinted — billed as "A Person Unknown." Truth to tell, we knew who he was — or rather, who he had been, more or less. "I don't know if it was before the shooting or after that it was mentioned that our skeleton had been a homeless, apparently," Nadja says. "The place where they got him — maybe a body farm — knew his identity, so finding that out was pretty creepy for me. He was my husband, but maybe in life he had another wife."

Something besides the skeleton was rattling Nadja: "The woman in Dick's nightmare, she had brown hair, and I was a blonde, so naturally he sent me to a colorist in New York. And it came out aubergine. *Dick* turned purple when he saw it. We were in Montauk by then, and the hair stylist on the shoot, Julien d'Ys, had to strip all the color out and re-color me dusty brown. And in a small sink in a smelly motel bathroom!"

When the French couture cleared customs (the carnet was the length of a couple of boas), three of the assistants were on hand to transport it to Montauk. I elected to ride with the clothes (I mean, nearer my God to thee). An unpropitious decision, as it transpired: thirty-five miles short of our destination, a brushfire broke out in the pine barrens and there were flames raging across the highway up ahead. The world's best-dressed van had to be rerouted onto the mazelike back roads. I called Dick, who said, "Whatever you do, don't bring any smoke home."

Dick felt that clothes with the exalted provenance of these deserved a home of their own. For the previous weeks, his property manager, Ed Johann, had been building two wooden enclosures in back of the derelict building. One was exclusively for the footwear Polly had picked: the seventy-five pairs of shoes, boots, moccasins, loafers, sandals, and pumps, by such designers as Chanel, Robert Clergerie, Paul Smith, Manolo Blahnik, J. M. Weston, Hush Puppies, and — my favorite, in

light of the eerie mis-en-scène — Early Halloween. The other structure would shelter sheaths, ascots, turtlenecks, coats, gloves, skirts, trousers, hose, bead wraps, ties, blouses, pajamas, socks, sweaters, belts, jackets, blazers, suits, hats, goggles, vests, scarves, smocks, dresses, gowns, robes, bustiers, furs, helmets, and even armor, sporting such deluxe labels as Alexander McQueen, Geoffrey Beene, Versace, Armani, Thierry Mugler, Joop!, Jean Paul Gaultier, Romeo Gigli, Richard Tyler, Matsuda, Chanel, Donna Karan, John Galliano, Helmut Lang, Dolce & Gabbana, Comme des Garçons, Martin Margiela, Issey Miyake, Yohji Yamamoto, Hussein Chalayan, and Christian Lacroix. "One of the biggest disconnects of my life," Ed marvels, "was seeing this gorgeous model parading around a teardown in millions of dollars' worth of couture."

As Dick had promised, Nadja's role would extend above and beyond that of a mere clotheshorse. "For each image he wanted to create, he talked to me about the feelings," she stresses. "For example, the skeleton and I make a baby, and for the picture where I am being the good mother and letting it ruin my nipples, Dick told me, 'It's only a doll you're holding, Nadja, but if you think of it as really feeding at your breast you'll find yourself getting attached.'" The doll in question was an antique that Marla had found at the New York Doll Hospital and then further "distressed." And now, swathed in a John Galliano baby blouse, it was being launched on a journey from rags to riches in the time-honored American tradition. Dick also suggested to Nadja that, for the scene where she has to contend with the floodwaters, she should "just channel the *Titanic*," and that, for the one where she dances around the fire, she should imagine herself as Joan of Arc (to that end, he rented the Carl Dreyer movie for her to watch).

The bills were mounting — toward the seven-figure range. When the time came to gather them up for *The New Yorker*, Dick said, "This is going to require a million-dollar present." I got hold of the biggest Tiffany box in stock, lined it with plush, and filled it to bursting with all the invoices and receipts. "Since it was the most elaborate shoot ever," says the *New Yorker*'s Pam McCarthy, "it *had* crossed my mind that the budget might be history-making and that in any case a big number was coming." She adds that when she saw the full-dress Tiffany presenta-

tion she rolled her eyes but had to laugh—"It was quintessential Dick, winking at me from Seventy-fifth Street, wrapping up unwelcome news and putting a ribbon around it." "I thought that was wonderful," says David Remnick, a staff writer at the time. "It's the kind of story that we will remember a certain bygone era by. Because, believe me, it will never happen again—*anywhere*. A whole epoch of extravagance ended with the delivery of that Tiffany box."

The taxing shoot lasted six weeks, yet everyone involved felt desolate when it came to an end—it was a little like the breakup of a family. We had taken practically all our meals together—eating, as Dick had laughingly ordered, only what grew, swam, waddled, and/or flew around his place. The whole aesthetic thrust of the endeavor had been toward creating and rendering mayhem, so it seemed peculiarly fitting when life began imitating artifice. Dick had had a swing set installed on the side of his house for his grandsons, and Ruedi Hofmann's visiting son fell off and broke his arm. Soon the studio manager, Kara Glynn, was added to the casualty list. "I kidnapped her one afternoon to take her riding," the property manager's wife, Dawn Johann, recalls, "and as we were hustling back, her horse spooked out from under her and she went straight down on her face. She was wearing glasses and they shattered, so she had some pretty good slashes up through her eyebrows and beyond."

"I wound up with around five hundred stitches in my head," Kara says. "I also sustained a very bad concussion, and I couldn't really move my arm. I was out of commission for over a week. Dick didn't talk to me for a month. The one thing he did say was, 'I never said you could go horseback riding.' He was mad at me anyway, because I had told him I was planning to leave in around a month. They get mad when you leave—they get mad when anything doesn't go exactly how they planned it. I went to work for Annie Leibovitz, as her studio manager and producer for three and a half years, and she got mad like that, too, when I left. Anyway, that was the very uncomfortable end of the Comforts shoot for me. I prefer to remember the nice things about it, like the big family-style dinners around the beautiful stone fire pit on the top of Dick's cliff where Ed Johann would roast a 'virgin goat' or grill fresh-caught tuna. And the great outdoor shower that had mint growing

underneath the wood panels, so when you turned the water on really hot you got a gust of herbal vapor."

Sam Shahid recalls the mood of anticipation: "I was in Miami shooting Versace with Bruce Weber, and everyone was dying to get a pre-pub peek at Dick's *New Yorker* pictures. The magazine was playing it very close to the vest, but Donatella managed to get hold of them somehow, and she put someone on a plane to bring them down to us— FedEx wasn't fast enough, right? The piece was genius, sheer genius."

"In Memory of the Late Mr. and Mrs. Comfort: A Fable by Richard Avedon" filled twenty-six out-of-this-world full-color pages in the November 6, 1995, issue. The cover line trumpeted "Richard Avedon Returns to Fashion." There were those who felt that he had done so with a literal vengeance—the portfolio bothered and bewildered as many readers as it bewitched.

"To be honest with you, the Comforts wasn't my bag," David Remnick demurs, "and had I been the editor of the magazine at the time, I would not have published it—you can only publish what your stomach tells you you're able to, much less your brain. But then, fashion, as anybody can see, isn't my bag. That admitted, I did feel that all those endless pages spoke to both Avedon's ambition and his—I say this word with love—craziness. And also to Tina's ability to take a giant flier. And also, it goes without saying, to the sheer amount of money sloshing around at that time." Even Dick's ardent old cheerleader at *Newsweek*, Charles Michener, wasn't twirling the baton this time around. "To me it was as if Fellini had directed *Funny Face*—the Comforts was just a cheap, old-fashioned attempt to shock." The ever-authoritative *Economist*, on the other hand, pronounced the portfolio "shocking."

To Salman Rushdie's jaundiced eye, the Comforts amounted to "Death and the maiden, a spectacular, with costumes by the great designers of the world . . . a high-budget, high-gloss elaboration of [a] type of mega-commercial rag trade extravaganza." He went on to wonder if Dick was "making a joke at his own expense, the skeleton as grand old man; perhaps he is hinting at the passing of the supermodel phenomenon."

"I had a hate-love affair with the Comforts," the stylist Joe McKenna reflects. "At first it felt like just an exercise to me. Only with time did I

come to understand that what it was was an elegy. Because Dick wasn't wrong—fashion *was* dead. It had become much more about accessories than beautiful clothes. And to think that he actually *created* all those fantasies in the Comforts, which nobody today could possibly do without digital."

"Some folks were outraged by Dick's picture of me having sex with the skeleton in a doorway," Nadja says. "And there was the whole nudity issue. For me, personally, that was not such a big deal, but professionally you do have to be careful—I had a contract with an American designer at the time that said no nipples even under a shirt, and my agent was angry, because I could have been fined. But there is vulgar nudity and there is beautiful nudity, and with Dick, especially when it was editorial, it was art."

The New Yorker organized an exhibition of the Comforts prints at a downtown gallery. The opening drew a slew of superstars, present and long past. Veruschka showed up—at age fifty-five, a fabulous ruin. After making a sweep of the premises, she began circling Dick, then retreating. She fastened on me instead, and said, "The pictures are interesting, ja—the skinny blonde from Berlin looks okay. But look now, over there, how Dick is not looking at his Veruschka! He must still be hurting that she ran off with another photographer, Rubartelli, who told her, 'Nobody photographs Veruschka but me!'" And with that, she took a powder.

A less vintage supermodel, the outspoken Kristen McMenamy, approached Dick—only to reproach him: "You know how much I always wanted to do editorial with you, so let me ask you something, Why *her*? Why didn't you pick *me*? I can't tell you how jealous I am." Dick just looked at her and moved off.

For Marla Weinhoff as well, the Comforts had a toxic aftertaste. "It took me a while to recover from it chemically," she says. "I was right there in the thick of it, brooming up the floor myself to get the best dust effect, then doing a *Fahrenheit 451* and setting fire to the books for the library scene and getting down on all fours and blowtorching the rug. There was plenty of lead around, too—I felt stuff in my lungs. I mean, I could have wound up being credited posthumously: '"The Late Mr.

and Mrs. Comfort" styled by the late Miss Weinhoff.' But you know something, I would die to have another project like it!

"I work for Lady Gaga now. Imagine—when Dick was alive, she was still just in high school. She loves his photographs, by the way. And *he* would have loved *her*, and wanted to photograph her. What I love about the House of Gaga is how collaborative it is—so similar to the Avedon studio in that respect. When Gaga was being interviewed once, she introduced me to the journalist and said, 'This is my art director, she worked for Richard Avedon—I don't know why she's working for *me*.' And I went, 'Because he's dead!'"

The day after Dick died, Harvey Mattison, the assistant who was more like a surrogate son to him, phoned me to condole. "I was up all night thinking of that series of skeleton pictures he took ten years ago," he said. "All those swirling, grasping shapes in that end-of-the-world scenario. During that shoot he called me very late one night to tell me how excited and agitated he was about making those photographs. I'm thinking now that he must suddenly have realized that it was more than an essay on the death of fashion. In the portfolio the skeletal figure first materializes in the guise of a photographer, after all—with a cable release in his hand. So, I mean, if that wasn't a conversation Dick was having with his own mortality, I don't know. *I* certainly see it as his own danse macabre."

19

BELIEVE IT OR NOT

—

L ATE IN 1997 THE RED PHONE IN THE STUDIO RANG. IT WAS Tina calling to say she had a hot new idea—religion. She was after Dick to make a portfolio of "phenomenal" photographs to commemorate the imminent millennium. "Do it any way you want," she said to him. Dick said to me, "There are always sixty ways to Sunday."

God knows, this was an unbelievable project. Dick was a die-hard atheist. Whenever he was asked if he believed in the Almighty, he would say, "God is incredible only in the sense of not credible—he's far-fetched." Or he might quote the English dramatist Dennis Potter to the effect that "God's a rumor." He had announced to the star-studded crowd at the black-tie dinner the Whitney threw to jump-start his 1994 retrospective, "I don't believe in God, but God spelled backward is dog, and so I call on dog to keep and help us." (As we well know, he didn't believe in dog, either.) *Divine* was an adjective Dick reserved for certain dresses (not to mention one that people in the fashion industry often used to describe *him*). When Princess Margaret asked him once, "What do you think about prayer?" he replied, "I haven't got a thought, ma'am, and I haven't got a prayer." To which she retorted, "Oh, so you are non-speaks with God."

His godlessness aside, Dick was convinced that his religious pic-

tures for *The New Yorker* would possess the requisite conviction—such was his faith in himself. "Matisse was a nonbeliever, and look what he did for that nothing little chapel in Vence," he said to me. "I can do amazing things, too, even when I can't feel them." In secular terms, he saw the project as a potential godsend: it could ultimately morph into a museum exhibition and a book.

DICK AND SUPERFACILITATOR SARAH GILES IN INDIA.

Tina tapped her old *Vanity Fair* colleague Sarah Giles, an indefatigably upper-class English girl, to assist Dick. Sarah was a facilitator on the level of Laura Wilson—top-of-the-line. "He told me straightaway he didn't want to go near Judaism—too fraught, he said—but that everything else was on the table," she recalled. "He was especially keen to include Buddhism, which he claimed to know a helluva lot about." It was certainly a religion in which you could say Dick was already heavily invested, in that he had been supporting his son's immersion in it for lo these many years. John's book *In Exile from the Land of Snows*, a history of Tibet since the Chinese conquest, had been published in 1984, shortly after which he was approached by His Holiness the Fourteenth Dalai Lama to write his official biography. "I'm just so dazzled to be his dad," Dick went around saying at the time. One of his assis-

tants recalls accompanying him to a screening of a documentary about the Dalai Lama in which John was extensively interviewed. "Dick was so proud because people came up to him afterward and were like, 'Oh you must be John's father.' He said to me, 'Finally people are saying that.'" But now with the advent of the religion project, Dick was concerned that John might feel he was trying to steal some of his thunder.

John's first two marriages had been what begs to be described as hotbeds of Buddhism. His first wife, Dick's erstwhile designer Betti Paul, left him for Buddhism's poster boy, Richard Gere, who then segued to Dick's model Cindy Crawford. Cindy remembers how Dick "bent over backward for Buddhism," taking photographs of guests at Tibet House galas and donating his fee, as well as editioned prints for the auction block, to the organization. When John remarried, a few years later, and had a big blow-out Buddhist cum interfaith wedding, the Dalai Lama's brother and sister-in-law made the trek from Dharamsala to Montauk Point. ("The Dalai Lama doesn't go to weddings—monks can't," explains the bride in question, Maura Moynihan. "That's why Nicky Vreeland couldn't come, either. Two hundred others did. My dad was there—the senator. No presidents, though—he wasn't one of *those* Washington people, which was why he was always able to keep his independence of mind. Paul Simon came, and Diane Sawyer and Mike, plus a lot of our Tibetan friends and a lot of my Indian friends from when my father was ambassador there. I've destroyed the wedding pictures—I burned them all.")

"Dick would brag to me about the seriousness of John's chosen life—what a highly evolved Buddhist he was, with a centeredness so great that the Dalai Lama had brought him into his innermost circle," Dick's museum-director friend David Ross says. "So it was a huge disappointment for me to see how John the Buddhist operated in the real world, which was just in a very materialistic way." Dick's trainer, Kerry Roland, adds, "John had injured his back in the gym he'd installed in his house in Sag Harbor, and Dick wanted me to advise him on what exercises to do. So we drove out there, and when we pulled up in front of the house, Dick said it must be the wrong address. I showed him that it was correct, and he refused to get out of the car, he just sat there in total shock. The place was in the process of being renovated at Dick's

expense by the architect who had built his place in Montauk, Harris Feinn, and now Dick was seeing for the first time that the addition was much bigger than the original house. I finally got him to go in, but he remained practically speechless—he was so quiet it was amazing. On our way home, he kept repeating, 'I don't understand it. He was supposed to be doing just a little annex. He's not behaving in a very Buddhistic way.'" But later, denial took hold and Dick was able to convince himself that John's beliefs were heartfelt.

To Sarah Giles, Dick had said, at the outset of the religion project, "The Dalai Lama is so important to my son and my son is so important to *me* that I'm prepared to go to the ends of the earth to photograph him again." Dick had photographed His Holiness for *Rolling Stone* in October 1979, but a little closer to home, at the Waldorf Astoria. On that occasion the Dalai Lama had stepped in front of Dick's seamless, then opened his mouth to speak. Dick was expecting the utterance to border on the momentous. "Color or black-and-white?" the high lama inquired.

"Before we went traipsing three-quarters of the way around the world in pursuit of Tibetan Buddhism," Sarah said, "I made so bold as to suggest that Dick have a little go at Christianity. I had just read in the paper that His All Holiness Bartholomew was doing a whirlwind tour of America. He was the archbishop of Constantinople and New Rome, and the ecumenical patriarch and spiritual leader of three hundred million Orthodox Christians. The Greek channel Odyssey was broadcasting daily updates of his progress, and we caught up with him on his final stop, Pittsburgh. I made the arrangements for a pre-breakfast sitting, through George Stephanopoulos's divine mother, Nikki, who did the public relations for the Greek archdiocese—it really *is* a very small world, isn't it? If it weren't for His All Holiness's stubby little hands and the fact that he was just the son of a Turkish coffee-shop owner, I would use the word *resplendent* to describe him—the jeweled crown he had on could certainly have given our queen's a run for its money."

Next stop was one of Her Majesty's former colonies. In January 1998 Sarah flew to the subcontinent ahead of Dick, to line things up as only she could. "I was an old India hand—I had a lot of insider connections there," she said. "The first thing I did was rent a high-grade mini-

bus for Dick and me and the three assistants, Sebastian Kim, Marc McClish, and Grant Delin. Dick and I would huddle in the back and have all these really intellectual conversations about all the people we knew in common—he was desperate to know if Tina had affairs, other than business. We would be munching on tangerines and dates as we bounced along on the rutted roads—such very long distances you can't imagine. Believe me, it was no stone's throw to Karnataka, where we were going to meet the Dalai Lama, who was conducting classes at the Gyumed Tantric Monastery."

In Karnataka, Dick was bidden to do something he had never done before—stay absolutely still for three hours. Sitting on a hard floor with his legs crossed, he listened impatiently to the Dalai Lama's teachings

DICK AMID THE MONKS.

in Tibetan. "He did bloody well," Sarah recounted, adding, "Whenever it looked like he might be even *thinking* of getting up, I tapped him on the knee and gave him a good old schoolmarmish scowl."

When the Dalai Lama received Dick at the monastery, Dick made a perfect courtly bow. "He had been rehearsing Tibetan high etiquette all week," Sarah said. "He was even wearing his jacket the way the monks wore theirs, a bit backward, and he continued wearing it like

that—he said he considered it a great new look." Dick reported to me by phone that the shoot had gone well—he had used the four-by-five, so there were only about twenty frames—and it had taken him all of ten minutes.

As they were departing Karnataka, Dick decided to make an impromptu side trip to visit Diana Vreeland's grandson Nicky, his assistant in the early seventies who was now a monk at the Rato Dratsang

DICK WEARING HIS COAT IN THE STYLE OF THE MONKS.

DICK WITH GESHE THUPTEN LHUNDUP, A.K.A. NICKY VREE- LAND, HIS ONETIME STUDIO ASSISTANT AND DIANA'S GRANDSON.

monastery. It was John Avedon who had introduced Nicky to the Tibet Center in New York, where he went on to become the director. Nicky had worked for Irving Penn as well as for Dick, but when his cameras got stolen he had decided to use the insurance money to study Buddhism full-time. It was now paying off big-time: the Dalai Lama had recently appointed him a Tibetan Tantric abbot, and Nicky was now the Venerable Nicholas Vreeland, a.k.a. Geshe Thupten Lhundup.

Next, Sarah presented Dick with the awesome opportunity to photograph not only the largest religious happening but the largest peaceful agglomeration of any kind in recorded history: the months-long Kumbh Mela Festival, held in 1998 in the district of Haridwar. "I decided not to mention to him the very real possibility of a stampede," she admitted. "To get the old photographic juices flowing, I painted a picture of millions of naked Hindus clustered on the banks of the freezing Ganges at the crack of dawn, getting ready to take a holy dip. He was intrigued, but what really did the trick was when I told him that the staunchest of the believers practiced extreme mortification of the flesh—all in the name of prompt karma clarification, of course. I was an eyewitness to some of those superhuman feats. I'd been running myself ragged photographing as much as I could with a Polaroid, because a big part of my job was to preview madness like this for Dick. Then if he liked the look of something, I would have to go back to the people involved and talk them into doing it all over again, exclusively for his camera.

"What totally grabbed Dick was the naked naga holy men pulling trucks with their penises—*I* call them lorries, of course. The point of the exercise was to break their erectile capacity so they could then devote themselves purely to God. A few of them took a different route from the trucks and tied a holy cord around their penises to lift heavy weights with. At first they were a bit reluctant to do their thing for Dick. But by hook or by crook, I was able to maneuver a few nagas to the makeshift studio he had set up on the banks of the Ganges. He surprised me a bit by insisting on tying the bundles of rocks onto their penises himself—he said he needed to fiddle with them to try and get them to swing back and forth rhythmically. I remember one of the holy men had a padlock tied on instead of a rock. I can't seem to get that

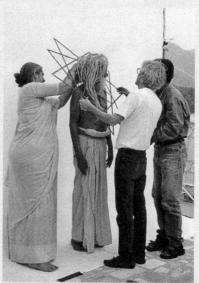

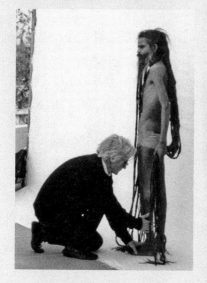

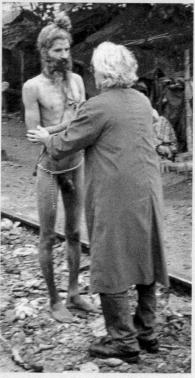

THE LENGTHS DICK WOULD
GO TO FOR A PORTRAIT:
HERE HE'S PREPARING
TO PHOTOGRAPH THE
NAGA HOLY MEN'S RITE OF
PENILE PURIFICATION.

grisly S&M image out of my mind. You should have seen the look on David Remnick's face when he was shown the choices from the penis shoot. But in the end he overcame his personal repugnance and published a couple of them. Frankly, he wasn't wild about the religion project to begin with. It had been initiated by his predecessor, Tina, so there you go."

Dick's assistant Sebastian Kim, looking back on the trip, prefers not to dwell on the nagas. "Give me the sadhus any day," he says. "They're ascetic wandering monks, renunciates, holy men of Hinduism. We lucked into a group of about twenty of them in Calcutta sitting in a tent in a circle eating off the floor with their hands. They gestured to us to join them. We all just did this pretend eating, while looking around at each other to see if anybody actually *was* eating from the ground. Grant was the only one of us who was really doing it. He knew the ropes in India and he whispered to me, 'Sebastian, just enjoy it—you're going to get sick here anyway.'"

"After we ate, or didn't," Grant fills in, "they passed around hashish, which we just touched to our lips, and sweetmeats, and we all did get sick, actually. We had a couple of interpreters with us that Sarah had found through her helpers on the ground, but really they were unnecessary—Dick was someone anyone could understand even without words. He didn't need language to accomplish what he wanted— his eyes did all the talking. In India they reacted to him the same as if they had been in the studio in New York, in the cyc. With the sadhus especially, it was like the camera wasn't even there. Dick was using the Deardorff so he wouldn't have to look through the lens and could just focus on the sitters. These sitters were *actually* sitting, and they leapt up as we were getting ready to clear out and heaped garlands of marigolds around Dick's neck."

Dick was looking forward to photographing a Ganges cremation. Sarah had recommended the holy Hindu city of Varanasi as "*the* place people go to be cremated"—indeed, the hotel she had found was advertised as "convenient to a major crematorium." For a change, it wasn't Sarah who had the "in" in Varanasi, it was Grant. "It's kind of a medieval Venice—the only way to get around is by boat, so I arranged for a boatman called Gopal, someone I'd used when I was there be-

DICK EN ROUTE
TO A GANGES
CREMATION.

fore," he says. "India had just won a big cricket match against Pakistan, and there were fireworks going off and everything. Marc McClish and I were cheering, along with the passengers on the other boats, and we were talking cricket to Gopal. But when I looked over at Dick I could see he was pissed at not being the center of the conversation. We were there on his ticket, so I felt we had no right to be blocking his enjoyment and I quickly changed the subject back to him—even on the Ganges the unwritten studio rules applied."

Their destination was the burning ghats. "The smell coming upriver that day was particularly putrid," Sarah recalled. "One whiff and Dick swore he would never eat a piece of barbecued meat again. I had applied for permission for him to get close enough to do a full-on photo, but it hadn't come through yet. He was getting ready to flash his laminated *New Yorker* press pass—he said, 'This will do it.' I knew bloody well it would not. It was beginning to look like we might have to bribe our way in—I had feelers out to a corruptible person high up in the local government.

"But then just a few hours later we got the green light to photograph on the Manikarnika Ghat. The proprietor handed us each a pair of thick black goggles to deflect the glare, which he explained came from the eternal cremation flame that in turn came directly from Lord Shiva. Meanwhile I noticed his wife was cooking their dinner on it, which put us all rather off our religious feed.

"Dick didn't know it, but he was about to get a real taste of India—a proper mouthful. He was photographing standing up in the boat. There were masses of oil lamps illuminating the pyres as they floated downriver in the dusk, and he became transfixed by them and leaned forward, rocking the boat. He got pitched headfirst into the septic water—I mean, there were gold teeth and nose rings and pieces of bone bobbing all around him. He was managing to hold his camera above his head—just. Sebastian and Marc dove in and fished him out. He was soaking bloody wet. The horror was I had just finished telling him about the post-cremation cleanup squad, a thing that only the brutally calculating Indian mind could have invented. The poor, you see, simply can't afford enough wood for their pyres, which means, if you get my drift, there are always going to be, shall we politely call them, leftovers. And those remaining odds and ends need attending to. So those clever old Indians bred up a species of marine reptile—a snapping turtle with a digestive capacity to stagger the imagination. Dick when he fell in must have been entertaining visions of *Jaws*.

"He stoically chose to continue with the shoot. And he was still going on about the beauty of those blasted oil lamps. The cadaver he was photographing had been just some minor civil servant. It was lying on a bamboo stretcher with its mouth wide open, and we watched it being set aflame and floated down the Ganges with the current— crackling and blackening. Didn't faze me a bit. I mean, I'd just had my dad cremated. And Dick told me likewise his mum."

Anna had slipped away a couple of years before, in the summer of 1996, at the age of ninety-seven, with Dick holding both her hands and John filling her ears with Tibetan prayers. "She looked so beautiful and so peaceful—like a kind of angel," he wrote to his old secretary Penny Cobbs. "Dick had me pick up his mother's ashes from Frank Camp-bell's," Grant offers, "but then he didn't like the urn they were in and

made me take it back. Then he didn't like the replacement urn any better, so back *it* had to go as well. In the end he decided the ashes should be divided among three urns, all of which he wanted to pick out himself." After Dick died, Sarah asked me, "What happened with his body?" When I told her that his long-standing wish to be cremated had been honored, she expressed amazement: "He was so appalled by the stench of burning flesh in India, I have trouble believing he would have elected to put himself through that process."

Back in New York, Dick learned that the Dalai Lama was coming to town, and quickly arranged to do yet another sitting. It took place on May 2, a Saturday morning. "We got there just as His Holiness was concluding an important meeting with Uma Thurman," Marc McClish recalls, adding, "It was going to be just a tight head shot—nothing more. Dick was using his Hasselblad because we were in a small space, and I put the lighting umbrella directly above it. He was peering down into the viewfinder, and he said okay, then stepped away to start shooting, so I dropped the light down. But in that split second he had gone and done something I had never known him to do—taken another look through the viewfinder. And just as he lifted his head up, the light cracked him on the noggin. Pretty hard, too, I'm afraid. Luckily for me, the Dalai Lama found it hilarious—he got a fit of the giggles, like a schoolchild: heeheehee, hahahaheehee, hooheeha . . . He was all lit up, the way a holy man *should* be. And Dick seized the moment and started clicking." "What made that shoot so unusual," Sebastian Kim adds, "was Dick only did four frames. Normally he would do, like, twenty-four. He had a big smile on his face, and that was the most amazing thing—the *two* big smiles. He said, 'That's it, Your Holiness, it's a wrap,' and the Lama trotted on out."

Dick gave the photograph to Nicole Wisniak for the cover of *Égoïste*. "The whole time we were in India he was telephoning her every night," Sarah said. "And hardly a day went by when he didn't try to buy her an expensive piece of jewelry. I steered him to the chicest shops and, if he liked the stones, I helped him do the deal. She wanted everyone to believe he was her boyfriend—never mind that she was married! But then, of course, Dick was married, too—although I never did get to meet the mad wife who lived midtown. I wouldn't have been snoopy,

that's not in my nature, but one day when I was in Dick's hotel room and he was out, there was an opened letter on the table with Nicole's signature, and basically she was pleading with him to marry her—I had the feeling he might have left it lying around on purpose. He had told me that when they traveled they shared a hotel bed, but I had the distinct feeling that all that ever took place on it was a lot of gossiping and intellectualizing, and a lot of eating of caviar on fur coverlets."

Although Dick was as intent as Nicole on having people believe they were an item, he was careful to never publicize the so-called affair—out of a sense of delicacy where Evie and John were concerned. I once heard him say to a journalist who had brought up the subject of Nicole, "She's an untouched area." I had to laugh, because that was exactly how *I* saw it, in a literal way. *Untouchable* was what he had probably meant to say.

After the trip to India and the Dalai Lama shoot in New York, Dick, with Sarah and Marc and Sebastian in tow, made a pilgrimage to San Vicente de la Sonsierra, in the La Rioja province of Spain. His hope was to catch flagellants in the act, on Good Friday yet—religious theater at its most grotesquely picturesque. To hear the assistants tell it, Dick failed to rise to the occasion, at least at first. "He must have taken something during the night because when he woke up he was slurring his words more than usual and he was very unsteady on his feet," Sebastian recalls. "Marc and I were really worried because the plan was for him to follow the flagellants up a steep hill—they were going to be walking barefoot, with their legs chained together, lugging a huge statue of the Madonna. But within half an hour he had pulled himself together, with the help of a picker-upper or two."

Over the phone Dick described these penitents to me as truly something to behold in their white hoods with eyeholes and their white knee-length robes with the opening in the back. He described how they lashed themselves ecstatically on the back with a rope or spiked steel ball, all the while praying and repenting like mad, and how their wounds were then lanced with shards of broken glass. A team of professional healers applied balls of beeswax embedded with crystals to the penitents' welts, followed by rosemary water and a secret cream. Dick

summed up the San Vicente scene for me as "masochist heaven," and his pictures were both supernal and infernal.

As they say, all roads lead to Rome. Sarah had gone ahead as usual to lay the groundwork. "Dick wanted to do the pope so badly," she said. "I told him not to get his hopes up, that the pope was easier said than done. He said, 'Just get me the pope.' So I spent two stifling weeks—it was the middle of June and over a hundred degrees—staggering around Vatican City making contacts. Finally in desperation I ran up to the priest who looked the most official, and you'll never believe who it was—*yes*, Cardinal Ratzinger, the one who became the next pope, Benedict the Quitter. But the closest I ever managed to get Dick to the reigning pope was the popemobile. I pulled out all the stops and arranged for him to run along behind it while the pope was in it—look, you don't have to tell me nearsies don't count. Ratzinger did set us up to photograph the cardinal who controlled the Vatican purse strings—Antonetti. I remember him holding his hand out to Dick to be kissed."

After the big papal letdown, Dick, Sarah, and the assistants flew to Paris, where Nicole had organized a portrait of the ninety-year-old Soeur Emmanuelle. Everything Dick had heard and read about her excited him: as a girl she hadn't been able to leave the boys alone; so she went and became a nun, spending years living among and improving the lot of the garbage collectors of Cairo, from whose midst she had emerged smelling like Mother Teresa. She had just been voted the sixth most popular personality in France, ahead of Carla Bruni and Gérard Depardieu. Dick took an uncharacteristically kindly picture of her, which appeared both in *The New Yorker* and on the cover of *Égoïste*.

The religion portfolio was published in *The New Yorker*'s November 29, 1999, issue under the heading "Revelations"—something that the photographs, accomplished as they were, were not. The feature was subtitled "a work in progress," but Dick decided not to. And frankly, unlike those Spanish flagellants, nobody at the magazine was screaming for more.

Dick continued to devote himself to the only religion he had ever

put any stock in. "It's not God who created our civilization, it's money," I had heard him declare on many occasions. "Money is the only power in the world, and *that's* my belief."

From Dick's lips to . . . God's ears? The next commission that came our way was truly heaven-sent.

20

THE CASH COW

—

THE MIRACLE OCCURRED IN THE FIRST WEEK OF THE MILLEN-
nium. A representative of the State of Qatar contacted the studio on
behalf of Sheikh Saud bin Mohammed bin Ali al-Thani to schedule a
meeting between His Excellency and Dick. The sheikh was the world's
reigning photography collector. He had recently purchased a collec-
tion of 136 historical images for more than fifteen million dollars, as
well as set the record for a single photograph, $840,000 for a nineteenth-
century Gustave Le Gray seascape. From there he went on to shatter
his own record, shelling out even more dosh for a daguerreotype of an
ancient Greek temple. And this was not even counting the fortune he
paid for a storied collection of vintage cameras.

During the course of his five-year $1.5-billion binge, the photo-
graphaholic sheikh had also splurged on priceless jewels, carpets, tex-
tiles, ceramics, metalwork, dinosaurs, meteorites, carvings, rare books,
Islamic art, botanical and natural-history prints, Art Deco furniture,
Egyptian antiquities, and vintage scientific instruments. And now, his
representative was telling me, the sheikh wished to commission a series
of portraits of himself from Richard Avedon.

Dick and I decided it would be better for business if we went to the
sheikh for the introductory meeting, so in effect the mountain went to

Mohammed. Or at least to the Helmsley Palace, where the sheikh and his entourage were occupying the entire top floor. His Excellency turned out to be young (early thirties), tall, dark, and heart-stoppingly handsome—just this side of magnificent, in fact. He looked like Omar Sharif. He had on green leather cowboy boots and an Italian suit with enormous shoulders, and the eye-blinding red beads he was worrying could easily have been cabochon rubies.

The sheikh was shy, and Dick and I had to make a big effort at small talk. But when Dick asked him what his favorite movie was and he answered *Lawrence of Arabia*, Dick said, "Mine, too!" and the ice was broken, or rather, the sands shifted. The sheikh warmed up, plunging into a fervent, far-reaching discussion of his current project. As chairman of Qatar's National Council for Culture, Arts, and Heritage, he had set in motion the building of a constellation of major museums along the Corniche in the capital city of Doha. "I plan to make Qatar the cultural mecca of the Middle East," he stated, adding that I. M. Pei was designing a museum of Islamic art, and Arata Isozaki a combined national library and natural history museum. A museum of traditional clothes and textiles was also in the works. But more to the point where Dick was concerned, there was to be a Santiago Calatrava–designed museum dedicated to photography—"one of my passions since boyhood," the sheikh confided. "I hold photography to be a very high art, and I revere masters such as yourself, Mr. Richard, and my very dear friend Mr. David Bailey." Dick visibly bristled at the mention of Bailey.

The first sitting was scheduled for the next day, and Dick suggested the sheikh dress casually. He arrived, however, in a three-piece bespoke Italian suit—accompanied by an aide-de-camp he introduced as an old school friend, who happened also to be named Saud. To Dick's relief, Saud Number Two produced a black turtleneck from a Hermès bag whereupon Saud Number One disappeared into the dressing room to slip into it. The shoot took ten minutes max, and set the sheikh back pocket change for him: $75,000 for the first-choice 20 x 24-inch black-and-white, another $75,000 for the second-choice 16 x 20, and an additional $50,000 for the third-choice 11 x 14. The cash cow was mooing.

A few days later the sheikh swept back into the studio for his more formal portrait. Saud Number Two presented an array of garments for

Dick to choose from, and he picked a black silk gold-trimmed robe for the sheikh to wear. Dick delivered a regal portrait. Another two hundred thousand, please.

Upstairs in Dick's kitchen, over mint tea and biscotti, the sheikh announced that he had a "grand proposition for Mr. Richard." He explained that he was an "impassioned" collector of exotic animals and birds, that several of the specimens he possessed were extinct in the wild, and that they were all housed in his private wildlife preserve and state-of-the-art conservation center in the desert just outside Doha. He voiced the "profound hope" that Dick could be persuaded to spend several weeks photographing an as-yet-unspecified number of these and other creatures, and intimated that he was prepared to make it worth our while. First off, Dick would be required to accompany the sheikh to a couple of American zoos whose collections included animals that not even he had been able to obtain ("a very big sadness for me").

Once we got to Qatar, he offered, he would certainly be commissioning additional portraits—of himself, his wife the sheikha, and their three young children. "Surely you are familiar with the portraits of the maharaja and maharanee of Indore accomplished by the great Man Ray," he said, adding that it would be no trouble to arrange for Dick to see the originals, given that he owned them. We would presently learn that the sheikh believed he bore an uncanny resemblance to said maharaja and that he had gone out of his way to amass almost everything that had ever belonged to him, down to his bed, and including his jewels, luxury automobiles, and Art Deco furniture (such as the macassar ebony bookcases and other equally fabulous pieces custom-designed for the International Style Indore palace by Émile-Jacques Ruhlmann).

Normally, whenever anybody of exceptional means wished to hire Richard Avedon badly enough, there was really no number I could ask for that would be too big. I now named a figure well into the millions, half of it payable before we set foot in a single zoo. The sheikh didn't bat so much as a long eyelash. Nor should he have: for those royal riyals, he would be getting twenty-five museum-scale (32 x 40-inch) and museum-quality original signed-on-the-front-and-stamped-on-the-back Avedon prints mounted on linen, in addition to twenty-five eight-by-tens and assorted engraver's prints.

The princely fee was not the only incentive for Dick—nothing was ever *just* a money job to him. Even in his early days, when he was shooting a plethora of toothpaste and bra ads, he was always able to find his way into enthusiasm. In this case, the commission would involve an extended trip to one of the few parts of the world still foreign to him, and he found himself hoping that the Arabian Peninsula could provide enough material for, say, an Eastern project to rival his Western one of yore. And finally there was the pleasure of the sheikh himself, who had revealed himself to be far more than just an ATM on legs—Dick and I had both fallen prey to his charm. The only downside, really, was that Dick had no use for animals of any stripe whatsoever.

The sheikh's staff kept the studio fax working overtime. Day and night it spat out lists of animals that Dick might be required to photograph. Flamingo, koala, and giant panda were species we knew from, but what in the name of Allah was a sifaka? Or an indri? Or—ay yi yi!—an aye-aye? We looked all of these up in zoological tomes, but failed to locate one species on the agenda—the albanda. Finally the sheikh's office notified us that it was a typo.

One of the lists had the worrying heading "Sit and Wait Animals." It included a bongo, an okapi, an edmi, a Mhorr gazelle, a Muscat gazelle, a Rihm gazelle, an Arabian tahr, a southern black rhinoceros, and a Masai giraffe. Another communication was alarmingly titled "The Sheikh's Wish List." That one consisted of a Jentink's duiker ("also known as gidi-gidi in Krio, and as kaikulowulei in Mende," the sheikh hopelessly pointed out in a handwritten aside) and a dibatag (an antelope native to Ethiopia and Somalia).

In his relentless quest for perfection, Dick had the entire studio researching animal portraits of all kinds, from Audubon's *Birds of America* to Prince Rodolphe II's *Bestiaire* to *Walker's Mammals of the World*. "I need to bone up on seducing savage beasts," he laughed. "And at *my* age!" He was pushing eighty—and, true to form, still pushing.

In both his written and face-to-face communications with Dick, the sheikh persisted in addressing him as "Mr. Richard." Dick finally wrote entreating him to "please call me Dick, which is what my friends and my assistants and even my servants all call me. 'Mr. Richard' makes me sound like a hairdresser. And by the way, how would

you prefer that I address *you*? "I am only too happy to call you any-
thing you deem fit, up to and including 'Your Highness.' Remember
please that I am not used to dealing with royalty." The sheikh faxed
back: "Dear Mr. Dick, in response to your recent inquiry, please call
me Saud."

DICK GIVING
DIANA, PRINCESS
OF WALES, A
PRIVATE TOUR BE-
FORE THE OPENING
OF HIS EXHIBITION
AT THE NATIONAL
PORTRAIT GALLERY,
LONDON, 1995.

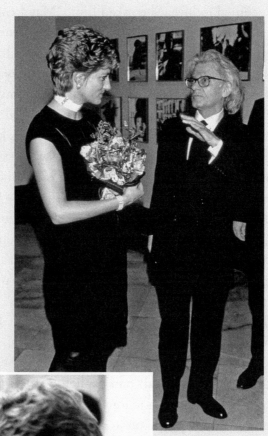

DICK AND THE
PRINCESS CHEEK
TO CHEEK.

PHILIPPE GARNER

(For the record, the sheikh was hardly Dick's first brush with royalty. In 1995 his onetime Southern-belle assistant, Marguerite Lamkin, had arranged for him to take her friend Princess Diana around his exhibition at the National Portrait Gallery in London before it opened. I curtsied to the princess—without, mind you, sinking into a heap on the floor—but Dick simply took her hand and called her Diana, which she seemed to love. She asked him, "May I call you Dick?" and they became instant friends and disappeared to look at his photographs together. "Diana told me he took her straight to the asylum pictures," Marguerite recalls. "Maybe because she knew I had opened the door to them for him in Louisiana back in 1963. Anyhow, she adored them. And she adored Dick—I had told her he had real paper-doll charm. She said to me, 'He's *such* a star!' Dick always knew how to draw a circle around him and whoever he was with—such a tight circle they couldn't imagine being with anyone except him." Afterward Dick said to me, "I found Diana's charm quite studied—the way she was always shyly looking down. And her blond good looks didn't do much for me, either. I'm afraid she's not anybody I could ever express myself through—she's just not an Avedon." And let's not forget—or rather, let's do forget—Dick's long-ago royal gaffe when he addressed the Duchess of Windsor as her *royal* highness.)

Dick put together a compatible team for Qatar: studio manager Sebastian Kim; first assistant Jos Schmid; makeup artist James Kaliardos, whom Dick hoped to sneak in under the category of wardrobe assistant, since the sheikh had explicitly stated that the sheikha would never permit a stranger to touch her face; and David Liittschwager, an assistant who had gone on to become a noted photographer of endangered species in captive situations—"David understands not only the way I work but the animals themselves and will be able to gauge their potential reaction to artificial light," Dick explained to the sheikh.

In mid-February, David, Sebastian, and Jos fanned out to the Saint Louis and San Diego zoos to do test sittings. The sheikh was meanwhile winging his way from London to New York to collect Dick and me. His plane was a knockout—the seatbelts boasted solid-gold buckles, and impossibly long-legged Nordic flight attendants passed buckets of Beluga and trays of light-as-air blinis. Dick remained nervously pre-

occupied with the unprecedented technical problems that lay just ahead. How, for instance, could he re-create, insofar as humanly possible, studio conditions in a wild-animal enclosure? How close could he safely get to each beast in order to light it precisely? How could Dick possibly communicate to, say, a dik-dik that if it moved as little as a millimeter it would mess up his picture? Could a Somali wild ass, for example, be made to sit still for the click of the shutter and then the changing of plates after each exposure? How could a Masai giraffe ever fully appreciate being photographed à la Marella-Agnelli-circa-1953?

"I was afraid Dick was going to find shooting untrained animals very frustrating, because they don't really take direction very well," David Liittschwager says. "You have to wait on their moods a long, long time, and Dick was someone who was not exactly known for his unlimited patience. At the two American zoos my job was to speak with the managers for mammals and ungulates and the lead keepers for birds to determine which situations were most likely to accommodate Dick's process, not to mention his big camera. We were going to have to assess which particular creatures might be capable of putting up with him and then how close they might let him get. These sorts of considerations could be a matter of life and death."

At the Saint Louis Zoological Park, Dick photographed the sheikh without incident with a number of animals: a Speke's gazelle, a white stork, a bongo, a koala, a gerenuk calf, and a mature gerenuk. "I am on extremely familiar terms with hoof stock," the sheikh had announced before striding unflappably in his Arab robes into the gerenuk enclosure. He was carrying something that could have passed for a green bean but that he identified as a browser—he told us he was going to use it to entice the creature to stand on its hind legs for him. After a bit of gazelle whispering, he lifted the hand that held the browser, and not only did the gerenuk rise to the occasion, it placed, with the utmost elegance, a delicate hoof on his shoulder. It was a *Dovima with Elephants* magical moment, and Dick captured the image in the split second that the sheikh, at Dick's instruction, dropped the browser so it wouldn't appear in the picture. The photograph was ultimately published in *The New Yorker*, with the sheikh looking no less exotic than the gerenuk.

From Saint Louis it was full Gulfstream ahead to the world-famous San Diego Zoo and its affiliated wild-animal park. When Dick's team had shown up the day before, they were denied the privileged access they expected after dropping the sheikh's name. Sebastian reached me in Saint Louis and I told him to try dropping Richard Avedon's name. Half an hour later he reported back, "It worked—we're going to get the royal treatment."

At the wild-animal park, Dick photographed the sheikh with an okapi and a giant eland without a hitch. The next day, at the zoo, he shot the following animals by themselves: a Mhorr gazelle, a southern warthog, a southern black rhinoceros, a beisa oryx, an edmi, and a Masai giraffe. The latter was around fifteen feet tall and had the beautiful big eyes that Dick always loved.

The sheikh had flown the coop by now, but Dick kept him abreast of the proceedings by fax, relaying his disappointment at having failed in a six-hour attempt to get three oryx to look his Deardorff in the eye. The sheikh's faith in Dick's ability to capture the next-to-impossible remained unshaken, and he faxed back that he now wanted him to take a stab at a dibatag. More accurately, *the* dibatag—the very last one in captivity. "The species is by far the most beautiful . . . my favorite . . . she is very important to me," the sheikh stressed. Clearly everything was now riding on the dibatag. Dick dispatched David Liittschwager to the Gladys Porter Zoo in Brownsville, Texas, where the creature resided, to gauge how the light fell in her outdoor enclosure and, failing that, if she could be lit from above with electronic flash in her indoor enclosure. At first David was cautiously optimistic, but the next day he assessed that she was too outgoing and was likely to come after Dick. Dick for his part was willing to risk the encounter—until, further along in David's fax, he read that her horns were asymmetrical and that she was past her prime. "In other words," he said, laughing, "this dibatag is an old bag."

The sheikh's head bird-keeper, Hans (a name that produced a frisson in Dick, given that it had been his late analyst Dr. Kleinschmidt's Christian one), faxed us an update on the progress he was making in training the sheikh's five varieties of birds of paradise: King Bird of Paradise, Magnificent Bird of Paradise, Greater Bird of Paradise, Lesser

Bird of Paradise, and Twelve-wired Bird of Paradise. He was confident that by the time Dick arrived they would know enough to come when called and not be spooked by the camera. He added that he was also working with the Spix's macaws (these were the rarest parrots on the planet, and the sheikh had all but cornered the private market on them).

The studio assistants departed for Qatar in late February, complete with the customary twenty-five or so cases (weighing over a hundred pounds each) containing the equipment, which had been covered with sheets of lead to keep it from being damaged by airport X-ray machines. Dick and I followed several days later, via Concorde to London. On our connecting flight to Doha, I studied the list of dos and don'ts that I had had the assistants assemble, since the last thing Dick and I could afford to do was unwittingly offend our exalted host. "Don't let the soles of your shoes show by crossing one leg over the other when sitting with a Qatari—it is considered deeply insulting," one of the prohibitions read. "Remember to watch out for wandering camels on the roads when driving outside the town, especially at night," another warning went. And another: "Don't forget to put strong sunblock on the tops of your feet when you are wearing open sandals—the temperature is going to be around 95." And finally: "BYOB!"

The Sheraton Grand Doha Resort and Convention Hotel where the sheikh was putting us up—Dick in the "Presidential Suite" and me in a mere "Executive Room"—overlooked the Persian Gulf. But it was sand rather than sea that would be our default visual in the days to come. The morning after our arrival, a sleek black Mercedes, complete with cream suede seats and a mouthwateringly handsome driver in a black Armani suit and dark movie-star glasses, materialized to transport us to the desert plain, all of thirty minutes away. En route I kept my eyes peeled for errant dromedaries.

An impregnable-looking steel gate, electronically activated, admitted us to the sheikh's 1.5-square-mile oasis of manicured greensward and rare varieties of palm trees and grasses. The Al Wabra Wildlife Preserve—a.k.a. AWWP—had been founded by his late father as a hobby farm, the sheikh told us, adding that for him it became an obsession: he had added species by the hundreds—gazelles galore, big cats,

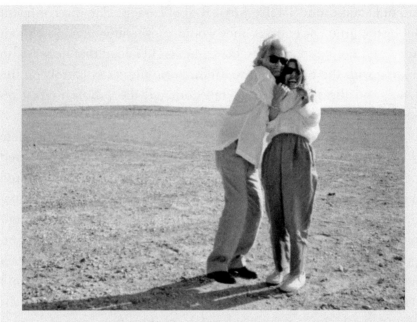

DICK AND NORMA IN THE DESERT OUTSIDE DOHA.

exotic birds . . . As many as three thousand animals now tenanted the place (including a Triceratops dinosaur in the rare form of a complete skeleton). There were cages and pens, primate houses, and antelope runs, not to mention breeding enclosures, orphan nurseries, quarantine units, operating theaters, necropsy rooms, food kitchens, and air-conditioned aviaries with private roosting rooms. AWWP was managed by an international team of veterinarians, biologists, keepers, and handlers numbering more than a hundred, the majority of whom had been trained at top Western and European schools and zoos.

When in residence at Al Wabra, the sheikh operated out of a white villa-like building furnished with lavish Arabic trappings (Oriental carpets, Islamic textiles) and museum-quality French furniture. He apologized to Dick and me for the modesty of this dwelling, explaining that a far more suitable residential compound was in the planning stages: a complex of "futuristic buildings" commissioned from Arata Isozaki (who had just visited the Taj Mahal at the sheikh's behest "for inspiration"), Achille Castiglioni, Ettore Sottsass, Philip Johnson, Zaha Hadid, and Jean Nouvel. "Philippe Starck," he added, "will be doing the loos";

Ron Arad and John Pawson, the interiors; Santiago Calatrava, the cutlery; and Anish Kapoor, Jeff Koons, Ellsworth Kelly, Richard Serra, and David Hockney, the art (Hockney was also on board to embellish a glass-domed swimming pool).

The sheikh had his long legs crossed, and when my eyes traveled down them to his open sandals, I couldn't help noticing that he had neglected to use the recommended sunblock on the tops of his feet. Suddenly he leapt up, exclaiming, "The animals can wait—they're not going anywhere. I wish first to introduce you to some of my other collections." He led the way toward a welter of air-conditioned hangar-like warehouses and high-tech barns.

Think *Citizen Kane:* crates, cartons, suitcases, display cases, ladders, all beyond number. The sheikh lifted the lid of a vintage trunk at random for us, revealing a medieval suit of armor (still sporting its auction-house tag) and, wonder of wonders, Redouté's botanical illustrations (*all* of them). A neighboring hangar turned out to house his transportation collection, which consisted of dozens of vintage luxury cars, hundreds of antique bicycles, and an ornate royal carriage that had belonged to Louis the Something or other. The sheikh was up on each item, down to its minutest detail—he pointed out, for example, that his 1911 Rolls-Royce Silver Ghost had "all its original Barker open drive coachwork."

"Are you by any chance into watches, Mr. Dick?" the sheikh asked. "I maintain what you could call a horological harem, and each night I take a different timepiece to bed with me." He pointed to an 1847 Patek Philippe and a 1907 Rolex—carelessly stored in ziplock bags. "Allow me to introduce you to my best beloved," he went on. "She is far and away the most exquisite of all pocket watches: the Henry Graves Jr. Patek Philippe Supercomplication. She has five hundred screws and over one hundred wheels and, like so many females, she is two-faced. Conveniently she is transatlantic—she has a celestial chart for the night sky over your Central Park, and every hour on the hour she plays the chimes from Big Ben. It took the Swiss seven years to construct her by hand—she was completed in 1932. And by the way, she is reputed to come with a deadly curse. This Graves fellow who commissioned her was a New York banker who went on to suffer terrible per-

sonal losses—two of his sons were killed in car crashes, and his closest friend died mysteriously. Fortunately I do not believe in ill luck." (Dick and I lost no time Googling the Graves when we got back to our hotel, and discovered that "she" was not only the most complex but the most expensive timepiece of all time, the sheikh having acquired her at auction the year before for eleven million dollars.)

Lunch took place in a disappointingly nondescript building nearby. Its massive doors opened on an Indiana Jones–type feast set out on a table so monumental it could have accommodated a small army, and very possibly had. The sheikh gave Dick and me leave to use the royal washstand, while Dick's assistants were directed to the communal trough. The board groaned with boar and wild goat. The servants had their work cut out for them, tearing off hunks of meat by hand and passing them to the ravenous men (I could easily have been the only woman for miles around). Dick and I were thoughtfully provided with cutlery, and Dick was licking his chops, having always had a soft spot for goat (it was the house specialty at his favorite neighborhood restaurant, Primavera). On our way out of the mess hall, we came upon a scad of the sheikh's second-tier retainers awaiting admittance. One of them explained that they would be consuming our leftovers and that, when they were through, *their* leftovers would be served to the servants.

Dick was now ready to begin work with the animals. "He would tell me what kind of picture he had in mind for each species," David Liittschwager recounts. "My role here was the same as it had been at the two American zoos we visited—conferring with the keepers about which areas of which enclosure to cordon off, and then, with them, trying to cajole a given creature into standing on the exact spot on the background that Dick wanted it in. Sometimes it would take hours to rearrange the situation inside an enclosure, or to conclude that that wasn't possible because the introduction of anything new could freak the animal out. At that point we would just have to work with what it was familiar with. I never went inside any of the cages myself, because just one other body might have been the straw that broke the camel's back."

One of Dick's first sitters was a female leopard, which its keeper was strongly recommending Dick shoot through the fencing. Dick said,

"I'm going in!" The guy replied, "Okay, then, it's your funeral. But when I say 'Enough!' you had better back the hell out—slowly." Dick entered the enclosure, with me shouting, "No, Dick, no! It's not worth it. This is too crazy!" I stood there with my heart in my mouth, ready as ever to pick up the pieces.

"I followed Dick in there," says the makeup artist James Kaliardos. "I just sensed that he would want me in the cage with him. I was always very protective of him." Dick had meanwhile gotten down, and was staying down. He had his camera focused and the leopard in his sights, and he was talking to her as if she were one of his models—"Beautiful! Amazing!" Amazingly enough, the animal proceeded to lift her head

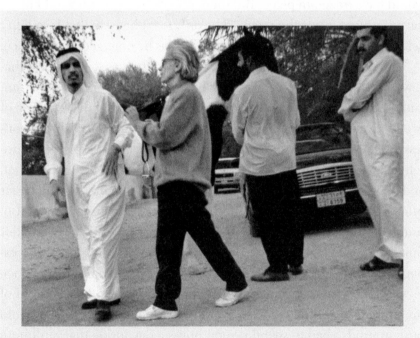

DICK AND THE SHEIKH INSIDE THE LATTER'S
PRIVATE AL WABRA WILDLIFE PRESERVE.

for him, open her eyes wide, and wet her lips. "He was shooting crazy-fast, almost as if he were using an auto-focus digital camera," James says. "I had recently done Scarlett Johansson's makeup for a *Vogue* shoot with a leopard, and they wouldn't let her anywhere near the thing—it was done digitally. But Dick was absolutely fearless, and right

after that leopard, he crept into another cage, to do a close-up of the sheikh's king cheetah in repose."

The most problematic moment occurred while Dick was shooting the sheikh's rams. He was inside their enclosure, down low against the fence, and just about to start when they began jumping off their rock formation—one after the other, fifteen strong. They made straight for him with their big, curly, razor-sharp horns. Then suddenly they stopped in their tracks and, crazy as it sounds, they performed for him, bouncing up (as high as eleven feet) and down, the latest in the long line of supermodels that had jumped for Dick over the years. I knew in my bones that those rams would never have jumped for Penn—they would have frozen in place. But then, it's safe to say, Penn would never have ventured inside their pen. "The only fear I had was that I wouldn't get the picture," Dick said to me cavalierly as he emerged in one piece.

The final sittings, two weeks later, were with the sheikh's Spix's macaws. "Dick asked me to take the photographs of the Spixes for him, and it was one of the ones I took that wound up in the final selection of twenty-five that he presented to the sheikh," David Liittschwager confesses, explaining that Dick had opted out of taking the pictures himself for several reasons. "The species had just officially become extinct, and he felt that I, as a professional wildlife photographer, would be far more likely not to stress out the precious-few remaining ones. Also, some of those on hand the sheikh had only just acquired from a major Spix's collector and flown in from the Philippines, and they were exhausted from the long flight. Dick would never have had the patience to wait for them to decide to walk across their cage and get in front of his white background—and these were definitely not birds you could push around. I had to spend several hours a day inside that birdhouse for three days, going in and out because you couldn't just sit there— that would have been too nerve-racking, for *them*." I can provide an additional reason: Dick had spent two weekends in Montauk trying his hand at bird photography, only to conclude it was for the birds.

"The picture of the Spixes I took for Dick is a diptych, and one of the two images is three individuals in flight," David goes on. "It's the only photograph that's in color, and it's absolutely gorgeous—the birds are all different hues of blue. For all the large-scale pictures, Dick

wanted to use an archival carbon-transfer process that only this one guy, who was based in Seattle, still did, so he sent me there to oversee the printing. The level of finish on those photographs is exquisite. Dick had photographed the creatures with such precision to begin with, and then he put the pictures together with the freedom of imagination of a great painter. He went far beneath the surface of the animals—he caught their personalities and captured their souls."

As for David's having taken the Spix diptych instead of Dick, I contend that the sheikh got a fair shake, given that color was never Dick's forte; he was strictly a black-and-white guy. "Let me stress that although it was I who took those Spix pictures, it's not like Dick *didn't* take them," David diplomatically adds. "Because he did, in a way—he was the one who trained me. It's like with a movie: the director has somebody operating the camera for him, but it's still his movie. And besides, Dick had more important things to do—the hours I spent waiting for just the right moment to photograph those birds he was busy taking pictures of the sheikh's non-avian family."

The people portraits were made in the house in Doha, which I playfully referred to as the sheikh shack. In all seriousness, it wasn't at all lavish—more like a big bungalow than a palace. The sheikh said to his wife, "I am honored to present Mr. Dick and Norma," and, to us, "May I present Sheikha Amna bin Ahmad bin Hassan bin Abdualla bin Jassim al-Thani." She was an eyeful as well as a mouthful. And anything but conservatively dressed: studded jeans with a big Dolce & Gabbana–looking rhinestone belt and fancy red and silver shoes, with sparkles yet. "She looks like a Kardashian," James whispered.

The shoot unfolded on the bungalow's lowest level—a garage area that had been turned overnight into a state-of-the-art studio for Dick. He politely suggested to the sheikha that she might want to "simplify" her outfit: "Let's see what else you've got in your closet." Practically everything in there was French couture—the most casual item Dick could find bore the label Dior. When she went into her dressing room to change, he said to the sheikh, "Let's let James go in—he'll just talk to her and relax her and maybe she'll allow him to do a couple of things."

"I had been led to believe that you don't touch a Muslim woman's

face unless you're the husband, so the situation was uncomfortable to begin with," James recalls. "And it was further complicated by the fact that she already had a lot of makeup on—powder and sparkles and really strange stuff. It was more about me trying to get her to let me take some of it off and then rebalance the mess. Dick had told me to give her more eye—he always loved eye—so I asked if I could do a little eyeliner tweaking, and she nodded okay. As for the hair, she had it in bangs, and I just swept them right off, and *voilà!* she was done.

"On the sheikh I got to do full makeup. He had a beautiful, almost pharaoh kind of face—he looked a lot like Akhenaton, the same kind of lips and nose. I did him like I would have done Omar Sharif on a movie set. With Dick you could always do as much makeup on a subject as you felt like, because it wasn't all going to show; that's what was so great about his lighting—it had a softening effect. I used a whole lot of eye shadow on the sheikh. And then I blow-dried his hair and shaped it. He wore it pretty short, so what I did was give it volume."

Dick also photographed the sheikh's three kids, who were all tarted up in Fendi. The six-year-old boy was frisky, and the sheikh interrupted the shoot at a couple of points to read him the riot act. He said to us, in front of his son, "He will never amount to anything. He doesn't concentrate, he doesn't do well at school . . ." I thought, Shades of Dick's father! As for the sheikh's father, he had been memorialized in a monumental needlepoint tapestry, and the sitting concluded with a group photograph taken in front of it. For this portrait, the sheikh was togged out in a tailored neck-to-ankle-length robe that I found myself coveting. I couldn't keep from asking where he had gotten it. He said, "I will see to it that two are run up for you this evening." And indeed, it cameth to pass that a pocket-sized Qatari visited my hotel room later that afternoon to measure me, and that a pair of beautifully woven robes, one of white cotton and the other of black silk, were delivered unto me the next morning.

In true courtly fashion the sheikh saw Dick and me to our car—or rather, *his* car, one of so many dozens. He informed us that the following day, at a time to be determined, we would be summoned to the royal palace, Emiri Diwan, for an audience with his cousin the emir, His Highness Sheikh Hamad bin Khalifa al-Thani. The next morning

JAMES KALIARDOS DOING THE SHEIKH'S HAIR FOR A
PORTRAIT IN DOHA WHILE DICK MONITORS EVERY STRAND.

Dick and I dressed in our best meet-the-emir attire: a white linen suit
and a pale-yellow linen dress, respectively. Unstructured linen being
notoriously wrinkle-prone, we spent several hours standing up. Finally
a Mercedes arrived to speed us through the palm-lined streets of Doha
to our destination.

We were ushered into a palatial marble hall where we were told in
so many words to sit tight, which we proceeded to do on a couple of the
blue velvet chairs that formed a circle around the rim of the room. We
were plied with desert dates and miniature cups of Turkish coffee, and
within half an hour the emir was receiving us in the throne room. I
curtsied—remember, I'm like that—and Dick shook hands. The emir
was heavy, dark, and mustachioed, and spoke the Queen's English (it
turned out he had been educated at the British Royal Military Acad-
emy at Sandhurst). He took Dick by the arm and said, "I admire very
much your charming photograph of Stephanie Seymour—the one
where . . . You know." At lunch, I was seated to the left of the emir, who
all but put me to sleep, sparing no detail of the schematic design for

the Qatari photography museum, which he told me was going to consist of two immense, intersecting feather-like wings that would open and close according to the light requirements of the changing exhibitions, yadda yadda yadda. The service was solid gold and brought back memories of Ann and Gordon Getty's, and the groaning board was heavy on goat. The men all ate with their hands, but once again, out of delicacy, Dick and I were provided with utensils.

The next day, as we were leaving for the airport, the sheikh took me aside, seemingly conspiratorially, but then, sounding the same anxious note as any other commercial client, pressed, "How soon can I see contacts? How long till finished prints?"

We hadn't been home more than a week when I received a call from Saud Number Two to the effect that Saud Number One wished to add Dick's old eight-by-ten Sinar to his camera collection. Dick consulted Dirk Kikstra, the assistant who was his technical mainstay. "The camera was getting a little loose, so I was thinking, Maybe it's not such a bad idea to unload it," Dirk recalls. "Dick had been using Sinars intermittently since the seventies, and they weren't making them anymore. We decided to buy the latest model on the market, which looked exactly the same as Dick's vintage Sinar, then take both cameras apart and assemble a perfect working one using all the good parts, and that one *we* would keep. We were able to get a whole, if defective, other one out of the leftovers, and that's what we sold the sheikh. So technically speaking, he didn't get Dick's camera—just parts of it."

The sheikh tried to buy two of Dick's assistants as well. "His factotum Saud contacted me at some point to say that his boss was in town and wanted to talk to me about coming to work in Qatar as his photography adviser," Sebastian Kim says. "By that time I had left Dick and was working for Steven Meisel. Saud said, 'Whatever it is you're getting paid, the sheikh will double it.' The thing was, I was happy where I was. So then, when the sheikh couldn't buy *me*, he approached Jos Schmid, who had just gotten professionally reestablished in Switzerland. Jos said no right away, too, but the sheikh did get him to do a lecture over there in a seminar connected with the Saud al-Thani Award in Photography that he had just set up. Saud Number Two contacted me again, to ask, 'Who was it you said you worked for now? What was the name?'

I was happy to repeat it to him, and a couple of days later he called back to say the sheikh wished to be photographed by Steven and could I set it up. I gave him the number of Steven's agent."

Meanwhile Dick and I became increasingly reluctant to let go—we couldn't face the thought of being untethered from our cash cow. These feelings were only exacerbated when we read in the paper that the sheikh had purchased a complete first-edition set of Audubon's *Birds of America* for $8.8 million at Christie's New York—a record for a book at auction. And further inflamed when, again at Christie's New York, he forked up $9.6 million for the fabulous Fabergé Imperial Winter Egg, which had been an Easter present from the ill-fated Czar Nicholas II to his mother. And then, adding insult to injury—"a blow upon a bruise"—he struck again, breaking the world auction record for an antiquity (at Christie's London this time) when he paid approximately $13 million for the so-called Jenkins Venus, a Roman marble statue from the second century A.D., a nude, no less—Islamic morality be damned.

These dizzy-making sums went to our heads. Half out of our minds with anticipation, Dick and I attempted to sell the sheikh on purchasing en masse roughly two hundred Avedon portraits. But when we named our price, $50 million, he shocked us by replying, "That's out of sight. I'm not made of money, you know." We thought, *That's* rich. In the end, he bought only the 1978 "Early Paris Fashion Portfolio" from us for a measly quarter of a million dollars (it was some small comfort to remember that the edition had initially sold for $5,000).

The sheikh's buying spree continued apace. In April 2004 he dropped around $10 million at Christie's London for the Clive of India collection of Mughal treasures, which included a bejeweled jade flask that had been on display at the Victoria and Albert Museum. Three months later, he purchased the third-century-A.D. Roman artifact known as the Constable-Maxwell cage cup for more than $4 million, making it the most expensive piece of glass ever sold. The British arts minister saw fit to impose an export ban on these unequaled pieces, affording his countrymen the opportunity to match the auction prices. The unforeseen result of his action was that these treasures languished in limbo for years.

"I want back in!" Dick railed. "We've got to come up with some sort of new exotics project." The only angle we could think of was to photograph the sheikh with a variety of newly endangered species and in the company of leading environmentalists and conservationists. A quick reject. Dick then abjectly offered to take a crack at the old dibatag. It was over.

One morning in March 2005, a few months after Dick's death, I read, with forgivable sangfroid, that the sheikh was being investigated by the Qatari Audit Bureau for "serious misuse and misappropriation of state funds," and that he had been placed under house arrest. The word on the Corniche was that his personal collections had all been impounded, and his phones, mobile lines, and Internet access cut off. His post as chairman of Qatar's National Council for Culture, Arts, and Heritage was toast; and his projected Isozaki-Calatrava-Castiglioni-Sottsass-Hadid-Nouvel-Philip Johnson-Philippe Starck–designed futuristic palace was now a thing of the past as well.

Follow-up articles reported that the sheikh was suspected of taking kickbacks: colluding with dealers to inflate the bills for the many items he had charged to the state. The emir had evidently had it with his profligate cousin. (This was not the first palace coup executed by His Highness, by the way. He had gotten where he is today—or rather, where he was the day before yesterday, since he is no longer emir—by deposing his own father in 1995.)

I thought, If only Dick were here to enjoy these recent developments! He had lived for dramas like this. For sure he would have said, "Let's get all the details!" Then he would probably have written the sheikh one of his condolence letters beginning, "Words fail." He would never have let go of Sheikhgate: "Has he been stripped of his robes? Has the sheikha left him yet? Any word on what's happening with the animals? Do you think they're going to let him keep that incredible watch?"

The sheikh remained under house arrest for an unascertainable period of time—some insist he did actual time. The charges were ultimately dropped, and before long he was back in the game. In 2008 he purchased 90 percent of the lots at a sale of ancient Chinese art at Sotheby's London for around $18 million, and in 2011 *ARTnews* named

him the world's top spender on art. Within the year, however, his riyal status was being called into legal question. It was revealed that he had left more than eleven auction houses and dealers holding the bag. He owed almost $20 million to a dealer of ancient Greek coins, and over $40 million to Sotheby's for bids he had won and then promptly failed to make good on. Now the noun most commonly used to describe the sheikh was "nonpayer"—something the Avedon studio would never have put up with for a minute. It was not, then, for nothing that I had always insisted on our being paid at least half up front, beginning with Italians and ending with Qataris.

During a dispute over some of his unpaid bills (among them, the more than $400,000 he owed the London law firm for advising him on these very matters), a High Court judge froze the sheikh's English assets. To cover his stupendous debt to Sotheby's he was forced to pledge $83 million worth of collectibles, including his horological inamorata, the Henry Graves Jr. Supercomplication.

On November 9, 2014, the sheikh died at his London residence, suddenly and mysteriously. He was only forty-eight, although, as *The New York Times* reported, "news media accounts have differed on his age over the years." Dick would have had a field day speculating on the cause of death: "Do you think he was murdered? Or did he do the honorable thing and kill himself?" A suspiciously long time after the fact, a statement was issued to the effect that the sheikh "appeared to have died from a complication from a heart condition." But could it not have been a Supercomplication? Indeed, the headline in *The Daily Mail* read: "CURSE OF THE MULTIMILLION-POUND WATCH STRIKES AGAIN; BILLIONAIRE OWNER DIES SUDDENLY."

Advertised by the auction house as "the Holy Grail of watches . . . a masterpiece that transcends the boundaries of horology and that has earned its place among the world's greatest works of art," the Supercomplication went on to achieve rock star status when it sold for over $24 million at Sotheby's Geneva, just two days after the sheikh's untimely demise. It was a world record for a watch, and another world record for the sheikh, for whom, however, time had grievously run out.

21

UNSULLIED LEGACY

—

NADULTERATED LOVE CAME TO DICK LATE IN LIFE, RELAtively speaking. That is, in the form of a relative: a first cousin twice removed, whom he grew to regard as a son second to none.

Dick invested himself to a preternatural degree in the portrait he took of the young man in 2002. "This boy's face expresses all my beliefs as a photographer," he declared to the head curator of photographs at the Metropolitan Museum, which was in the process of mounting an Avedon portraits retrospective. "It's the purest picture I've ever taken— the holy grail." The curator picked up the metaphor and ran with it: she congratulated Dick on having captured the youth standing at the threshold of his future "like Sir Galahad." Verily, Dick decided on the spot to hang the portrait in the exhibition's last room, with his personal and cultural heroes.

The relationship between Dick and this young man was the fulfillment of a deathbed promise. Galahad had been dubbed Luke at birth. Dick and Luke's father, Keith, who was a good quarter of a century younger, didn't meet until Keith was an adult. Dick's father and Keith's grandfather, William, were brothers, which made Dick and Keith's father, Arthur, first cousins, but they, too, had met for the first time as adults. Arthur started out as a ballroom and tap-dancing instructor at

the Arthur Murray Dance Studio (Dick might well have been able to teach *him* a thing or two in that department), married the nice Irish receptionist Myra Duggan, and went on to a career as a commercial portrait photographer—yearbook pictures and the like. Dick had in fact rented his first studio space from him: a small back room that reeked of chemicals in a dingy building next to Brentano's bookstore on Forty-eighth Street and Fifth Avenue, nine blocks north of his father's former woman's specialty store. He took some of his earliest photographs for the *Bazaar* in that miserable studio. Arthur thought the pictures Dick was taking were "weird," Dick told me, and confidently predicted he would never amount to anything.

Keith contracted polio when he was two and spent a year in the hospital. Despite the twelve operations he underwent on his withered limbs, he would walk with a limp and carry a cane for the rest of his life. "People stopped coming to our apartment in Queens," recalls his sister, Pat Avedon Turk, a longtime general manager of the New York City Ballet. "Nobody wanted to come anywhere near us. They couldn't even bear to say the word *polio*—they whispered it." And so Dick's father, Jack, and Keith's father, Arthur, each had a child with an unmentionable infirmity, because let's not forget Louise.

Arthur, it turned out, had been the same kind of father to Keith as Jack had been to Dick. When Keith announced that his goal was to be a classical pianist (he secretly fantasized a career as a rock musician and songwriter), Arthur promptly sold the family piano. Keith for his part left home (the missing instrument notwithstanding, he was also being repeatedly violated by a close relative). To pay for his classes at the Manhattan School of Music he found work as a music tutor to the four young sons of a well-to-do Upper West Side couple who let him stay in one of their maids' rooms. The boys' babysitter was an extremely pretty seventeen-year-old Dalton School junior by the name of Elizabeth Cox. Betsy, as she was called, was musical, too (she studied and played the flute), and soon she and Keith were making beautiful music together, in the end running off to London.

Betsy was a keeper, and presently the couple got engaged. Dick was delighted that an Abaddon was going to marry a descendant of both the first chief justice of the United States, John Jay, and America's poster-

boy robber baron, Cornelius Vanderbilt. Betsy's father was a prominent attorney; one of her paternal uncles was the chaplain at Princeton and later the headmaster of Groton; and another, Archibald Cox, was the U.S. solicitor general and later the first Watergate special prosecutor, infamously fired by President Nixon. "I had a tendency to let the so-called family silver tarnish," Betsy says, "but Keith kept it brightly polished. He literally memorized my family tree, and he saved all the press clippings of Uncle Archie." To each, plainly, the other was exotic. When Dick met Betsy he was instantly smitten—she was as beautiful as she was well born.

Keith formed a band and was soon playing trendy clubs. Dick and I were there for his debut gig, at Danceteria, and had the same reaction: "This guy's really got it." And Keith for his part hero-worshipped Dick, writing him the morning after the opening of the Avedon fashion retrospective at the Met: "When I arrived at the museum and waited in the crush outside—that staggering mob—and I looked up and saw the banner with your name, which is our name . . . I was struck with an incredible pride that my own flesh-and-blood relative was a hero to generations. My family (immediate) is without heroes, but there *you* were, the man, doing it all."

Dick not only did a portrait of his charismatic cousin but directed a five-minute video of him performing, in order to promote him to Calvin Klein. Calvin was impressed enough to audition Keith to do the music for the Brooke Shields TV commercials. "That was a huge, nervous-making day," Betsy recalls. "I can still see Keith packing his portable keyboard to take up to Calvin's office. As he was leaving, Calvin said to him, 'I like your music, and I like your jeans—where did you get them?'" Keith got the job, and Dick and I got to see a lot more of him, which was hard on neither our ears nor our eyes.

When my son, Max, was about to turn thirteen and I was casting about for a way to make a bar mitzvah celebration unorthodox and fun, Dick said, "Leave it to Keith and me—we'll put on a show that'll bring the pillars of the temple down." On the day my son became a man Dick arrived at the party in a suit and tie. He sat quietly at the "studio table" with his mother, his secretary Penny Cobbs, and my nine-year-old daughter, Molly, whom I had allowed to go without me to Cerruti

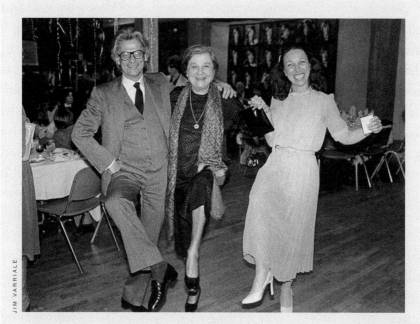

JIM VARRIALE

DICK, HIS MOTHER, AND NORMA DOING THE HORA
AT HER SON MAX'S BAR MITZVAH.

to pick out a dress for the occasion. Dick gushed over the silk, lavender-and-white floral number, with sleeves edged in lace: "Oh, Miss Molly, I love your outfit! You're still my favorite model." (One afternoon earlier that year, when Molly burst through the studio door on her way home from the Brearley School to pay me an impromptu visit, Dick dropped what he was doing and exclaimed, "I'm going to photograph you right this minute!" The celebrity hairstylist John Sahag, who was on hand for a scheduled sitting, proceeded to curl Miss Molly's hair into a great mane. Dick led her by the hand to the cyc, turned up the music, and ordered me to keep out. Five minutes later Molly emerged laughing, and Dick said to me, "You have nothing to worry about—a tall, dark, handsome fella is going to take her off your hands someday." There was quite a range of picture choices, but Dick and I favored the same one: Molly all eyes and hair. He gave us a print, inscribed "Miss Molly." In the years that followed, the odd Brearley mother, seeing the portrait in our apartment, commented, "How *could* you let your daughter model!")

Shortly after the serving of the bar mitzvah lox, Dick excused himself. When he reappeared, five minutes later, he was unrecognizable, thanks to a Warhol-style fright wig and a leather motorcycle jacket with silver chains. What's more, he made his re-entrance in a wheelchair — pushed by a uniformed "nurse" who in reality was the head of the middle school at Dalton, which Max attended (she was also, incidentally, the granddaughter of the legendary Jennie Grossinger, founder of the eponymous Catskill resort hotel). Taking a pretend swig from the bottle of Fantastik he was holding, Dick proceeded to make good on the title of the skit he had written (behind my back) for the occasion, "You Gotta Get Up": he rose from his wheelchair and began tripping the light fantastic in a simulated punk-rock routine. "Keith later sang a musical composition of his own — he and Dick were total rock stars that day," recalls Betsy, who had been something of a star herself, playing the flute. (Dick presented Max with a set of his solarized Beatles posters in psychedelic colors: Ringo with a dove, John with granny glasses, Paul with flowers, and George with Indian symbols. "I was awed by the hugeness of his personality," Max remarks, looking back at his thirteen-year-old self, "but I was always at a total loss for how to be around him." Dick once told me that he considered his performance at the bar mitzvah to be the high point of his long life as a show-off.)

It was at some point during the bar mitzvah that Betsy told Dick she was pregnant and asked him to be the child's godfather. "I kept missing my due date," she says, "and when it moved into May, Dick's birthday month, I thought, 'Oh my God, it's going to be a Taurus! Another Avedon bull. I'm going to give birth to a monster. Dick, the big atheist, showed up for the baptism at Saint Thomas Episcopal Church clutching a Bible."

Dick was soon steering another plum assignment Keith's way — producing the soundtrack for Calvin's Obsession commercials. On the strength of those, Dick got him hired to do the musical arrangement for his commercial introducing the Chanel perfume Coco. This meant Keith would be conducting the London Philharmonic, and recording at the storied Abbey Road Studios. "It was a dream — two dreams — come true that didn't, and it's going to make me cry," Betsy says. "In the months before he left for Europe, Keith had had persistent coughs,

DICK PERFORMING TO BEAT THE BAND AT MAX'S BAR MITZVAH.

JIM VARRIALE

chronic diarrhea, intermittent fevers, shingles, colitis, hepatitis, and
whatnot. But still, the last thing I was expecting was the call I got from

Brown's Hotel in London informing me that my husband had collapsed in his room and was now in intensive care on a respirator. I grabbed Luke and flew to the airport."

Dick, who had just flown in from Europe, flew right back on the Concorde. He told me, "This is major. And one of the things it's going to be about is money. I can do that—whatever it takes." It was. And he could. And he did. And it took a lot of everything. And a lot out of everyone.

"At the hospital, Dick told me I needed to keep my strength up and said he would be glad to pay for me to eat a steak every day for lunch," Betsy recalls. "And then he said something that was nourishing to my *spirit*—that if anything happened to Keith, he would always take care of Luke and me. I hugged him, and then I literally cried on his shoulder. I kept repeating how scared I was of being a widow—I remember stuttering on the *w*. Then he went in to see Keith, and he held his hand and solemnly promised him he would take care of us all. We were totally financially unprepared for any disaster, let alone one of such biblical proportions. Dick immediately put me on the studio payroll, which meant not only a salary but health insurance.

"We all knew by now what Keith had," Betsy says, sighing. "And everybody but me knew how he'd gotten it. His sister, Pat, took me aside in the hospital and said, 'There's something I have to tell you—Keith has had a homosexual past.' With those words, *my* past, not to speak of my present and future, got rewritten, or at the very least was going to have to be seriously rethought and reinterpreted. I didn't want anyone outside the immediate family to know what Keith had. I couldn't bear the thought of baby Luke being discriminated against—I had this recurring image of him gouging his knee in the playground and people being afraid to touch him for fear of getting contaminated."

Dick had Keith flown back to New York. In the ensuing months he improved enough to be able to work sporadically. Dick got him another gig with Calvin. Betsy says, "Dick kept following Keith around on the set with a chair, trying to get him to sit down." During one of Keith's recurring hospitalizations, John Avedon generously arranged for the Dalai Lama's personal doctor to pay a visit. Aglow in robes of gold and maroon, and accompanied by an entourage that included a secretary

THE BAPTISM OF DICK'S GODSON LUKE AVEDON,
SAINT THOMAS EPISCOPAL CHURCH, NEW YORK, 1984.

and a translator, he handed the patient two containers of what he called
"precious pills"—one kind for his lymph glands, the other for his liver.
He assured Keith that he would be cured if he abstained from sex for
seven months.

It was a drawn-out dying. By the end Keith had been spared almost
nothing, including near-blindness, which had the hypochondriacal
Dick obsessing about his own eye health. At one haunting stage of his
illness, Keith hallucinated that he was back in the polio ward of his
toddlerhood. Dick was in regular attendance at the deathbed, deter-
mined to say what he described as an "in-depth goodbye." "One time
when he was visiting, early spring '87," Betsy remembers, "Dick was
regaling Keith with the story of a Raquel Welch shoot, how when she
couldn't fit into her body suit he had told her, 'You have to get in, no
matter what, even if I have to screw you in,' and Keith began laughing.
I couldn't believe that Dick had managed to get him laughing. But
then I thought, Why are you laughing, you're dying."

SEPTEMBER 30, 1984 LUKE MAXWELL AVEDON'S BAPTISM

1. RICHARD CARLSON, FRIEND
2. GLENN BERGER, UNCLE
3. JAY SCHIEFFELIN, GREAT-GREAT UNCLE
4. LAWRENCE TURK, UNCLE
5. CAROLE DESCHAMP, FRIEND
6. MICHAEL AVEDON, UNCLE
7. MIRANDA COX, FIRST COUSIN, ONCE REMOVED
8. ELIZABETH COX BIGELOW, GREAT AUNT
9. POLLY KING, SECOND COUSIN, ONCE REMOVED
10. MARY JORDON COX, GREAT AUNT
11. IRVING APPLEMAN, GREAT UNCLE
12. LORRAINE AVEDON APPLEMAN, GREAT AUNT
13. ANN HARTENSTEIN, FRIEND
14. PATRICIA AVEDON TURK, AUNT
15. JOANNE McKENDRY, FIRST COUSIN, ONCE REMOVED
16. GRACE DUGGAN, GREAT AUNT
17. RUTH AVEDON, GREAT AUNT
18. ANNA AVEDON, GREAT-GREAT AUNT
19. LOIS SCHIEFFELIN, GREAT-GREAT AUNT

20. RACHEL COX BERGER, AUNT
21. MARY BROWN COX, GRANDMOTHER
22. MAXWELL COX, GRANDFATHER
23. ROBERT COX, UNCLE & GODFATHER
24. KEITH DUGGAN AVEDON, FATHER
25. MARY WEYBURN, GODMOTHER
26. ANN COX HALKETT, AUNT
27. JESSE HALKETT, FIRST COUSIN
28. MARIE McKENDRY, SECOND COUSIN
29. KEVIN McKENDRY, FIRST COUSIN, ONCE REMOVED
30. ELIZABETH EVARTS COX AVEDON, MOTHER
31. LUKE MAXWELL AVEDON
32. RICHARD AVEDON, FIRST COUSIN, TWICE REMOVED & GODFATHER
33. MYRA DUGGAN AVEDON, GRANDMOTHER
34. ARTHUR AVEDON, GRANDFATHER
35. BRANDON AVEDON TURK, FIRST COUSIN
36. MATTHEW McKENDRY, SECOND COUSIN
37. JEREMY McKENDRY, SECOND COUSIN

DIAGRAM CREATED BY KEITH AVEDON.

Dick was laughing, too, but his laughter was hysterical—he would come back from every visit to Keith shaken to the core. The last time he saw Keith, Dick told him, "Luke doesn't ever have to know." (As it turned out, Betsy had already told him!) On that disorienting occasion, he had mistakenly taken a drink from Keith's water glass. The next day he went for another AIDS test.

Keith died on April Fool's Day 1987. It was no joke. He was thirty-nine.

Within the year, Betsy had begun writing a book—encouraged and

supported by Dick. He edited her successive drafts, though it meant reliving Keith's death, and introduced her to a top literary agent. When *Thanksgiving: An AIDS Journal* was published by Harper & Row in 1990, it made Betsy's name (at least her maiden one — Dick had persuaded her to publish it under "Elizabeth Cox"), as well as enough money for her to be able to go back to school. She would eventually co-found a support group for women like herself, the "negative partners" whose husbands had died of the disease. Today she works for the Actors Fund as a clinical social worker counseling entertainers with AIDS. In a word, Betsy is a saint.

So, nominally speaking, is her son — Luke. "One of my earliest memories is seeing my mother on *The Richard Simmons Show* — live," he says. "She was on a lot of pretty trashy shows promoting her AIDS book — *Maury Povich, Geraldo* . . . I was off from school for some reason and she couldn't get a sitter, so she had to take me with her to the Simmons show. They settled me in the audience, and then out came this really skinny guy who they were touting as formerly the world's fattest man — he was waving around a pair of his old pants, which would have fit a hippopotamus. Now he looked like my father did before he died. And right after him, my mother came on.

"I knew as far back as I can remember that Dick was 'it' as far as our little family was concerned. My mother had books with his name on the cover all around the apartment. And there were all these photographs that he had taken of *us*. I spent a lot of time staring at them. I was not even three when my father died, and I had almost forgotten what he looked like — I thought maybe if I stared at Dick's photos long enough it might bring him back."

Luke and Dick first connected in earnest over a third-grade homework assignment. Luke was attending Saint Ann's, a free-form private school in Brooklyn Heights whose board of trustees Betsy's father chaired, and the assignment was to write a few lines about a famous person. "The other kids all went for Ben Franklin and Thomas Edison and stuff like that," Luke says, "but I picked Dick." I remember Betsy bringing him to the studio that first time, dressed in one of his father's old superhero T-shirts. She waited around with me while Dick and Luke "hung out" upstairs.

DICK WITH
ELIZABETH
"BETSY" COX
AVEDON,
WHO IS
CRADLING
THE CAKE
FOR SON
LUKE'S THIRD
BIRTHDAY,
CELEBRATED
A MONTH
AFTER HIS
FATHER'S
DEATH.

"His apartment was the most magical place in the world for a kid—pictures and flowers and trees everywhere. And he had this amazing little meal for me all ready to eat. He looked kind of like a mad scientist—you know, with his Einstein hair and crackling intelligence. He right away began telling me all his stories. He said that in the Merchant Marine they had told him that if he ever saw an enemy ship, he should go for his gun, but he said he would have gone for his camera. He told me that his whole photography thing was a Civil War–era camera and just real basics and that most photographers messed up by trying to do gimmicks. And then he told me for some reason that his whole family thing was a catastrophe and that he was someone who wasn't as good at life as he was at taking pictures. I couldn't believe he was telling all this stuff to an eight-year-old kid. But *this* eight-year-old was a kid who liked to shock his teachers, so I put it all in my little essay. I sent a copy to Dick, and he wrote back saying how great it was

that I remembered everything he told me and that my father would have been proud.

"He had wanted to know all about *me*. But I mean, what was there to tell? Except I did have some silly childish crush going on at the time—one of those love-triangle things. I'd gone to the movies with some girl I didn't like all that much and she'd brought along her best friend, who I realized I liked a whole lot more. Dick took my love problems as seriously as if I were some forty-year-old friend of his talking to him about an affair or a divorce or something. He said, 'What are we going to do about this? How are we going to get the girl *you* like to like *you*? Maybe you should just sit them both down and tell them the score.' So from very early on we always talked about our women."

After Luke left that first day, Dick said to me, "This little boy is special." When Christmas came around, he pondered what to give him—a bike? a pair of skates? "He gave me *The Big Book of Tell Me Why*," Luke recounts, "and he said, 'Look, I know it's not a bazooka, but . . .' And that became what he would always say when he gave me a gift."

Dick's gifts to Luke soon took a cosmetic turn. "I wore braces for six or seven years, and he just kept writing the checks," Luke says. "I felt sure my orthodontist was fixing things that didn't need fixing. Dick was so happy when I appeared on the cover of the *American Journal of Orthodontics*—well, just my teeth." By that point Dick was also covering Luke's tuition and helping with Betsy's rent. "I kept pinching myself," she says, "asking, Who am *I* to Dick? I'm only the widow of his second cousin and he doesn't even talk to his first cousin."

Looking back, Betsy reflects, "Luke and Dick didn't really become friend-friends until he was around nine and sort of a formed verbal person. Dick didn't know what to do with him when he was seven and eight—I mean, what *do* you do? They just mostly watched movies together upstairs in the studio." "Our whole relationship when I was seven through nine," Luke elaborates, "was he would send a car to my house, and I would get driven to the studio and go through the rabbit hole and be in this amazing bubble of, like, every film ever and incredible food, and sometimes we would get in the car and go to movies and restaurants."

Dick went to Brooklyn to see Luke perform in his school play, nar-

rating an adaptation of E. B. White's *The Trumpet of the Swan*, and afterward he took Luke, Betsy, and Luke's aunt Pat to dinner at the scenic River Café. "It was right around Dick's birthday, so he ordered champagne, and he would slip his glass over to me and whisper, 'Take a sip, it's almost your birthday, too,' then pull it away, then slip it over again and say, 'It's okay to have another sip,'" Luke remembers. "And always after that, we celebrated our birthdays together."

"Dick was very big on birthdays—he had invited not only Betsy and Luke but me and my thirteen-year-old son to his mother's ninetieth," Pat Turk recalls, "and that was quite the occasion. He rented a party room at the Carlyle and had it decorated with family photographs, and he'd hired a piano player and a flutist. The minute Anna walked in, he dropped to his knees and sang her favorite song to her: 'Moonlight becomes you, it goes with your hair / You certainly know the right thing to wear . . .' Anna invited me to lunch in her apartment, and she had the music box I had given her for her birthday sitting right on the table, which was such a nice touch. For the whole two hours she counseled me on what I should do as a mother. She had only just met my son, Brandon, at her party, but she had really taken him in, because she told me, 'He's very good-looking, and obviously very smart, but he's shy— you're going to have to push him. I pushed Dick as far as I could, and then the wind just took him, and now *you've* got to push Brandon with everything you've got.' She must have been the first tiger mom."

"Dick once gave me a piece of motherly advice," Luke offers, laughing. "Having told me time and again that you should never be too busy for your mother, he spilled the beans on himself and told me that when he called his mother every Sunday he would make himself a cup of espresso or whatever and set the kitchen timer for fifteen minutes and when it rang he would tell her, 'There's someone at the door.' I was thinking, What a thing to tell a little boy! He said he loved her with all his heart but that she was a big talker and time was money. Unfortunately I find myself remembering this every time I'm on the phone with *my* mother. The funny thing is, almost everyone I ever told this to started doing it with *their* mother. I'm probably responsible for the sale of a ton of kitchen timers."

One afternoon the doorbell rang in Luke's apartment and Dick was

standing there. "I had gotten to the point where I was able to discuss world history with him, and he felt I needed to have access to more background material. He handed me this huge box—'It's not a bazooka, but . . .' But this time it *was* a bazooka—a computer! With all the bells and whistles. And he had his assistants set it up for me."

As Luke was an only child, Dick encouraged him to become friends with his two grandsons, Matthew and William. They lived with their divorced mother practically around the corner from Betsy, near Union Square, and the three boys all went to the same school—William was just a grade ahead of Luke. "My mother began dropping me off at Dick's studio when they were there," Luke recalls. "We would play in this incredible teepee that Dick had bought for them in Arizona when he was out there photographing the West—it was like seven feet in diameter and maybe nine feet tall.

"My mother didn't like their mother one bit—she never actually said so, but a kid could tell. I remember being a little afraid of her myself because she always looked so angry. And then she went and did that horrible thing to Dick—she and Matthew and William together—and I never really spoke to any of them again. After that, my mother always referred to them as 'the enemy camp.'"

"I found out about it before it hit the headlines," Betsy says. "Every Sunday morning around eight-thirty, though we certainly never planned it that way, Betti and I would be in Union Square Park with our sons. William and Matthew would be on their skateboards, and Luke and I would be rollerblading, and at some point we mothers would have to make conversation—the two Elizabeths who were no longer married to their Avedon men. The funny thing was we were constantly getting each other's calls. One day I decided to have a little fun with this and not inform her hot-to-trot telephone caller that I was the wrong Elizabeth Avedon—I said instead, 'I have no idea who you are.' He said, 'That really hurts! You don't remember last night?' Anyway, during one of our little conversations in the park, Betti dropped the bombshell that she wasn't speaking to Dick and wasn't letting her boys see him. She wouldn't elaborate, so I called Dick to ask what was going on, and he broke down and told me the whole ugly story."

"I was so confused I didn't know what to believe," Luke admits.

"The next time I saw Dick it *was* on my mind—but only for the first five seconds. I knew in my heart he could never have done anything like that."

ONE MIDNIGHT IN LATE October 1993 my phone rang: Dick, who else, though it certainly didn't sound like him. He said, "Can you get over here right away, I really need you." He was waiting for me in front of the studio, in his old Hermès terry-cloth robe and big furry slippers. I followed him up the stairs, slowly—he said his legs felt like stone, dead weights. His face was stony, too. "I'm a dead man," he said tonelessly. "Dead before my time. She's trying to take my life away from me." With that, he poured me a cup of coffee and handed me a document that began, "Elizabeth Avedon, as parent and natural guardian of William Avedon and Matthew Avedon . . . and Elizabeth Avedon, individually, plaintiffs, against Richard Avedon, defendant . . ."

In a nutshell, his former secretary/graphic designer/daughter-in-law was accusing him of having taken inappropriate pictures of her sons, then aged thirteen and ten. The affidavit went on to state graphically—in black-and-white—that both boys had complained about their grandfather's behavior in regard to them, and that "said behavior" had "formerly caused John and me to be cautious about permitting him to be alone with the boys." Those allegations were stale: they had been leveled during John and Betti's bitter divorce case six years before, at the time when she was petitioning the court for sole custody, and they were duly investigated by the judge and found to be baseless.

I mean, those kids were happily in and out of Dick's studio for years. He had purchased two mid-century tubular aluminum twin bedsteads for their sleepovers, and in summer he had Verlie put pine-needle sachets on the pillows that exuded the feeling of camp. He liked to think of his cedar-shingled faux-sea-captain's house in Montauk as a family compound. Each member had his or her place on the property—the main house was for John and Betti and the two boys; the wing with its own terrace was for Evie, who rarely came but who had decorated it herself with her preferred Clarence House and Brunschwig & Fils fabrics (she thought pink and had the denim for the sofas run up in that

color); and the small guesthouse with a porch was for Dick. "My guess is that for Dick the experience of making a family compound, besides being an interesting art project, represented resolution of many personal needs," the architect, Harris Feinn, muses, adding, "I think he was more emotionally attached to the idea and the fulfillment of the dream than to the place itself." Dick definitely did not enjoy being out there alone: he would call me and say, "I've just taken three outdoor showers, so now what do I do?" (He was wary of the outdoors, and paranoid about ticks; he would go about in long pants, socks, and a hat—all white.) John enjoyed the house but, Dick felt, only when *he* wasn't there.

Both the Montauk house and the apartment were cluttered with toys. He was the most involved grandfather imaginable, always thinking up new, exciting projects to do with the kids. Now he was saying to me, in a voice I barely recognized as his, "The first thing I'm doing is getting rid of that fucking teepee—I'm going to give it to Ruedi Hofmann for his kids, and I'll throw in the building blocks and all the children's books."

Betti was seeking an injunction against the sale or display of Dick's photographs of her sons and of any and all photographs that Dick had ever taken of *her* (with a single exception: the one with the braid that had hung in the last room of the Metropolitan Museum's Avedon fashion exhibition). She was also demanding that Dick turn over to her posthaste not only all the photographs in question but the negatives as well. At the same time, she was petitioning the court for an order of protection against Dick. And—no surprise there—she was also coming after him for serious money.

Dick got through the week by leaning heavily on Dr. Kleinschmidt, running to him sometimes twice a day and calling him around the clock. Then on October 26, at break of day, my phone rang: "I need you here *now*. Desperately." Once again he was waiting for me out front in his robe. He wordlessly handed me the *New York Post*. The front-page headline read: "ANGRY AVEDON DENIES SEXUAL ACCUSA-TIONS." The story went: "Celeb photog has been sued for $5 million by his former daughter-in-law, who charges he showed off nude photos of

his thirteen- and ten-year-old grandsons and behaved in sexually inappropriate ways with the kids." I could think of nothing useful to say beyond the all-purpose, "Okay, we'll deal with it."

Dick had put studio manager Marc Royce in charge of what he described as a "very sensitive project"—to go through the files and pull every photograph of his grandsons, starting with Day One. "I may need to prove in a court of law that those photographs are the same as any doting grandfather would take," he explained, adding that Matthew and William were inured to nudity—their parents had often been naked around them, which Dick had spoken to John about, and the boys themselves were often to be seen running around the house with nothing on.

Dick issued, through his lawyer, Martin Garbus, an official denial: "The statements made about me are totally false and slanderous . . . it is a tragedy for my grandchildren that Elizabeth would try to gain a financial advantage by launching this type of attack." John had his father's back on this one: he was quoted in the press to the effect that "only a vindictive and deeply troubled woman could misuse her children in public and lie so blatantly about my father for financial gain." I thought, Hear! Hear! *That's* the stuff!

I had never trusted Betti. She succeeded in catching John's eye only after—in my view (in my full view)—trying and failing to catch Dick's in that respect. She was great-looking, yes, in a hippie kind of way: long hair, long skirts, Western belts, Mexican coats, espadrilles. I remember the time she took her shoes off in the studio and then couldn't find them and became convinced that people were taking her things, and that got ugly. After she left John for Richard Gere and Gere took up with Cindy Crawford, she began an affair with Dick's stunningly handsome studio manager and sometime model Ling Li. When Dick found out, he understandably asked her to leave the studio. Ling he inadvisedly retained, in the hope that he would keep his professional and personal lives separate. But then when Betti went after John for more money in the divorce and Ling got involved, Dick had to fire him.

In the wake of the *Post* story, the studio lines all lit up. *The New York Times* called. Ditto the London *Times, Women's Wear Daily, Advertising Age, The Wall Street Journal, Le Monde* . . . Dick's mother called

after seeing it on the Times Square electronic billboard. Twyla weighed in. Mike Nichols called not only to commiserate but to recommend lawyers and advise on strategy.

Dick's landscape artist and onetime receptionist, Maggy Geiger, sent a flat of narcissus. Nicole Wisniak sent him a red boxing glove from Paris—"to get me in the fighting mood," Dick needlessly explained, adding, also needlessly, "You see! Some people still love me." (Five months earlier, Nicole had given him a framed original Proust letter plus a bottle of Grand Vin de Lafite Rothschild 1923, the year of his birth, for his seventieth birthday, which they celebrated together in Venice. Suzy Parker, for her part, had baked him seventy chocolate chip cookies, for which he thanked her with the single word "Slurp!"—a steal from Mike, who had employed it to thank *him* for something delicious. What haunted Dick now was that Suzy had said in her accompanying note that she hoped he would share them with his grandsons.)

After gathering up all the photographs of William and Matthew he could lay his hands on, Marc Royce made contact sheets for Dick so he could make his choices. Included in the twenty-five or so that he eventually turned over to the court were some that featured the boys frolicking in their naked innocence on the beaches of Saint Bart's and Montauk. "I made small prints and put them between glassine sheets in a loose-leaf binder, and he was out the door with them to a meeting with his lawyer," Marc recalls. (Decidedly not included in the mix was a picture of Dick and the boys all playfully sucking their thumbs. Dick had laughed when he came across that one, and it was good to hear him laugh—it was beginning to seem as if he had forgotten how.)

"When I got to the studio at eight-fifteen the morning after the *Post* headline," Dick's trainer, Kerry Roland, recalls, "he was just wrecked. I was afraid he was going to have a breakdown. He said to me, 'There's nothing worse than being accused of something you not only didn't do but would want to kill anybody who did.' That day he did more push-ups and crunches and stretches than ever, which communicated to me how determined he was to ride this thing out. He discussed it constantly with me. I mean, you get to know people very well. It's a very intimate thing I do—you're dealing with their body, you know, and they start talking about everything very personally. I had come to Dick

through Andre Gregory, who I'd been working with for years. He told me that he had to do a lot of taking pictures from the floor and that he was beginning to have trouble getting back up and couldn't stand to have two assistants grabbing him by the arms and lifting him. So we set up a program to build more strength in his legs and lower back. He was taking so much medication—the blood thinners and all the other stuff—that I told him, 'You're gonna kill yourself.' I at least got him to eat a little less fettuccine alfredo.

"I always saw him three times a week for an hour—Monday, Wednesday, and Friday mornings. And I would also see him sometimes on the weekend, in Montauk—I would usually spend the night in the little guesthouse. One night I left the door open, and there was quite a breeze coming off the ocean, and it was a full moon and the light was coming in, and there was fog billowing, and it was magic. I had just a pair of boxer shorts on and I went out onto the lawn and did a whole dance. I was a mess when I got back to the house—I was covered with grass clippings and who knows what else—but it was this amazing feeling. The next morning I came into the big house for breakfast and Dick was bouncing up and down kind of, and I said, 'What is it?' And he said, 'I was awake and I watched you last night. It was the most beautiful thing I ever saw.' I said, 'Come on, don't be ridiculous.' He said, 'I wish I could have filmed it.'

"Dick put me onto Mike, and through Mike I got Elaine May and Stanley Donen, so I had all of them, really. He loved Mike, there was such love in Dick's heart for him, and justly so, and then whenever I would bring up Dick to Mike, *he* would get emotional, too.

"I saw Dick's mother a couple of times a week, too—I've had quite a few people in their nineties. She had a nickname for me that Dick found hilarious—'Pink Cheeks,' and she would always squeeze them. She would tell me—she would get into the mood of back then and her eyes would go furtive in the cutest way—how she always snuck Dick into Carnegie Hall and the theater. There was a picture of Dick in her bedroom—he's in his forties, with the black hair—and she would look across at it and blow kisses."

Dick had a long-standing date for dinner with Anna a few days after Betti's accusations hit the papers—at Lusardi's, where they often went

and where, to Dick's amusement, she never failed to order the eggplant parmigiana. He asked me before setting out, "What do you say to your ninety-four-year-old mother about something like this? Words will fail." He needn't have worried. "She told me she knew I could never do anything like Betti said and that she had never approved of the way Betti controls those boys," Dick reported. "She also said I was absolutely right not to give her another red cent, that I work too hard for my money."

"I had never seen Dick so hurt, so *wounded*," David Ross recalls. "The wicked daughter-in-law was robbing him of his grandsons, who had meant a fresh start for him—a chance to build some healthy family relationships for a change—and *that* was the only criminal thing that was going on there."

Betti's allegations centered on a weeklong excursion to Venice and Paris that Dick had taken the boys on in 1992. It was a classic Dick trip: five-star hotels (the Gritti Palace and the Ritz) and, to make it even more fun for them, a college student in tow who not only was conversant with history and architecture but could toss a ball around with them on the Lido and in the Bois. This was not so long after Betti had been informed that there would be no more money coming. Not incidentally, it was also the summer Mia Farrow came across six beaver-shot Polaroids that Woody Allen had taken of her nineteen-year-old adopted daughter Soon-Yi Previn, which led to her accusing him of sexually molesting their own adopted daughter, seven-year-old Dylan.

"The minute John and I got engaged, which was three years after his divorce from Betti, she came raging back into the picture," says Maura Moynihan. "The minute she saw him rebuilding his life with *me*, that was it. She served us with legal papers at our wedding, and she made screaming phone calls to me every day—she was accusing me of not only sexually molesting her sons, my stepsons, but beating them and giving them drugs. I ended up having to submit to an interview with a court-appointed psychiatrist. All these charges drove John and me crazy. A friend of mine said to me, 'She's parked herself in between you and your husband—she's there in bed with you every night.' You know, what Princess Diana said about Camilla Parker Bowles. I even wrote a screenplay about it, for Oliver Stone—I called it 'First Wife.'

Betti destroyed my marriage, and she persecuted Dick and John non-stop. And now she has a blog with lovey-dovey pictures of her and Dick in the good old days—she's still using him as her dining-out card, and she's still clinging to the Avedon name.

"I pleaded with Dick to just get Betti off our back, and finally he agreed to give her half a million dollars. He said, 'That's right—pay the bitch off.' But John got on his moral high horse and told him that giving Betti money would be the equivalent of aiding and abetting terrorism."

"What John said to Dick was, 'You don't pay people off if you're in the right,'" Renata Adler recalls. "But he was dead wrong—you *do* pay people off, even and especially if you're in the right. And when the time came that John and Maura broke up, Dick should have paid Maura off, too. I mean, supposing it *was* five hundred thousand dollars a wife, that's not extravagant." Maura attests, "I spent time in Montauk with Matthew and William the day Dick brought them back on the Concorde. They were happy, they were laughing, they were still excited—the last thing they looked and acted like were kids who had had a traumatic experience of any kind. They were beautiful, wonderful boys."

Dick's vaunted imagination of disaster went into overdrive: Where would it all end? Would somebody come out of the woodwork and expose him as gay, and would everyone then be inclined to believe Betti? That cruel April, *The New Yorker* assigned him to do a portfolio on gays in the military: portraits of seven men and women between the ages of twenty-one and forty, five of whom were in the process of being discharged for the then unmentionable, because punishable, offense of homosexuality. Dick hosted a catered Margarita-fueled Mexican dinner in his apartment after the sitting. I heard him tell one of the men, "When I was in the Merchant Marine, a couple of the mates in my unit got booted out for this, and now it's half a century later and plus ça change." Eileen Travell, who was in Dick's master class and who worked in the photography department at the Met, was seated next to Dick and remembers him saying to her, "You know, if I were gay I could never do what they've done—make the statement with a capital s." She goes on, "There were rumors that Dick *was* gay. But if he was,

he sure as hell didn't want anyone to know, and it would have been a very vulnerable position he was in at that moment."

"When the molestation charges were leveled, I had just left John — it all happened at the same time," Maura recalls. "I tried to get Dick on the phone — to offer to testify on his behalf — but he wouldn't take my call. I kept writing and reaching out to him over the years, but he had cut me out of his life. I saw him at a David Remnick party just before he died and I went over to him. I said, 'Dick, it's Maura,' and he got up and ran away from me like I had a communicable disease. And he had once loved me! And inundated me with his tidal wave of charm."

Dick's day of deliverance was at hand. In the first week of January 1994 the case was settled, according to a stipulation filed with the State Supreme Court in Manhattan, with "no findings of misconduct on Mr. Avedon's part" and "without payment by either party." Moreover, it was "discontinued with prejudice," meaning that it could not be the subject of another lawsuit. Both parties agreed to "remain subject to the [previous] gag order" and also agreed that "the relevant pictures and negatives presently existing of the children shall be delivered within 20 days to be put into the court file, and said pictures, negatives, and prints shall be delivered to each child, if that child wishes, upon the child attaining 18 years of age. These pictures are given to the children by their grandfather as a gesture of his goodwill. Each child shall at that time have all the rights and title to any of the pictures." The document went on to confirm Dick's stated position: "The photographs are those that one would expect anyone to take during a family vacation." And happily, the file was to remain sealed.

There was an additional proviso: "All photographs, negatives, and prints of Elizabeth Avedon shall be destroyed, except the photograph that is . . . a part of the Avedon archive and is a part of a book that has been released years ago." Dick commented to me, "With pleasure! We should have a shredding orgy!"

Although the stipulation admonished that "neither party shall issue any press releases concerning the disposition of this action," Dick couldn't help himself, after a fashion — he faxed or messengered copies of the document to close friends and associates, with a note trumpeting, "Oh happy day!" From far-off Milan, Gianni and Donatella Ver-

sace and Paul Beck jointly faxed back: "We are so happy about your happy day!!! But we were already sure that it would be a happy end!"

A happy end? *I'm* not so sure. From that moment on, Dick referred to the episode as the "family drama" and to William and Matthew only as "them." "He would often tell me how much he resented them," Luke says, adding, "It wasn't such a bad thing for *me* that he felt he didn't have grandsons anymore — I had been a little jealous that there were kids my age that he was closer to in blood. Then one day he told me that there was this cute new grandson, Michael, but that was okay — an infant wasn't much competition. And then later there was a daughter from John's third marriage. Dick resented that John kept having all these kids, that he was in the habit of falling in love with a woman and getting her pregnant and then he wouldn't want her to have an abortion because he was a Buddhist, and then he would have to ask Dick for money to help with the kid."

"What a thing that episode with the two grandsons was! It was such a touchy subject," Dick's last psychiatrist, Dr. Robert Millman, reflects. "*Especially* because that wasn't Richard's trip, you know. I didn't become his doctor until four or five years afterward, but he often talked about how horrible it still was for him — the memory of the humiliation, the public ridicule. Now, there were many possible ways for a doctor to approach this — the tack *I* took was to be matter-of-fact. I explained how common this kind of accusation was in the general culture, and that I had had at least three or four cases where it was part of the deal, and that the targets were usually rich and powerful men like himself. I mean, what was the ex-daughter-in-law's evidence? *I've* taken photographs of *my* kids in the bathtub — what parent hasn't? One of the accuser grandsons reappeared in his life while Richard was my patient. He had become a male model and he asked Richard if he would take pictures for his portfolio. Richard wanted to know from me how he should act toward him — if he should be open to him or not. I told him that only his heart could tell him how to handle it." Dick was of two minds: Matthew, after all, was the boy about whom he had said, from the time he was a baby — and right up until 1993, when all too understandably he ceased saying it — "He can charm the pants off anybody." In the end Dick decided not to do the photographs.

"Matthew had started modeling professionally when I was still in high school," Luke remembers, "and it looked like he was making a ton of money—I would see these billboards of him in Times Square. Dick thought it was tacky of him to be a model. But then later, when he got so concerned about my ability to ever make a buck in this life, he said, 'Maybe *you* should try to get into this modeling thing as well,' and he went and bought me a membership in the New York Sports Club. But then before I could get really fit, he changed his mind—he said, 'Forget it, you're a little too short for the clothes these days.'"

Luke was now a teenager, and a turbulent one. Coming to grips with his mother's book had been a struggle. "I finally screwed up the courage to read it, and I freaked out," he says. "The AIDS thing I had known about forever—my mother wore *that* on her sleeve. But she had never said anything to me about my father being gay. When I confronted her about that, she said that she hadn't known how to talk to me about it. Something else disturbing that I learned from her book was that she and my father's doctor wanted to give him goodbye pills and that my father was okay with that, and that they had consulted Dick and *he* was okay with it, too. I wasn't so sure *I* was okay with that."

"Luke was acting out all the time and cutting class, and class wasn't the only thing he was cutting," Betsy says. "I knew I had to get him to a good therapist quick." Reenter Dick with his trusty checkbook. Luke was able to turn himself around. The summer of his junior year in high school he got a job as a busboy in an Upper East Side restaurant. Dick gave him two thousand dollars not to take it, and told him to do "something interesting" instead. Betsy objected. "I felt Luke should work for his money—I didn't want him turning into another John," she says. "But at least he used the windfall from Dick to buy music equipment, to follow in both his mother's and father's footsteps."

"I didn't think I wanted to go to college," Luke confesses, "until I visited Sarah Lawrence. Then I couldn't wait to get in, so I applied for early admission. Dick offered to cover the tuition. He told me that one of his first jobs out of the Merchant Marine was taking pictures of the Sarah Lawrence seniors for the 1944 yearbook—his cousin Margie was graduating and got him the gig. He said she had written the lyrics to the college song, set to a seventeenth-century Dutch carol or something,

and it was having its premiere at her commencement. He also re-
minded me that John had graduated in the first Sarah Lawrence class
that took boys."

DICK AND LUKE
ABOUT TO
LEAVE FOR
LUKE'S HIGH-
SCHOOL
GRADUATION.
LUKE IS
WEARING THE
TUXEDO THAT
HIS FATHER
USED TO
PERFORM IN.

ELIZABETH COX AVEDON

Dick would call Betsy every day: "Did he hear?" When Luke suc-
ceeded merely in being wait-listed, Dick asked to see the essays he'd
handed in. After taking one look at them, he said to me, "I wouldn't
have let him in, either. He's going to have to reapply, for regular admis-
sion this time, and you and I are going to get him in if it's the last thing
we do—we're going to rewrite those essays."

One of Luke's compositions was on his love of music and dance. "I
had a sentence in there about how much I enjoyed prancing when I

was little," Luke recalls, "and Dick said, 'Take that out, it makes you sound gay.' I had even been thinking of writing an essay where I could play the dead gay father card, but Dick said to definitely forget that one. He suggested I interview one of my high-school teachers instead and call the essay 'A Conversation with an Inspiration.' He said, 'That will show them how much you love learning, and it will also give Norma and me a respite from having to be relentlessly interesting on your behalf.' So I interviewed my English teacher, but when Dick read the transcript he said she was an imbecile."

Dick turned the Avedon studio into a ghostwriting collective. He and I spent days firing up those Luke-warm essays. One was on *Blade Runner*, and Dick made me watch it—after which I began mixing up the words *replicant* (the movie's biorobotic being) and *applicant* ("Attached please find my college replication essays"). "The story of how I got into Sarah Lawrence drives my wife absolutely crazy," Luke admits today. "She thinks it's not only unethical but bitterly unfair, since *she* had to work so hard to get in."

On Luke's Matriculation Day, Dick was away on location. Betsy sent him a photograph of her and Luke, which he had enlarged, printed on archival paper, and framed in oak. He was looking forward to Grandparents Day, and he consulted John on the most useful thing to give a freshman. Groceries, John said. So Dick took Luke grocery shopping in Bronxville and stocked him up. He sweetened the pickings with one of his blue cashmere turtlenecks. "I lived in that sweater," Luke says. "It didn't remotely fit me but I wore it every damn day, fall and winter, till it fell apart on me." For his twentieth birthday Dick would give Luke a suit custom-made by his Bond-Street-trained tailor Mr. Cheo, of East Sixtieth Street; the gift was accompanied by a poem ending "Get ready, dear Luke, for looking just right, / When illegally buying your Amstel Light!" The sweater and suit and the lighthearted poem were followed by a heavier gift: two of Dick's portraits of Bob Dylan.

To justify Dick's faith and considerable investment in him, Luke became a "super hardcore student," as he puts it. "For my dorm room Dick sent me a photo of himself with Alexey Brodovitch, who he said had taught him everything that was still his standard—he said that that

was his equivalent of my college years. He had already come clean to me about not even having graduated high school. He told me that, looking back now, he realized that he had never needed school, he didn't need the credential—he had *emotional* credentials. What he needed, he said, was just to meet the people that he met, learn from them, and collaborate with them."

It was not only Luke's grades that Dick was keeping his eye on, he was also sizing up his girlfriends. "He would insist on meeting all the more serious ones," Luke says. "And *they*—my God, they were so nervous! They thought they were going to have to have something deep to say about photography. I told them it was okay to just be themselves. He would get after me to send him samples of their handwriting to analyze before he met them, and he would say stuff like, 'Her *d* is too thin.' Or 'her *y* is too loopy, it's mostly way below the line—that means she could be dangerous to you.' Or 'her writing's too teeny, she must be a very small person, very stingy.' He told me to break up with quite a few of them just on the basis of that. He analyzed my handwriting, too. He told me it was 'dashing' and that he particularly liked the way I signed my name. The *L* is big and looks like a Z, and he said that that made him think of Zorro, that it was 'King of the World' writing.

"I remember saying to him about one of my girlfriends that the sex was great but I didn't really like her very much. He said, 'Luke, go for it! I didn't have good sex till I was in my forties.' He didn't give any details, but he always wanted *all* the details about all *my* sexual experiences. He did tell me about his girlfriend—the Frenchwoman. He said what kept it fresh was her living on a different continent from him. I met her with him once, at his big Met opening in 2002, and she was a little disappointing-looking. I mean, she was, like, a fright. I happen to hate frizzy hair—Dick had described it to me as a pre-Raphaelite cloud, whatever *that* is. She seemed like a nice enough lady, though."

Dick was always on the lookout for a girlfriend for Luke—preferably an heiress. "He told me that one of his main goals in life was to find a rich girl for me to marry," Luke recalls. "He was just thinking of himself there, because he was afraid he was going to have to take care of me financially forever. He did introduce me to one very rich lady, but she was way too old—in her early thirties or something."

Dick also tried to widen Luke's musical horizons. He took him to hear Ian Bostridge and Matsuko Uchida at Carnegie Hall; Jonsi Birgisson of the band Sigur Ros, whom he breathlessly described to Luke as an "abstract-scatting space rocker from Iceland"; Thom Yorke of Radiohead when the group did an evening with Merce Cunningham; the young soprano Lorraine Hunt Lieberson; Richard Strauss's *Salome*; and a lot of the musical events he "covered" for *The New Yorker*. It worked both ways: Luke was Dick's go-to guy on super-cool bands. When *The New Yorker* assigned Dick to photograph a garage-indie-rock-revival group called the Strokes that had had the sensational debut album *Is This It*, Luke told him that it definitely wasn't. Dick said, "Okay then, I won't do it," and canceled the shoot. "It turned out the Strokes was one of Dick's studio manager Daymion's favorite bands and he was dying to meet them," Luke adds with a laugh, "so when I next saw him he made a point of letting me know how pissed he was."

Dance was another discipline that Dick exposed his disciple to. "He took me to the Joyce Theater a bunch of times to see the tap dancer Savion Glover, who he was totally obsessed with. He liked to keep me separate from his friends, although he did once invite Adam Gopnik to go to the theater with us—*Hamlet*, at Lincoln Center. I asked him what he did for a living, and he told me he wrote for *The New Yorker*, and I went, 'That's awesome.' And Dick was horrified—he immediately took me aside and said, 'You can't use a word like *awesome* with Adam Gopnik.' Occasionally he would invite John to the theater with us, and Dick would always say, 'He's really nice, isn't he?' I didn't really know the guy."

In 2004 Dick and Luke celebrated their May birthdays together as usual. "We went to one of his favorite neighborhood restaurants, Quatorze, on Seventy-ninth Street—his table was way in the back, against the wall," Luke recounts. "Being with him that night, you would never in your wildest dreams have imagined it was going to be his last birthday on earth. I completely lost it when he died. And you know what saved me? Don't laugh— Buddhism. John was always after Dick to try it, and Dick always told me he thought it was maybe *the* most ridiculous thing in the world, and since I took everything he said as gospel I never gave it the time of day. But after he was gone I was so miserable

I started doing it. And now I meditate every day, and I stay at Buddhist monasteries and stuff.

"A couple of years ago I was at this Buddhist holiday party and some woman I was introduced to said, 'You must be connected to the great Richard Avedon, I just have to touch you.' I explained to her that the blood wasn't that close, that basically I was just his godson. Later I could have kicked myself for that—I mean for saying 'just.' Dick had even written to me, 'I don't believe in God but I do believe in godson.'"

Luke had been far more than a godson to Dick—he had been no less than a godsend. He was the one person to whom Dick had felt free to just give. And the giving didn't end with his death. "I was surprised out of my mind by his bequest," Luke says. "It was a bazooka, all right—no *buts*. He left me the same as his grandsons." Betsy adds, "He thought through Luke's bequest very carefully. It was the right amount—not enough to kill his ambition. Dick was the godfather to end all godfathers."

22

THE
LAST PICTURE SHOW

—

MUSEUM-QUALITY LOVE CAME TO DICK WITH THE MILlennium, in the fit form of the perfect curator. The museum in question was once again—twice in a lifetime!—the Met.

A curator's relationship to an artist is protean—parent, psychoanalyst, judge, protector, sometimes antagonist. Dick had had any number, and all kinds, of curators over the years, but the curator in charge of the department of photographs at the Met, Maria Morris Hambourg, was his idea of collaboration heaven, complete with the occasional thunderclap and lightning bolt. He had been anticipating that, since most of the photographers she dealt with weren't in a position to talk back, being good and dead, she would be wary of a living artist who was known for strong opinions when it came to the selection and presentation of his work. In this, Dick was dead wrong—in no time he recognized and wholeheartedly embraced what he described as a "partner in the process."

He made a point of reading everything Maria had published, starting with her seminal essays on Atget, Nadar, and Helen Levitt. He was dazzled by her take on Sigmar Polke—"You've managed to do the impossible by reifying the irrepressible," he raved. Nor, later, when he came to read the catalogue essay on *him*, would he be any less elated:

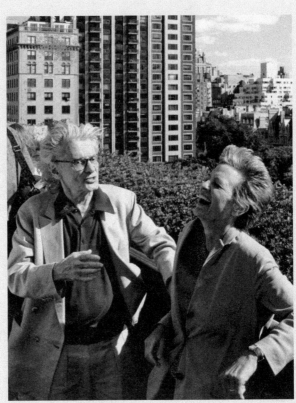

DICK AND
MET PHO-
TOGRAPHY
CURATOR
MARIA
MORRIS
HAMBOURG
ON THE
ROOF OF
THE MUSEUM.

"Laureate of the invisible reflected in physiognomy, Avedon has become our poet of portraiture." He told her, "I reread those words all the time, glowing like something nuclear hit me."

If Dick was enamored of Maria intellectually, he was also emotionally available to her as he had been to no curator before. He behaved as if he were in the thrall of a schoolboy crush, uttering such fond nonsense as, "There always seems to be so much more to what we say than what we say, and I say this with the deepest of unsaid feelings" and "You make my old heart go pitter-patter, and I live for the fibrillations." He referred to their days apart as "creatus interruptus," and later, in her absence, he would listen to her "flowing, smoky" voice on the museum audio guide.

Maria's first experience of Dick's pictures had been visceral, to hear her tell it. "In 1974 I was working as an intern at MoMA when John

Szarkowski did the show of Avedon's portraits of his father, and I remember being stunned by how raw they were—their sort of spectral, cranial quality. It was a little difficult having them in your face as you came and went every day. Outside the entrance to the little chapel that Marvin Israel had created for them in the lobby there was a picture of Avedon and his father confronting each other, and from that alone I already knew that any production on the part of this photographer was going to be as much about him as about his subject."

At Dick's Marlborough Gallery show the next year, Maria was knocked out: "I just stood there with my mouth open, thinking, Nothing like this has ever been done before. The trio of monumental murals—*Andy Warhol and Members of the Factory*, *The Mission Council*, and *The Chicago Seven*—made an impression commensurate to their scale, and may still be the grandest and most spectacular photographic group portraits ever staged. *The Mission Council* was the opening image through the doorway, and it faced the Duke and Duchess of Windsor, Marilyn Monroe, Stravinsky, Andy Warhol's scarred torso, and the two *In Cold Blood* killers. I mean, the pantheon of people in those rooms! A whole epoch. The exhibition was shocking in terms of its breadth as well as its vision—the hair on the back of my neck stood up. And the images of all these famous people all possessed this complete authority: They were not about celebrity at all, they were what I call constitutive portraits, where absolutely everything—the entire meaning of the person, not only his or her place in the world but his purpose on this earth—somehow got expressed through the face.

"And then, three years later, the first Met show. People were standing in line for an hour at a time to get into the opening, and the line seemed to go on for miles. I managed to get in just before they locked the doors. When I saw the Agnelli portrait I immediately thought Brancusi. I'd seen plenty of pictures of the woman, and she didn't look like that in any of them. And then you saw *Dovima with Elephants* and, I mean, the panache, the flair of it, was just so celebratory, and the surprise of it made you smile. I stood there marveling at the mystery of the photographer's genius. If anyone had told me that a quarter of a century later I would be working with Richard Avedon on a second Met retrospective, I would have asked them what mushrooms they were on."

———

IN THE YEAR 2000, Dick's dealer, Jeffrey Fraenkel, was exploring ways and means to prop up Dick's position in the art world. In the course of reviewing what he describes as "sixty years of everything," he discovered that Dick had retained all the original prints from the Marlborough show, and a flashbulb went off. "Jeffrey called me and said, 'Do you remember Avedon's Marlborough show?' and I said, 'Do I ever!'" Maria recalls. "He asked if I would consider remounting it, and he let drop that Avedon was prepared to donate more than a hundred of those portraits to the museum."

Jeffrey set up a meeting between Maria and Dick at the repository of Avedon archival prints, the Center for Creative Photography, in Tucson. The plan was for us all to convene beforehand at the bar of the Arizona Inn. "There was a definite risk," Jeffrey admits. "Much would hinge on whether or not there was a connection in the first minutes between Dick and Maria, both of whom were people with strong intuitions. She was a widely respected scholar and he was a celebrity, and that is not necessarily a winning combination." In this case, it instantly was.

After intensively studying the Marlborough prints, Maria asked to see both older and more recent portraits. Jeffrey asked, "How much time do you have? Forever?" She extended her stay in Tucson, and over the next several days, vintage Avedons were presented to her scrutiny one by one, beginning with the 1947 image of the boy in Sicily that Dick had come to regard as both his first true portrait and his first self-portrait. Then and there, Maria determined that the show should be an overarching portraiture retrospective, of which the Marlborough pictures would serve as the nucleus. The set of images of Dick's father would occupy a small room of its own, and the Western work would be prominently featured—those portraits of "the unsung citizenry, where Avedon successfully plumbed the other side of celebrity, so to speak, in search of what we all have in common," as Maria so eloquently put it. The portraits of the drifters in particular struck her as being "like younger American cousins of Beckett's gentleman tramps—ravaged antiheroes, isolated yet driven to carry on by their own internal impera-

tives." She knew now that, as had been the case with Nadar, the show would be about something even more significant than photography, because "Avedon's subjects were seminal to, and emblematic of, the whole culture."

The exhibition was scheduled for fall 2002. The Met's director, Philippe de Montebello, grandly proclaimed that Richard Avedon's work would now "take its proper place in the larger history of art, representing the culmination of the time-honored tradition of public portraiture." The show was envisioned as a multi-platform cultural event: the audio would incorporate readings by some of the poets and writers of whom Dick had made iconic images, such as Marianne Moore, Ezra Pound, and William Burroughs; the CD would feature selections from some of the musicians he had captured, such as Bob Dylan, Joan Baez, Igor Stravinsky, Vladimir Horowitz, Marian Anderson, Louis Armstrong, and the Everly Brothers; and there would be a whole host of lectures, poetry readings, film screenings, and teacher workshops — in other words, the works.

Within a few weeks of its announcement, the show was literally on the road. In an access of euphoria Dick faxed Maria that the truck had left Tucson at 9:13 a.m. She had good news to report as well: the Tisch galleries that the two of them had been pushing for — at eight thousand square feet they constituted the museum's largest and grandest exhibition space — were theirs. Recalling from a Giacometti drawings exhibition at the Pompidou how intimate a daunting space could be made to feel, Dick told Maria, "Don't start sawing till I get there!" No joke — he was as determined as ever to have final say on everything: the reconfiguring of corridors, the sizing of doors, the height of baffles, the color of walls, the covering of floors . . .

Dick was a shapeshifter to whom production costs meant less than nothing, and he soon exhausted the goodwill of the Met's Plexi shop, machine shop, rigging operation, and conservation and lighting departments. The museum said a flat-out no to Dick's importing his own lighting consultant, but that didn't prevent him from consulting, more or less on the sly, the renowned lighting designer Jennifer Tipton. They went through the mock-up in the studio room by room, drawing up what she calls the "lighting plot." (She was only sorry that it remained

to be executed by means of the Met's antiquated equipment. "Museums seem to have all the money in the world to assign to everything but lighting," she says. "Lighting is a stepchild.")

Maria was meanwhile fast becoming part of the studio family, just as Dick was becoming part of *her* family. "I had a boy and girl, ages three and four, whom I adopted from Vietnam, and he became their Uncle Dick," she says, adding, "It was wonderful having children to share with him. We'd been discussing the progression of ideas in his work, and I said, 'This photograph was almost certainly done before that one—that's the sequence, am I right?' He expressed amazement at how I could possibly have known that. I explained that I was someone who understood how things develop, either from something simple toward something more complex, or from chaos into something that becomes more and more structured until it makes sense. I told him that even with my kids' finger paintings I could always tell which one they had done first, and the next time I came over I brought a handful of them to show him, and he got it. He asked if he could have some of them, and he framed them and put them up in his apartment.

"One day I asked him to demonstrate for me how he physically related to people with his camera. He said, 'Okay, get on the set.' I was struck by the way he attended to the person opposite him, which in this case happened to be me: he worked with his whole body—it wasn't just his eyes and brain. He was a virtual membrane of relation, completely absorbing and mirroring you, giving back these infinitesimal responses to any shift in gesture or facial expression that he had gotten out of you."

During marathon sessions at the long table in his apartment, Dick and Maria reviewed countless Avedon prints and contacts. They took a hard look at his *New Yorker* work (Dick claimed he found it "monotonous on the whole"); wrestled with which of the Western Project pictures to include, and how much, if any, reportage (Dick rejected his Brandenburg Gate series as "just journalism" and "terrible to boot," the Buddhists as "too messy," and the Volpi Ball as "too revolting"). For the most part he and Maria saw eye to eye on what his finest pictures were, and soon the walls of the mock-up were thick with thumbnail reproductions. From time to time Dick would put his foot down—"It's one

of my natures to try to please," he explained to Maria, "but that's not the part of me that makes and defends the work."

The installation was designed to run in concordance with the important passages in Dick's career, proceeding, in other words, with structural logic. "In organizing photography shows, I've always been very aware of the interweaving of time from gallery to gallery," Maria says. "What I'm doing is telling a story—making something that has a beginning, middle, and end, with perhaps several detours and digressions for the sub-themes. People don't see a show standing still—they walk through it. It's a moving, breathing, expanding entity, a progression through space."

Juxtaposition—what Dick preferred to call "the dialogue between pictures"—was one of his fortes. Clearly the *Mission Council* mural had to face the *Chicago Seven* for dramatic contrast, and the seventy or so eight-by-tens that comprised "The Family" had to be laid out in a grid. "When I asked him what order we should hang them in," Maria recalls, "he surprised me by saying, 'Let the Family hang themselves. We'll just deal them out like cards.' But then of course he later switched a few of them around—just because he couldn't stand *not* tinkering with something. He wanted the viewer to be able to get close enough to see the individual portraits, and at the same time be able to stand far enough away to appreciate them as a group. With the murals, on the other hand, he wanted the viewer who's looking up at those larger-than-life figures to feel like Gulliver among the Brobdingnagians, or like the Lilliputians with Gulliver—he told me that one of his favorite books growing up was Swift's *Gulliver's Travels*. He was supersensitive to how scale acts on us and within us."

Midway through the installation, the Met opened a Penn show. "Earthly Bodies" consisted of his 1949–50 nudes: fleshy, headless fertility goddesses, Mother Earths, which critics had interpreted at the time of their making as Penn's reaction to his day job of photographing scrawny *Vogue* models. Dick had taken the measure of them in full when they debuted at the Marlborough Gallery in 1980. Now he said, only half-joking, to Maria, who had of course curated the show, "What are these fatties doing here?"

Dick nixed the idea she had just come up with—to embellish the

walls of his exhibition with aperçus from Proust, Camus, Beckett, Forster, Virginia Woolf, and the like. He felt that could be misinterpreted as the museum's not having sufficient confidence in his photographs to carry the day. He did, however, consent to the show's opening with a quotation, and he picked the perfect one, from Pinter's *No Man's Land*: "I might even show you my photograph album. You might even see a face in it which might remind you of your own, of what you once were. You might see faces of others, in shadow, or cheeks of others, turning, or jaws, or backs of necks, or eyes, dark under hats, which might remind you of others, whom once you knew, whom you thought long dead, but from whom you will still receive a sidelong glance, if you can face the good ghost."

And speaking of ghosts, there was an evil one shadowing the show, spooking it in fact: The one-year anniversary of September 11 would be falling right around opening night. Dick was informed that a couple of the Met director's paragraphs dealing with the exhibition were being stricken from the museum publication in order to free up space for an appeal to the membership to look to the Met for solace. Dick was outraged by the idea of the cuts: "It isn't going to bring them back . . . We can't let the terrorists win!" He lost.

His next tussle with the museum ended in a compromise. The two photographs he had designated for promotional purposes were the cross-dressing dancer John Martin and the Bee Man, but now the Met wanted to replace them with the sad Marilyn (a photograph that her own husband, Arthur Miller, had described as "succeeding as much as any single picture can in its attempt to portray her as 'herself'" and that *Time* magazine characterized as "the most psychologically inward picture ever taken of her"). The museum argued that Marilyn enjoyed a "Q Score" of twenty-five (high for a "deleb," or dead celebrity) and that using her to advertise the exhibition could make a disproportionate difference in the number of attendees. Dick protested that this would be exploiting her as a sex celebrity and proposed using June Leaf instead. In the end the Met got their Marilyn, and Dick got his June on the cover of the catalogue.

The catalogue design was triggering in Dick the usual vacillations in regard to juxtaposition. At one point he had Cleve Gray, and then

Vladimir Horowitz, facing Renata Adler, and the English actor/writer/ director Simon McBurney and the American designer James Galanos facing each other—all for little discernible reason. At another point he contemplated wife-swapping—Evie facing Robert Frank, and Dick facing June Leaf. For the front cover of the slipcase he chose Isak Dinesen, then dispensed with her in favor of the Bee Man, before flying to Milan to oversee the final engraving and printing of the catalogue at the Pizzi press.

As in Dick's first Met show a quarter of a century before, the last room in his second was conceived to convey the Big Message—to say *everything*. "In many instances throughout the process," Maria recalls, "I would say, 'I have to have this picture,' and he would go, 'Hmmm,' and then, 'Well in that case *I* have to have *this* picture,' and I'd say, 'Okay, *I* get this, *you* get that'—you know, we horse-traded. But this last room was something very personal for him." Not to mention a logistical challenge: its walls could hold no more than ten photographs and Dick was insisting on including new and recent work.

"I thought that the picture of Roy Lichtenstein that he'd taken in 1993 would be wonderful in that last room, because Roy had died recently and the photograph was very high-keyed, very ethereal," Maria says. "Roy's white hair and white skin and the whole way he was presented by Dick were such that he was evanescent, already moving toward the other side. Dick broke up the black borders around the picture to show that Roy had broken through. And of course Dick himself, as much as it felt like he would never reach the end of what he had it in him to do, was also moving toward the other side. But at the eleventh hour he decided that the Lichtenstein was too light and needed to be reprinted for depth, and then, later, that it wasn't white *enough*."

"Dick wanted me to see the Lichtenstein reprinted that final way," Jeffrey Fraenkel recalls, "so he sent a twenty-four-by-twenty-inch print to the gallery, with the instruction, 'Be sure to tear this up after you look at it.' So someone on staff trimmed Lichtenstein's face out of the print, and then a few other staff members placed their faces in the gap and sent him snaps, to prove that it had been destroyed. The print with the missing face is still hanging in a back office. Dick was not unlike other artists in the sense that most have made objects they wouldn't want to

exist after their lifetimes. Whenever he destroyed a print, I never for a second thought he intended to do anything that would negatively impact his legacy—and it didn't. He was keenly aware that when he tore a print in half in front of you, it would have a dramatic effect, and he enjoyed that." The whitened Lichtenstein made it into the last room with flying colors.

"Dick had me convinced that it would all come together at the end," Maria says. "He told me that Truman Capote in the final stages of their collaboration on *Observations* had recommended he go out in the field and get 'a few more good faces' and that in the space of a single month he nailed Picasso, Cocteau, Maugham, Dinesen, and Chaplin. And now he said he was determined to get *us* a few more good faces for that last room." Two people he wanted to photograph turned him down. Disappointed as he was, he appreciated the irony of the great portrait painter Lucian Freud thumbing his nose at the prospect of an Avedon portrait. "The message he's sending is that he doesn't recognize photography as art, and by the way," Dick couldn't keep himself from adding, "he out-and-out copied me—I'm thinking of his portraits of his dying mother." The other declining artist was the ninety-year-old street photographer Helen Levitt, who Dick insisted was "the only photographer still living whose work I liked when I was young." She scribbled a note to him on a postcard of one of her early 1940s New York photographs: "Imagine turning down an Avedon portrait! But that's what I have to do."

Another candidate for enshrinement in the last room was the so-called social-landscape photographer Lee Friedlander. He agreed to pose, but only on the condition that he could photograph Dick right afterward. "We drove up to his place in Rockland County late in May and set up the seamless between two sheds in his backyard," Dirk Kikstra recalls. "Dick got his picture pretty quickly. Then Lee pounced: 'Now it's my turn.' So I started to walk away. And Lee was like, 'Where are *you* going?' And I went, 'What do you mean where am I going?' He said, 'The kid stays in the picture.' I put two and two together: He's a photographer who likes to capture his subjects at work, so he's out to record the making of an Avedon photograph, to show the world the three-ring circus that's an Avedon shoot. That day there were three as-

sistants, two behind the camera and me standing next to Dick, because I worked the aperture and the fill card. I'd never seen Dick looking so self-conscious and uncomfortable. Lee gave him a print, but Dick hated that picture so much he gave it to *me*."

Dick's photograph of Lee Friedlander was deftly deconstructed by the dealer they shared, Jeffrey Fraenkel, in the photography journal *Aperture:* "The fulcrum of the portrait rests in Friedlander's translucent open gaze, and a steady intelligence radiates out through the exquisitely rendered lines of face and forehead. His offhandedly rumpled clothing seems of a piece with his face, and every button, thread, and stitch is detailed with absolute precision. Donned in one of the safari vests that have been his standard working outfit for years, he carries (through Avedon's lens) the air of a veteran hunter perhaps a bit past his prime. But as striking as its tone of scrutiny is the picture's utter lack of drama. Without affect, Friedlander stands as a fact, insistently and indisputably *there*."

"The way I read it when I look at both of the pictures, Lee's of Dick and Dick's of Lee," says veteran curator Peter Galassi, "is that Lee won the battle, although Dick's is the better picture. Lee is the victor because for him it wasn't *about* making the better picture. It was about his not ending up looking like the sitters in most of Dick's pictures — seriously depressed. The image is notable for the stubbornness of Lee's refusal to be pictured that way. He looks like Lee — cheerful."

In Friedlander's photograph of Dick, what Dirk describes as a "three-ring circus" Jeffrey Fraenkel sees as "an intricate ballet of picture-making," with Dick, "the lithe, elegant older artist," presiding as the central figure while "his scruffy majordomo [Dirk!] observes with wary readiness." To complement Dick's retrospective, Maria was in the process of assembling forty masterworks of portraiture to be exhibited in the museum's small Howard Gilman Gallery, and she had her heart set on including the Friedlander photograph of Dick. But when she mentioned this to him, he flew into a rage: "If you hang that picture, I'm taking my show down!"

The photograph that Dick had taken the year before of his friend the Abstract Expressionist artist Cleve Gray suddenly struck him as a must for the last room. "We were having dinner with him one night, we

hadn't seen him in six months," Cleve's widow, Francine du Plessix Gray, recalls, "and out of the blue he remarked that he thought Cleve's face had taken on so much gravitas he wanted to make his portrait. So he came to Connecticut, not that we wouldn't have gone to him, and set up outside. He stood three or four feet away from Cleve, and after about fifteen minutes he said, 'Your face just did what I was waiting for.'"

"Dick decided to add Doon to the room, and I must say she made a great sort of Miss Havisham," Maria says. (The critic Vince Aletti would pronounce that huge portrait "the most compelling of Avedon's 2002 work . . . Her mouth set, her eyes cold, she's magnificently malevolent—a fury . . .") "And he put his godson, Luke, who was beautiful, young, vibrant, and *family,* in there, too. As Dick explained to me, 'Lichtenstein is fading out of life, and Luke, his neighbor on the wall, is just coming into his own." Maria's one reservation about including Luke was that the image lacked gesture. Dick pointed out that the room would hardly be wanting in that respect—witness Doon fiddling with her necklace, Simon McBurney folding his arms, and Michelangelo and Enrica Antonioni clasping hands. Dick had photographed the great director and his wife in Rome in 1993 for *The New Yorker.* A recent stroke had left him paralyzed on his right side and all but unintelligible, though clear of mind. Dick implored him, through the medium of his wife, to express some irony or bewilderment about his situation, and Antonioni complied, managing a lopsided grin—or grimace. Signora Antonioni was then wordlessly encouraged to guide her husband's hand to her groin. "That was to show that the old boy still had a little life left in him," Dick explained to his assistant, Marc Royce, after the shoot.

Dick also wanted Maria to know that *New Yorker* critic Anthony Lane's original preference for a photograph to accompany his upcoming article on the exhibition was that particular portrait of Luke. He declared that he couldn't even begin to tell her how deep and complicated he felt it to be—it even had "links to the West." "He did several sittings with me," Luke recalls. "The first one, because he wanted natural lighting, was in that daylight studio he built up on the top floor, which normally he never used. Then the next time, we did some pho-

tographs downstairs in the cyc, with all the lighting gear. And then another time we did it on the street, in front of the building. And the last sitting, the one he ended up using something from, was down by the Seventy-second Street embankment of the FDR Drive, which he said was his new favorite studio. I really appreciated Dick taking my picture all those times, it was just a very sweet thing—it was his way of really connecting."

Art director Sam Shahid recalls, "One afternoon in the studio Dick showed me the maquette of the show, with all the photographs hanging inside, real tiny, and he motioned for me to look into one of the mini-windows. He said, 'This one is the single purest photograph I've ever taken.' I couldn't wait to see it blown up, and when I did, I understood exactly—the boy was so beautiful. And he used that picture to close the show, more or less. I remembered that the boy's father had written a score for a Calvin show that was just *beyond*—everyone was begging Calvin for the cassette—and that after he died his wife wrote that touching AIDS memoir, where she told about how Dick had supported them, and I had never known Dick to be like that."

Dick was adamant that his portrait of John Cheever grace the last room, and so he, and then Joseph Brodsky and Jennifer Tipton, joined the lineup of Friedlander, Lichtenstein, Simon McBurney, Cleve, Luke, Doon, and the Antonionis. "Cheever was very important to him," Maria confirms. "They had no personal relationship that I know of, but with Dick, sensibility was everything. I mean, that was why his portrait of Harold Bloom wound up in there—you know, the great scholar of the English poetic tradition, the propagator of the Western canon." *In* there? No—*almost* in there. In the end Dick placed him in the exit passageway, next to the self-portrait—a triptych—that he had taken on the last day of May, with Dirk tripping the shutter. He put that image of himself on the back cover of the catalogue, saying simply that it was how he wished to be remembered.

"It made sense that Dick put himself and Harold Bloom closest to the shop that sells books," Maria says, "because great literature was certainly very much who Dick was. The alter-ego name he put on his doorbell was Dr. Aziz, the soulful character in A *Passage to India*, so you couldn't not think of Forster's epigraph for *Howard's End*, 'Only

connect.' Dick *was* Forster. He was Beckett, too. And he was Proust. And he was Chekhov. Their blood was running in his veins. He told me that he had been more influenced by literature than by anything visual. The European intellectual tradition was so much a part of how he had learned to see—it was what his appreciation of the world was channeled through. And he was able to bring all of that to bear as he worked behind and then next to a camera all those years, expressing the absolute values of human beings, which is what great creative artists do. They see—and can build—worlds for us that are symbols of our condition. He had his own situation, of course—his mother, his father, his sister, his two wives, his son. All of that contributed to his artistry, but it was also the reading and the theatergoing that gave him the navigational tools to see into life as fully and deeply as he did."

Harold Bloom confided to Dick that before leaving his house in New Haven he had had his wife carefully comb his hair. Dick lost no time restoring it to its disheveled glory atop Bloom's droopy, marvelously lugubrious face. Bloom remarked later to Maria, "I had evidently been an Avedon all these years without knowing it." For all the banter, he hated Dick's portrait of him on sight and complained that it didn't look a thing like him. "That's a very dumb thing for a very smart man to think," Dick said. "As I've been saying for more than fifty years, a portrait is not a likeness. I mean, would Bloom have protested to Modigliani, 'My neck doesn't look like that'?"

On September 23, a neck-craning, head-turning mix of fashion, society, media, and arts and letters swelled the galleries. Among the more than six hundred guests at the opening were Joan Didion and John Gregory Dunne, Kathleen Turner, Robert Hughes, Barbara Jakobson, Marisa Berenson, Betty Comden, Adolph Green and Phyllis Newman, Owen Edwards, André Emmerich, Veronica Hearst, Reinaldo and Carolina Herrera, Hendrik Hertzberg, Patricia Marx, Art Spiegelman, Al Hirschfeld, Nan Kempner, John Post Lee, David Levine, William S. Lieberman, Leonard Lopate, Santo Loquasto, Gerard Malanga, Paul Morrissey, Sonny Mehta, Louis Menand, Lachlan Murdoch, Herbert Muschamp, John Russell and Rosamond Bernier, Si Newhouse, Dr. Norman Orentreich, Mandy Patinkin, Carroll Petrie, Charlie Rose and Amanda Burden, Angelica and Neil Rudenstine, Robert Silvers,

Hedi Slimane, Twyla Tharp, Calvin Tomkins and Dodie Kazanjian, Gloria Vanderbilt, Jann Wenner and Matt Nye, Edmund White, Helen Whitney, and Jayne Wrightsman.

Dick's extended family was everywhere in evidence: his housekeepers Verlie Fisher and Juana Page; his trainer Kerry Roland; Jeff Rose, the owner of Attitude, the car service we used; and assistants past and present, including Daymion Mardel, Dirk Kikstra, Ruedi Hofmann, Andrea Blanch, Gideon Lewin, David Liittschwager, Harvey Mattison, Marc McClish, and Maggy Geiger. "It was old home week," says Maggy. "I saw Polly Mellen and China Machado, both of them stationed in front of their portraits. And Mike Nichols was there with the wife. And Lauren Bacall. Dick was talking with his French girlfriend, and when he noticed my little boy, Jake, he broke away and had a grown-up chat with him about life." (Speaking of Maggy's little boy, the Met, with the Warhol Factory mural's eye-level penises firmly in mind, had seen fit to place an "inappropriate for children . . . parental discretion advised" sign at the entrance to the show. A couple of years later, when Olivier Sarkozy, the half brother of the then president of France, bought Dick's studio and began acquiring Avedon prints, he wanted to purchase the Warhol Factory, but his then wife, Charlotte, cautioned, 'Pas devant les enfants.'")

Despite the crush the Bee Man bumbled over to me. "Norma, look!" he said, pointing to his image on the cover of the slipcase. Luke was busy telling me how "unbelievably bizarre" it had been for him to see his picture hanging in the Metropolitan Museum: "I didn't know I was going to be so big! It feels kind of frightening. My mom is here with her gay friend who lent me the off-white linen Banana Republic shirt I'm wearing in my portrait—it's his fifteen minutes of fame, too. Daymion told me tonight that somebody actually bought one of the three prints Dick made of me, for a fortune. And then this guy I didn't recognize came up to me and said, 'Congratulations on your portrait, he never did one of me,' and who it was was Dick's grandson Matthew—I hadn't seen him since we were kids. I felt like saying, 'Well, I never accused him of anything.'" Betsy, Luke's mother, joined us. "It was maybe the weirdest experience of my life," she said, "to walk into that last room and there's Lauren Bacall looking at my son as a work of art."

When *I* finally got to walk into the last room, what I saw was Jennifer Tipton standing well away from her portrait, regarding herself out of the corner of her eye. "I had taken off my glasses just before the sitting," she explained, "and as I was leaving I put them back on, and Richard went, 'Wait wait wait *wait*! Get right back in here!' And he photographed me with them on. And smiling! And he certainly didn't do too many of *those*—I remember him saying that smiling was just something that came in with the snapshot. Anyway, I was thrilled—I think I look better when I smile. Jerry Robbins used to call me his Smiling Buddha."

Exiting the exhibition, I came upon Dick contemplating his self-portrait triptych in the passageway. "I'm standing here trying to look at myself not as the photographer or the subject—merely as a viewer," he said. He told me he had overheard two old women behind him debating how old he was in the picture: "One of them thought not a day over sixty, and the other one said sixty-five, so I turned around and set them straight—'Girls,' I said, 'you're both wrong, he's going on eighty.'"

From the Met I headed over to the Carlyle to make sure that all was in order for the celebratory dinner. Dick had originally planned to just have a few friends over to his apartment to "eat risotto on the floor." I persuaded him that the hotel's Bemelmans Bar, what with its black-granite trappings, gold-leafed ceiling, and Central Park murals, would make for a more inviting venue. "It was kind of a silly place to have it," Dr. Millman counters, asking, "What on earth could Richard have been thinking?" I was left to wonder why Richard's psychiatrist, of all people, had to wonder what he was thinking—Millman had, after all, been in a position to actually know. "That room is so cramped," he goes on, "and the seating was so strange—tiny tables for three." Hello? Dick *liked* small tables—they facilitated intimacy.

Among Dick's guests at the Carlyle were Mike Nichols and Diane Sawyer; Tina Brown; and Dick's good old friend Joanne Stern; Cleve and Francine du Plessix Gray; David Remnick and his wife, Esther Fein; MoMA curator Kirk Varnedoe and his wife, Elyn Zimmerman; Andre Gregory and his wife Cindy Kleine; Marisa Berenson; Simon McBurney; John Lahr; and Stanley Donen. "That night Richard was

really happy," Dr. Millman reflects. "He seemed relaxed for once—he was charming and gracious to everybody, even to someone he didn't know, like my daughter. Unfortunately, he stuck me with that actor. You know, the one who was fat and sloppy and always played crazy people—Seymour something."

"Guess who I was seated next to that night?" David Ross says excitedly. "Someone I actually became friends with. The great Philip Seymour Hoffman." Jeffrey Fraenkel was equally taken with his placement. "In the days before the opening, Dick dropped hints that he had something special in mind for me," he recalls. "And indeed he did—he seated me between Stephen Sondheim and Elaine May. It was stupendous as far as I was concerned, but I almost felt a little sorry for *them*."

"I was at the table behind Elaine May, and I was fascinated by her somehow," recalls Judith Thurman, the author of the effervescent essay in *Made in France*, the book of Dick's vintage Paris photographs published that year by Jeffrey. "And I was also very interested to see Dick's French girlfriend—I had this sort of prurient curiosity about her. I wondered what kind of buoyancy and light Dick could produce in a truly private encounter, as opposed to a quasi-private one. I mean, when I had lunch alone with him at Petrossian he made me feel as if I were Suzy Parker at the bar of the Café des Beaux Arts and that all of Paris was looking at me and thinking how special I must be to be there with him. Every moment alone with Dick was a heightened one: his beauty was heightened—he was like a boy, a beautiful old boy—and so was your sense of complicity. His stock-in-trade was his complicity, and he had a quintessential genius for it—and an urgent need for it born out of a deep loneliness. It's a survival adaptation, this having to construct with another human being a very ethereal and very spider-like, very spontaneous, bond. The instant intimacy he created with his subjects was entirely different, because it was false: that sense of it's-only-the-two-of-us-so-just-give-me-your-soul—and then he takes your picture *and* your soul and that's it. But with people whose picture he wasn't taking, the few he actually wanted the complicity with, it was one of the most powerful currents you could ever experience with another person. Anyway, Nicole was very elegant—she was wearing a

fabulous Chanel dress. And I? When the invitation arrived, I remember thinking, Oh my God, what can I wear to *this*? In the end I chose a strange, very old Comme des Garçons."

So what was *I* wearing? If you must know: a pink satin slip dress, with a hand-painted puffy jacket designed by a student at the Fashion Institute of Technology. And where was I seated? Nowhere. I was standing. Helping to run the show. I was, faute de mieux, the hostess: I knew everyone there, and everyone knew me, and one of my jobs was to go from table to table to see that people had enough to drink and if they were getting enough fun out of a good time.

As I walked Dick to his car he said, "The opening was great, and our little dinner was certainly a ten. Now we just have to wait and see how the show fares with the critics" —he was hopeful, he said. But you can't keep a good pessimist down, meaning you can't get him up, and by week's end his age-old apprehensions had crept back. "*Newsday* is almost word for word what was written about my work thirty years ago— 'ugliness, wrinkles, celebrities, fashion,' etc.," he lamented to Maria. *The Wall Street Journal*, not to be outdone, was just as negative—Dick's sitters were "as readily apprehensible as McDonald's golden arches," they were no more than logos.

The *New York Times* review lifted his spirits a little. Although the paper's lead art critic, Michael Kimmelman, began by rehashing the 1994 Avedon retrospective at the Whitney ("unfortunate, badly edited, badly designed"), he was soon extolling the Met show as "gorgeous: a pitch-perfect mix of modest-size, big, and unbelievably big prints, each an exquisitely made object." He saluted Dick for having produced "many photographs in the last 50 years [that] have become part of our mental furniture," going on to remark on the "subtler pitch" achieved in some of his most recent portraits, such as those of Cleve Gray and Lee Friedlander. "They seem natural, lifelike, less about Mr. Avedon wielding authority over his subjects," Kimmelman wrote, taking care to add, "but they're not going to sear into your consciousness the way other photographs by him do. This is the tradeoff with Mr. Avedon: between style and substance. It's the tension he has made into his art."

Dick had personally invited Penn to see the show and, when he made his excuses, mumbling something about the crowds, Dick ar-

ranged for him to see it alone. Penn dutifully walked around the galleries while Dick and I waited in the lobby, just as we had done eight years before with his Whitney retrospective. I thought, This had better turn out better than that! When Penn reappeared, he told Dick, "That was certainly the big picture," then added, with a slight smile, "It confirmed my thoughts about your work." After he left, Dick said to me, "What do you think he meant by that?"

In the throes of postpartum exhibition depression, Dick wrote to Maria in early December to assure her that out of sight was not out of mind and that he was looking forward to having a last walk-through of the show with her, followed by "tears and caviar." There would be nothing to cry about. For Maria, the exhibition succeeded in presenting a "radically purified view of the artist" through "the finest prints of his classic images." For Jeffrey Fraenkel, it served to "redress the imbalance in Avedon's reputation, which had remained unsettled as far as critics and curators were concerned. It was a lightning rod, a definite turning point toward fixing him firmly in the pantheon of great portraitists."

For the Met, the show was an unprecedented success. Over the course of its ninety-six-day duration, it was visited by almost half a million people, the number it would take to fill—as Laura Wilson's husband, Bob, a Dallas TV pioneer, pointed out to Dick, inadvertently invoking three venues that were Greek to him—Yankee Stadium ten times over, Madison Square Garden twenty-five nights in a row ("Not even the Rolling Stones could do that!"), and five Super Bowl stadiums.

23

THE LIVING END

—

ICK WAS BASKING IN THE AFTERGLOW OF THE MET SHOW: He felt that his stature as an artist of considerable consequence had been reified. One afternoon I found him contemplating a picture of Man Ray's photograph of a sunken-eyed Proust on his deathbed. "When I photographed Cocteau in '58," Dick reminisced, "he told me how he had telephoned Man Ray that morning from Proust's apartment and told him to get his ass over there with his camera." He added, "I just can't get over that stingy little bed," and then, with a brittle little laugh, "*I'm* going to have a deathbed to die for."

He was dead serious. Moreover, he knew just the man for the job—Brian Tolle, who manipulated the skeleton for him on the Comforts shoot in Montauk. Dick had kept up with him over the years. He had gone to his solo show in SoHo, tickled—you could say slain—by the overkill title, "Overmounted Interiors: Colonial Revival Revisited." (Brian had done grad work at the Yale School of Art in furniture as sculptural form.) When the Victorian Arts and Crafts Gothic-inspired daybed that Marla had installed in Dick's living room began going to pieces (one of the carved-oak pelican finials went flying off, followed by another), he hired Brian to repair it. Later Dick commissioned him to make a coffee table versatile enough to accommodate his miniature-

book collection. Brian created a striking-looking rectangle of slats and oak straps terminating in three tightly massed shelves.

On the strength of that coffee table, Dick commissioned a dining table, which, he told Brian, he wanted to echo his Western Project photograph of an abandoned Montana copper mine. "I knew that he knew from my overmounted interiors show that I love to sink my teeth into historical references and that that was one of the things I could bring to the table," Brian says. "I envisioned it at first as a nineteenth-century industrial construction with girders, but it ended up much less elemental: an octagon of walnut-constructed I-beam supports that crisscrossed at angles and interlocked to support the top—which I in-laid with hammered copper—creating gravitational channels for draw-ers that could hold the lapis-and-jade silverware that Dick had just brought back from Paris. Simple is always better, don't you think?"

In the year 2000 Brian invited Dick to a group show in Chelsea catchily titled "Innuendo." It included an elaborate bed he designed, boxed in by carved Gothic Revival–style prayer kneelers, which *The New York Times* described as a sly marriage of the sacred and the pro-fane. Now, two years later, Dick picked up the phone. "He said to me, 'This is a once-in-a-lifetime commission—you're going to make me a bed that's going to make you famous,'" Brian recalls. "But by then I already *was* kind of famous—I had won the competition for the Irish Hunger Memorial in Battery Park City. We were supposed to break ground in 2001, but then the World Trade Center collapsed on the site and I had to reconceive my sculpture to commemorate a tragedy on top of a tragedy. I made the front page of *The New York Times* twice."

From the outset, Dick referred to it as his deathbed. "I could tell that this whole business was a very emotional thing for him," Brian says. "Off the top of my head I told him that I saw the deathbed as living sculpture, with him as the most important element within it. He said, 'Astonish me. But just remember, no prayer kneelers needed.' My part-ner, Brian, and I had a house in the Catskills, and there was this old Bear Mountain water-cooler wooden crate lying around in the shed. It was just this twelve-inch-square cube, with a solid bottom and open top and slats on the side, but it really spoke to me—it called up that coffee table with the wraparound slats that I'd made him. I brought it down to

the city to show him, and he got that I was into making a whole family of furniture for him. I demonstrated how he would be able to turn the unit in any direction and it would work. Upright, it could be a wastebasket; sideways a bookshelf; upside down, a telephone stand—it had this mind-blowing versatility. It was the prototype for the building blocks for my design: boxes that could be screwed together to create solid sides around a bed—a sectional bedstead."

Dick was intrigued, but insisted on having the idea tested in cardboard first. So Brian brought a hundred twelve-inch-square collapsed boxes to the studio and assembled them, then he and Dick stacked them around the bed. The structure kept getting higher—it was beginning to resemble a fortress, except for one side, which had been left open so Dick could get in and out. He had recently replaced his broken-down old cot with an adjustable single-width hospital bed. Daymion made off with the cot—the mattress, too. "Anything Dick was throwing away, I took," he cheerfully admits. "It had been his bed for years, and now I wanted to make it mine."

Dick practiced sleeping surrounded by the piles of cardboard boxes, to see how being embedded felt. He had several objects placed around him, including a telephone, an answering machine, a plaster cactus-form lamp with a paper shade painted with Western scenes that Marla had found for him, the cast of his baby shoe, and one of the three urns containing his mother's ashes (Dick could now be said to be happily mummified in both senses of the word).

Within a matter of days—or rather, nights—he gave Brian the green light to have a hundred boxes built out of mahogany and treated with an oil-rubbed buttery Danish finish that Dick liked. They were delivered to the studio one hundred strong, needing only to be screwed together (later, strip lights would be installed inside each one). As Brian screwed his heart out, Daymion exclaimed, "It's going to look awesome! Like a Frank Lloyd Wright building."

Dick couldn't wait to show off his new resting place. "After he photographed me in his studio for *The New Yorker*, in 2003, he gave me a little tour of his apartment, and he said, 'This is the bed where I'm going to die,'" Isabella Rossellini recalls, with a mock shudder. "I remember thinking, What a strange joke, how dark, how macabre. And

DAYMION MARDEL

THE MOCK-UP, WITH CARDBOARD BOXES,
FOR DICK'S "DEATHBED."

the funny thing is, he didn't die in that bed. As my mum would say, he died with his boots on—she had always wanted to die with her boots on also, alas. So there he was, age eighty, going on about his death, which didn't seem possible, because he had still more energy than anybody. Mental as well as physical—I mean, the way his hair stood sort of straight up gave you that feeling of this brain boiling underneath. David Lynch had hair like Dick's—that's maybe why I fell in love with him. I was traveling in California when my daughter called to say she had just

heard on the radio that Dick died, and I burst into tears. It felt like a huge door had closed—and I wasn't even a close friend or anything. I took my daughter, who was a model, to his ICP fashion retrospective a few years later. We went around to every photo, marveling at every gesture, and I saw that fashion photography really could be divided into Before Avedon and After Avedon."

When Baryshnikov arrived at the studio for a portrait, Dick invited him upstairs afterward for a viewing. "My God!" he cried. "The Rolls-Royce of deathbeds."

"That bed was something," Jeffrey Fraenkel allows, "but what Dick kept under it was something else. One day he hauled out the clear Plexiglas box containing Diane Arbus's jaw-dropping portfolio, 'A Box

THE REAL-LIFE "DEATHBED"—
IN MAHOGANY.

of Ten Photographs.' Marvin Israel had worked with her to design the box, which she once described as being almost like ice. The market for her work back then, in 1971, was virtually nonexistent, and she sold only four sets during her lifetime. Dick was the first to buy, and in fact he bought two, for a thousand bucks each, and gave one to Mike Nichols. The portfolio contains many of her best-known photographs: *Identical twins, Roselle, N.J.*; *Boy with a straw hat waiting to march in a pro-war parade*; *A Jewish giant at home with his parents in the Bronx* . . . On the vellum sheet under the cover of Dick's portfolio, Arbus had written 'especially for RA' and scratched out the word 'ten' and replaced it with 'eleven.' She had included a print of *A masked woman in a wheelchair*, an image she'd made not long before assembling the portfolio. I knew these images well, but it was tremendously exciting to see such prints come out from under that bed."

Also hidden under Dick's bed were a couple of tightly sealed containers wrapped in brown paper. These were packages that Dick claimed never to have opened. They were gifts from "two people who mean the world to me—Suzy Parker and Nicole. I asked them each to send me what they thought I would most like to see just before I died—assuming of course that I would have some notice of that event." The box from Suzy probably contained a few of the stripped chicken wings that she and Dick had been playfully exchanging for half a century—ever since the day in 1962 when, during a *Bazaar* shoot in Antigua, a wing with a pleasing shape washed up on the beach and they fought over it. They christened it the "bone of contention," and it went winging its way back and forth between them. He sent it to her when one of her kids was born and then again when one of them got into or graduated from Harvard, and she meanwhile sent it back to *him* when he had his first show at the Met, in 1978, and so on and so forth. "Mom would keep the bone in a small gold-leaf box by her bed," Suzy's daughter Georgia Thoreau La Salle reports. "The bone was gone when she died, in 2003, so she'd probably sent it to Dick for his Met portraits exhibition the year before."

The other untouchable box, from Nicole no doubt, had a few of the frilly blue ribbons that she liked to stick in the pockets of Dick's coats to remind him of her when she wasn't around; and maybe a lock or two

of her red hair; and surely some of the love letters she was always writing him.

"He told me about those boxes under his bed when he was asking me for input on some of the boxes *around* his bed," Luke recalls. "One of them was going to have a chess set, because he wanted me to teach him to be better at it—he said that John had been able to beat him when he was six. Another box was going to be for his ice-cream maker. He said, 'A deathbed is your ultimate bed, and mine is going to be the ultimate deathbed.' When I finally saw the thing all set up, I told him I really liked it, because I didn't want to hurt his feelings. But to me it looked like it came from Ikea." (Dick had once said of Luke, if affectionately, "I wouldn't call him a visual.")

In September 2004, just a few weeks before he did in fact die, Dick invited Brian over to see how well he was doing with his deathbed. "He said he wanted to show me the degree to which his use of it had evolved," Brian recalls. "He was lying on it when I got there, and he motioned me to sit on one of the boxes, which I was happy to discover made a great ottoman. I was also pleased to see that he had put something in almost every box. It was like he had drawn his whole world to him: everything he wanted or needed was within arm's reach, beginning with movies, tapes, books. And that's when it dawned on me that this had become a biblical story: Dick's deathbed was a modern take on a pharaoh's tomb—you know, the way they equipped themselves for the next world. By the way, I was never notified that the family was putting it up for sale. That all seemed to happen way too quickly. I would really like to know who's sleeping in it now."

"That he built that bed was the weirdest thing," Dr. Millman reflects. "Or maybe it wasn't—maybe it was sort of a clear-eyed way of anticipating his gradual wearing down. Anyway, he never really got to enjoy it as such, because he simply died."

"I loved that bed more than anything in Dick's apartment, and I loved *everything* in his apartment," says designer Santo Loquasto. "But I just couldn't bear to go to the auction that his son had at Sotheby's of all Dick's personal things. I *had* gone to Jerry Robbins's auction a few years before, where I bought a Ben Shahn I wanted, but I didn't have the same feeling for Jerry as I had for Dick, to put it

mildly. I just liked Dick too much to go and bid on his bed. But a couple of years later, when I was doing the sets and costumes for *Three Days of Rain* on Broadway, with Julia Roberts, which turned out to be a big disaster, I copied his bed exactly. I had it made just from photos—complete with all those marvelous crates that he had surrounding it. After the show closed, the producers scooped them all up for themselves."

Until the end, Dick was capable of putting on a good show—Anthony Lane had written in *The New Yorker* that "there are teenagers in this city who would kill for a taste of the hectic hipness that Avedon maintains as he nears his eightieth year." But the truth was, he was wearing down. The stairs were now a big problem. He had to take them very slowly, one at a time. If we were going up together, I made sure I went first. Or else I'd let *him* go and just take his time—I'd say, "Oh Dick, I'll be up in a minute." The thing was to not be in the position of being right behind him—and, above all, to never offer to help him. I remembered his telling me how, after he photographed the then ninety-year-old ACLU founder Roger Baldwin for the "Family" portfolio and was trying to help him up some stairs, Baldwin hit him.

One night Dick gave me a real fright. We were having our customary last call of the day. He was in bed, and suddenly his voice dropped, then his speech slowed, and then . . . dead silence. I said, "Dick? Dick! Are you there?" I hung up and called back—only to get a busy signal. When I called his other line and he still didn't pick up, I said to my husband, "Martin, I think Dick just died." We raced over to the studio and I ran up the stairs, my heart going a mile a minute. When I got to the landing, I turned and said to Martin, "*You* go in, I can't face this." He said, "No, *you* go—this is *your* funeral."

Dick was lying back against the pillows, eyes closed, mouth open, phone dangling from hand, but breathing—seemingly normally. And his color was good. I shook him gently and got him to sit up, and then I delivered a wake-up call: "This is the last time—it *has* to be. You've got to stop with the pills, they're bad for your heart." He mumbled, "I know, I know, I will."

The next morning he was grouchy: "So sometimes I need a little help from the medicine chest, a little something to bring the energy

forward—no big deal! Don't worry, I'm not going to die on you." He certainly had every contingency covered. His Rolodex was brimming with doctors, some of whom he had already outlived: Andersen, Blaivas, Blumenthal, Cahill, Carniglia, Clarke, Cohen, DeMann, Fields, Goldberg, Grasso, Greenberg, Harmon, Hart, Hartman, Jacobs, Kastenbaum, Klein, Kobayashi, Kurth, Kushner, L'Esperance, Lennon, Leonard, Loo, Magid, Malpeso, Maxfield, McCarron, Miscovitz, Mouallem, Nagler, Nash, Orentreich, Petito, Reckler, Roberts, Rosberger, Rosenfeld, Schmerein, Slavit, Spivach, Stimmel, Tyberg . . . Some of the names had notations beside them, such as "Kissinger's doctor," or Ralph Lauren's, or Mike Nichols's.

Dick devoted an awful lot of thought to his obituary. One fine day he called me from location in Monte Carlo, out of breath, to say he had run into Helmut Newton, who drove them to a restaurant somewhere along the coast for lunch: "He was playing Russian roulette on the scariest hairpin turns in the world—so tell me, if the car really *had* gone over the edge, who do you think would have gotten more ink, Richard Avedon or the King of Kink?" Dick then reminded me of Helmut's giddy greeting to him on his, Dick's, seventieth birthday ten years before: "Hello there, Dick, long time no see, too long—you're going where I am and where I'll be and I can tell you it's not too bad—specially as we're rich and famous—makes life easier."

Dick often said that life was the biggest contradiction of all, built as it was on the certainty of death. He was determined that his name not be "writ in water." To that end he became mortally obsessed with his *New York Times* obituary. He was confident it would start on the front page. But above or below the fold? That was the question. That, and whether it would add up to more words than Irving Penn's. As with most notables, there was an obituary of Dick already on file at the *Times*, but at least once a year, unsolicited, he would send an update. "You can never let up—you have to keep giving them fresh material or they'll just bury you with a lot of old stuff from their morgue," he explained. "I have to do everything I can to combat the label 'fashion photographer.' I've done seven books of portraiture, which I have to hope will give them a picture of the proportions of my career when they're sizing it up after I die." Another besetting worry was that some-

body "even bigger" would croak on the same day—he remembered that Aldous Huxley and C. S. Lewis had each had the misfortune to die on the same day as JFK.

Meanwhile, it was Evie who was dying. She had cancer. On the advice of Dr. Irwin Redlener, a nationally recognized expert in disaster medicine, Dick moved her to a hospice in the Bronx. He visited as often as he could, and a few times he asked me to go with him. After more than a half century of resisting the idea of his photographs on her walls, she had allowed as how she wouldn't mind a few for her sickroom. Dick made a selection of second-choice prints, including Suzy Parker roller-skating with Robin Tattersall on the Place de la Concorde, China Machado at the bar of a Paris boîte, and Sunny Harnett at the casino in Le Touquet. All three models were women Evie had known in the years when she accompanied Dick to the collections looking like a chic Parisienne herself. At the last minute Dick threw in his portrait of a cadaverous Isak Dinesen. When I protested that this wasn't a suitable choice for someone who was now skin and bones herself, he countered, "She loves Dinesen—she wanted me to bring her her copy of *Out of Africa*."

Dick had photographed the great Danish writer in a Copenhagen hotel room in 1958. She had come to the sitting wearing a coat of uncured black wolfskin and a skullcap, and the first words she addressed to him were equally fierce—"I always judge a person by what he thinks of *King Lear*." They served to awaken all his high-school-dropout insecurities (he confessed to me in 1980 that he had yet to read the play, but by the millennium he was telling interviewers that he had read it "at least a hundred times"). "He wasn't going to let her get away with that kind of ridiculous intellectual snobbery," says Judith Thurman, who wrote the National Book Award–winning biography of Dinesen. "She was impossible with him, and that's the reason those pictures look the way they do—he caught the greed and the ravenousness in her." Dinesen had been expecting a glamorous Avedon portrait and found the photograph "ungallant" and unforgivable. "Only one subject rankled whenever she thought of Americans: how angry she was with Richard Avedon," the first of her American biographers, Parmenia Migel, wrote in 1967. "How hurt she had been when he sent her

Observations . . . How she had hated . . . his cruel rendering of her hands!" Dick insisted that he saw beauty in those hands: "So much has been written there, there is so much to be read . . ." Her legs he left to his collaborator Truman Capote to dissect: "thin as the thighs of an ortolan." As for her neck, Truman reckoned "a ring could fit" around it, adding that her lips "twist in a sideways smile of rather paralytic contour . . . Time has reduced her to an essence, as a grape can become a raisin." (Dinesen retaliated by threatening to renege on her promise to write the preface to the Danish edition of *Breakfast at Tiffany's*; write it she did in the end, but "with bitterness in my heart.") Dick rated his portrait of Dinesen "beautiful on a level way way above Audrey Hepburn."

Five decades later came a runic answer to Dinesen's arrogant question—what did Richard Avedon think of *King Lear*. In 2004 Christopher Plummer was playing the tragic king on Broadway and Dick photographed him for *The New Yorker*. When his editor Pam McCarthy wrote to congratulate him on the picture ("You have him looking so perfectly ravished, with one eye fading and the other seeing and understanding all; how you got the eyes to do two different things is beyond me, and would clearly have been beyond anybody but you"), Dick replied, "I have my own picture of Lear—looking a little bit like myself."

Dick pinned up the Dinesen print in Evie's hospice room, along with the three fashion photographs. I had my hands full as well, arranging the two big bouquets of white French tulips and white lilac that we had brought. Evie was napping, and when she opened her eyes and took in the trio of Suzy, Sunny, and China, she seemed to smile. But then her gaze wandered to the other wall where she got an eyeful of Isak, and she made a terrible face. Dick interpreted that as a signal to take them *all* down.

Evie's situation went from bad to worse, then from worse to *the* worst. She could no longer do anything for herself, even breathe—she was on a respirator. "One night that February Dick invited me over so we could watch *Terminator* together," Luke recounts. "I had told him I felt a deep connection to that film, because for me the demon that wouldn't die was the AIDS that killed my dad. Dick was making a big

effort to get interested in my interests—he told me he was trying to enter my world and that he had finally seen the original *Matrix* on television and thought it was great.

"That night he said to me, 'Well, Luke, I have nothing good to say about getting old.' I remember saying something like, 'Dick, come off it, don't say that—you have wisdom and things.' He said, 'It's the energy that's the problem.' But then in the same breath he told me that he still came to every sitting all charged up and that his heart pounded and his pulse raced every time he took a picture—he said he wouldn't have it any other way, since he needed to transmit a sense of that tension to the sitter. He gave me a lot of life advice that night. His whole message to me had always been, 'Get excited!' but now he was dialing that back and telling me stuff like, 'Luke, life isn't really like that. Don't be *too* optimistic. Slow and steady is maybe better . . .' I suddenly felt this urgency to have as much him-and-me time as possible, I wanted to know every single thing about him."

A few weeks later Luke was back at Dick's apartment and they were about to sit down to dinner when the phone rang. "Dick picked up, but he wasn't saying much, he was just shaking his head. I had a bad feeling—I mean, I knew Evelyn was terminal—and when he hung up he told me that she had died," Luke recounts. "I went over and gave him a kiss on the forehead. He said, 'I'll never forget how sweet you just were.' Needless to say, we never got to watch *Terminator.*"

As soon as Luke left, Dick called me. "I don't really know how I feel," he said. "A little sad. A little empty. A little guilty—make that a lot. But, mostly, relieved that her suffering is over." The stylist Nicoletta Santoro recalls, "We were doing a Levi's shoot at Industria, and Dick arrived late—something he never did. Immediately he took me aside to communicate that the wife had passed the night before. But he did the shoot. His personal point of view about life was what is alive is important and what is dead is dead."

Two weeks later, Dick left for Mexico City to photograph Nobel laureate Gabriel García Márquez for a second time (the first was in 1976). He did the sitting outdoors, in under five minutes, and was moderately disappointed with the results. The highlight of the trip, he said, was a tarot-card reading he got on the street that predicted he was going

to enjoy a very long life (how he would have dwelled on the irony of that!). Being in Márquez's house, where everything was so white, had given him "a little idea" for his living space, and now he wanted me to have all the rice-paper lamps in Evie's apartment brought to the studio to "lighten things up."

ON A TRIP TO MEXICO CITY TO SHOOT NOBEL LAUREATE GABRIEL GARCÍA MÁRQUEZ, DICK WAS STOPPED IN THE STREET BY A MEXICAN FAMILY WHO ASKED HIM TO TAKE THEIR PICTURE WITH THEIR CAMERA, LITTLE KNOWING THAT HE WAS THE WORLD'S MOST FAMOUS PHOTOGRAPHER.

Dick asked me to accompany him to Frank Campbell's to collect Evie's ashes. On the way over there, he said, "I gave her everything she wanted—rings on her fingers and bells on her toes, elephants to ride upon . . . Of course I *have* to think that, don't I—for my own peace of mind." As we were leaving Campbell's, he said, "Let's stop in at all the Evie places." And so, on a bright, blustery day, with me carrying a Bloomingdale's shopping bag with the metal container of Evie's ashes, we made ritual stops at her bereaved haunts: Lobel's, her butcher; William Greenberg, her baker; and Archivia and Crawford Doyle, her booksellers. Our last stop was Zitomer, her pharmacy. There Dick reached into the bag, pried open the container, and surreptitiously

sprinkled a few pinches of ash in the aisle that had the Dead Sea Mud Deep Cleansing Bars that Evie had put such stock in. "The perfect ending," Mike Nichols said when I shared this with him. "She died as she had lived—by Laszlo."

When Dick called late that night, his voice was raw: "I'm now beginning to think that maybe I *didn't* really do enough for her. Do you think her life would have been better if I had tried to get her out more? Frankly, she would probably have been better off without me and my ambition. The guilt, the guilt." I told him to stop tormenting himself. As his friend Charles Michener says, "It was better for Evie that Dick kept her hidden away, like in a Victorian novel, where she didn't have the strain of having to deal with people. He was faithful to her to the end—he never tried to walk away from his responsibility. He wasn't like Arthur Miller, who had the retarded son he never even visited."

It wasn't only Evie that was torturing Dick. He had begun to feel he was getting old in the place where he was the most vulnerable—his work. "It just isn't happening in a big enough way anymore," he said. Dick, constitutionally, was someone who would rather push through to something new and fail than hark back—you had to "kill the past and move on." "Time . . . can't seem to outrace him," Vince Aletti once wrote. "He is like the Red Queen in *Through the Looking Glass* who was always running but took the landscape with her as she went." But now Dick felt that the sight lines of his life were all behind him. And for him, life without meaningful work was hardly worth the living. (Commissions such as a post–9/11 one from Burger King to do a series of portraits titled "Courageous Americans," which ran as full-page ads in *USA Today*, could hardly be counted as sustenance.)

A decade or so before, Helen Whitney, the writer, director, and producer of that PBS *American Masters* documentary on Dick, *Darkness and Light*, invited him, along with uncountable other friends and acquaintances of hers, to her place downtown one Sunday afternoon to watch *An Interview with Dennis Potter*. The film had been made from a televised deathbed interview with the British screenwriter and television dramatist (*Pennies from Heaven*, *The Singing Detective*), and Dick, who had photographed Potter in London for *The New Yorker*, had seen it nine times already. Now he was looking forward to seeing it a tenth—

"How can you not revere a man who came up with the line 'God's a rumor'?" he asked rhetorically.

Not having seen the film even once, I went along, and was pleasantly surprised to find it anything but morbid. Potter got things off to a good start by announcing that he had named the pancreatic cancer that was killing him "Rupert" (after Murdoch, whose journalistic practices he said he deplored). Taking swigs from a morphine cocktail, he was downright buoyant at times. "I feel I can write anything at the moment, I feel I can fly with it," he raved. "My only regret would be to die four pages too soon." In fact, he lived to finish the two plays he was working on.

Several of Helen's guests lingered after the film to talk about death. At one point the documentary filmmaker Albert Maysles (*Gimme Shelter, Grey Gardens*) took the floor and basically said, "Potter didn't even bother to mention his wife, who was well known to be also terminally ill at the time. All he talked about was his work." Dick flew to his feet. "Potter clearly felt he couldn't afford to waste a precious second talking about anything that wasn't of earth-shattering importance, and his work was everything to him," he declared. "He knew that work is the best medicine."

The big idea Dick had been dying for finally came to him: to undertake an extended cross-country trip "reading faces" as to the state of emergency that he felt existed in the United States on the eve of the 2004 presidential election. "It's perfect for Remnick," he accurately predicted. He pitched his "apocalyptic vision" of the portfolio to the *New Yorker* editor as embracing "politicians from the right and the left . . . those responsible for our country's failure in AIDS research, drugs, the environment, women's rights, education, foreign relations . . . protesters at the conventions as well as the candidates and delegates . . . golfers who are executives at Enron or Halliburton . . . Texas border stuff . . . migrants." As Dick saw it, the challenge lay in balancing "the necessary journalism with the necessary soul." He told Remnick that he was even prepared to fly to Iraq to photograph our soldiers.

"It was all very exciting," David confirms. "He believed he could do something as important on politics as he had done in previ-

ous decades—and not only match that achievement but maybe even transcend it. He hoped it would be a combination—if not the culmination—of all his various ways of working against the white background." Dick decided to call the portfolio "Democracy"—he liked the ringing, reconciling sound of it. And what better way to inaugurate a project so called than at the Democratic National Convention, which was to take place in Boston in late July. And then to follow it up with a turn at the Republican National Convention, to be held in late August in Madison Square Garden.

Dick's two biggest Democratic "gets" were Jimmy Carter and Barack Obama. He photographed Obama the day after the Illinois state senator and U.S. senatorial candidate had electrified the convention with his keynote address. Dick had both the future president and the former pose in plain shirts, which he'd sent his assistant Cameron Sterling off to the Gap to buy—he didn't want their own clothes distracting from their faces. Dick decided to shoot Obama in color, against a twelve-foot-square piece of white silk suspended from the ceiling. Then he and his charismatic sitter sat down and had a cup of coffee, or tea, together. Dick called me right afterward to announce that even though he was only just beginning "Democracy," he knew how it had to end: with his portrait of Obama—or, as he put it, "with the future."

The eminent historian Simon Schama described Dick's portrait of Obama as "impossibly beautiful . . . You look at the clever, artless, eager child preserved in the star orator, civic gravity and American ardor overlaid on the same face, the open collar an advertisement of moral transparency." Overall, he wrote, Dick "evoked presence more distinctively than any other photographer who has ever turned their hand to portraiture; more powerfully than Mathew Brady, Julia Margaret Cameron, August Sander or Alfred Stieglitz. For, like Rembrandt, Avedon caught the shorthand signature of an entire life, and the pose became a print of individual spirit."

With Obama and Carter and a scattering of other political portraits under his belt, Dick veered sharply in the other direction, zeroing in on the powerless—the homeless, the unemployed, the migrant workers, the elderly without health insurance—"all the people not properly represented by our government." But in marked contrast to Walker

Evans and James Agee in their watershed collaboration on sharecroppers in the South, *Let Us Now Praise Famous Men*, Dick didn't "see sainthood and passivity as going hand-in-hand with poverty . . . rage and potential violence are a big element." When Laura Wilson, Dick's Western Project coordinator whom he had just reengaged, alerted him to an upcoming gun show in Winnemucca, Nevada, he said, "Perfect!"

As Dick was preparing to leave for the airport, I was hovering—we had some last-minute studio business to go over. He was throwing things into his black T. Anthony suitcase, and Verlie was pulling them out and folding them neatly and putting them back in. On his way out the door he stopped to tell Bill Bachmann to schedule a couple of telephone appointments with Dr. Millman. I followed him onto the sidewalk. He hugged me, as he always did when he was leaving on a trip without me, and said what he always said, "You're in charge."

I knew that not more than five minutes would elapse before he'd be calling from the car: "I forgot to tell you to . . ." That day he checked in another couple of times from the airport lounge: "What's in the mail? Anything happening?" And yet again when he reached his destination— Reno, a three-hour drive to Winnemucca.

Dick hit pay dirt at the gun fair. He got the money shot in nothing flat, and it would end up opening the published portfolio. He had caught sight of a young man with a hard-bitten face, accompanied by a young woman holding an infant in her right arm. "They were an auto mechanic and his wife," Laura fills in, "and they were almost too good to be true. She had the baby's pacifier looped over the index finger of her left hand, which happened to be resting on the stock of an AK-47. Dick told me that he was thinking of Grant Wood's iconic painting *American Gothic* when he photographed them."

Next stop: Fort Hood, in central Texas, where he planned to devote a couple of days to photographing soldiers recently back from Iraq or about to be deployed there—"It was hell either way," he commented. It was certainly hot as hell in Texas—101 degrees and counting, but Dick insisted on scanning the face of each of the occupants of nearly a hundred Bradley Fighting Vehicles, which the soldiers were being trained to use. He selected seven men for a group photograph in their full armor.

THE LAST FORMAL PORTRAIT OF RICHARD AVEDON,
BY STUDIO MANAGER DAYMION MARDEL. TAKEN AT THE
WINNEMUCCA, NEVADA, GUN SHOW ON SEPTEMBER 19, 2004.

Full steam ahead to Fort Sam Houston in San Antonio, where Dick
was the first outsider ever granted permission to photograph in the
burn unit of Brooke Army Medical Center. I reached him while he was
en route there in the Suburban, to convey the news that Donald Rums-
feld, William Rehnquist, and Alan Greenspan were "booked in" for
the following Tuesday in Washington (Dick Cheney remained on the
fence). He was elated, but called back fifteen minutes later with the

usual follow-up worries: "Are you one-hundred-percent sure we're all set? Do we have someone testing the electricity in the Pentagon and the Supreme Court?" He said he was thinking of the time in the mid-seventies when his strobe lights had set off the bells that signaled a vote on the floor of the House of Representatives.

He called again around midnight to let me know that he had arrived in San Antonio, after a stop in Austin for dinner at a Mexican restaurant Laura recommended. He shared every detail of the meal, starting with the "knockout margaritas—I wasn't *not* going to have one, so then I had two; I'm not going to let Coumadin control my life."

There were horrors lying in store for Dick that day, September 24—a searing repeat of Saigon 1971, when he had made what he always referred to as his atrocity pictures (the female napalm victims). Of the thirty-five patients at Brooke, seventeen had consented to be photographed. Some had been burned almost beyond recognition. Dick went from bed to bed, introducing himself and asking a few matter-of-fact questions—then he made his appallingly difficult choices. A sucker for masks, he was riveted by the clear silicone one on the face of a young sergeant named Joe who had suffered third-degree burns in Baghdad when his Humvee was engulfed in the flames from an exploding chemical plant. Dick photographed GI Joe both with and without the mask.

He was still casting about for "the best domestically abused woman in Texas" to photograph. *The New Yorker* had located a promising candidate—she had been knifed eighty-one times by her husband. But as far as Dick was concerned there were two things against her: Her wounds were "not fresh enough," and they were on her body. It was, as always, a face he was looking for, and in this case "the more recently battered, the better."

That night Dick, along with Laura, studio manager Daymion Mardel, and third assistant Jim Martin, dined in the garden of a Mexican restaurant within spitting distance of the Alamo. Once again he called to tell me what he had had for dinner, and by the time he was finished I'd had *my* fill of Mexican. He hung up saying he had to leave messages for Pam McCarthy and studio art director Ruth Ansel regarding the "Democracy" layout—he had decided he wanted Jimmy

Carter and Barack Obama on facing pages. "Talk to you tomorrow," he said.

Dick was meeting Laura for breakfast at their hotel, the Hyatt. "Shortly before nine he called me to say he wasn't feeling up to it," she says, "and about half an hour later he called again and asked me to stop by his room. He had left the door open for me. He was still in his pajamas, and I remember noticing that they were the same color blue as his stationery. He had wanted to discuss the sequencing of the portraits he'd taken at the national conventions—he had little prints of them pasted in a notebook and he'd been obsessing over them for days. His speech was really slurred, but he was able to focus and we worked for about twenty minutes. But then when he stood up he was unsteady and had to sit right back down. He said he had a terrible headache, and I urged him to try to go back to sleep. Naturally I was alarmed, and I left to get Daymion."

"I was in my room at the other end of Dick's floor, loading eight-by-ten film for our one p.m. sitting," Daymion says, adding, "It was one of Laura's greatest finds—from a social services agency, as I recall. It was an overweight, unwed, seven-months-pregnant black teenager who had a four-year-old and a two-year-old and was trying to finish high school. Dick said that this girl had everything going for her as far as being a young female in trouble—he was hoping to capture the hopelessness of children having children. This lap of the project—two weeks totally on the road—had been nonstop intense emotionally as well as physically exhausting because it was all such supersensitive material. Dick complained about his back the whole time. And now Laura was banging on my door.

"I hurried to his room. He was hugging the wall, trying to maneuver himself back into bed. I said, 'Oh my gosh!' He said, 'Daymion, don't worry, we're still on. It's just a really bad headache. I'm going to get dressed in a minute.' Then a minute later he said, 'I think I can do the sitting if you get me a wheelchair.'"

"Daymion came running to my room," Laura goes on. "He was distraught because Dick was adamant that we not call a doctor and was still insisting on photographing the unwed obese. I went back to Dick to try to reason with him. I found him lying on the bed, with only one

eye open. He was completely quiet, and the sun had left the room. I said, 'Dick, we have to get you to the hospital,' and he said, 'No! Don't you understand, I have a portrait to do.' He told me he had been up all night and that he kept seeing the burned faces of those soldiers. Moments later he lost consciousness. I rode with him in the ambulance, and Daymion and Jim followed in the Suburban."

Daymion: "The EMT said to us, 'Looks like severe head trauma. We can take him to the nearest hospital, it's only five minutes away, the only problem is they don't have a neurosurgeon and they'll just send him on to Methodist, which is twenty-five minutes from here, and we'll have lost valuable time.' So of course we said to take him directly to Methodist. I had on me the five laminated sheets listing all Dick's medications—I knew that would be the first thing they'd ask for. I had put in a call to Dr. Millman, because he was the one who had prescribed most of them and Dick really trusted him."

"I was not the doctor who prescribed the Coumadin," Dr. Millman clarifies. "There was a risk to it. But there was a risk to his *not* taking it as well—Richard had had some dizzy spells, and there was the possibility he would have a stroke. Which maybe he did. Or he could simply have fallen and hit his head—he was a little unsteady—and then, because of the Coumadin, bled inside his brain."

"I sat with Dick in his hospital room," Daymion continues. "He was semiconscious. I asked him if he knew where he was, and he said, 'New York Presbyterian.' There were nurses and doctors running in and out. They were conferring about how to reverse the effect of the Coumadin before operating, because these blood thinners can be real killers. The head doctor said to me, 'There's no time to lose.'"

Laura: "The surgeon was very aggressive. He said, 'I'm going to have to cut his head open immediately.' This was now around noon."

Daymion: "There hadn't even been time to call off the obese. The tragic thing is we were only a few pictures away from finishing the portfolio—Rumsfeld, Rehnquist, Greenspan, maybe even Cheney. Just before they wheeled Dick into surgery, the nurse removed his watch and handed it to me for safekeeping. It was just this black beat-up-looking Porsche knockoff, but it was his favorite of all his watches and he had some really expensive ones. One of my jobs was to look

after it—I would have to take it to be fixed about once a month. I still have it. I'm one of the only studio managers in Avedon history who never got to have a farewell party. And that was because I never left. It was Dick who left."

It was a classic early-autumn late afternoon in New York. That morning I had driven up to Tarrytown in the Hudson River valley to see the Rockefeller mansion and art collection that had only recently been opened to the public. On the way home, I stopped at Fairway for a hit of peanut butter, the one substance Dick had gotten me hooked on. I was heading down one of those superwide supermarket aisles when my cell phone rang. It was my husband, calling to tell me that Daymion had just called from San Antonio saying that Dick had had some kind of cerebral episode and "it doesn't look good."

I remember standing there frozen in place, thinking, Should I get the peanut butter or not?

Not.

At some point during the difficult drive back to town, I managed to get hold of Daymion. He said that they had already operated and Dick was in a coma. I knew then what I had to do the minute I got to the studio.

I found the necessary document without any trouble: the DNR (Do Not Resuscitate). Filed with it, in what Dick lightly referred to as the "Mortality File," were some notes I'd taken of his latest end-of-life conversation with me: "The long slide down is just around the bend." And then his mantra: "Don't want to end up like Steichen photographing the same pathetic tree out the window from a wheelchair . . . *Your* job: to make sure the plug gets pulled real good."

I saw that Dick had added a few pieces of scrap paper covered with his handwriting. One of them read: "I would detest being a burden when for so long I have had the pleasure of being a pleasure.—William Maxwell." Another was some sort of fever-dream fragment: The figure of death was pinning Dick down, putting his arms around Dick's thighs, and the next thing, Dick was performing fellatio on him—"slowly." Dick had scribbled, "Was Death my father?" Reading that, I thought, Dear God, the father complex unto death! The third scrap consisted of a couple of lines that I recognized from a draft we'd been working on

of his latest "auto-obit" update for the *Times*: "Very little is known of his private life, despite the fact that he was almost always to be seen and photographed in the company of the most beautiful and desirable women on earth. He preferred the company of artists and intellectuals . . . There will be no funeral. A memorial service with designated speakers will be announced at a later date."

I was afraid that John the Buddhist might want to keep his father alive regardless. I knew I had to personally deliver that DNR to the doctors in San Antonio, and there wasn't a second to lose. When I entered Dick's hospital room the next morning, a nurse was shouting, "Mr. Avedon, can you hear me? Mr. Avedon, wake up!" Dick in his *hospital* hospital bed (as opposed to the hospital bed he slept in at home) looked ashen, and his head was shaved on the side where the surgeons had gone in. The nurse turned to me: "Why don't *you* give it a try now?" I began shouting, "Dick, Dick! It's *me*. *Normie*. Everything is going to be *okay*. If you can hear me, squeeze my hand." The nurse was now shouting along with me: "*Dick*, I mean Mr. Avedon, move a finger, wiggle a toe, *blink*."

One of the doctors showed me the X-ray of Dick's skull and told me they were considering performing a second operation the next morning. I asked, "What would he be like?" The doctor said, "You mean if he survived? That's a very difficult question. There could well be permanent impairment." At that point I produced the DNR from my bag and handed it to him wordlessly. My job was done.

The day Dick died—October first—I made three calls. One was to Irving Penn. The phone in his studio was answered by Michael Wright, who was now assisting Penn, and he put me right through. Penn said, "This is dreadful. Now I'm alone." After a pause he added, "He was the greatest of fashion photographers." He couldn't possibly have meant that as a dig, and in fact Michael told me later that Penn, after he and I had finished speaking, asked not to be disturbed for the rest of the afternoon and sat at his desk with his head in his arms. That's certainly an image for the ages.

The second call I made was to Bob Reicher.

The third—the most difficult somehow—was to Mike Nichols. "I

can't imagine life without Dick," he gasped, "I can't talk." Neither could I. When he called back a few hours later, he was rambling. "Last summer he kept trying to get me to come into town to see Simon McBurney's *The Elephant Vanishes* with him—I said, 'It's in Japanese,' but he insisted it was our kind of theater. He always brought all his energy and enthusiasm to being your friend. And he was my *best* friend. I was in a clinical depression in the mid-eighties that I couldn't get myself out of—I'd cracked up, I was broken, I even became convinced that I was broke—Dick came to the Carlyle where I was holed up and he yanked me out of bed. He said, 'I'm taking you for a walk around the block.' I remember I had my sheepskin coat on, because that's what softened the blow—midway around the block he suddenly said, 'Snap out of it!' and whacked me on the back as hard as he could. Later I thought, What a pal! Everybody else had pretty much given up on me.

"The only bad moment Dick and I ever had in almost fifty years was, horribly, the last time I saw him, and it was over Johnny. No, that's not quite right—there was an earlier episode. About forty years before that, when we were saying goodbye for the night, he said, 'I'm off,' and I said, 'To photograph bras?' Because he had been going on and on about photographers as artists. He wouldn't speak to me for a month. And I got pissed at *him* once, when he had the nerve to congratulate me on having finally married a woman who, when we walked into an A-list party together, I didn't have to worry that people would be speaking only to me. So anyway, last month I was having dinner up at his place, just the two of us, at the long table that he had all his stuff on— he had cooked one of his peasant repasts—and I said something to the effect that we were each unlucky to have a kid who had no sense of what it meant to earn money. And he got incredibly defensive. I was shocked at how angry he was. He said, 'What do you mean? Maybe that's *your* offspring, but it certainly isn't mine. John writes these very important books and I'm more than happy to underwrite them.' So, not such a good last time. And now I'm in utter despair."

"The last time I saw him, it was with my mother," Luke remembers. "We'd all been to a show and dinner, and we were skipping down Broadway and singing, and he said, 'I'll never have a night like this

again.' Right before he left for Texas we talked on the phone and, I don't know, I may be projecting, but somehow it felt deeper than just an ordinary goodbye. It happened on my mother's birthday, too—October first. She had Yahoo! on and it just floated up that he had died, and she called me with tears in her voice. A little later she put up a picture of Dick on a shelf in the hallway outside my room—the photo that his son sent to friends and family—and in front of it, the way good Jews put stones on a grave, I placed a lingam stone from India that he'd brought back for me. The only good thing is *how* he went—he died at his trade. He had what's called a compression of morbidity—so now you know he got his money's worth out of my Sarah Lawrence education! It means you live full-energy, squeeze every drop out of life, and then hopefully just drop dead—what you don't do is one of those long declines."

"Cleve came into my room weeping when he got the call that Dick had died," Francine du Plessix Gray recounts. "We had a dinner date with him coming up, on the twentieth. Cleve said, 'I want to die just like Dick—on my way to work.' You see, they both suffered from the same thing—AFib, atrial fibrillation—and they took the same blood thinner, Coumadin. And one morning two months later, almost to the day, Cleve was walking to his studio in the country and slipped on some ice and struck his head. There's a wonderful medical term I learned from this—the 'lucid interval.' It refers to the two or three hours after a traumatic brain injury when you're still with-it, and that was the case with Cleve, and with Dick, I gather, more or less."

Dick's friend the *New Yorker* humorist Patricia Marx recently reminded me of an evening she had with Dick a few months before he died. "He took me to see the Broadway revival of Sondheim's *Assassins*," she said, "and then to dinner at Orso with Sondheim and Mike Nichols and some Hollywood studio head. The talk was mostly about their heart problems. All of them seemed to have had them, and it was the most competitive conversation I had ever heard—each was trying to outdo the other in terms of the severity and exceptionalism of his condition. One of them said, 'I had a heart problem before *either* of you.' And another answered, 'Maybe so, but mine is worse—they oper-

ated on the wrong part of my heart.' Dick's claim to cardiac fame was that he had a different kind of problem from the others—an inflammation, which made it more special. It was hilarious, except for the fact he won in the end—*his* heart stopped first."

As everyone keeps pointing out, Dick died the way he always said he wanted to—working. It was the right kind of wrap. The one thing he would have chosen to do differently was not die on a Friday, which meant his obituary would appear in the Saturday *Times*, which meant, he maintained, nobody would read it. He would have far preferred to die on a Saturday so he could have been written up in the Sunday edition, which everybody read.

Dick's obituary began on the front page, as he had felt sure it would. But below the fold, as he had feared. It was the headline that was the killer: "RICHARD AVEDON, THE EYE OF FASHION, DIES AT 81." Dick's recurring nightmare. "I thought that headline was great," Renata Adler offers. "I mean, 'the eye of fashion' is just so alive. It wasn't one of those boring ones with no bite whatsoever, like 'Richard Avedon, Immortal Photographer.'"

Helmut Newton had beaten Dick to the obituary punch: he had gotten there eight months earlier, crashing his car as he pulled out of the Chateau Marmont in Beverly Hills. His *Times* obituary amounted to 922 words (Dick counted them), while Dick's now added up to 2,904. One would have to wait five years for Penn to die in order to learn whose was bigger—in the end, Penn's came to 2,589. It was Avedon by a nose.

ONE NIGHT ABOUT THREE weeks after Dick's death I had a dream about him. He wanted to make my portrait—that was a dream come true. Still, I was anxious. I asked him what I should wear. He said, "Anything you like." So: should I try to look like an intellectual—glasses, black turtleneck? Younger—blouse with ruffles? Like the dancer I once was—pink tights, ballet slippers? An executive in a power suit? I was racing around trying to find all of the above. Dick was already going, "Beautiful! Amazing!" "I know you don't mean it," I protested. "You're just saying that." His hair looked different—shaved on

one side. He called, "Film in the camera!" to his assistant and I looked to see if it was going to be Hiro, but no, it was Penn. The next morning he buzzed me in my office. "I have two chromes to show you—*you* decide." I flew down to the kitchen, but it wasn't where it was supposed to be. He was bent over the lightbox. I was about to see how Richard Avedon saw me. But just then I woke up. Dick was gone. I burst into tears.

PAM MCCARTHY PERSONALLY DELIVERED an advance copy of the *New Yorker's* November 1 issue containing Dick's thirty-two-page "Democracy" portfolio. How Dick and I would have pounced on the magazine, pored over his pages, then celebrated with a glass of champagne. Now I had to have a sip before I could even bring myself to pick the issue up.

As familiar as I was with the individual images, from the gun-toting Winnemucca couple all the way through Barack Obama, I experienced the excitement of seeing how beautifully they worked together. The cast of characters had come to include a Sikh priest; a J. P. Morgan banker; the founder of the Poor People's Economic Human Rights Campaign; the presidents, respectively, of NOW, Planned Parenthood, and the Feminist Majority; Robert Kennedy Jr.; Bill O'Reilly; James Carville; Jon Stewart; Ronald Reagan Jr.; members of ACT UP; union leaders; Sean Penn; Michael Moore; members of the Greenpeace Forest Rescue Unit; Karl Rove; members of Billionaires for Bush . . . The sheer breadth of the endeavor—all of it accomplished in a preternaturally short time—took my breath away. The portfolio spoke volumes about the America that Dick had gone in search of, on this the last of his self-initiated assignments.

"It was bittersweet, of course," Pam reflects. "Dick gone, the studio empty and half-dark. But the work was strong. He had once said that he thought of his photographs as being each like a sentence in a long book. A few months before, he had told David Remnick that he felt he was 'in the last chapter' and that he knew we'd 'protect every last sentence.' I like to think we did. We channeled him as we worked— pruning, rearranging, reinstating, juxtaposing—all to tell the story he wanted to tell. This project had been a mission for him: to articulate

the things about this country that moved him, amused him, enraged him—the things that made him crazy with despair and the things that gave him the rare burst of frenetic hope. I mean, my God, it killed him!"

And yet, there he was, in his work, still undeniably alive.

24

PARTING WORDS

—

ICK DIDN'T GO TO FUNERALS IF HE COULD HELP IT AND rarely attended memorial services. "What's the point?" he would say. "They're not going to be there to notice you didn't turn up." What he would do when a friend or acquaintance died was sit down and write his default condolence note: "Words fail . . ."

When the unthinkable happened and Dick himself died, his favorite curator, Maria Hambourg, suggested the Met for the memorial—the Grace Rainey Rogers auditorium, no less. I began drawing up the invitation list and was on the verge of ordering all the Dick things: masses of flowering branches for the Met, and caviar and blinis and Russian vodka for the more intimate gathering at the studio afterward. But John Avedon overruled me. "No memorial," he said. "Dad didn't want one." I thought, Like fun! "We wanted it," Maria remarks. "We needed it. We were all bereft."

Knowing—for a fact—that Dick's bucket list for eulogists would have included Twyla Tharp, David Remnick, John Lahr, Jeffrey Fraenkel, Adam Gopnik, Jann Wenner, Deborah Eisenberg, Wallace Shawn, David Ross, Bill Bachmann, and Andre Gregory, I asked them for their thoughts and feelings about him.

GIDEON LEWIN

DAVID REMNICK: Dick Avedon was a genius. Before he ever came to *The New Yorker*, he had established that; then he went about remaking the look of the magazine. He was all Tina Brown's idea. She came in as editor of *The New Yorker* in 1992, succeeding Bob Gottlieb, who was a very effective and intelligent transitional figure. Bob made *The New Yorker* a healthier version of its already-established self. But he was not interested in revolutionizing anything; and he was true to his intentions.

Tina was entirely different. First of all, she was English, so she hadn't grown up with *The New Yorker*—certainly not as a kind of secular religion. And then, she was a magazine editor, as opposed to a book editor, which Bob had been, and that made her instinctively more visually oriented. And now she had this magazine in her hands that, other

than the covers and the gag cartoons and the little interstitial spot drawings, and of course the ads, was of no visual interest at all in the standard sense, although certainly in the classical sense it had a "look": if you threw an issue on the floor, from ten feet away you would know it was *The New Yorker*, thanks to the cartoons and the body type—column after column of Caslon.

Tina, being very shrewd, knew that if she was going to open up the magazine to photography and make her case for it to readers and critics, she would have to do photography at a level commensurate with the best writing in the magazine. And at that time there were really two magazine photographers in this country who were thought to be leaps above everybody else. One of them, Irving Penn, was already taken—he had a contract with *Vogue*. The other, Richard Avedon, no longer had a strong single-magazine affiliation. You could say there was also Annie Leibovitz, but Tina would have been accused of borrowing from her *Vanity Fair* past; the word on the street would have been that she was just doing her old tricks. And besides, Annie was already signed up with *Vanity Fair* and *Vogue*. So Tina exerted a full-court press and hired Avedon. It was a brilliant move. The plan was to use him to establish photography in the magazine as a form; it would be as if you were introducing poetry by having only W. H. Auden.

With all due respect to Tina, the toughest trick was just getting him to come in the door. He was not somebody who was going to have to be guided. This was not an artist who had to figure himself out—this was a guy who'd been around, taking and publishing iconic photographs for forty years. You were calling on an artist both immensely talented and endlessly prolific.

Avedon brought to *The New Yorker*, first of all, a gigantic library. Every time somebody would write about a figure from the postwar past, it was almost inevitable that there was a fantastic portrait by Avedon. Artists, authors, fashion people, musicians, composers, politicians, radicals . . . Whom had he *not* photographed? When our senior drama critic, John Lahr, did a profile of Mike Nichols, we did a new shoot, but we also had the old Avedon Nichols-and-May shoot. And when Lahr wrote about his dad for us, we had Avedon's amazing Bert Lahr photo. Ezra Pound, the Beatles, Dylan, Katharine Hepburn, Sly Stone . . . So

many of those old photographs were used to accompany a book review or a profile, or Tina just used them on their own to enliven an issue. You could not lose. And, of course, what was also so striking was the fact that, even though Avedon had been around for quite a long time, he was not yet fading. He was still full of the real creative sap, the urge to make images, to improve, to make it new. The pattern with most creative careers is, first, apprentice work, then a moment of discovery, then elaboration of that discovery, and finally the period of self-imitation. The more freakish pattern of constant, long-lasting evolution—the most freakish being Picasso's—is rare. But Dick's period of discovery and elaboration went on and on.

In exploiting his library we were bringing his vintage photographs to a new audience in a very simple layout and display, which he controlled exceedingly tightly. The level of quality control that he demanded and exerted was unbelievable, right down to how big his byline was going to be. He had a pretty firm sense of his own importance and self-display.

I was a youngish writer on the magazine when I met Dick, around 1994. I knew his work of course—how could you not? I mean, if you were alive and had your eyes open at a certain extended time in history, you knew his stuff the way you knew the music. Which was what Tina had been banking on. I remember going through his big picture book, *An Autobiography*, when it came out the year before, and there wasn't a photograph in it I didn't know—and I'm not somebody who's a student of photography as such. I knew every single one as if I'd seen it in a magazine the week before. That speaks, I think, to just how deeply his work had permeated the American visual imagination. Some of it, of course, has to do with the fact that many of the people he photographed were very famous, but a lot more has to do with the expressiveness of the pictures. You can't un-see them.

The first time I intersected with him in any professional way was when I was doing a big piece on Marion Barry, who had just gotten out of jail, where he'd been for all the sad reasons we remember, and who had decided to run for mayor of Washington, D.C., again. Barry and his wife, Cora Masters, arrived at the Avedon studio to be photographed . . . They stepped in front of Avedon's camera, and he went

click click—maybe click click click—and the shoot was over. Thirty seconds, tops! I think he may have taken two, three frames. And I thought, What is this! How easy is this! I've been working for weeks on this fucking piece, with more to come, and *he's* done in thirty seconds.

I'd never seen anything like it. It was like watching Joe DiMaggio swing a bat. You wonder, Why did the ball go so far when all he did was swing so easily, so effortlessly? Later I would learn that he had mapped out the shot beforehand, that it was all about preparation. The thinking. The eye. The instant! Anyway, then he said to me, "David, jump in!" so I got behind the Barrys and he shot me with them. The lighting was naturally geared to the coloring of the couple, with the result that I've never looked whiter in my life—in that picture I look like the albino guitar player Johnny Winter. That photograph is one of my prized possessions. And then the Barrys were out the door. For me, this was all an incredible mini-drama. For Avedon it was just another day at the office.

Four years later—the summer of 1998—within a day of my being hired as editor of *The New Yorker* I got a congratulatory fax from Dick and a very gracious phone call from Norma inviting me to lunch at the studio. Only now, all of a sudden, I was going back there as Avedon's editor! What a ridiculous thing. At least I recognized the preposterousness of that, and it seems preposterous to me still, all these years later. I didn't dare appear terrified, but of course I was. I was nervous as a cat. I'd never edited anything in my life. Now I was off to visit "my photographer" (hah!) at his studio. I had to figure out how to be this . . . thing.

Dick and Norma had clearly put some thought into what to serve this Jewish kid from North Jersey that they've got coming who's the new editor of *The New Yorker*. They laid on an exquisite silver platter of lox on a fine layer of cream cheese on pumpernickel. They must have figured, Okay, he'll like that. They were not wrong.

After we ate and talked awhile, he took me up a flight of stairs, and there in front of us was this big exhibition room full of enormous photographs of religious acolytes—utterly bizarre images of devotion and self-flagellation and the like. Right in the middle of them all, on the wall facing me, was a photograph of an Indian figure with a rope tied around his penis with a brick dangling off the end of it. Yowza. That

was one strong and enduring dick. I was speechless. When I got back to the office, the penny dropped, thanks to Pam McCarthy. She informed me that Tina had commissioned Dick to do a big millennial religion project, and that the magazine was already in for a lot of money. Tina, I gathered, was ambivalent about the images. So now I had a decision to make: Do I start my relationship with Richard Avedon by, in essence, saying a big thudding no to the guy with the brick hanging from his dick? Or do I say yes? I said yes, and history will have to judge whether it was because I was, pardon the expression, ballsy, or because I was intimidated by Dick, or impressed by the work itself. Probably all of the above.

We ran a sixteen-page portfolio of these pictures in November 1999. The naga holy man with the brick attached to his member was on the opening spread. Why he was smiling in the picture is part of what we call religious mystery.

So as you can tell—at the beginning, certainly—the relationship was dictated by Dick. And frankly, I was never at my most assertive as an editor with him. And that was okay. I can't regret that at all. If you have Babe Ruth in right field, you don't spend a lot of time thinking about Babe Ruth—you're thinking about who's playing second base, and third. The other day I went through my correspondence with Dick—nearly all of it by the ancient, beloved technology of fax—and most of it was either logistics or praise, a lot of teasing, the trading of ideas. Occasionally, Dick would express frustration, either with himself or with my choices—once he was quite angry that I had published a photograph by one of his imitators that he considered a kind of insult—but the overall tone is extreme affection and regard.

Still, I'm sure that anytime I said no to Dick, he hated it. And it's possible that sometimes when I said no I wasn't wrong. Not that I said no to him all that often—I mean, once you'd said yes to that hanging scrotum thing, what could there be left to say no to? Why not take a chance? Why not bet on the eye of a genius?

For a while, Dick was pushing me to run a photograph on the cover. I said no right off the bat to that, and I did not relent. And I was right, he finally admitted, because if you go to a newsstand, virtually or actually, it's all photographs: it's newsmakers, or girls in bikinis, the usual

things. So it comes down to a matter of distinctiveness—a particular aesthetic or, God forgive me, brand—and if you break that cover barrier once, you're going to break it again. You're going to get tempted over and over, and then the next thing you know you look like everybody else.

That said, the most fun thing, the most pleasant thing, the most satisfying thing you can do as an editor is to say yes. That's the job—saying yes or no—to at least some extent. This piece, not that piece; this photograph, not that one. It's always great to be able to answer excitement with excitement. Dick and I had great periods and good periods and less good periods. And there were whole periods where he wouldn't be available—he'd be off on location somewhere doing commissioned projects, like when he went to Qatar to do those exotic animals for that sheikh for millions of bucks. *The New Yorker* couldn't compete with that.

Dick was one complicated cat: brilliant, excitable, unpredictable, passionate, intelligent. And the sheer energy! If you attached a jumper cable to Richard Avedon he could have powered a small Midwestern city. With time, of course, there were times when he was slower. And that frustrated him. He could be a little erratic in the last years, angry at age, angry at what he saw as self-repetition. And sometimes when he pushed himself to do better, to evolve, he might land on an idea that was eccentric but inelegant, not his best. And he almost always knew it.

Look, aging . . . One of the hardest things to deal with as an editor, or as a human being, is the aging of the creative self, and the greater and the more self-aware the artist, the more sensitive he or she is to any sense of falling off. It's a very rare thing for an artist to do what Philip Roth recently did and just call it quits.

At a certain point, late in the day, Dick said to me, "I'm going to shoot for you every week and it's mostly going to be theater." He loved theater, and he had a strong relationship with John Lahr. And he damn well tried to have a show-business photograph for us almost every week to lead the critics' section with—like his great shot of Kevin Kline as Falstaff, with all the padding exposed. There was a streak of these pictures that lasted for well over a year, and in that sequence I thought there was stuff that really ranked way up there.

What I admire about Dick's final months is that he went out and pushed himself to do what he loved. He was at it to the last. Just like Updike, who was writing poems in hospice care. Now, do the photographs in Avedon's "Democracy," which we published posthumously, stand with his best? I mean, what artist does his best work at eighty? Titian, maybe. But were there first-rate pictures there? Signs of Avedon at his peak? There were.

Dick was just about the last creature on earth who still faxed, and his faxes with their giant signatures kept arriving without letup. They would be instances of brilliant inspiration or harebrained idea or complaint. The one he wrote me from San Antonio just before he had his cerebral hemorrhage was the most enormously moving and generous letter I'd ever received from anybody in my entire life. He was an open-hearted man, in my experience.

When I got the bad news that Dick died, I felt stricken. Because he was all life—the guy really did feel like the substance of life itself. He seemed unkillable. Dick Avedon dead? Don't be ridiculous. So in addition to shock and sadness and a sense of loss I felt a sense of surprise.

Who was there to inherit the wind photographically? We had by then a number of photographers at *The New Yorker*. Eventually, at a certain point, with Dick's say-so and under his control, others had been allowed in. Having the same anything all the time would have been boring—I mean, were you going to have only John Updike in *The New Yorker*? That's called a book.

But how do you replace Richard Avedon? The answer is you can't. You can't replace the irreplaceable. You don't replace Philip Roth or Alice Munro or James Baldwin; you can't replace Saul Steinberg. You keep your eyes alert and your net in the water. And if you are lucky enough to encounter a real artist and form a relationship with that artist, you give them the freedom and the space they need to be their best creative selves. What else can you do?

JANN WENNER: The thing that really irritates me the most when I think about Dick is the fact that there was no memorial. That was a crying shame. It was ridiculous. A man like Dick, who was engaged with the world, who was one of the major nexuses of our culture and

time, needed to be publicly and powerfully celebrated. But to just let him slip away like that? To let it all end with a whimper? That wasn't right.

I had always aspired to work with Dick. The mid-seventies was a pretty adventurous time in the history of *Rolling Stone*. We had Tom Wolfe and Hunter Thompson, and we had just run a huge piece by Truman Capote. I had all the best writers in town in my pocket, but I wanted us to stand out in photography as well. I was looking for a new way to cover the bicentennial election, so I called Dick and proposed that he photograph the candidates for us. He said he liked the idea of getting back into politics. He always said this was the best assignment anyone ever gave him—the kind of assignment he would have given himself.

My first clear memory of actually meeting him is taking Annie Leibovitz with me to lunch at the studio. I thought that exposure to Dick would be a great opportunity for her to lift her game. He had the situation totally under control from the get-go. It was a real production—an elegant meal and all that—and he was totally friendly and chatty. But Annie was so nervous she couldn't speak—she spent most of the time pacing around. Remember, she wasn't nearly as big then as she became—she was just the new kid on the block, making her stride and gunning for Dick, which of course he was very aware of.

We were shooting a cover of the Rolling Stones around then, and I suggested Annie do it as an Avedon, sort of black-and-white against the seamless—and get them to take their shirts off. It was basically an homage to Dick. If he minded, he never said. And a few years later he wrote to tell her that her photo for us of Bette Midler lying in a bed of roses was the most imaginative magazine cover he'd seen in ages. But Annie was paranoid, she was going, "What do you think he *really* means by that?"

Anyway, Dick took my idea about photographing the candidates and expanded it. In much the same way that Tom Wolfe, when I'd suggested he write about New York, came up with a whole epic novel, *Bonfire of the Vanities*, Dick decided that it shouldn't be just the candidates and the conventions, that it had to be *everybody big in America*—the whole fucking establishment. He said, "Let's do it as a special

issue." I said an immediate yes to that. It was very daring and ambitious for *Rolling Stone:* first of all, magazines at that time didn't devote most of their issues to single topics, and to run page after page of nothing but pictures was radical, not to mention that the subject matter was way off our radar.

He got Renata Adler to work with him on the project. I made my suggestions, but really it all came out of the heads of those two. Lots of the people he approached were thrilled at the prospect of having their picture taken by Richard Avedon. Afterward, George H. W. Bush, who was CIA director at the time, wrote me, "I don't know if the great Avedon was as scared to come out here to CIA as I was in posing for him, but he sure has a neat way of putting his victims at ease and I enjoyed our short time together. I am really looking forward to having a signed copy of the portrait." One critic later described that photo: "Bush has his head cocked and eyebrows lifted, as if he were both a sniper aiming at you and a cocker spaniel that just heard thunder."

Other prospective sitters were more suspicious. Dick went to work courting and romancing the holdouts—with letters and flowers and, famously in the case of old Rose Kennedy, chocolate-dipped strawberries. It was a gradual gathering process. In each case, when he photographed them he let the subjects come through on their own. He didn't impose himself—he stepped back for a change. No drama. No bias—no tilting things politically to either the right or the left. He just let them be.

From time to time he and I would sit down and refine the list of who was going to be in and who wasn't, and in my opinion every one of the seventy-three photographs we wound up publishing was dead-on. This was a couple of years before I moved the magazine to New York, so he would come out to San Francisco to work with me. I say *with* me, but you know basically how it was with him—it was more me working for Dick. He was the creative boss all the way. Later I would discover that he had strong mood swings and could be very cunty about things, but working with him on that bicentennial issue was just magic. And I *mean* magic—he was positively enchanting. He was excited about the opportunity to have most of a magazine—forty-six pages— given over to his noncommercial work, his *serious* work.

The juxtaposition of photographs was very meaningful to him: the pairings—who would be facing whom, and who would get a quarter of a page as opposed to a half or a full page. He was creating a narrative, telling a story, and weighing all the elements for balance. We didn't want to clutter up the issue with a lot of text and captions, and Renata had the inspiration to just use the subjects' *Who's Who* entries, reproduced in the same typeface—talk about minimal. She also came up with the title "The Family."

Dick wrested control of the cover away from our art director, and it ended up being unlike any cover *we* could have conceived of—all graphics and absolutely great. He was such an insane perfectionist he insisted on flying to Saint Louis to oversee the printing. I knew that his being at the plant was going to be a pain in the ass for everyone, but I called the manager and told him to let Dick do his thing. I pictured him with a whip leaving bloody gashes on the backs of the printers, till he got the quality he wanted.

I had run my little editor's introduction by him before he left, but at the plant his eagle eye picked up that I had changed some infinitesimal thing at the last minute, maybe in the wording of Renata's credit, and he woke me up in the middle of the night. I told him that the next time we did a plate change I'd put it back the way he wanted. So then what does he do? He decides not to wait for the next run; he takes his hotel-room key—and they were very big in those days—and when no one is looking he sidles over to the press and runs the key along the edge of one of the rolls of paper going through at high speed. It rips, of course, but even that isn't enough for him—he throws the key into the web, gumming up the works. He literally stopped the presses.

The workers assumed the machine had broken down on its own, and when they informed me, I thought, Hmmm, how convenient for Dick. Yet it never for a minute occurred to me that he would have actually done a thing like that—I mean, who the fuck would have the nerve, you know? He didn't admit it was him for a long time.

In hindsight, I'm surprised he let us get away with shipping the copies that had already been printed. I mean, who knows, he could have set them on fire or had the truck hijacked or something. Anyway, it turned out to be one of the great issues of any magazine of all time—

August 1976—and it won us a National Magazine Award for photography.

For a few years starting in the late seventies I had Dick doing covers for *Rolling Stone*. He did about a dozen in all. I gave him interesting people to shoot—Robin Williams, Eddie Murphy, Prince, Nastassja Kinski in bed, Bob Hope, Jack Nicholson, Boy George, Fleetwood Mac, the Bee Gees . . . I was always trying to get Bob Dylan for him. Dick had done him early on, but by this time Dylan had become a very vain guy and didn't want to be photographed in Wrinklevision, which had kind of become Dick's specialty: the human face as a study of age and character and experience. Dylan's would have been perfect for him.

We even ran some of Dick's Western stuff. But in the end, as we know, he went to *The New Yorker* under Tina Brown. Sorry, but Tina's not as good as me and Dick was not at his peak there. He thrived on collaboration, and he needed the right person in order to really bounce. As far as I was concerned, what he did for her was just a retread of what he had done for me. He was definitely not expanding—you can't look at any of that *New Yorker* work and feel that it's just busting out with originality. And then, at the *very* end, there was that cheesy attempt to redo "The Family." It was called "Democracy," and it should just never have been done, because there was no way you could top "The Family," let's face it.

Look, for a period of time *Rolling Stone* was the home of the work that was dearest to Dick—his editorial work. He and I did some great things, and we did them together, and we had fun doing them. Let's put it that way.

DAVID ROSS: If there wasn't going to be any memorial, there should at least have been a party. Dick loved a good party, and the least he deserved was to have everybody remembering him with a glass of champagne or a shot of vodka.

I'm so proud to have been his good friend, especially when I think of the extraordinary people who were in his inner circle—Twyla, Andre, Mike, Wally and Debbie, John Lahr . . . We were the chosen few. Dick wasn't one for empty, air-kiss kinds of relationships. He was

more than happy to fill his life with work work work work work work work work and theater theater theater theater theater theater theater. I mean, was there a night when he *didn't* go to the theater? Now, theater was not one of the interests I shared with him—I have a very hard time suspending disbelief. We did go to movies together. He was almost as crazy about the movies as he was about theater. And he knew his cinema history, and he had a fine sense of modernist cinematography. He was a great director, basically.

Dick and I first got together in the late seventies when I was the chief curator at the art museum in Berkeley. One day the director asked the curators to draw up a list of ten twentieth-century artists who were household names. Picasso, as you would expect, was top of everyone's list, with Warhol a close second, but Avedon was right up there and the director decided to do a big Avedon show. He said, "Temperamentally I don't think I can handle a guy who's that intense and controlling—I hear he's a horror show. *You're* going to have to do it." I came home that day and said to Peggy, my wife, "Richard Avedon is being forced down my throat." I mean, you have to picture me at the time with my Jewfro and little beard. Plus my thing was performance art, video art—the world of fashion was utterly foreign and irrelevant to me. I don't think I'd ever paged through an issue of *Vogue*. But after I began working with Dick and really studying the pictures, I came to understand that his fashion work constituted a very personal critique of both the nature of the aspiration to glamour and the effects of that on the so-called fashionable woman—I mean the hollowness of that life.

Looking back, I can't imagine why I had initially thought of him *only* as the guy who did the fashion. Because it turned out Peggy and I had not one but two copies of the "Family" issue of *Rolling Stone* at home—when she moved into my bungalow in Venice we discovered that we had each saved it. That portfolio in itself demonstrated that he was light-years away from only being interested in what was beautiful. And the fact that he died doing what was in effect the sequel to "The Family"—his remarkable "Democracy" portfolio in *The New Yorker*—is kind of wonderful. He had remained just as serious about what power looks like—what it does to people's faces. I'm someone who doesn't see

Dick's various bodies of work as being schizoid in any way—I see them as completely integrated.

So anyway, I went to New York to meet him, and, well, you know, I was transfixed. How long did it take to be charmed by Dick? Two seconds? He was human, *real*—refreshingly self-dissatisfied and self-challenging. Remember, Dick at this point wasn't so confident about where history was going to place him—which, before he was through, would be on a great big banner in front of the Metropolitan Museum for a second time.

One of the reasons we bonded to the degree that we did was we were both autodidacts. As powerful as Dick was as a mind, we shared the same level of intellectual insecurity—neither of us could ever believe that we had read enough or thought through ideas enough. From the beginning, we talked only about the things that mattered. He was a classic liberal, starting with the civil rights movement, and politically I felt very aligned with him. There weren't any meltdowns in our relationship—never a negative minute. I would rank him as somewhere between a big brother and a father to me. Those photos he took of *his* father, by the way—a man who, to hear him talk, was just terrible—mean, harsh, unforgiving—constitute one of the most compelling portrait series in the whole twentieth century. Because they were taken with honesty, which is more important than love or hate.

After my tenure at the Berkeley museum I was hired to lead the Institute of Contemporary Art in Boston, and one of the first things I did was make us one of the stops on the tour of Dick's "In the American West" exhibition. So then that became a continuation of our working life together. I gave him the whole ICA building, which had been converted from a police station, and he designed the show himself. I mean, did *any*thing ever happen with him that he didn't have *every*thing to do with? He was the complete artist. And he had this operatic sense that what he was creating was theater or cinema—only with still images.

From the ICA I went to the Whitney as director, and the first show I put on the books there was the Avedon retrospective, for which I wound up taking an incredible amount of shit. Seven tumultuous years later, in 1998, I got fired. The San Francisco Museum of Modern Art

snapped me up at double my Whitney salary—plus the job came with a $140 million war chest that meant I had more money to spend on acquisitions than any art-museum director in America.

I got fired after seven years—there, too! I was in shell shock, and that night Jeffrey Fraenkel and his partner, now husband, Alan Mark, took Peggy and me to this little restaurant somewhere near Golden Gate Park. While we were having drinks, a motorcycle roared up and this really ripped guy in black leather stomped inside. He was carrying a sizable package, and I heard him say to the maître d' that he was looking for a guy by the name of David Ross. The next thing I knew he had planted himself in front of our table and was asking which one of us was me. Then he opened his bag, and out popped a bottle of very expensive champagne and a huge tin of caviar, with a note from Dick that said "Fuck 'em if they can't get a joke!" Which I interpreted to mean that the trustees who had just axed me didn't understand what they had in me. And then the messenger pulled me to my feet saying, "This is from Mr. Avedon, too!" and he planted a big fat kiss on my lips. Well, I just broke down in tears. Not a single one of my close friends had called that day to commiserate. And there was Dick reaching out to me across the country with caviar and champagne and a nice platonic kiss.

That said, I always had the feeling that Dick struggled throughout his life with his sexual identity. He may very well have been what used to be called an undeclared major. He was twice-married and had a kid and everything, and he certainly never had an open relationship with a man—or with a woman other than a wife, for that matter. I don't even know if he ever had a closeted relationship with a man—I mean, no one knows.

When he died, I was totally devastated. I still cry about it—when I think of what I've lost. But what he left me I'll go on having for the rest of my life: he taught me how to see, and my whole sense of the world continues to be enhanced by his vision.

Have I mentioned how much I loved watching *The New Yorker* change its entire identity to accommodate his photographs? Tina Brown deserves the credit there. I mean, talk about swimming up-

stream! She brought photography to the fucking *New Yorker* the way I brought it to the fucking Whitney, pardon my language.

TWYLA THARP: Every May for years Dick and I had a standing date to make a pilgrimage to the three blossoming magnolia trees in the Fifth Avenue garden of the Frick. He said they symbolized how he liked his friendships—well-tended.

The first time I met him was on a street corner, and he was with Andre Gregory. The corner of Sixth and Fifty-sixth, to be exact, where the stage door to City Center is. It was around the time I was doing *As Time Goes By*, so this had to be 1973.

Our first real meeting—an early Sunday breakfast at the Palm Court of the Plaza—was the warm-up to a solo shoot he was doing for *Vogue*. He told me over strawberries and cream that he thought I had rewritten the language of dance, created a whole new vocabulary—dance would never be the same. I mean, I never had a fan like Dick. Once, when the *Times* was unkind about one of my pieces, he wrote a letter to the editor giving him all kinds of shit. He would come to my rehearsals, and tell me truthfully if I was getting through, if there was a shortfall. He admittedly didn't know a whole lot about dance, but as a great designer of movement he had intuitive call on the material, and nobody was more helpful to me in terms of looking at something and going, "This is a big mistake." I would have to have been an utter fool not to listen to anything he had to say. He had such a clear sense of narrative and composition and such a full mastery of detail. I used his vision on a regular basis, and in the process I absorbed some of his way of looking at the world. What I'm trying to say is he's very much a part of who I am.

Dick took so many classic pictures of my company. I live surrounded by Avedons. David Byrne in *The Catherine Wheel*. *Uncle Edgar Dyed His Hair Red*. Misha and me in the studio. Misha jumping. *Singin' in the Rain*. So: a lot of history—mine and Dick's. He always came to the set with an idea in his head, and his photographs shot my ballets into another dimension. We must have done at least twenty-five sittings together. These were the only times I ever saw him dance—whipping

about on the floor of either his studio or mine while he was shooting. And this was someone who wasn't in his first youth—more like his third. His whole movement in the world was like a dance. And feet are so telling. They never lie.

One look around Dick's apartment, which was so much who he was, and you could see how his mind operated, how he handled order and disorder. It all looked pretty casual, but the ease was studied. He had a big thing for a long table with an abundance of everything on it. He always had those bowls of walnuts and good cheese to start with, and then Verlie would have cooked up something tasty that he would manage to heat up—he got pretty good at heating things up. And he had very nice plates. He was excellent with presentation, and he preferred things country-style.

As long as he could keep working he was happy. I'm the same way—I'm only interested in the next piece. The trouble is there are no happy endings—to put it exceedingly simply, one gets older. And one develops certain insecurities as the body fails. Particularly if you're a physical person, which Dick was and I am—I mean, the minute the plane takes off I get out of my seat and do stretches in the aisles. One of the reasons his photographs are so amazing is because he moved around as much as he did when he was making them happen. The inevitable loss of some of his agility impacted how he could shoot, and he would often become extremely exasperated over that.

Dick was like a semipermeable membrane through which you could almost see the work flowing into the life and overtaking it. The work had commanded him, "Thou shalt have no other gods before me." Not that he didn't have a pretty great life, too, so let's not cry for him. His genius aside, he had the money to do basically what he wanted, in the style he wanted, and that is already a giant step up on most people. And he had the extraordinary privilege of being able to get to anybody in the world in a flash—all Richard Avedon had to do was pick up the phone. So there you go! And if he achieved immortality at the expense of life, that makes him the most fabulous thief of all time.

ADAM GOPNIK: Dick and I met in the summer of 1985. I was getting my PhD in art history—which, for the record, I never finished—and

working three days a week at GQ, one of the Condé Nast magazines he was under contract to do the covers for in those years. I had started off as the grooming editor, and did so well with moisturizers and shampoos that I was promoted to fashion copy editor and, eventually, literary editor. Because I seemed to know something about photography the editor-in-chief, Art Cooper, asked me to accompany the young writer he was sending to do a piece about Richard Avedon.

I knew Dick's work, though of course I didn't think of it as *Dick's* work, I thought of it as Avedon's, which was a distinction that would persist through the next twenty years. "Dick" and "Avedon" were intimately related—yet very different people. And very different presences.

The first thing that happened in the studio that first day is I recognized somebody I had once known—I spotted Andre Gregory in an ad for the Diors that was hanging over the secretary's desk. I told Dick that I had been in Andre's repertory company as a child, and we had ourselves a good laugh over the whole idea of Andre's having become a New Age guru thanks to the success of *My Dinner with Andre*. Later, when I got back to my office, my phone was ringing and it was Dick inviting me over for dinner that night.

He served grilled swordfish and baked potato and champagne, and we had a wide-ranging discussion about literature and art and history and ideas. If you will allow me an egotistical moment, the record shows now, some thirty years and about a thousand *New Yorker* pieces later, that I presumably have something to say about some of those things. Not that I particularly felt that way at the time, mind you. I remember we talked about Velázquez, because there was a show up at the Met, and Cartier-Bresson. He spoke extravagantly about his oeuvre, which surprised me since I wouldn't have spotted a direct connection—he described him as "the greatest photographer there's ever been . . . the Tolstoy of photography." And then he added, disarmingly, "I don't think he likes *my* work."

My wife, Martha, was out of town, but the minute she got back, Dick invited us both to dinner at his favorite restaurant, which at that time was La Tulipe, a wonderful place. Martha wore a white Kenzo dress—the same one she would put on when he photographed her years later. Not more than five minutes in, Dick turned to me and ex-

claimed, "I'm so relieved! I'd been thinking, What if she's a lemon? Then you and I would have had to have a *lunch* friendship."

Dick was a one-on-one kind of guy, or a one-on-two when he liked both members of a couple. You only have to look at his work to see that that's what he was about—even his group murals, like the Warhol Factory, are essentially a sequence of individual portraits. The one-on-one-ness, or one-on-two-ness, of Dick was one of the wonderful things about him. He liked to compartmentalize his life—he would go with Twyla to the Frick to marvel at the magnolias in the garden, and he would go there with *me* to discuss the art. I knew the things that art-historical people know, but what was so great about looking at pictures with him was that he *wasn't* looking at them art-historically, he was looking at them as if they had been painted the day before.

The big things I learned from him continue to fill my life. His restlessness in pursuit of greatness. His annoyance when he felt that somebody he respected was trying to get away with "good enough," which wasn't a category he thought tolerable. When I started off writing for *The New Yorker*, he was ambitious for me in a way that was very touching. My phone would often ring and it would be Dick with his verdict on the last thing I'd written. His general tone, if he liked it, was relief and gladness, and, if he didn't, ruthless criticism.

Another indispensable lesson I learned from him is that you always have to keep something aside, something that's your own and inviolable. He said that working for *Harper's Bazaar*, then *Vogue*, and then *The New Yorker* was one of the ways he fed his family and supported his studio and became a public person, but that he always felt that if he wasn't also working on a very personal project, he was letting *them* win.

Dick loved it when the people he cared about took risks—did something he considered courageous. Anything that put you in a combative relationship with orthodoxy, anything that shocked and scandalized a little bit, he thought was positive. When Kirk Varnedoe and I curated "High and Low: Modern Art and Popular Culture" at MoMA in 1990, Dick, who didn't at all like the art, was thrilled by the scandal the exhibition caused. Kirk and I were deeply disoriented by the scale of the hostility, but Dick was delighted, *proud*, that we were shaking the world by the tail a little bit—he thought that that was what you *ought* to do in

life. And that was a very salutary thing for me, because, you know, in the nature of things, when you're young, there's some part of you, a large part, that wants to please the powers that be. And although Dick himself was a past master at pleasing those very powers, he knew that that was not the destiny of either an artist or a serious intellectual.

The night of the "High and Low" opening, he took Martha and me and the Varnedoes to the swanky Rainbow Room, and there we all were, living it up, when somebody brought us the excoriating *Times* review. Four years later Dick invited us all back there to celebrate, so to speak, *his* excoriating *Times* review—of his Whitney retrospective. Martha had had the idea to commemorate the double disaster by commissioning a bakery on First Avenue not far from the studio to decorate two cakes to look like a page of the *Times:* one said, in white icing, "HIGH-LOW STINKS," and the other, "AVEDON STINKS." Cakes in tow, the Gopniks and the Varnedoes and Dick repaired to the Rainbow Room, where we ordered lots of champagne. It was a great night—one of those releasing moments. Martha took this wonderful photograph of Dick and Kirk and me, and Dick had prints made and framed for the three of us. His was up in his apartment until he died, and Kirk had his up in his loft until *he* left us. I have mine in my office. Now, sad to say, I'm in possession of all three.

Occasionally Dick would ask me to run a pencil through something he'd written, or to make suggestions. He may not have ever graduated from high school, but he spoke and wrote with enormous eloquence, and what he would say himself would usually be better than anything I could contribute. The only work I had to do with him, really, was encourage him to believe that he could do it himself—to trust in his own natural way of saying things. This man who was so good at emboldening others needed a little emboldening himself from time to time.

He said to me once, as kind of a joke, "You need to do one thing in life to sort of ease your way through the world, so do one book for the maître d's." What he meant was there's a nice element to being well known—you get a better table, you can get house seats, and so on. *His* "one thing," of course, was the fashion. He realized that his fame was built around that accomplishment, which was, after all, very real and

very large and quite remarkable, but he also knew that being a fashion photographer was, in the universe of fame, a strange thing to be. In any case, for better *and* worse, the label had stuck. And one of the things I always felt was worth doing with Dick was to make him feel less ambivalently about that segment of his work. It was a struggle for him, but by the time he did the last book, *Made in France*, very near the end of his life, I think he genuinely understood that his fashion photographs were as profound as any of his portraits. In terms of form, they were the pure liquid to the portraits' solid mineral, but it was all one body of work amounting to an incomparable study in human performance.

Dick did a very beautiful thing for the Gopniks, which is just now kicking into existence. To mark the birth of our son, Luke, he sent a wonderful vintage valise that he'd found in London, all covered with stickers, and he filled it with the things he thought it was important for a young man to have when the time came for him to leave home. These included, Luke's middle name being Auden, a first edition of his namesake's *Epistle to a Godson*; George F. Trumper extract-of-limes cologne; an address book; some music; and lots of little sort of masculine things. Dick instructed us to keep adding to the valise ourselves, and it's now just about full. He also made a booklet for us called *Looking for Luke Auden*, and in it was a photograph of an empty little chair in Montauk. The conceit was that, since Martha and I were based in Paris at the time, he was missing Luke, but of course we understood that it was us he was missing. Just as *we* were missing *him*.

He gave us that magical portrait he took of Auden in 1960. Dick was an artist who could fill any picture with the kind of expressive contradiction you would normally only find in some full-length performance. Auden had simply shambled out onto the street, St. Mark's Place in the East Village, in the dead of winter, in whatever he had on, which happened to be baggy pants and bedroom slippers. Thus the beautiful contradiction between the slovenly mortal and the perfect, dreamy poet—a ghost with a ravaged face walking in the ethereal snow.

Dick loved working for *The New Yorker*. In an odd way it took him back to his stint in the late forties doing all those great photographs of creative people for *Theatre Arts* magazine. We had one fight at *The New Yorker*, if you can call it that. I had written a piece about Thurber,

and Dick, knowing how much I loved Thurber, gave me one of his portraits of him as a present. I was hoping he'd choose that one to accompany my piece, because it was very delicate and expressive. But he opted for a much more dramatic image—Thurber wiping his eye—to point up for the reader the fact that he was blind. I still prefer the portrait he gave me, which sits on my desk to this day, but in retrospect I can see that he was right, that the one *he* preferred was indeed more graphic. He was always incredibly attuned to the needs of a particular magazine.

Dick was a human being who was present for his friends in a crisis as no one else on earth would be, but at one and the same time he was a single-minded, obsessive artist who cared about nothing but his work. These were the two most powerful, most defining drives in him, and they were sometimes at odds—you could say that he was truly divided in that way. Look at all he did for his cousin, Keith Avedon, who died of AIDS. And for Keith's son, Luke. Dick would quip, "I have two Lukes in my life." Which, after all, is one more than Jesus had. Actually, Dick had a third—Cleve and Francine Gray's artist son.

He was a man of persuasive and limitless charm, who loved charming things, who loved jokes, who loved a great song. I remember driving around with him late one night in Montauk looking for someplace that was still open for dinner and listening to Mel Tormé and George Shearing on the car radio while having a conversation about Samuel Beckett. He said, "Aren't you just *glad* you're living in a world that has people like George and Mel and Beckett in it?" It was such a beautiful, kind of naïve thing to say—it was like a sixteen-year-old kid talking. Martha always said that Dick was the youngest person in our circle. In some ways he was the least jaded man I have ever known, and in many others the most worldly—yet another contradiction!

The key thing about Dick was that he was a performer. Most of his most profound ideas, and most of his idols, came from the theater. Something I stole from him, one of the countless things I took from him, was that he would always arrive at a lecture he was giving beautifully dressed in a suit and tie and then do sort of a striptease as the session progressed. First he would undo the tie, then unfasten a button or two on the shirt, then take off his jacket, then roll up his sleeves. This

was all in aid of connecting with the audience—a form of coming closer to them—and it certainly had, as Dick was the first to admit, an element of intentionality. But also, to be perfectly frank, there was a metabolic consideration, on both our parts, which we used to joke about: we were both very short men who quickly overheated under the lights. Dick and I did several joint performances over the years, including a dialogue at the Fogg Museum at Harvard and a conversation at the Met in 2002 called "The Constructed Moment." But whenever we were onstage together I took care to keep all my clothes on, to stay all buttoned up, as it were. I wasn't going to muscle in on his act.

Dick invited me to attend as an observer the master classes in photography that he gave both in his studio and out at Montauk in the early nineties. He was a great teacher in the sense that he inspired all those kids to think big. He made them feel that what they were doing as photographers was not the trivial, artisanal business of somehow getting a picture that would pass some craft standard—it wasn't a microbrewery where you were trying to make a good beer. He communicated to them that their entire life was at stake when they took a picture and that if they could bring all of themselves to it—their sexuality, their guilt, their past, their hopes for the future—the odds were they would end up with something worthwhile.

Dick's teaching of the class was a revelation, of a kind. He was even better than perhaps one would have expected, given his often single-minded focus on his own vision and practice. That's to say that he was open to nascent visions, and had the knack of seeing what was possible in imagery that was as yet scarcely formed. He always seized on the one photograph in the midst of the pile or portfolio that seemed original, unlike anything else he knew. "That's so strange and beautiful," he would say enthusiastically of something he liked in a student's work, and it was the very modern marriage of those two words, *strange* and *beautiful*, that defined the aesthetic he was trying to share with the kids. A good photograph, he held, should be strange—I recall an image of three fierce little girls at a wedding, looking a bit like Mafia hit men; another, of roadkill, a porcupine or the like, framed in the middle of the road as nobly as a dead Christ. But it should also be beautiful, and by beautiful he didn't mean *just* strange—he meant properly pulled

together, formally commanding, able to claim its own space as pure design.

He was hard on work that seemed to him merely beautiful, and hard on work that seemed to him merely strange. I recall him tussling with a young gay photographer in the class who thought that simply asserting his gay subjects as portrait-worthy was sufficient. Dick's point was that gayness in 1994 might well be a major subject, but first had to be made major by its treatment, its organization, its beauty.

Graphic was a word he loved, and used often—I suspect it was a Brodovitch word. He meant by it something that worked as well as an abstract drawing as it did as a specific image. Indeed, being in the classroom with Dick when he chose to show his own prints—which he did often, having the great teacher's sense that the best way of teaching is often to show the vulnerability of the master—made you aware that the graphic quality of his work was in many ways the first thing to be taken away from it. His photographs were just hugely commanding as black-and-white design, even before you took in their subject.

Portraits were the things he valued most, of course, and spent the most time teaching. The human face was what he knew, and really all he cared about. Martha and I used to tease him about the moment during an appearance on early-morning television when, asked to comment on a shimmering Ansel Adams, he said, "That's trees. I don't know anything about trees." "That's trees" immediately became a kind of Gopnik family slogan for venturing too far outside one's area of expertise.

Dick organized a fantastic weekend for the class at his Montauk place, where the assignment was for them to take portraits of each other. I have the one that someone or other did of me where I'm glaring and black-handed—I was coming from the grill where I'd been roasting soft-shell crabs for the multitudes. For those three days Dick communicated—hammered home—his essential truth: that portraiture was not lighting or framing or anything but the exchange between two people, and that the portraits the students made would be exactly as good as the insight and empathy they possessed for each other. "Create a little theater of two-ness" was, I recall, a phrase of his that weekend. Of course, the delicate choreography of two-ness that was second

nature to him—approach, avoidance, seduction, and formality, with a necessary selfishness on the artist's part; it was his picture, after all—wasn't something that was truly teachable. But he gave them at least a sense that composing the picture and pressing the shutter were the least essential things you did, and connecting with the subject—in love, anger, appetite—the most.

I also recall that he began almost every session by saying something slightly disparaging about Irving Penn. I teased him about this as well. Being competitive with Penn, his only real rival, was always Dick's way of getting energized for the day's work.

The night before he was stricken in Texas, he called me with a plan. He said there was a wonderful couple Martha and I were going to love who were coming to town—Ian Bostridge, the singer, whose portrait he had recently done for *The New Yorker*, and his wife, Lucasta Miller—and he was inviting us all to dinner that next Tuesday at the Samovar. I said, "That sounds fantastic," and I asked him how things were going. He answered, "Oh you know, it's the road." Martha and I were worried about him. Lately he had seemed to us, frankly, frail. Old age is normally not a gradual slope, it's a series of lurches, and we felt that he had definitely lurched in the previous six months—his legs were shaky, and his skin had become sort of transparent.

During the several days in the hospital he spent clinging to life, I spoke often to his psychiatrist, Dr. Millman, who was keeping in close touch with the doctors in San Antonio and so was one of the chief conduits of the medical information. I kept needing to know if there was any change, if there was hope. Millman finally said it was clear that the best thing for Dick would be for him to . . . to . . . why am I hesitating on that word? Anyway, he did—die.

Martha and I kept the date with the Bostridges at the Samovar. I remember saying to the maître d', "The reservation is under 'Avedon.' A party of five, but we'll only be four." The blessing was that Ian and Lucasta went on to become two of our dearest friends in the world. We always say that they were Dick's last gift to us. And that was touching, because it was so much exactly what he was about—building family.

Well, his last gift to us but one. He had—taped to his bathroom mirror—a blowup of the last poem Beckett ever wrote, "What Is the

Word." Dick would read it aloud to himself every morning. It was the one thing of his that Martha and I wanted, and we have it up now in our bedroom.

DEBORAH EISENBERG: On his wall there was a photo, which I remember as being huge, though it probably wasn't—in fact I remember his apartment as being in black-and-white, which it certainly wasn't—but whatever size the photo was, it was immensely arresting. The image was so uncanny that on several occasions I asked him what it was that I was looking at, though he had already told me: a Lipizzaner.

The beautiful white horse, tail and mane streaming, appears to be sailing through the sky at a great speed, high over the earth, and I suppose I saw it as a counterpart of Dick, who himself didn't seem bound by the usual laws—of physics or of human limitations. He was just much faster than other people, and aerial—an aerial event.

I didn't actually think of Dick as a sailing white horse—I thought of him more as an imploding black star. Everything was an occasion, everything was festive, everything was an unknown country to be explored, a project to be undertaken, a challenge to be met; there was no time to be wasted, and no time *was* wasted, that I ever saw. Looking, watching, talking, reflecting, of course, were not wasting time.

The sheer energy was a little scary to be around. You felt that you might be singed by flying sparks. He was deeply kind, I believe, but you never knew what he might think, or say. He was involved in too intense an adventure to be soft. I'd guess it was his own beauty, or partly, that put him behind the lens; maybe he was there lest he end up in front of it. I suppose he talked about that, but I never heard him do so, and it—his own beauty—was probably a subject he got well sick of early on. In any case, it was a reality that he would have had to navigate, ineradicable even when I last saw him, not long before he died.

I wouldn't say that he seemed fearless to me, but he seemed courageous—someone who was determined not to be fearful, and that, too, gave him power to look at things in ways that other people didn't. Not that it constituted his talent, but surely it fortified his talent.

He was always on his way somewhere or just returning from somewhere. It was wonderful to be swept up in the currents of his constant

motion. It wasn't that he put you at your ease or in any way made you feel that life was easy, but he did make you feel that life was worth living, every second of it, no matter what was going on. I never felt that I really knew him or that I understood him, and yet whenever I got to spend some time with him it was always as though he were pouring some of his private stock into a glass just for me, and the feeling of that dazzle, that specialness, that insight into things you can't see on your own, would last for days afterward.

JEFFREY FRAENKEL: My first real engagement with Richard Avedon's work came from scraping up the money, when I was in college, to buy his book *Portraits*, which had just come out. I remember very well the feeling of being pulled into the pictures. Then in 1980, a year or so after my gallery opened, in San Francisco, the University Art Museum at Berkeley presented a huge Avedon retrospective, David Ross's show, which was a stunning installation. The opening-night crowd was uncommonly fashionable for the Bay Area, but when I'm around good art I'm generally more interested in the art than the people. I did, however, meet Avedon, briefly, but nothing he'd ever remember.

The next step toward Avedon took place in 1994: his full-throttle Whitney retrospective. I was turned off by the staginess, the dramatic lighting and wall colors—you noticed the installation more than the work itself. I remember feeling that such an installation must have come out of insecurity on the part of its maker. I came away with the suspicion Avedon must be a nightmare to work with, tremendously controlling, because I'd been around long enough to know that no self-respecting curator would install an exhibition that way without being pressured into it. Still, that didn't stop me from purchasing any book by Avedon whenever it came out.

In 1998, a call came out of the blue from a mutual friend of Avedon's and mine, asking if I had any interest in representing him. I hesitated. Avedon was far and away the most well-known photographer alive, but for me fame has never been a good reason to represent an artist. He had in effect been representing himself over the years, partly, one heard, because he was allergic to the thought of having to share a percentage of a sale with a dealer. It would later become clear to me

that, wealthy as he was, he never felt secure financially, which, after all, was a feeling shared by others who'd grown up during the Depression. Whenever someone wanted to buy a photograph, he and Norma Stevens would come up with a magic number, usually extremely high and based mostly on how "up" he was feeling that day. If some European heiress, say, had fallen in love with a particular picture and happened to be in New York, she might be invited to come by the studio and meet Avedon; and all of that was irresistible to certain people, who would often pay whatever he asked, more or less. The trouble was, that is not a way to build a market with any structure or cohesion. There was no sense of stability about his work from that perspective—the legitimate market for his photographs at that time was a mess.

Primarily, though, it was his reputation for requiring total control that gave me the greatest pause—I mean, the very idea of not being able to have final word on what we would show at the gallery, and what form the installations would take. But then, one rainy weekend at home, on an impulse, I happened to pull out my Avedon books. I went through them one by one, picture by picture, and emerged from that experience shaken by how truly great a photographer he was. It felt like he was the least known most famous photographer out there—in other words, that what he was most famous for was not necessarily his best or deepest work.

Through our mutual friend, a visit to the studio was arranged for the next time I was in New York. The place was a beehive of activity. Within five minutes of my arrival a retoucher appeared on the scene. Displayed on a little easel on a table were three or four pictures that Avedon said were slated for the next issue of The New Yorker, and he was giving instructions right and left: "Make this area darker . . . Make this lighter . . . Make that a little more contrasty." I couldn't shake the suspicion that this might have been an orchestrated performance. He and Norma took me to lunch someplace around the corner, in the course of which I discovered that Dick and I spoke a mutual language beyond photographs—theater.

The first show we saw together was Contact, at Lincoln Center, a quasi-musical directed by Susan Stroman that had received universal raves. At intermission I looked at him and he looked at me—no words

required—and we left, and that was the real beginning. I'd had a bit of my guard still up, but when you go to the theater with someone and you mutually hate or love something, the guard can come down, on both sides. This intense feeling we each had about theater helped us go deep into other things. One of the better side benefits of our collaboration for me, by the way, was that he was always able to get great seats to anything in town, even last minute.

Professionally, our relationship was smooth—he never behaved like the control ogre I'd worried about. I did from time to time need to strongly advise him to avoid certain moneymaking projects that would do no service to his reputation. On one of my early visits to the studio he pulled out the nudes he'd made for a Pirelli calendar. I mean, these were not nudes that were deep or particularly original. They were essentially high-class soft-porn calendar pictures. He was surprised at how emphatic I was that he not edition them, since he'd assumed that, being a dealer, I would look at them as a cash cow. And of course they would have been salable, but I'd been brought in for presumed expertise in how to get his best work taken seriously. He didn't push back. Anyway, that was one of the first tests.

Dick's first show at the gallery took place in 1999, titled simply "Portraits." The two photographs I'd proposed for the exhibition announcement were Dick Hickock, one of the killers from *In Cold Blood*, and his father. He went along with those unexpected suggestions, and they sent the right message. The next show, "Made in France," came about two years later in an unforeseen way. After dinner in his apartment he pulled some prints out of a crate that he said were about to go to storage. These were his *Harper's Bazaar* engraver's prints of Suzy Parker in Paris from the fifties, on their original mounts, with phenomenal notations of every variety. It didn't take a genius to see how incredibly great these were, so I told him, "This has to be an exhibition and a book." He said, "But so many of them have already been published," and I said, "Not the way they should be: *as is*—with the mounts, and your grease-pencil notations, and the copyright stamps, and Carmel Snow's descriptions of the outfits." It was not easy to sleep that night, and the next morning I set about fast-tracking the project for November 2001. Dick came to San Francisco for the opening and book signing. The book was

priced at seventy-five dollars, and the line was out the door. Today a signed copy in pristine condition can go for as much as three thousand dollars. The special edition, with an original print, would be a good bit more. This is one of those rare books I look at and think, This could not be improved.

The top of the line as far as his fashion work goes is, for me, the photograph of Suzy Parker and Robin Tattersall on roller skates in the Place de la Concorde. A print of that image arrived one day in a package along with various other photographs Dick was sending us for clients. I had of course known the picture from books, but seeing the actual print spurred me to look at it in a different way. I brought it into my office to spend some time with it alone. It's one of those super-complex, super-brilliant pictures that, once you get started, it's hard to stop. I called him and must have gone on about it for half an hour, and when I was finished he said, "Keep it, it's yours." And so it joined the two other Avedons I was living with: the portrait of Alexey Brodovitch and an early portrait—the boy in Sicily.

Two thousand two was a banner year for Dick, with the Met's "Portraits" exhibition, which had resulted from the introduction to Maria Hambourg. He appreciated how much that show blasted through preconceived notions about the seriousness of his achievement. The next year the gallery presented the exhibition "The Factory & The Family." The Warhol mural, ten by thirty-one feet, occupied an entire wall of the main space, and it was exhilarating for visitors, not to mention all of us at the gallery, to walk in and be confronted by that. In the second room were all the *Rolling Stone* "Family" portraits.

In mid-September of 2004, a couple of weeks before he died, Dick came to San Francisco to photograph Sean Penn and others for his *New Yorker* "Democracy" portfolio. He spent a full afternoon at the gallery, royally charming the staff. He was high on the portraits he'd made at the recent Democratic and Republican conventions, and in my office he pulled out some preliminary *New Yorker* layouts. He said the high-ranking Republicans had been warned to steer clear of him and his camera, but that he was still hoping to nail at least Rumsfeld and Cheney. Then he took off, saying he was walking to City Lights bookstore and might even drop in at Francis Ford Coppola's café in

North Beach. The next day was particularly beautiful. We went for a ride on my Vespa, down crooked Lombard Street and up to Coit Tower, taking in the hills. A total blast.

That week we went to Zuni two nights in a row, where he always ordered the roast chicken. Dick was like that with theater, too—when he found something he liked, he wanted to go back the next night. One evening we went to the theater. It was, I'm pretty sure, the last performance he ever saw, and it's too bad it couldn't have been something a little more edifying than Dame Edna, but he had wanted to see it. After dinner his last night in San Francisco, he insisted on several of us accompanying him to a club in the Mission where Adam Gopnik's nephew was performing. It was a lot of fun, but I slipped away after midnight, totally exhausted. Dick stayed on. And that was the last time I ever saw him.

I was on a hiking trip with friends in Yellowstone when I got the call from the studio about the incident in San Antonio. Our itinerary had us moving into ever more remote areas, where you couldn't count on being able to get or make calls. Whenever I had a bit of a cell signal I would call for an update on Dick's condition. The news was never encouraging.

The place where I was staying on October first had no cell service and no phone in the room—to call the studio I had to go out and find a pay phone. When they told me Dick had just died, I couldn't talk. It's a cliché, but he was too young—eighty-one going on forty-eight. Truly, was anyone ever more crazy-contagious fun to be around? At the very bottom of the evolutionary scale of my thoughts, and I remember smiling as I thought it, was, No more great last-minute theater tickets.

Dick was gone, but there was still plenty to do. Working with Norma and the Richard Avedon Foundation over the next several years, I initiated a European retrospective that began at the great museum near Copenhagen called Louisiana and traveled to other institutions, including the Jeu de Paume in Paris—a few feet from the spot, by the way, where Dick had photographed Suzy Parker and Robin Tattersall on those roller skates. The crowds, to nobody's surprise, were huge.

The gallery presented two further exhibitions: one concentrating on the idea of performance, and the other, "Eye of the Beholder" it was

called, consisting of photographs by artists from Dick's personal collec-
tion. Most important, we continued to place Dick's work in significant
private collections and museums, including a sale of about thirty or so
great pictures to MoMA.

JOHN LAHR: Like most of Dick's friends, I still feel a little bitter that
there was never a proper memorial service. There are two things I
would have wanted to stress about him. One was his passion for
theater—and, by extension, the theater of life. The other was his genius
for friendship.

Long before I met him, Richard Avedon was an inescapable pres-
ence in our household—in the person of the photograph he took of my
father, Bert Lahr, in 1956. It was the only picture of himself that Dad
allowed in the apartment. He had it hung in his bedroom, and I can
still see him, in his terry-cloth slippers and blue Sulka robe with the red
tassels, staring at it with a kind of grateful amazement. Avedon had
asked him to dress in the costume of the role he was playing at the
time: Estragon in *Waiting for Godot*—the ultimate tatterdemalion.
The picture that resulted is sublimely, irreducibly Dad in all his tragi-
comic bewilderment—he was someone playing Beckett who didn't
know what the word *existential* meant.

For his portraits retrospective at the Met in 2002, out of the thou-
sands of photographs he had to choose from, Dick chose Dad to be one
of the two that flanked the entrance to the first room. Buster Keaton
was the other, and both of them are profound studies: Dick's under-
standing of the world of clowns and comics, his take on masquerade
and on frivolity in general, was nonpareil. He was magnanimous in
not only allowing me to use his photograph of Dad on the cover of
my Bert Lahr biography, *Notes on a Cowardly Lion*, but in giving me
a print of it—along with, over the years, photographs he took of Noël
Coward, Willie Mays, Marilyn Monroe, and Audrey Hepburn, not to
mention me.

At that Met opening I ran into André Gregory. We toured the galler-
ies arm in arm, visiting the visages on display as one would a series of
geographical landmarks, and concluding—it was a no-brainer—that
no one had ever given this country a deeper, wider-ranging photo-

graphic document of itself. Then I circled back to the entrance, to spend some time with Dad.

It could be said that Dick "discovered" me. He happened to read an article of mine in a give-away weekly called *Manhattan East* and he sat down and wrote me a fan letter. It was like hearing from God. We began meeting regularly. On one occasion he noticed I wasn't my usual self for some reason, and the next morning a note arrived by messenger: "Consider me your father—anything you need, anytime, I'm here for you." And he was.

Small wonder I wanted to knock it out of the ballpark for this second father of mine. Dick was foremost among the readers I kept in mind when I was writing, and as soon as he'd read any piece of mine in print, he would weigh in. Not always positively—for instance, when I had some negative things to say about Stephen Sondheim. On the overwhelming whole, though, he not only cheered me on but acted as a cheerleader *for* me, extolling me in print as "one of the few constructive intellectuals" writing about the contemporary theater. It felt great to have someone who *was* truly great believe in me. He was always the first person I went to when I had to make a tough career choice.

It was Dick who recommended me to Tina for the job of senior drama critic on *The New Yorker*, Dick who gave her my books and articles to read. I was one of her first hires, and went on to enjoy a twenty-year run, the happiest period of my writing life. Six months into my tenure, the magazine ran a four-page Avedon portfolio of the Broadway cast of *Angels in America* to accompany my review. I was always thrilled when Dick took the photographs for one of my pieces, because his instincts about performance were so fantastically acute. But let's face it, he could be a diva. He was a split personality: as a friend he couldn't have been kinder and more generous, but at *The New Yorker* he was autocratic, insisting on absolute control of his pictures, down to where they sat on the page. With management he was high-handed and not above throwing wobblies: a churning presence who created theater—generated drama—wherever he treaded. That he was a certified genius, of course, excused a lot.

In addition to the example of excellence and inquiry that Dick set for me, he was the engine of my getting to know a number of people I

admire, such as Mike Nichols and André Gregory, who in turn sent Wally Shawn my way. Wally showed up on my doorstep with his Magdalen College, Oxford, scarf around his neck and a pile of plays under his arm. He had them numbered one through nine, and handed them to me one by one, saying, "I want you to read these, but I don't want to know what you think." What I was thinking was, I love this guy! And, by some goofy irony, Wally wound up playing me, in *Prick Up Your Ears*, the movie that Stephen Frears made from my biography of Joe Orton. So I have Dick to thank also for that. He was a big part of my luck.

WALLACE SHAWN: Renata Adler had been urging me to go see this play by somebody called André Gregory, which she said was a madder version of *Alice in Wonderland*. And after resisting strenuously, because I didn't want to risk being influenced by a type of theater I didn't believe in, even though I had never seen it, finally I went, and I met Andre and became a believer. And best of all, he introduced me to Dick. And, gee, it was like Richard Avedon walked into a picture of himself that was already in my head—I had seen *Funny Face* when I was a boy—and that was the impression he conveyed to me the whole time I knew him.

He was effervescent, always celebrating whatever was happening. I mean, if he was having some toast, it was the best toast possible and it was a great, beautiful occasion. When I first met him, I had never done anything successful, had never done anything even acceptable, and my prospects looked pretty poor, but that didn't stop Dick from celebrating me. He just bet on me. And over the years he came to everything I did—many times over.

Andre did my first play, which got mixed reviews and never really won public approval—there were often more actors onstage than audience members in the house. Around midnight on opening night, Dick and Andre and Debbie Eisenberg and I all went to the *New York Times* building to get the life-or-death Clive Barnes review. It turned out to be one of those notices that could be read either way, but Dick characteristically chose to interpret it as very positive and made our little outing a happy event instead of a wake.

He photographed me for *The New Yorker* in 1994, along with Andre Gregory and Louis Malle, in connection with the film *Vanya on 42nd Street*—I played Vanya, Louis was the director, and Andre wrote the screenplay. But he had also photographed me once before, in 1979. I was doing a little acting, had even been in a couple of movies, and he was working with Harold Brodkey on a print and TV campaign for the Japanese company Suntory Old Whisky and he decided he wanted to use me in one of the ads. I was rehearsing a play in London, but he said, "We'll put you on the Concorde, the sitting will take less than three hours, and we'll fly you right back." This was pretty rich stuff for a guy who only three years before had been working as a Xerox-machine operator for three bucks an hour.

The problem was that by the time I landed I realized I didn't want to have any truck with advertising, especially liquor advertising, and I wanted to pull out of it. I never would have, really, because that's not how my mother raised me, which was that if you said you were going to do something, you had to do it. When I explained the deep reservations I had to Dick and Harold, they tweaked the ad to make it work for me. They had me sitting in a chair, with a glass of the old Suntory in my hand that I never so much as had to take a sip of—I just looked into the camera and said something harmless like "I don't drink, but if I ever *were* to drink, it would definitely be Suntory Old." That ad was a life-changing experience, because I promised myself I would never do another one as long as I was lucky enough to be able to do real acting and performing. And I can tell you in all truthfulness that I would be a wealthy man today if I *had* been willing to, because in the eighties I was quite a popular little man, lisping and small and bald and whatever else I was—I was getting so many offers to do ads I finally had to tell my agents not to even bother to run them by me. And by the way, that Suntory ad, thank heavens, was shown only in Japan.

Around 1996 I had the preposterous idea that my play *The Designated Mourner* should have its original production at the Royal National Theatre in London and that David Hare should direct it. I screwed up my courage and asked Mike Nichols if he would be willing to do a reading of it for Hare, and he said yes, and then Dick generously offered to have it at the studio. So Mike, Julianne Moore, and the poet

Mark Strand read my play at the kitchen table in Dick's living quarters. Mike was so mind-boggling as "Jack" that Hare asked him on the spot to be in it for real, and again Mike said yes. Then the theater designer Bob Crowley said he thought Dick's table would make the perfect set and he proposed building a replica of it for the National Theatre. So *The Designated Mourner* was a play made, so to speak, in Dick's apartment. And of course, being Dick, he flew to London for the opening.

He would sometimes show up at the parties my parents would give to jointly celebrate my birthday and Debbie's, which are not too far apart, and again, you just always felt that nothing too bad could happen when Dick was around. My father was the editor of *The New Yorker* at the time, and it's a safe assumption that Dick would have had a negative opinion of the fact that the magazine didn't use photographs. Yet he and my father seemed to find each other incredibly interesting. Growing up in that household, I had been exposed to many certified geniuses, but they were all introverted ones. To be with Dick, in contrast, was almost always a heightened experience, one in which you came to really appreciate being alive yourself. He exuded this incredibly infectious sense that you should just go out and *do* the things that you would like to—within reason, it goes without saying. The only person I would compare him to in that respect was my mother, because she, too, believed that it was your obligation to be joyful.

And by the way, I met *his* mother, many a time. I remember her as someone with a sense of fun, someone who enjoyed the comédie humaine, and someone who was maybe even rather wily. There was a certain shrewdness there, like if she wanted the butcher to give her the center cut, she could make it happen.

I'm sure Dick had moments when he sat around in his bathrobe feeling miserable, but I never saw those—there were only seconds, not even minutes, when there might have been a hint of that side of him. It would never have crossed my mind to say to him anything like, "Dick, our lives are finite, we're not going to be around forever, so tell me about your soul—what you regret, what you grieve about in the middle of the night."

I was certainly aware that he had anxieties, that he was inwardly tortured by different issues. I knew how desperately he had craved to be

accepted into the safe center of America. I mean, he was a Jew—we were *all* fleeing from something, afraid of being tracked down and killed. Naturally we sought security, and security in this country comes from being wealthy, from being so far on the inside that no one can come and get you. Dick certainly achieved that—he became one of those people who are themselves the center of things.

I knew how hard he had taken that Robert Brustein review of *Nothing Personal* in *The New York Review of Books*. I told him that it couldn't have been worse than what Brustein had had to say about *me*, in the *New Republic*. He wrote about me twice, actually, and then reprinted it all in one of his books. Dick took those things so seriously. He took *The New York Times* unbelievably seriously. I assumed that that was just part of that safety thing, you know: the *Times* was like the Bible—you could go into certain neighborhoods and every single person would be clutching it.

The other day I was faced with having to search the *Times* online for something relating to one of my plays, and the first words in the first thing that came up were something like "Wallace Shawn is well-known for his comical lisp, his laughable size and face, but believe it or not, he also writes plays." There's been practically nothing written about me as a writer that didn't begin that way. So—not to compare myself to Dick in any way—I do understand his feelings of helplessness there. About Dick they would say, "This is a man who has photographed the most beautiful women in the world surrounded by snakes, and then, believe it or not, he went out West to photograph a bunch of ugly no-bodies." They have this stupid need to categorize. But Dick to the end believed, wrongly I think, that a person could control his reputation, that if you schemed cleverly and relentlessly enough, you could control what society and the culture thought about you.

Debbie and I had dinner at his place not terribly long before he died. I'd seen a lot of people become weaker as they aged, become not like what they were, but nothing of that sort seemed to me to be happening with Dick. It would have been unimaginable. I very vividly remember how I felt when I looked at his photographs of his father shortly after he had taken them—while finding them great, I knew that that would be absolutely the last way Dick would ever want to wind up.

A far better thing that he ended the way he did—quickly and on the side of life.

ANDRÉ GREGORY: Dick came to forty-two performances of my *Alice* in 1970. He came backstage after the eighteenth time and announced that he wanted to photograph the play, make a documentary record of it—a book. I didn't quite see how a photographer, even a Richard Avedon, could express its spontaneity and playfulness, the kinetic quality it had. But as we well know, Dick had charm off the charts, he was like a pied piper—there was simply no way to say no to him.

He rented a special studio to shoot in, and we performed the play for him on twelve separate occasions—my actors were fresh out of theater school and had phenomenal energy. The other big extracurricular project he had going at the time was his book with Lartigue. I had always felt that Lartigue and I had something in common: neither one of us thought of himself as a professional. I'm very happy to sometimes be called a dilettante. In Rome it was considered a great achievement to be one. If you look up both the Latin and the Sanskrit roots of that word, you'll find something like "he of many talents who digs his hands into the earth and releases the waters of life."

I operate completely outside the so-called professional theater. My way of work is similar to the Actors Studio in its heyday. I use mostly the same actors, and we play to audiences of only around twenty. A normal rehearsal period lasts five or six weeks, but mine sometimes go on for fourteen years. Dick and I had a big ongoing fight about this. I don't think there was anyone who appreciated my theater work more than he did, but the fact that I wasn't a Mike Nichols and would take forever to rehearse a play drove him nuts. He accused me of being extremely lazy—he said, "I'm sure if you put your mind to it, you could do ten times as many plays." Well, I couldn't, and I didn't want to.

Now I have to confess something: I didn't like Dick's *Alice* photographs all that much at first. Because of all the white. My production was very funky, full of dust and rags, yet the photos he took were all crystalline. I'm embarrassed to tell you how long it took me to appreciate that they're probably the best pictures he ever did—the most emotional and original. When we got the estimate on what the paper for

the book was going to cost, it was prohibitive. The thing was going to have to sell—even in paperback—and in 1973, mind you—for over a hundred dollars, and we wanted students to be able to afford it. And then one day the most beautiful Japanese paper materialized—Dick had paid for it all out of his own pocket. *The New York Times Book Review* called his photographs of the production the best evocation of an American theatrical event ever published.

His largesse didn't end there. He hosted a reading upstairs in his studio for *My Dinner with Andre*. His living room, by the way, was one of the most beautiful rooms I've ever seen. Every object was a thing of real beauty. Somebody like Picasso might have had a room like that. Or Matisse. It was an artist's room. And what went on downstairs was artistic, too. I would sometimes be there for lunch, and it always had the feeling of a meal you might have had with Renoir and his friends by the Seine a hundred years earlier.

Anyway, after the reading, Dick said to me, "This is a great, great work. Except for you. You're terrible at playing yourself—they've got to get an actor to play you. Somebody like Peter O'Toole." I hadn't done any acting since I was twenty-two, and I was very insecure. I went running to my director, Louis Malle, to tell him Dick's great idea. He said, "Yes, Peter O'Toole would be great, but then who would direct the movie? The only actors *I* would work with are you and Wally Shawn." To be fair to Dick, fifteen years later he called me the first thing one morning and said, "Just for the hell of it I put *My Dinner with Andre* on last night and I have to admit I was dead wrong. I didn't understand that you weren't trying to *be* yourself, that you were giving a *performance* as yourself." That was good to hear—at long last.

I made the mistake once of critiquing some of *his* work. I thought those religious pictures he took for *The New Yorker* in India and places like that were far from his best. I mean, Dick just wasn't a spiritual man. I felt perfectly entitled to criticize them, since I *had* been on a spiritual journey. Now, I'm not crazy about most religions, but the spirit is something different. And by the way, I kept asking myself, How come he's *not* a spiritual man when he's spent his entire working life looking at light?

Dick was someone who was very much there for you if you were in

deep trouble. He was extremely sweet to me when my wife Chiquita died. New York, you know, is all about success—in my experience, it's the absolute worst place to be in trouble in—and death is the ultimate failure, and when somebody close to you goes, nobody much wants to be around you. But if it wasn't about something quite serious like death, Dick enjoyed your being in trouble—he loved drama of all kinds.

He photographed Chiquita and me and our kids a number of times over the years. And he used me as a model in that over-the-top campaign he did for the Christian Dior licensees in the U.S. I played the character called the Wizard, the luscious model Kelly Le Brock played the Mouth, and an art-dealer friend of Dick's, Vincent Vallarino, was somebody called Oliver: we were the Diors. Those ads were deliberately titillating. Dick told me he had gotten the idea for them from a set of still photographs of Noël Coward's 1933 play *Design for Living,* which was about a ménage à trois. When two of us Diors got married and said "I do" and "I do," respectively, the third one piped up, "I do, too!" The married couple went on to make a baby, which was "played" by an infant grandson of Dick's. The ads ran in installments, like a soap opera—once a week for thirty weeks, in *The New York Times Magazine* and *The New Yorker,* among other places. I was featured in all of them, and not only did I get pretty famous in an entirely new world, I got paid.

I remember once saying to Dick that immortality meant nothing to me, I just didn't give a damn if nobody knew my work after I was gone. He took offense at this. Because, of course, for him, immortality *was* a big deal. I always thought that if somebody wanted to write *the* great American novel about a great American artist, he would be the perfect subject. The right writer could take Dick and just riff on him endlessly. Saul Bellow could have done it.

BILL BACHMANN: Dick's denouement was straight out of a novel and then some. A couple of months after he died, his housekeeper Verlie was whipping up one of her delicious lamb stews for Dick's son, John, and his wife upstairs at the studio. She kept her spices in the set of stainless-steel canisters that Dick had purchased in Paris because

they matched the color of his Sub-Zero refrigerator. John had just told a hilarious joke and Verlie was laughing so hard she opened the wrong canister and, thinking it was oregano, sprinkled Dick's glorious remains onto the sizzling lamb, carrots, and potatoes.

NORMA STEVENS: Words fail.

ACKNOWLEDGMENTS

——

IRST, WE WISH TO THANK OUR GOOD FRIENDS NATALIE ROBINS and Christopher Lehmann-Haupt whose inspired idea it was to put us together as co-authors.

We thank all those who spoke to us about Richard Avedon: Renata Adler, Vince Aletti, Ruth Ansel, Pierre Apraxine, Amy Arbus, Lisa Atkin, Nadja Auermann, Elizabeth Cox Avedon, Luke Avedon, Dr. Nathan Averick, Lauren Bacall, Bill Bachmann, David Bailey, Nelson Bakerman, François-Marie Banier, Jed Bark, Stephen Barker, Mikhail Baryshnikov, Peter Beard, Paul Beck, Małgosia Bela, Shari Belafonte, Marisa Berenson, Rosamond Bernier, Jamie Bernstein, Iris Bianchi, Andrea Blanch, Koto Bolofo, Julie Britt, Sandy Buchsbaum, Chris Callis, Naomi Campbell, Oribe Canales, Drew Carolan, Paul Cavaco, Susan Chieco, Arthur Cohen, Cindy Crawford, Billy Cunningham, Yolanda Cuomo, Kitty D'Alessio, Mike Davis, Carlyne Cerf de Dudzeele, Garren DeFazio, John Delaney, Grant Delin, Carmen Dell'Orefice, Raymond DeMoulin, Janice Dickinson, Pamela Dillman, Jeremy Dine, Shelley Dowell, Nina Drapacz, Ingrid Drotman, Frederick Eberstadt, Owen Edwards, Deborah Eisenberg, John Enos, Linda Evangelista, Harris Feinn, Frances FitzGerald, Eileen Ford, Jeffrey Fraenkel, Michael Frankfurt, Kevin Funabashi, Sarah Funke, Robert Gabriel, Peter Galassi, Maggy Geiger, Sarah Giles, Ann Giordano, Richard Gluckman, Kara Glynn, Adam Gopnik, Jill Graham, Francine du Plessix Gray, Amy Greene, Joshua Greene, Andre Gregory, John Gruen, Jerry Hall, Maria Morris Hambourg, Willis Hart-

shorn, Nicholas Haslam, Ashton Hawkins, Simon Head, Dr. Lauren Helm, Maxine Henryson, Brian Hetherington, Lizzie Himmel, Hiro, Jane Stanton Hitchcock, Jade Hobson, Ruedi Hofmann, Nancy Hoving, Colta Ives, Junichi Izumi, Barbara Jakobson, Dawn and Ed Johann, James Kaliardos, Helen Kanelous, Julie Kavanagh, Dodie Kazanjian, Dirk Kikstra, Sebastian Kim, Calvin Klein, Susan Graham Kraus, Evelyn Kuhn, John Lahr, Jeanne Landwehr, Jennifer Landwehr, Professor Irving Lavin, June Leaf, Kelly Le Brock, David Leddick, John Post Lee, Robert Lee, Dr. Steven Lee, Estelle Lefébure, Gideon Lewin, David Liittschwager, Marguerite Lamkin Littman, Jane Livingston, Stanley Lobel, Alicia Grant Longwell, Santo Loquasto, "Doc" Losee, Jonathan Losee, Mark Lyon, Peter MacGill, China Machado, Alen MacWeeney, Edoardo Mantelli, Daymion Mardel, Patricia Marx, Harvey Mattison, Pamela Maffei McCarthy, Marc McClish, Patricia Knack McKay, Joe McKenna, Polly Mellen, Paul Meyer, Marlene Meyerson, Charles Michener, Diana Michener, Caterine Milinaire, Dr. Robert Millman, Grace Mirabella, Isaac Mizrahi, Ben Monk, Maura Moynihan, Barry Munger, Weston Naef, Kaz Nakamura, Mike Nichols, Susan Copen Oken, Cynthia O'Neal, Guido Palau, Claude Picasso, Robert J. Reicher, David Remnick, Kerry Roland, Barbara Rose, Jeff Rose, Camilla Rosenfeld, David Ross, Peggy Ross, Isabella Rossellini, Marc Royce, Rene Russo, Nicoletta Santoro, Ellen Schwamm, Penny Cobbs Sepler, Sam Shahid, Mary Shanahan, Wallace Shawn, Ellie Shearing, Brooke Shields, Anney Siegel-Wamsat, Barbara Sinatra, Stephen Sondheim, David Spear, Tony Spinelli, Carol Squiers, Kenneth Starr, Earl Steinbicker, Cameron Sterling, Alfred R. Stern, Peggy Stern, Martin Stevens, Max Stevens, Molly Stevens, Robert Stevens, Robin Tattersall, Stella Tennant, Twyla Tharp, Judith Thurman, Jennifer Tipton, Brian Tolle, Eileen Travell, Penelope Tree, Deborah Turbeville, Patricia Avedon Turk, Christy Turlington, Shonna Valeska, Amber Valletta, Jim Varriale, Donatella Versace, Veruschka von Lehndorff, Tim Walker, Nick Waplington, Bruce Weber, Marla Weinhoff, Jane Wenner, Jann Wenner, Richard Wheatcroft, Helen Whitney, Laura Wilson, Nicole Wisniak, Meg Wolitzer, and Michael Wright.

Thanks also to Larry J. Abowitz, Francie Alexander, Christopher

and Jean Angell, Barbara Bachman, Nejma Beard, Sally Berman, Ashley Bete, Frish Brandt, Annie Chagnot, Mengfei Chen, Gerald Clarke, Dr. Frances Cohen, Ann Dexter-Jones, Diana Dyjak Montes de Oca, Susan Forristal, Jonathan Frembling, Philippe Garner, Aaron Richard Golub, Julie Grau, Pat Hackett, Jerome F. Hamlin, Pierre Henry, Stephan Johansson, Alan Kleinberg, Vincent La Scala, Peter Lev, William LoTurco, Matthew Martin, James R. Mellon, Vivian Mellon, Greg Mollica, Patricia Patterson, Robert M. Pennoyer, Jeff L. Rosenheim, Paul Roth, Mary Carroll Scott, Patty Sicular, John Silvis, Jillian Suarez, Georgia Thoreau La Salle, Nancy Tilghman, Patricia and Robert Volland, Shelley Wanger, and Margaret Zoller.

We are greatly indebted to Jennifer Kinney, Rachel Valinsky, and Ariella Wolens, who were extraordinarily resourceful at finding whatever was needed to clarify the picture. We remain grateful to our wise and enterprising agent, David Kuhn. And finally, no one deserves more gratitude and praise than our editor and publisher, Celina Spiegel, who nurtured this project every step of the way, with good humor, good taste, and unfailingly sound judgment.

PHOTO CREDITS

Page 151: Photograph by Paul Himmel © Estate of Paul Himmel

Page 157: Marc Riboud/Magnum Photos

Page 158: Henri Cartier-Bresson/Magnum Photos

Page 161: Walter Sanders/The LIFE Picture Collection/Getty Images

Page 168: Everett Collection

Page 171: © The Cecil Beaton Studio Archive at Sotheby's

Page 173: Alen MacWeeney

Page 174: David Seymour/Magnum Photos

Page 175: AP Photo

Page 176: Ron Galella/Getty Images

Page 200: Denis Cameron/REX/Shutterstock

Page 201: Sheldon Ramsdell

Page 205: Bachrach/Getty Images

Page 210: Photograph by Adrian Panaro © 1977

Page 214: Ruedi Hofmann

Page 220: Ron Galella/Getty Images

Pages 222, 224: Laura Wilson

Page 227: Alan Kleinberg

Pages 229, 230: Laura Wilson

Page 231: Stevens Family Collection

Page 234: Ruedi Hofmann

Page 240: Reg Lancaster/Stringer/Getty Images

Page 243: Dan D'Errico/Penske Media/REX/Shutterstock

Page 251: Nina Drapacz

Page 255: Eric Weiss/Penske Media/REX/Shutterstock

Page 257: Stevens Family Collection

Page 276: George Chinsee/Penske Media/REX/Shutterstock

Page 322: Stevens Family Collection

Pages 324, 325: Susan Chieco Collection

Page 329: Martin Stevens

Page 330: Stevens Family Collection

Page 346: Alen MacWeeney

Page 349: Tazio Secchiaroli © Tazio Secchiaroli/David Secchiaroli

Pages 361, 362: Stevens Family Collection

Page 413: Marc Royce

Page 428: Andrew L Moore

Page 432: Martin Stevens

Page 455: Bertrand Rindoff Petroff/Getty Images

Page 467: Stevens Family Collection

Page 471: PL Gould/IMAGES/Getty Images
Page 478: Stevens Family Collection
Page 521: Sarah Giles Collection
Pages 524, 525, 527, 528, 529, 531: Sarah Giles
Page 541: ROTA/Camera Press/Redux (top); © Philippe Garner (bottom)
Pages 546, 549, 553: Stevens Family Collection
Pages 561, 563: Jim Varriale
Pages 565, 566, 568: Elizabeth Cox Avedon Collection
Page 582: Elizabeth Cox Avedon
Page 588: Stevens Family Collection
Pages 609, 610, 618, 623: © Daymion Mardel
Page 635: Photo © Gideon Lewin

INDEX

———

ABOUT THE AUTHORS

———

NORMA STEVENS was a copywriter and creative director in advertising when Richard Avedon wooed her to become his studio director in 1976. She collaborated with him on all his commercial, editorial, and fine-art projects and traveled the world with him for his ad campaigns and museum exhibitions. At his death, in 2004, she became the founding executive director of the Richard Avedon Foundation, which she led for five years. She is a longtime board member of the Twyla Tharp Dance Foundation.

STEVEN M. L. ARONSON met Richard Avedon in 1970, and their paths continued to cross throughout Avedon's life. A former book editor and publisher, he is the author of *Hype* and the co-author of the Edgar Award–winning *Savage Grace*. He contributed the biographical section to the collector's edition of the work of the photographer Peter Beard. His profiles, interviews, and articles have appeared in *Vanity Fair, Vogue, New York, Esquire, The Village Voice, Architectural Digest, Poetry, Interview,* and *The Nation.*

ABOUT THE TYPE

———

This book was set in Electra, a typeface designed for Linotype by renowned type designer W. A. Dwiggins (1880–1956). Electra is a fluid typeface, avoiding the contrasts of thick and thin strokes that are prevalent in most modern typefaces.

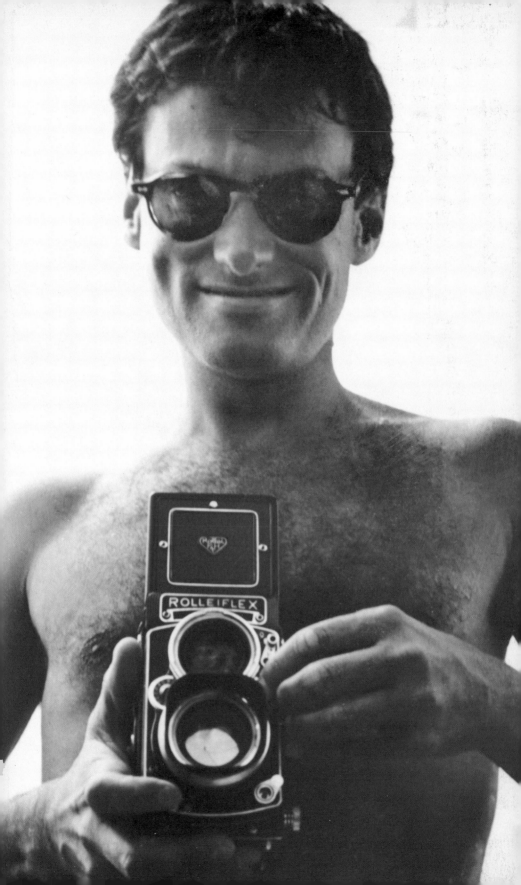